American Light

THE LUMINIST MOVEMENT ❧ 1850-1875

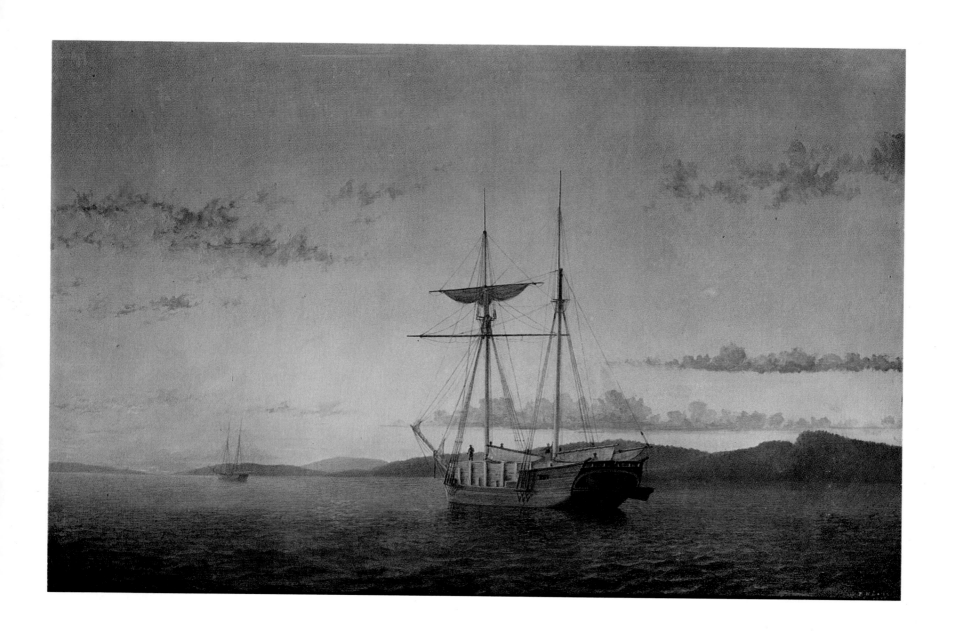

American Light

THE LUMINIST MOVEMENT ❧ 1850-1875
PAINTINGS ❧ DRAWINGS ❧ PHOTOGRAPHS

JOHN WILMERDING

with contributions by

LISA FELLOWS ANDRUS WESTON NAEF

LINDA S. FERBER BARBARA NOVAK

ALBERT GELPI EARL A. POWELL

DAVID C. HUNTINGTON THEODORE E. STEBBINS, JR.

Harper & Row, Publishers

National Gallery of Art, Washington

Cloth edition published by Harper & Row, Publishers, 10 East 53rd Street, New York, N.Y. 10022 in association with the National Gallery of Art, 1980.

Published in Canada by Fitzhenry & Whiteside Limited, Toronto.

Manufactured in the United States of America
ISBN 0-06-438940-5

This catalogue was produced by the Editors Office, National Gallery of Art, Washington. Printed by Eastern Press, Inc., New Haven, Connecticut. The type is Galliard, set by Composition Systems Inc., Arlington, Virginia. The text and cover papers are Warren Lustro Offset Enamel Dull. Designed by Frances P. Smyth.

Exhibition dates at the National Gallery of Art
February 10-June 15, 1980

Cover: Fitz Hugh Lane. *Ships and an Approaching Storm Off Owl's Head, Maine,* 1860. Governor and Mrs. John D. Rockefeller IV (detail, plate 9)

Frontispiece: Plate 1. Fitz Hugh Lane. *Lumber Schooners at Evening on Penobscot Bay,* 1860. Private collection. Photo: Herbert P. Vose (see fig. 1)

Library of Congress Cataloging in Publication Data

Main entry under title:
American light.

An exhibition to be held at the National Gallery of Art, Feb. 10-June 15, 1980.
 Bibliography: p. 313
 Includes index.
 1. Luminism (Art)—Exhibitions. 2. Landscape painting, American—Exhibitions. 3. Landscape painting—19th century—United States—Exhibitions. 4. Hudson River School—Exhibitions. I. Wilmerding, John. II. Andrus, Lisa Fellows.
ND1351.5.A46 758'.1'09730740153 79-24409

Contents

Plate 2. John Frederick Kensett. *Beach at Newport*, c. 1850-1860.
National Gallery of Art, Washington, D.C.; Gift of Frederick Sturges, Jr., 1978 (see fig. 2)

Foreword

FROM THE TIME OF ITS FOUNDING THE NATIONAL GALLERY has asserted a strong and continuing interest in the art of our own country. Quite appropriately, several key American paintings were among the earliest acquisitions Andrew Mellon made for the Gallery, and over subsequent decades this core has grown steadily in quality and numbers to one of the largest departments in the institution. The American collection now offers an outstanding overview of this nation's most significant achievements in painting and, in the company of other Washington collections, constitutes an unparalleled resource.

In sponsoring this publication and the accompanying exhibition, *American Light: The Luminist Movement, 1850-1875,* the National Gallery inaugurates a renewed and vigorous program in the study of American art. Our current activities would not have been possible without the devoted nurturing of the collection and periodic exhibitions by the late William P. Campbell, who for many years served as assistant chief curator and was senior curator and the curator in charge of American painting. Following Mr. Campbell's untimely death in 1976, John Wilmerding was appointed senior curator and curator of American art at the Gallery. Among the projects his department has undertaken in the last two years have been the complete rehanging of the American galleries in the West Building, publication of a new illustrated handbook of the American collection—an early step in the ongoing cataloguing of our total holdings—and the initiation of a major new series of exhibitions focusing on important figures or aspects in American art.

Over a decade ago the Gallery mounted large monographic exhibitions devoted to such artists as Gilbert Stuart, John Singleton Copley, Winslow Homer, and John Sloan as well as Thomas Eakins, George Bellows, William Sidney Mount, and John Gadsby Chapman. *American Light* has been a similarly ambitious undertaking, although its scope is somewhat broader. Concentrating on a crucial period in the middle of the nineteenth century, it examines a style now called *luminism,* widely practiced by a number of fascinating figures only fully discovered in recent years. Such talented painters as Fitz Hugh Lane, Sanford Gifford, John F. Kensett, and Martin Johnson Heade were largely obscured after their art passed out of fashion in the later nineteenth century. Perhaps the most crucial artist of that period, Frederic Edwin Church, now emerges as the most technically able and original painter in America prior to Homer and Thomas Eakins. This exhibition brings before the public a group of pictures with a common interest in the radiant effects of light and atmosphere. Together they stand as some of the most beautiful and compelling paintings ever executed in the history of American art.

The Gallery is equally proud to publish this substantive book on the occasion of the exhibition. We are honored to have contributions from some of the most distinguished scholars in the American field. To their great credit and our pleasure they have all transcended previously established views on the subject of luminism with essays of provocative and fresh insights. We are confident that the eloquent images of American landscape shown in this exhibition and volume offer a memorable experience. Equally, the scholarship reflected here promises to make an influential impact on our writing and thinking about American art.

Our gratitude goes to Mr. Wilmerding for organizing this entire undertaking, and to Linda Ayres, the assistant curator of American art, for her tireless efforts in coordinating many technical aspects of the exhibition and catalogue. We are also indebted to Polly Roulhac for her skillful editing of these essays.

Above all we would like to thank the many lenders who have so generously made this exhibition possible.

J. Carter Brown
Director

Lenders to the Exhibition

Albright-Knox Art Gallery, Buffalo, New York
Lyman Allyn Museum, New London, Connecticut
Amon Carter Museum, Fort Worth, Texas
Mr. and Mrs. Harold Bell
Boston Public Library
The Bostonian Society, Old State House, Boston
The Brooklyn Museum, New York
Butler Institute of American Art, Youngstown, Ohio
Cape Ann Historical Association, Gloucester, Massachusetts
The Century Association, New York
Cincinnati Art Museum
The Cleveland Museum of Art
Cooper-Hewitt Museum, New York
The Smithsonian Institution's National Museum of Design
The Corcoran Gallery of Art, Washington, D.C.
The Currier Gallery of Art, Manchester, New Hampshire
Dallas Museum of Fine Arts
Dartmouth College Library, Hanover, New Hampshire
Mrs. James H. Dempsey, Jr.
Denver Public Library
Maitland C. DeSormo
Mr. H. Richard Dietrich, Jr., Philadelphia
The Board of Governors of the Federal Reserve System, Washington, D.C.
Jerald Dillon Fessenden
Flint Institute of Arts, Flint, Michigan
John Davis Hatch
Mr. and Mrs. Stephen G. Henry, Jr., Baton Rouge, Louisiana
The High Museum of Art, Atlanta, Georgia
Indiana University Art Museum, Bloomington

Indianapolis Museum of Art
Joslyn Art Museum, Omaha, Nebraska
The Lano Collection
The Library of Congress, Washington, D.C.
Los Angeles County Museum of Art
Margaret Farrell Lynch
Richard Manoogian
The Mariner's Museum, Newport News, Virginia
Massachusetts Institute of Technology Libraries, Cambridge
Mrs. Flagler Matthews, The Henry Morrison Flagler Museum, Palm Beach
Mr. and Mrs. Paul Mellon, Upperville, Virginia
Memorial Art Gallery of the University of Rochester, Rochester, New York
The Metropolitan Museum of Art, New York
Dr. and Mrs. M. S. Mickiewicz
Mint Museum of Art, Charlotte, North Carolina
Montclair Art Museum, Montclair, New Jersey
Munson-Williams-Proctor Institute, Utica, New York
Museum of Art, Carnegie Institute, Pittsburgh
Museum of Fine Arts, Boston
Museum of Fine Arts, Springfield, Massachusetts
The Museums at Stony Brook, New York
The National Archives, Washington, D.C.
National Collection of Fine Arts, Smithsonian Institution, Washington, D.C.
New Bedford Whaling Museum, New Bedford, Massachusetts
New Britain Museum of American Art, New Britain, Connecticut
The New-York Historical Society, New York
New York State Historical Association, Cooperstown
Newark Museum, New Jersey
The Pell Family Trust; Hon. Claiborne Pell, Trustee

Acknowledgments

Pennsylvania Academy of the Fine Arts, Philadelphia
Mr. and Mrs. Andrew S. Peters, New Jersey
Philadelphia Museum of Art
The Art Museum, Princeton University, Princeton, New Jersey
Reading Public Museum and Art Gallery, Reading, Pennsylvania
Mrs. H. Brown Reinhardt, Newark, Delaware
Reynolda House, Inc., Winston-Salem, North Carolina
Governor and Mrs. John D. Rockefeller IV
Mr. and Mrs. Wilbur L. Ross, Jr.
St. Johnsbury Athenaeum, Inc., St. Johnsbury, Vermont
The St. Louis Art Museum
The George Walter Vincent Smith Art Museum, Springfield, Massachusetts
Southwest Harbor Public Library, Southwest Harbor, Maine
J. B. Speed Art Museum, Louisville, Kentucky
Eugene B. Sydnor, Jr.
The Putnam Foundation—The Timken Art Gallery, San Diego, California
The Union League of Philadelphia
United States Naval Academy Museum, Annapolis, Maryland
University Research Library, University of California, Los Angeles
Vassar College Art Gallery, Poughkeepsie, New York
Virginia Museum of Fine Arts, Richmond
Wadsworth Atheneum, Hartford, Connecticut
Walker Art Center, Minneapolis
Walters Art Gallery, Baltimore
Daniel Wolf
Mr. and Mrs. Erving Wolf
Yale University Art Gallery, New Haven, Connecticut
and
Private Collections

THE NATIONAL GALLERY OF ART
wishes to express its gratitude
especially to the following individuals
for their assistance with this publication and exhibition:
Margaret Bond, Memorial Art
Gallery, University of Rochester, Rochester,
New York; Jeffrey R. Brown; Doreen Bolger
Burke and John K. Howat, Metropolitan
Museum of Art, New York; Beverly Carter;
Carl Crossman, Childs Gallery, Boston; Karen Current; John Paul Driscoll;
Stuart Feld and Jane Richards, Hirschl & Adler Galleries, New
York; Mrs. Marjorie Frost; Professor William
H. Gerdts, City University of New York;
Professor George Heard Hamilton, Williams
College, Williamstown, Massachusetts; Sylvia Hochfield;
Meredith Hutchins, Southwest Harbor Public Library, Southwest Harbor,
Maine; Karen M. Jones, *Antiques;* John R.
Lane, Brooklyn Museum, New York; Janet
Lehr, New York; Laura Luckey, Museum of
Fine Arts, Boston; Maria Mallus, National
Gallery of Art, Washington, D.C.; Kathie
Manthorne; Thomas Wendell Parker, Bostonian
Society, Boston; Suzanne Pastor and Susan Wyngaard,
International Museum of Photography at George Eastman House,
Rochester, New York; Bertha Saunders;
William Talbot, Cleveland Museum of Art;
Robert Vose, Jr., Vose Galleries, Boston; Joan
Washburn, Washburn Gallery, New York; Paul
White, National Archives, Washington, D.C.;
Cathy Gebhard; Patricia Alexiou and Carolyn Wistar.

Plate 3. Frederic Edwin Church. *Twilight, "Short Arbiter Twixt Day and Night,"* 1850.
Collection of the Newark Museum, New Jersey (see fig. 205)

Introduction

John Wilmerding

THIS PUBLICATION, IN CONJUNCTION WITH AN EXHIBITION on the subject of "American Light," attempts a fresh and comprehensive examination of the culminating phase of Hudson River painting. This particular movement, now commonly called *luminism,* is one of the most inconclusively studied areas of American art, yet one with works of quality and interest as high as any in the national school. The period in question is the third quarter of the nineteenth century, from the death of Thomas Cole in 1848 to the country's centennial in 1876.

The central development of the luminist movement may be seen most clearly in the work of a few key figures—Fitz Hugh Lane, Martin Johnson Heade, Sanford Gifford, John F. Kensett, and Frederic Edwin Church, though we shall also want to compare exemplary achievements by other contemporary and related artists—such as Albert Bierstadt, A. T. Bricher, William S. Haseltine, Worthington Whittredge, William Bradford, and William Trost Richards—as well as the antecedents of luminism in the personalities and works of the founding members of the Hudson River school. With the latter group is to be found America's first sweeping consciousness of its landscape, and out of their often idealized and literary conceptions gradually emerged more specific plein-air recordings of nature.

Although generally presented chronologically, the material is worth considering thematically as well. For example, several artists painted contemporaneously along the Newport-Narragansett shore, around the coast of Mt. Desert Island, Maine, and at Lake George. Likewise, at certain moments many of these painters undertook similar views of glowing atmospheric sunlight, threatening and explosive storm scenes, and incandescent twilight vistas. Seeing together a number of depictions of a favored locale, or different versions of an obsessing meteorological drama, offers revealing insights into American attitudes toward nature and the national identity during a crucial period of the country's development.

One important aspect of this material requiring attention is the group of principles of luminist style and how they apply to drawings and photography of the period—material that, to date, has hardly been treated in this context. In looking at relevant sketchbooks, along with other preliminary and finished drawings, we may gain a sense of how precisely the luminist painter responded to nature and then began to shape his conception artistically. Certain contemporary photography, too, shared similar modes of composition, viewpoint, and recording of light effects. These examples of graphic arts demonstrate that the luminist style resides not merely in the rarified colors of oil sketches and finished canvases (though the paintings in this movement are among the most beautiful and subtly colored in all of American art) but equally in the spare outlines, spacious formats, and light-filled expanses of other related mediums. Thus, luminist structure and light emerge as key stylistic elements to be analyzed here. Aiding our understanding will be a few selected sequences of sketches or versions of a particular subject—Heade's Newburyport marshes, Lane's Brace's Rock series, Carleton Watkins' Yosemite Valley—where this distinctive process is eloquently at work.

Such a study of luminism brings together a number of major American painters, most of whom have been treated in separate monographic exhibitions or books, though never in the comparative or focused manner undertaken here. By proposing luminism as the conclusive development of early American landscape painting (in contrast to the more traditional and often uneven Hudson River school surveys), one can view it as the central movement in American art through the middle of the nineteenth century. Indeed, its crystalline pictures of the 1850s stand as supreme manifestations of Jacksonian optimism and expansiveness—along with America's belief in the transcendent spiritual beauty of nature. Moreover, the apocalyptic storm and twilight scenes of the 1860s—so visually and thematically different, yet conceptually and structurally related—speak vividly of the turbulent Civil War years and the

poignant sense of loss in the aftermath.

During the seventies and after, the serenity of luminism yielded to a new, more sober realism—evident in the work of Eastman Johnson, Winslow Homer, and Thomas Eakins—while luminist structure began to give way to the looser palette and fancies of impressionism—as seen in examples by George Inness, Homer Dodge Martin, and James A. M. Whistler. For a time, however, luminism clarified the special qualities of space and light in America's mental and physical geography.

* * * *

The concept of luminism has existed in the vocabulary of American art history for the past thirty years. It owes its early definition perhaps most to the historian John I. H. Baur, who in the late 1940s discussed the particularly American consciousness of light and atmosphere in mid-nineteenth-century landscape painting, and in 1954 first employed the specific term *luminism* for the title of an article. His first and most ambitious essay, "Trends in American Painting, 1815 to 1865," was written in 1947 as an introduction to the catalogue of the pioneering M. and M. Karolik Collection of nineteenth-century paintings, given to the Boston Museum of Fine Arts two years later.[1] In this survey of a, till then, neglected period, Baur described the significant circumstances leading to the rise of landscape painting during the second quarter of the nineteenth century—among them, the influence of Ruskin's criticism, the political nationalism of the Jacksonian era, and changes in taste away from earlier neoclassical, historical, and biblical subjects.

Interestingly, he called attention to the later phase of Hudson River school painting as having distinctive qualities and used the title James T. Flexner also stressed later of the "Rocky Mountain school." This seems in retrospect primarily an effort to take account of the more distant horizons pursued by the generation of painters following Cole. But Baur also found that generally the early generation of Hudson River painters "limited their palette to dull greens and browns within a fairly restricted range."[2] It was the new use of intense sunset colors, such as were evident in Thomas Rossiter's *Opening of the Wilderness* of 1849 in the Karolik Collection, that he saw exemplifying the later luminist style and unifying its adherents in a single school.

Besides this original treatment of light and color, Baur described the intimate relation between artist and nature, the artist's concentrated process of observation, lack of literary associations, interest in atmospheric tonalism, and above all impersonal touch. Attempting to define various types of realism in American painting of the period, he basically equated romantic realism with the primary Hudson River painters and turned to the term of *pantheistic realism* for the later painters of light. To him the purest example of this type was Fitz Hugh Lane, who, with Martin Johnson Heade, Baur cited as representative of

1. Fitz Hugh Lane. *Lumber Schooners at Evening on Penobscot Bay,* 1860. Oil on canvas. 0.712 x 1.016 (28 x 40 in). Inscribed, l.r.: *F.H. Lane/1860.* Private collection. Photo: Herbert P. Vose (see frontispiece)

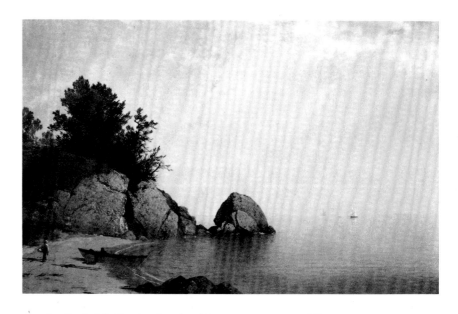

2. John Frederick Kensett. *Beach at Newport,* c. 1850-1860. Oil on canvas. 0.558 x 0.864 (22 x 34 in). National Gallery of Art, Washington, D.C.; Gift of Frederick Sturges, Jr., 1978 (see plate 2)

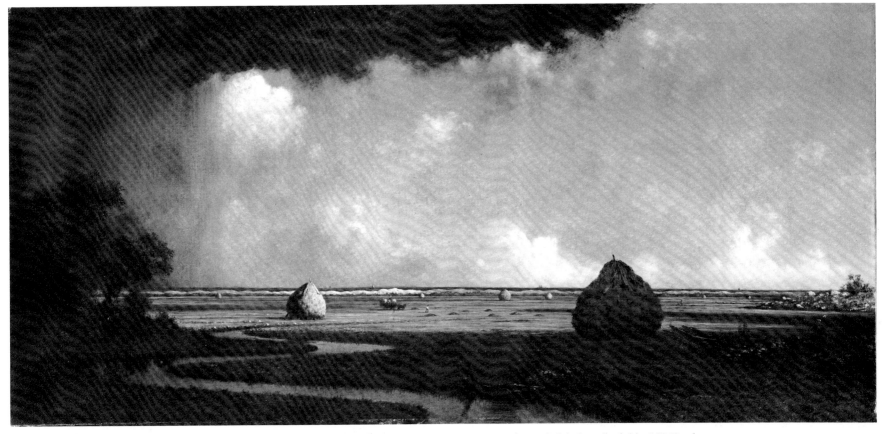

3. Martin Johnson Heade. *Marshfield Meadows, Massachusetts*, c. 1865-1875. Oil on canvas. 0.438 x 0.921 (17⅛ x 36¼ in). Inscribed, l.l.: *M J Heade*; and on stretcher: *Marshfield Meadows, Mass.* Amon Carter Museum, Fort Worth, Texas

an artistic mode culminating in the 1850s and sixties. The luminists were typical also of a crucially neglected period in nineteenth-century American art, as Baur confirmed in recounting their virtual lack of mention in the histories of American art throughout the nineteenth and early twentieth centuries. Along with the work of Lane and Heade, Baur also called attention to the small landscape studies of William Sidney Mount and the mature pictures of John F. Kensett. Characteristic compositions of this group tended to stress a strong sense of abstract formal design:

It consisted chiefly in a balanced grouping of masses with some simplification of volumes and structure. At the end of the period it was modified, however, by a few men who explored the possibilities of asymmetrical compositions and subtler spatial relations.[3]

Finally, Baur observed that at the very moment when the painting of atmospheric light was reaching its zenith, a new "visual realism" was emerging in the Barbizon-impressionist styles of William Morris Hunt and George Inness. Today we can speculate that the rise and fall of what Baur came to call *luminism* was indebted to indigenous factors as much as foreign influence, but these initial perceptions of a separate period style hold up as remarkably prescient.

In two subsequent articles, one appearing in 1948 and the other in 1954, Baur refined and amplified his ideas. Reiterating that Cole "seems to have painted in an atmospheric vacuum," he argued that the next generation around Lane and Heade were part of "a spontaneous and general movement towards research in atmospheric problems."[4] The contemporary writing of James Jackson Jarves

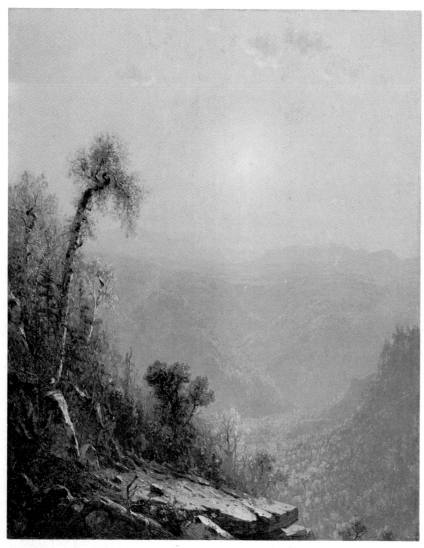

Plate 4. Sanford Robinson Gifford. *October in the Catskills,* 1880. Oil on canvas. 0.924 x 0.746 (36⅜ x 29⅜ in). Inscribed, l.l.: *S.R. Gifford 1880.* Los Angeles County Museum of Art; Gift of Mr. and Mrs. Charles C. Shoemaker, Mr. and Mrs. J. Douglas Pardee, and Mr. and Mrs. John McGreevey (also fig. 4)

proved to be an important source for some of these thoughts, most notably the often quoted lines

The thoroughly American branch of painting is the landscape. It surpasses all others in popular favor, and may be said to have reached the dignity of a national school To such an extent is literalness carried, that the majority of works are quite divested of human association.[5]

This last notion of the detached artistic presence discussed in the writing of Jarves and Baur was to provide a key theme for elaboration by Barbara Novak in her book of 1969, *American Painting of the Nineteenth Century.* Both in his Brooklyn Museum essay and in the one for *Perspectives* (1954) Baur also initially raised the comparison of Heade's painting with that of the early French impressionists. At this point he merely noted Manet's belief that light was the most important person in a picture, and that Monet too had painted a series of haystacks in precise, changing conditions of time of day and atmosphere. At the same time he did argue that "American light *looks* different from that of Europe,"[6] though examination of these differences was to be more fully pursued by Novak and others later.

Baur's "American Luminism" for *Perspectives* broke other critical ground. Correctly he saw that the movement was largely spontaneous, with various catalysts and pervasive sources but no recognized leaders or organizers. Attention was called to several then obscure, and some still little-known, precursors—George Harvey, Robert Salmon, John S. Blunt, and George Tirrell—while related images were found in the work of Mount, George Caleb Bingham, Jasper F. Cropsey, James Suydam, James Hamilton, and W. S. Haseltine. In particular, Baur cited the formative influence of Robert Salmon's crisp style of drawing and rendering light on the otherwise self-taught career of Fitz Hugh Lane. Though we would argue today with Baur's assertion that "Lane was not much interested in composition," we recognize his accuracy in stressing that artist's "preference for scenes of considerable depth and long, horizontal lines."[7] Baur's sense of the ominous foreboding and threatening drama in Heade's Newport thunderstorm pictures strikes another revealing note. The surreal romantic strain in the latter's art would be picked up by Stebbins, who sees this as part of an American current running from Allston to Ryder, while other writers later sought to explore these images of "impending catastrophe" in the turbulent national context of the mid-1860s.[8]

Even as other modes of realism began to emerge in the 1870s, such major figures of the later nineteenth century as Eastman Johnson and Winslow Homer nonetheless grounded their early styles in the meticulous delineations and limpid clarities of luminism. Baur accurately read a painting like Homer's *Dad's Coming* of 1873 (fig. 177) as at once being indebted to earlier luminist principles and intimating a new breadth of artistic touch and vision. However much these first surveys of this movement might now be susceptible to points of challenge, almost all current scholarly thinking on the subject has initiated its argumentation in Baur's essays.

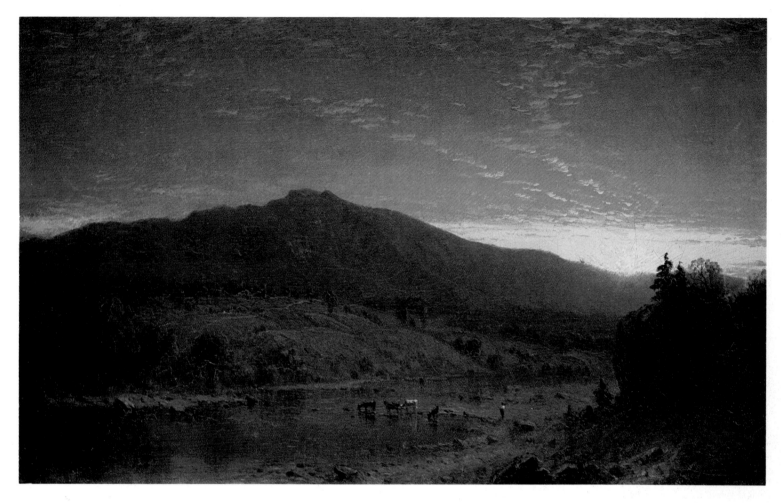

Plate 5. Sanford Robinson Gifford. *Sunset*, 1863. Mr. and Mrs. Erving Wolf. Photo: Vose Galleries (see fig. 125)

Comparable in stature as a founder of modern American art scholarship is E. P. Richardson. Although his 1944 volume *American Romantic Painting* makes no mention whatever of Heade, he did include some brief comments on both Heade and Lane in his survey, *Painting in America*, first published in 1956. Richardson widely separated his discussions of Lane (whom he described as a "minor poet of light") and Heade on the grounds that they belonged to different generations. He placed Lane in what he categorized as the second generation of romanticism (1825-1850), along with George Loring Brown, James Pringle, and Russell Smith, figures who by comparison now seem a good deal less interesting or able. Heade, understandably, is put in the context of what Richardson titles, "The Closing Phase of Romanticism: The Genera-

tion of 1850. Luminism, Naturalism, and Sentimentalism."[9]

Less cogent and probing than Baur's, Richardson's summary of luminism nonetheless included some important observations about luminist color. In part, these were stimulated by Jarves' criticism in 1864, when he talked in *The Art-Idea* about the romantics' "overstrained atmospheric effects . . . intense gradations of skies and violent contrasts of positive color."[10] Richardson also emphasized this major coloristic element in certain luminist painting; he noted that by the 1850s many artists were rendering vivid hot sunsets and twilights across their canvases. Though various chemical dye colors had become available in pigments to artists during the eighteenth and early nineteenth centuries, these were mostly cooler hues of greens and blues, along with zinc white and

5. Frederic Edwin Church. *Twilight*, c. 1856. Oil on canvas. 0.610 x 0.915 (24 x 36 in). Inscribed, l.l.: *F. E. Church*. Private collection. Photo: O. E. Nelson

chrome yellow. As Richardson observed, "The year 1856 is a landmark in the history of the painter's medium"; for, important to American painters and painting, this was when pigments in the hotter hues dramatically appeared.

After 1856 a series of sharp new reds and purples flared upon the artist's palette. Mauve was quickly followed by magenta and cobalt violet (1859) and cobalt yellow (about 1861). In the next few years most of the ancient mineral colors and practically all the organic colors gave way to new synthetic products. Some of these proved to be fugitive and quickly faded, others blackened in chemical combination with other pigments, but all were new, brilliant, and irresistibly tempting to the artist's eye.[11]

This revealing scientific information is borne out by a glance at the fiery panoramas of wilderness twilights painted by Lane, Heade, Frederic Church, Sanford Gifford, and others during the 1850s and sixties. Actually, Lane's first canvas to employ the new intense reds and purples was his *Twilight on the Kennebec* (private collection), painted in 1849 and exhibited that year at the American Art-Union in New York. The catalogue noted that "the western sky is still glowing in the rays of the setting sun."[12] This would suggest that at least some red pigments were available by this date. Thus, our awareness of signifi-

cant technical evidence has greatly helped to explain a major reason for the luminist's turn to glowing evening subjects at this moment, in spite of what Richardson noted as discoloration in certain pigment combinations (a number of Lane and Heade canvases in particular have seen subsequent darkening, "bleeding," or striating of the reds across their surfaces). What remains to be explored now is their ideational relationship to the fiery turmoil of the Civil War years and its aftermath.

This and other issues about luminism have emerged in the research of a younger generation of art historians, whose publications began to appear in the middle 1960s. The first exhibition of the luminists as a group was a modest but well-focused project undertaken by Theodore E. Stebbins, Jr., and fellow graduate students at Harvard in 1966. The small accompanying catalogue, *Luminous Landscape: The American Study of Light 1860-1875*, made a valuable contribution in focusing on some of the possible artistic relationships among the various painters and in addressing the problematic role of Frederic Church's art within the movement.[13]

This same year also saw the publication of a key monograph on Church by

David Huntington, written in conjunction with efforts at the time to preserve the artist's house and studio in Hudson, New York, and with the mounting of the first major exhibition of his work in modern time.[14] Huntington did not address the topic of luminism directly but concentrated instead on Church's originality of vision, particularly in terms of the artist's ideas about American nature and his related adjustments of composition, color, and brushwork. Clearly, all of Church's work does not belong within the classic luminist canon, though several important pictures exemplify the style either in their panoramic structure (*Cotopaxi*, fig. 225, and *The Parthenon,* fig. 29) or in their meticulous draftsmanship and intense colors (*Twilight in the Wilderness,* fig. 204, and *Morning in the Tropics*, fig. 128). Huntington's great achievement was to bring Church out of a critical oblivion—one even more complete than the long obscurity of Lane and Heade—into virtually the central place in mid-nineteenth-century American art.

Largely owing to these concerted efforts at the rediscovery of Church's career, a number of his major pictures were acquired for distinguished American collections in the mid-sixties, most notably *Twilight in the Wilderness* by the Cleveland Museum, *Morning in the Tropics* by the National Gallery, and *Rainy Season in the Tropics* and *Andes of Ecuador* (fig. 186) by J. William Middendorf. Paintings as impressive as these demonstrated the one large oversight in the 1949 Karolik gift to Boston. For although this shrewd and farsighted acquisitor had gathered some dozen Lanes and over two dozen Heades, he only sought out three rather minor oils by Church. At the same time works long in public collections, like the Corcoran's *Niagara* of 1857, were now reexamined as singular national images.

The most far-reaching and influential reevaluation of this whole area took place with the publication in 1969 of Barbara Novak's *American Painting of the Nineteenth Century.* With this volume she, along with Huntington, addressed the crucial issue of the iconography of American painting, a matter largely neglected in the more biographical and literary approaches previously taken by historians. The book gives its foremost and most substantial attention to luminism as a style and to its principal practitioners, although its author had not as yet found Church to be of more than peripheral interest.

Seeing luminism as especially (though not uniquely) American, Novak grounds the style in a native tradition that gave preference to measurement, factuality, and scientific values.[15] She persuasively links to Emersonian transcendentalism the luminist's distillation of light as a concretion of divine presence—more in the pictures of calm, glassy clarity rather than ones of vibrating, exotic color. With Baur's 1954 thoughts as a springboard, she goes further in defining the specific qualities of light and space in luminism: its sharp clarifications of objective form along with the parallel and regulated marks of compositional divisions. Above all there is the anonymous artistic presence, leaving on canvas no mark of individual stroke, only a classic silence of time stilled. In addition, there is apparently a basic relationship between luminist

6. Alfred Thompson Bricher. *Grand Manan,* c. 1890. Ink, wash, and Chinese white on gray paper. 0.091 x 0.200 (3⁹/₁₆ x 7⁷/₈ in). Inscribed, l.r.: *ATB* (in monogram). Private collection

7. David Johnston Kennedy. *Entrance to Harbor—Moonlight,* 1881. Gouache, Chinese white, and pencil on paper. 0.235 x 0.380 (9¼ x 14¹⁵/₁₆ in). Inscribed, l.l.: *D.J.Kennedy. 1881.* The Metropolitan Museum of Art, New York; Purchase, 1968; Rogers Fund

8. Seneca Ray Stoddard. *The Letter "S" Ray Brook*, 1890. Silverprint photograph. 0.167 x 0.217 (6⁹⁄₁₆ x 8⁹⁄₁₆ in). The Library of Congress, Washington, D.C.

thinking and the conceptual approach to art in the American folk tradition, seen in the popular image of *Meditation by the Sea* (c. 1860; fig. 150) and in the primitive, self-trained work of Lane's early work in printmaking.

Novak's thesis has proved to be provocative and stimulating ever since the book's publication over a decade ago. Some have taken issue with certain extensions of her argument, such as stretching luminism into an American vision going back to Copley and forward to Sheeler, Hopper, Wyeth, and Sol Lewitt. Questioned, too, have been her applications of luminist principles to still life, genre, and portraiture, as well as the assumptions about the movement's distinctively American character. Theodore Stebbins and William Gerdts both have found surprising parallels in both eastern and western European art. Now that this study has had time to take its own place in American art literature, we might wonder more about the author's treatment of Sanford Gifford as a "cosmopolitan luminist" or her virtual neglect of Church.[16] Nonetheless, this has been a book of singular importance in raising and broadening our understanding of luminism's place in the history of American art.

During the decade from 1966, when Huntington's work on Church was published, to 1976, when several new surveys of American art appeared with sections devoted to luminism, almost all the painters of the movement were the subject of exhibitions or monographs. These included Kensett, Gifford, Bierstadt, Richards, and Bricher. Two books and two separate exhibitions were devoted to Lane between 1964 and 1974, while Heade received a comprehensive show in 1969, followed by a full study and catalogue raisonné six years later. Aspects of luminism were taken up at various points in the later monograph on Lane, while Theodore Stebbins includes a full and succinct section on the topic in his 1975 biography of Heade.[17]

Partly owing to the national Bicentennial, a flurry of books and exhibitions devoted to American art appeared in 1976. Among those relevant to the subject at hand were the Pelican history *American Art*, which allocated an entire chapter to "The Luminist View," and the Museum of Modern Art's ambitious and controversial show, *The Natural Paradise, Painting in America, 1800-1950*. The book-length catalogue for the latter was comprised of several essays touching on luminism in varying degrees, the most direct being "Fire and Ice in American Art, Polarities from Luminism to Abstract Expressionism." The next year saw publication of the most recent major survey of American art, that by Milton Brown, who also devoted to luminism a specific subsection of a chapter on landscape. Curiously, however, he reverts here to Richardson's relatively circumscribed view of Lane and follows with comments on the idiosyncratic and unrelated career of George Henry Durrie.[18] Still, the very presence of such a discussion in an authoritative history of American art is a reminder of how compellingly the subject of luminism has entered the field to stay, when both the general term and individual painters of luminism were virtually unknown just thirty years ago.

If luminism is a definable style at all, its principles ought to be visible in media other than paintings. Yet parallel to the relative lack of attention to American drawings and photography in general, close to no critical examination whatever exists on luminist drawings, sketches, and photographs. Even in his most recent survey, his fresh and comprehensive *American Master Drawings and Watercolors*, Stebbins chooses to discuss Heade's exquisite charcoals of the Newburyport marshes within the larger romantic traditions of Hudson River and American Barbizon school landscapes. Lane, David Johnston Kennedy, Henry Farrer, Bricher, and Richards, all of whom produced luminist art, are treated under other categories like romanticism, folk drawings, and the Victorian watercolor.[19]

Similarly, a photographer like Seneca Ray Stoddard is as obscure today as Lane and Heade were three decades ago, and figures like Carleton Watkins and William Bradford are not much better known. The most recent exhibition given to luminism, that at the Coe Kerr Gallery in New York in the autumn of 1978, occasioned a thoughtful catalogue essay by William Gerdts but concentrated entirely on luminist painters and paintings.

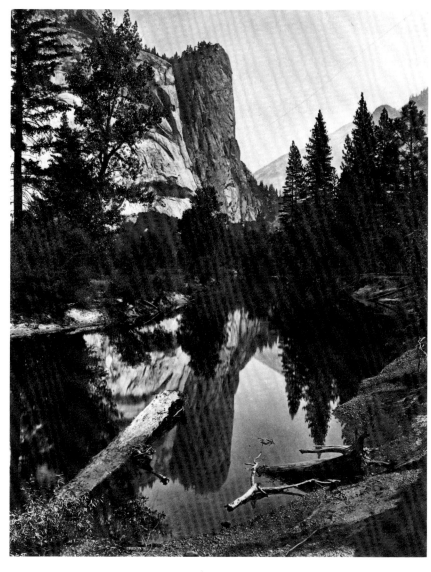

9. Carleton E. Watkins. *Washington Column, 2,082 Feet, Yosemite (no. 81)*, c. 1866. Albumen photograph. 0.495 x 0.375 (19½ x 14¾ in). Daniel Wolf

All of which brings us to the present exhibition and publication. The ambitious sweep of concept here brings together the efforts of several individuals who have thought and written about luminism for more than a decade. While collectively we hope to summarize the state of argumentation on the subject to date, there is the equal aspiration to search the luminist horizons afresh and to view them as panoramically and precisely as the style itself, while furthering the dialogue on this crucial period of American art.

Notes

1. John I. H. Baur, "Trends in American Painting, 1815 to 1865" in *M. and M. Karolik Collection of American Paintings, 1815 to 1865* (Cambridge, Mass., 1949), xv-lvii.

2. Baur, "Trends in American Painting," lii.

3. Baur, "Trends in American Painting," liii.

4. John I. H. Baur, "Early Studies in Light and Air by American Painters," *Brooklyn Museum Bulletin,* 9, no. 2 (Winter 1948): 3, 7.

5. James Jackson Jarves, *The Art-Idea* (New York, 1864), 231; quoted in Baur, "Early Studies," 1.

6. John I. H. Baur, "American Luminism, A Neglected Aspect of the Realist Movement in Nineteenth-Century American Painting," *Perspectives USA,* 9 (Autumn 1954): 90. For subsequent analyses of the comparison between Heade and Monet, see Barbara Novak, *American Painting of the Nineteenth Century: Realism, Idealism, and the American Experience* (New York, 1969), 129-131; John Wilmerding, "Introduction" in *The Genius of American Painting* (New York and London, 1973), 19-21; and Theodore E. Stebbins, Jr., *The Life and Works of Martin Johnson Heade* (New Haven and London, 1975), 54-55.

7. Baur, "American Luminism," 92-93.

8. Baur, "American Luminism," 94. See also Stebbins, *Heade,* 67; and Wilmerding, "Fire and Ice in American Art: Polarities from Luminism to Abstract Expressionism" in *The Natural Paradise, Painting in America, 1800-1950,* ed. Kynaston McShine [exh. cat., Museum of Modern Art] (New York, 1976), 44 and *passim.*

9. E. P. Richardson, *Painting in America, From 1502 to the Present* (New York, 1965), 171, 226-227.

10. Jarves, *Art-Idea,* 231.

11. Richardson, *Painting in America,* 219.

12. Mary B. Cowdrey and Theodore Sizer, *American Academy of Fine Arts and American Art-Union Exhibition Record, 1816-1852* (New York, 1953), 221. See also John Wilmerding, *Fitz Hugh Lane* (New York, 1971), 47.

13. Gail Davidson, Phyllis Hattis, and Theodore E. Stebbins, Jr., *Luminous Landscape: The American Study of Light 1860-1875* [Fogg Art Museum] (Cambridge, Mass., 1966).

14. David C. Huntington, *The Landscapes of Frederic Edwin Church: Vision of an American Era* (New York, 1966), and his *Frederic Edwin Church* [exh. cat., National Collection of Fine Arts] (Washington, D. C., 1966).

15. Novak, *American Painting,* 95.

16. Novak, *American Painting,* 15, 240.

17. John Wilmerding, *Lane,* 56 and *passim;* and Theodore E. Stebbins, Jr., "A Note on Luminism" in *Heade,* 105-110.

18. John Wilmerding, *American Art* (London and New York, 1976), chap. 12; and "Fire and Ice." See also Milton Brown, *American Art to 1900: Painting, Sculpture, and Architecture* (New York, 1977).

19. Theodore E. Stebbins, Jr., *American Master Drawings and Watercolors, A History of Works on Paper from Colonial Times to the Present* (New York, 1976), chaps. 4-7.

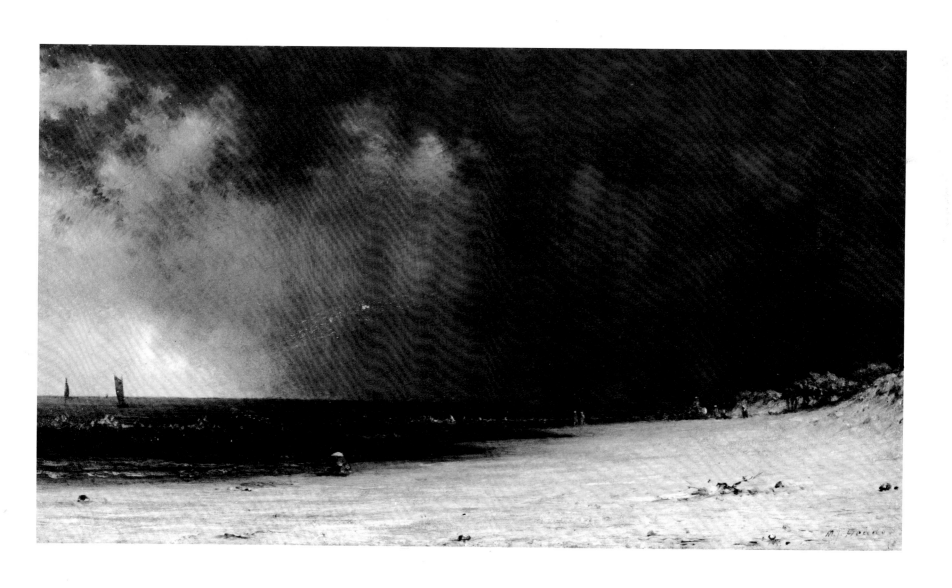

11. Fitz Hugh Lane. *Brace's Rock, Brace's Cove*, 1864. Oil on canvas. 0.254 x 0.381 (10 x 15 in). Inscribed, l.r.: *F. H. Lane/1864*. The Lano Collection (see plate 11)

Previous page: 10. Martin Johnson Heade. *Thunderstorm, Narragansett Bay*, c. 1870. Oil on paper mounted on canvas. 0.245 x 0.470 (9⅝ x 18 ½ in). Inscribed, l.r.: *M.J. Heade;* illegible date. Museum of Art, Carnegie Institute, Pittsburgh

On Defining Luminism

Barbara Novak

SINCE ITS RECOGNITION AND NAMING SOME TWENTY-FIVE YEARS AGO, luminism–a clear, lucid mode of expression–has been subject to some misunderstanding and confusion. This is an appropriate moment to define the term, as I understand it, and to discuss the key difficulties in its interpretation. The main question is: Which paintings do we call *luminist* and which do we not?

Many factors enter into the luminist mode. Not all of them are always present in a single work. Thus we might establish a scale of priorities that must be discernible in a work before we can call it *luminist*. That such works resist labeling may be further testimony to their excellence. But a viable concept of the luminist mode can only be sustained by strictly adhering to a set of guidelines that give the definition of luminism the same clarity as the paintings themselves. What are these factors? And how do we evaluate them in deciding that we are indeed dealing with a luminist work of art?

On Structure

Luminist structure stresses the horizontal and fortifies an extended format with what I have called *luminist classicism,* an organization in which planes take measured steps into space, parallel to the picture surface.[1] My use of the term *classic* here is essentially Wölfflinian and depends on the mensurational control of the parts between the planes.[2] These delineations are often aided by subtle horizontal alignments, as in many of Martin Johnson Heade's marshes and seascapes, in Fitz Hugh Lane's quiet waters, or in John F. Kensett's Newport marines. Short vertical accents and occasional diagonals play against these, but horizontality is the dominant factor. In more mannered luminism, as in Heade's *Approaching Storm: Beach Near Newport* (1860; fig. 79), anticlassic elements enter in, but the diagonal pull operates as a foil for the sea's strict horizon. Here, luminist anticlassic structure can be seen as a subcategory of luminism, dependent upon luminist classicism before it can exist in opposition to it.[3]

On Measure

In luminist landscapes, measure confines natural elements within an abstract or ideational order. This order operates both across the surface and in depth. As in classic art, mathematical and geometric correlations predominate over organic irregularities. Luminist measure, imposing an absolute order on reality, also gives specificity to the ideal. Thus the categories of the real and ideal are reciprocally tempered. Quantification affects every aspect of luminist art: structure, form, tone, light are all subject to the subtlest discretions of calculated control. These minute and economic discriminations release poetic rather than cerebral effects.

On Planarism and the Primitive

With luminist paintings, the attitude to the picture surface or plane is of central importance. Firm respect for the plane is characteristic of American painting at large and can be termed a major indigenous factor. The luminist emphasis on the plane keeps us conscious of surface aspects. This planar stress is fortified by the existence of a strong parallel tradition of primitivism that has endured in America from the limners on. That tradition is, of course, conceptual—as is luminism. Insofar as luminism is predominantly mental, it is less optical; and relative levels of opticality might also be used to gauge whether or not a work is luminist.

Luminist planarism is sometimes directly related to the primitive bias of the artist. Lane often lapsed back into primitivism, disrupting the idea of chronological "progress." But the line between primitivism and conceptualism in luminism is hard to draw. Kensett's best luminist work comes after an optical or pragmatic beginning; it suggests more a preoccupation with concept than a reversion to primitivism.

On Primitivism and Provincialism

At times the primitive "look" can also be characterized as provincial, with no pejorative overtones. Moreover, there is, in the nineteenth century, a "Western Hemisphere" look that unites the art of the United States with that of Canada and South America as well. Distance from the mainstream, especially from the sophisticated art centers that would familiarize the artist with the formulae for "matching"—in E. H. Gombrich's terms—would to some extent account for this look.[4] The bias of American art would seem to be toward the more natural instinct of "making." Extended access to traditions that stress the "matching" formula can change this, as is often evident in the works of American expatriate artists.

On Indigenous versus Unique Properties

While some qualities of luminism are indigenous, none is unique in the sense of being exclusive to America. Uniqueness in this sense is almost impossible to find in the history of art. There are only a limited number of formal factors the painter can rearrange and combine in any culture. But it is precisely the "mix" of these factors that we can ultimately isolate as indigenous. *Webster's New World Dictionary* defines indigenous as 1. born, growing, or produced naturally in a region or country; native. 2. innate; inherent, inborn.[5]

Elsewhere, I have stressed similarities with painting in Germany (especially the art of Caspar David Friedrich) and in Scandinavia.[6] In Scandinavian art these seem to emerge from the tempering of a strong folk or primitive tradition, similar to that of America, resulting in parallel attitudes to structure, and especially to the plane. In a few instances, as in occasional paintings by Christian Købke and C. W. Eckersberg, the parallels with American luminism are striking. But much other Scandinavian landscape painting of the mid-nineteenth century apparently had more effective recourse to the "matching" formula and tends to be more painterly. Thus, *how often* such parallel comparisons occur must be considered in determining whether American luminism *per se* can be said to exist elsewhere.

We must also assess how many of the complex factors that comprise American luminism are present in other works and other national traditions and in what combinations. Nor can we leave out the strong philosophical component. Friedrich, even more than the Scandinavians, shared the American sense of God in nature. There are often similarities, as in the mystical denial of ego that comprises a large part of the luminist definition. Yet in other instances, as part of the German and northern European tradition, Friedrich stresses ego and the alienation of ego that progressed into twentieth-century expressionism.

On Sources of Luminism

A possible explanation for certain parallels of structure between American

12. John Frederick Kensett. *Narragansett Bay,* 1861. Oil on canvas. 0.356 x 0.610 (14 x 24 in). Inscribed, on rock: *J.K. 61.* Private collection. Photo: Herbert P. Vose (see plate 12)

luminism and paintings in Europe lies of course in similar sources. The two main pictorial sources open to late eighteenth- and early nineteenth-century landscapists, Claude Lorrain and the Dutch, were precisely those drawn upon by the Americans, who continued using them later than their European colleagues. It is very likely that the open-ended unframed compositions that characterize luminism derive at least in part from seventeenth-century Dutch art. Traditional Hudson River compositions rely more heavily on the lateral tree frames of the Claudian mode, as well as on other conventions of Claudian organization (the foreground coulisse, the middle-ground pool of water, the distant mountain). These are used almost interchangeably by some members of the school for bucolic or pastoral effect.

When some of these same artists—especially Kensett—produce luminist pictures, the Dutch paradigms are transformed into compositions in which the sky occupies less space, and the horizontal format is further emphasized (*Shrewsbury River*; fig. 202). The Dutch paintings are often melting and painterly in touch (Jan van Goyen, Aelbert Cuyp). Their American luminist counterparts, harder and more crystalline in surface handling, frequently abandon the almost monochromatic gold of the Dutch for local color exuding cool luminist light. They are also more deliberately classic in their orientation to the plane.

The most significant American addition to the open-ended Dutch convention is the classic alignment of planes. Luminist classicism, in this instance, has little to do with what has been called the "classical" tradition of the Claudian

landscape. Rather it represents an alternative convention which, in abandoning Claudian prototypes, draws not only on the example of the Dutch but on the primitive orientation to the plane and on certain pragmatic responses to what John Neal called the "prose" of nature.[7]

That prose is transformed into poetry by luminist artists through a powerful penetration of the real. It is not a poetry imposed, through certain conventions of the picturesque, *upon* nature. It is a poetry floated up to the surface from within nature and made manifest by a source of light that also wells up from within.

On Luminist Light

The nature of luminist light has been widely misunderstood. Like any much-used term, *luminism* is now subject to a certain amount of debasement. In lay parlance, any painting in which light is the most expressive feature may be called *luminist*. For me, this abandons other factors, both formal and philosophical, crucial to the definition of luminism.

Luminist light is indeed one of the key factors of the mode. It is, in fact, questionable whether we are dealing with luminism at all if the light is not present. But luminist light has its own specific properties, just as impressionist light has. Luminist light tends to be cool, not hot, hard not soft, palpable rather than fluid, planar rather than atmospherically diffuse. Luminist light radiates, gleams, and suffuses on a different frequency than atmospheric light. With atmospheric light, which is essentially painterly and optical, air circulates between particles of strokes. Air cannot circulate between the particles of matter that comprise luminist light.

Luminist radiance occurs not because of interactions, overlaps, and dissolutions of stroke, but because of minute tonal modulations, nearly invisible when viewed close-up. From a distance, the coalescence of these tonalities mimics the effect of radiant light and negates the idea of paint. For this reason, many paintings by Lane do not yield their full quota of light until viewed from afar. An impressionist painting, such as a Monet, might also radiate light effects but rarely loses its equal insistence on paint.

The smooth glow of luminist light is only on few occasions (as in Købke's *Frederiksborg Castle,* Hirschsprung Collection, Copenhagen) found in European paintings. Even Friedrich does not achieve it. His surfaces are more mat. Despite the smoothness of surface, his light exists more as painted color than as crystalline transparency. Paint, touch, handling, stroke interfere with the purity of luminist light. Soft, atmospheric, painterly light is not luminist light. It is something else. How much can stroke be allowed to mediate the textures of light in a painting we wish to call *luminist*?

On Stroke

The absence or presence of stroke would seem to be a decisive factor in

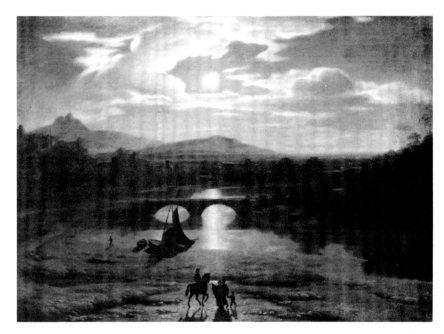

13. Washington Allston. *Moonlit Landscape,* 1819. Oil on canvas. 0.610 x 0.889 (24 x 35 in). Museum of Fine Arts, Boston; Gift of Dr. W. S. Bigelow (not in exhibition)

determining whether we are dealing with luminism. Stroke carries with it the sense of paint. When this happens, the idea of light as pure emanation gives way to an idea of paint that approximates or represents light. The illusion is lifted. We remember we are dealing with a *painting* of light, not with light itself. The reminder of the actual process of painting recalls to us the agent of process, the painter. It denotes not only the artist's activity, but the artist's presence. That presence introduces us to a self, who, as it were, stands between the image seen and the spectator. The more that artist's self, embedded in the "signature" of stroke, occupies our attention, the less we are dealing with the selfless image of luminism.

Stroke also transmits an idea of ongoing time. Luminist time is absolute. It is Platonic and Newtonian. It is a "shaped" time, controlled by strict measure. There are good art-historical reasons for reading paintings in terms of time as well as space. The introduction of the relativism of stroke violates luminist eternity, which has already been set by the mensurational definition and planar parallels of luminist structure.

Stroke lessens the hyper-clarity of object penetration central to John I. H. Baur's 1954 definition of luminism. In luminism, the absence of stroke heightens the textural properties of natural elements beyond the compass of normal vision: the hard, taut ripples in a lake, the crystallinity of rocks, the

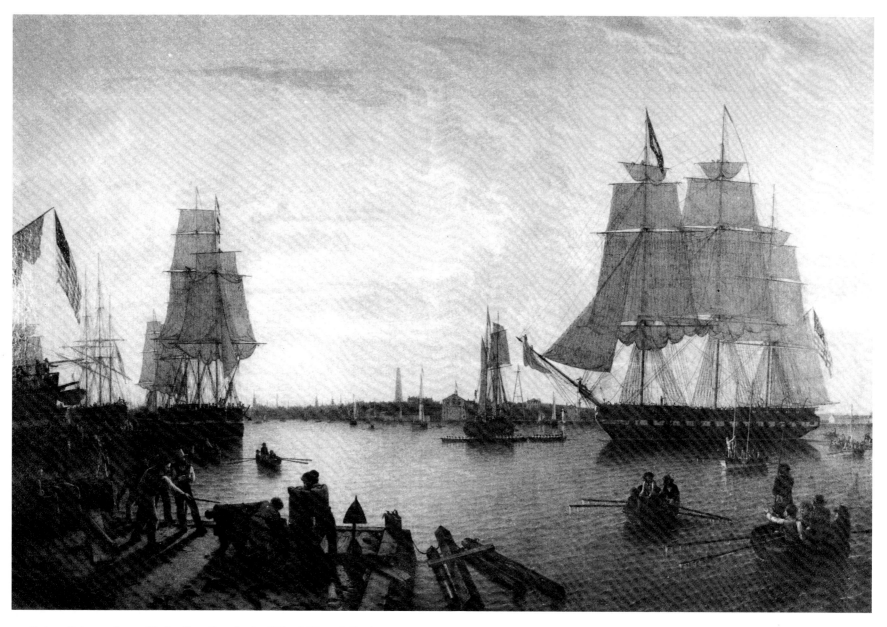

14. Robert Salmon. *Boston Harbor from Constitution Wharf (View of Charlestown, 1833)*, 1833. Oil on canvas. 0.680 x 1.035 (26¾ x 40¾ in). United States Naval Academy Museum, Annapolis, Maryland

15. Albert Bierstadt. *The Marina Piccola, Capri,* 1859. Oil on canvas. 1.167 x 1.829 (42 x 72 in). Inscribed, l.r.: *A. Bierstadt, 1859.* Albright-Knox Art Gallery, Buffalo, New York; Gift of Albert Bierstadt

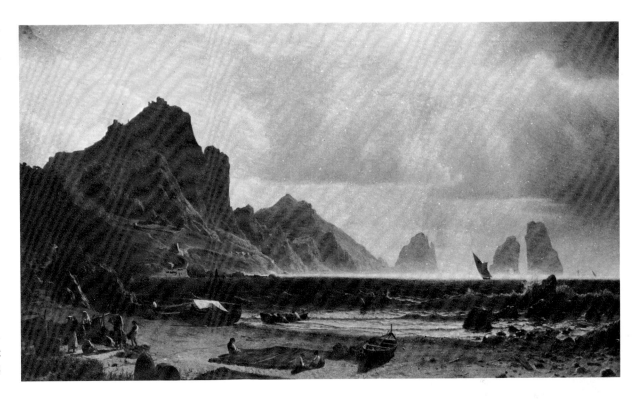

16. William Stanley Haseltine. *Marina Piccola, Capri,* 1856. Oil on paper on canvas. 0.305 x 0.470 (12 x 18½ in). National Gallery of Art, Washington, D.C.; Gift of Mrs. Roger H. Plowden, 1953 (below)

minute identities of pebbles. Luminist anonymity erases both artist and spectator and penetrates thingness, the *ding an sich* of which Aldous Huxley has written.[8]

Though Baur did not include luminist classic structure in his definition,[9] he stressed the selflessness of the smooth luminist surface. The expressive impact of luminism is dependent on the glassy surface, which transforms paint into a substance that shines and emanates. The medium itself is subsumed by the illusively hyper-real image. The linear edges of reality are pulled taut, strained almost to the point of breaking. This is why I have called luminism a kind of impersonal expressionism.[10]

On Silence

We can also say that stroke, carrying action, implies sound. A key correlative of luminism is silence. Luminist silence, like luminist time, depends on measured control. Without movement between strokes or between units of form, we hear nothing. Luminist silence implies presence through the sense of *thereness* rather than through activity. Inaudibility is a correlative of immobilized time and objects. Contemporary critics spoke of Kensett's *repose.* Yet luminist si-

17. William Stanley Haseltine. *Capri*, 1869. Oil on canvas. 0.505 x 0.802 (19⅞ x 31⅝ in). Inscribed, l.l.: *W S Haseltine/1869 Rome*. The Cleveland Museum of Art; Purchase, Mr. and Mrs. William H. Marlatt Fund

lence, in the repose of inaction, represents not a void but a palpable space, in which everything happens while nothing does. We have here a visual analogue of Eckhart's "central silence," and Thoreau's "restful kernel in the magazine of the universe."[11]

On Size

The intimacy of the luminist mode sets certain limits on size. In contrast with more ambitious Hudson River school rhetoric, there are few large luminist paintings. Yet the paradox is that we seem to be dealing with what Gaston Bachelard has called "intimate immensity": "As soon as we become motionless, we are elsewhere; we are dreaming in a world that is immense . . . immensity is the movement of motionless man."[12] Thus the measured spaces of luminism are immense in scale, though small in size. This is further evidence of its conceptual nature.

Though much nineteenth-century nature painting in America was to some extent touched by transcendental attitudes, luminism was the most profound expositor of transcendental feelings toward God and nature and God as nature. Insofar as they were timeless, universal, and mystical, those feelings were best served in landscape painting by luminist classic structure, luminist selflessness, and luminist light.

On Luminist Chronology

It seems unprofitable to set a clear developmental timetable for luminism. Depending upon our criteria for definition, we might want to consider Washington Allston's *Coast Scene on the Mediterranean* (1811; fig. 101), with its open-ended composition and radiant back-lighting, the earliest luminist painting in America. If we call such a painting proto-luminist, we can probably push the problem ahead several decades, to include such works as Robert Salmon's *Boston Harbor from Constitution Wharf* (1833; fig. 14), Thomas Cole's *American Lake Scene* (1844; Detroit Institute of the Arts), and the remarkable genre pictures by William Sidney Mount (*Eel Spearing at Setauket,* fig. 256) and George Caleb Bingham (*Fur Traders Descending the Missouri,* Metropolitan Museum of Art, New York) around 1845. Bingham's *Fur Traders* especially is an archetypical example not only of luminist light but of luminist structure. There is an increasing incidence of luminist pictures in the oeuvre of Lane, Heade, Kensett, and, with variable frequency, Asher B. Durand, Sanford Gifford, Jasper F. Cropsey, William Bradford, William S. Haseltine, Frederic E. Church, and Albert Bierstadt (to name only major figures) through the fifties and into the sixties. Though Lane dies in 1865, others continue to make luminist paintings after that time. But a strict developmental emphasis somewhat mitigates our view of luminism as a mode, larger than style, to which many American artists had access at will, when need so dictated.

*　　*　　*　　*

We return to the problem stated earlier. What are the priorities we set for deciding which paintings are luminist? Luminism has many components. In practice, they often separate out. We encounter paintings with luminist structure, but not luminist light. We discover others with luminist light, but without the structure. In still others, light and structure are major expressive factors, but stroke mitigates the egoless mood.

What are we willing to dispense with to place a painting under the rubric of luminism? Do we abandon anonymous selflessness, and the correlative intensity of object penetration? Then we could allow for the "painterly luminism" of, say, a Gifford. But is not "painterly luminism" a contradiction in terms? The tolerance of stroke will, to some extent, eliminate luminist time as well as the intense probing of "things" in nature. It will also eliminate the famous Emersonian transparent eyeball and set the stage for the entrance of personality and ego into the luminist arena. Yet some works by Gifford, as for example *Hook Mountain, Hudson* (1866; fig. 84), fall naturally within the luminist canon. Beyond this, can we not sometimes speak of luminist characteristics or properties, without the need to label a whole painting luminist?

It becomes evident, as I have said elsewhere, that there are few pure luminist artists.[13] But there are pure luminist works. Perhaps if we see luminism more readily not as a movement but as a mode to which artists had recourse whenever it was formally and philosophically viable, we might also clarify our guidelines for definition. It is time we attached to the term the lucidity that luminism itself implies.

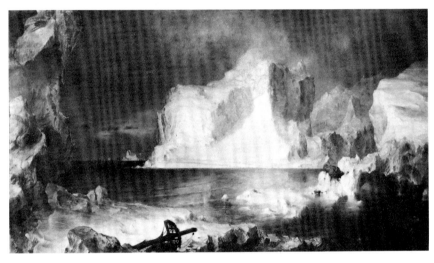

18. Frederic Edwin Church. *The Icebergs (The North)*, 1861. Oil on canvas. 1.632 x 2.851 (64¼ x 112¼ in). Inscribed, *F. E. Church/1861*. Dallas Museum of Fine Arts, Anonymous gift. Photo: Sotheby Parke Bernet (see plate 19)

Notes

1. *Barbara Novak, American Painting of the Nineteenth Century: Realism, Idealism and the American Experience* (New York, 1969), 105.

2. See Heinrich Wölfflin, *Principles of Art History* (New York, 1932).

3. Novak, *American Painting*, 126 ff.

4. See E. H. Gombrich, *Art and Illusion* (New York, 1960) especially chap. 9, pp. 291 ff.

5. *Webster's New World Dictionary*, College Edition (Cleveland and New York, 1960), 742.

6. See Barbara Novak, "Influences and Affinities: The Interplay Between America and Europe in Landscape Painting before 1860" in *The Shaping of Art and Architecture in Nineteenth-Century America* [Metropolitan Museum of Art] (New York, 1972), 27-41. See also Novak, *American Painting*, 9, 55.

7. See Harold E. Dickson, ed., *Observations on American Art: Selections from the Writings of John Neal (1793-1876)*, Pennsylvania State College Studies no. 12 (State College, Pa., 1943), 46.

8. Aldous Huxley, *The Doors of Perception* (New York, 1954), 28.

9. See John I. H. Baur, "American Luminism, A Neglected Aspect of the Realist Movement in Nineteenth-Century American Painting," in *Perspectives USA, 9* (Autumn 1954): 92, where Baur observes: "Lane was not much interested in composition; indeed there is evidence to show that he scarcely composed at all except to choose, like a photographer, his place in the landscape and the extent of his view." Luminism went far beyond this, I feel, in its calculated planar distinctions and controlled alignments.

10. See Novak, *American Painting*, 97.

11. Carl Bode, ed., *Selected Journals of Henry David Thoreau* (New York, 1967), 33-34, entry for Aug. 13, 1838.

12. Gaston Bachelard, *The Poetics of Space* (New York, 1964), 184.

13. Novak, *American Painting*, 95.

19. Frederic Edwin Church. *The Ox-Bow* (after Thomas Cole), 1844-1846.
Oil on canvas. 0.514 x 0.768 (20¼ x 30¼ in).
Inscribed, l.l.: *FEC*. Mr. and Mrs. Andrew S. Peters, New Jersey

Design and Measurement in Luminist Art

Lisa Fellows Andrus

LUMINISM HOLDS A UNIQUE PLACE IN AMERICAN ART. As one aspect of a mode of painting based on measurement and design, it shares stylistic attributes with such indigenous American artists as Copley and Eakins: with its portrayal of the specific and familiar according to precepts of pictorial order, luminism is characterized by a heightened perception of reality carefully organized and controlled by principles of design.[1] As one of the styles of landscape painting to emerge in the nineteenth century, luminism embraced the contemporary preoccupation with nature as a manifestation of God's grand plan. It was luminism more than any of the other schools that succeeded in imbuing an objective study of nature with a depth of feeling. This was accomplished through a genuine love and understanding of the elements of nature— discernible in the intimate arrangement of leaves on a bough—and their arrangement to reveal the poetry inherent in a given scene.

If we cannot explain the quality of an artist's perception or sensibility that causes him to create paintings in a certain style, we can at least examine contemporary attitudes toward art and nature that may have influenced his stance toward reality and composition. Particularly important in reflecting and influencing the landscape painter's viewpoint are the "Letters on Landscape Painting" Asher B. Durand published in *The Crayon* in 1855 and 1856[2] and the works of John Ruskin, the first of which appeared as volume one of *Modern Painters* in 1847. Such writings along with instruction books provided precepts and procedures for the creation of landscape paintings through measurement and design.

The first principle of landscape painting in the mid-nineteenth century was the preeminence of nature over art. Consequently, the young artist was advised not to seek tutelage with a master or to study books and other paintings before he had first learned all he could from a dedicated study of nature. He must "scrupulously accept *whatever* she presents him, until he shall, in a degree, have become intimate with her infinity. . . . I would see you impressed, imbued to

the full with *her* principles and practice," Durand wrote, "and after that develope [*sic*] the principles and practices of art."[3]

The young artist turned to nature to learn her alphabet, the multiplicity of her forms—the way a weed grows, the life history of a tree as evidenced in the conformation of limbs, the effect of atmosphere on light and color, the mathematical ratios of reflections on water. By studying nature with such intensity he increased his power of sight and his ability to define forms. Even more important, he developed his capacity for love, love that grew with knowledge, seeing what was there exactly for what it was without artifice or false sentiment. As Ruskin explained, "Sight is a more important thing . . . than drawing; and I would rather teach drawing that my pupils may learn to love Nature, than teach the looking at Nature that they may learn to draw."[4] It was only through the cultivation of the eye, the mind, and the heart, as well as the hand, that an artist could hope to create paintings that elevated the portrayal of nature. It was this transformation from fact to art that had to be learned for oneself and could not be taught.

Studying with an established artist or adopting the conventions found in books as a shortcut for the representation of nature only replaced technique for perception, and the American landscape painter abhorred the substitution of the hand of man for the hand of God. As Durand explained, a painting "will be great in proportion as it declares the glory of God by a representation of his works, and not the works of man."[5]

Durand and Ruskin were so persuasive in their advocacy of this, the first step in a young painter's education, that many artists made the mistake of thinking that imitation was all that was required in finished pictures. The true beauty in nature, however, could only be conveyed through a careful selection and composition of her forms. Once the elements of nature were fully understood, therefore, Durand recommended the study of books and other paintings for an understanding of the principles of art, but always with the reservation that the

student weigh these against his own observations.[6] The rules of art must not intrude upon a true appreciation of nature.

Painters could turn to several different sources to learn about selection and design in landscape. First were writings on the picturesque, most notably the series of volumes by William Gilpin. Although Gilpin's point of view was pictorial—he gave the art-idea precedence over truth to nature—he did describe types of composition that were adapted by the luminist artists to create works in a more natural mode. Second, were the manuals designed to teach the Anglo-Dutch tradition of landscape to painters of watercolor. The guidelines provided by these books were the most useful to the luminists since they taught the artists how to emphasize order already present within nature. Third, were the works of Ruskin with their celebration of J. M. W. Turner, providing a visionary interpretation of reality that countered the more orthodox luminist commitment to the view selected. Even though these three approaches to landscape painting were strikingly different, it was not unusual for one artist to work in more than one mode or, as Frederic Church did, to create paintings in all three.

The books by William Gilpin provided the most conventional formulas for the selection of a view for a painting. Taking as models the pastorals of Claude Lorraine and the stormy landscapes of Salvator Rosa, Gilpin sought out scenery in the British Isles that resembled these canvases. The pictures accompanying his texts were general enough to provide prototypes for American artists seeking appropriate views in their own country and included variations on only a few basic motifs. The scenery chosen was rough and uncultivated, with mountains in the background; a lake, winding river, or hills in the middle distance; and an irregular foreground usually with rocks, dead trees, or a few clumps of shrubs providing a base for the composition. The tripartite division of the picture was further conventionalized by the gradation of tones: usually a dark foreground, a light middle ground, and a tone in between for the distance. A framing element such as a tree, an outcropping rock, or the slope of a mountain embraced the main view and further guided the eye in the progression through the landscape.[7]

Once the major subject had been selected the artist still had to adjust his viewpoint and arrange the minor elements to create "a harmonius whole."[8] He could choose an asymmetrical disposition of forms so that the dark foreground was set off from the distance by a strong diagonal. This was the type of composition used by Thomas Cole and Church in their representations of the Oxbow River (Metropolitan Museum of Art, New York, and fig. 19) and by Albert Bierstadt in his *View from the Wind River Mountains, Wyoming* (1860; fig. 136). Or the artist could select the more usual symmetrical massing of forms that carried the eye back to the center of the picture.

Although the master subject was to be portrayed substantially as found—Durand believed this was more important than Gilpin—it was not to be expected that the secondary elements such as rocks and trees would necessarily

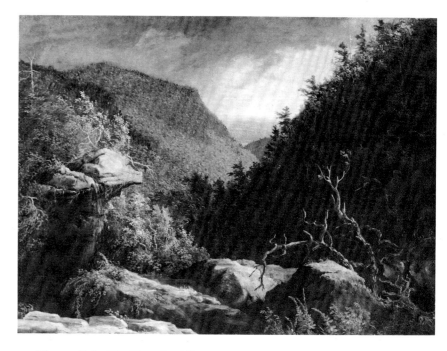

20. Thomas Cole. *The Clove, Catskills,* 1827. Oil on canvas. 0.635 x 0.838 (25 x 33 in). New Britain Museum of American Art, New Britain, Connecticut; Charles F. Smith Fund. Photo: E. Irving Blomstrann

be of the appropriate form or that they would occupy the most auspicious place in the view.[9] The subordinate motifs could, therefore, be arranged at will; and, according to the principles of picturesque beauty, they should be selected and distributed to provide interest and contrast. Consequently, the foreground was rough and broken and often strewn with lichen-covered rocks and decaying logs to set off the more regular forms in the middle distance. Trees were useful to provide a vertical accent to a predominantly horizontal view, and both trees and rocks could be placed to lead the eye to the center of the composition. In Cole's *The Clove, Catskills* (1827; fig. 20), for example, our gaze is directed in a zigzag pattern from the contrasting light-colored rocks in the left foreground, across on a diagonal to the gnarled tree on the right, then to the left and the rocky outcropping with the waterfall, and to the right, left, and right again in the three overlapping mountains. These succeeding components in the composition act as relays, conducting our perusal of the scene further back to the climax at the opalescent horizon. While the clove itself was a well-known example of a picturesque view in America, our experience of the view is carefully orchestrated by the character and the placement of the subordinate elements and the calculated contrast of dark and light.

21. Thomas Cole. *Summer Sunset,* 1834. Oil on wood panel. Inscribed, back of panel: *T Cole/Catskill/1834.* 0.343 x 0.495 (13½ x 19½ in). The New-York Historical Society, New York

22. Asher Brown Durand. *Sunset,* 1878. Oil on canvas. 0.635 x 0.940 (25 x 37 in). Inscribed, l.l.: *A.B. Durand/1878.* The New-York Historical Society, New York

The selection of the view and the situation of the major and minor forms according to Gilpin's formulation still did not determine whether a painting was substantially picturesque or true to nature. This was decided by the treatment or manner of representation, whether an artist turned to a conventional or perceptual portrayal of the elements of nature.

Before an objective representation of nature could elicit the kind of aesthetic response described by Ruskin and Durand, nature had first to be deemed worthy of artistic consideration. Criteria were thus first established by Gilpin in choosing the paintings of Claude Lorraine and Salvator Rosa as models. These artists served as intermediaries between art and an aesthetic appreciation of nature through the portrayal of landscape in terms that were recognizably pastoral or sublime. The elements of nature as depicted by Claude and Rosa became conventions adapted by other artists seeking the same kind of literary associations.

Thomas Cole as founder of the American school of landscape painting adapted the principles of picturesque beauty and the conventions of Claude and Salvator Rosa to his representation of the native scenery and opened up a path that eventually led to an appreciation of nature without the intermediary of artistic formulas. Although he had been influenced by Wordsworth to see

nature as a manifestation of the Divine Being, Cole was still attached to the pictorial and associative qualities that precluded a true appreciation of nature. He did make drawings of views, but he disliked painting specific scenes which he considered mechanical exercises. Instead, he believed the artist should create original compositions based on a selection and combination of his sketches. He wrote to Durand that it was important to "wait for time to draw a veil over the common details, the unessential parts, which shall leave the great features, whether the beautiful or the sublime dominant in the mind."[10]

The representation of nature as a revery of impressions most often elicited stereotyped compositions and conventional treatment: the irregular rhythms of the contours of the land, the reflecting body of water, the graceful framing tree, the stumps, dead limbs, and clumps of weeds, and over all, an enveloping, generalizing haze. Cole's *Summer Sunset* (1834; fig. 21) and *Catskill Creek* (1845; fig. 69) and Durand's *Sunset* (1878; fig. 22) were paintings made with other paintings in mind and the experiences in the open air temporarily forgotten. The nondescript landscape forms treated in a general manner do not refer to a specific place but are dream images recalled through the golden haze of Claude. Why Durand should create such paintings after damning the "poisons of conventions" in his "Letters" is difficult to understand.[11] He had praised Claude's portrayal of light but at the same time condemned the substitution of "mere[ly] pleasing pictures" for a "true representation of nature."[12]

The treatment of landscape in conventionally poetic terms announced the presence of the artist's sensibility within the picture. The painter could also assert himself through the touch of paint on the canvas. Cole's paintings often contain an energy that speaks more of the man than of nature. We are aware of movement through the leaves, in the reach of limbs, and even running through rocks. The artist's brushstroke becomes a factor in animating nature with his personality. It is difficult to look at a painting by Cole without thinking of Cole, himself.

In Durand's *Kaaterskill Clove* (1866; fig. 23), on the other hand, it is possible to lose all sense of the artist and self in an appreciation of nature. The main features of the view are the same as in Cole's *Clove, Catskills* and follow the general formulation for a picturesque view with a dark foreground, framing trees, and distant mountains; but the selection of the subordinate elements and their treatment are not guided by conventional formulas. Nature is not made to appear pastoral or theatrical or anything other than itself. Durand's picture is much less dramatic than Cole's and more fully integrated. The rocks and trees in the foreground seem less studio props than inherent parts of the scene. Durand has avoided the typically picturesque twisted boughs and cascading waterfall. His trees are not dependent upon a conjunction of ideas for their interest but upon the close observation of specific individuals studied for their unique qualities. The fallen trees are evidently carefully placed to provide

23. Asher Brown Durand. *Kaaterskill Clove*, 1866. Oil on canvas. 0.972 x 1.524 (38¼ x 60 in). Inscribed, l.r.: *A.B.Durand/1866*. The Century Association, New York. Photo: Frick Art Reference Library

opposition to those still standing, to underscore the position of the rocks beneath them, and to direct our eye to the clove, but their role, although important, is a subtle one. They appear as they might have been found and do not call attention to themselves through association with the pastoral or sublime or the artist's touch. Although Durand did experiment with a proto-impressionist technique in some of his studies, his purpose was clearly to depict nature as truthfully as possible, not to assert his own presence; and in fact, we are more aware of the textures of nature than brushstroke and paint.[13] In *Kaaterskill Clove*, the principles of art are clearly used at the service of nature to reveal the poetry inherent in a well-known view.

With a greater concern for a perceptual representation of nature came a new emphasis on the accurate portrayal of the sky and light. Although Gilpin had recommended the observation of weather conditions and of light at different times of the day, his admiration was reserved for glowing sunsets reminiscent of Claude and for the contrast of overcast and broken skies that accounted for alternating tones across the landscape.[14] In Cole, light and weather were also used for effect rather than a measure of perceptions. They set the mood for his paintings—a radiant harmony for his *Summer Sunset* and drama and contrast in *The Clove, Catskills*. In Durand's *Kaaterskill Clove*, on the other hand, a perception of atmospheric perspective becomes the main subject of the painting, for the artist replaced Cole's picturesque alternation of dark and light with progressively paler tones for the receding mountains. Durand had described in his "Letters" the properties of atmosphere as "the power which defines and measures space . . . a veil or medium interposed between the eye and all visible objects. . . . It is *felt* in the foreground, *seen* beyond that, and palpable in the distance. It spreads over all objects the color which it receives from the sky in sunlight or cloudlight."[15]

Until the end of his life, Durand continued to describe his moisture-laden skies within a narrow range of values. He recommended gray as "the principal ingredient in atmospheric tone"[16] and avoided the brilliant colors and crystalline air often portrayed by the luminists. He persevered in his admiration for Claude's representation of light, atmosphere, and water; his acknowledgment of Turner's contribution to the depiction of skies was vague and probably no more than a concession to the popularity of Ruskin.[17] Durand had refined the perception of certain types of atmospheric conditions, but it remained for others to discover the pictorial possibilities of light outside of the conventional categories.

The increased concern with the perceptual representation of light in the 1850s was a result of the value placed on the objective study of nature in the open air and the growing distrust of theory and conventions that did not coincide with personal experience. Ruskin's *Modern Painters* which was "in every landscape painter's hand"[18] reaffirmed the merit of relying on sight rather than tradition. His descriptive passages were widely admired for their eloquence, perception, and scientific knowledge.[19] He devoted four chapters alone to an analysis of the

26. Sanford Robinson Gifford. *Mt. Mansfield,* 1858. Oil on canvas. 0.178 x 0.356 (7 x 14 in). Inscribed, l.l.: *S.R. GIFFORD.* The George Walter Vincent Smith Art Museum, Springfield, Massachusetts. Photo: Jill Gibbons Hammond

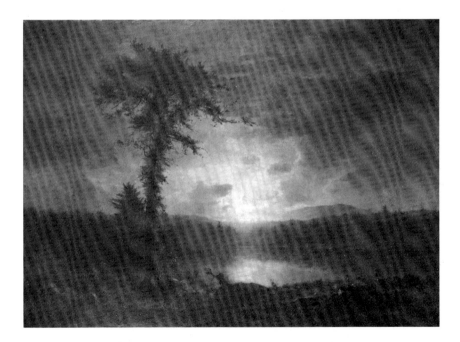

24. George Inness. *The Close of Day,* 1863. Oil on canvas. 0.635 x 0.889 (25 x 35 in). Inscribed, l.r.: *Geo. Inness, 1863.* The J. B. Speed Art Museum, Louisville, Kentucky

25. Martin Johnson Heade. *South American River,* 1868. Oil on canvas. 0.660 x 0.571 (26 x 22½ in). Inscribed, l.l.: *M J Heade 68.* Museum of Fine Arts, Boston; M. and M. Karolik Collection (at right)

sky and clouds.[20] Unquestionably Ruskin inspired many to *see* for the first time effects and forms in nature they had previously barely observed.

By the 1850s the features of the picturesque composition—rough foreground, reflecting body of water in the middle ground, and mountains in the distance—were a commonplace. There was even a standard circuit taken by artists and tourists of the picturesque spots in the mountains of New York state and New England. The most favorable viewpoints for observing the famous scenery were often marked by a rest house and publicized in books illustrated by the traveling artists.[21] It must have been the most natural thing in the world for the painter to stroll through the countryside with his sketchbook or painting paraphernalia in hand looking for the site where the scenery arranged itself to create the expected relationships.

The picturesque composition continued to be employed well into the 1880s. It provided a balanced arrangement of the features of the landscape that seemed particularly satisfying and that could be adapted to a variety of intents, from poetic revery to a perceptual rendering of a carefully selected view. Among the most subjective canvases were those of George Inness, an intense, brooding man who sought to infuse his paintings with the divine through the medium of his own spirituality rather than an objective portrayal of God's handiwork. In such pictures as *The Close of Day* (1863; fig. 24), the master subject is not a distant mountain but the double appearance of the setting sun glowing in the hazy sky and reflected in the water, the dual image enframed by the vertical tree, the land masses, and clouds. A similar arrangement of light and forms can be found in Martin Johnson Heade's *South American River* (1868; fig. 25) and Church's *Morning in the Tropics* (1877; fig. 128), but the exotic vegetation is more precisely delineated than Inness' generalized landscape elements and nearly engulfs the double core of light. These two paintings are neither the subjective dream images of Inness, nor the perceptual renderings of specific views, but compositions created from sketches and memory.

Church was also capable of a pastoral interpretation of the typically picturesque composition. In his *Mt. Ktaadn* (1853; fig. 194), he introduces the graceful elm, watering cows, road rutted with wheel marks, bridge, and cluster of buildings that appear so often in European antecedents. The conviction that comes from the study of perceived truths, that is evident in the predominance given to the sky, the clarity of the atmosphere, and the rendering of the contours of the mountain, is diminished by the incorporation of the timeworn conventions.

The picturesque composition was given new vitality in the views of the American wilderness. Instead of reiterating the pictorial clichés set forth by Gilpin and prevalent in the European tradition of landscape painting, artists now made new discoveries. In Church's *Sunset* (1856; fig. 89) and *Twilight in the Wilderness* (1860; fig. 204) the elements of the landscape are portrayed with an eye for the unique qualities that made each view distinctive from all others. The rocks and trees are rough and untamed but not histrionic. They are rendered with regard to their individual characteristics, not just in the foreground but as foreground blends into the middle distance. The contours of the hills and mountains have a singularity about them, and they are sharply delineated, not obscured by the intervening atmosphere. For the first time we are aware of the ground and water as a horizontal plane extending into the distance, the penetration of space measured and marked by a rock or shrub or reflections. More than anything else, it is the lucidity of the atmosphere and the quality of the light that gives the views freshness and specificity by sharpening forms and recording time of day and weather conditions. In *Sunset*, all the elements of the landscape conduct our eye from the lower left to the right and the point of greatest contrast in the sky. The curving and broken trees on the left introduce the movement that is carried along the irregularly descending foreground and

distant mountains and the horizontal reflections in the water. The momentum to the right is halted and directed upward by the rising foreground and rocks. In *Twilight in the Wilderness* our eye is led to the sky by the framing tree, the reflecting body of water, and the dip in the mountains in the center of the canvas. In both paintings the landscape serves as a mediator for the brilliant effects above that could only be realized by the intense perception of specific conditions. In *Twilight in the Wilderness* we are especially struck by the carefully studied cloud formations and are reminded of Ruskin's descriptions of the types of clouds, their transparency and evanescence, the role of the wind in their configuration, and the effect of light and color.[22] By capturing the transient effects of light, when the color is constantly changing, Church gave the painting of landscape views an immediacy and new meaning.

The prominence given to the sky in *Sunset* and *Twilight in the Wilderness* is largely a factor of the new breadth of the composition: the large portion of the canvas devoted to sky and water, the horizontal continuance of the mountains uninterrupted by a pronounced summit, and the open penetration of the framing trees. The effect of the panoramic composition is to render the painting less "pictorial," less self-sufficient, less an exclusive entity with reference only to itself, and more a segment of a larger whole, of a horizontal extension expanding for 360 degrees.

Sanford Gifford developed a modification of the picturesque composition that enabled him to emphasize his major concern and master subject, the effects of light and color. He selected and modified views to create bowls of the landscape to serve as containers for the light-filled air. In his most conventional compositions, *Mt. Mansfield* (1858; fig. 26) and *October in the Catskills* (1880; fig. 4), the mountains rise up on either side of the view to embrace the color-filled atmosphere. The clarity of the trees and rocks in the foreground are in contrast with the veiled forms in the distance. Gifford believed that "the really important matter is not the natural object itself, but the veil or medium through which we see it."[23] More than anyone else's, Gifford's paintings describe the quality of atmosphere noted by Durand: "It is *felt* in the foreground, *seen* beyond that, and palpable in the distance. It spreads over all objects the color which it receives from the sky in sunlight or cloudlight."[24] Gifford's contribution was to portray the atmosphere as a vehicle for color rather than a modifier of tone.

October in the Catskills was preceded by two other paintings, *Kauterskill Falls* (1862; Metropolitan Museum of Art, New York) and *Sunset in the Adirondacks* (1865; private collection),[25] where the same compositional format was adapted to different views. Very similar trees on the left, together with secondary trees and rocks, provide a frame for the color-laden atmosphere and indistinct mountains and waterfalls. In *Twilight on Hunter Mountain* (c. 1865; fig. 85), the bowl is adjusted to a more panoramic scene. A preliminary sketch (1865; Sketchbook IV, Vassar College, Poughkeepsie, New York) reveals that Gifford regularized and broadened the depression and shifted it to the center of the

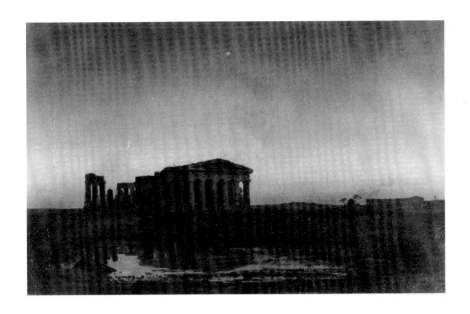

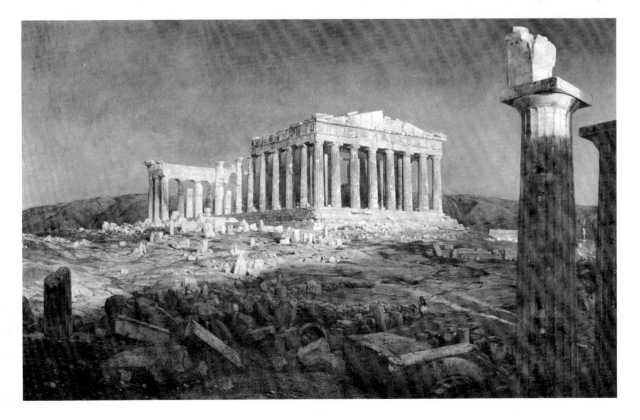

27. Jasper Francis Cropsey. *Evening at Paestum*, 1856. Oil on panel. 0.241 x 0.394 (9½ x 15½ in). Inscribed, l.r.: *J. F. Cropsey 1856*. Vassar College Art Gallery, Poughkeepsie, New York. Photo: Peter A. Juley & Son (above)

28. Sanford Robinson Gifford. *Roman Campagna*, 1859. Oil on canvas. 0.152 x 0.258 (6 x 10⅛ in). Inscribed, l.r.: *S R Gifford 59*. Vassar College Art Gallery, Poughkeepsie, New York. Photo: Peter A. Juley & Son (above, right)

29. Frederic Edwin Church. *The Parthenon*, 1871. Oil on canvas. 1.122 x 1.832 (44³⁄₁₆ x 72⅛ in). Inscribed, l.l.: *F. E. Church/1871*. The Metropolitan Museum of Art, New York; Bequest of Maria De Witt Jesup, 1915 (right)

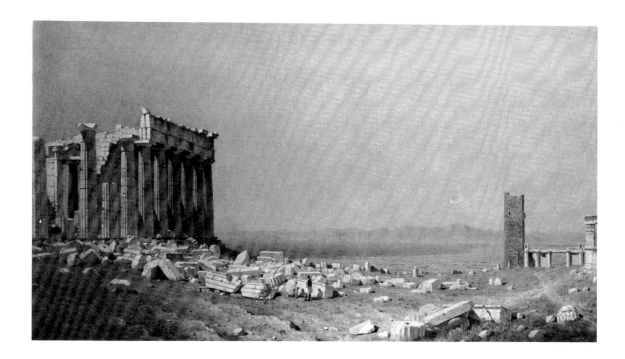

30. Sanford Robinson Gifford. *The Ruins of the Parthenon*, 1868. Oil on canvas. 0.705 x 1.356 (27⅝ x 53⅜ in). Inscribed, l.l.: *S R Gifford 1880*. The Corcoran Gallery of Art, Washington, D.C.

picture so that it complemented the ascending curve of the mountain in the background; he thus created an oval of mountain and valley bisected by the stand of trees in the middle distance. Gifford carefully repositioned the fallen logs to underscore the slope of the depression and the tree stumps to mark off distances. The thoughtful placement of the minor forms to create a sense of balance and measured ratios is equivalent to his weighing of color sensations: the lavender of the mountain against the complementary yellow of the sky and the touches of complementary green in the red landscape.

The quality of measure and precision that Gifford introduced into his pictures had the effect of rendering them less picturesque. Twice he painted famous views and reduced the characteristics that had previously made them pictorial. When Cole and Jasper Cropsey portrayed the Roman *campagna* (*Roman Campagna*, 1843, Wadsworth Atheneum, Hartford, Connecticut; *Evening at Paestum*, 1856; fig. 27) they depicted the foreground as rough and broken and emphasized the irregularity of the ruins diminishing the classical qualities of poise and mensuration. Gifford, on the other hand, smoothed out the landscape to create a shallow depression that rises to meet the vertical arcade and harmonizes with the descending slope of the mountain (fig. 28). He also eliminated the broken, solitary piers that lent Cole's and Cropsey's paintings their air of picturesque decay. He preferred to maintain the diagonal alignment of the lintels and thereby preserve the integrity of the classical

architecture. Interestingly enough, by substituting measure and precision for the picturesque conventions of rough and irregular forms Gifford convinces us of his commitment to the truth of the view; and, yet, this was also an invention, a transformation of the given topography according to principles of design.

Nothing could more dramatically illustrate Gifford's subordination of the elements of a view to the quality of light and air than a comparison of Church's and Gifford's representations of the Parthenon. In Church's painting (1871; fig. 29), based on a photograph,[26] the point of view was clearly selected to make the Parthenon the master subject of the composition. It is given prominence by its position in the center of the pictorial field on a slight rise of ground, silhouetted against the sky, and bathed in light. Its poise and serenity are set off by the framing columns on the right, in contrast to the jumble of large-scale fragments cast in shadow in the foreground.

In Gifford's painting (1880; fig. 30), the master subject is the view from the Acropolis with the southwest corner of the Parthenon on the left and a medieval tower and the Erechtheum on the right enframing the distant bay and mountains. The foreground is nearly empty. The fragments now in the middle distance and of the same scale as the temple lead our eye up to the columns with the crisp play of light and shade on the flutes set off against the expanse of sky. Gifford was fascinated by the Parthenon. He meticulously measured it and noted its subtle curvature, but the painting he created he considered "not a

picture of a building but a picture of a day."[27] Although the Parthenon is but a fragment in Gifford's version, the painting as a whole is more classical than Church's. The nearly empty foreground, the horizontal sweep of bay and mountains poised between the verticals of the architecture, and the gentle concavity of the ground relate to the lessons learned from measuring the building rather than reproducing it. Church's use of scale-jump and the diagonal shadow are baroque in comparison; the elements of the picturesque, whether they were applied to landscape or architecture, were based on irregular rhythms and contrast. The more measured and serene the composition the less it had to do with picturesque beauty.

Whereas the picturesque composition continued to be the preferred format of American artists for representing views of mountains, lakes, and winding rivers, there was an increased desire to portray segments of nature that Gilpin would have found simply uninteresting. The landscape lacked the distinctive master subject, the terrain did not have enough variety or contrast, the foreground sometimes extended into space without being distinguished as a separate plane, and the minor elements of lichen-covered rock and decaying log might be omitted altogether. But what was most telling was the omission of a framing element that penetrated significantly above the horizon. Such views were particularly fresh because the reference was clearly to nature itself rather than to pictorial conventions. As early as 1850 Church painted *Twilight, "Short Arbiter Twixt Day and Night"* (fig. 205), where the unassuming landscape serves as a foil for the effects of the sky. Only the rocks on the left provide enough of a contrast and of a modified frame to show that the conventions of the picturesque were not entirely forgotten.

William Hart made a conscious effort to avoid picturesque conventions altogether in his *Upland Meadow* (1872; fig. 31). Traditionally, the foreground had served as a visual base for the spectator and as a transition into the middle distance, but in *Upland Meadow* the foreground forms a triangle that rapidly draws us into the pictorial space. At the last minute the plunge into the landscape is blocked by a post and rail that are aligned with a fence further back, thus opening up the landscape to a broad panorama. The view is entirely composed of sloping lines creating interlocking triangles. There are no trees to give a vertical accent to counter the low-lying forms, and the few smooth rocks are close enough to the same size to provide homogeneity rather than contrast. Such pictures were only possible when the artist accepted the pictorial ideas presented by nature rather than tradition.

Upland Meadow provides visual documentation for the principles of landscape painting that Hart described in his lecture as president of the Brooklyn Academy of Design. While he acknowledged "that art, like everything else, was founded on theory and governed by rule," he warned the student against choosing a view simply "because 'it looked like a picture.'" The result "would be tame," and the artist justifiably censored for imitating "some ideal picture." It was better "to select a subject or scene as far removed from the conventional

31. William Hart. *Upland Meadow*, 1872. Oil on paper. 0.292 x 0.508 (11½ x 20 in). Inscribed, l.l.: *Wᵐ Hart/1872*. Private collection. Photo: Helga Photo Studio (see plate 27)

as possible" and to establish a point of view that revealed "the individuality of the scene. . . . Accessories should not be made to appear as the principal in the completed work"; and, Hart further explained, "'sky treatment' was of the highest importance." After working out of doors, the artist should return to the studio and "contract, intensify, and subject the sentiment to the picture," incorporating his own ideas and feelings that caused him to select the view or that were inspired by it. The artist was advised, however, "not to alter or modify the scene at the expense of nature and truth."[28]

John F. Kensett was well known for his ability to endow a typically picturesque view with his own poetic feeling.[29] While the general format of his compositions might be familiar enough (*Sunset, Camel's Hump, Vermont,* c.1851; fig. 80), the details were portrayed with the perception and love Durand and Ruskin claimed as the true province of the landscape painter. In his representation of light suffused through the atmosphere or reflecting off the limpid surface of water he created a mood of perceptive meditation that induced the spectator to see the poetry inherent in nature. Perhaps from a desire to appreciate nature free of formulas Kensett developed a compositional format for portraying picturesque views independent of picturesque conventions.

In *View Near Cozzens Hotel, West Point* (1863; fig. 243), Kensett depicted the famous scene from an unorthodox vantage point. Instead of symmetrically enframing the Hudson River with elevated foreground, the sloping headlands at either side, and distant mountains, as was the general practice, he shifted his angle of observation to create an asymmetrical composition: the river on the

left, the western bank on the right, the mountains in the background, and no foreground at all. In his lecture, Hart explained that the artist "having found his subject, . . . is next to enquire how much of his picture or panorama, of which he is the centre, he can take in upon the canvas."[30] Kensett's decision was to select a portion of the panorama that countered Gilpin's definition of the picturesque: a scene that looked like a picture. Kensett's painting decidedly did *not* look like any picture from the tradition of landscape painting, unless it was a segment of one of those endless, moving panoramas that had stopped; it was a segment poised between views of the river and the land. The effect of such a composition was threefold. First, it makes the spectator think of a painting less as an art object and more as a fragment of nature related to a larger whole. Second, it demonstrates the possibilities of design in unorthodox relationships. And third, it reveals how endlessly fascinating is the portrayal of light: the subtle modulation of tone on the glassy surface of the water, the graduated veils of atmosphere enveloping the mountains, and the evanescent illumination in the sky. Again and again, the eye is drawn away from the contrast of color and form in the landscape to the water and air as a medium for the play of luminescence.

Because of the prominence given to the sky and so to the effects of light, the panoramic landscape became the preferred compositional format for the luminist artist, and the coast and marshlands replaced the mountains as the primary theme. The extended horizon presented an alternative to the irregular rhythms and enclosed compositions of picturesque beauty and the primary formal motif against which minor variations of verticals, diagonals, curves, irregular lines, and parallel horizontals were played. The importance of the horizon as a straight line, an element of geometry, meant that the other components of the composition must necessarily be placed with a consciousness of design which was almost architectonic. The location of each form in terms of its relationship to every other and the intervals between them became a matter of carefully measured ratios.

The incorporation of measure and design in panoramic compositions had a number of origins. Foremost was the importance given to depicting the specific and familiar in the earliest landscape paintings made in the New World: topographical views of gentlemen's seats and townscapes recording the likeness of a growing metropolis. Related to this concern with the representation of portraits of places were the portraits of ships. Both types of paintings served to document appearances for those who were closely associated with the subject in question. Accuracy was important, and the pictures were often prosaic. Around the middle of the nineteenth century, the topographer's concern for recording facts was blended with the landscape painter's preoccupation with realizing the truth of nature, truth derived from a perceptual study of the facts filtered through the mind and endowed with a depth of feeling.

The transformation from topography to poetry and from fact to truth was enhanced by a portrayal of light and the application of principles of design.

There were three sources for the adaptation of design in panoramic compositions. First were the practical techniques used in the making of pictures and the transferring of images from paper to canvas. Second were the examples from the tradition of art: the precepts outlined in the instruction books and adapted by other artists. Third was the artist's own sensibility that enabled him to realize the potential for design in a given subject. Naturally, the pragmatic, traditional, and intuitive origins of design were fused in the creation of the final image.

In the course of his career Fitz Hugh Lane developed from an uninspired topographer of town and harbor views and a painter of ships' portraits to the most sensitive of the luminist painters. It was in his early years that he acquired the tools of his trade: knowledge of perspective and ship's architecture. Undoubtedly it was then that he first relied on the mechanical aids which stood him in good stead later: a drawing machine to measure distances accurately and use of transfer lines to transpose the views from his sketchbook to his canvas.[31]

A comparison of Lane's paintings of Norman's Woe (*Norman's Woe, Gloucester*, 1862, fig. 61; and *Norman's Woe*, 1862, fig. 32) with the drawing on which they were based (1861; fig. 33) reveals that in his mature style he maintained the topographer's allegiance to the accuracy of the view but, through the principles of art, elevated the factual to the poetic. The selection of the scope of the panorama demonstrates that the process of design was already at work. Lane chose a point of sight with an eye for the balance of contrasts: the solid curve of the shore against the void of sea and sky, the reach of land anchored by the island, one rock in the foreground silhouetted against the water and another enclosed within the line of the shore. The forms are situated on the paper with a precision that marks off the recession of space and locks the coast and island into the plane of water. The smaller rocks act as units of measure charting the distance across the inlet. The commitment to the carefully measured view is documented by the ruled grid superimposed over the drawing to aid in the transfer of the scene to the canvas.

In the two paintings the dimensions and placement of the island and coastline have been scrupulously reproduced; but contours have been subtly adjusted, and the details introduced in the first painting to give interest have been modified or omitted from the second to emphasize the structure of the composition. The picturesque wrecked hull has been eliminated from the final version, and the plants in the foreground subordinated. The ripples in the first canvas are stilled in the second, the three parallel curves moved up the shore to become tide lines. In both paintings the outlines of the island and rocks have been regularized toward the geometric. One of the foremost lessons of the instruction books demonstrated the importance of recognizing geometric analogies to the forms being copied.[32] This was to help in the delineation of contours—unnecessary, of course, if the artist was using a drawing machine—and to create order and harmony. The manuals also taught the artist to discover alignments in nature to create order.[33] In the second painting Lane aligns the

33. Fitz Hugh Lane. *Norman's Woe*, 1861. Pencil on paper. 0.216 x 0.647 (8½ x 25½ in). Inscribed, l.c.: *F. H. Lane del., 1861.* Cape Ann Historical Association, Gloucester, Massachusetts

32. Fitz Hugh Lane. *Norman's Woe,* 1862. Oil on canvas. 0.546 x 0.895 (21½ x 35¼ in). Cape Ann Historical Association, Gloucester, Massachusetts

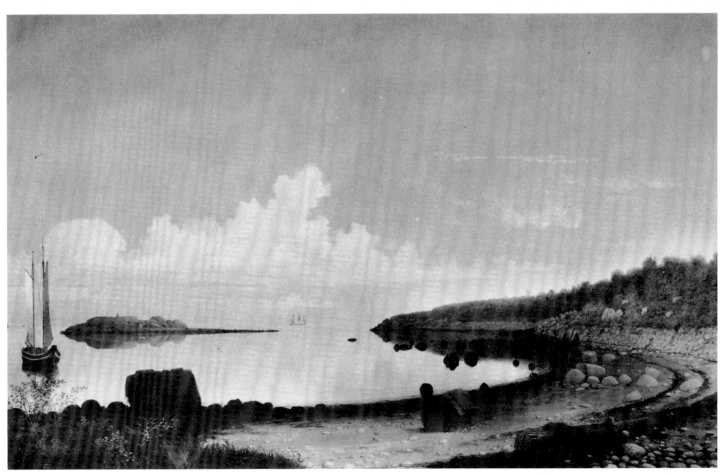

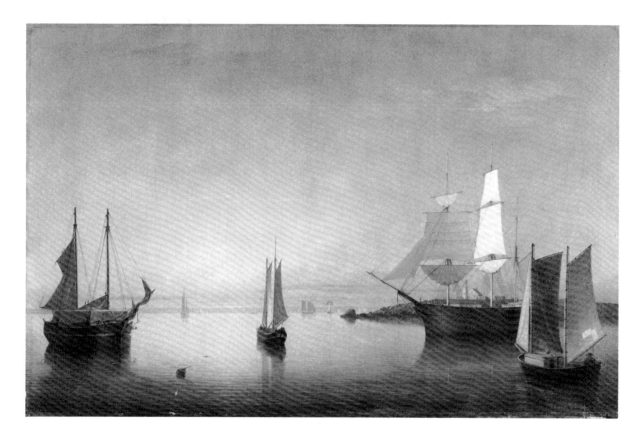

34. Fitz Hugh Lane. *Gloucester Harbor at Sunset,* late 1850s. Oil on canvas. 0.622 x 0.978 (24½ x 38½ in). Private collection. Photo: Fogg Art Museum, Harvard University, Cambridge, Massachusetts

reflection of the headland with the rocks in the water. The result is to subordinate the minor elements of the rocks to the more significant pattern created by the shore and its mirror image. The reflections, not present in the drawing, are important in setting the mood of crystalline stillness but also in stating the philosophical relationship of land and sea. The dark form of the land and its reflection is intersected by the light form of the sea of the same dimensions. They complement and complete each other. Similarly the prominent horizon is opposed by the verticals of the schooner's masts. In the first painting the placement of the boat may have been suggested by the ruled line in the drawing that intersects the horizontal spit of the island. In the final version the schooner was placed to the left to create a subtler and more evocative relationship, countering the panoramic thrust of the painting, the sweeping curve of the shore and its offshoot, the island, and providing a link between the sea, the island, and the cloud above. The center of the inlet is now a void around which the tensions of curves, horizontals, and verticals are poised. Lane discovered abstract relationships only intimated by the site. The balances he achieved in

his paintings were never stable, never resting on a firm foundation, but were suspended along the horizon like the transfer lines in his drawings and the riggings of the ships that were often an important part of the pictorial structure.

As a painter of ships' portraits Lane became thoroughly familiar with different kinds of vessels, the shapes of their sails, the lengths of their masts and spars, and the complex system of ropes, shrouds, and ratlines. In the early portraits the ships were situated parallel to the picture plane with their sails full. In his later paintings the ships provide a structure superimposed on the glowing sky and luminous sea. They pivot on their axes to define the plane extending from foreground to horizon. The vertical masts counter the prominent line of the horizon, and the hulls interrupt, then discreetly continue the lateral thrust through alignment with deck or portholes. Most remarkable is the fragile balance achieved through a subtle tension among forms. In both *Gloucester Harbor at Sunset* (late 1850s; fig. 34) and *Boston Harbor* (c.1850-1855; fig. 239) ships, barks, and schooners revolve around a smaller schooner near the

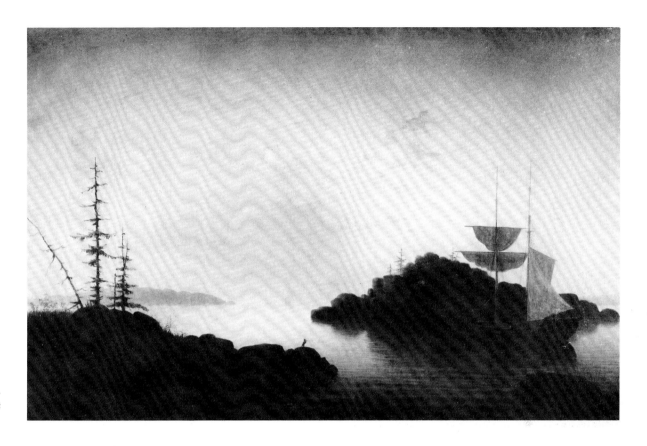

35. Fitz Hugh Lane. *Christmas Cove, Maine*, 1863. Oil on canvas. 0.394 x 0.610 (15½ x 24 in). Private collection. Photo: Childs Gallery

center of the picture, silhouetted against the evening light. The position of each vessel relative to the point of balance is determined by a reckoning of its size, the amount of foreshortening, and the disposition of the sails, furled or deployed, cast in shadow or in light. In *Boston Harbor*, for instance, the bark on the left with dark sails distended approximates in mass the ship on the right partially hidden by the smaller vessels, its topsails reefed. The schooner in shadow is countered by the smaller schooner placed against the light, masts intersecting the horizon and oars extended, a compendium of the poised balance of the picture as a whole.

In *Entrance of Somes Sound from Southwest Harbor* (1852; fig. 72), *Owl's Head, Penobscot Bay, Maine* (1862; fig. 113), and *Christmas Cove, Maine* (1863; fig. 35), the verticals of the barks are juxtaposed to the low-lying land, their balance echoing the perpendicular and horizontal relationship established in the right foreground, the man and rowboat in the first two paintings and the rocks and trees in the third. In both harbor and coast views the vessels' role is crucial in establishing order and balance through right-angled geometry along the hori-

zon and through the precise measurement of hulls by portholes, masts by masthoops and spars, and sails by reef bands and reef ropes. The verticals and horizontals subdivided by increments of mensuration provide lines of regulation against which to gauge the topography of the land and the spacious latitudes of the sea.

The solution to the problem of creating contrast and order in panoramic seascapes was provided in part by the very nature of the content: sailing vessels against the horizon; but there were also present in Lane's paintings artistic principles that he most likely gleaned from one of the manuals that taught the Anglo-Dutch tradition of landscape to the painter of watercolors. These instruction books were much more pragmatic than the theoretical writings of Durand and went further than Gilpin in particularizing the creation of order in a variety of landscapes. Although written for watercolorists the rules for composition and tone could be applied equally well by the painter of oils, and even the descriptions of techniques were relevant to the luminist artist who sought to conceal his brushstrokes by a careful blending of tones.

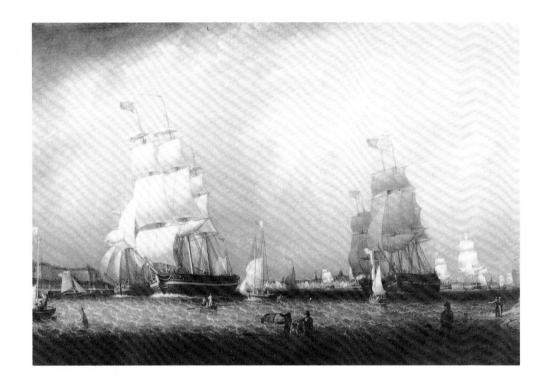

36. Robert Salmon. *Boston Harbor from Castle Island*, 1839. Oil on canvas. 1.016 x 1.524 (40 x 60 in). Signed, l.r.: *Painted by R. Salmon.* Virginia Museum of Fine Arts, Richmond; Adolph D. and Wilkins C. Williams Fund, 1973

The most comprehensive of the instruction books on landscape painting published in the United States was Fielding Lucas' *Progressive Drawing Book* (1826-1827), which incorporated the writings of the English watercolorist John Varley.[34] Varley's intention was to give the representation of views variety and order by achieving a balance through the opposition of forms and tones. He described the creation of contrast by juxtaposing an irregular shape such as a rock or a tree with the smooth surface of a body of water in the middle distance as Gilpin had done, but he also discussed balance through opposition in panoramic seascapes, a topic which Gilpin had avoided. To relieve the lateral expanse of the horizon and the recession of planes parallel to the pictorial surface characteristic of marine paintings Varley stressed the value of foreshortened sailing vessels. He also described how sails adjusted to provide contrast of dark and light could offset the spacious breadth of sea and sky, and how reflections on water introduced shade without weight and a streak of light gives relief to vessels.[35] The alternation of dark and light tones was useful for leading the eye into the picture especially if a light object were placed against a dark ground and a dark object against a light ground, as Lane had done with the stones set on the shore and others silhouetted against the inlet in his paintings of Norman's Woe.[36] The principle of "partially intercepting one object by another, in order to subdue it, for the sake of elevating a third object"

is illustrated in all Lane's paintings of harbors, and the advocation of a little red to alleviate the prevailing grays and greens of seascapes was met by Lane through the expediency of a sailor's shirt.[37]

Ideally, the thoughtful disposition of contrasts created a harmony that appeared completely natural, the result of "observation" rather than "contrivance." As Varley explained, "All the leading lines, ascending or descending, should so balance each other from the different sides of a picture, that a ball, rolling down one of them, should be impelled up on the other side, and so on in succession, til it settled near the centre of the picture."[38]

In some of Lane's paintings (*Gloucester Harbor at Sunset*) the balance of contrasts achieves a poised stillness that is totally assured. In others (*Norman's Woe*) there is a brittle tension as if with the slightest movement the image would crack. Lane was capable of a fluid handling of forms; but more and more he created compositions where the abstract relationships were not hidden but self-evident, and this is what distinguishes his paintings from those closer to the European tradition such as the work of the English-born Robert Salmon (fig. 36; also figs. 14, 104-105). Reality is selected and composed with an eye for geometric relationships that provided a structure for observations of the ever-changing effects of light.

The introduction of sailing vessels in Lane's paintings meant that the balance

38. Fitz Hugh Lane. *View in Town Parrish*, 1863. Pencil on paper. 0.248 x 0.737 (9¾ x 29 in). Inscribed, l.c.: *F. H. Lane del.* Cape Ann Historical Association, Gloucester, Massachusetts

37. Fitz Hugh Lane. *Babson and Ellery Houses, Gloucester,* 1863. Oil on canvas. 0.540 x 0.896 (21¼ x 35¼ in). Inscribed, l.r.: *F.H. Lane,1863.* Cape Ann Historical Association, Gloucester, Massachusetts

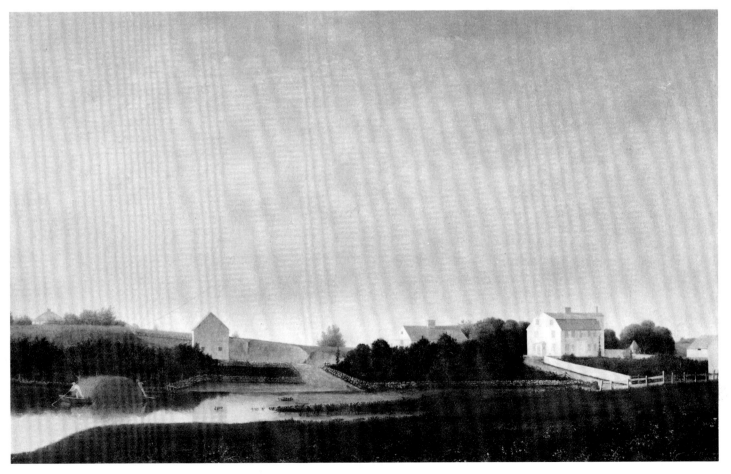

39. Sanford Robinson Gifford. *On the Nile,* 1872. Oil on canvas. 0.432 x 0.787 (17 x 31 in). Inscribed, l.r.: *S.R. Gifford, 1872.* Eugene B. Sydnor, Jr. Photo: Herbert P. Vose (see plate 22)

of forms was often intricate, hinging on the delicate weighing of tones on a sail's patch. Other artists who used the same principles could select views where the contrasts were far less subtle depending on the situation of a few well-chosen forms or lines to provide contrast with the panoramic horizon.

The types of composition for the organization of views of the sea, shoreline, or low-lying landscape were limited to the location of an isolated object against the horizon; the arrangement of forms parallel, diagonal, or curving into the picture plane; and the asymmetrical placement of rocks or a headland to interrupt the extension of the horizon.

The most prevalent luminist composition was based on the organization of the major forms parallel to the picture plane, to emphasize the panoramic expanse of the taut horizon. According to an article that appeared in the *Art-Union* (London) in 1844 the horizontal composition was the most

easily managed, . . . and after that the horizontal and perpendicular. . . . They are . . . productive of more grandeur and solemnity than any others, from the natural associative character of the two orders of forms. A horizon of water is a fine thing in itself, and never fails, with the contemplative, of ordering up vast associations, and amongst them those of eternal duration, repose, latent power, and danger. . . .

The [horizontal and perpendicular] possess all the elements of pictorial harmony, that is, relation on some points, and opposition on others, with subordination of one to the other: the horizontal is indicative of a universal law of nature, that of a general subsistence and repose of inanimate matter; and the perpendicular, that of power and action to preserve its position; added to which the horizontal is its own base, being a subsistence of all other lines in nature, while the perpendicular requires one.[39]

The horizontal and perpendicular composition, therefore, had a twofold advantage. It was a straightforward means of creating pictorial order through the balance of contrasts, and it had universal connotations.

Variety within the format of parallel horizontals could be achieved through the broken forms of shoals of rocks, the curves of islands, hills, and mountains, and the uneven contours of clouds and vegetation. Vertical accents were introduced by the masts of ships, trees, beacons, smokestacks, or even figures. (Compare, for instance, Lane's *Brace's Rock,* c.1864 [figs. 11, 74, 91, 116-117], and *Babson and Ellery Houses, Gloucester,* 1863 [fig. 37; see also fig. 38], Church's *Beacon Off Mt. Desert,* 1851 [fig. 88], Heade's *Thunderstorm, Narragansett Bay,* c.1870 [fig. 10] and *Becalmed, Long Island Sound,* 1876 [fig. 249], Gifford's *The Desert at Siout, Egypt,* 1874 [fig. 126] and *On the Nile,* 1872 [fig. 39], and Samuel Colman's *Storm King on the Hudson,* 1866 [fig. 148].) In each case the quality of luminism portrayed was determined not only by the representation of light and the panoramic composition but by the pervasive quietude and the rigor of the design.

Heade's paintings and drawings of marshes (figs. 40-42) are among the most disciplined of those created in the luminist style. In over one hundred pictures[40] he worked within a limited vocabulary experimenting with the abstract relationships presented in the instruction books as the basis for contrast and harmony. The major element to which all others are related is the panoramic horizon dividing the low, flat landscape from the sky. The pronounced horizontal proportions of paper and canvas emphasized the breadth of the topography, and oblong clouds and attenuated shadows cast by the rising or setting sun were frequently used as minor parallel accents. Contrast was furnished by the snaking curves or diagonals of the river, which defined the receding plane of the landscape extending from foreground to horizon. Vertical articulation followed the suggestions in the books for domed, angled, or vertical forms.[41] Occasionally, Heade introduced a small tree at one side of the canvas, but primarily he worked with the haystacks. Their domed shape provided two kinds of opposition: the contrast of curve to straight line and the contrast of a short object to the length of the horizon. The haystacks, like the river, emphasized the depth of the ground plane, marking off distances in measured ratios. In his charcoal drawings Heade interjected the angle of a sloop's sail to counter the extended horizon and the curve of haystacks. The vertical mast links the alternating dark and light tones of the marsh to the dark and light clouds, and the dotted diagonal of birds adds a lightness of touch to the predominantly heavy forms. In each of his pictures, Heade reordered the pictorial elements, setting line against curve and angle and dark against light to achieve the desired balance of contrasts. The marsh scenes are a compendium of the luminist purpose: the portrayal of the particular facts of a specific place arranged to reveal universal truths through a measured and balanced composition and tonal modulations of light.

Although luminism was foremost a style of landscape, the luminist atmo-

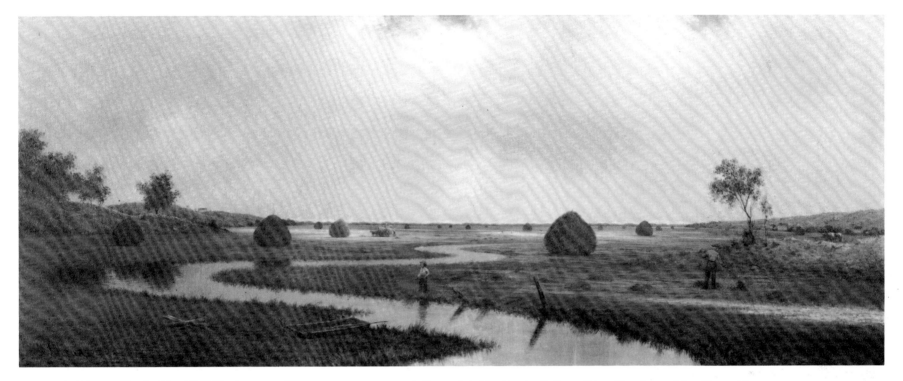

40. Martin Johnson Heade. *Marshfield Meadows,* 1878. Oil on canvas. 0.451 x 1.118 (17¾ x 44 in). The Currier Gallery of Art, Manchester, New Hampshire

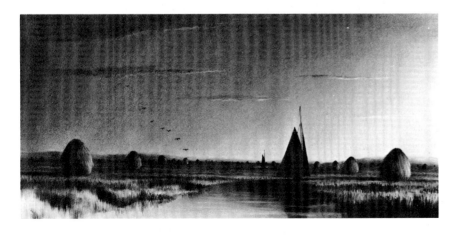

42. Martin Johnson Heade. *Newburyport Marshes,* 1860s. Charcoal and chalk on paper. 0.251 x 0.521 (9⅞ x 20½ in). Private collection.

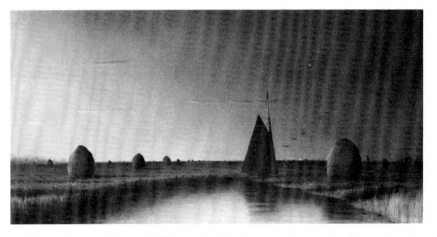

41. Martin Johnson Heade. *Twilight on the Marshes,* 1860s. Charcoal and colored chalks on paper. 0.280 x 0.559 (11 x 21⅝ in). Museum of Fine Arts, Boston; M. and M. Karolik Collection.

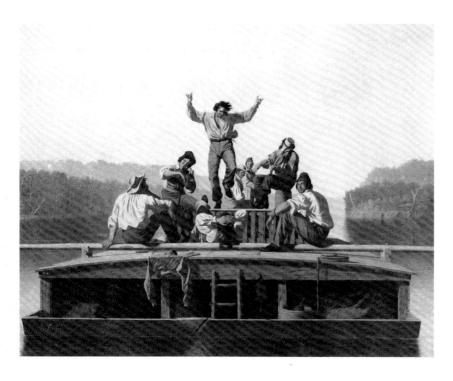

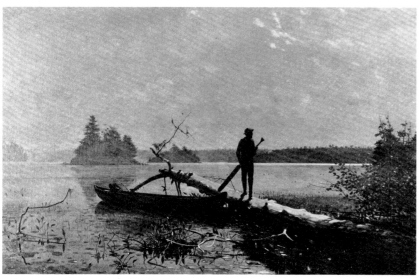

43. George Caleb Bingham. *The Jolly Flatboatmen,* 1846. Oil on canvas. 0.965 x 1.232 (38 x 48½ in). Inscribed, on boat, l.r.: *C.C. Bingham.* The Pell Family Trust, Hon. Claiborne Pell, Trustee. Photo: National Gallery of Art, Washington, D.C. (upper left)

45. Thomas Eakins. *Shad Fishing at Gloucester on the Delaware River,* 1881. Oil on canvas. 0.308 x 0.464 (12⅛ x 18⅛ in). Inscribed, on back: *T. E.* Philadelphia Museum of Art; Gift of Mrs. Thomas Eakins and Miss Mary A. Williams (upper right)

44. Winslow Homer. *An Adirondack Lake,* 1870. Oil on canvas. 0.616 x 0.971 (24¼ x 38¼ in). Inscribed, l.l.: *Winslow Homer 1870.* Henry Art Gallery, University of Washington, Seattle (not in exhibition)

46. Eastman Johnson. *The Cranberry Harvest, Nantucket Island,* 1880. Oil on canvas. 0.692 x 1.384 (27¼ x 54½ in). Inscribed, l.r.: *E. Johnson—1880.* The Putnam Foundation—The Timken Art Gallery, San Diego, California (lower right)

sphere and balanced scenery also provided a setting for the arrangement of people outdoors. As early as the 1840s William Sidney Mount and George Caleb Bingham created genre paintings where the figures are the primary structural element in the landscape. In *Eel Spearing at Setauket* (1845; fig. 256), the woman and boy with oar and pole define a triangle with the boat as the base. The two figures are tied to the shore in the background through alignment and parallels, primarily the thrust of landscape and reflection reinforcing the angled thrust of boat and pole. In *The Jolly Flatboatmen* (1846; fig. 43), the dancer is the apex of a triangle enclosing the other men with the extended oars as the base. Each figure is posed with an eye for alignments with verticals, horizontals, and diagonals. The dimensions of the ladder and hanging shirt-sleeves introduce modules that are repeated throughout, creating a stable and architectonic composition, against the parallel planes of ever-lightening blocks of scenery.[42] The use of figures as ordering elements in the landscape was further developed by Thomas Eakins, Winslow Homer, and Eastman Johnson in the second half of the nineteenth century. Occasionally the ruler-straight horizon and parallel shoreline act as a proportional gauge for a statuesque maid (Johnson, *Lambs, Nantucket*, 1874; fig. 175); but more frequently there was a balance between figures and setting (Homer, *Dad's Coming*, 1873; fig. 177), or the figures served as focus, modules, or contrasting verticals in the panoramic view (Homer, *An Adirondack Lake*, 1870, fig. 44; *High Tide: the Bathers*, 1870, fig. 298; *Promenade on the Beach*, 1880, fig. 178; Eakins, *Max Schmitt in a Single Scull*, 1871, fig. 179; *Shad Fishing at Gloucester on the Delaware River*, 1881, fig. 45; Johnson, *The Cranberry Harvest, Nantucket Island*, 1880, fig. 46). The specific quality of the light and character of the setting became more important with the increased interest in working outdoors, and the landscape became less a foil and backdrop for the figures and more an environment in which they participated along with the other elements in the composition.

In the desolate views of the coast only an occasional small-scale figure or boat relieved the vast expanse of sea, sand, and sky. The major contrast to the panoramic horizon was provided by the diagonal thrust or the sweeping curve of the shoreline. In the diagonal compositions the proportion devoted to the beach and ocean varied from painting to painting as did the angle of the slope dividing the breakers from the beach. In some paintings the breakers are almost parallel to the picture plane, and in others the diagonals of high-tide mark and rollers plunge sharply to the horizon where they are gathered together. In all the different views the major formal interest is the opposition of the dynamic tension of diagonals against the restful horizon, the energy of the breakers against the smooth sand. (Compare Heade's *Thunderstorm, Narragansett Bay* [fig. 10]; Bricher's *Morning Sunlight, Narragansett Bay*, 1872 [fig. 47], *Rocks in Surf*, 1871 [fig. 297], and *Seascape* [fig. 352]; Richards' *Shipwreck*, 1872 [fig. 295], *East Hampton Beach*, 1871-1874 [fig. 294], *On the Coast of New Jersey* [fig. 48]; Hamilton's *What are the Wild Waves Saying?* 1859 [fig. 49]; and Silva's *A Summer Afternoon at Long Branch*, 1885 [fig. 50].)

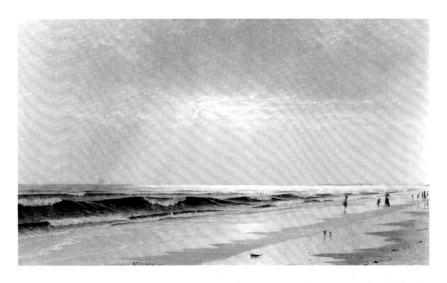

47. Alfred Thompson Bricher. *Morning Sunlight, Narragansett Bay*, 1872. Oil on canvas. 0.356 x 0.622 (14 x 24½ in). Inscribed, l.c.: *A.T.Bricher 1872*. Private collection. Photo: Herbert P. Vose

48. William Trost Richards. *On the Coast of New Jersey*, 1883. Oil on canvas. 1.022 x 1.835 (40¼ x 72¼ in). Inscribed, l.r.: *Wm T. Richards. 1883*. The Corcoran Gallery of Art, Washington, D.C.

49. James Hamilton. *What Are the Wild Waves Saying?*, 1859. Oil on canvas. 0.508 x 0.750 (20 x 29½ in). Inscribed, l.l.: *Hamilton;* and on verso, l.r.: *Jas Hamilton/Philada 1859/touched up—1868*. The Brooklyn Museum, New York; Gift of Mr. Robert E. Blum

50. Francis A. Silva. *A Summer Afternoon at Long Branch*, 1885. Oil on canvas. 0.610 x 1.118 (24 x 44 in). Inscribed, l.l.: *FRANCIS A. SILVA./85.* Mr. and Mrs. Wilbur L. Ross, Jr. Photo: Herbert P. Vose

51. Martin Johnson Heade. *The Coming Storm*, 1859. Oil on canvas. 0.711 x 1.118 (28 x 44 in). Inscribed, l.l: *M J Heade/1859*. The Metropolitan Museum of Art, New York; Gift of the Erving Wolf Foundation, 1975 (not in exhibition)

In paintings with the curving shoreline, the water is a smooth plane locked and bound by the rocky coast, sand and beach grass, or tall pines, like the relation of a mirror to its frame. Waves are little more than ripples in the surface. In views where the shore has the added contrast of vertical trees or hills and rough boulders, the paintings become less panoramic and more picturesque as the horizon is blocked or concealed by rough and irregular forms. (Compare Lane's paintings of Norman's Woe [figs. 32, 33]; Heade's *The Coming Storm*, 1859 [fig. 51] and *The Stranded Boat*, 1863 [fig. 120]; Bradford's *Fishermen's Homes, Near Cape St. Johns, Coast of Labrador*, c. 1876 [fig. 52]; Suydam's *Beach Scene, Newport*, 1860 [fig. 351]; Gifford's *Hook Mountain, Hudson*, 1866 [fig. 84] and *Twilight in the Adirondacks* [Adirondack Museum, Blue Mountain Lake, New York].)

The asymmetrical view with headland or iceberg heavily weighted at one side of the composition and tapering off or abruptly stopped could be the most picturesque of all seascapes or the most startlingly realistic. The picturesque views portrayed dramatic, usually inhospitable, and remote scenery characterized by a roughness of forms, broken surfaces, and jagged contours. In Church's *Grand Manan Island, Bay of Fundy* (1852; fig. 53) and *Sunrise Off the Maine Coast* (1863; fig. 214), Bierstadt's *The Marina Piccola, Capri* (1859; fig. 15), and William T. Richards' *The League Long Breakers Thundering on the Reef* (1887; fig. 54), a serrated wedge of rocky cliffs, rising precipitously from a rough

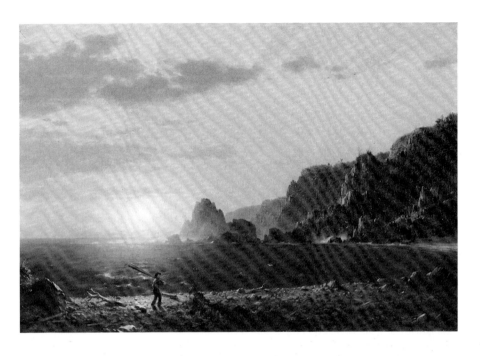

52. William Bradford. *Fishermen's Homes, Near Cape St. Johns, Coast of Labrador,* c. 1876. Oil on canvas. 0.432 x 0.736 (17 x 29 in). Inscribed, l.r.: *Wm Bradford 76* (?). Elton R. Barber. Photo: Brenwasser (not in exhibition)

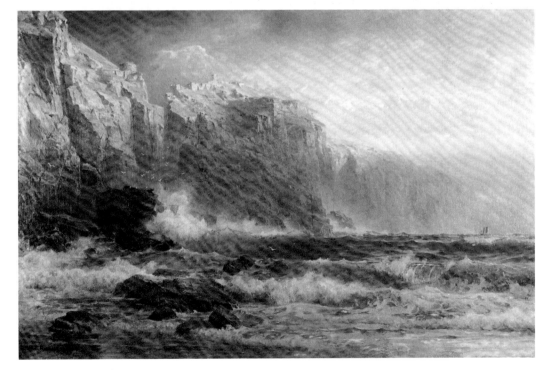

53. Frederic Edwin Church. *Grand Manan Island, Bay of Fundy,* 1852. Oil on canvas. 0.538 x 0.789 (21³/₁₆ x 31¹/₁₆ in). Inscribed, l.l.: *F Church/52.* Wadsworth Atheneum, Hartford, Connecticut; Gallery Fund. Photo: E. Irving Blomstrann (upper right)

54. William Trost Richards. *The League Long Breakers Thundering on the Reef,* 1887. Oil on canvas. 0.710 x 1.112 (27¹⁵/₁₆ x 44¹/₁₆ in). Inscribed, l.l.: *Wm. T Richards 1887.* The Brooklyn Museum, New York; Bequest of Alice C. Crowell (lower right)

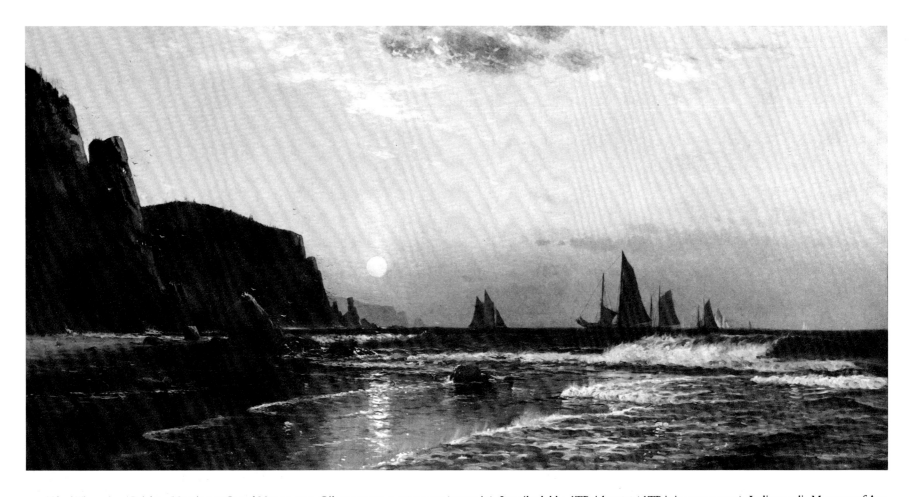

55. Alfred Thompson Bricher. *Morning at Grand Manan*, 1878. Oil on canvas. 0.635 x 1.270 (25 x 50 in). Inscribed, l.l.: *ATBricher 1878* (*ATB* is in monogram). Indianapolis Museum of Art; Martha Delzell Memorial Fund. Photo: Robert Wallace

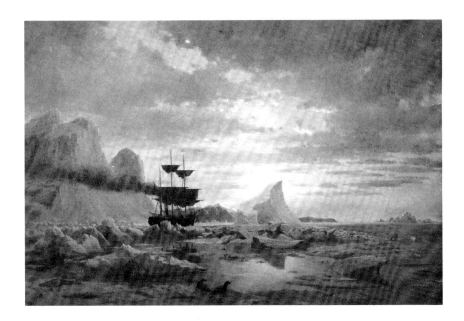

56. William Bradford. *Ice Dwellers Watching the Invaders,* c. 1870. Oil on canvas. 0.870 x 1.327 (34¼ x 52¼ in). Inscribed, l.l.: *Wm. Bradford.* New Bedford Whaling Museum, New Bedford, Massachusetts; Gift of William F. Havemeyer, 1910 (see plate 20)

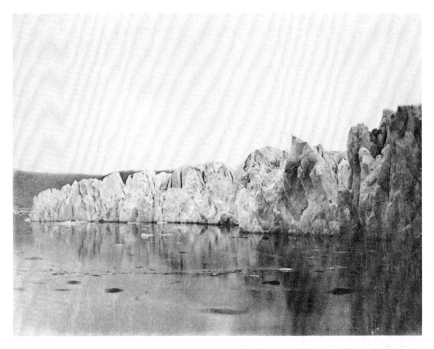

57. William Bradford. *Extended Section of the Front of a Glacier,* 1872. Albumen photograph. 0.284 x 0.383 (11⁵⁄₁₆ x 15¹⁄₁₆ in). Private collection. Photo: Janet Lehr

sea, is thrust across the center of the canvas. The straight horizon line either is absent altogether or presents a contrast to the prevailing, irregular forms. Even in Alfred Bricher's *Morning at Grand Manan* (1878; fig. 55), where the horizon and sky are given greater prominence, seven schooners interrupt the horizontal expanse, their angled sails echoing the slope of the escarpment. Bricher considered the painting "very picturesque"[43] acknowledging the qualities of pictorial contrast in crisp sails linking precipice and sea, the morning mist above the light-reflecting water, and the crossing diagonals of breakers and smooth overflow.

The most picturesque seascapes were the Arctic paintings of William Bradford reconstructed back in the studio from a selection of photographs made on the spot and from his memory and imagination *(Ice Dwellers Watching the Invaders,* c. 1870, fig. 56; and the work *In Polar Seas,* 1882, fig. 346). While the photographs (fig. 57) were often of an isolated wall of ice or ship and iceberg the paintings were a compendium of the experience of smooth water, towering crags of ice, and the broken terrain of smaller floes. The geometry of the ship's masts and spars provide the only gauge to chart and measure the inhospitable region. Bradford, like Church in his paintings of South America *(Andes of Ecuador,* 1855, fig. 186; and *Cotopaxi,* 1863, fig. 225) and Bierstadt in his pictures of

the far West *(Storm in the Mountains,* 1870-1880; fig. 58) sought to encompass the breadth and drama of the newly explored territory by incorporating different views in the same painting. Ruskin had demonstrated that to realize a view in all its actuality it was necessary to include the multiple aspects that could be seen by looking, turning, looking, and remembering—thus creating a visionary topography more true than a detached portion of the panoramic scene.[44]

The most strikingly realistic of the panoramic views were precisely those that Ruskin had denounced: a narrow slice of the sweeping horizon that left the spectator wondering about the portion of the landscape cropped at either edge of the frame. Kensett's *Beacon Rock, Newport Harbor* (1857; fig. 59), *Shrewsbury River* (1859; fig. 202), and *Eaton's Neck, Long Island* (1872; fig. 83), Mount's *Crane Neck Across the Marsh* (c. 1851; fig. 106), Richards' *Lighthouse on Cape Cod* (1865; fig. 60), and Suydam's *Paradise Rocks, Newport* (1865; National Academy of Design, New York) juxtapose the irregular headland with the straight horizon to create an asymmetrical composition of solid against void. Although these pictures are unorthodox they are not painted without a knowledge of artistic principles. The abstract design, the weighing of a few simple forms, is of

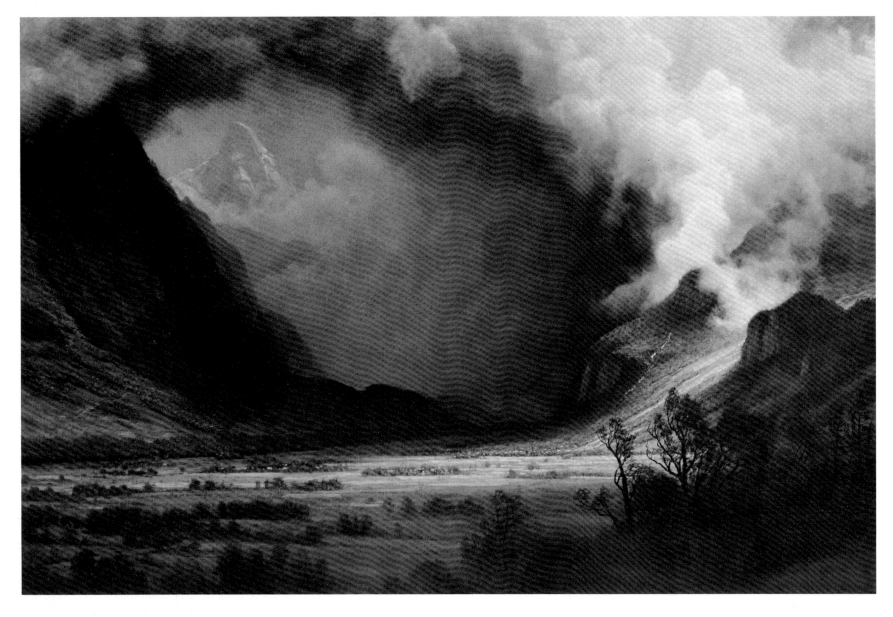

58. Albert Bierstadt. *Storm in the Mountains*, c. 1870-1880. Oil on canvas. 0.965 x 1.524 (38 x 60 in). Inscribed, l.r.: *A Bierstadt* (*AB* is in monogram). Museum of Fine Arts, Boston; M. and M. Karolik Collection

crucial importance because of the absence of the more obvious pictorial elements to give interest.

With luminism the artist's transition was completed: from an appreciation of landscape to a realization, through the intermediary of art, of the harmony inherent in nature. The commitment to the facts of the view and the truth of nature together with a knowledge of artistic principles led to the creation of paintings that seemed to compose themselves. The artist's educated and intuitive eye selected scenes that were naturally ordered and directed the subtle rearrangement and introduction of accents that convey that order to others. Above all, it is through the most orthodox luminist works, the quiet, understated paintings, that the artist makes the viewer aware of his own depth of feeling. He reveals the poetry in nature as inevitable, self-evident, and ever present.

60. William Trost Richards. *Lighthouse on Cape Cod*, 1865. Oil on canvas. 0.229 x 0.407 (9 x 16 in). Inscribed, l.l.: *W.T.R./July 6.65*. Mrs. James H. Dempsey. Photo: Cleveland Museum of Art (see plate 24)

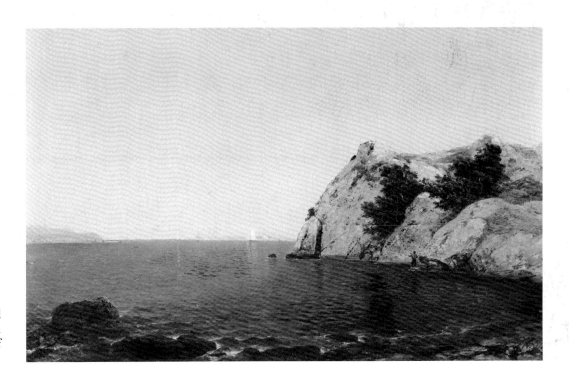

59. John Frederick Kensett. *Beacon Rock, Newport Harbor*, 1857. Oil on canvas. 0.571 x 0.915 (22½ x 36 in). Inscribed, l.r.: *J.F.K. 57 (J F* is in monogram). National Gallery of Art, Washington, D.C.; Gift of Frederick Sturges, Jr., 1953

Notes

1. Many of the ideas in this paper first appeared in my published dissertation *Measure and Design in American Painting 1760-1860* (New York, 1977). I would like to acknowledge my debt to Barbara Novak for her thought-provoking questions and encouragement.

2. A. B. Durand, "Letters on Landscape Painting," *The Crayon*, 1 (1855): 1-2, 34-35, 66-67, 97-98, 145-146, 209-211, 273-275, 354-355; and 2 (1856): 16-17.

3. Durand, "Letters," *Crayon*, 1:2.

4. John Ruskin, *The Elements of Drawing*, intro. by Lawrence Campbell (London, 1857: rpt., New York, 1971), 13.

5. Durand, "Letters," *Crayon*, 1:66.

6. Durand, "Letters," *Crayon*, 1:66.

7. William Gilpin, *Observations on the River Wye, &c. and Several Parts of South Wales &c. Relative Chiefly to Picturesque Beauty, Made in the Summer of the Year 1770*, 5th ed. (London, 1880), 21, 46, 128-129; *Observations Relative Chiefly to Picturesque Beauty, Made in the Year 1776 on Several Parts of Great Britain; Particularly the High-Lands of Scotland*, 2 vols., 2nd ed. (London, 1792) 2:2, III-112; *Two Essays: One, on the Author's Mode of Executing Rough Sketches; the Other, On the Principles on Which They Are Composed* (London, 1804), 28-29; *Three Essays on Picturesque Beauty; on Picturesque Travel; and on Sketching Landscape; with a Landscape Poem and Two Essays*, 3rd ed. (London, 1808), 12, 28, 125.

8. Gilpin, *Wye*, 31.

9. Durand, "Letters," *Crayon*, 2:16; Gilpin, *Three Essays*, 68.

10. Cole to Durand, Jan. 4, 1838; quoted in Louis Legrand Noble, *The Life and Works of Thomas Cole*, ed. Eliot S. Vessell (New York, 1853; rpt. Cambridge, 1964), 184-185.

11. Durand, "Letters," *Crayon*, 1:2.

12. Durand, "Letters," *Crayon*, 1:274.

13. See Durand, "Letters," *Crayon*, 1:274 for the importance of the "concealment of pigments and not the parade of them." Barbara Novak, *American Painting of the Nineteenth Century: Realism, Idealism and the American Experience* (New York, 1969), 91.

14. Gilpin, *Wye*, 139, and *Scotland*, 1:12; 2:177; Elizabeth Wheeler Manwaring, *Italian Landscapes in Eighteenth Century England* (New York, 1925), 37.

15. Durand, "Letters," *Crayon*, 1:146.

16. Durand, "Letters," *Crayon*, 1:274.

17. Durand, "Letters," *Crayon*, 1:274-275.

18. Worthington Whittredge, "Autobiography," ed. John I. H. Baur, *Brooklyn Museum Journal*, 1 (1942):55.

19. See Roger B. Stein, *John Ruskin and Aesthetic Thought in America 1840-1900* (Cambridge, 1967).

20. *Modern Painters*, 5 vols., 3rd ed. (Boston, 1873), 1:314-388.

21. The best-known books are Joshua Shaw's *Picturesque Views of American Scenery* (1820); William Guy Wall's *The Hudson River Portfolio* (1828); *American Scenery* illustrated by the English artist William Bartlette (1840); and *Lotus-Eating* with drawings by Kensett (1852).

22. For Church's drawings of clouds see Theodore E. Stebbins, *American Master Drawings and Watercolors, A History of Works on Paper from Colonial Times to the Present* (New York, 1976), 127. For Church's use of photographs of clouds see David C. Huntington, *The Landscapes of Frederic Edwin Church: Vision of an American Era* (New York, 1966), 79.

23. Nicolai Cikovsky, *Sanford Robinson Gifford 1823-1880*. [exh. cat., University of Texas Art Museum] (Austin, 1970), 16.

24. Durand, "Letters," *Crayon*, 1:146.

25. Illustrated in *Gifford*, 56.

26. Elizabeth Lindquist-Cook, "Frederic Church's Stereoscopic Vision," *Art In America*, 61 (1973): 74.

27. Ila Joyce Weiss, "Sanford Robinson Gifford, (1823-1880)" (Ph.D. diss., Columbia University, 1968), 328-330.

28. William Hart (1823-1894) became the first president of the Brooklyn Academy of Design in 1865. The synopsis of his talk is provided by Henry Tuckerman, *Book of the Artists* (New York, 1857; rpt. 1966), 549-551.

29. Tuckerman, *Artists*, 510-514.

30. Tuckerman, *Artists*, 550.

31. Evidence of Lane's use of a drawing machine is given in drawings with convex horizon. See Andrus, *Measure and Design*, 275, n. 8.

32. John Gadsby Chapman, *The American Drawing Book* (New York, 1858), 43, 59.

33. John Burnet, *Practical Essays on Art* (London, 1893), 73.

34. The book was associated with the name of the publisher Fielding Lucas, Jr., but was compiled and illustrated by John H. B. Latrobe under the pseudonym E. Von Blon (Baltimore, n.d. [1826-1827]).

35. Lucas, *Progressive Drawing Book*, 31-36, 46, 48, 60-62.

36. Lucas, *Progressive Drawing Book*, 29, 30.

37. Lucas, *Progressive Drawing Book*, 53-54; Philip F. Hersh ("F. H. Lane: With a Fetish for Red," *Gloucester Daily Times*, July 14, 1967), noted that there is a little red in 95 percent of Lane's paintings.

38. Lucas, *Progressive Drawing Book*, 51.

39. J. B. Pyne, "The Nomenclature of Pictorial Art," (London) *Art-Union*, 6 (1844):42.

40. Theodore E. Stebbins, Jr., *The Life and Works of Martin Johnson Heade* (New Haven and London, 1975), 42.

41. Lucas, *Progressive Drawing Book*, 60-61.

42. Andrus, *Measure and Design*, 58-59.

43. Jeffrey R. Brown, with Ellen W. Lee, *Alfred Thompson Bricher 1837-1908* [exh. cat., Indianapolis Museum of Art] (Indianapolis, 1973), 23.

44. Ruskin, *Modern Painters*, 2:409, 4:138-143.

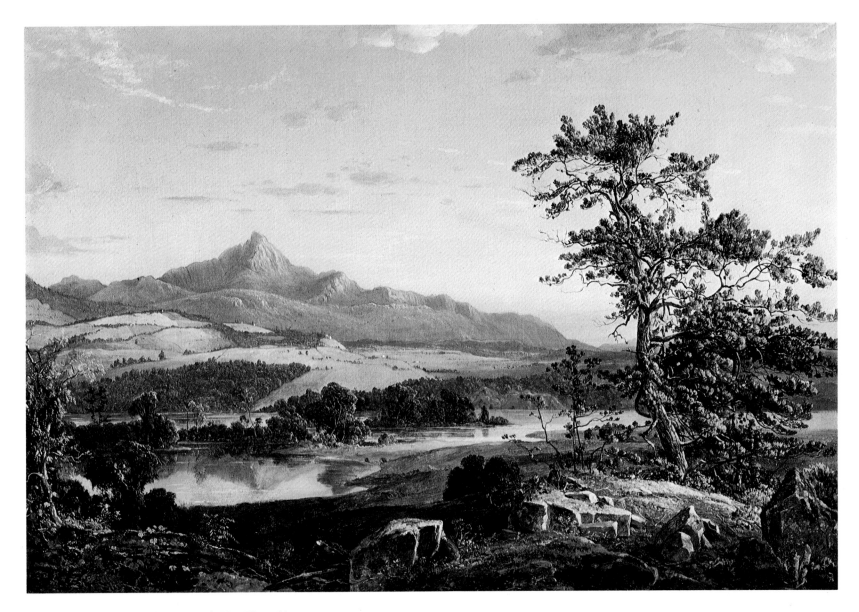

Plate 6. David Johnson. *Chocorua Peak, New Hampshire,* 1856.
Private collection. Photo: Helga Photo Studio (see fig. 110)

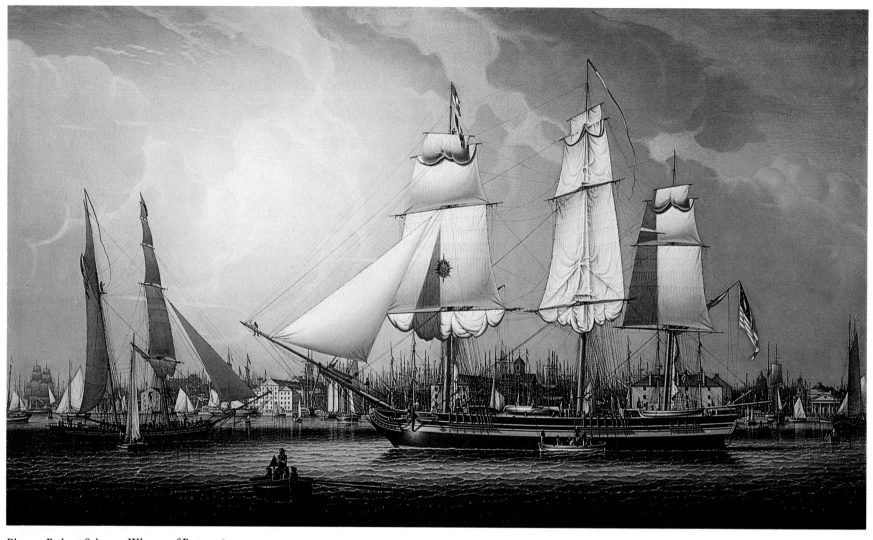

Plate 7. Robert Salmon. *Wharves of Boston*, 1829.
The Bostonian Society, Old State House, Boston; Gift of the Estate of Edmund Quincy, 1894.
Photo: Richard Cheek (see fig. 105)

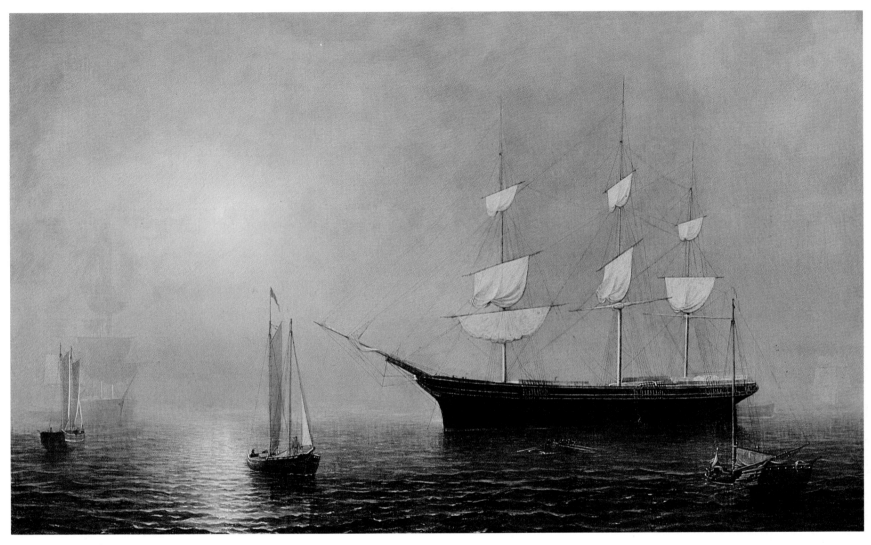

Plate 8. Fitz Hugh Lane. *Ship "Starlight" in the Fog,* 1860.
Butler Institute of American Art, Youngstown, Ohio (see fig. 112)

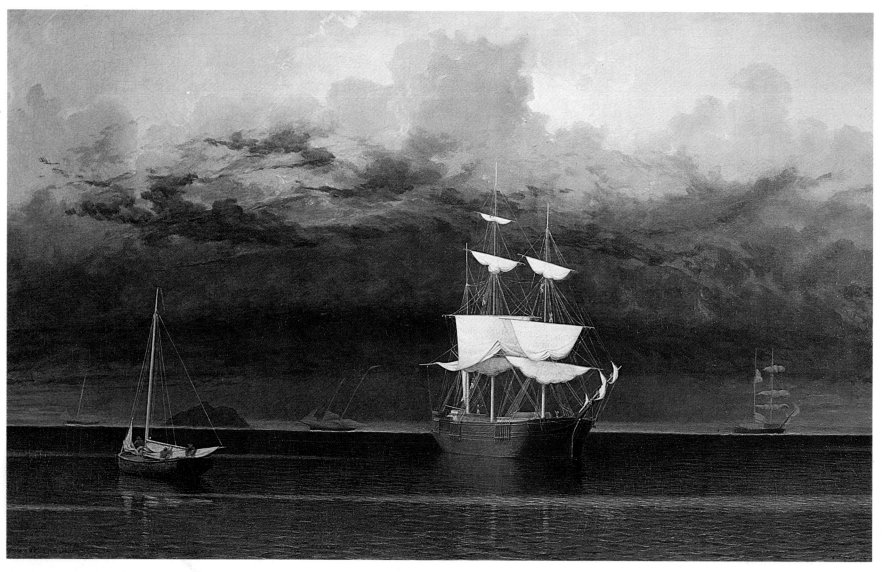

Plate 9. Fitz Hugh Lane. *Ships and an Approaching Storm Off Owl's Head, Maine*, 1860.
Governor and Mrs. John D. Rockefeller IV (see fig. 73)

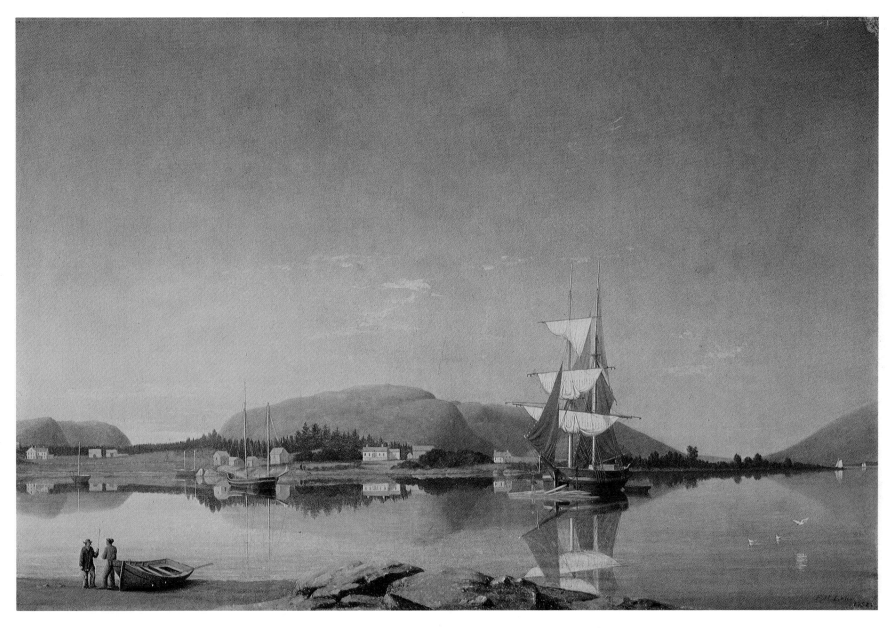

Plate 10. Fitz Hugh Lane. *Entrance of Somes Sound from Southwest Harbor,* 1852.
Private collection. Photo M. W. Sexton (see fig. 72)

Plate II. Fitz Hugh Lane. *Brace's Rock, Brace's Cove*, 1864.
The Lano Collection (see fig. II)

Plate 12. John Frederick Kensett. *Narragansett Bay*, 1861. Private collection. Photo: Herbert P. Vose (see fig. 12)

Plate 13. John Frederick Kensett. *Sunset, Camel's Hump, Vermont,* c. 1851. The Art Museum, Princeton University, Princeton, New Jersey (see fig. 80)

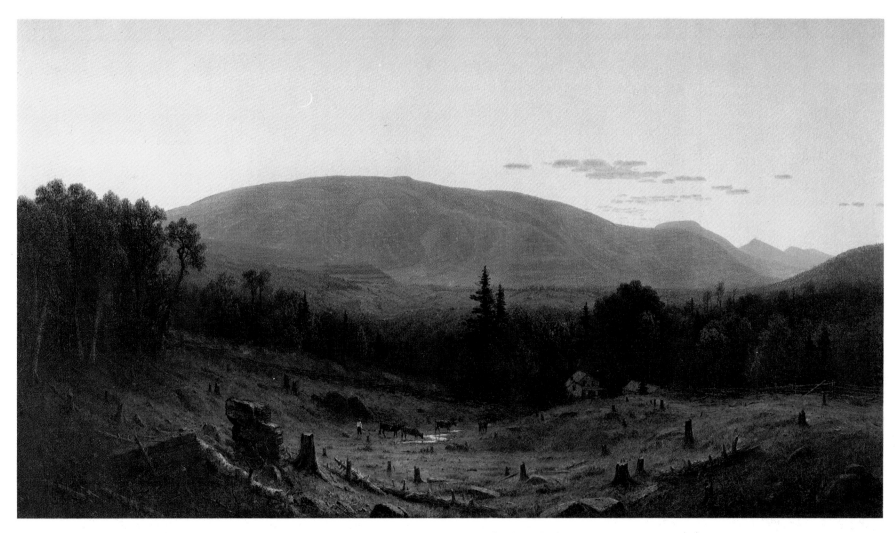

Plate 14. Sanford Robinson Gifford. *Twilight on Hunter Mountain*, 1866.
The Lano Collection (see fig. 85)

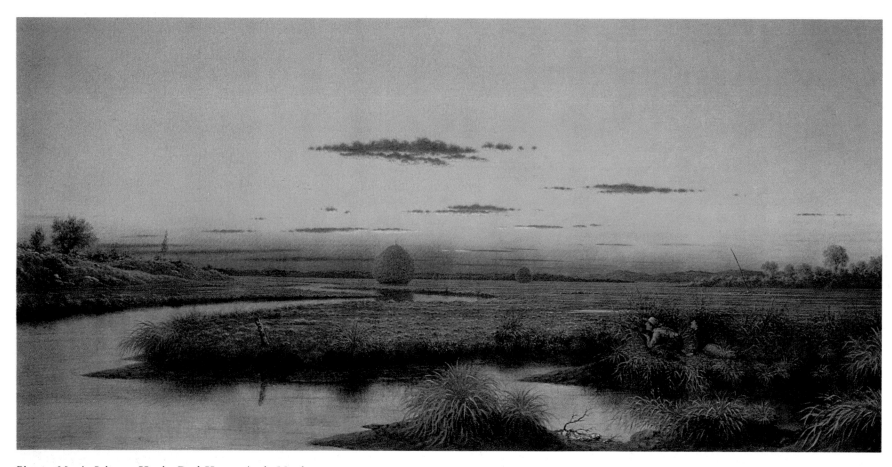

Plate 15. Martin Johnson Heade. *Duck Hunters in the Marshes,* 1866.
Private collection. Photo: Vose Galleries (see fig. 344)

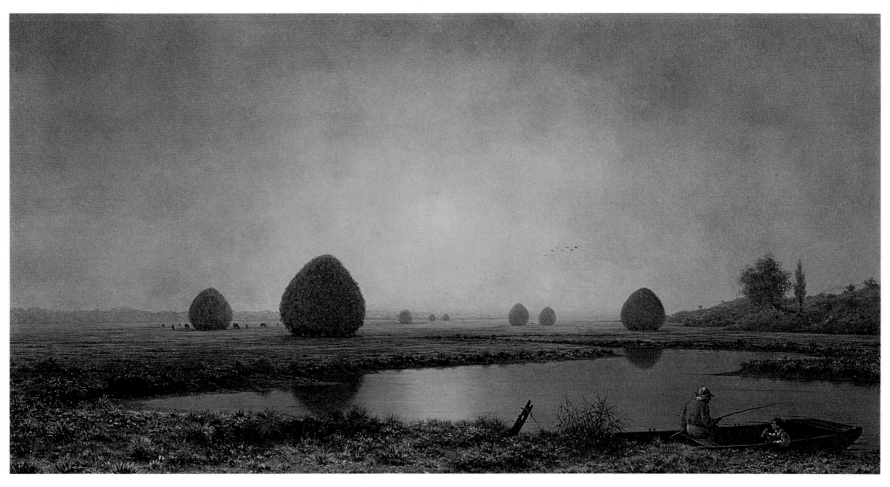

Plate 16. Martin Johnson Heade. *Sunrise on the Marshes*, 1863.
Flint Institute of Arts, Flint, Michigan;
Gift of the Viola E. Bray Charitable Trust, 63.5 (see fig. 77)

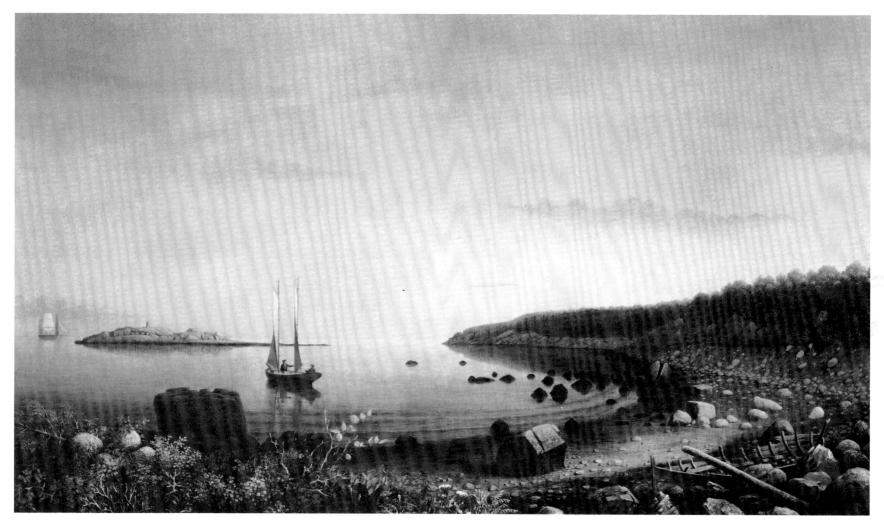

61. Fitz Hugh Lane. *Norman's Woe, Gloucester*, 1862. Oil on canvas. 0.712 x 1.270 (28 x 50 in). Margaret Farrell Lynch. Photo: Kennedy Galleries

Luminism and the American Sublime

Earl A. Powell

BY THE BEGINNING OF THE NINETEENTH CENTURY the philosophical concept of the sublime had developed as an aesthetic which associated the emotions of fear, awe, and exaltation with certain aspects of the natural landscape. During the previous century this aesthetic had evolved in the critical writings of European philosophers to explain the intensity of emotion they felt when inspired by scenes in nature that revealed vastness of dimension, sharp contrasts of light and shadow, storm-ravaged and tormented landscapes, and mountainous scenery—all settings that illustrated the disparity that existed between man and nature. However, during the early nineteenth century the meaning of the sublime was expanded to encompass also the feeling of spiritual calm man derived from the contemplation of boundless panoramas and light-filled landscapes that emphasized the illusion of space, infinity, and quiet.[1]

Landscape painting in both Europe and America reflected these changing perceptions of nature and the sublime. In particular, the visual legacy of the sublime experienced a rich and complex evolution in the United States. There the philosophy of Edmund Burke (1729-1797), later synthesized by Immanuel Kant (1724-1804), was fused with religious and nationalistic attitudes long associated with the mythology of America. The sublimities of the American wilderness provided American painters with an unparalleled opportunity to create a new national iconography based on a biblical interpretation of nature. This interpretation was central to the Puritan idea of the "American" as a prophetic identity; it was a theology that underscored the redemptive importance of the New World experience in the grand scheme of salvation. That America was seen by early theologians as the New Jerusalem and later as redeemer nation established a framework for the development of a biblical interpretation of American history within the context of Protestant reformed thought.[2]

Puritan theology was based on man's fulfilling the prophecies of the scriptures, and America was interpreted as the new world, the future millenial kingdom, described in the Book of Revelations. This interpretation was in part inspired by the Protestant idea of prophetic selfhood. According to Sacvan Bercovitch,

The American made his sainthood visible by identifying the literal-spiritual contours of the land. For the European, nature might evoke the spiritual qualities in the viewer's mind, enlarge *his* soul, fill *him* with ideas commensurate with *his* deepest feelings. But in its historical reality, as the English or German landscape, nature remained part of his specific, concrete, and therefore limiting (if cherished) personal or national past and present. The American scene by definition transcended past and present.[3]

Such an interpretation of the scriptures, associating landscape with biblical prophecy, had an eduring influence on American perceptions of nature and, by extension, on American landscape painting. Interest in the Apocalypse and the ensuing millenium (during which Christ would reign and holiness would prevail) and its association with landscape imagery experienced a surge of popularity in the years following the establishment of the Republic. At that time American writers and artists were most concerned with the problems involved in creating a national art which would emphasize the new nation's unique position in world history. American landscape painters, beginning with Thomas Cole, associated the purpose of art with their scriptural interpretation of wilderness themes. Cole announced with conviction in his "Essay on American Scenery," published in 1835, a belief in the prophetic mission of the artist:

Prophets of old retired into the solitudes of nature to wait the inspiration of heaven. It was on Mount Horeb that Elijah witnessed the mighty wind, the earthquake, and the fire; and heard the 'still small voice. . . .' St. John preached in the desert;—the wilderness is YET a fitting place to speak of God.[4]

Significantly, in American landscape painting the recreation of the sublime experience was infused with national and historical importance based on the

literal visualization of a new world landscape that was unavailable as a source of inspiration to European artists. Thus Americans drew separate visual conclusions from the same philosophical and rhetorical sources, based on their acute sensitivity to their land's unique historical position as a new world. And in the confluence of the idea of the sublime with perceptions of the American landscape in the work of certain aritsts—particularly the so-called luminist painters, Fitz Hugh Lane, John Frederick Kensett, Martin Johnson Heade, and Sanford Gifford—a new formulation of sublime expression eventually emerged.

The notion of the sublime inherited by nineteenth-century landscape painters derived primarily from two principal sources, Burke's *Essay on the Sublime and Beautiful,* published in 1756, and Kant's *Critique of Judgement,* which appeared in 1790. However, the concept of sublimity had first emerged in antiquity in the rhetorical treatise of Longinus, which was later revised by Boileau in 1694. Delivered conceptually intact to the philosophers of the eighteenth century, the theory of the sublime underwent further transformation at the hands of Dennis, Addison, Baillie, Hume, Burke, Kames, Reid, and Alison. Kant, however, in his *Critique of Judgement,* the summation of eighteenth-century aesthetics, ultimately coordinated and synthesized all speculation on the sublime in that era. Samuel Monk attributed cardinal importance to the *Critique* and its influence on the arts of the nineteenth century:

In his [Kant's] critiques are expressed the philosophical ideas which form the basis for the art of his time, and this is true even if a given artist was not familiar with his works . . . it may be said that eighteenth century aesthetic has as its unconscious goal the *Critique of Judgement.* [5]

As the precursor to Kant, Burke's *Essay* occupies a central place in the development of the history of naturalism in painting because it firmly and consummately explained the emotion of the sublime in categorical terms. Moreover, it identified sublime emotion as religious. Burke defined the sublime as "the strongest emotion which the mind is capable of feeling," and he associated it with the power and majesty of God: "we may be admitted, if I may dare say so, into the counsels of the Almighty by a consideration of His works." [6] Landscape imagery was central in providing inspiration to the sublime, and in the *Essay* Burke consolidated earlier arguments which associated nature with God. In so doing he resolved many of the issues of concern, about the relationship between God and nature, that had occupied the interests of earlier philosophers. Thomas Burnet's important treatise, *The Sacred Theory of the Earth,* of 1681-1689, was a preliminary and influential model for the translation of theological concepts into an aesthetics of landscape. *The Sacred Theory,* as scholars have noted, was a central work in the evolution of naturalism and the sublime, for Burnet for the first time found positive religious values in the contemplation of those parts of the landscape—mountains, for instance— which were vast and, by traditional standards, ugly. He endowed them with

both aesthetic and quasi-theological significance; in the imperfections of nature, as M. H. Abrams notes, "the speaking face of the earth declares the infinity, the power, and the wrath of a just deity." [7] Most importantly Burnet gave respectability as visual symbols to a particular geological formation, mountains, by identifying them with the Almighty. His reaction to nature would inspire Burke to construct his theory of sublimity and would later stimulate the high romantic imaginations of Wordsworth and Coleridge.

There is something august and stately in the Air of these things that inspires the Mind with great Thoughts and Passions; we do naturally, upon such Occasions, think of God and his Greatness.

And yet these Mountains . . . are nothing but great Ruins; but such as shew a certain Magnificence of Nature. [8]

Burke's essay was an attempt to advance the assumptions of Burnet's *Sacred Theory.* He based his logic on the correctness of Burnet's contention that the physical forms of nature declared the presence of the deity. He constructed his analysis of sublime emotion based on an assumption that there is a psychological reaction to size and scale in nature: "By looking into physical causes our minds are opened and enlarged." [9] Ultimately, for Burke, the experience of fear was the highest form of sublime emotion:

Whatever is fitted in any sort to excite the ideas of pain and danger . . . whatever is in any sort terrible . . . or operates in a manner analogous to terror, is a source of the 'sublime'; that it is productive of the strongest emotion which the mind is capable of feeling. [10]

Fear, gloom, and majesty, aspects of nature which evidenced some manifestation of God's wrathful power, were primary sources for inspiring the sublime, as was a vastness of dimension. In addition to seeing the large size of objects as a physical representation of the sublime, Burke also included their opposite: "as the great extreme of dimension is sublime, so the last extreme of littleness is in some measure sublime likewise. . . ." [11] He also devoted a separate section of his treatise to space, commenting that "infinity has a tendency to fill the mind with that sort of delightful horror, which is the most genuine effect and truest test of the sublime." [12]

The essential difference between Burke's ideas and those of Kant involved the distinction between theoretical principles and empirical ones. Kant referred to this distinction as the "transcendental exposition of aesthetic judgements . . . compared with the physiological, as worked out by Burke." [13] In *The Critique of Judgement* Kant did not devalue the physical manifestations of nature and the landscape as a source of the sublime; rather, he adapted Burke's categories of the sublime to fit his own philosophy. Like Burke, Kant included desolation, natural cataclysms, gloom, abrupt contrasts of light and dark, and the scale and magnitude of objects as phenomena capable of inspiring the sublime. The crucial difference between the two theories of sublimity was Kant's insistence that "the sublime is not to be looked for in the things of nature, but only in our own ideas." [14] The experience of the sublime, moreover, transcended and transformed the importance of the object; for Kant "sublimity

62. James Mallord William Turner. *The Fall of an Avalanche in the Grisons*, 1810. Oil on canvas. 0.902 x 1.200 (35½ x 47¼ in). The Tate Gallery, London (not in exhibition)

63. Martin Johnson Heade. *Thunderstorm Over Narragansett Bay*, 1868. Oil on canvas. 0.819 x 1.384 (32⅛ x 54½ in). Inscribed, l.l.: *M J Heade/1868*. Amon Carter Museum, Fort Worth, Texas (see plate 17)

must be sought only in the mind of the judging subject."[15]

The significance of Kant's theory in the formal development of painting lies in the belief that the function of the artist as creator and arbiter of the aesthetic experience must be accorded the highest priority in the evolution of a work of art. Literary assumptions about art found no place within this new philosophical context nor within later luminist painting. Thomas Cole believed, by comparison, that art had a literary and didactic function and that its major purpose was to contribute to the moral well being of humanity. In an article published in 1840, in the *Knickerbocker*, he remarked,

The art of painting is not merely a thing for amusement . . . it forms, on the principles of eternal nature a world of its own. Its influence on man, morally and intellectually, has been and is far more extensive than many of you have ever dreamed of. In ages past, it has made moral and religious impressions on the mind and character of nations. . . . It is an engine capable of great good, or great evil. It speaks a language intelligible to all nations.[16]

Cole's famous Course of Empire series (The New-York Historical Society, New York) of 1836 is a case in point. Cole enjoyed using art as propaganda to enforce his own argument for nature. In the development of high romantic art such as his, the artist, as a creative sensibility working to produce a self-conscious formal statement through style and composition, was of singular importance. In luminist painting the reverse is true; the personality and style of the artist were effaced and great efforts were made to develop a formal style consistent with the moods of nature as it actually appeared. The "idea" contributed by the artist lies in his choice of scene and the realistic manner in which he conveyed the condition or mood of nature, not in the translation, interpretation, or rearrangement of nature as in romantic art. The quiet stability and mirrored reflections of Fitz Hugh Lane's *Norman's Woe, Gloucester* (1862; fig. 61) illustrates the ultimate influence of this transcendental philosophy. Ralph Waldo Emerson discussed concepts which had their source in Kant in his *Thoughts on Art*, 1841, in which he commented on the "productions of the Fine Arts," noting, "Here again the prominent fact is the subordination of man. His art is the least part of his work."[17]

This distinction would have far-ranging and important consequences on the art of landscape painting in the nineteenth century, because Kant's interpretation of the sublime caused a revolution in perceptions of nature and attitudes toward landscape. Interest in an object as being sublime in and of itself gave way to representations of nature in which nature was transformed to personify a subjective state of mind.

Kant's interest in the sublime and the premises of his *Critique* were echoed in Archibald Alison's influential *Essays on the Nature and Principles of Taste*, which had achieved considerable notoriety by 1825. First published in 1790, Alison's *Essays* did not receive full appreciation until a second edition appeared in 1811; other editions followed in quick succession in 1812, 1815, 1817, and 1825, with a final edition appearing in 1842.[18] Though Kant's *Critique of Judgement* was the great

document which synthesized all aesthetic speculation on the sublime at the end of the eighteenth century, Alison's work was important because it supported a parallel interpretation of sublimity that was more accessible to readers less inclined to come to terms with the complexities of German philosophy. Alison's *Essays,* as Monk noted, "by translating beauty and sublimity into purely mental 'emotions' . . . stressed the importance of the individual as opposed to the object in the aesthetic experience."[19] Nature as object was replaced in the aesthetic experience by the judging faculties of the perceiver, which interpreted natural facts as spiritual emblems. Under the influence of the new transcendental philosophy perceptions of nature and the use of landscape symbology altered significantly, and with them the formal appearance of landscape art. The important new emphasis on the condition of mind and imagination in the experience of art resulted in the transformation of the older, gothic-literary sublime of Burke to new artistic concerns for space, light, and infinity as symbols or emblems with equal emotive and religious impact. It meant in formal terms the difference between J. M. W. Turner's *The Fall of an Avalanche in the Grisons* (1810; fig. 62) and Martin Johnson Heade's *Thunderstorm Over Narragansett Bay* (1868; fig. 63), a difference between activation of the elements in the former and contemplation of future action in the latter—the known experience versus the unknown potential. Samuel Monk speculated that in the new art "there might grow up a tendency to reduce the object to its minimum importance and to emphasize above all the impression which the object makes on the artist. In its extreme phases this tendency would produce impressionism, as it did in the paintings of Turner. . . ."[20]

Turner was the most advanced landscape artist of the romantic age, the most capable of drawing the visual conclusions that were, indeed, attributed to his art by Monk. Kant's transcendentalist philosophy influenced other landscape artists both in Europe and the United States in a different but related way. If the diminution of nature as object and as a source of aesthetic pleasure could produce one extreme, in Turner's diffused, light-filled watercolors, it also encouraged another, intense realism devoted to concerns for color and light in literal space, in which artistic identity is sublimated and the perceiving faculties of the artist function as a "sensibility." The placid, quiescent canvases of the luminists, austerely composed and tightly painted, were American equivalents of Kantian and neo-Kantian visualizations of the sublime. These paintings more clearly reflect the imperatives of transcendentalist philosophy than any others of the period. They were not, however, insular or provincial reactions to Kant. These pictures related to international developments in landscape art in northern Europe and England. Barbara Novak has eloquently discussed the relationship of luminism to Emerson's transcendental writing,[21] but it is important to realize that Emerson was himself deeply, crucially influenced in his perceptions of nature by Kant.

Emerson came to appreciate Kant primarily through Samuel Taylor Coleridge and Emmanuel Swedenborg; but he clearly acknowledged his in-debtedness to Kant in his writings. In *The Transcendentalist,* he wrote, "The extraordinary profoundness and precision of that man's [Kant's] thinking have given vogue to his nomenclature, in Europe and America, to that extent that whatever belongs to the class of intuitive thought is popularly called at the present day *Transcendental.*"[22] Consequently, luminist painting is as interesting for the important correspondences it maintained with international romanticism as it is for its distinctively American qualities of form and style. Novak attributes the appearance of luminist paintings to Emerson's influence directly, particularly with regard to the luminist artists' self-effacement of style, citing in support of this interpretation Emerson's famous lines,

Standing on the bare ground,—my head bathed by the blithe air and uplifted into infinite space—all mean egotism vanishes. I become a transparent eyeball; I am nothing; I see all; the currents of the Universal Being circulate through me; I am part or parcel of God.[23]

Emerson and luminist painting, the visual paradigm of transcendentalism, were clearly American manifestations of a new perception of nature, its source in Kant, which affected landscape art and poetry in an important, indeed crucial, way. William Wordsworth, in *The Prelude,* commented on the struggle between the physical eye and the eye of the poet's imagination.[24] Friedrich Schiller likewise discussed a similar conception of the poet/artist and his relationship to nature, in which nature became a unit of idea through a sensibility seeking to unify itself with divine authority. In his important essay *On the Aesthetic Education of Man* he commented on the potential for divinity which man carried within himself, and which could be realized through a union of absolute "reality" and absolute "formality" which involved an imaginative fusion of the sensibilities with nature.[25]

In this union the sublime experience was transformed into a new mode of landscape expression; the traditional sublime setting was augmented by the transcendental sublime sensibility, a sensibility that found its roots in man's internal perception of time and space. A contemplative view of nature thus displaced terror and majesty, and luminist art concentrated on developing an intense realism in which absolute stillness prevailed in compositions resonant with colored light. To enforce the contemplative idea, as opposed to the grand theater of Burke's sublime, required a new emphasis on space, and space, implying infinity, was a central concern of luminist painters. It was emphasized laterally, along the horizon line, and in depth, through the traditional manipulation of perspective devices. Another distinguishing characteristic of luminism was silence, silence echoing in still waters. Barbara Novak emphasized this aspect of the transcendental sublime, commenting, "If the older sublime could be characterized by the vigorous sound of a cataract, the repose of Lake George, steeped in silence, found its oral equivalent in unruffled water."[26]

It is important to emphasize that the transcendental sublime did not actually create a new vocabulary of formal expression or add new meaning to the

categories of sublime expression already attributed to it by Burke and others. Luminist painting developed existing attributes of sublimity within an entirely new context of visual expression and philosophical support. Burke, for instance, had previously associated the concept with silence and infinity. He had also declared that "littleness" was sublime to a degree, anticipating Emerson's reference to nature and "the still small voice." In discussing the transcendental sublime defined here, Novak has asserted that "in this new concept of sublimity, oneness with Godhead is complete, and the influx of the divine mind is no longer mediated by the theatrical trappings of the late eighteenth century Gothic."[27] This insight is accurate; however, the traditional sublime would have continuing relevance for Frederic Church and Albert Bierstadt, for instance, each of whom developed an important formal vocabulary based on the awsome grandeur of nature in the American West, the South American tropics, and the Arctic. The older sublime was perfectly adaptable to the newer American ideas concerning Manifest Destiny. What is fascinating about the concept of the sublime is that it offered flexibility of interpretation which could accomodate the older theories of Burke as well as the contemplative argument for nature offered by luminist painters.

For a painter such as Church the external forms of nature were as important to his conception of art as was his interpretation of American light; for luminist artists intuition and mood were more important. The latter looked upon landscape composition from a point of perspective conditioned by Kant and later interpreted by Emerson and others. Luminist painting articulated a perception of nature in which, to quote Emerson, "the whole of nature is metaphor of the human mind."[28] It is interesting that both "sublimes" corresponded to traditional religious positions first articulated by Puritan theologians who associated God with landscape and saw in the wilderness of America the promised millenium. In the landscape art of nineteenth-century America the sublime found its widest, most diverse and interesting range of expression. Sublimity in landscape related to nationalistic and religious mythology and added a new chapter to the history of the concept. The simple but important distinction that obtained between the formal resolutions of painters was the condition of the landscape itself, which in America offered wider potential for symbolic interpretation. Indeed, as Bercovitch has noted,

Intermediary between the Puritan and God was the created Word of scripture. Intermediary between the Romantic and God was the creating imagination. Intermediary between the Transcendentalist and the Oversoul was the text of America, simultaneously an external model of perfection and a product of the symbolic imagination. . . .[29]

In his *Essay* Burke commented that the sublime as a concept was not adaptable to visualization, that painters failed "to give us clear representations of these very fanciful and terrible ideas."[30] As interest in the sublime developed, however, as a central component of anticlassical sentiment and with the displacement of the formal concerns of the Enlightenment for the subjective

64. Philippe Jacques de Loutherbourg. *An Avalanche, or Ice-Fall, in the Alps, Near the Scheideck, in the Valley of Lauterbrunnen*, 1803. Oil on canvas. 1.099 x 1.600 (43¼ x 63 in). The Tate Gallery, London (not in exhibition)

65. James Mallord William Turner. *Snow Storm: Hannibal and his Army Crossing the Alps*, 1812. Oil on canvas. 1.461 x 2.375 (57½ x 93½ in). The Tate Gallery, London (not in exhibition)

66. John Martin. *Belshazzar's Feast*, 1826. Mixed media intaglio with hand coloring. 0.481 x 0.680 (18¹⁵/₁₆ x 26¾ in). National Gallery of Art, Washington, D.C.; Gift of Mr. and Mrs. William Benedict (not in exhibition)

interest in nature that characterized the romantic era, sublime art increased in direct proportion. In England Philip James deLoutherbourg, J. M. W. Turner, and John Martin, to name only three of the many artists who attempted to embody the sublime in their art, created a new visual context for the development of sublime imagery which related most specifically to Burke. In Germany Caspar David Friedrich evolved a singular expression of the sublime which was inspired by the writings of the German romantic philosophers and critics, including Kant, Schiller, and the Schlegel brothers,[31] and which in its actualization of nature relates most specifically to luminism. In English art the sublime was translated into pure theater in an attempt to inspire appropriate emotions. DeLoutherbourg's *Avalanche, or Ice-Fall, in the Alps* . . . of 1803 (fig. 64) is an excellent example of the approach toward the sublime adopted by artists who elected to depict natural disasters in which nature, as surrogate for the Almighty, demonstrates His wrath. The melodramatic quality of the painting is emphasized by its theatrical use of chiaroscuro. The scene is presented as simple drama, which should not be surprising since the artist made an important reputation in England as Garrick's stage and scene designer and who created the famous panorama he called the *Eidophusikon*.

The precocity of Turner's achievement in visualizing the sublime is evident in two early landscapes, *The Fall of an Avalanche in the Grisons* (1810, fig. 62) and *Snowstorm: Hannibal and his Army Crossing the Alps* (1812; fig. 65). Both pictures convey an impression of nature churned into an apocalyptic fury. In form, style, and subject, each work incorporates the range of Burke's association of sublimity with majesty, gloom, and terror. These pictures are of particular interest because of the way in which Turner expressed the force of the disaster by identifying emotive response with vigorous, painterly brushwork. Confronted by these paintings we might remember that the sublime was initially formulated as a rhetorical construct. What Turner succeeded in accomplishing in these pictures was a fusion of form, content, and idea that is relevant for understanding the stylistic intent of romantic realist art, including luminism. Bialostocki has noted,

From the fifteenth century on, when theories of rhetoric greatly influenced the art of the Renaissance and the Baroque, the doctrine of the appropriateness of form to content that was developed by Aristotle and other ancient theoreticians assumed increasing importance. The doctrine had two aspects, often closely interrelated: (1) the figures should accord with the traditional characterization of the historical or legendary heroes represented: (2) the form should be suited to the subject matter.[32]

In 1829 Thomas Cole visited Turner in his studio where he viewed *Hannibal Crosing the Alps* and declared it "a sublime picture, with a powerful effect of chiaroscuro," while at the same time decrying Turner's later work because it was, "destitute of all appearance of solidity: all appears transparent and soft. . . ."[33] Cole defended his opinion of Turner's painting by referring to Alison. His comments are interesting because they implicitly support the concept of a relationship between style and idea that explains the commonality pertaining between the turbulent, apocalyptic sublime of *Hannibal* and the still, quiescent canvases of the luminists.

I think there is in Alison's work on taste a passage in which he attributes the decline of the fine arts to the circumstance of painters having forsaken the main object of art for the study of its technicalities. The same cause yet exists to the very great deterioration of painting. The means seem a greater object of admiration than the end,—the language of art, rather than the thoughts which are to be expressed. The conception, the invention, that which affects the soul, is sacrificed to that which merely pleases the eye.[34]

That style should reflect idea, be subservient to it, explains the intent of much romantic landscape painting. This concept of art supported differing visualizations of the sublime when the artistic document referred to a condition or mood of nature.

The most spectacular sublime art to emanate from England was that of John Martin, who evolved a conception of sublimity based on interpretations of the Bible, particularly the Book of Revelations, and on John Milton's *Paradise Lost*. Martin confirmed what Wordsworth had maintained, that "the grand storehouse of enthusiastic and meditative imagination is the prophetic and lyrical parts of the holy Scripture, and the works of Milton."[35] More so than any

English artist of the period Martin accentuated the formal elements of the sublime attributed to it by Burke. In mezzotint engravings, avidly collected in their day, he succeeded in visualizing and stereotyping sublime emotion. Engravings of Martin's paintings such as *Joshua Commanding the Sun to Stand Still* (1816), *Belshazzar's Feast* (1826;fig. 66), or the *Deluge* (1826) popularized the sublime throughout Europe. But his engravings of *Paradise Lost,* which were published in 1827, gave him an international reputation. Martin's engravings after Milton combined the diverse elements of the sublime in compositions which emphasized dizzying perspectives, extraordinary scale, desolate, vast landscape, and mighty architectural complexes of fantastic proportions. These elements attained visual unity in the rich chiaroscuro effects inherent in the mezzotint medium itself. Such imaginative landscapes were, of course, theatrical in the extreme; but the notion of the sublime conveyed in their imagery was infectious. Nathaniel Parker Willis in *Pencillings By the Way,* published in 1835, related an experience he had during his travels in Europe that was colored by Martin's work.

We were coursing the banks of a river, in one of the romantic passes of the mountains of Styria, with a dark thunderstorm gathering on the summit of a crag overhanging us. I was pointing out to one of my companions a noble ruin of a castle seated very loftily on the edge of one of the precipices, when a streak of the most vivid lightening shot straight upon the northernmost turret, and the moment after several large masses rolled slowly down the mountainside. It was so like the scenery in a play, that I looked at my companion with half a doubt that it was some optical delusion. It reminded me of some of Martin's engravings. The sublime is so well imitated in our day, that one is less surprised than he would suppose when nature produces the reality.[36]

In a study of the development of the sublime in American art Thomas Cole is of particular importance because he was the first major talent to confront the ideas of the sublime and attempt to incorporate them within a formal vocabulary of American landscape. His art was transitional; and in his painting he never approached the transcendental realism of the luminists of the following generation, although in his writings he came near to an understanding of the kind of imagery and style that would characterize the luminist conceptualization of nature and its reflection of spiritual mood.

Cole equivocated on the sublime, which is one reason for characterizing his art as transitional. However, he was the first landscape painter of great ambition and commensurate talent to attempt to unite the sublime with the mythology of America. In so doing he virtually created a new art form by elevating landscape to the level of history painting. But he did not, for instance, find Niagara to be sublime when he went to visit it before he departed for England in 1829. Niagara, to American viewers, was the quintessence of the sublime experience, but Cole, according to his biographer, Noble, "was disappointed. Lifted by no rapture, burdened by no sense of overpowering grandeur, he gazed upon it almost without an emotion above that of surprise at himself."[37] Cole's painting of Niagara supports Noble's observation. The artist

67. Thomas Cole. *Expulsion from the Garden of Eden*, c. 1827-1828. Oil on canvas. 0.990 x 1.372 (39 x 54 in). Inscribed, l.l.: *T Cole*. Museum of Fine Arts, Boston; M. and M. Karolik Collection (not in exhibition)

painted a distant view of Niagara, in which the presence and immense scale of the cataract are diminished, although the wilderness setting of the falls was restored to its original pristine setting, obviously to impress the English audience for whom he painted this work. Cole was more interested in depicting the American landscape as a sublime wilderness, a totality of experience in and of itself, than he was compelled to exploit the sublimity of man's relationship to nature through the size and scale associated with sites such as Niagara. His art was interesting in this way; more than any other American painter of his time Cole employed the language of art in literary and metaphorical terms, to enforce an idea of America as the first Garden. Noble commented that

Niagara to Cole was, by his own declaration, far less than the mountains. They were symbols of the eternal majesty, immutability and repose, which no cataract could ever be. And no multitude of such symbols could ever detract from the dignity and force of each single one. Nay, the greater the multitude, the more impressive the symbolism of each, arising from the greater skill which the mind would naturally acquire in tracing it, and the ever-deepening insight into the divine realities which were symbolized.[38]

In his later *Essay on American Scenery* of 1835 Cole revealed no evidence of disaffection for Niagara, referring to it as "that wonder of the world where the sublime and beautiful are bound together in an indissoluble chain."[39] But he

68. Thomas Cole. *Landscape with Tree Trunks*, 1825. Oil on canvas. 0.673 x 0.820 (26½ x 32½ in). Museum of Art, Rhode Island School of Design; Walter H. Kimball Fund (not in exhibition)

never attempted to paint another version of the falls to substantiate his mature judgment. Concurrent with his painting *Niagara* (1830; Art Institute of Chicago), however, Cole painted two important compositions, only one of which is known to exist. This picture, *The Expulsion from the Garden of Eden* (fig. 67), was painted in 1827-1828 and was exhibited in 1828 at the exhibition of the National Academy of Design to unfavorable criticism. Cole realized that these first attempts at what he called "a higher style of landscape," may have been failures, but the *Expulsion* was the first major attempt by an American artist to combine the beautiful and the sublime in a single work. Of the *Expulsion* Cole wrote, "I have introduced the more terrible objects of nature, and have endeavored to heighten the effect by giving a glimpse of the Garden of Eden in its tranquillity."[40] The picture is a singular documentation of the sublime and reveals Cole's interest in the theatrical sublime which was influenced by Martin's engravings of *Paradise Lost*.

Cole's most effective sublime images were envisioned as grand theater. Critics praised his great series The Course of Empire, completed in 1836, for the sublimity of its conception and interpreted it as a great epic poem.[41] We should remember that earlier romantic art was consciously crafted and carefully com-

posed with the intent to stimulate responses traditionally associated with an experience of literature and poetical imagery. The Course of Empire represented the apex of didactic, moralizing art. The series was a watershed in the evolution of romantic landscape painting in that it concentrated in its imagery the agony of a conscience unable to reconcile both the onward progress of history and the economic changes associated with nascent industrialization with the theological position which traditionally interpreted American landscape as the biblical garden. In formal terms the great series was grand theater in the same way that Turner's Carthage paintings and Martin's *Paradise Lost* mezzotints were.

In his picturesque canvases Cole invoked the idea of the sublime through traditional associations with storms, such as that depicted in his well-known 1825 painting *Landscape with Tree Trunk* (fig. 68). However, in his *Essay on American Scenery* Cole alluded to the direction the development of the sublime would take in making reference to emerging transcendental concerns with nature. In the *Essay* he discussed silence, stillness, and solitude, which he identified with the lakes of America:

Embosomed in the primitive forest, and sometimes overshadowed by huge mountains,

69. Thomas Cole. *Catskill Creek*, 1845. Oil on canvas. Inscribed, l.r.: *T. Cole/1845*. 0.661 x 0.915 (26 x 36 in). The New-York Historical Society, New York

they are the chosen places of tranquillity; and when the deer issues from the surrounding woods to drink the cool waters, he beholds his own image as in a polished mirror. . . .[42]

Cole's reference to water as a reflecting surface symbolizing the sublime of stillness was not an image he would develop with frequency in his later work. But it was prophetic of the static, mirrored waters the luminist painters preferred to the craggy, picturesque landscapes Cole favored in his own wilderness landscapes. He was inspired to comment on this form of the sublime after contemplating twin lakes in the White Mountains of New Hampshire.

There are two lakes of this description, situated in a wild mountain gorge called the Franconia Notch. . . . Shut in by stupendous mountains which rest on crags that tower more than a thousand feet above the water . . . they have such an aspect of deep seclusion, of utter and unbroken solitude, that, when standing on their brink a lonely traveler, I was overwhelmed with an emotion of the sublime, such as I have rarely felt.[43]

Here Cole indicates that his experience of the sublime of solitude, the transcendental sublime, was revelatory and wholly new, for he contrasts this feeling with the traditional sublime of Burke. It is a fascinating transitional description contrasting the physiological sublime, which he discusses by refer- ring to the physical scale of his surroundings—the "stupendous" mountains towering a thousand feet above him—with the contemplative image of still water. For Cole the sense of isolation in a wilderness setting reinforced by the tranquil lakes symbolized the ultimate sublime. This description of this experience "of awfulness in the deep solitude" is essentially equivocal in the literature of the sublime, as was the appearance of water in Cole's landscapes. In his wilderness landscapes Cole generally restricted the areas of water to the middle distance of the picture, consistent with his interest in balancing the elements of a picture to conform to the compositional rules of the picturesque. Even late in his career, when he began to show a concern for greater expanses of sky, such as that in the landscape *Catskill Creek* (fig. 69) of 1845, he achieves careful balance through discreetly apportioned areas of land and water. The reflective surface of the water is relatively small and appears as a circular orb in the lower center of the picture, locking the composition into a rigid formal arrangement. This represents in fact a very different attitude toward light, space, and reflected light than the luminists would adopt. In this picture the viewer is aware of compositional equilibrium arrived at through careful arrangement of the masses of nature. Pictorial unity does not result from tonal gradations of color

and light. Cole was always acutely conscious of the need for such balance in his landscapes, and this concern did not permit a specific element of landscape to achieve dominance, symbolic or otherwise, as a primary artistic concern. He noted in his *Essay:*

It was not that the jagged precipices were lofty, that the encircling woods were of the dimmest shade, or that the waters were profoundly deep; but that over all, rocks, wood, and water, brooded the spirit of repose, and the silent energy of nature stirred the soul to its inmost depths.[44]

Early in his career Cole defended his position with regard to the idea of "composition" in a well-known letter to his patron Robert Gilmor. In the letter, written in December 1825, Cole responded to Gilmor's request for a landscape that described an actual view. Cole's famous response—"If the imagination is shackled, and nothing is described but what we see, seldom will anything truly great be produced either in Painting or Poetry"[45]—was an eloquent defense of compositional principles based on a close association of literature, poetry, and painting. Cole went on to note, "The most lovely and perfect parts of nature may be brought together, and combined in a whole, that shall surpass in beauty and effect any picture painted from a single view."[46] Thus, in most of his landscape paintings Cole adjusted the general view of nature, usually by arranging foreground elements, to conform to his idea of nature as a spiritual experience. He never relinquished this sense for balance and harmony in his compositions, nor permitted one aspect of the landscape to intrude as a dominant visual symbol.

Luminist painting did not adhere to the same understanding of the principles of composition. If one compares Cole's late *Catskill Creek* (fig. 69) of 1845 with a luminist canvas such as Fitz Hugh Lane's *Norman's Woe* (fig. 61) of 1862, the difference in the perception of nature, its significance as metaphor, and the basic understanding of composition clearly differentiate the two artists and their work, and the generation separating them. Cole belonged to the earlier generation of landscape artists who were deeply influenced by Anglo-romantic notions of nature derived from Wordsworth and other literary figures. *Catskill Creek* with its lowered horizon and what, for Cole, is a vast expanse of sky, reflected in a pool of water in the center, identifies with an earlier tradition of landscape. Nature as a described experience, not stillness and light, is its subject, and the picture reveals the textural, expressive style Cole favored. He has clearly blocked out the elements of composition on the canvas to obtain overall harmonic balance. The large tree on the left of the picture penetrates the expanse of sky, as do smaller trees on the right, which tend to unify earth and sky with water as the primary visual anchor, creating what Cole would have described as a true classical "composition" of American wilderness. In Lane's *Norman's Woe* the perception of nature is such that sea and sky fuse in a mirrored union in which time stops and the artifice of classic landscape composition is no longer apparent. In luminist painting the viewer does not experience nature from outside the picture but from within as an intuited

phenomenon: the plane of a luminist canvas extends toward the viewer to encompass his presence in the conceptualized space of the landscape itself. This aspect of luminism has drawn extended discussion from other scholars, who have explored its affinities with Emersonian transcendentalism, explained its formal style in terms of photography, and described its influence on the emergence of a tight, realistic mode of expression derived from Ruskin's *Modern Painters*.[47] Luminism unquestionably evolved as the result of impact with these important sources. However, luminist art relates as well to the general dissemination of Kantian thought throughout northern Europe and America.

In its American phase luminism represented Kant's perceptions of nature at their most distinguished and refined level. There were earlier related parallels in European romantic art. These occurred most eloquently in the art of the German romantic landscapist Caspar David Friedrich, whose enigmatic paintings, laden with religious symbols, puzzled many contemporary critics, who responded with curiosity to this artist's precocious and unique concern for space and light. As such, Friedrich's paintings were the first manifestations of an emotive response to nature which did not involve human events and which was concerned with transmitting an internal vision of nature coincidental with external reality. Heinrich von Kleist's criticism of Friedrich's painting *Monk by the Sea* (Mönch am Meer, 1808-1810; fig. 70), one of the most quintessentially sublime paintings of the century, could as easily have been a critical response to certain pictures of Lane, Heade, or Kensett, particularly Heade's remarkable drawings of the marshes on the Plum Island River at twilight. Von Kleist was astonished by *Monk by the Sea*, commenting, "Because of its monotony and boundlessness, with nothing but the frame as a foreground, one feels as if one's eyelids had been cut off."[48] Friedrich's art represented the first visual consolidation and influence of Kant in European art and the first demonstrated interest in the transcendental sublime, the sublime of space and its attendant light. In this picture and in others, for instance *Large Enclosure Near Dresden* (1832; fig. 71), light assumes major importance as a spiritual metaphor for divinity in nature. It also unites with space and silence in a pictorial union that designates a new visualization of the sublime.

The same interest in uniting an internal, or intuited experience of nature, with the reality of natural appearances can be seen in American landscape during the decade of the 1860s. The unifying characteristics of style in the art of Kensett, Lane, Heade, and Gifford conspired to recreate an experience of nature that was associated with God and in which, as Novak remarked, "oneness with Godhead is complete."[49] This art related to Emerson and through his writing the overriding influence of Kant in a wholly unique way. What luminist art achieved, in Europe and America, was a reformulation, under the impact of transcendentalist philosophy, of the formal appearances of nature into a new vocabulary of religious symbols. Earlier romantic landscape art such as Cole's was overtly didactic; one can "read" the symbolism in most of

70. Caspar David Friedrich. *Monk by the Sea*, 1808-1810. Oil on canvas. 1.100 x 1.715 (43⁵/₁₆ x 67½ in). Staatliche Schlösser und Gärten, Schloss Charlottenburg, Berlin (not in exhibition)

71. Caspar David Friedrich. *The Large Enclosure Near Dresden*, 1832. Oil on canvas. 0.735 x 1.030 (28¹⁵/₁₆ x 41¹/₁₆ in). Gemäldegalerie Neue Meister, The State Art Collections of Dresden, German Democratic Republic (not in exhibition). Photo: Gerhard Reinhold, Leipzig-Mölkau

72. Fitz Hugh Lane. *Entrance of Somes Sound from Southwest Harbor*, 1852. Oil on canvas. 0.604 x 0.908 (23³/₄ x 35³/₄ in). Private collection. Photo: M. W. Sexton (see plate 10)

73. Fitz Hugh Lane. *Ships and an Approaching Storm Off Owl's Head, Maine*, 1860. Oil on canvas. 0.610 x 1.007 (24 x 39⁵/₈ in). Governor and Mrs. John D. Rockefeller IV. Photo: O. E. Nelson (see plate 9)

Cole's paintings, which consciously made reference to the classical landscape tradition represented by Claude Lorrain. Luminist paintings attempt, on the other hand, to visualize an intuited experience of nature through the stylistic confluence of color, light, and space and the supra-reality of silence. One of the important arguments presented by Kant, as Gombrich noted, was his opposition to logicians who separated the symbolic from the intuitive act.[50] Kant believed that all knowledge of God was merely symbolic, and the symbolic for him meant intuitive experience. This same application applies to luminist landscape and explains the special concern for eradicating evidence of expressive style in this art. This resulted in interpretations of nature that most closely approximated an intuited spiritual experience of the sublime.

Fitz Hugh Lane and Martin Johnson Heade, working independently, created luminist pictures that exemplified the transcendentalist fascination with the contemplative sublime. Lane's interest in the stillness and serenity of frozen time, encapsulated in compositions of austere beauty with images reflected in the mirrored surfaces of water, is evident in his 1852 picture, *Entrance of Somes Sound from Southwest Harbor* (fig. 72). In this precocious example of Lane's early maturity primary visual concern is manifested for duplicating an experience of nature in which all elements are locked into a rectangular format stabilized by verticals and horizontals. The compressed

horizontal waterline of the landscape is reinforced by its reflection in the water, and the vertical masts of the ship are likewise emphasized through the duplication of reflection. The atmosphere of the painting glows with a unifying, warmly tinted light which bathes the scene from above. The absence of cast shadows further emphasizes the severely controlled impression of stasis in this picture, which distills an intuition and mood of nature, eternalizing it in silence and light.

The decade of the 1860s was an historical watershed for America. The convulsions of the Civil War shattered the national psyche. It is both curious and revealing that during the years immediately prior to the conflict Lane produced a series of paintings that further distilled the concept of transcendental sublimity. In 1860 he painted *Ships and an Approaching Storm Off Owl's Head, Maine* (fig. 73), a picture that looks back to the traditional sublime in which storms figured prominently. This painting conveys a brooding anticipation in the darkness, stillness, and silence compressed in its severe formalism. The primary visual element, the large vessel in the middle center of the composition, counterpoints the impending drama of the storm, as its listless white sails, furled and shortened in readiness and anticipation, hang limply, silhouetted against the darkening sky.

During the war years Lane painted his most profound and refined landscapes, including the versions of *Norman's Woe* and culminating in the oils

depicting Brace's Rock, Gloucester (figs. 11, 74, 91, 117). The pictures of Brace's Rock were completed in 1863 and 1864 and represent in Lane's art the extreme of the sublime of silence. Their impact is made more profound if one realizes that these fragile visions, surreal in their intense, penetrating analysis of the silence of nature, unifying that mood with a state of mind, were painted during the American apocalypse. Once again Lane's interest in structure and geometry asserts itself; the composition is organized, in each of these canvases, along horizontal bands which recede into the light and space of the sea. The Brace's Rock paintings are remarkable, ideated mirrors of nature that reflect the soul of the artist, fusing the mind of man with the sublime spiritual universe of the Almighty, represented in the empty, light-filled atmosphere of the Atlantic.

Younger than Lane, who died in 1865, Martin Johnson Heade continued and expanded the luminist imperatives which evolved in Lane's art. Although there is no evidence that the two were familiar with each other's style, the formal affinities and interest in the essential characteristics of transcendental art and the sublime make it impossible to separate their achievements. Heade's 1862 painting *Lake George* (fig. 75) is particularly interesting to study in comparison with earlier American romantic landscape concerns such as Cole's. In this work Heade has reduced the scale and dominance of the mountain range and focused instead on the space of sky, reflected in an equally large surface of water. The tightly painted and painstakingly detailed foreground rocks intensify the impression of a stilled experience of nature encapsulated within the spatial container of the picture. The foreground in this picture is of interest in addition to the intense realist style in which Heade painted it. The spatial construction in most luminist paintings is achieved by means of receding horizontal lines, or bands; Lane's *Somes Sound* is a case in point. In the 1860s, however, an interest in careful foreground technique was coupled with discrete spatial concerns that involved leading the eye into luminist space along a serpentine curve progress-

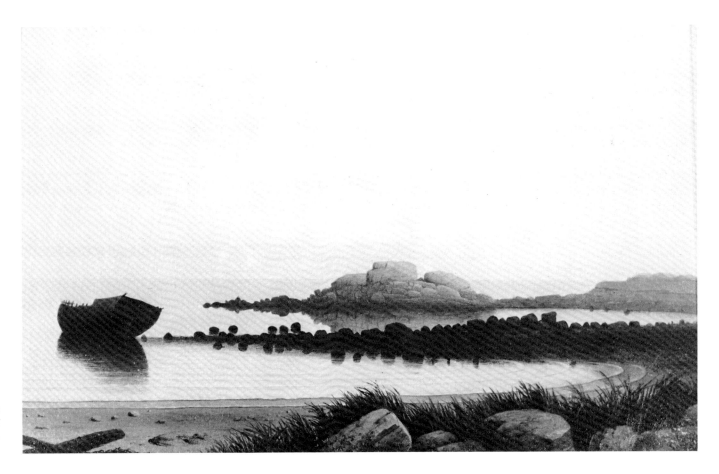

74. Fitz Hugh Lane. *Brace's Rock*, 1864. Oil on canvas. 0.261 x 0.387 (10⅛ x 15⅛ in). Private collection. Photo: Childs Gallery

75. Martin Johnson Heade. *Lake George*, 1862. Oil on canvas. 0.661 x 1.264 (26 x 49¾ in). Inscribed, l.l.: *MJ Heade/1862*. Museum of Fine Arts, Boston; M. and M. Karolik Collection

ing from a lower corner of the picture and receding diagonally until it curves back into the composition in the middle distance. This has the effect, in pictures such as Lane's *Norman's Woe* and Heade's *Lake George,* of creating a spatial wedge, a geometric triangle of water. Kensett would favor this compositional format as well, because it offered the artist the option of directing visual focus gradually into the well of sublime space and suffusive color that was the subject of luminism. The precedent for this kind of composition, so effective in affirming the singular identity of the open, laterally configured space favored by these artists, could have been Frederic Church's brilliantly innovative canvas, *Niagara,* painted in 1857 (Corcoran Gallery of Art, Washington, D.C.). In this picture the rim of the falls is described by a receding diagonal, which

progresses into space from the lower left corner of the composition and then cuts back to the left abruptly at an angle to define the far rim of the horseshoe falls and which, simultaneously, becomes the horizon of the picture. In other luminist paintings the negative space, demarcating the emptiness into which the waters of Niagara pour, is transformed into the reflected, mirrored space of still water. Space-defining geometry occupied the concerns of these artists and facilitated the creation of a visual experience of space which seemed to be a continuum of the viewer's own world.

Heade, more so than Lane, experimented with the formal geometry of space that emphasized infinity in more exaggerated but extremely effective compositions. He too became interested in the theme of the stranded boat and in 1863

76. Martin Johnson Heade. *Sunset on the Newbury Marshes*, 1862. Oil on canvas. 0.638 x 1.270 (25¹/₁₆ x 50 in). Inscribed, l.r.: *MJ Heade/1862*.
Walters Art Gallery, Baltimore; Gift of Dr. Alan C. Woods, Jr.

painted this subject in a format very close to that of Lane's Brace's Rock series. At this time Heade also began to paint the pictures of the Marshfield and Newbury marshes which were so conceptually precocious and clearly established his artistic reputation as a major contributor to the tradition of the sublime. These paintings are paradigmatic of the open composition of luminism and emphasize wide-angled perspective recession. As such, they create the sensation of sublime space more than other landscape art of the same period. Heade, moving in the same tradition established decades earlier by the German Friedrich, extends the space of the picture to incorporate conceptually the viewer's world. When one views a Heade painting of the marshes, it appears as if one were looking at nature with one's "eyelids cut off." *Sunset on*

the Newbury Marshes of 1862 (fig. 76; see also fig. 77) is one of the earliest examples of Heade's manifest interest in space, light, and the silence of the sublime. In the picture a triangular wedge of water, the bend in the salt river, opens up the solid plane of earth and marsh grass which appear to extend uninterrupted and unimpeded beneath the viewer. The lines of recession are established by discreet placement of haystacks that recede into the distance with dramatic and compelling effect. The lines of the juncture between the higher ground on the perimeter of the marsh and the edge of the marsh itself also expand to exaggerate and reinforce the visual experience of rushing into deep space. In no other American landscapes does spatial recession play such an important role or is it developed with such careful geometric precision. In this

77. Martin Johnson Heade. *Sunrise on the Marshes*, 1863. Oil on canvas. 0.661 x 1.276 (26 x 50¼ in). Inscribed, l.r.: *MJ Heade 63*. Flint Institute of Arts, Flint, Michigan; Gift of the Viola E. Bray Charitable Trust (see plate 16)

78. Martin Johnson Heade. *Twilight on the Plum Island River*, 1860s. Charcoal and colored chalks on paper. 0.276 x 0.556 (10⅞ x 21⅞ in). Private collection

sense Heade's marsh pictures are fixed points in a Copernican universe in which space and light fuse to simulate world and God.

If Lane's pictures of Brace's Rock represent the intensity of his interest in the sublime of silence, Heade's charcoal drawings of twilight on the Plum Island River (1860s; fig. 78) are counterparts to them. In no other collected body of work does an artist manifest concerns for space as a visual sublime continuum. These drawings were produced at various times between 1862 and 1868, and their refined sense of geometry and spatial development require special consideration. In the drawings, which together sequentially emphasize the passage of time, Heade situates the viewer literally in the reflecting mirror of water which opens into the space of the picture. As a result the landscape is not framed in any traditional sense but "bends" or warps around the viewer, implying in the most sophisticated visual terms an extension of space in both directions, into and away from the picture plane. The haystacks are placed in dual line on either side of the receding diagonals, which define the riverbanks and enforce further the sensation of infinite space as well as the impression that one is rushing forward, into and through it. The placement of the sailboat, whose stern just touches the apex of the triangle formed by the banks of the river, and the flat plane of the sail block the headlong rush forward into space implied by the receding perspective lines. This design contributes to the creation of a visual and spatial tension that enforces what is a consummate experience of the sublime of space and silence.

Heade's thunderstorm paintings are perhaps his most dramatic sublime pictures—that is to say, in a traditional sense where they individually invoke an impression of impending disaster. Stebbins has discussed these works as having apocalyptic significance, comparing them to Church's *Twilight in the Wilderness* (1860; fig. 204).[51] These paintings, like Lane's *Ships and an Approaching Storm* (fig. 73), incorporate in their stillness and sense of nervous anticipation an emotive content of rare power and impressiveness. *Approaching Storm: Beach Near Newport* (1860s; fig. 79) reveals Heade's interest in the intensity of foreground realism that appeared in his earlier painting of Lake George; but here the landscape appears distant and surreal; the rock formations in particular do not seem to be of this world. The stillness of the scene is enforced by Heade's intense focus on the rocks and also his depiction of the waves, which are frozen in time at the peak of cresting and appear as if they had been torn from paper. The blackness of the sky is contrasted against the whiteness of the beach, a dark-light contrast that relates to Burke's psychological description of sublime scenes. But the overall impression achieved is one of extreme tenseness and apprehension. *Thunderstorm Over Narragansett Bay* of 1868 is more open in composition and is perhaps more accessible as a perceived human experience of nature. In this work the storm is closer to us in time, and those soon to be inundated by it are making preparations in anticipation. One sailboat has been beached and others are making toward shore or lowering sail to prepare for the first strong gusts of wind which will announce the arrival of the storm. The sense of stillness just prior to the blast is heightened and maintained by the mirrorlike reflections and calm of the water.

The art of John Frederick Kensett and Sanford Robinson Gifford represents a different stylistic approach to silence and light than the art of Lane and

79. Martin Johnson Heade. *Approaching Storm: Beach Near Newport*, 1860s. Oil on canvas. 0.711 x 1.479 (28 x 58¼ in). Museum of Fine Arts, Boston; M. and M. Karolik Collection

Heade. Kensett was interested in related aspects of natural experience, and in his Newport marines and his pictures of the Shrewsbury River his art approaches an intensity of expression with regard to silence and light similar to the other mid-century painters. More than Lane and Heade, Kensett approaches a tonalism which evokes a feeling for the atmosphere and light which envelops nature at a specific time of day. In his compositions Kensett preferred to offset the masses with voids to create space and to emphasize its openness and light. Lane's concern for receding horizontals does not seem to have affected Kensett's style, although many of his Newport scenes incorporate the curving serpentine waterline which both Lane and Heade adopted in the sixties, perhaps in response to Church's *Niagara*. More than that of any other American landscape painter identified with luminism, Kensett's career demonstrates a shift in the visual concern for landscape, from the conventional picturesque to an interest in open space and quietism. The painting *Sunset,*

Camel's Hump, Vermont (c. 1851; fig. 80) is, for instance, very close in its compositional arrangement to Cole's *Catskill Creek* of 1845 (fig. 69). It is, nevertheless, a picture of mood, depicting a poetic experience of nature. The distinction between the picturesque mode of landscape expression and the intuited unification of light, space, and silence that identifies Kensett's mature style is considerable. If we compare his painting *Shrewsbury River* (fig. 81) of 1856, which is filled with the white light of luminism, with the earlier work, we can see the extent to which Kensett's vision has altered. In the later picture Kensett balances the mass of landscape, along with its reflection in the still water of the river on the left of the canvas, against an area of marsh grass on the lower right. The remainder of the composition consists of light, hovering in the palpable atmosphere and reflected in the unrippled surface of the river. The refinement of this picture, in which nature has been reduced to cryptographic essentials of composition, is supreme. Three-dimensional masses are opposed

80. John Frederick Kensett. *Sunset, Camel's Hump, Vermont*, c. 1851. Oil on canvas. 0.305 x 0.410 (13¾ x 16¹⁄₁₆ in). The Art Museum, Princeton University, Princeton, New Jersey (see plate 13)

81. John Frederick Kensett. *Shrewsbury River*, 1856. Oil on academy board. 0.152 x 0.305 (6 x 12 in). Inscribed, l.l.: *JFK 1856*. Private collection, Woodstock, Vermont. Photo: Charles Uht

in diagonal opposition with the rarified and insubstantial veils of light, color, and atmosphere reflected in water. Unlike Heade's marsh pictures, in which an impression of deep, recessive space is conceived by an almost horizontal orientation of objects along wide-angled perspective lines, Kensett's pictures wrap the viewer in a tinted spatial envelope, which offers an equivalent experience of silence, color, and light. Kensett's Newport paintings such as *Newport Coast* (fig. 82) and *Beach at Newport* (see pl. 2), both painted in the decade of the 1850s, are supreme examples of Kensett's mature execution and his interest in heavy, palpable atmospheric effects. In each of these pictures the eye follows the gently curved contour of the waterline from the lower center of the picture to a massive rock formation, painted in great detail. The compressed mass and heaviness of the rocks, consolidated in the lower left of each picture, is contrasted by the openness and space of the water and sky. A sense of visual release into space is effected in this opposition of earth and rock with water and air, a release that is both exhilarating and contemplative and conducive to feelings of sublimity which correspond with the imperatives of the transcendental sublime. Kensett's interest in depicting nature as an experience of light, space, and silence occupied his interest for a considerable period, as is evident in the 1872 painting *Eaton's Neck, Long Island* (fig. 83), which comes as close as any work in his oeuvre to duplicating the sense of acceleration into space visualized in Heade's work. This picture, minimized in detail and reduced in the extreme to simple geometric areas of dark and light masses in juxtaposition, is a classic example of the luminist artist's interest in a continuum of space and light as the principal subject of painting.

Sanford Robinson Gifford was concerned with special effects of light and color, especially at twilight; and his pictures, more than those of his contemporaries, exaggerated the natural appearances of light for expressive effect. James Jackson Jarves commented on this feature of Gifford's style in his book *The Art-Idea*: "Gifford has an opulent sense of color, but its tone is artificial and strained, often of a lively or deep brimstone tint, as if he saw the landscape through stained glass."[52]

In most of his pictures Gifford favored the warm spectral colors, unlike Kensett, whose light usually appeared to be watery and silvered and heavily atmospheric. Gifford's pictures are thus more dramatically charged with colored atmosphere, which, because of its hotness, often appears "smoky." But in his river paintings he adheres to many of the same formal conventions of composition which appear in the work of the other luminists. *A Twilight in the Adirondacks* (1864; Adirondack Museum, Blue Mountain Lake, New York) and *Hook Mountain, Hudson* (1866; fig. 84) are classic luminist compositions, in which the eye is led into space following a curving beach. The landscape is minimal and reflected in clear, mirrorlike surfaces of water which multiply the effects of silence and space. Gifford is perhaps better known for his more original contributions to the corpus of mid-century landscape, which focus on effects of twilight in mountainous regions. *Twilight on Hunter Mountain* of 1866

82. John Frederick Kensett. *Newport Coast*, c. 1850-1860. Oil on canvas. 0.461 x 0.769 (18¹/₁₆ x 30¹/₄ in). Richard A. Manoogian. Photo: Helga Photo Studio

83. John Frederick Kensett. *Eaton's Neck, Long Island*, 1872. Oil on canvas. 0.457 x 0.915 (18 x 36 in). The Metropolitan Museum of Art, New York; Gift of Thomas Kensett, 1874

85. Sanford Robinson Gifford. *Twilight on Hunter Mountain*, 1866. Oil on canvas. 0.775 x 1.372 (30½ x 54 in). Inscribed, l.r.: *S.R. Gifford 1866*; on back: *Hunter Mountain/S.R. Gifford Pinxit*. The Lano Collection (see plate 14)

(fig. 85) is one of Gifford's most interesting pictures, revealing the excessive color effects which he preferred, to Jarves' distaste. The slumbering orange light which bathes this landscape and the purple haze which obscures the mountain are of a visual intensity that relate more to the pyrotechnics of Church than to the frozen luminosities of Lane and Heade. Gifford is interesting for this; his art related to the contemplative, or transcendental sublime, particularly in his river scenes, in which smoky atmospheric effects are mirrored in silent waters darkening at twilight (fig. 86). At the same time, however, Gifford was able to draw inspiration from the high romantic tradition continued by Frederic Edwin Church in his generation and, before him, Thomas Cole. The foreground of *Hunter Mountain* is dotted with the stumps of trees which have been cleared to make way for a westward-expanding frontier. Such references to the encroachment of civilization appear often in Cole's painting. Gifford's twilight pictures of the 1860s, particularly *Hunter Mountain,* are important transitional pictures in which luminism as an atmospheric perception of nature and space is combined with more traditional landscape concerns.

The emphasis Gifford placed on tinted, sulphuric, atmospheric effects, by combining them with other associative references to landscape, relates his work to both classic luminism and to the more spectacular and melodramatic concerns for apocalyptic effects and light which occupied Church.

Frederic Church was the quintessential painter of the American sublime. His art formed the standard against which virtually all other talent in the United States was judged, and in the decade of the 1860s his influence on landscape painting in America was enormous. Church however was not a luminist painter in the sense that Lane was. His landscape paintings were not intuitive. But he maintained an interest in American light and explored light in the landscape with spectacular results that associated his art with the imperatives of the traditional sublime. In a series of important pictures depicting sunset in the wilderness, Church created a startlingly vivid body of work using the newly available cadmium colors. The culminating painting in this series, whose prophetic symbolism anticipated the Civil War, was the 1860 picture *Twilight in the Wilderness*. Church became interested in this theme early in his career during

84. Sanford Robinson Gifford. *Hook Mountain, Hudson*, 1866. Oil on canvas. 0.207 x 0.482 (8⅛ x 19 in). Yale University Art Gallery, New Haven, Connecticut; Gift of Miss Annette I. Young in memory of Professor D. Cady Eaton and Mr. Innis Young

86. Sanford Robinson Gifford. *River Scene by Moonlight*, 1870s. Oil on canvas. 0.226 x 0.400 (8⅞ x 15⅜ in). Inscribed, on back: *Gifford*. Mr. and Mrs. Erving Wolf

a trip to Mt. Desert Island in Maine in 1850. Following his visit to Maine he commenced painting water scenes which attempted to capture the transient effects of light as the sun rose over the Atlantic. These paintings resound with vivid hues—oranges, reds, and purples—which reflect off and through a low-lying, scudding cloud cover and from the surface of the water. The color is thus entrapped in a rich band of brilliant light emphasized between two areas of dark. The idea for these pictures was probably Fitz Hugh Lane's *Twilight on the Kennebec* of 1849 (private collection), which he exhibited at the Art Union that year.[53] Lane was one of the first artists to take advantage of the new colors, and this precedent also could have had an important influence in Church's decision to employ cadmium colors. During the fifties Church painted *Mt. Desert* (c. 1850; fig. 87), *Beacon Off Mt. Desert* (1851; fig. 88), and *Sunset* (1856; fig. 89) all of which explore pyrotechnic effects of light reflected off water and clouds. *Twilight in the Wilderness* of 1860, in which color resonates with a fiery intensity, culminates in an experience of the sublime new to American art, one which David Huntington has called "the supreme moment of cosmic time . . . the natural apocalypse."[54] It is an extraordinary painting in which primeval wilderness, the traditional American symbol of the biblical Garden, is depicted at the most dramatic, awesomely beautiful and mysterious moment of the day. It is a picture through which Church offers visual access to a moment of communion with the Almighty. It is a heightened visualization of a moment in an experience of nature as it unfolds in time; one is acutely aware of the significance of time in this picture, of its transience and ephemerality. The subject of the painting is light, charged with vivid pinks and oranges, which reflect from the underside of heaven and are mirrored in still, reflective waters. The band of intense yellow light that separates the earth and sky emphasizes the space compressed between. The combined union of light, color, space, and silence in this painting celebrates an experience of sublimity unknown before its time in the world of art. The painting defies simple categorization as a "luminist" work of art, but there can be no doubt that the subject of the picture is, literally, American light, symbolic of the new world Apocalypse. It is a compelling work of art which combines two aspects of the sublime, the traditional interest in nature as object and the transcendental concern for nature as experience, through color, space, and silence.

Church was the first artist to extend American landscape to include such traditionally sublime subjects as erupting volcanoes, monumental icebergs, and ancient ruins, painted experiences from his travels in South America, the Arctic, and the Holy Land. *Cotopaxi* (fig. 225), the dramatic tour de force he painted in 1863 at the height of the Civil War, would undoubtedly have appealed to traditionalists well versed in the psychological implications of Burke. Church's *Aurora Borealis* (fig. 190) of 1865, on the other hand, carried representations of light in nature to a new extreme of sublimity and drama. Church interpreted nature as history, employing a vocabulary of the sublime which visualized every mode of expression attributed to it. He was an encyc-

87. Frederic Edwin Church. *Mt. Desert*, c. 1850. Oil on paper. 0.228 x 0.357 (8¹⁵/₁₆ x 14¹/₁₆ in). Cooper-Hewitt Museum, New York, The Smithsonian Institution's National Museum of Design.

lopedic artist, incorporating in his art aspects of the aesthetics of Burke and Kant. Most importantly, Church recreated the American experience, as he did in *Twilight in the Wilderness*, as an apotheosis of light.

It is important to remember that the American landscape had long been identified as the site of the promised millenium. The Apocalypse of St. John as described in the Book of Revelations had been incorporated in the wider context of Protestant theology by Puritan ministers intent on delimiting the new world experience and identifying it with the course of sacred history. Interest in the millenium and the Apocalypse was resurgent in the nineteenth century and it is a possible, though tentative assertion that a vocabulary of apocalyptic symbols emerged in landscape painting which related to the long tradition of considering American history as religious history. American light was the most obvious and overriding symbolic concern of mid-century painters; but other images, which can be identified in the Book of Revelations, appeared in landscapes painted in a quietistic mode, as well as in Church's spectacular visions of natural apocalypse, bringing together the transcendental and high romantic sublime. The crescent moon appears, for instance, in the works of Sanford Gifford with some frequency and is ascendent in the evening sky, along with the evening star, in *Twilight on Hunter Mountain*. The moon appears often in the art of the German romantics, particularly Friedrich. It is mentioned in Revelations as symbol of the Apocalypse and is described "a great wonder in heaven: a woman clothed with the sun, and the moon under her

88. Frederic Edwin Church. *Beacon Off Mt. Desert*, 1851. Oil on canvas. 0.787 x 1.168 (31 x 46 in). Inscribed, l.r.: *F.Church/—51*. Private collection. Photo: Helga Photo Studio

89. Frederic Edwin Church. *Sunset*, 1856. Oil on canvas. 0.610 x 0.915 (24 x 36 in). Inscribed, on rock, l.r.: *F. E. Church 1856 c*. Munson-Williams-Proctor Institute, Utica, New York

feet, and upon her head a crown of twelve stars" (Rev. 12:1).

The rainbow is also introduced as an apocalyptic image in the Revelations of St. John, where one is described as encircling the throne of heaven ("there was a rainbow round the throne, on sight like unto an emerald"—Rev. 4:3). Frederic Church had a special fascination for rainbows and they were prominently featured in two major paintings, *Niagara* of 1857, and the spectacular South American landscape painted in 1866, *Rainy Season in the Tropics* (The Fine Arts Museums of San Francisco). The introduction of symbolic imagery from the Bible to support a high romantic argument for wilderness is consistent with Church's visual references to light as a metaphor. The appeal of such symbolism for the American imagination had always been strong and touched on a deeply ingrained Protestant tradition, in which the American landscape was interpreted as a metaphor for biblical landscape.

The Last Judgment was most often associated in the popular imagination with the catastrophes described in Revelations. The engravings of John Martin depicting these events are a case in point and represent the visual extremes of the traditional sublime. However, the Bible also introduces the sublime of silence in the extraordinary discourse in Revelations which establishes the visual setting of the throne of heaven on the Day of Judgment. This fascinating and provocative passage has, perhaps, a special significance in relation to the transcendental sublime of mid-century landscape. What is described is the biblical equivalent of a luminist vision: "before the throne there was a sea of glass like unto crystal" (Rev. 4:6). This reference to still, mirrored water which defines the space intervening between the viewer and the throne of the Almighty has a special poignance in the context of the landscape painting of nineteenth-century America.

Indeed, the Reverend Louis Noble, Thomas Cole's biographer and Church's companion on an 1859 voyage to Labrador and Newfoundland, used this very language from Revelations to describe his impression of icebergs in the northern waters:

Wonderful to behold! It was only a fair field for the steepled icebergs, a vast metropolis in ice . . . glittering in the sunset. Solemn, still, and half-celestial scene! . . . I said aloud, but low: 'The City of God! The sea of glass! The plains of heaven!'[55]

Luminism, depicting the transcendental sublime, represented a paradigm of the "sea of glass" referred to in the Bible. However, even in such spectacular apocalyptic visualizations as Frederic Church's *Cotopaxi*, reflective water is important in the composition where it contrasts with the drama of the volcanic eruption, the active Apocalypse. Still water in American landscape painting represented more than a contemplative view of nature. For the symbolic imagination, such scenes were associated with the sublime of silence and space and related at yet another level, in which American light subsumed all experience as a manifestation of the sublime, a symbol of the throne of heaven. The frozen light of the transcendental sublime and the high romantic drama of the traditional sublime depicted extremes of emotive responses to nature, both of which identified American nature with the sublime.

These disparate but related expressions of the sublime continued to interest American landscape painters as the century drew toward a close and other forms of art, notably impressionism, began to displace older literary and biblical concerns for landscape. Albert Bierstadt capitalized on the majestic sublimity of the mountains of the far West but he also found the image of the stranded boat just as compelling as late as 1889, when he painted the *Wreck of the "Ancon" in Loring Bay, Alaska* (fig. 90). Space and light continued to have symbolic significance in American landscape following the Civil War; but the spiritual light and stilled silence of mid-century American landscape was perhaps the most refined form of expression the sublime achieved in art. The perception of nature that was so carefully cultivated in this art represented the end of a tradition which associated American landscape and American light with sacred history and the sublime.

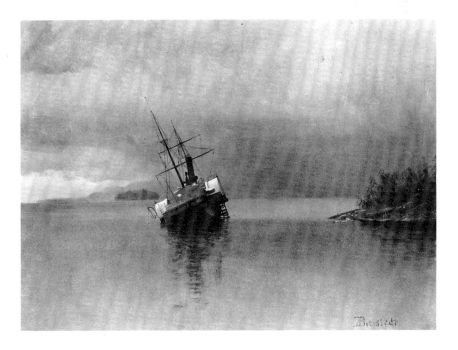

90. Albert Bierstadt. *Wreck of the "Ancon" in Loring Bay, Alaska*, 1889. Oil on paper mounted on panel. 0.356 x 0.502 (14 x 19¾ in). Inscribed, l.r.: *A Bierstadt* (*AB* is in monogram). Museum of Fine Arts, Boston; M. and M. Karolik Collection

Notes

1. For an extended discussion of the concept of the sublime see Samuel H. Monk, *The Sublime, A Study of Critical Theories in Eighteenth Century England* (Ann Arbor, 1960).

2. See Sacvan Bercovitch, *The Puritan Origins of the American Self* (New Haven, 1975), for a detailed and comprehensive discussion of Puritanism and its influence on American perceptions of history and religion, especially chap. 5, "The Myth of America."

3. Bercovitch, *American Self*, 151-152.

4. Thomas Cole, "Essay on American Scenery," 1835, republished in *American Art, 1700-1960, Sources and Documents,* ed. John McCoubrey (New Jersey, 1965), 98-109, 99-100.

5. Monk, *The Sublime*, 6. See also Rosario Assunto, "Tragedy and the Sublime" in *Encyclopedia of World Art, 14* (New York, 1967): 268-276.

6. Edmund Burke, *An Essay on the Sublime and Beautiful,* ed. Prof. Henry Morely (New York, 1886), 44, 60. First edition 1756.

7. M. H. Abrams, *Natural Supernaturalism* (New York, 1971), 101.

8. Abrams, *Natural Supernaturalism,* 101.

9. Burke, *Essay,* 12-13.

10. Burke, *Essay,* 44.

11. Burke, *Essay,* 81.

12. Burke, *Essay,* 81.

13. Immanuel Kant, *The Critique of Judgement,* trans. James Creed Meredith, Great Books of the Western World (Chicago, 1952) *42:* 511. First edition 1790.

14. Kant, *Critique of Judgement,* 498.

15. Kant, *Critique of Judgement,* 501.

16. Thomas Cole, "A Letter to Critics on the Art of Painting," *Knickerbocker, 16* (1840): 230-233, 233.

17. Ralph Waldo Emerson, "Thoughts on Art," 1841; republished in *American Art,* 70-80, 73.

18. See Walter John Hipple, Jr., *The Beautiful, the Sublime and the Picturesque in Eighteenth Century British Aesthetic Theory* (Carbondale, Ill., 1957), 158.

19. Monk, *The Sublime,* 154.

20. Monk, *The Sublime,* 155.

21. See Barbara Novak, *American Painting of the Nineteenth Century: Realism, Idealism, and the American Experience* (New York, 1969), chaps. 5, 6, and 7.

22. Ralph Waldo Emerson, "The Transcendentalist" in *Selections from Ralph Waldo Emerson,* ed. Stephen E. Whicher (Boston, 1960), 198.

23. Cited in Novak, *American Painting,* 110.

24. Monk, *The Sublime,* 204.

25. Friedrich Schiller, *On the Aesthetic Education of Man,* trans. and intro. Reginald Snell (New York, 1965), 63-64.

26. Barbara Novak, "American Landscape: Changing Concepts of the Sublime," *The American Art Journal, 4,* no. 1 (Spring 1972): 36-42, 40.

27. Novak, "American Landscape," 42.

28. Emerson, "Nature" in *Selections from Ralph Waldo Emerson,* 35.

29. Bercovitch, *American Self,* 165.

30. Burke, *Essay,* 70.

31. William Vaughan, "Caspar David Friedrich" in *Caspar David Friedrich 1774-1840, Romantic Landscape Painting in Dresden* [exh. cat., Tate Gallery] (London, 1972), 13.

32. Jan Bialostocki, "Characterization" in *Encyclopedia of World Art, 3* (New York, 1960): 371-375, 371.

33. Louis Legrand Noble, *The Life and Works of Thomas Cole,* ed. Elliot S. Vesell (Cambridge, Mass., 1964), 81. First edition 1853.

34. Noble, *Thomas Cole,* 81-82.

35. William Wordsworth, *Literary Criticism,* quoted in Abrams, *Natural Supernaturalism,* 33.

36. Nathaniel Parker Willis, *Pencillings By the Way,* 3 vols. (London, 1835), *2:* 37-38.

37. Noble, *Thomas Cole,* 72.

38. Noble, *Thomas Cole,* 73.

39. Thomas Cole, "Essay on American Scenery," in *American Art,* 105.

40. Noble, *Thomas Cole,* 64.

41. Noble, *Thomas Cole,* 168-169.

42. Thomas Cole, "Essay on American Scenery" in *American Art,* 104.

43. Cole, "Essay on American Scenery" in *American Art,* 104. Cole had been impressed by this scene earlier. In his notes pencilled into the leaves of his sketchbook on a trip to the White Mountains in 1828, Cole commented, "The perfect repose of these waters, and the unbroken silence reigning through the whole region, made the scene peculiarly impressive and sublime; indeed, there was an awfulness in the deep solitude, pent up within the great precipices, that was painful." Noble, *Thomas Cole,* 67.

44. Thomas Cole, "Essay on American Scenery" in *American Art,* 104.

45. Noble, *Thomas Cole,* 63.

46. Noble, *Thomas Cole,* 63.

47. See Novak, *American Painting,* and John Wilmerding, *American Art* (London and New York, 1976).

48. Heinrich von Kleist, cited in Vaughan, "Documents and Reminiscences," *Caspar David Friedrich,* 107.

49. Novak, "American Landscape," 42.

50. E. H. Gombrich, *Symbolic Images, Studies in the Art of the Renaissance* (London, 1972), 184.

51. Theodore E. Stebbins, Jr., *Martin Johnson Heade* (New Haven, 1975), 77.

52. James Jackson Jarves, *The Art-Idea,* ed. Benjamin Rowland, Jr. (Cambridge, Mass., 1960), 193. First edition 1864.

53. John Wilmerding, *Fitz Hugh Lane* (New York, 1971), 49.

54. David C. Huntington, *The Landscapes of Frederic Edwin Church* (New York, 1966), 82.

55. Louis L. Noble, *After Icebergs with a Painter, A Summer Voyage to Labrador and Around Newfoundland* (New York, 1861), 223.

97. Timothy H. O'Sullivan. *Summits of the Uinta Mountains, Utah Territory*, c. 1868-1869. Albumen photograph. 0.203 x 0.286 (8 x 11¼ in). The National Archives, Washington, D.C.

The Luminist Movement: Some Reflections

John Wilmerding

Luminism and Literature

THE PULL OF AMERICAN "LIGHT," THAT PALPABLE, SPIRITUAL BEAUTY of the American wilderness, was first felt across the western reaches of the Atlantic Ocean as Europe's earliest explorers to the New World glimpsed its indefinite edges. Almost from the beginning were fused the real vastness of space (experienced at sea and soon discovered on land), the sun's golden radiance setting in the west, and the sense of spiritual as well as physical riches in this new continent. Looking to the glowing western horizon, therefore, promised the gold of this world and of the next. That consciousness of salvation and of the divine presence in man's world was stimulated by Puritan theology and revivified by transcendentalism. Indeed, Henry David Thoreau could write:

Every sunset which I witness inspires me with the desire to go to a West as distant and as fair as that into which the sun goes down. He appears to migrate westward daily, and tempt us to follow him. He is the Great Western Pioneer whom the nations follow. We dream all night of those mountain-ridges in the horizon, though they may be of vapor only, which were last gilded by his rays.[1]

As F. O. Matthiessen has pointed out, the culmination of transcendentalism coincides with a great moment in American cultural expression around the midpoint of the nineteenth century. For example, just between 1850 and 1855 appeared Ralph Waldo Emerson's *Representative Men*, Nathaniel Hawthorne's *Scarlet Letter* and *House of the Seven Gables*, Herman Melville's *Moby Dick* and *Pierre*, Thoreau's *Walden*, and Walt Whitman's *Leaves of Grass*, let alone John Greenleaf Whittier's *Songs of Labor* and Henry W. Longfellow's *Hiawatha*.[2]

Matthiessen's own important book on this period, *American Renaissance*, was first published in 1941, and stands as a broad seminal study of American culture and literature parallel to John Baur's writing at the time on painting. Here are many of the first observations, we now take for granted, about social and intellectual developments in mid-nineteenth-century America: the emergence of technology over agriculture, the gold rush of 1849 and its initiation of a truly gilded age of acquisitiveness, the rise of photography concomitant with plein-air painting. But perhaps most of all there was what Emerson himself claimed as "a new consciousness. . . . Men grew reflective and intellectual."[3] Since Matthiessen's perceptive remarks about Emerson and his contemporaries are frequently directly related to the work of the luminist painters, some of these themes deserve recapitulation here.

For example, speaking of Nathaniel Hawthorne, Matthiessen cites the central role of abstraction, meditation, and symbolism in the writer's work. Whether we look at the novel or essay of the time or at the first classic examples of luminist imagery, we become aware of a spiritual presence abstracted before us. Further, by the sense of order and balance present we too assume a posture of contemplation. However critics may continue to interpret the meaning of the letter *A* in *The Scarlet Letter*, it clearly reverberates with the symbolic content of art and creativity. As David Huntington has shown us, so, too, do the eloquent canvases of Frederic Church speak their own symbolic language of an American Edenic paradise. But the abstraction Matthiessen notes has equally to do with form as with content. He cites the symmetrical design of Hawthorne's novel, the author's use of light and dark contrasts in the ordering of his scenes (both dramatic and landscape), and his keying of events to specific moments of time or season.[4] Heade's measured marshes and Lane's stilled surfaces possess parallel symmetries, contrasts, and clarities.

One of the most revealing images Hawthorne employs, that of the mirror, is a recurring theme in others as well, from Emerson to Fitz Hugh Lane:

Glancing at the looking-glass, we behold—deep within its haunted verge—the smouldering glow of the half-extinguished anthracite, the white moonbeams on the floor, and a repetition of all the gleam and shadow of the picture, with one remove further from the actual, and nearer to the imaginative.[5]

In other words, the mind's eye itself is a form of mirror—observing, imagining, and transforming, such that for writer and painter alike *reflection* truly meant both *what* was perceived and the *act* of perceiving, inextricably fused together. Or, to quote Matthiessen: "perpetually for Hawthorne the shimmer of the now was merely the surface of the deep pool of history."[6] Clearly, the mirror surfaces found so repeatedly in luminist canvases were equally vehicles for carrying the mind's eye from the specific objectivity of the present moment and place to a transcendent cosmos beyond time.

Of course, it was Emerson the philosopher who has most famously articulated for us the union of man and God through nature. Announcing himself to be a "transparent eyeball," he found it possible for the "currents of the Universal Being" to circulate through him.[7] Not accidentally, Emerson himself had overlapping careers as a minister, natural scientist, and poet. Indeed, he stated, "America is a poem in our eyes; its simple geography dazzles the imagination, and it will not wait long for metres."[8] We need not look beyond the controlled measurements and design of a Martin Johnson Heade or Lane composition from the 1860s to see the American landscape shaped in poetic rhythms. One capacity the artist-poet possessed was to perceive the harmony between the soul and matter, the sublime and the ordinary, the seer and seen. Emerson often compared this "Oversoul" to water, which like the currents passing through the transparent eye, brings us back to the layered meanings of reflection.[9]

Emerson's observations, taken here primarily from the landmark essays *Nature* (1836) and *The American Scholar* (1837), seem to fall into three natural groupings—first, the significance in looking at horizons:

Our age is ocular.

But is it the picture of the unbounded sea, or is it the lassitude of the syrian summer, that more and more draws the cords of Will out of my thought and leaves me nothing but perpetual observation, perpetual acquiescence and perpetual thankfulness.

The health of the eye seems to demand a horizon. We are never tired, so long as we can see far enough.

There is a property in the horizon which no man has but he whose eye can integrate all the parts, that is, the poet.

In the tranquil landscape, and especially in the distant line of the horizon, man beholds somewhat as beautiful as his own nature.

The link between mental states and moments in nature:

Every hour and change corresponds to and authorizes a different state of mind, from breathless noon to grimmest midnight.

Nature always wears the colors of the spirit.

And, finally, the ordering of nature:

In view of the significance of nature, we arrive at once at a new fact, that nature is a discipline.

Nature hastens to render account of herself to the mind. Classification begins.

Things are so strictly related, that according to the skill of the eye, from any one object the parts and properties of any other may be predicted.[10]

Not merely do horizontal depth and order dominate most pure luminist designs, even as Emerson sees their dominance in nature; but the cogency and compactness of Emerson's style would also seem to find counterparts in such intimately wrought works as Lane's *Brace's Rock* (1864; fig. 91) or Albert Bierstadt's *Wreck of the "Ancon" in Loring Bay, Alaska* (1889; fig. 90). In this regard it is worth noting the penchant of Emerson and most of his contemporaries for such smaller-scale forms of writing as the essay, short story, and sketch. Even the epigrammatic sentences and notational recordings of Thoreau suggest a parallel with the scrupulous delineations of natural details in luminist pictures. It is a provocative coincidence that the most famous political utterance of the day, Lincoln's Gettysburg Address, dates from exactly the same time as Lane's painting *Brace's Rock*. Both are startlingly compact and poetic; they are self-contained meditations on the moment; they intimate a higher, timeless serenity.

As with Lane and Emerson, we feel with Thoreau too the desire for full immersion in nature. Thoreau seeks to take nature's pulse as much as his own. He records his delight in the sensations of touch, as with water on the skin; of hearing, as with birds or a telegraph wire; or of sight, as in the autumnal tints on a red maple. The total union of artist and subject is a central aspect of pure luminism as most recently summarized by Barbara Novak; and with Lane's *Brace's Rock* still in mind, we can see the same aspiration of the transcendentalists to achieve both the spaciousness of the horizon and the immediacy of observed phenomena. There is an essence of fact and feeling, in this small painting of vast scale, that parallels Thoreau's intention to "cut a broad swath and shave close."[11] This landscape is as much an embodiment of thought as of nature. Its patiently adjusted design seeks to provide, through revealed physical order, a construct for revery: "In the spaces of thought are the reaches of land and water, where men go and come. The landscape lies far and fair within, and the deepest thinker is the farthest traveled."[12]

Distance, therefore, both measured and mental, is a significant element in the imagery of nature at this time. On one walk Thoreau urged climbing a tree to elevate our vantage point and gain the broader, deeper view. It is noteworthy that quite frequently the luminist painter sought out vistas from unusually high points of view. See, for example, John F. Kensett's *View Near Cozzens Hotel, West Point* (1863; fig. 243), Frederic Church's *Andes of Ecuador* (1855; fig. 186), Sanford Gifford's *Mt. Mansfield* (1858; fig. 26), Worthington Whittredge's *Home by the Sea-Side* (1871; fig. 92), or Eadweard Muybridge's *Valley of the Yosemite from Glacier Point* (1872; fig. 93).

Stillness and silence are two other elements that we have already noted in the classic luminist style, and these too form a theme Thoreau celebrates. Consider how closely his word images match paintings like Lane's *Entrance of Somes Sound from Southwest Harbor* (1852; fig. 72), Gifford's *Hook Mountain, Hudson*

92. Thomas Worthington Whittredge. *Home by the Sea-Side*, 1871. Oil on canvas. 0.369 x 0.648 (14½ x 25½ in). Inscribed, l.r.: *W. Whittredge*. Los Angeles County Museum of Art; William Randolph Hearst Collection

93. Eadweard J. Muybridge. *Valley of the Yosemite from Glacier Point (no. 33)*, 1872. Albumen photograph. 0.430 x 0.545 (16¹⁵⁄₁₆ x 21⁷⁄₁₆ in). University Research Library, Special Collections, University of California, Los Angeles (below, right)

(1866; fig. 84); drawings like David Johnson's *Tongue Mountain, Lake George* (1872; fig. 274), Aaron Draper Shattuck's *Lake George* (1858; fig. 275); and photographs like S. R. Stoddard's views of *Upper Saranac Lake* (figs. 94-95), Carleton Watkins' *Mirror Lake, Yosemite* (1866; fig. 96), and Timothy O'Sullivan's *Summits of the Uinta Mountains, Utah Territory* (c. 1868-1869; fig. 97):

To be calm, to be serene! There is the calmness of the lake when there is not a breath of wind. . . . So it is with us. Sometimes we are clarified and calmed healthily, as we never were before in our lives, not by an opiate, but by some unconscious obedience to the all-just laws, so that we become like a still lake of purest crystal and without an effort our depths are revealed to ourselves. All the world goes by and is reflected in our deeps. Such clarity![13]

Reflection took on an especially reverent air at evening. Twilight was a poignant period of time's passage, and by the 1860s, it seemed to assume association with loss of more than day. Thoreau wondered,

What shall we name this season?—this very late afternoon, or very early evening, this severe and placid season of the day, most favorable for reflection, after the insufferable heats and the bustle of the day are over and before the dampness and twilight of evening! The serene hour, the Muses' hour, the season of reflection![14]

Sunset pictures by later Hudson River school and luminist painters appeared from the 1840s on, as may be seen in the examples by Thomas Cole, John S. Blunt, Asher B. Durand, Lane, Heade, Kensett, Bierstadt, Gifford, Jasper F. Cropsey, and, above all, Church. The latter's series of some half-dozen major

94. Seneca Ray Stoddard. *Upper Saranac Lake, East From Saranac Inn*, 1889. Silverprint photograph. 0.165 x 0.217 (6½ x 8 9/16 in). The Library of Congress, Washington, D.C.

95. Seneca Ray Stoddard. *Upper Saranac Lake, South from Saranac Inn*, 1889. Silverprint photograph. 0.167 x 0.219 (6 9/16 x 8 5/16 in). The Library of Congress, Washington, D.C.

canvases throughout the 1850s culminates with the spectacular *Twilight in the Wilderness* of 1860. Virtually burning with the intensity of stained-glass windows, these paintings inspire deeply contemplative, even devotional, responses.

Although Emerson and Thoreau come most readily to mind as intellectual and literary parallels to luminism, there are striking relationships also in the early work of other major writers. Herman Melville was at this time a youthful friend of Hawthorne's, and several of his themes follow directly from the older writer's work. An opening paragraph of *Moby-Dick* contains the familiar phrase, "meditation and water are wedded for ever."[15] Like Hawthorne, too, Melville often constructed his word pictures around oppositions of light and dark, calm and storm, good and evil. And reminiscent of the writing of Emerson and Thoreau is his synthesis of general and specific, or philosophical and reportorial. Just as Thoreau sought to tie his own existence to the larger rhythms of nature, Melville modulated his prose to match the changing environment of the sea as he experienced its flux. The chapter entitled "Sunset" is a perfect, and particularly appropriate, example here. In it emerge Melville's sense of self, subject, and artifact as comparable organisms: "Yonder, by the ever-brimming

goblet's rim, the warm waves blush like wine. The gold brow plumbs the blue. The diver sun—slow dived from noon—goes down; my soul mounts up!"[16]

By contrast, Walt Whitman's poetry can be less directly linked to the spare meditations of much luminist art, yet his exultant and celebratory songs of self and America do bear comparison with the large-scale pyrotechnics of Church and Bierstadt. In setting out to catalogue his cosmos in *Leaves of Grass*, first published in 1855 just four years after *Moby-Dick*, Whitman's all-encompassing lines set down the variety and vastness of America with Church's naturalist sweep. Whitman joined his colleagues by calling out, "Give me the splendid silent sun with all his beams full-dazzling."[17] In fact, the colors of sky and earth are recurring motifs, as exemplified in the short poem "A Prairie Sunset":

> Shot gold, maroon and violet, dazzling
> silver, emerald, fawn,
> The earth's whole amplitude and Nature's
> multiform power consign'd for once
> to colors;
> The light, the general air possess'd by
> them—colors till now unknown,

91. Fitz Hugh Lane. *Brace's Rock*, 1864. Oil on canvas. 0.254 x 0.381 (10 x 15 in). Inscribed, on stretcher: *F.H. Lane/1864*. Mr. and Mrs. Harold Bell

No limit, confine—not the Western sky alone—
the high meridian—North, South, all,
Pure luminous color fighting the silent
shadows to the last.[18]

Matthiessen contrasts this language of nature's harmonies to the plein-air paintings of William Sidney Mount.[19] For example, in *Farmer's Nooning* (1836; fig. 98) and especially *Eel Spearing at Setauket* (1845; fig. 256) we enter a rarified world of optimism and self-contentment.

Finally, we can note the perhaps surprising correlation between luminist imagery and the early writing of Henry James. Baur first called attention to an apt passage in a story called "A Landscape Painter," which James published in *The Atlantic Monthly* in 1866:

I shall never forget the wondrous stillness which brooded over earth and water. . . . The deep, translucent water reposed at the base of the warm sunlit cliff like a great basin of glass, which I half expected to hear shiver and crack as our keel ploughed through it. And how color and sound stood out in the transparent air! . . . The mossy rocks doubled themselves without a flaw in the clear, dark water. . . . There is a certain purity in this Cragthorpe air which I have never seen approached—a lightness, a brilliancy, a *crudity*, which allows perfect liberty of self-assertion to each individual object in the landscape. The prospect is ever more or less like a picture which lacks its final process, its reduction to unity.[20]

96. Carleton E. Watkins. *Mirror Lake, Yosemite*, c. 1866. Albumen photograph. 0.521 x 0.400 (20½ x 15¾ in). The Library of Congress, Washington, D.C.

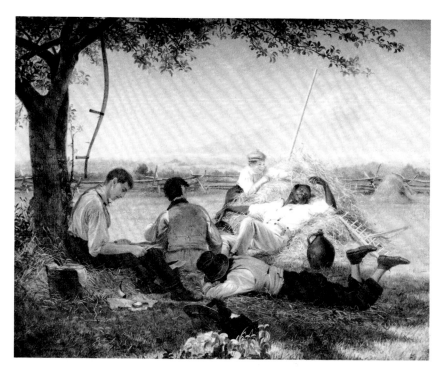

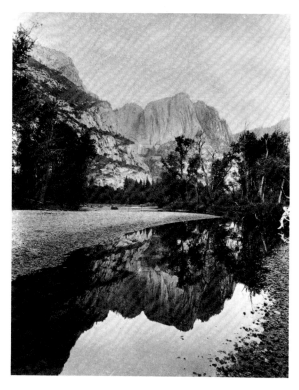

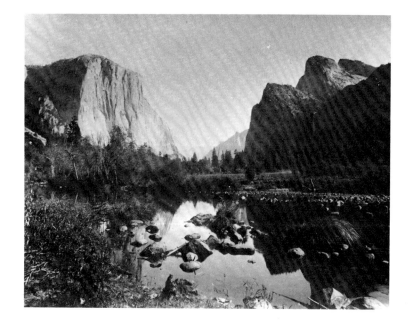

98. William Sidney Mount. *Farmer's Nooning*, 1836. Oil on canvas. 0.511 x 0.629 (20⅛ x 24¾ in). Inscribed, l.l.: *Wm. S. Mount 1836*. The Museums at Stony Brook, New York, Gift of Frederick Sturges, Jr., 1954

100. John K. Hillers. *Yosemite Valley*, c. 1886. Albumen photograph. 0.327 x 0.206 (12⅞ x 8⅛ in). The Denver Public Library, Western History Department (at right)

99. John K. Hillers. *Yosemite Falls Cliff, California*, c. 1886. Albumen photograph. 0.327 x 0.206 (12⅞ x 8⅛ in). The Denver Public Library, Western History Department

Although we ordinarily associate James' writing with a more cosmopolitan culture and style of writing fashionable later in the nineteenth century, paradoxically this piece captures the quintessential features of luminist art. The repose, the wonder, the glassy mirror are obvious keynotes. At the same time the brooding and threatened cracking suggest a hidden tension also seen in the darker side of luminism, in such works as Heade's thunderstorm series at Newport or Lane's *Ships and an Approaching Storm Off Owl's Head, Maine* (1860; fig. 73). The image of mossy rocks doubled in dark water finds corollaries in the latter's Brace's Rock (figs. 11, 74, 91, 116-117) and Norman's Woe (figs. 32-33, 61) series, Kensett's *Shrewsbury River* (1856; fig. 81), and Jack Hillers' views of Yosemite Valley (figs. 99-100). James' reference to "crudity" is a reminder of the conceptual strain Barbara Novak has explored. The individuality of all objects perfectly describes the self-effacing precision of the luminist touch; and "reduction to unity," its process.

The Precursors of Luminism

When does luminism begin?

As Baur argued, "The beginnings of American luminism were everywhere and nowhere."[21] That is to say, its sources can be found in the work of a number of artists, and while there is no one focal precedent, several precursors are readily identifiable. Perhaps the major forerunner is Washington Allston, southern born, Harvard educated, and European trained. His years with Benjamin West in London, along with travel to the great European art centers during the first decade of the nineteenth century, gave him a solid grounding in the traditions of heroic history painting. Yet coming from a younger generation attuned to the rising tide of romanticism, and responding to the experience of travel through the alluring landscapes of Switzerland and Italy, Allston increasingly found nature herself to be his most forceful mode of artistic expression.

To capture his feelings about nature on canvas Allston made special use of color glazing techniques he had observed in the Venetian masters. These imbued his grand biblical subjects set in dramatic landscapes with a character of mystery. When he turned to pure landscapes, he fused observation and recollection in paintings which seemed indebted simultaneously to experience and imagination. In a few memorable scenes light suffuses the composition. Literally as well as poetically light organizes the central axis in *Coast Scene on the Mediterranean* of 1811 (fig. 101) and *Moonlit Landscape* of 1819 (fig. 13; see also fig. 102), both frequently cited as notable proto-luminist canvases. Although the radiance of sunlight and moonlight respectively dominates these designs, the genre elements of figures silhouetted in the foreground also engage our attention. This sort of diversionary detail is, for the most part, suppressed in pure luminist painting by the next generation. Still, the clear, classical structure and enveloping aura of reverie, which imply a unified harmony between the soul and nature, are among the earliest notes in American painting anticipating a fully developed style a few decades later. Quite appropriately the transcendentalist Margaret Fuller could write of Allston's work: "The calm and meditative cast of these pictures, the ideal beauty that shone *through* rather than *in* them, and the harmony of coloring were unlike anything else I saw."[22]

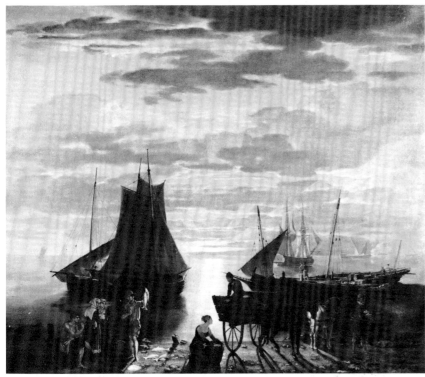

101. Washington Allston. *Coast Scene on the Mediterranean*, 1811. Oil on canvas. 0.864 x 1.016 (34 x 40 in). Columbia Museum of Art, Columbia, South Carolina (not in exhibition)

102. Washington Allston. *American Scenery. Time: Afternoon with a Southwest Haze*, 1835. Oil on canvas. 0.470 x 0.622 (18½ x 24½ in). Museum of Fine Arts, Boston; Bequest of Edmund Dwight

Among the first artists to be interested in rendering similar light effects across identifiable harborscapes were John S. Blunt and Robert Salmon. The former was a native of Portsmouth, New Hampshire, while the latter was born on the English border with Scotland; both made their way to Boston and were actively painting there during the 1820s. With their work we immediately sense a new documentary awareness of the landscape, missing in Allston's imaginative idyls. The formulas of their compositions are still close to Allston, who had, during that period, himself settled in Boston, receiving younger aspiring painters and attempting vainly to conclude his own commissions. Notable in Blunt's *New York Harbor at Sunset* (c. 1815-1824; fig. 103) and Salmon's *Moonlight Coastal Scene* (1836; fig. 104) are the same axial and central light, and silhouetted figures. But now instead of Allston's promenading family greeting a lone horseman, we have laborers and fishermen engaged in their practical tasks of the moment.

Allston's *Moonlit Landscape* was exhibited periodically in the years after its completion in 1819; and it seems to have had an influence on others as well, for Lane painted similar moonlight marines during the 1850s, when he was visiting Boston regularly. Blunt's New York scene also anticipates the strong red and yellow tonalities of Lane's later Boston harbor pictures. While there is no concrete proof Blunt spent any time in the New York area, at least one of his previously known paintings has long been titled *Picnic on Long Island* (1823; Nina Fletcher Little, Brookline, Massachusetts) and like most artists of his time he doubtless did some traveling along the east coast in search of subjects.[23] Although the coloring and rather open design of *New York Harbor at Sunset* might initially support a dating closer to mid-century, we can firmly place this scene in the early 1820s; for shortly after, a parapet railing was constructed around the top of the fortress and would surely have been recorded in any later rendering. Moreover, the relatively simplified forms of the ship and architecture all point to Blunt's hand and other comparable views by him at that time.

The pictures by Salmon that come closest to early luminism are his large views across Boston harbor painted toward the end of the decade. Shortly after his arrival in Boston in 1828, he painted several major canvases, some for theater backdrops, as well as the ambitiously scaled *Wharves of Boston* (fig. 105). In this a crisp, golden light clarifies the myriad details of shiprigging and shoreline architecture. It is on one level an image of bustling industry, evident in the

103. John Samuel Blunt. *New York Harbor at Sunset*, c. 1815-1824. Oil on canvas. 0.578 x 0.734 (22¾ x 28¾ in). Private collection (not in exhibition; above)

104. Robert Salmon. *Moonlight Coastal Scene*, 1836. Oil on panel. 0.422 x 0.616 (16⅝ x 24¼ in). Signed, l.r.: *R.S. 1836*. The St. Louis Art Museum; Purchase: Funds provided by Mr. and Mrs. Duncan C. Dobson, Contributions in memory of Henry B. Pflager, Tax Funds 1973 and Eliza K. McMillan Fund (not in exhibition; below)

great sailing vessels doing business on distant seas and in the crowded wharf buildings recently built along the expanding waterfront. But the warm serenity of light and atmosphere also reinforces a pervasive feeling of bursting optimism, a visible index of Josiah Quincy's productive mayoralty locally, as well as of the new energies of Jacksonian Democracy then just emerging nationally.

With his two major Boston views done later in the 1830s—composed respectively from Constitution Wharf and Castle Island—Salmon achieved an even greater spaciousness. His maintenance of a relatively low vantage point and horizon line allows the great expanses of light-filled sky to envelop the design. More importantly, he has now pushed his shoreline into the far distance; and while figures still give scale and activity to the foreground, our vision goes more intentionally to the central panorama. These shifts in design and in the viewer's relationship to the subject are crucial steps luminism would refine even further. What they mean is that genre elements previously favored are being absorbed into the greater drama of nature in flux. We might conclude, therefore, that Salmon's art was significantly moving toward luminist light, structure, and subject matter, though without achieving all three completely or together.

Mention of the genre elements in his landscape foregrounds brings us to the major genre painters who were forerunners of pure luminism: William Sidney Mount and George Caleb Bingham. Virtually Mount's entire career is associated with eastern Long Island, New York, where he was born and grew up. After some training in New York City, he returned to the Stony Brook area to paint the familiar scenes of everyday life among his friends and neighbors. In effect, the doings of local farmers were, in Mount's hands, the new subjects of a contemporary American history painting. The former biblical or mythological themes so preferred by earlier academicians are now transformed into celebrations of the everyday.

The warmth, humor, and calm we find in such Mount paintings as *Farmer's Nooning* speak unabashedly of the Jacksonian era's expansive spirit. But it is the role of light as an agent of tranquility that is of pertinent concern here. Although the anecdotal activity among the foreground figures remains the principal subject, we are also drawn to the golden fields opening up in the background, while all is bathed in the full light of high noon. This presence of light as a metaphor of plenitude and well-being reaches its supreme form in Mount's art in *Eel Spearing at Setauket,* where harmonious order derives as well from the carefully balanced and utterly stilled composition. Now, for the first time in a major way, clear, sharp reflections play a vital role in the total design. Mount's effort to record a specific place ("Hon Selah B. Stong's residence in the distance during a drought at Setauket, Long Island") and moment ("calm, and the water as clear as a mirror, every object perfectly distinct")[24] is regularly cited as a singular early instance of the luminist sensibility. But his method of near-mathematical measurements and scientific precision, along with the instinct to compose in horizontal parallel zones, likewise brings us to the thresh-

106. William Sidney Mount. *Crane Neck Across the Marsh*, c. 1851. Oil on wood panel. 0.324 x 0.432 (12¾ x 17 in). The Museums at Stony Brook, New York; Gift of Mr. and Mrs. Carl Heyser, Jr., 1961

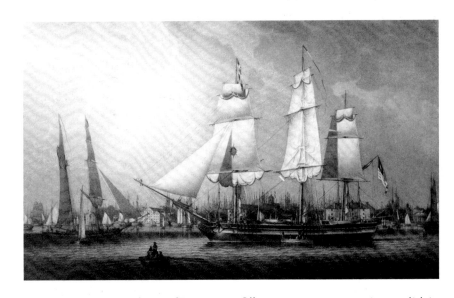

105. Robert Salmon. *Wharves of Boston*, 1829. Oil on canvas. 1.016 x 1.689 (40 x 66½ in). Inscribed. l.r.: *R. Salmon/1829*. The Bostonian Society, Old State House, Boston; Gift of the Estate of Edmund Quincy, 1894. Photo: Barney Burstein (see plate 7)

107. Thomas Cole. *View Across Frenchman's Bay from Mt. Desert Island, After a Squall*, 1845. Oil on canvas. 0.968 x 0.588 (38¼ x 62½ in). Cincinnati Art Museum; Gift of Miss Alice Scarborough (not in exhibition)

old of typical luminist processes. In a later oil sketch, *Crane Neck Across the Marsh* (c. 1851; fig. 106), he moves even further to the open distances of luminism (compare Heade's *Becalmed, Long Island Sound*, 1876; fig. 249).

With George Caleb Bingham's flatboatmen pictures painted on the Missouri and Mississippi rivers, also in the later 1840s, we encounter an equivalent fusion of genre themes and plein-air landscape. Before leaving for a period of study and travel in Düsseldorf in the later 1850s, Bingham drew an extensive picture of daily river life in the American Midwest, exemplified in *Fur Traders Descending the Missouri* (Metropolitan Museum of Art, New York) and *The Concealed Enemy* (Peabody Museum, Harvard University, Cambridge, Massachusetts) of 1845, and *The Jolly Flatboatmen* (fig. 43) from the following year. Here are combined a precision in rendering solid forms and a warm hazy light that makes the space behind seem to dissolve into an atmospheric infinity. On this point Barbara Novak has argued that "the sharply focused foreground and hazed distance represent . . . the unique polarity of luminist vision."[25] It is arguable whether such dominant figuration in Mount and Bingham is consistent with classic luminism, though certainly the rigorously measured parallels, balanced masses, and envelope of light all establish an ambience for uplifted thought.

However, only when we turn to pure landscape do we find the formulas of history and figure painting transferred fully to the frame of nature. In fact, Thomas Cole has very much treated *The Clove, Catskills* (1827; fig. 20) as if it were a stage now occupied not by people but by gesturing trees and assertive

rocky promontories. The vivid colors of autumn and dramatic passage of storm clouds also articulate the theatrical and even spiritual drama of natural and cosmic history. Now the inventory of nature's moods and elements is alone capable of carrying elevated moral narratives. This notion that landscape might be charged with symbolic content was an important foundation for the evolution of luminism. Proclaimed Cole, "The wilderness is *yet* a fitting place to speak of God."[26] In his "Essay on American Scenery," published in 1835—thus making it almost exactly contemporary with Emerson's *Nature*—he argued that one should study American scenery both for pleasure and edification.

To Cole what distinguished the American landscape from Europe's was its wildness, because it had not yet been altered or ravaged by past civilizations. This meant not merely that Americans could contemplate the promise of the present ("the mind's eye may see far into futurity"), instead of meditating on a lost past, but that it signified that one was truly in the purer world of God's making: "We are still in Eden."[27] Like his contemporaries Cole saw a heightened purity worthy of thought in

another component of scenery, without which every landscape is defective—it is water. Like the eye in the human countenance, it is a most expressive feature: in the unrippled lake, which mirrors all surrounding objects, we have the expression of tranquility and peace.[28]

If lakes were "chosen places," the sky was the "soul of all scenery," and the autumn was the "one season when the American forest surpasses all the world in gorgeousness."[29] Cole and his fellow painters often linked these themes together in what Emerson described as "the sublime moral of autumn and of noon."[30] Looking at Cole's paintings *Summer Sunset* (1834; fig. 21) and *Catskill Creek* (1845; fig. 69), we might well be reminded of Emerson's opening lines of his second essay on "Nature":

There are days which occur in this climate, at almost any season of the year, wherein the world reaches its perfection; when the air, the heavenly bodies and the earth, make a harmony. . . . These halcyons may be looked for with a little more assurance in that pure October weather which we distinguish by the name of the Indian summer. The day, immeasurably long, sleeps over the broad hills and warm wide fields. To have lived through all its sunny hours, seems longevity enough.[31]

In Cole's more direct transcriptions of nature, such as his Catskill pictures done later in his career, there is a new openness of composition as well as an attention to more specific light effects. Both these aspects anticipate the full-blown treatment by his luminist successors. He himself remarked about the symbolic and observed features of light at day's end: "At sunset the serene arch is filled with alchemy that transmutes mountains, and streams, and temples, into living gold."[32] Other late Cole subjects, particularly the paintings done at Mt. Desert Island, Maine on a trip there in 1844, look forward to the thematic and compositional features of luminism. For example, his large canvas *View Across Frenchman's Bay from Mt. Desert Island, After a Squall* (fig. 107) gives us a bold panorama of natural drama across both sea and sky, which

108. Asher Brown Durand. *American Wilderness*, 1864. Oil on canvas. 0.641 x 1.016 (25¼ x 40 in). Inscribed, l.l.: *A.B. Durand/1864*. Cincinnati Art Museum, The Edwin and Virginia Irwin Memorial

109. Asher Brown Durand. *Landscape with Birches*, c. 1855. Oil on canvas. 0.610 x 0.457 (24 x 18 in). Museum of Fine Arts, Boston; Bequest of Mary Fuller Wilson

will receive even grander resolution during the next two decades in the work of Lane, Church, and A. T. Bricher.

Following Cole's death in 1848, the mantle of informal leadership of the Hudson River school passed to Asher B. Durand, who had been trained as an engraver and, after a period of portrait painting, had turned late to a career as landscapist. As a consequence of several factors—his work in prints, the increasing taste for accurate recordings of identifiable American scenery, and the influential writings of John Ruskin—Durand's style was a good deal more precise in drawing and finish than Cole's. He generally continued many of the same formulas of design, notably the solid foreground platform, framed by rising silhouetted trees, and usually a valley tunneling our vision into the distance. These devices are variously apparent in his paintings *Kaaterskill Clove* (1866; fig. 23) and *American Wilderness* (1864; fig. 108), while his *Sunset* (1878; fig. 22) and *Landscape with Birches* (c. 1855; fig. 109) present that central suffusion of glowing light increasingly common in his later work and, of course, basic to the mature luminist style.

As a widely read critic at home in England as well as in America, John Ruskin very much influenced the artistic thought of Durand, Lane, and many of their contemporaries. *Modern Painters* by Ruskin was first published in London in 1844 and appeared in New York three years later; his *Elements of Drawing* was published on both sides of the Atlantic in 1857. The earlier volume was notable for its warm praise of J. M. W. Turner, whose work was itself much admired by Cole, Church, Gifford, and probably also Lane. Ruskin further affected a good deal of Durand's thinking as the latter articulated it in his "Letters on Landscape Painting." These appeared in *The Crayon* in 1855, almost contemporaneously with Ruskin's volume on drawing.

Where Ruskin argued that "we have to show the individual character and liberty of the separate leaves, clouds, or rocks," Durand stated that "every kind of tree has its traits of individuality."[33] If Durand could speak of nature "fraught with lessons of high and holy meaning," Ruskin also talked of "moral analogies" and urged us to listen to nature's "sweet whispers of unintrusive wisdom, and playful morality."[34] Glancing again at Durand's paintings, we

110. David Johnson. *Chocorua Peak, New Hampshire*, 1856. Oil on canvas. 0.486 x 0.717 (19⅛ x 28¼ in). Inscribed, l.r.: *D.J./1856* (*DJ* is in monogram); on verso: *Chocorua Peak.N.H./D. Johnson, 1856*. Private collection. Photo: Helga Photo Studio (see plate 6)

might well keep in mind Ruskin's ethereal description of clouds as "definite and very beautiful forms of sculptured mist" and his more down-to-earth observation that "all distant colour is *pure* colour: it may not be bright, but it is clear and lovely."[35] In this regard the painter advised:

When you shall have acquired some proficiency in foreground material, your next step should be the study of atmosphere—the power which defines and measures space. . . . I can do little more than urge on you the constant study of its magic power, daily and hourly, in all its changes.[36]

It is clear that in the later paintings of Cole and Durand are present several qualities which will be fully refined by their luminist successors. One interesting secondary figure of the Hudson River school is David Johnson, who as a painter fairly closely followed the conventions of the movement's leaders. His *Chocorua Peak, New Hampshire* (1856; fig. 110) has the familiar, carefully observed details, reflecting river, enframing tree, and golden distance. This painting foremost—effulgent, almost glaring—is just about as near as Johnson and the basic Hudson River conventions come to luminism. In fact, he was able to move further in some of his drawings, for instance *Tongue Mountain, Lake George* (1872; fig. 274) where material foreground disappears altogether. Our eye instead is carried across the glassy water—hardly interrupted by a small promontory in the left middle ground—to the distant mountains bathed in

sunlight. Just the barest touches of pencil indicate shoreline reflections in an otherwise purified scene. The new emphatic horizontality of composition enhances this perception of broad depth and stillness. Only a few painters, now grouped as luminists, synthesized these variables together, and even then with individual variations of style. Paradoxically, those who emerged to work fully in this refined mode around 1850 have left us a legacy both recognizable and elusive.

Mature Luminism

The principal exponents of luminism are commonly thought to be four: Fitz Hugh Lane (1804-1865), John Frederick Kensett (1816-1872), Martin Johnson Heade (1819-1904), and Sanford Robinson Gifford (1823-1880). However, historians have placed differing emphases on these figures and the relationships among them. Baur found Lane and Heade to be the leading figures; James Thomas Flexner put Kensett foremost. Barbara Novak calls Lane "a paradigm of luminism," while Stebbins argues that "the archetypal luminists now appear to be Heade and Sanford Gifford."[37] Novak makes her judgment largely on the grounds that Lane's mature art appears to embody the quintessential processes and attitudes of the style, whereas Stebbins reasons that Heade and Gifford worked most consistently within the luminist format. In addition, he cites the important contribution of Heade's friend Frederic Church (1826-1900) to the movement. Yet Church's role here is an idiosyncratic one, in which he brought to the movement a distinctively nationalist iconography through his powerful sunset paintings. As these made the most daring use, relative to that of his colleagues, of the new cadmium colors, his wilderness landscapes have come to occupy a critical position in the luminist treatment of light.

Speaking generally, we may observe that, as in the evolution of many styles in the history of art, here there is an early archaic phase, lasting from around 1848 to 1855. During these years the first dramatic light effects began to appear in the work of these painters, as did the new open formats. For Lane and Kensett it was a period of breaking out of earlier graphic traditions and away from the compositional conventions of Salmon and Durand, as they moved toward the new poetic style. Over the next decade luminism held to a classic phase. Some of the most stilled and peaceful creations come at this time. In the early fifties Lane and Kensett were painting harbor scenes in broad noontime light, but by the end of the decade they and others were turning increasingly to conditions of haze, fog, and mist. Also, during this time Church commenced his series of twilight paintings, which stimulated others to attempt the subject often from 1860 on. By the mid-sixties and running into the later seventies, a late phase of more romantic or painterly luminism is evident. In this period occur many of the great evening pictures by Heade and Gifford, as well as most of the major thunderstorm subjects. Though several of the group had begun to travel quite

III. Fitz Hugh Lane. *Salem Harbor*, 1853. Oil on canvas. 0.660 x 1.067 (26 x 42 in). Inscribed, on sail of center boat: *FHL/1853*. Museum of Fine Arts, Boston; M. and M. Karolik Collection

far afield from the New England coast by this time, now several set off widely—to the Arctic, South America, California and Alaska, the Mediterranean, and the Near East—in search of more exotic subject matter. At the same time we may further notice a new loosening in brushwork, appropriate to an interest in denser, softer envelopes of light and moisture.

The earlier years of luminism coincide with and illuminate the culminating years of Jacksonian optimism. The middle period of course parallels the national crisis of the Civil War, and it is unsurprising that emerging out of these years are the luminist subjects of violence and explosion. During the last phase one is conscious of an almost schizophrenic polarity in the luminist vision, as it is torn between drama and calm, clarity of ideals and melancholy meditations on loss, one period of history and art left behind and another uneasily unfolding.

In the work of Lane, who died as the Civil War was coming to an end, there is only the scantest intimation of the turbulence and escapism to appear later in luminism. A Gloucester, Massachusetts, native, who grew up and first practiced art there, Lane also spent several years in Boston learning lithography. This gave him a basic grounding in conceptualizing forms in linear patterns, and something of the graphic clarity in his prints carries over to his oils. During

112. Fitz Hugh Lane. *Ship "Starlight" in the Fog*, 1860. Oil on canvas. 0.762 x 1.270 (30 x 50 in). Butler Institute of American Art, Youngstown, Ohio (see plate 8)

113. Fitz Hugh Lane. *Owl's Head, Penobscot Bay, Maine*, 1862. Oil on canvas. 0.406 x 0.660 (16 x 26 in). Inscribed, on back of canvas: *Owl's Head—Penobscot Bay, by F.H. Lane, 1862*. Museum of Fine Arts, Boston; M. and M. Karolik Collection

the 1840s he had the opportunity, in Boston, of seeing the work of Salmon first hand, as well as most probably Allston's landscapes and the marines by Thomas Birch of Philadelphia. In any case, his early paintings are close to earlier established traditions, indebted to seventeenth-century Dutch and eighteenth-century English art.

A major turning point in Lane's career seems to have come with his first trip to Maine in 1848, when he went to Castine to visit the family of his Gloucester friend, Joseph Stevens. Although Cole and Alvan Fisher had visited Mt. Desert Island earlier in the 1840s, Lane painted on his visit *Twilight on the Kennebec* (private collection), his first response to that wilderness area seen in the burning reds of pigments newly available. Subsequent trips to the Maine coast in the summers of the 1850s led Lane to sketch extensively around Owl's Head at the southern end of Penobscot Bay, the town of Castine on its eastern side, and, further east, Blue Hill and the region around Mt. Desert Island. Two typical paintings from this period are the arresting *Entrance of Somes Sound from Southwest Harbor* of 1852 (fig. 72) and *Salem Harbor* (fig. 111), painted closer to home the following year.

We know Stevens owned a copy of Ruskin's *Modern Painters,* which Lane most likely knew as well.[38] Certainly, these placid scenes by him with their glaring light and painstakingly ordered reflections recall the English critic's instructions:

A piece of calm water always contains a picture in itself, an exquisite reflection of the objects above it. If you give the time necessary to draw these reflections, disturbing them here and there as you see the breeze or current disturb them, you will get the effect of water. . . . The picture in the pool needs nearly as much delicate drawing as the picture above the pool.[39]

By the end of the 1850s Lane's compositions had become more horizontally shaped and designed, and the glowing light earlier pervasive was now focused along the horizon or around the sun directly seen above it. This is true in the paintings *Gloucester Harbor at Sunset* (fig. 34) and *Boston Harbor* (fig. 239), both mid to late 1850s; *Ship "Starlight" in the Fog,* 1860 (fig. 112); and *Christmas Cove, Maine,* 1863 (fig. 35). The presence of the sun in its axial position in several of these later pictures also suggests some awareness on Lane's part of Turner's work, easily brought to his attention through Ruskin's writing.

If we look closely at Lane's handling of the ripples on his water surfaces, with their small intermingled strokes of different colors, Ruskin's detailed passages on color mixing spring to mind:

In distant effects of rich subject, wood, or rippled water, or broken clouds, much may be done by touches or crumbling dashes of rather dry colour, with other colours afterwards put cunningly into the interstices. . . . The process is, in fact, the carrying out of the principle of separate colours to the utmost possible refinement; using atoms of colour in juxtaposition, instead of large spaces.[40]

In the early 1860s Lane undertook a number of paintings which indicate he may have become aware of the work of Heade, who was just at this time beginning to paint not far from Gloucester in the Newburyport and Ipswich marshes. For example, Lane's only known storm subject, *Ships and an Approaching Storm Off Owl's Head, Maine* (fig. 73), dates from 1860 and was a theme that almost obsessed Heade in the next few years. Likewise, two pastoral landscapes rather reminiscent of Heade and quite unusual for Lane, *Riverdale* (Cape Ann Historical Association, Gloucester, Massachusetts) and *Babson and Ellery Houses, Gloucester* (fig. 37), were painted in 1863. Among Lane's most beautiful achievements from his last years are two jewels of mind and soul, *Lumber Schooners at Evening on Penobscot Bay* (1860; fig. 1) and *Owl's Head, Penobscot Bay, Maine* (1862; fig. 113). Thinly painted and delicately colored, these works seem to possess an infinite transparency as our inner and outer vision carries outward to the rosy tints of day's passage.

Consideration of time was a special matter for Lane and luminism. Instead of the more generalized renderings of season to be found in Cole's work— whether in such allegorical works as the Voyage of Life (National Gallery of Art, Washington, D.C.) and the Course of Empire (New-York Historical Society, New York) series, or in observed New England scenery in spring, summer, or autumn—now time is marked to a moment. Color and light match not merely a precise meteorology but appear to stay nature's flux with a poignant yet alluring subtlety. Occasionally, Lane painted more than one version of a particular locale. In some instances there was the promise of additional commissions; more often he became intrigued with viewing a subject at different times of day. The most obvious contrasts were between day and night, as in the records he made—of Half Way Rock, off the Marblehead shore (1850s; collection of George Lewis) and Indian Bar Cove, Brooksville, Maine (1850; collection of Mr. and Mrs. Joseph H. Davenport, Jr., Lookout Mountain, Tennessee). Elsewhere he drew and painted Owl's Head near Rockland, Maine, from various shifting vantage points around the headland.[41] These latter suggest the changes in day and hour as he cumulatively experienced the environment. With the two versions of Norman's Woe we have the even more unobtrusive shifts in late afternoon daylight and tide levels.

The summary series of Lane's career in every respect is that devoted to Brace's Rock, an outreaching ledge off Eastern Point, Gloucester, Massachusetts. In August 1863, he made two pencil drawings of the point, one from each side. The more familiar view looks easterly, and Lane's executor Joseph Stevens noted at the lower corner of the drawing that five versions of the view were painted for different friends (fig. 114). At the same time Lane also made a drawing from the other side of the point, looking westerly, which he entitled *Brace's Cove, Eastern Point* (fig. 115). On this was noted "Painting ordered from the entire sketch by Mrs. S. G. Rogers of Roxbury. Shortly before his death Lane prepared a canvas 22 × 36 for it, and that was all!" The location of this canvas is not known, if it was ever saved, but a smaller oil from this approximate vantage point came to light in 1977.

It is impossible to tell in what order Lane worked on these various drawings

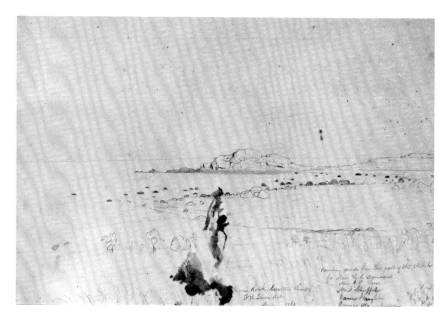

115. Fitz Hugh Lane. *Brace's Cove, Eastern Point*, 1863. Pencil on paper. 0.273 x 0.381 (10¾ x 15 in). Inscribed, l.l.: *F. H. Lane/Aug. 1863*. Cape Ann Historical Association, Gloucester, Massachusetts (not in exhibition)

114. Fitz Hugh Lane. *Brace's Rock*, 1863. Pencil on paper. 0.267 x 0.381 (10½ x 15 in). Inscribed, l.c.: *F. H. Lane del., Aug. 1863*. Cape Ann Historical Association, Gloucester, Massachusetts

and oils. Moreover, one of the views of Brace's Rock, also discovered only in recent years, is but a small oil sketch (fig. 116), and there is no way of knowing if this is one of the five paintings Stevens listed. At present, beyond the little oil sketch there are three finished oils of this view located. Obviously, the drawing was Lane's initial record of the site. It is taken from some distance back on the beach; and while the contours of the protruding rock itself are accurately detailed, the nearer spit of dark rocks is only vaguely delineated. With the oil sketch (a relative rarity for Lane—only a few others are extant), the colors of early morning are added, along with the small beached sailboat. The yellow rays of the sun radiate up from the horizon, bathing the whole with the fresh promise of day.

In the finished oils, all about ten by fifteen inches, Lane has made the crucial change to late afternoon (fig. 117; see also figs. 11, 74, 91, 116). The sun is no longer visible; only a clear light fills the sky before us, while its last pink rays are cast from our right across the top of the rocky outcropping. Other changes have occurred as well. The small boat is now abandoned and wrecked in shallow water, making the human presence more remote than before, whereas the lowered sails in the oil sketch imply recent activity. Like a zoom lens, Lane has moved in closer to the rocky ledges cutting off much of the foreground beach sketched in the initial drawing. Likewise, the nearer spit of dark rocks is more

sharply exposed by the lowered tide (in keeping with the ebbing hour). But this closer finger of rocks is also more solid and perfectly tapered, as if to punctuate the space evenly between Brace's Rock in the background and the beach edge in the foreground. Further, these now equally clear lines of land find a minor echo in the triple points of the bowsprit and broken masts on the boat.

Ruskin's extensive remarks about symmetry, balance, and order seem so apt to the process of composition here that it is hard to believe Lane was not well aware of his ideas:

Symmetry, or the balance of parts or masses in nearly equal opposition, is one of the conditions of treatment under the law of Repetition. For the opposition, in a symmetrical object, is of like things reflecting each other: it is not the balance of contrary natures (like that of day and night), but of like natures or like forms; one side of a leaf being set like the reflection of the other in water.

Symmetry in Nature is, however, never formal nor accurate. . . . [42]

Elsewhere Ruskin comments on other aspects evident in Lane's Brace's Rock series—shadows in shallow water and how they shift according to our changing angle of vision:

When you are drawing shallow or muddy water, you will see shadows on the bottom, or on the surface, continually modifying the reflections. . . . The more you look down

into the water, the better you see objects through it; the more you look along it, the eye being low, the more you see the reflection of objects above it.[43]

Quite probably the final picture in the group is the one in which the masts of the abandoned hull have been turned inward, to carry our vision back into the center and to balance more directly the stretching points of rock opposite. Also, Lane has made a number of minor adjustments in the outlines of the ledges and their complementary reflections mirrored below, to achieve that Ruskinian "living symmetry, the balance of harmonious opposites." In the same way the clumpy foreground rocks are now barer, in echo of the lumpy shape of Brace's Rock beyond, while a tuft of yellow wildflowers angles up across the water's edge as a parallel to the broken masts rising just above the horizon. In short, like some piece of classical chamber music, all components work with individual purity and total clarity. We may summarize Lane's contribution to luminism here as twofold: the near-serial vision evident in his slight shifts of vantage point and moment from image to image, and a structure of nature revealed to be the transcending touch of the first Creator.

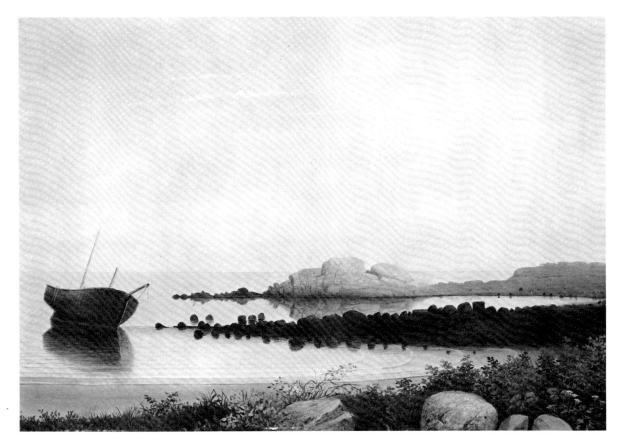

116. Fitz Hugh Lane. *Brace's Rock, Eastern Point*, 1864. Oil on canvas. 0.133 x 0.216 (5¼ x 8½ in). Inscribed, on log: *F.H. Lane*; at l.r.: *F.H. Lane*. The Lano Collection. Photo: Bob Grove (above)

117. Fitz Hugh Lane. *Brace's Rock, Eastern Point, Gloucester*, c. 1864. Oil on canvas. 0.254 x 0.381 (10 x 15 in). Private collection. Photo: Museum of Fine Arts, Boston (not in exhibition; below)

118. John Frederick Kensett. *An Inlet of Long Island Sound*, c. 1865. Oil on canvas. 0.362 x 0.610 (14¼ x 24 in). Inscribed, on rock at l.l.: *F.K.* Los Angeles County Museum of Art; Gift of Colonel and Mrs. William Keighley

119. John Frederick Kensett. *Water Scene, Newport*, 1860s. Oil on canvas. 0.457 x 0.381 (18 x 15 in). Indiana University Art Museum, Bloomington; William Lowe Bryan Memorial

* * * *

Twelve years Lane's junior, John F. Kensett also followed a similar path during his early career, arriving as well by the late fifties at a style of serene and orderly painting. Kensett came from Connecticut and gained his first art experience as an engraver in New Haven. His learning to draw with precision was to imbue his subsequent work with its own clarity of outlined and well-balanced forms. But whereas Lane confined most of his travel to the northern New England coast, Kensett made an early visit to Europe for several years of study and experience. And more like the other younger luminist artists, he continued his artistic excursions back to Europe and across America into the 1870s. At just about the same time that Church was undertaking his twilight series, Kensett painted his own *Sunset, Camel's Hump, Vermont* (fig. 80). Though the relatively enframed tunnel view into the background recalls similar compositions by Cole and Durand that must have been familiar to Kensett, the great care and attention given to the hot ethereal drama is strikingly close to Church's contemporary vision.

By 1859 when Kensett painted his view of Shrewsbury River in New Jersey, he had decisively embraced the strongly lateral panorama of mature luminism (fig. 81). In addition, all sense of a foreground platform is gone, save for a few mossy strips to the side. Our eyes carry quickly across to the bold hill coming down seemingly near the far horizon. In this instance, as with Lane, it is instructive to compare the initial oil sketch with the larger finished canvas. For although the view is clearly identifiable as the same in each, certain crucial refinements are evident as Kensett moved, so to speak, from nature to art. Most obvious are all the sharpened contours. But other distracting bands of marsh grass are gone in the final design. The white and gray sails acquire crisper silhouettes bisecting the shorelines behind. Kensett has also slightly exaggerated the profile of the headland to give it a more commanding presence. Its mirror image in the water is equally strengthened, now smoothly coinciding, rather than messily intersecting, the tuft of marsh grass in the left foreground. Altogether we are again witnessing that luminist process of fusing observation with meditation.

Much the same approach appears in all of Kensett's subjects from this date on, as he virtually discards the dark and narrow woodland interiors associated with Durand and earlier conventions for wider and farther reaching views. In scenes painted around New York we find Kensett consciously giving the viewer a sense of open distance, whether in the uninterrupted foreground of *An Inlet of Long Island Sound* (1865; fig. 118) or the aerial vantage point of *View Near Cozzens Hotel, West Point* (1863; fig. 243). Perhaps his most familiar pictures are those around the beaches and rocky promontories of the Newport, Rhode Island shore, done mostly during the decade of the 1860s. Here we find him selecting variably elevated viewpoints across the coves and water, corre-

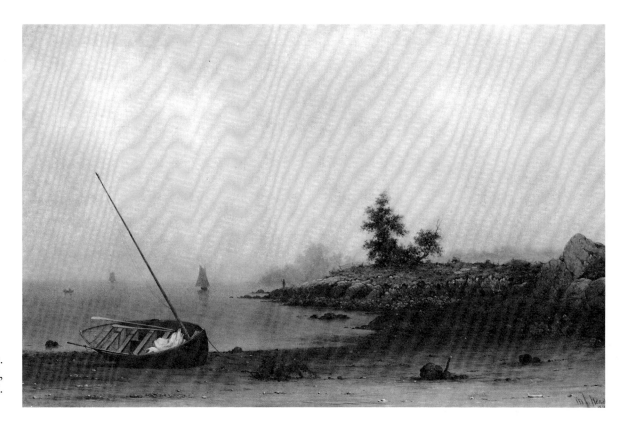

120. Martin Johnson Heade. *The Stranded Boat*, 1863. Oil on canvas. 0.578 x 0.927 (22¾ x 36½ in). Inscribed, l.r.: *M. J. Heade/1863*. Museum of Fine Arts, Boston; M. and M. Karolik Collection

spondingly shifting densities of clear light to hazy atmosphere and subtly changing colors in the water from dark blue to the palest silvery greens.

Kensett painted some subjects such as Beacon Rock in Newport Harbor many times, altering each version with minute changes in tide or horizon level or in intensity or angle of sunlight and with inclusion of minor figural details. In the case of the pair titled *Newport Coast* (fig. 82) and *Beach at Newport* (fig. 2), both c. 1850-1860, there is the obvious addition of figures and rowboat in the latter, but also the altered angle of view to the horizon and different cast of sunlight on the rocks. Newport offered, with other areas of inland and coastal New England (such as Lake George, New York; Cape Ann, Massachusetts; and Mt. Desert, Maine, were others), a special appeal for artists at this time, for recently advancing road and rail transportation were making such attractive places increasingly accessible. The first resort hotels were under construction, and by the seventies the building of summer cottages had proliferated. Consequently, such locales at once possessed pleasing civilized amenities and still untrammeled landscape scenery. In these years joining Kensett at Newport were numerous colleagues: Heade, Worthington Whittredge, James Suydam, W. S. Haseltine, and A. T. Bricher. For the luminists especially, the repeated versions they undertook of one view reveal a characteristic intensity, devoted foremost to defining nature's timeless unity through its momentary fluctuations.

The format of one of Kensett's last pictures, *Eaton's Neck, Long Island* (fig. 83), though it was unfinished at his death in 1872, is one which Martin Johnson Heade made an essential part of his luminist achievements. Heade's art also evolved out of a conceptual tradition related to folk art, for his first art training near his native Lumberville, Pennsylvania, came from the painters Edward and Thomas Hicks. After early travel abroad and in America, Heade turned from portraiture and genre to landscape subjects in the 1850s. These are based on standard Hudson River school formulas, though by the early sixties he had found in the coastal marshes of New England a subject to be of life-long attraction for his brush. First in Newburyport, Ipswich, and Marshfield, Massachusetts, later in New Jersey and Florida, he painted canvas after canvas of the broad, nearly empty wetlands, in varying conditions of light, hour, and atmosphere. Appropriately, these tidal areas, neither wholly landscape nor seascape, whose solidity and direction were always undulating, appealed to this restless and introspective personality.

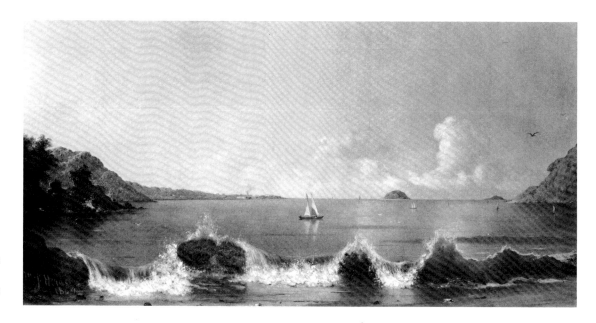

121. Martin Johnson Heade. *Rio de Janeiro Bay*, 1864. Oil on canvas. 0.455 x 0.911 (17⅞ x 35⅞ in). Inscribed, l.l.: *M.J. Heade/1864*. National Gallery of Art, Washington, D.C.; Gift of the Avalon Foundation 1965

Very possibly his path crossed that of Lane's around 1863, as there is stylistic evidence in both painters' work at this time of an apparent exchange of influence between them. For his part, Lane seems to have been newly attracted to pure landscape, as in his *Riverdale* and the *Babson and Ellery Houses, Gloucester* (fig. 37), wherein one is reminded of Heade's pinker, gray-green tonalities and clumpy haystack forms. On the other hand, Heade's *The Stranded Boat* (1863; fig. 120) is similar in composition (albeit quite personal in its wetter atmosphere) to Lane's *Brace's Rock* of the same date (fig. 117). Certainly, the two artists were working not very far apart along Boston's North Shore. One of Heade's earliest dated pictures here is *Sunset on the Newbury Marshes* of 1862 (fig. 76). Paralleling Lane's technique of shifting viewpoints in the Brace's Rock series, Heade undertook a companion painting to his Newburyport scene the next year, now titled *Sunrise on the Marshes* (fig. 77). He has simply moved the pair of trees at the left of the earlier painting to the right hand side of the second picture and turned his gaze around to face the early morning sun. What is singular about these marshland compositions is the attenuated ratio of width to height which Heade introduced. Whether this was in response to the impact of his friend Church's monumental painting *Niagara* (1857; Corcoran Gallery of Art, Washington, D.C.) which boldly stressed such a horizontal format, or to the naturally open character of the terrain is hard to determine with certainty. In any case, it remains the basic format for most of Heade's later treatments of the subject. Among the modulations he does introduce during the 1870s are softer, wetter light effects and correspondingly looser brushwork and textures (see the views on the Marshfield Meadows, fig. 40).

One painting of 1862, *Lake George* (fig. 75), is hauntingly surrealistic and seems to forecast the impending storm scenes Heade would paint over the next few years. The Lake George area attracted at this time numerous other colleagues, including Kensett and David Johnson. The geography of the surrounding mountains, broad inland lake, and cloud-filled sky was to have a continuing appeal as well for photographers, from Seneca Ray Stoddard to Alfred Stieglitz. Heade's pink and blue colors reflect the immediate beauty of this popular wilderness locale. Yet somehow the barrenness of his stony foreground and the dryness of the air seem also to suggest some unseen tension. To what extent that hidden drama might be related to the larger crisis of the nation, then full into civil strife, is a provocative speculation. Whatever was unconscious for Heade in the *Lake George* painting certainly erupted in a powerful group of storm scenes, painted almost entirely near Narragansett in the years between 1859 and 1868. Interestingly, these generally tend to be of storms threatening or just breaking, so we face the almost unbearable and unsustainable strain of a moment between calm and explosion, day turning into artificial night, and earthly geography becoming unworldly.

Closely related were Heade's first South American canvases, also from the middle and later sixties, such as *Rio de Janeiro Bay* (fig. 121; also fig. 122), *South American River* (fig. 25), and *Omotepec Volcano, Nicaragua* (fig. 123), which variously give us visions of wild tropical light, dense, primal jungle, and exploding meteorological drama. One cannot help but wonder if there was not some escapist impulse in these deep excursions into distant heartlands, a flight and pursuit—on the one hand, a search for an expanding American frontier

122. Martin Johnson Heade. *The Harbor at Rio de Janeiro*, 1864. Oil on canvas. 0.467 x 0.848 (18⅜ x 33⅜ in). Inscribed, l.l.: *M.J.Heade/64*. Richard A. Manoogian. Photo: Helga Photo Studio

123. Martin Johnson Heade. *Omotepec Volcano, Nicaragua*, 1867. Oil on canvas. 0.470 x 0.927 (18½ x 36½ in). Inscribed, l.l.: *HEADE '67*. Private collection. Photo: Henry D. Childs (not in exhibition; below)

and, on the other, a withdrawal from turbulence at home. Whatever the explanation, Heade's stormy world was confined to the decade of the Civil War. During the 1870s he returned to vistas of serene and intimate calm, almost abstract in their emptiness (*Becalmed, Long Island Sound*; fig. 249), and even into the eighties continued to indulge in luminist themes long after he had moved on to other subjects and places. The painterly *Great Florida Sunset* (1887; fig. 124) glows with the long-past passion of luminism for those hot cadmium colors, like the smouldering embers of a fire burning into the dawn of a very different day.

Heade's career has numerous echoes in that of Sanford Gifford, the youngest of the classic luminist painters: his love of travel and the exotic, his penchant for the long horizontal composition, and his attempts at hazy afternoon and evening landscapes. Coming from upstate New York, Gifford made frequent excursions to paint throughout the upper Hudson valley and other mountain areas of New England, though he was interrupted by several visits to Europe, first in 1855 and again in 1868. From Thomas Cole he derived many of his compositional formulas, such as the elevated view down a valley or across a mountain range, and from Joseph Turner's art (experienced both through Cole and at first hand abroad) he gained a love of suffused amber light flooding his landscape vistas.

His most derivative subjects are those from the 1840s, when his pictorial designs retained Cole's rather closed-in stages, but gradually during the fifties his views opened out into depth as well as breadth. Sky began to command an increasing ratio of the canvas surface; and by the next decade he was exploring

the full range of sunlight effects throughout the day and evening, along with a brushwork that varied from the precise to the painterly. Some of his river and lake views done along the upper Hudson and in the Adirondacks exhibit the familiar luminist favoring of a sweeping panorama across placid water, delicately balancing bands of light and dark forms in the manner of Kensett. In other instances he selected deep views taken from mountain crests or ridges; among his favorites repeatedly painted were Kaaterskill Falls, the Catskill Mountain House, and Mt. Mansfield, Vermont. And he joined Kensett, Church, and others in exalting the end of day, as in the impressive *Twilight on*

124. Martin Johnson Heade. *Great Florida Sunset,* 1887. Oil on canvas. 1.321 x 2.439 (52 x 96 in). Inscribed, l.r.: *M.J. Heade 1887.* Mrs. Flagler Matthews, The Henry Morrison Flagler Museum, Palm Beach, Florida. Photo: Lee Brian

Hunter Mountain (1866; fig. 85) or the more intimately scaled *Sunset* (1863; fig. 125) and *A Winter Twilight* (1862; fig. 233). With the first we have a picture of almost melancholic desolation. Its date of 1866 reminds us not only of the recent losses the nation had suffered but also of the advancing axe of civilization over nature. Here across the entire foreground are the felled trees of a recently cleared wilderness forest.

This mixture of praise for nature and melancholy for its loss drew Gifford, as it did Church, to the sites of older civilizations in Italy, Greece, and the Near East. Now distance of place and time were fused with the spatial distances of classic luminism. In part the worn and tumbled columns of the Parthenon, as painted both by Gifford and Church, are petrified surrogates for the fallen trees they had recorded in the American wilderness. Church went on to Petra, and Gifford to Egypt, as if in deeper search of renewal amidst the silent heat and light of Western man's most ancient landscapes. It was at this time Gifford painted *Ruins of the Parthenon* (1868; fig. 30), his last major picture. Of his visit he recorded: "I broke my shins among the marble fragments of the Parthenon, and drowned my eyes in the exquisite blue of the Aegean and the lovely hues of the Pentelicus and Hymettus."[44] An appropriate metaphor of the luminist

sensibility, a kneeling figure (probably Gifford himself) measures the marble fragments of the temple in the foreground, thereby fixing both his golden landscape and his place within it. Not long after, he was dead, and the following year a memorial exhibition and catalogue were planned at the Metropolitan Museum. A former colleague had this to say:

Gifford loved the light. His finest impressions were those derived from the landscape when the air is charged with an effulgence of irruptive and glowing light. He has been criticized for painting the sun; for dazzling the eye with the splendors of sunlight verging on extravagance. But is it not a quality of genius, in all the arts, to *verge* on extravagance, and yet remain calm?[45]

This special strain between extravagance and calm marked the culminating glory of the luminist achievement. But it was also a strain that finally cracked the bell jar of its world.

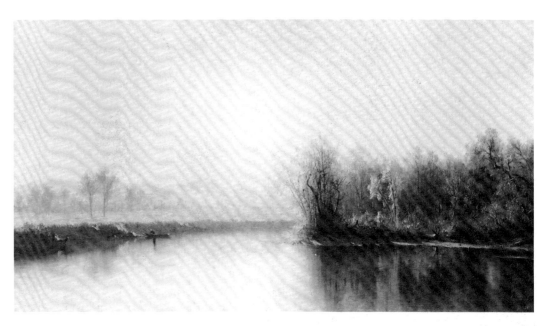

125. Sanford Robinson Gifford. *Sunset*, 1863. Oil on canvas. 0.242 x 0.394 (9½ x 15½ in). Inscribed, l.r.: *S. R. Gifford 1863*. Mr. and Mrs. Erving Wolf. Photo: George M. Cushing (see plate 5)

127. Sanford Robinson Gifford. *Indian Summer on Claverack Creek*, 1868. Oil on canvas. 0.419 x 0.762 (16½ x 30 in). Inscribed, l.l.: *S.R. Gifford;* and on the reverse: *S.R. Gifford pinxit 1868.* Private collection. Photo: Herbert P. Vose (at right)

126. Sanford Robinson Gifford. *The Desert at Siout, Egypt*, 1874. Oil on canvas. 0.533 x 1.016 (21 x 40 in). Inscribed, on back: *S R Gifford 1874.* Jerald Dillon Fessenden. Photo: Herbert P. Vose

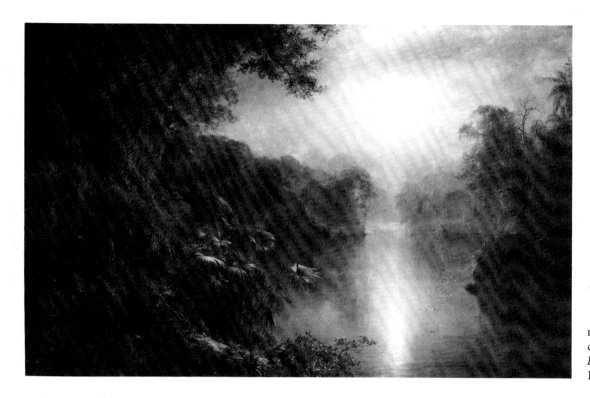

128. Frederic Edwin Church. *Morning in the Tropics,* 1877. Oil on canvas. 1.381 x 2.137 (54³/₈ x 84¹/₈ in). Inscribed, l.r.: *F.E.CHURCH/1877.* National Gallery of Art, Washington, D.C.; Gift of the Avalon Foundation 1965 (not in exhibition)

Frederic Edwin Church and Other Related Figures

The one significant figure integral to any discussion of luminism, Frederic Edwin Church, was never purely a luminist painter. Born in Hartford, Connecticut, he became Thomas Cole's only formal pupil in the mid-1840s, just before the older master's death. As a kind of homage to that important period of apprenticeship, Church painted his own version of *The Ox-Bow* (1844-1846; fig. 19), after Cole's well-known masterpiece now in the Metropolitan Museum. Though all the familiar configurations are present, and the palette a similar pale green-blue, Church's picture pays less attention to the artist surveying the scene from the foreground and more to the overall brightness and freshness of the landscape spreading out beyond. Within the next few years Church made dramatic steps toward an independent personal style, no longer tied to what David Huntington has described as the "Old World" conventions of European landscape painting that included the darker and framed compositions Cole had borrowed from English art. Rather, with his bold rendering in the *Niagara* of 1857 Church importantly altered the shape of American landscape imagery. For in this monumental canvas he deemphasized and destabilized the foreground by sweeping it almost clean of diverting details and by placing the viewer virtually on a platform of rushing water. Further, he suggested a vast unfolding continent over the horizon with clouds rising half into view at our most distant point of vision. Perhaps most influential was his decision to increase the canvas width to more than twice its height, thus stretching the traditional pictorial rectangle for a view of nature. Huntington persuasively argues that all these devices were Church's original response to the particular character of the American wilderness: its purity, force, and expanse. They certainly contributed to the picture's immediate popularity and, with it, the artist's ascendant reputation.

Church did not experiment greatly with this new horizontal format in subsequent paintings, though, as we have seen, it appears to have widely affected the work of others such as Heade and Gifford. He did continue its use regularly in his small oil sketches of light and cloud effects, where the panoramic shape seemed most congenial to capturing expressive sections of sky. He also carried on with the large-scale canvas he had used for *Niagara,* as if increased physical size metaphorically suited both America's literal spaciousness and his own grandeur of vision. *Niagara* relates to luminism only in its structure and moral sense of American nature. It is otherwise too painterly and action-filled, quite distinct from the usually stilled and fixed moments painted

by Heade and his colleagues. Church's great cataract was nonetheless a part of two major wilderness sequences he was pursuing throughout the 1850s and early sixties, one North American and the other South American. Possibly conscious of these contrasting continental polarities, he also alternated within these groups between landscape and seascape, sunrise and sunset, tropical heat and Arctic ice.

The most consistently spectacular is the northern series, which took Church to interior New England and coastal Maine, Grand Manan Island off Canada, and ultimately to the Arctic. Several stimuli may have been at work: the examples of Cole and Lane who had been to Mt. Desert Island, Maine, respectively, in 1844 and 1848. The latter's *Twilight on the Kennebec* was exhibited in New York in 1849. Meanwhile Thoreau began his trips into the Maine woods in 1846 with a voyage to Mt. Katahdin, followed by other ventures to inland lakes and rivers during the mid-fifties. His account of the difficulties of reaching and climbing the great mountain must have presented the painter with an exciting vision to pursue. Among the key pictures in this sequence were, chronologically: *Twilight, "Short Arbiter Twixt Day and Night"* (1850; fig. 205), *Beacon Off Mt. Desert* (1851; fig. 88), *Grand Manan Island, Bay of Fundy* (1852; fig. 53), *Mt. Ktaadn* (1853; fig. 194), *Sunset* (1856; fig. 89), *Twilight in the Wilderness* (1860; fig. 204), *Sunrise Off the Maine Coast* (1863; fig. 214), and *Aurora Borealis* (1865; fig. 190). Generally, the coastal marine pictures face easterly to sunrises, while the inland landscapes look to western sunsets. Some have speculated that Church saw nationalist associations in the western orientation, which all agree culminates with the apocalyptic *Twilight in the Wilderness* of 1860. Yet if we can also consider the allusions of optimistic promise in dawn and melancholy loss in dusk, this complex group could equally illuminate the troubled picture of America in these years.

Manipulation of the brilliant cadmium reds and yellows in many of these paintings to such an intense key is possibly Church's singular contribution to luminism. Basically, he was able to identify their brilliant orchestration with the heroic and sublime nature of the American paradise and thus enlarged the stylistic limits previously characteristic of luminism, namely that vision of "the still small voice" of calm. By setting these pyrotechnics in wilderness locations Church brought the American viewer closer to the awesome presence of the divine hand. At the summit of Katahdin, Thoreau breathlessly exclaimed,

What is this Titan that has possession of me? Talk of mysteries!—Think of our life in nature,—daily to be shown matter, to come in contact with it,—rocks, trees, wind on our cheeks! the *solid* earth! the *actual* world! the *common sense! Contact! Contact!*[46]

Thus while Church's handling of composition and paint only peripherally borders on luminism, the sense of vast stillness verging on an imminent crescendo of light and sound had a profound impact on the movement.

Church made his first excursion to the Arctic north in 1859 along with the Reverend Louis L. Noble, biographer of Thomas Cole. Two years later Noble published their account of the adventure, *After Icebergs with a Painter*, and it was clear that in scenes like *Aurora Borealis* and the recently discovered *Icebergs (The North)* (Pl. 19) the artist felt himself participating in a cosmic experience:

All the sea in that quarter, under the last sunlight, shone like a pavement of amythest, over which all the chariots of the earth might have rolled, and all its cavalry wheeled with ample room. Wonderful to behold! it was only a fair field for the steepled icebergs, a vast metropolis in ice, pearly white and red as roses, glittering in the sunset. Solemn, still, and half-celestial scene! In its presence, cities, tented fields, and fleets dwindled into toys. I said aloud, but low: "The City of God! The sea of glass! the plains of heaven!"[47]

If Thoreau's naturalist writings served as the prophetic context for Church's pilgrimages in northern terrains, then the explorations of the natural scientist Alexander von Humboldt provided a strong stimulus for Church to follow in probing the scenic grandeur of South America. Humboldt had made a number of pioneering trips through the northwestern mountain ranges of that continent at the beginning of the nineteenth century, and Church owned several volumes of Humboldt's books about the region. In addition, Turner's art offered those radiant precedents of centrally illuminating eruptions of sunlight, which Church was to adapt to his huge South American canvases, exemplified by *Andes of Ecuador* (1855; fig. 186), *Cotopaxi* (1863; fig. 225), and *Morning in the Tropics* (1877; fig. 128). Again, we find Church fascinated with sunrise and sunset as cyclical components in this cosmic theater. Here one might stand as a newborn American witnessing the very unfolding of natural history through the first passages of Genesis itself.

Church was so attuned to the original vision of his day that he was one of the first to sense the subtle but marked shifts in artistic taste following the Civil War. He himself largely gave up painting in the 1870s and turned rather to the creation of his own literal world of nature, history, and art in the building and landscaping of his house, Olana, at Hudson, New York. But, like Gifford at the end of his painting career, he undertook to depict the great inspirational ruins of the ancient past in eastern Europe. Ironically, although the clear light of luminist order and design bathes the standing remains of *The Parthenon* (1871; fig. 29), fully the lower half of the picture is darkened by a broad advancing shadow. The shining sun is also setting.

* * * *

Beyond Church there are a large number of other painters whose work borders on the luminist style in varying aspects or degrees. Some, familiar names in the pantheon of the later Hudson River school, only painted partially luminist pictures; others are simply lesser figures either not so original in vision or able in technique as the core group discussed here; still others are close to totally unknown, producing the rare work of surprising luminist qualities.

Works on the edge of luminism include those by Jasper Cropsey, Albert Bierstadt, and Worthington Whittredge—all contemporaries of Church, Heade, and Gifford—who took up certain basic luminist subjects and

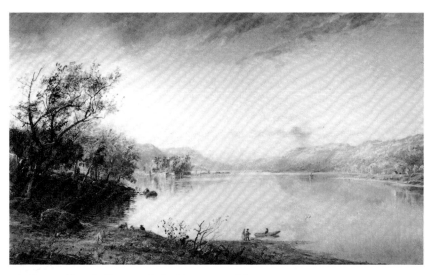

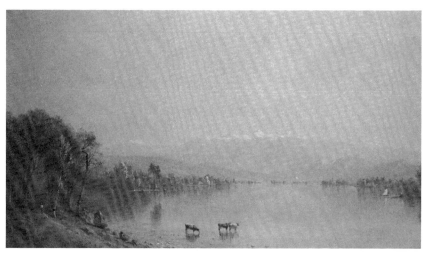

130. Jasper Francis Cropsey. *Lake George,* 1871. Oil on canvas. 0.508 x 0.838 (20 x 33 in). Inscribed, l.r.: *J.F. Cropsey/1871.* The New-York Historical Society, New York

131. Jasper Francis Cropsey. *Mt. Washington from Lake Sebago, Maine,* 1871. Oil on canvas. 0.407 x 0.762 (16 x 30 in). Inscribed, l.l.: *J F Cropsey/1871.* The Mint Museum of Art, Charlotte, North Carolina

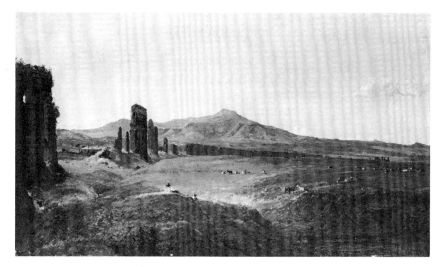

129. Jasper Francis Cropsey. *Italian Campagna,* 1848. Oil on paper mounted on canvas. 0.241 x 0.406 (9½ x 16 in). Inscribed, l.r.: *ROME J.F. Cropsey 1848.* Mrs. H. Brown Reinhardt, Newark, Delaware. Photo: William D. Pugh

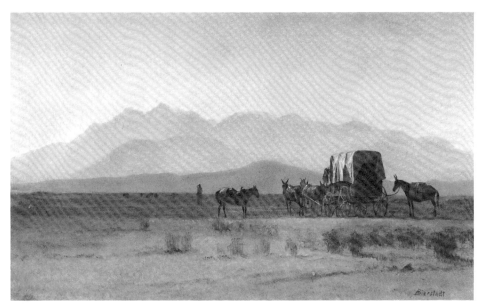

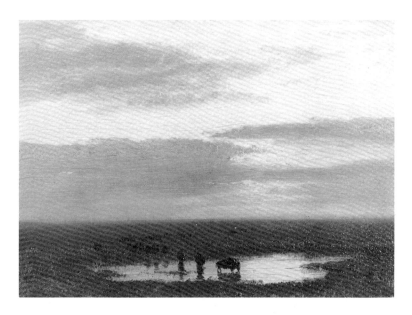

132. Albert Bierstadt. *Surveyor's Wagon in the Rockies,* probably 1858. Oil on paper mounted on canvas. 0.197 x 0.327 (7¾ x 12⅞ in). Inscribed, l.r.: *ABierstadt* (*AB* is in monogram). The St. Louis Art Museum; Gift of J. Lionberger Davis 158:1953

133. Albert Bierstadt. *Buffaloes on the Prairie,* 1881. Oil on board. 0.140 x 0.200 (5½ x 8 in). Inscribed, l.l.: *AB 1881 AB* (*AB* is in monogram). Collection of Dr. and Mrs. M. S. Mickiewicz (see plate 28)

methods. Cropsey's style emerged from its early indebtedness to Cole and, paralleling the direction of many colleagues, moved toward more open and light-filled compositions around mid-century. In *Bareford Mountains, West Milford, New Jersey* (fig. 302) of 1850 we recognize the crisp drawing, clear light, and horizontal space related to luminist thinking. Also fairly early, Cropsey painted the Italian *campagna* in Cole's footsteps, but with even greater attention to the glowing ambience of atmospheric light (fig. 129). With his *Evening at Paestum* (1856; fig. 27), of course, we come to that central theme articulated by Church and Gifford. Later in the seventies Cropsey expanded his formats further, painting extensively throughout upper New York and New England. His views of *Lake George* (1871; fig. 130) and *Mt. Washington from Lake Sebago, Maine* (1871; fig. 131), are typical in holding over from Cole's generation such devices as the genre details and framing trees to the side in the foreground, while drawing our principal attention to the bathing haze, tinted skies, and quiet reflections occupying most of the view.

By contrast, Bierstadt became Church's great rival during their maturity and painted similar pictorial machines of enormous size and bombastic effect. German by birth, he grew up in New Bedford, Massachusetts, and made several return trips for study abroad. Familiar with the European landscape and with its artistic traditions, especially the influential training of the Düsseldorf school, Bierstadt developed a style emphasizing meticulous draftsmanship, strong local coloring, and often melodramatic effects. At his best he put

these elements to powerful use in the many western landscapes he did deriving from his various travels across the American plains and Rocky Mountains to the west coast.

Interestingly, one of his first major works employing a luminist sensibility was a specific Civil War subject, *The Bombardment of Fort Sumter* (1861; fig. 301). With its aerial point of view, sharp uninterrupted horizon line, and crystal clear sunlight, the painting suppresses the narrative action in the background in favor of this outwardly serene environment. From his western trips came his small study of the *Surveyor's Wagon in the Rockies* (probably 1858; fig. 132); its empty foreground belongs to the space of luminism, while its subject lends an appropriate metaphor for its stylistic process. One reason luminism so suited exploration painting and photography was that it was literally involved in the measurement of landscape. But Bierstadt was also capable of exploiting, to highly expressive ends, the vivid reds of luminist sunsets, as is evident in both his small oil sketch and larger finished canvases of buffaloes on the prairie (figs. 133-135). These stand as partial responses to Church's eastern paintings but carry similar exclamations of nationalist feeling about the endless western plains.

When Bierstadt got to the western mountains, he found it natural to position himself in elevated vantage points, as in the *View from the Wind River Mountains, Wyoming* (1860; fig. 136). The general composition reverts back more to older Hudson River school conventions, although its gold haze across the distance belongs to luminism. Entering the Yosemite Valley elicited from

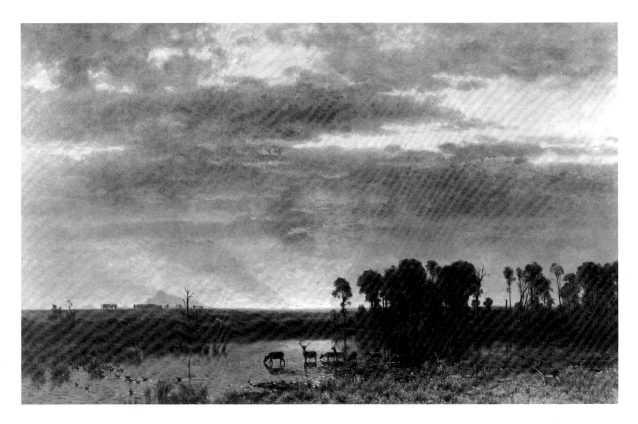

134. Albert Bierstadt. *Sunset on the Prairie,* 1861. Oil on canvas. 0.686 x 1.117 (27 x 44 in). Inscribed, l.r.: *A. Bierstadt, 1861.* Private collection. Photo: Herbert P. Vose

Bierstadt the same reverential sentiments Church experienced in the Arctic seas. His friend Fitz Hugh Ludlow described their conviction of "going to the original site of the Garden of Eden"; heroically attempting to measure the stunning distances of earth and mountains, he admitted, "When Nature's lightning hits a man fair and square, it splits his yardstick."[48] Moving up and down the valley, Bierstadt set down numerous views on the spot and later, in gigantic canvases in his studio, of the valley from sunrise to sunset. Ludlow spoke for him with a similar language of heightened metaphor and celebration:

There lies a sweep of emerald grass turned to chrysoprase by the slant-beamed sun— chrysoprase beautiful enough to have been the tenth foundation-stone of John's apocalyptic heaven. Broad and fair just beneath us, it narrows to a little strait of green between the butments that uplift the giant domes. Far to the westward, widening more and more, it opens into the bosom of great mountain-ranges,—into a field of perfect light, misty by its own excess,—into an unspeakable suffusion of glory created from the phoenixpile of the dying sun.[49]

Bierstadt followed other luminist impulses in seeking subjects in Italy and in portraying the melodrama of a thunderstorm. Yet while the central and spiritual presence of light places many of his pictures close to pure luminism, his treatment of nature in resounding movement is outside its classic and orderly harmonies. Certainly the turbulent theme of his *Storm in the Mountains* (c. 1870-1880; fig. 58) at once recalls Heade's Newport sequence but has none of the luminist sense of time suspended, even as Heade strains it with the black *horror vacui* of impending doom. Bierstadt's light and storm have exploded out of luminism's control.

* * * *

William Bradford was a neighbor and friend of Bierstadt's in New Bedford and pursued some of the same themes as a result of the association. Lane's work was another early influence, as was the presence in the area during the mid-1850s of the Dutch-trained painter Albert Van Beest. On the one hand, Lane gave him an example of careful drawing and precise compositions, while Van Beest on the other introduced a Dutch sensibility for low horizons and dense atmospheric skies. Although Bradford later followed in Bierstadt's footsteps out west to paint a sunset in the Yosemite Valley, a view of Mt. Shasta, and a few

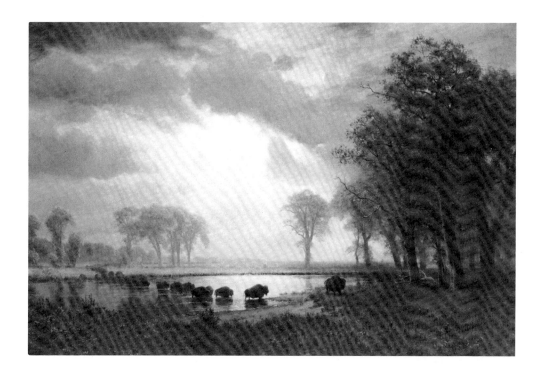

135. Albert Bierstadt. *The Buffalo Trail*, 1867-1868. Oil on canvas. 0.813 x 1.220 (32 x 48 in). Inscribed, l.r.: *ABierstadt* (*AB* is in monogram). Museum of Fine Arts, Boston; M. and M. Karolik Collection

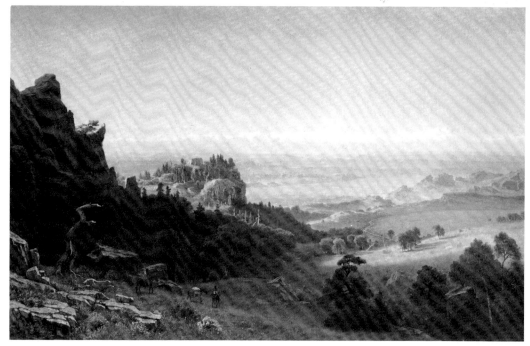

136. Albert Bierstadt. *View from the Wind River Mountains, Wyoming*, 1860. Oil on canvas. 0.768 x 1.226 (30¼ x 48¼ in). Inscribed, l.l.: *A Bierstadt 1860* (*AB* is in monogram). Museum of Fine Arts, Boston; M. and M. Karolik Collection

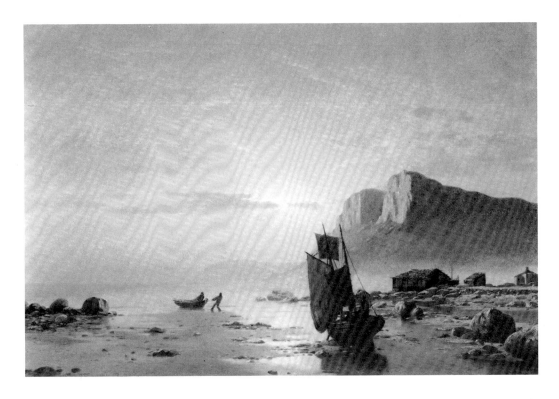

137. William Bradford. *Coast of Labrador,* 1866. Oil on canvas. 0.508 x 0.762 (20 x 30 in). Inscribed, l.r.: *Wm Bradford 1866.* Collection of The High Museum of Art, Atlanta; Gift of Mr. and Mrs. Frank L. Burns, 1977.1. Photo: Jerome Drown

138. William Bradford. *Labrador Coast,* c. 1860. Oil on canvas. 0.406 x 0.765 (18¹/₁₆ x 30⅛ in). Inscribed, l.r.: *Wm. Bradford.* The Cleveland Museum of Art; Purchase, Mr. and Mrs. William H. Marlatt Fund (see plate 21)

other Western landscapes, his real love of travel found fullest expression in several long summer expeditions to the Arctic. These began in the mid-fifties and culminated with an ambitious voyage in 1869, documented in a large folio publication with over a hundred illustrative photographs.

Generally, Bradford's earlier views—such as *Fishermen's Homes, Near Cape St. Johns, Coast of Labrador* of 1876 (fig. 52) and *Coast of Labrador* from the sixties (fig. 137; see also fig. 138) and *Arctic Scene* of 1870 (fig. 139)—are characterized by precise detailing, controlled alterations of dark and light forms, cool light reflections, and pale green-blue tonalities. *Cape St. Johns* is particularly appealing for its glint of light running along a brief edge of the horizon. Bradford's weakness was in repeating himself so often in later years that some works simply become formula pieces. He also devoted much attention in that latter part of his career to Arctic photography. In his paintings of the 1870s and eighties he turned increasingly to daring and sometimes effusive light and color effects. The strangely refracted and reflected sunlight in the polar summer created wondrous luminist environments. In the paintings of icebergs alone he caught surreal combinations of intense greens and blues tinting the otherwise white ice and atmosphere. By contrast, *Ice Dwellers Watching the Invaders* (c. 1870; fig. 56) pushes beyond the extremes of light and dark in Church's *Cotopaxi* with its hot orange sunset across the frigid floes. There are further comparisons

139. William Bradford. *Arctic Scene,* 1870. Oil on canvas. 0.489 x 0.902 (19¼ x 35½ in). Inscribed, l.r.: *Wm Bradford.* Indiana University Art Museum, Bloomington. Photo: Ken Strothman

intended between man and nature, embodied in the image of the "machine in the garden." As the title implies, this is in part an invasion of the steam engine and its black smoke into the white purity of this ultimate earthly wilderness. As with Bierstadt, it is the morality in nature as expressed through light in such Bradford paintings which make them relevant to a discussion of luminism.

Likewise, in a way parallel to Bierstadt, certain works by the Hudson River school painter Worthington Whittredge deserve attention here. In two areas especially—the Newport shore and the Colorado plains—he found subjects naturally suited to the luminist style. His painting *Second Beach, Newport* (1870s-1880s; fig. 140) possesses the flat open luminist structure, though the rather loose handling of paint and details, along with the motion of shallow waves and fair-weather clouds, is not truly luminist in character. More fully typical of the style are the various views he undertook overlooking the distant shoreline beaches from the rolling hills above, known by such titles as *Old Homestead by the Sea* (see fig. 141). Standing on elevated ground, we glance out through warm hazy light to expanding fields and ocean. At the farthest point of sight in the center of the canvas is the ruler straight horizon, a line we feel is at the juncture not merely of earth and sky but of the finite seen and transcendent unseen.

When Whittredge got to the western plains and mountains, he responded similarly to the expansive views all around him. Known in several versions is the scene *Crossing the Ford, Platte River, Colorado* (see figs. 142 and 259). He had spent the entire decade of the 1850s in Europe, traveling with fellow artists and studying at Düsseldorf. Now seeing the western spaces of America, he identified the awesome breadth as a distinctive feature of the national landscape, physically and mentally:

I had been accustomed to measure grandeur, at the most, by the little hills of Western Virginia; I had never thought it might be measured horizontally as on our great Western plains. In fact, I believe it is the accepted idea that all grandeur *must* be measured up and down. . . .

Often on reaching an elevation we had a remarkable view of the great plains. Due to the curvature of the earth, no definite horizon was visible, the whole line melting away, even in that clear atmosphere, into mere air. I had never seen any effect like it, and it was another proof of the vastness and impressiveness of the plains.[50]

For all the stilled light throughout and open water in the foreground, however, the towering screen of trees establishes attention in the middle ground thus modifying the luminist aspects of his work.

The Newport shore and adjacent Narragansett Bay area also attracted in the 1870s painters like Alfred Thompson Bricher, William Trost Richards, and Francis A. Silva, who devoted almost their full careers to recording coastal

140. Thomas Worthington Whittredge. *Second Beach, Newport,* c. 1870s-1880s. Oil on canvas. 0.775 x 1.277 (30½ x 50¼ in). Inscribed, l.l.: *W. Whittredge.* Collection, Walker Art Center, Minneapolis; Gift of the T. B. Walker Foundation

141. Thomas Worthington Whittredge. *Old Homestead by the Sea,* 1883. Oil on canvas. 0.559 x 0.812 (22 x 32 in). Inscribed, l.l.: *W. Whittredge 1883.* Museum of Fine Arts, Boston; M. and M. Karolik Collection

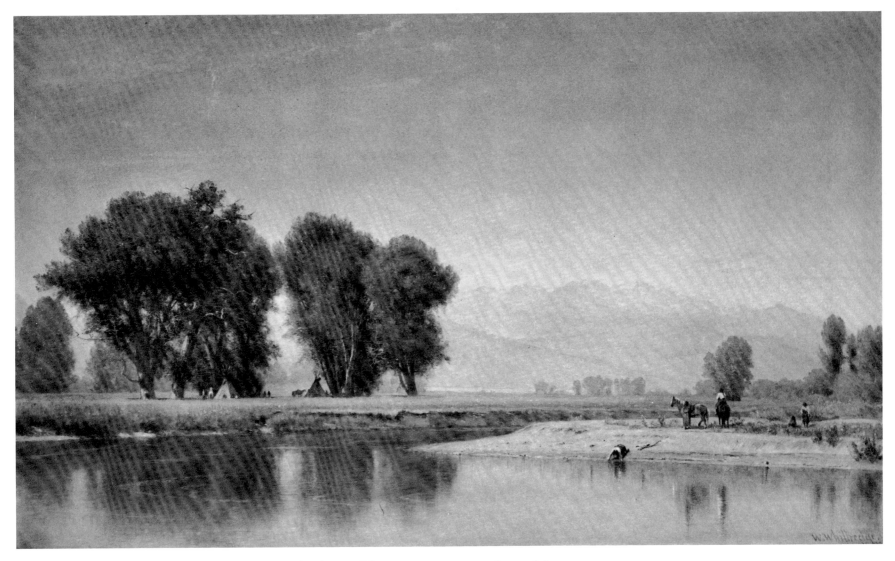

142. Thomas Worthington Whittredge. *On the Plains, Colorado,* 1877. Oil on canvas. 0.762 x 1.270 (30 x 50 in).
Inscribed, l.r.: *W. Whittredge 1877.* St. Johnsbury Athenaeum, Inc., St. Johnsbury, Vermont

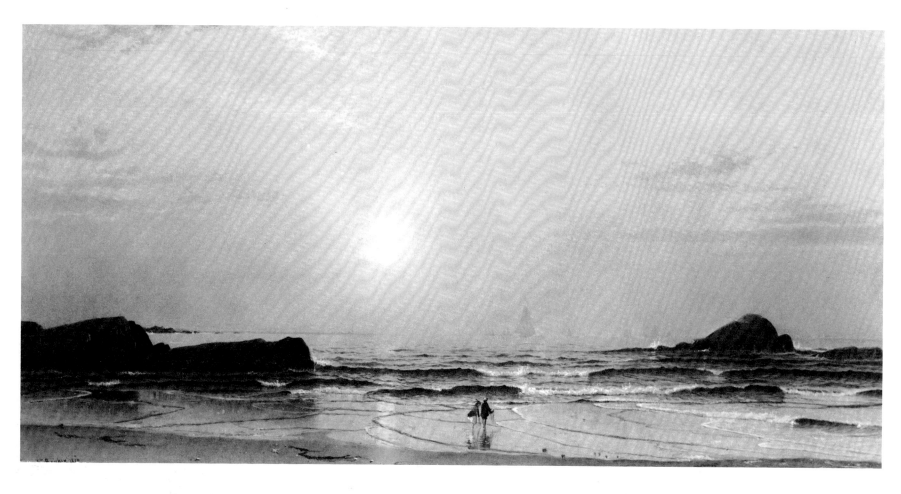

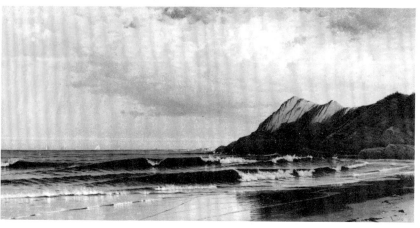

143. Alfred Thompson Bricher. *Narragansett Beach—The Turn of the Tide*, 1870 (?). Oil on canvas. 0.508 x 1.016 (20 x 40 in). Inscribed, l.l.: *A T Bricher 1870* (?). Mr. and Mrs. Stephen G. Henry, Jr., Baton Rouge, Louisiana. Photo: Herbert P. Vose

144. Alfred Thompson Bricher. *Time and Tide*, c. 1873. Oil on canvas. 0.639 x 1.277 (25$\frac{1}{8}$ x 50$\frac{1}{4}$ in). Inscribed, l.l.: *ATBRICHER (ATB* is in monogram). Dallas Museum of Fine Arts; Foundation for the Arts Collection, Gift of Mr. and Mrs. Frederick M. Mayer. Photo: Bill J. Strehorn (at left; see also plate 30)

145. Francis A. Silva. *Indian Rock, Narragansett Bay*, 1872. Oil on canvas. 0.502 x 0.902 (19$\frac{3}{4}$ x 35$\frac{1}{2}$ in). Inscribed, l.r.: *F.A. SILVA. 72.* Mr. and Mrs. Erving Wolf (opposite page)

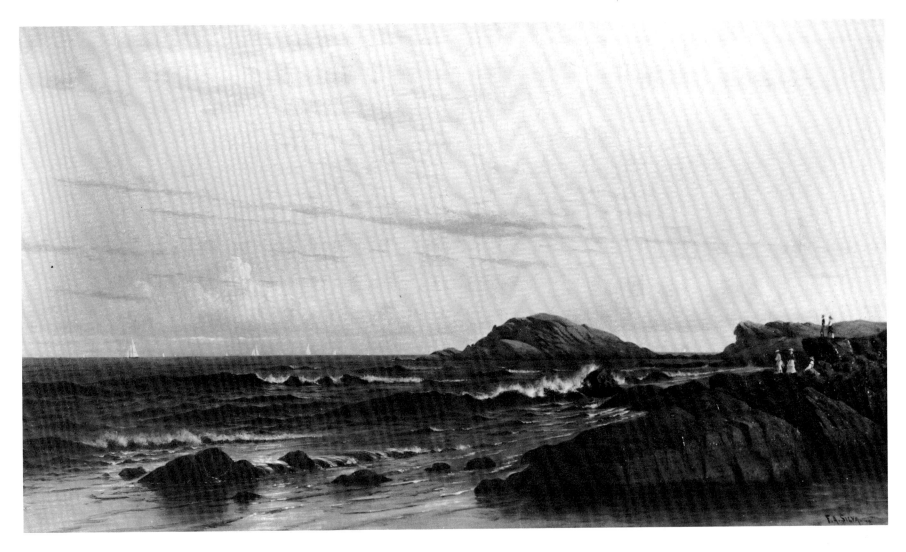

marine scenes. Often not as original or varied as the major figures of the later Hudson River school or of the luminist movement, they nonetheless produced a number of memorable and strong images. Bricher was fully capable of lovely luminist effects in insistently lateral beach views looking out on Narragansett Bay (fig. 143), some with a hazy sun dominating the axis of the composition, others with only a glare of light flooding along the horizon's edge. He selected similar motifs on the New Hampshire beaches at Little Boar's Head, and in the later 1870s he was inspired to execute some eloquent luminist oils at Grand Manan Island off Canada. In a manner reminiscent of Kensett, he contrasts the bold headlands on one side with the glassy expanses of water on the other (fig.

144). In *Morning at Grand Manan* (1878; fig. 55) we further recognize luminism's discovery of intense golden colors, given focal order by the molten sun.

The same general format preoccupied Francis A. Silva and James Hamilton. Neither is a major talent, yet each was occasionally capable of approaching the quality of the leading luminists. Silva painted extensively around the Narragansett Bay area, often carrying Bricher's formulas to excess. He did paint a noteworthy view of *Indian Rock, Narragansett Bay* in 1872 (fig. 145), seen from the opposite direction of the vantage point Bricher chose for an oil done at the same time. This was a popular rocky promontory for artists; William S.

146. William Stanley Haseltine. *Castle Rock, Nahant*, 1865. Oil on canvas. 0.610 x 0.965 (24 x 38 in). Inscribed, l.r.: *W.S. Haseltine/1865*. The Corcoran Gallery of Art, Washington, D.C.

Haseltine joined the group sketching there and made his own painting the same year. James Hamilton preferred to paint empty stretches of beach with breaking waves, devoid of such identifiable headlands. Usually his crashing breakers intimate too much noise and activity to belong within the restrained confinements of luminism, but he frequently relished stressing the long reflections of sunset or moonlight crossing great stretches of water.

Somewhat different variants of these coastal subjects, so appealing to the luminist mind, appear in the work of W. S. Haseltine and William Trost Richards. Both were highly able draftsmen and took special pleasure in recording the rock faces of bold headlands and promontories. Haseltine is best known for his many pictures done along the Massachusetts coast just north of Boston at Nahant. As we look at several of his works together, we become aware of a process similar to that explored by Lane and Heade, namely, the methodical movement of the angle of vision step by step up and down and across an intentionally limited terrain. Like Bierstadt, too, Haseltine found Italian light and water to offer similarly compelling views, most notably at Capri. For his part, Richards' work offers us such sparkling small gems as his *Lighthouse on Cape Cod* (1865; fig. 60), a perfect exemplar of infinite luminist tranquillity. His Newport marines make interesting comparisons with the contemporaneous examples of Whittredge, Kensett, and Bricher already mentioned. Likewise,

his coastal panoramas at New Jersey and his geological studies of rising cliffs in the 1880s invite scrutiny with Haseltine's sequences at Nahant (see figs. 146-147).

Luminism was a widespread phenomenon, finding idiosyncratic expression in the occasional picture of other painters known better for their places in the mainstream of the Hudson River school. Certainly, Samuel Colman's *Storm King on the Hudson* (1866; fig. 148) possesses powerful luminist elements: the impending storm clouds, the relatively still plane of water, and the focusing of attention deep into the expanding horizon. William Hart, generally considered a second-level artist in the school, still could produce the utterly peaceful landscape of rolling green meadows quite equal to Kensett's work. And in *Across the Marshes* (c. 1877; fig. 149) by the little-known Frederick DeBourg Richards, we have a luminist work of surprising beauty and quality. At once obviously recalling the green wetlands of Heade's art, this also has its own personal note in the dazzling red flowers dotted across this watery prospect. We may see yet further evidence of luminist elements appearing in other less familiar figures and areas of the country. For instance, hazy light and wet atmospheric effects often dominate the oils of Louis Henry Mignot, Norton Bush (a follower of Church), Joseph R. Meeker, and Richard Clague—the latter two working principally along the gulf coast of Louisiana and Miss-

147. William Stanley Haseltine. *Rocks at Nahant, Massachusetts*, 1864. Oil on canvas. 0.559 x 1.016 (22 x 40 in). Inscribed, l.l.: *W.S. Haseltine/1864*. The Lano Collection. Photo: Washburn Gallery

148. Samuel Colman. *Storm King on the Hudson*, 1866. Oil on linen. 0.816 x 1.520 (32⅛ x 59⅞ in). Inscribed, l.r.: *S.Colman, 66*. The National Collection of Fine Arts, Smithsonian Institution, Washington, D.C.; Gift of John Gellatly

149. Frederick DeBourg Richards. *Across the Marshes,* c. 1877. Oil on canvas. 0.365 x 0.724 (14³/₈ x 28¹/₂ in). Inscribed, l.r.: *F.DeB. Richards.* Private collection. Photo: Helga Photo Studio (see plate 26)

150. Anonymous. *Meditation by the Sea,* c. 1860. Oil on canvas. 0.343 x 0.495 (13¹/₂ x 19¹/₂ in). After an engraving illustrated in *Harper's monthly, 21* (1860): 450. Museum of Fine Arts, Boston; M. and M. Karolik Collection

issippi. Luminism as a style elsewhere reached over the boundaries of folk art, as may be seen in the somewhat crude but silvery-gray beach scenes of James A. Suydam and in the outright primitive painting of *Meditation by the Sea* by an unknown artist (c. 1860; fig. 150). For all its unique charm, this little work shares with luminism that almost surreal emptiness, here reinforced by the razor line of the horizon, let alone its title, which reminds us that once again we are in the presence of intensely thoughtful landscapes.

Graphic Arts

Occupying narrower but very important corners of the luminist world are its drawings, watercolors, and photography. In the former we secure our first glimpse of the artist's receiving and interpreting eye. The luminist process is usually at work on a more intimate and hesitant scale, offering the preliminary lines of structures to be illuminated more fully in larger, finished forms. It is clear that even without color, most luminist drawings are still sensitive to suggesting precise nuances of light, whether it models form, falls in reflections across water, or suggests spacious passages of earth and sky. In terms of design we find the familiar emphasis on strongly horizontal formats with the foreground usually open.

Lane was the most indifferent draftsman of the major luminists. Probably because he was partially crippled in his legs, getting around was not easy and prompted him to carry the least cumbersome equipment he could. His draw-

ings seldom have the refinement or assurance of his mature oils. Sketching for him was a process essentially of recording the outlines of coastal features, plus occasional shading to suggest textures or tonal contrasts he might amplify in his paintings. Only in a few instances did he add passages of watercolor to his initial drawings; more often he simply made notes on details or areas he knew should have specific colors in the subsequent oils. In this regard we may speculate again about his awareness of Ruskin's criticism. For in the *Elements of Drawing* are a number of advisory passages which seem directly relevant to Lane's way of working: "It is best to get into the habit of considering the coloured work merely as supplementary to your other studies; making your careful drawings first, and then a coloured memorandum separately."[51]

Two aspects especially about Lane's drawings are basic to luminism: his frequent practice of taping together, horizontally, sheets from his sketchbook so to extend his lateral record of a shoreline, and his less usual method of ruling the paper off into mathematically calculated quadrants so to place objects in space with exactitude. For him it was initially important to define both observed and pictorial space, such that the world he saw as well as interpreted would have an ultimate order among its parts and harmony in its whole. That he usually reserved the subtle delineation of light and color for execution in the

studio confirms that the atmospheric ambiences of his paintings are truly distilled by acts of memory and recollection.

By comparison, the drawings of Heade are quite different in numerous ways. There are a few small sketchbooks known with several dozen generally slight pencil drawings, but these are mostly quite notational and seldom display noteworthy luminist qualities. More remarkable are the larger charcoal drawings, numbering nearly a dozen and on the average, measuring eleven by twenty-two inches. They appear to be a singular group: most depict the Newburyport marshes in charcoal and chalks, and together they form an unusually close sequence of a carefully circumscribed and identifiable locale. No other such series is known in his career, which suggests that these were deeply related to his major period of luminist subjects and working methods.

In the marsh group specifically there is one early small watercolor with the primary features carried through the rest. We view along the marsh river to a sailboat in the middle distance, with salt haystacks placed to either side, all just about intersecting the horizon like notes on a sheet of music paper or columns observing *entasis* in a classical Greek temple. Following this preliminary sketch, Heade continued the same view on larger sheets of tan paper with pencil and charcoal and finally on darker paper with yet stronger, blacker charcoal and highlights of white gouache. In what are obviously the final drawings in the series, an arc of ducks descends from the sky, and the loom of a distant lighthouse is visible at the horizon. With the lines of shadows cast by the haystacks in an earlier drawing falling across the page from right to left and then reversed in later works, Heade was systematically capturing the shifts in light from morning to afternoon and lastly in the darker views, to twilight.

But where Lane was largely interested in outline, Heade cared far more about modeling solid forms and palpable space. As with the Brace's Rock group, he was also seeking to focus a serial vision on a fixed quadrant of landscape, as light and mood shifted by the hour (figs. 41, 42, 78). At the same time these are not photographic records, for the luminist pictorial processes were at work on more than observed phenomena. Heade selectively eliminated haystacks unnecessary to his increasingly pure design as he moved from version to version. The foreground contours of the river become gradually equalized, and the line of ducks, first loose in appearance, changes to a gentle arc mirroring the river's edge below. A second sailboat introduced in an earlier drawing likewise disappears as unessential. Finally, the flat linear wisps of clouds acquire greater tightness of shape and placement in the last image (presumably that in the Karolik Collection, Museum of Fine Arts, Boston). Provoked, one wonders if the final linking of the central cloud with the mast of the sailboat in the form of an unobtrusive cross did not perfectly suit the underlying spiritual content of much luminist art.[52]

David Johnston Kennedy's eerie moonlight coastal scenes, done along Delaware Bay (see fig. 151), and Bradford's Labrador watercolor (fig. 152) contain something of Heade's surreal tonalism. In all cases the horizon line is very low,

151. David Johnston Kennedy. *Ship Ashore on the Atlantic Beach*, 1876. Watercolor. 0.232 x 0.391 (9⅛ x 15⅜ in). Inscribed, l.l.: *D.J.Kennedy/1876*; on back: *Ship Ashore on the Atlantic beach./October 20th 1876/by D.J.Kennedy Philada*. Private collection. Photo: Helga Photo Studio

152. William Bradford. *Repairing the Fishing Lugger*, 1862. Wash drawing on paper. 0.245 x 0.442 (9⅝ x 17⅞ in). Inscribed, l.r.: *Wᵐ Bradford/1862*. Private collection. Photo: Helga Photo Studio

153. Sanford Robinson Gifford. *Shelburne, New Hampshire,* July 30, 1859. Pencil on paper heightened with white. 0.152 x 0.235 (6 x 9¼ in). Inscribed, l.c.: *Shelburne—July 30th 59—*. Vassar College Art Gallery, Poughkeepsie, New York

154. William Trost Richards. *Coastal Scene,* c. 1882. Pencil on sketchbook page. 0.127 x 0.200 (5 x 7⅞ in). The Brooklyn Museum, New York; Gift of Miss Edith Ballinger Price

and the orange moon or sun sits weightily within the bottom half of the composition. Both Bradford and Kennedy (even with the latter using some touches of intense color) rely foremost on strong oppositions of light and dark for expressive effect. The calculated choice of paper darker than white or off-white, such as tan or blue, with details heightened in white wash, was one way of approaching coloristic effects in luminist drawings by tonal means alone. Thus, in William Hart's sketches of the White Mountains we can see such uses of white chalk and gouache for his passages of sunset. Although his compositions are not particularly luminist in layout, these light effects do approximate the brilliance and character of the red pigments in Church's major canvases.

When we turn to Gifford's body of drawings, we may discern various ingredients of luminism at work: the aerial view *(Palmer Hill, Catskill Mountains,* 1849, fig. 269; and *View at Lake George,* 1848, fig. 276), the panoramic format expanded by employing two adjacent sketch sheets together as one (see the 1868 Sketchbook, Brooklyn Museum, New York), and the entire foreground given to a glassy water surface *(Adirondacks,* 1866, fig. 272; *Lago d'Orta,* 1868, fig. 268; and *Shelburne, New Hampshire,* 1859, fig. 153). The same lateral sweep and attenuated format are present in Whittredge's infrequent luminist drawings, such as the *View from Mr. Field's Farm at Newport* (c. 1859, fig. 299), in the unusual early sketch of *New York at the Entrance of the Hudson from Hoboken* (1846; fig. 300) by L. R. Mignot, and in the evocative double view of

155. William Trost Richards. *Paradise, Newport,* 1877. Gouache on gray paper. 0.584 x 0.940 (23 x 37 in). Inscribed, l.r.: *Wm. T. Richards, 1877.* National Gallery of Art, Washington, D.C.; Adolph Caspar Miller Fund and Pepita Milmore Memorial Fund, 1979 (see plate 25)

156. William Trost Richards. *Paradise Valley, Newport,* 1882. Gouache on paper. 0.559 x 0.915 (22 x 36 in). Inscribed, l.l.:
W^m T. Richards. 1882. The Board of Governors of the Federal Reserve System, Washington, D.C. Photo: eeva-inkeri

158. Homer Dodge Martin. *Landscape, Fort Ann,* 1861. Pencil on paper. 0.219 x 0.299 (8⅝ x 11¾ in). Inscribed, l.r.: *Fort Ann Aug. 27-61.* The Art Museum, Princeton University, Princeton, New Jersey; Frank Jewett Mather, Jr., Collection

157. Homer Dodge Martin. *Landscape, Mt. Marino,* 1860. Pencil on white wove paper. 0.254 x 0.340 (10 x 13⅜ in). Inscribed, l.c.: *Mt Marino Oct 16 1860.* Cooper-Hewitt Museum, New York, The Smithsonian Institution's National Museum of Design

Lake George (1858; fig. 275) by Aaron Draper Shattuck. The pencil drawings by Haseltine, Richards, and Bricher anticipate the same planar rock faces and shoreline stretches executed on a larger scale in their oils. However, the relative fineness of drawing and shading in many of these sketches attests to the quasi-scientific nature of much luminist thinking, in this case the concern for marking geological surfaces accurately. Richards as well was capable of the most refined and controlled effects in varied uses of pencil, sepia, and full watercolor. Such resplendant works as the tiny stippled drawing (in Sketchbook B, c. 1882, at the Brooklyn Museum, New York, fig. 154), or the larger *Lake Squam from Red Hill* (1874; fig. 340) and the major *Paradise Valley, Newport* (figs. 155-156), indicate he was equally adept at drawing on almost every scale.

Kensett, who was usually so consistent as a luminist in his artistic maturity, as a draftsman worked more in a traditional Hudson River school mode. Many of his sketches have a fragile, slight character not quite up to the measured delineations of pure luminism, though his natural sensitivity to distances and full light is noteworthy. Conversely, David Johnson seemed less adventurous in embracing full luminism as a style in his paintings, yet could produce totally luminous drawings like that of *Tongue Mountain, Lake George* (1872; fig. 274). Lastly, with regard to the whole area of drawings it remains to take note of the

surprising luminist moments captured in the little-known works of Henry Farrer, or the drawing of Gloucester (fig. 277) by the unidentified M.L.B. on July 23, 1872, so reminiscent in subject and handling of Lane's work at the same site a decade before. And in the landscape views of Homer Dodge Martin (figs. 157-158) we are brought to an artistic personality who seemed to be conscious not just of earlier Hudson River details and certain contemporaneous qualities of luminist light but also of soft optical sensations closer to the independently emerging currents of American Barbizon and impressionist painting.

* * * *

Having quite a different relationship to luminist art than drawings is the distinct and fascinating category of photography. Partly for technical reasons photography did not fully come into its own as a medium for luminist landscape until the 1860s and seventies. By then the wet-plate process had supplanted earlier Daguerrean and related techniques; larger cameras and glass-plate negatives were developed; and steadily improved lenses made possible shorter exposure times. Photographers were increasingly able to transport their equipment further and develop exposed plates more readily. All these factors well suited the coincidental needs of artists in search of the last frontiers. Photography additionally provided just the means of joining the aesthetic with the naturalist vision and for measuring light and space with

perfect luminist precision. Thus to some degree the scientific ideals and technical underpinnings of the medium helped to produce a body of luminist images that carried the style to the end of the nineteenth century, well after the movement in painting had lost its coherence and appeal.

In the person of William Bradford we have the one individual who produced luminist works in all the mediums of oil, pencil, wash, and photography. With his assistants he began taking photographs on his Arctic voyages in the 1860s and in later years often used them like preliminary sketches as the basis for subsequent studio paintings. He also eventually became proficient in photographing his own canvases and making lantern slides for lecture purposes. A large number of his best pictures stand up as complete strong images in their own right. Using "the sun-given powers of the camera," he explored "Nature under the terrible aspects of the Frigid Zone."[53] Like Church following Thoreau to Katahdin or Humboldt to the Andes, Bradford went to the north in the steps of Elisha Kent Kane and others on expeditions in search of the lost English explorer, Sir John Franklin.

On his own several voyages Bradford took large numbers of photographs (see fig. 159), and the well-documented excursion of 1863 resulted in the subsequent publication of *The Arctic Regions*. This last was the result of Bradford's work as well as that of an assistant, John Dunmore. Bradford was ecstatic and acutely observant. He would be alternately conjuring metaphors for the exotic mutations of icebergs or diligently recording each nuance of light. On reaching their farthest point north at latitude 75 degrees, Bradford determined,

This period I proposed to devote to ice studies. I certainly could have found no place better adapted for the purpose. The icebergs were innumerable, of every possible form and shape, and ever-changing. As the sun in his circuit fell upon different parts of the same berg, it developed continually new phases. On one side would be a towering mass in shadow, on the other a majestic berg glistened in sunlight; so that without leaving the vessel's deck I could study every variety of light and shade.[54]

The iconography of Bradford's photographs was in keeping with that in luminist painting: geologically interesting walls of rock or ice, sharp silhouettes, contrasting shapes and tones, glassy reflections, near-empty horizontal fields punctuated by astutely placed vertical details. His earlier training as a methodical draftsman influenced his photographic sensitivity to exacting records of texture, line, and surface. As for Church, the Arctic region all the while was a sublime experience of a timeless natural history unfolding around him.

Meanwhile, during the same years the American West was luring other photographers, often in company with painters, on government-sponsored expeditions to survey the uncharted meridians of the country's newly acquired states and territories. Among the best known of these are Timothy O'Sullivan (recently turned from taking some of the most unforgettable images of the Civil War battlefields), A. J. Russell, William H. Jackson, Jack Hillers, Eadweard Muybridge, and Carleton Watkins. Again, a review of their photographic images reveals frequent luminist themes, though the work in its

159. William Bradford. *Schooner.* Albumen photograph from *Photographs of Arctic Ice* (1864). 0.216 x 0.165 (8½ x 6½ in). The Library of Congress, Washington, D.C.

160. Timothy H. O'Sullivan. *Alkaline Lake, Carson Desert, Nevada*, 1868. Albumen photograph. 0.200 x 0.267 (7⅞ x 10½ in). Massachusetts Institute of Technology Libraries, Cambridge (upper left)

161. William Henry Jackson. *The Upper Twin Lake, Colorado (no. 1012)*, c. 1880. Albumen photograph. 0.426 x 0.540 (16¾ x 21¼ in). Private collection, New York. Photo: The Metropolitan Museum of Art, New York (upper right)

162. John K. Hillers. *Mouth of Zion Park*, c. 1872-1873. Albumen photograph. 0.206 x 0.352 (8⅛ x 13⅞ in). The Denver Public Library, Western History Department (at left)

entirety was by no means consistently a part of the movement. Frequently, for example, devices of Hudson River landscape composition are apparent in their siting and framing of views. But selected works by these individuals do reveal remarkable counterparts to familiarly painted prospects in the East.

O'Sullivan's *Pyramid and Tufa Domes* (1868; fig. 317) makes a stunning parallel to Lane's *Brace's Rock* in its stark lateral silhouetting of the rock formations, while his mirrored water surfaces elsewhere (see fig. 160), along with those pictured by Russell, Jackson (see fig. 161), and Hillers, recall any number of similar scenes on canvas. Hillers and Muybridge were also interested in seeking the high vantage point surveying a deep valley to the horizon (witness the former's *Mouth of Zion Park* [c. 1873; fig. 162] and the latter's *Valley of the Yosemite from Glacier Point* [1872; fig. 93]); in their format as well as pervading hazy light

163. Carleton E. Watkins. *North Dome, Yosemite,* c. 1861. Albumen photograph. 0.387 x 0.515 (15¼ x 20¼ in). Daniel Wolf

164. Carleton E. Watkins. *Half Domes, Yosemite,* c. 1866. Albumen photograph. 0.413 x 0.521 (16¼ x 20½ in). The Library of Congress, Washington, D.C.

165. Carleton E. Watkins. *Merced River, Yosemite Valley,* c. 1861. Albumen photograph. 0.387 x 0.521 (15¼ x 20½ in). Daniel Wolf

they compare well with such standard luminist oils as Gifford's views of Kaaterskill Clove.

But the most imaginative and compelling figure in Western photography is Carleton Watkins, whose large wet-plate views in the Yosemite Valley (figs. 163-165) are sublime images of daring and fresh talent. Aside from his meticulous technical accomplishments, occasionally stunning choices of viewpoint, and classic luminist themes of still water, breathtaking vistas, and calculated spatial recession, he above all made pure, ineffable light his object of attention. Indeed, more than the clear capturing of geology, he seemed to treat intangible air itself as truly objective—ultimately worthy of praise and affection— independent of the physical earth. Yet another important contribution of his photography in the Yosemite is his conscious effort to take views through the valley that he could arrange in calculated serial fashion. In a proto-cinematic manner he shifted his lens across the given quadrant of his view and moved from point to point through it, slicing off, as it were, frames of space and light. This procedure resulted in a set of pictures which both describe comprehensively the physical environment and recreate its perceived total harmony.

Comparable to Watkins as a photographer in the East is the insufficiently known figure of Seneca Ray Stoddard. Born in upstate New York, he began taking stereo views of scenery in the upper Hudson valley during the 1860s and, by the end of that decade, was making extended trips through the Adirondacks region to map and photograph the terrain. Beginning in the seventies and continuing through the nineties, he returned more than anywhere else to the beautiful lake regions of New York and Vermont. A restless and peripatetic adventurer, he also sailed the full New England coast to Canada in the mid-eighties and made other trips to Alaska, Europe, and the American West. Working around the Lake George area about the time the first large tourist hotels were opening, contemporaneous with the arrival of Kensett, Heade, and other painters, Stoddard sailed about the lake in his sloop *Wanderer* in search of views he might sell to local hotels or visitors. Here he took some of the purest luminist photographs we might find.

His view of *The Horicon Sketching Club* (1882; fig. 286) is typical of his work through the 1870s and early eighties. Despite the charming inclusion of the ladies at their leisurely recreation, the image has the stillness of mood and flat balanced order of a luminist vision and, in fact, is very close to the drawings and paintings David Johnson did nearby during the same years. Other photo-

167. Seneca Ray Stoddard. *Lake George,* 1902. Silverprint photograph. 0.078 x 0.200 (3¹/₁₆ x 7⅞ in). The Library of Congress, Washington, D.C. (above)

166. Seneca Ray Stoddard. *"The Giant," Keene Valley, Adirondacks,* 1888. Silverprint photograph. 0.162 x 0.213 (6⅜ x 8⅜ in). The Library of Congress, Washington, D.C.

graphs at Lake George, Upper Saranac Lake, and Little Tupper Lake display various luminist qualities: horizontal order, balanced tonal contrasts, open surfaces of silvery water, and low sunlight faced centrally across the view, its reflection a vertical bar perfectly intersecting the shorelines' horizontals. At Lake Champlain three limpid photographs draw our attention to infinitely subtle variations of hillside reflections in near-motionless water. Their balancing of silhouetted shapes, both vertically and horizontally, immediately calls to mind the oils of Lane and Kensett. Stoddard understood the ideals of recording such scenery, as shared by his generation:

All who love the sublime and majestic in nature or the dainty and beautiful scenery of lake and woodland will find here, within easy reach, a variety which is charming and a peaceful grandeur which must soothe and elevate their weary minds.[55]

Elsewhere, he makes us think of the sloping meadows painted by Kensett and William Hart (see his *"The Giant," Keene Valley, Adirondacks,* 1888, fig. 166), or of Heade, as in the amusing but lovely anagrammatic *The Letter "S" Ray Brook* (1890; fig. 8). Lastly, his grainy, elevated view *Lake George* (Tongue Mountain from Shelving Rock) in 1902 (fig. 167) brings the luminist format into another

168. Louise Deshong Woodbridge. *Pontoosuc Lake, Pittsfield,* 1885. Albumen photograph. 0.117 x 0.198 (4⁷⁄₁₆ x 7¹³⁄₁₆ in). Private collection. Photo: Scott Hyde

169. Louise Deshong Woodbridge. *Pontoosuc Lake, Showing Greylock,* 1885. Albumen photograph. 0.115 x 0.196 (4³⁄₄ x 7¹¹⁄₁₆ in). Private collection. Photo: Scott Hyde

170. Louise Deshong Woodbridge. *The "Carry," Lake Placid to Whiteface,* 1885. Albumen photograph. 0.116 x 0.199 (4¹⁄₂ x 7¹³⁄₁₆ in). Private collection. Photo: Scott Hyde

world altogether, that of Alfred Stieglitz's photogravures and "equivalents."

Two other unknown photographers deserve notice here, the Philadelphian Louise Woodbridge and Henry L. Rand of Boston. Little is known about the former, but besides her various scenic views around Philadelphia there are some typical luminist efforts from her camera, taken in familiar areas of the Adirondacks and New England (see figs. 168-170). Rand is also a recent redis-

covery and substantial artistic personality. A Boston businessman, he spent many leisure hours with his avocation of photography in some of the favorite corners of the luminist world, including Gloucester, Massachusetts, and Mt. Desert, Maine. In fact, he was one of the first to build a summer cottage at Southwest Harbor in 1884. A partial listing of places he photographed, many with a luminist eye, is almost a directory of territory intimately associated with Lane and Heade: Rye Beach, the marshes of Little River and Rowley, Brace's Cove, Rockland Harbor, Owl's Head, and Mt. Desert Island. But he went as well to the glaciers of Scandinavia and the shores of the Mediterranean, recalling Bradford and Bierstadt respectively. His subjects at home included woodland tunnels, valley vistas, hillsides overlooking water, and haystacks on Cape Ann. (One seemingly anomalous print—Cherokee roses on a cloth-covered table—suggests a direct indebtedness to another Heade subject.)

The body of Rand's work, known primarily from a large collection deposited in the Southwest Harbor, Maine, Public Library, dates from the 1890s and just after the turn of the century. Technically very able and inventive, almost certainly familiar with his luminist predecessors, Rand presents us, in a representative selection of his prints with sharp rock forms and complementary reflections (*Cloisters and Isolated Rock, Sutton's Island,* 1890-1891; fig. 171), worthy of Haseltine and Richards. Others—*Off Sandy Hook* (1896-1897; fig. 172), *Moonlight on the Upper Saranac* (c. 1897; fig. 339) and *Beach, Fox Dens Point and Norwood Cove* (1907; fig. 173)—are remarkable experiments with moonlight, illuminated clouds above vast seascapes and effects of the setting sunlight. *Island House Slip, Thick Fog* (1892; fig. 338), taken at Southwest Harbor, bears the typical marks of luminist vision. It is a totally reflective image in its intended

171. Henry L. Rand. *Cloisters and Isolated Rock, Sutton's Island,* 1890-1891. Platinum photograph. 0.114 x 0.168 (4½ x 6⅝ in). Southwest Harbor Public Library, Southwest Harbor, Maine. Photos: National Gallery of Art, Washington, D.C.

174. Henry L. Rand. *Bass Harbor Marsh,* 1909. Platinum photograph. 0.061 x 0.168 (2⁷⁄₁₆ x 6⅝ in). Southwest Harbor Public Library, Southwest Harbor, Maine.

173. Henry L. Rand. *Beach, Fox Dens Point and Norwood Cove,* 1907. Platinum photograph. 0.120 x 0.170 (4¾ x 6¹¹⁄₁₆ in). Southwest Harbor Public Library, Southwest Harbor, Maine.

172. Henry L. Rand. *Off Sandy Hook,* c. 1897. Platinum photograph. 0.114 x 0.159 (4½ x 6¼ in). Southwest Harbor Public Library, Southwest Harbor, Maine.

ambience of calm and its effort to elicit a response of thoughtfulness. But the photograph further carries characteristic luminist notations, for Rand recorded about this, as he did others, his precisely descriptive title, followed by other fixative details ("F 16, 1/5 [second], 11:40 A.M., August 13, 1892"). In yet three other images (*Bass Harbor Marsh,* 1909, fig. 174; *Somes Sound, Looking South,* 1893, fig. 337; and *Across the Bay, Gloucester,* 1892, fig. 336), we come to scenes haunting in their evocation of Heade and Lane. Indebted to but not derivative of their predecessors, these elegaic images form a final deja vu of the luminist landscape.

175. Eastman Johnson. *Lambs, Nantucket*, 1874. Oil on board. 0.483 x 0.397 (19 x 15⅝ in). Inscribed, l.r.: *E. Johnson /Aug. 29–74*. From the Collection of Mr. and Mrs. Paul Mellon, Upperville, Virginia. Photo: National Gallery of Art, Washington, D.C. (see plate 32)

When does luminism end?

Although we have seen that its photography attenuated the vision through the later nineteenth century, essentially the movement loses its coherence and impact during the 1870s. Lane had died in 1865; Church had largely given up painting by 1870 to design his house Olana; Kensett's death came in 1872 and Gifford's six years later; Heade turned to more painterly methods and still-life subjects in the seventies and after. Beyond these personal circumstances, the mood of America and tastes in art at large were changing. Much of the optimism of the pre-Civil War years had been shattered. Expansion to the west increasingly faced contentions in rising regionalism; technology, at first a thrilling agent in the romance of science, now was a disquieting invader of nature's paradise. Gradually, the raison d'etre underpinning luminism crumbled, and with it came the escape of some to final frontiers.

The decade of the 1870s is one of the most interesting and complex in American art, for during this period the luminist style still held favor with many, though the intensity of its light and color in retrospect seem more often than not the fevers of expiration. At the same time clearly newer and different styles of realism were emerging, some even carrying modified aspects of luminism into their changed environment of art and thought. Broadly speaking, we may discern two general tendencies in American painting which developed in replacement of luminism. The first might be described as psychological realism, seen foremost in the hands of Eastman Johnson, Winslow Homer, and Thomas Eakins. The second can be given a comprehensive term like romantic impressionism, and this would include figures as individually diverse as Homer Martin, George Inness, James Whistler, and Ralph Blakelock. Collectively, both of these groups transformed landscape painting with modes of brushwork, composition, subject matter, handling of light and detail, that were no longer luminist.

If we look at Johnson's work in the 1870s, contemporaneous with the last phase of luminism, we find him occasionally making use of clear luminist light, its sense of distant space and ruler-sharp horizon, even the markedly lateral format. Nonetheless, in both *Lambs, Nantucket* (1874; fig. 175) and *The Cranberry Harvest, Nantucket Island* (1880; fig. 46) there is the decisively new element of figures again dominating our attention in the foreground. While the air of both is meditative, we are now aware of figures poised in thought rather than the quiet order of a landscape serving as a vehicle for our own contemplation. Johnson was a New Englander by birth, and his early training was as a printmaker; but his mature style owed something of its cosmopolitan quality to Dutch seventeenth-century and German and French nineteenth-century art, to which he had been exposed while abroad in the 1850s. Thus his

176. Winslow Homer. *Long Branch, New Jersey,* 1869. Oil on canvas. 0.406 x 0.552 (16 x 21³⁄₄ in). Inscribed, l.r.: *Winslow Homer/1869.* Museum of Fine Arts, Boston; Charles Henry Hayden Fund

177. Winslow Homer. *Dad's Coming,* 1873. Oil on panel. 0.229 x 0.350 (9 x 13³⁄₄ in). Inscribed, l.l.: *WINSLOW HOMER/1873.* From the Collection of Mr. and Mrs. Paul Mellon, Upperville, Virginia (below)

subsequent interest in the narrative presence of the human figure emerged from a tradition outside luminism and ultimately became primary in his later work.

Homer also belonged strongly to New England and to the American graphic tradition. Like Lane before him, he apprenticed as a lithographer and brought to his painting a solid grounding in drawing and tonal organization. Although his two trips to Europe in 1869 and 1881-1882 had less definable effects on his style than the European influences on others, he too reintroduced the human figure into the foreground stage of his paintings. Surely, however, luminist light and space are present in such oils of his early maturity as *Long Branch, New Jersey* (1869; fig. 176) and *An Adirondack Lake* (1870; fig. 44). There is even a stillness of mood suggested in these pictures and others of the early seventies, notably *High Tide: the Bathers* (1870; fig. 298) and *Dad's Coming* (1873; fig. 177), but what is new here is the powerful sense of human drama. Where for the classic luminist nature's mutability was the high issue, this successor generation addressed instead the mortality of man. In this new light one can acknowledge the hidden human tensions present in Homer's paintings: the central shadows and barking dog disturbing *The Bathers* or the vacuum of steely light and stoic isolation lending an uneasy expectation to the title of *Dad's Coming.*

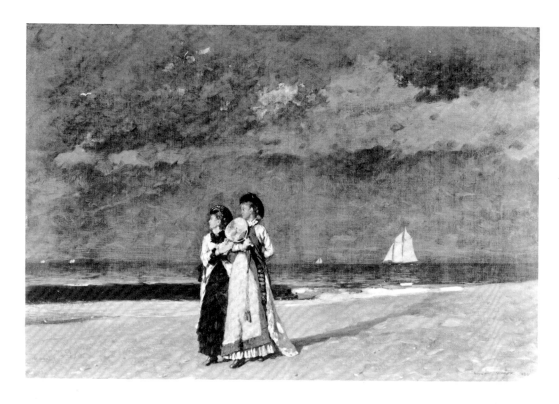

178. Winslow Homer. *Promenade on the Beach*, 1880. Oil on canvas. 0.508 x 0.765 (20 x 30⅛ in). Inscribed, l.r.: *Winslow Homer 1880*. Museum of Fine Arts, Springfield, Massachusetts; Gift of the Misses Emily and Elizabeth Mills, in Memory of their Parents

179. Thomas Eakins. *Max Schmitt in a Single Scull*, 1871. Oil on canvas. 0.819 x 1.175 (32¼ x 46¼ in). Inscribed, on scull in background: *Eakins/1871;* on scull in foreground: *Josie.* The Metropolitan Museum of Art, New York; Purchase, 1934, Alfred N. Punnett Fund and Gift of George D. Pratt (not in exhibition; below)

We need only compare such beach scenes with those of Kensett and Whittredge to perceive the transformation of luminism at this time. Indeed, Homer paints an even fuller suggestion of meteorological and psychological turbulence in *Promenade on the Beach* of 1880 (fig. 178), where the structure of luminism remains without its tranquil serenity of air or light. He provides us with a final coda to luminism in his later work with *The Artist's Studio in an Afternoon Fog* (1894; fig. 348). The golden haze of the centrally seen sun fixes the scene much like earlier examples by Church, Haseltine, or Lane. It is probably even indirectly indebted to Turner, but the incipient qualities of aestheticism and even abstraction in the expressive paint surface and formal patterns are far removed from the luminist's self-effacing presence previously along this coast.

Likewise, the oils and watercolors of Thomas Eakins from the decade of the seventies give us a seriousness of mood quite advanced from the exhilarated pantheism of luminism. *Max Schmitt in a Single Scull* (1871; fig. 179) has all the luminist properties of calculated charting of pictorial space, machine precision in rendering details and atmosphere. Yet its total feeling is an elegiac, almost melancholy one: this is an afternoon of Indian summer light, sad and sere with reminders of time passing, not stopped in ideal perfection. Even as Eakins draws our eye across broad passages of water to the far horizon, he returns us to

180. Thomas Eakins. *Sailing*, c. 1875. Oil on canvas. 0.810 x 1.175 (31⅞ x 46¼ in). Inscribed, l.r.: *To his friend/William M. Chase/Eakins.* Philadelphia Museum of Art; Alexander Simpson, Jr. Collection

181. George Inness. *The Lackawanna Valley,* 1855. Oil on canvas. 0.861 x 1.276 (33⅞ x 50¼ in). Inscribed, l.l.: *G. Inness.* National Gallery of Art, Washington, D.C.; Gift of Mrs. Huttleston Rogers, 1945

182. George Inness. *Lake Nemi,* 1872. Oil on canvas. 0.762 x 1.143 (30 x 45 in). Inscribed, l.r.: *Inness Nemi 1872.* Museum of Fine Arts, Boston; Gift of the Misses Hersey

183. Homer Dodge Martin. *On the Upper Hudson,* 1860s. Oil on canvas. 0.686 x 1.022 (27 x 40¼ in). Inscribed, l.r.: *H.Martin.* Joslyn Art Museum, Omaha, Nebraska; Mr. and Mrs. Edwin S. Miller Bequest Fund

individuals seriously engaged in work or the disciplines of exercise. He made his own trip to Europe for study in the late 1860s, acquiring a taste for the direct realism of Velázquez and Rembrandt. One result was that his art moved steadily away from concern with the condition of nature to that of man. His masterful early outdoor views on the Schuylkill River in Philadelphia and along Delaware Bay pay unconscious homage to a light that was irrevocably fading in American art, while setting forth the sober themes for an unsettled national state of mind in the later nineteenth century (see fig. 180).

Concurrently, another broad redirection in American painting was occurring in the hands of George Inness and Homer Dodge Martin. Inness' early masterpiece, *The Lackawanna Valley* (1855; fig. 181), is bathed in the cool light and shaped in the receding horizontal zones of luminism. The nostalgic contemplation of a foreground dotted by tree stumps summons up the image made so poignant later by Sanford Gifford in *Twilight on Hunter Mountain* (1866; fig. 85). But Inness' inspiration here derives as much from Durand's American tradition as from the Barbizon school in France. *The Close of Day* (1863; fig. 24) similarly employs the hot cadmiums of a luminist sunset, but with a more painterly brushwork and framed composition coming from French sources. Even the spacious and restful ambience of *Lake Nemi* (1872; fig. 182) finds Inness in the early 1870s recalling luminist practices but introducing an

184. James Abbott McNeill Whistler. *The Sea*, c. 1865. Oil on canvas. 0.527 x 0.959 (20¾ x 37¾ in). Montclair Art Museum, Montclair, New Jersey

185. Ralph Albert Blakelock. *The Sun, Serene, Sinks into the Slumberous Sea,* 1880s. Oil on canvas. 0.406 x 0.610 (16 x 24 in). Inscribed, l.l.: *R. A. Blakelock.* Museum of Fine Arts, Springfield, Massachusetts; The Horace P. Wright Collection (below; see also plate 29)

altogether personal substructure of Swedenborgian spiritualism. Martin, for his part, steadily moved away from his artistic initiation in Hudson River art as exemplified in Kensett toward a dramatic and romantic manner tempered by Barbizon precedents and French impressionism. His airy view *On the Upper Hudson* (fig. 183) seems to hint of these diverse elements, as luminism in this instance fades over the border into an alternate vision.

While he was in Europe, Martin became a friend of James A. M. Whistler, whose *The Sea* of about 1865 (fig. 184) looks out on a severe and almost empty horizon. Novak and others have noted how close this is to Courbet's marines. Now the structure only approximates that of luminism, but the advanced abstraction of design, subjectivity, and exploitation of brushwork in an expressive more than representational role belong almost wholly within a European tradition moving toward modernism. Finally, the introspective personality and art of Ralph A. Blakelock provides a concluding elegy for luminism. The hermetic and symbolic vision of his *The Sun, Serene, Sinks into the Slumberous Sea* (1880s; fig. 185) glimpses that low horizon, axial sunlight, and radiant aura of a style once as classically balanced and full as high noon. But now the luminist day languishes, as Blakelock's poetic title intones, into the inevitable twilight of another artistic day.

Notes

1. *Thoreau: The Major Essays,* ed. Jeffrey L. Duncan (New York, 1972), 205.

2. F. O. Matthiessen, *American Renaissance, Art and Expression in the Age of Emerson and Whitman* (London and New York, 1941), vii, x.

3. R. W. Emerson, "Historic Notes of Life and Letters in New England," quoted in Matthiessen, *American Renaissance,* 6.

4. Matthiessen, *American Renaissance,* 243, 275, 281, 351.

5. Nathaniel Hawthorne, *The Scarlet Letter,* quoted in Matthiessen, *American Renaissance,* 262; see also 273-274.

6. Matthiessen, *American Renaissance,* 355; see also 255.

7. Emerson, "Nature" in *The Complete Essays and Other Writings of Ralph Waldo Emerson,* Modern Library (New York, 1950), 6.

8. Matthiessen, *American Renaissance,* 29; see also 15-17.

9. Matthiessen, *American Renaissance,* 31, 40, 47, 68.

10. Matthiessen, *American Renaissance,* 51, 62; and Emerson, *Complete Essays,* 5-7, 10, 20, 47, 413.

11. Quoted in Matthiessen, *American Renaissance,* 95; see also 88, 91-92.

12. *Thoreau: Major Essays,* 26.

13. H. D. Thoreau, *A Writer's Journal,* ed. Laurence Stapleton (New York, 1960), 38.

14. Thoreau, *Journal,* 103.

15. Herman Melville, *Moby Dick, or, The Whale,* Modern Library (New York, 1950), 2.

16. Melville, *Moby Dick,* 166. See also Matthiessen, *American Renaissance,* 286-289, 408.

17. Walt Whitman, *Leaves of Grass,* Mentor (New York, 1954), 255. See also "Thou Orb Aloft Full-Dazzling," 355, and "Song at Sunset," 377.

18. Whitman, *Leaves of Grass,* 400.

19. Matthiessen, *American Renaissance,* 517, 565, 599, 652.

20. Quoted in John I. H. Baur, "American Luminism, A Neglected Aspect of the Realist Movement in Nineteenth-Century American Painting," *Perspectives USA,* 8 (Autumn 1954): 93.

21. Baur, "American Luminism," 91.

22. Quoted in John McCoubrey, *American Art, 1700-1960, Sources and Documents* (Englewood Cliffs, N.J., 1965), 58.

23. See John Wilmerding, *A History of American Marine Painting* (Boston and Salem, Mass., 1968), 144-150.

24. Quoted in Alfred Frankenstein, *Painter of Rural America, William Sidney Mount, 1807-1868* [exh. cat., National Gallery of Art] (Washington, D.C., 1969), 37.

25. Barbara Novak, *American Painting of the Nineteenth Century: Realism, Idealism, and the American Experience* (New York, 1969), 159.

26. Quoted in McCoubrey, *American Art,* 100.

27. McCoubrey, *American Art,* 109.

28. McCoubrey, *American Art,* 103.

29. McCoubrey, *American Art,* 104, 107.

30. Emerson, *Complete Essays,* 407.

31. Emerson, *Complete Essays,* 406.

32. McCoubrey, *American Art,* 108.

33. John Ruskin, *The Elements of Drawing; in Three Letters to Beginners* (London and New York, 1857), 164; and McCoubrey, *American Art,* 111.

34. McCoubrey, *American Art,* 112; and Ruskin, *Elements of Drawing,* 289, 291.

35. Ruskin, *Elements of Drawing,* 189, 240.

36. Quoted in John I. H. Baur, "Early Studies in Light and Air by American Painters," *Brooklyn Museum Bulletin,* 9, no. 2 (Winter 1948): 6.

37. Novak, *American Painting,* chap. 6; and Theodore E. Stebbins, *The Life and Works of Martin Johnson Heade* (New Haven and London, 1975), 108.

38. John Wilmerding, *Fitz Hugh Lane* (New York, 1971), 50.

39. Ruskin, *Elements of Drawing,* 178.

40. Ruskin, *Elements of Drawing,* 226-227.

41. See Wilmerding, *Lane,* figs. 40-43, 61-62, 88-89.

42. Ruskin, *Elements of Drawing,* 257-258.

43. Ruskin, *Elements of Drawing,* 182-183.

44. Quoted in Nicolai Cikovsky, Jr., *Sanford Robinson Gifford (1823-1880)* [exh. cat., University of Texas Art Museum] (Austin, 1970), 31.

45. John Ferguson Weir, "Address, Sanford R. Gifford Memorial Meeting, The Century" (New York, November 19, 1880); quoted in Cikovsky, *Gifford,* 16.

46. Henry David Thoreau, *The Maine Woods,* Apollo (New York, 1966), 93.

47. Louis L. Noble, *After Icebergs with a Painter, A Summer Voyage to Labrador and Around Newfoundland* (New York, 1861), 223. See also the discussion of Church in Theodore E. Stebbins, Jr., *Close Observation: Selected Oil Sketches by Frederic E. Church* [Cooper-Hewitt Museum of Decorative Arts and Design] (New York, 1978).

48. Fitz Hugh Ludlow, *The Heart of the Continent: A Record of Travel Across the Plains and in Oregon with an Examination of the Mormon Principle* (Cambridge, Mass., 1870), 412, 426.

49. Ludlow, *Heart of the Continent,* 431-432.

50. John I. H. Baur, ed., *The Autobiography of Worthington Whittredge* (rpt. ed., New York, 1969), 31, 46.

51. Ruskin, *Elements of Drawing,* 198.

52. This point is more fully argued in John Wilmerding, "Fire and Ice in American Art: Polarities from Luminism to Abstract Expressionism" in *The Natural Paradise, Painting in America, 1800-1950,* ed. Kynaston McShine [Museum of Modern Art] (New York, 1976), 47-52.

53. William Bradford, *The Arctic Regions, Illustrated with Photographs Taken on an Art Expedition to Greenland, with Descriptive Narrative by the Artist* (London, 1873), 12.

54. Bradford, *Arctic Regions,* 74.

55. Maitland C. De Sormo, *Seneca Ray Stoddard, Versatile Camera-Artist* (Saranac Lake, N.Y., 1972), 80.

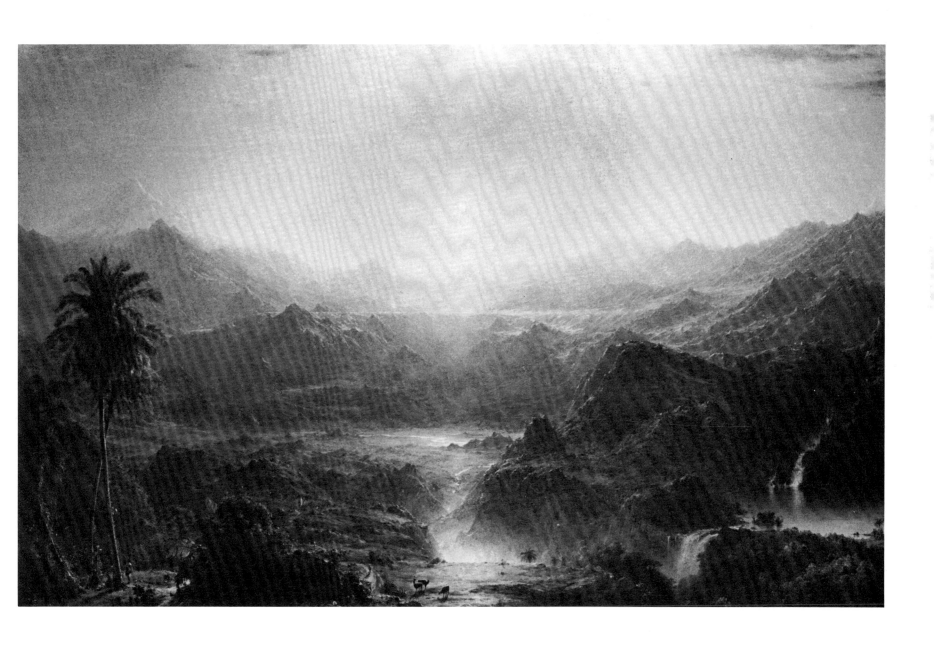

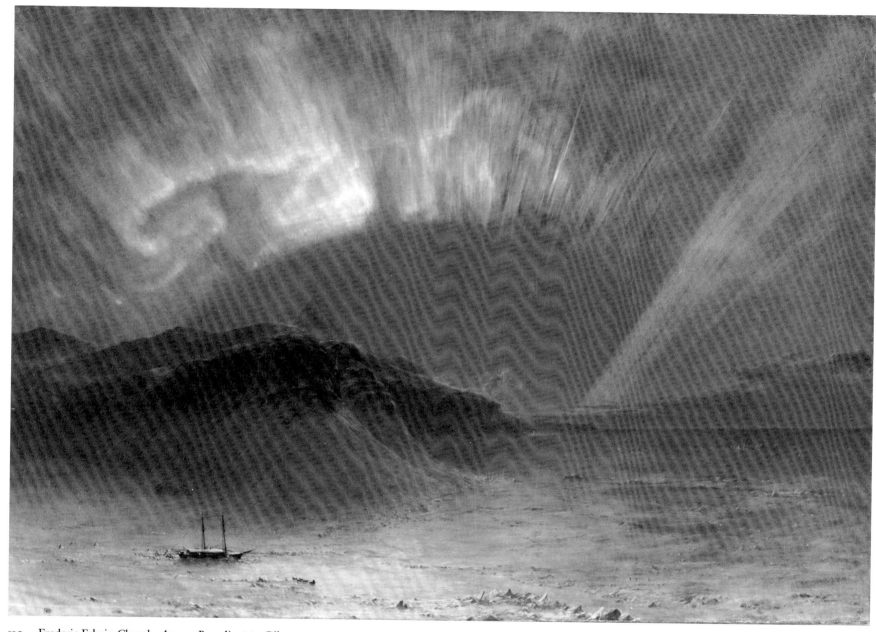

190. Frederic Edwin Church. *Aurora Borealis,* 1865. Oil on canvas. 1.423 x 2.122 (56⅛ x 83½ in). Inscribed, l.l.: *FC 65.*
The National Collection of Fine Arts, Smithsonian Institution, Washington, D.C.; Gift of Eleanor Blodgett

186. Frederic Edwin Church. *Andes of Ecuador,* 1855. Oil on canvas. 1.229 x 1.905 (48 x 75 in). Inscribed, l.c.: *F. E. Church/1855.*
Reynolda House, Inc., Winston-Salem, North Carolina (previous page)

Church and Luminism: Light for America's Elect

David C. Huntington

And then they will see the Son of man coming in clouds with great power and glory.
And then he will send out the angels, and gather his elect from the four winds, from
the ends of the earth to the ends of heaven. [Mark 13:26-27]

"CHURCH EXHIBITS THE NEW ENGLAND MIND PICTORIALLY DEVELOPED."[1] These are the words of the Reverend Henry Theodore Tuckerman, spoken in 1867, and indeed the roots of Frederic Edwin Church's art do go back to seventeenth-century New England. Intriguingly his art is a sort of latter-day Puritan baroque, the Protestant Reformation's delayed response to the art of the Counter-Reformation. And, as the papacy shaped the art of Bernini and Borromini, so in a sense did the Massachusetts theocracy shape—even though it took two hundred years—the art of Frederic Church. Though his landscape paintings were fit icons for the American Adam of the nineteenth century, they were, more profoundly, cogent parables for God's Chosen People, and while their appeal was manifold, they were painted primarily for "those who have eyes to see and a mind to understand." These words, quoted or paraphrased time and again in the presence of Church's canvases, resonate with Scripture.[2] They are banner words of the would-be Elect, and words which have more to do with John Calvin than with Ralph Waldo Emerson or Henry David Thoreau. Those today who would fathom Church's art must also look at his canvases with eyes that "will to see and a mind that wills to understand." We need to view his work through the spirit of his age, or—to be more exact—through the Puritan spirit of his age.

In 1867 luminism would have been at high tide, though the term itself is one that Tuckerman as the author of *American Artists Life* did not employ. It is a term coined by modern scholars to denote a sensibility toward light that appears to distinguish almost a whole generation of landscape painters. That Tuckerman did not perceive that unifying sensibility is of some significance to this study, for in a curious way the accessibility of Emerson and Thoreau to our understanding has served to confer, in hindsight, a spiritual consistency upon the vision of the period. Indeed, from the vantage point of the present a luminist sensibility would seem to fit transcendentalism with almost elegant precision.[3] However, there may be less spiritual consistency than scholars had supposed.[4] Provoked on this occasion by the question, "What is Church's relationship to luminism?" I have taken a fresh look at "the New England mind pictorially developed." The question and the quest will lead in this essay to the conclusion that the Almighty has significantly more to do with Church's art than the Over-Soul, that atmosphere has more to do with Church's light than luminism.

* * * *

Wonderful Hazy ridges of mountain-peaks, flooded with tropical sunlight. Sharp pinnacles, just tipped with eternal snow, soaring like white birds to heaven. Vast torrents, dashing over rocky ledges into bottomless ravines that gape for the silver waters. Faint gleams of tropical vegetation reddening the foreground, with all detail, all shape, lost in the neutral bloom over lonely places. Grandeur, isolation, serenity! Here there is room to breathe. One feels the muscles grow tense gazing over that great Alpine panorama.
[On *Andes of Ecuador, Harper's Magazine, 1,* May 30, 1857, 339]

Prejudice of every kind, like the mists of the lowlands, should lie far beneath us; for it is our privilege, if we deserve the name, to breathe a clear, refined atmosphere, where no exhalations of earth come between us and the sunlight. From these heights we have a wide circuit of vision. The past opens to us its experience, the great present is spread out before us, and, so far as they can be inferred from the comparison of the past with the present, we discern the contingencies of the future. If it be possible not to feel the influences of sect, part, or vicinage, let us not be in bondage to either. Christianity is more than sect, patriotism more than part, our country than the section where we live.
[George Washington Bethune, *An Oration Before the Phi Beta Kappa Society of Harvard University,* July 19, 1849 (Cambridge, 1849)]

God is light. [1 John 1:5]

Behold, I make all things new. [Revelations 21:5]

If there is one single canvas by Church which first declares the distinctive unity of light and faith that characterizes his mature work it would surely be *Andes of Ecuador* (fig. 186) painted in 1855. With this inspirational tour de force of radiant atmosphere the claim for a "luminist Church" can be made on sure ground—or rather, sure air. "Here," exclaimed one of its first viewers, a critic for *Harper's Magazine,* "there is room to breathe. One feels the muscles grow tense . . ., gazing over that great Alpine panorama." In the eyes of Church's contemporaries the painting had "caught and conveyed a new feeling to the mind."[5] None of the luminist painters at this date or at any date would, on their light-filled canvases, ever catch and convey that same new feeling. It was a new feeling caught and conveyed more readily by words than in images painted at the easel. That *Andes of Ecuador* could inspire comments that might just as well be spoken in a church or lecture hall as in a gallery is a telltale clue to the uniqueness of Church's vision; for the words of the *Harper's* critic might almost have preceded or followed the passage from the Reverend George Washington Bethune's Harvard address quoted above.

We can be sure that the tenor of Bethune's Phi Beta Kappa oration carried over into his sermons. The oration itself is a masterpiece of American liberal Calvinist typology, charged with the nationalist mystique of Manifest Destiny, imbued with the ideals of New England's Elect. Bethune's fifty-two-page text is a synthesis of mid-century patriotism, science, and religion and, as such, seems a virtual prescription for the ideology of Church's art. Interestingly, Bethune at that date occupied the pulpit of the Central Reformed Church of Brooklyn ("the Church on the Heights"), and it was to hear his sermons on Sundays that Church as a young man took the ferry from Manhattan across the East River.[6] Consider the susceptible mind of the youthful painter, bred in Connecticut Congregationalism, listening to this admonition from the pulpit:

Neither the law of our Creator, nor the urgencies of the times, permit . . . luxurious self-indulgence. Thought, truthful, clear, and augmentative of good deeds, is an oracle from heaven; eloquence, whether of the voice or of the pen, comes from a divine *afflatus;* and woe, woe, in this world and in the next, to the man that God has thus ordained his prophet, if he utters not, or if he perverts, the revelation![7]

These words would have been no less applicable for the man whose God-given talent was the brush, as for the man whose talent was the voice or the pen. Moreover, the two quotations exemplify Bethune's mode of discourse. Biblical, if not oracular, the *Oration* is replete with the hyperbole of a mythology which is all but extinct in post-Watergate America. To us it is at once arcane and archaic. But to the self-appointed elite of Manifest Destiny "the claims of our country on its literary men"—claims that applied equally to its artists—were imperatives dutifully, willingly obeyed, obeyed, that is, if one felt himself thus called by God.

Judging by what we know of other American landscapists of his generation,

186. Frederic Edwin Church. *Andes of Ecuador,* 1855. Oil on canvas. 1.229 x 1.905 (48 x 75 in). Inscribed, l.c.: *F. E. Church/1855.* Reynolda House, Inc., Winston-Salem, North Carolina

certainly none, it would seem, was so flawlessly qualified as Church to conceive of himself as preordained "prophet." Church grew up in an atmosphere redolent of the spirit of New England Puritanism. Five generations earlier his first ancestor on this continent landed at Plymouth. This was Richard Church, who in 1636 migrated with the Reverend Thomas Hooker from Braintree to Hartford. Richard's descendant Frederic, born 190 years later, grew up attending Hartford's Central Congregational Church. In the painter's formative years religious controversy raged in the city, focused on the personalities of his family's pastor, the conservative evangelical Joel Hawes, and the pastor of the North Congregational Church, the liberal yet staunchly Calvinist Horace Bushnell. That the painter was, in his manhood, to draw close to the controversial Bushnell and away from the conservative affiliation of his childhood is a critical point as Church in his mature years seems to have been inspired by the same latter-day Puritan faith that Bushnell so vigorously defended against Unitarianism and transcendentalism.[8] The writings of Hartford's would-be prophet of liberal nineteenth-century New England Calvinism, especially *Nature and the Supernatural* and *Sermons for the New Life* (a copy of which the painter owned), have a decided application to our understanding of Church.[9] Dominating these texts is the author's steadfast belief in the divinity of Christ, the triune nature of God, and the presence of God in the operations of human and natural history. One conviction of Bushnell's that would be of especial pertinence to the visual arts was that religious symbols are necessary to man-

187. After Frederic Edwin Church. *The Heart of the Andes*, 1859. Watercolor on paper mounted on cardboard. 0.502 x 0.918 (19¾ x 36⅛ in). Inscribed, l.l.: on tree trunk: *F E CHURCH/1859*. National Gallery of Art, Washington, D.C.; Gift of Robert H. and Clarice Smith, B25809. Scholars are uncertain whether this is by Church's own hand or a copy by an English watercolorist

kind. A reading of these and others of his works goes far to point up the importance of the distinction between liberal Calvinism and Unitarian transcendentalism. (Hartford was both socially and religiously Church's home at the very time that luminism was taking form as an aesthetic discipline. True luminists would have been more at home in Concord, at least religiously.)

* * * *

While science was repeatedly to be invoked by Bushnell and by Bethune, science would in no way absorb their minds as it did the mind of the Reverend James McCosh, the Scots theologian who was, in Church's time, to become one of the principal luminaries of American Presbyterianism. (He was president of the College of New Jersey, i.e. Princeton University, for twenty years.) In the library at Olana, Church's former home in New York State, is a copy of the 1881 edition of McCosh's *Typical Forms and Special Ends in Creation*, a treatise first published in 1856.[10] For those who will have remarked the visible absence of an explicitly Christian context in the *Personal Narratives* and *Cosmos* of Alexander von Humboldt, works which inspired Church twice to visit South America, McCosh's treatise would seem to provide a missing link between Church's religious and Humboldt's secular approach to natural history. *Typical Forms and Special Ends in Creation* is a dedicated Calvinist's guide to the "Science of Design."[11] Geology is viewed as a Bible in stone, infallibly inscribed with the story of creation. Like the verbal Bible, known to the generations who

lived without the benefit of the new dispensation of science, the physical world is as much, so McCosh tells us, the word of God as is the word recorded by the prophets and the apostles. And as the Old Testament prefigures the new, so does the life of one geological era prefigure that of the next. Ceaselessly, the mantle of the planet has been preparing the way for ever higher forms in the chain of animal being. McCosh's God needs millions of years to accomplish his purposes. (The Scottish-born Presbyterian is liberal enough to be unembarrassed by the chronology of a Bishop Ussher who dated the creation as occurring in 4004 B.C.) All creatures, of course, have in "the womb of time" been created to fulfill some end in the great design of things envisaged by the Almighty ere time began:

The Supreme could foresee that which was to come, and which He had pre-ordained; the revelations of geology enable us to take a retrospective view. But they do more; they afford us the means of exercising a reflex faculty; we can examine the first figure in the vertebrate series, and from that point look down the long vistas that are opened, to the

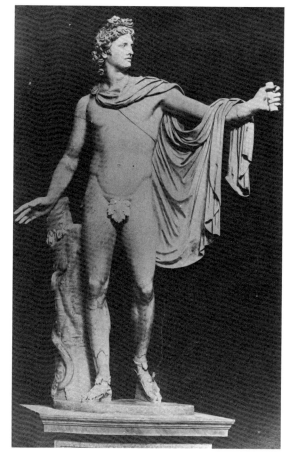

188. Unidentified photograph of the Apollo Belvedere. 0.362 x 0.235 (14¼ x 9¼ in). Olana State Historic Site, Taconic Region, New York State Office of Parks and Recreation, Hudson, New York. Copy photo: Tony Novak (not in exhibition)

period when man appears as the final and foreseen product of one mighty plan—the last in time, but the first in the contemplation of Him who called them all into being.

Let us behold this creature "which had so long been prepared":

The consummation of the earthly type comes out—in a goodly frame, with gait erect; in eyes to contemplate, and mental faculties to appreciate, the beauty of the objects around him. . . . Doubtless the structure of his body binds him to the earth's surface, but he has mental powers which enable him to soar from earth to heaven, to penetrate far into the regions of space, and throw back a reflective glance upon the remotest points of time.[12]

While Church's photograph of the Apollo Belvedere (fig. 188) might envision this divine creature, the *Andes of Ecuador* (fig. 186) is a scene fit to be viewed by the God of Light himself. So, too, before the painting would the spectator of 1855 discover himself to be the "consummation of the earthly type," for the first time beholding Creation. No wonder *Andes of Ecuador* "conveyed a new feeling to the mind." Like Adam at the dawn of human consciousness the beholder awakens to the beauty of the earth which has been so long preparing for him. Yet this first awakening is, in effect, the type for a reawakening into a higher consciousness, which is the consciousness of a soul reborn in Christ, as with fresh eyes he "sees all things new." The old dispensation is manifest in the guise of the church and wayside shrine, each marked by a cross. The new dispensation is manifest in the guise of a heavenly cross whose all-pervasive radiant light blesses and hallows all nature. As the crosses made by human hands adumbrate the cross made by divine hands, so has the sequel of ever higher orders of life through aeons adumbrated the mind-spirit which now, for the first time, contemplates Creation with "Intelligence." As he "soars" suspended between earth and heaven in the presence of *Andes of Ecuador* and looks out upon the world's divinity, the spectator becomes a "demi-god."[13]

It is the newly apprehended spiritual dimension of light perceived in a moment of revelation which causes Church to play the luminist here. But even the material dimension of light is the object of reverent contemplation. "Our earth," writes McCosh,

has . . ., on the one hand, powerful fires to heat it and on the other hand, an extensive reservoir of cold to keep it cool; its surface is warmed by the internal heat, and by the heat of the sun; and its temperature being thus rendered higher than that of the vault of heaven, it is ever radiating heat towards the regions of space, according to the beautiful law of the universe, whereby all things tend towards an equilibrium.[14]

The very atmosphere of the earth itself was testimony to the beneficence of the Creator. Through generations of landscape painters the atmosphere had been regarded as an agent of sentiment, by many painters, the chief agent of sentiment. But for Church's generation the atmosphere signified even more; for without a layer of air and water surrounding the earth, man's home would be uninhabitable. Thus Church portrays on canvas the blend of air and water that makes life possible, that inspires his spectator to "breathe." There is reverence in his painted atmosphere, as well as mood and drama. How to recreate the earth's envelope modified by latitude and season would be second

189. Frederic Edwin Church. *Mt. Desert, Moonlight*, c. 1860. Oil on lightweight cardboard. 0.140 x 0.304 (5½ x 13⅜ in). Cooper-Hewitt Museum, New York, The Smithsonian Institution's National Museum of Design, 1917-4-1355

to none among Church's concerns as both scientific and religious landscape painter. This concern would draw him close to the luminists. Yet Church's eye reached out still farther into the atmosphere than was characteristic of his luminist associates—indeed, even beyond the atmosphere into the celestial order.

Andes of Ecuador was Church's first painting to project a sense of the "cosmic," the cosmic both in its Humboldtian comprehensiveness and its almost God-like scope of time and space. The scale of the scene, suggesting the length and breadth of the doublespined backbone of South America, connotes a whole continent which in turn represents a portion of the globe's surface. And the luminous axis emanating from the life-giving sun links the earth to the anchor of the solar system, bonding the equilibrium of a designed cosmos. In other works, too, Church looked about the planet and beyond for sublimities distant and near. In 1860 Church intercepted on a small canvas a passing incident in the cycle of the universe: the large meteor that arced for a few nights through the earth's atmosphere giving to viewers a few minutes' pause for thoughts of the infinite. A gem of nocturnal luminism, *The Meteor* (1860; private collection) is as much a portrayal of the darkness of outer space as it is a portrayal of a missile shimmering for an instant on a path measured in light-years. Closer to earth and almost familiarly cosmic is a night-luminous study of the moon (fig. 189); but as sheer natural spectacle, perhaps no painting by Church provokes thoughts of the cosmos more dramatically than his *Aurora Borealis* of 1865 (fig. 190; see also figs. 191-192). Overhead, flashing, waving, vibrating sheets of electric hues speak at once of the very outer limits of the stratosphere and the mutual attraction of the earth's poles. Such phenomena as these could have been assimilated in Puritan cosmology.

Church was not to be dependent upon any one source of inspiration for the

191. Frederic Edwin Church. *Aurora Borealis*, c. 1860-1870. Oil on lightweight cardboard. 0.162 x 0.252 (6⅜ x 9¹⁵⁄₁₆ in). Cooper-Hewitt Museum, New York, The Smithsonian Institution's National Museum of Design, 1917-4-1376

192. Frederic Edwin Church. *Aurora Borealis*, c. 1860-1870. Oil and pencil on light-weight cardboard. 0.227 x 0.336 (8¹⁵⁄₁₆ x 13¼ in). Cooper-Hewitt Museum, New York, The Smithsonian Institution's National Museum of Design, 1917-4-1261

typology of natural history. *Andes of Ecuador,* which so compellingly evokes McCosh's text, was nonetheless painted a year before the publication of *Typical Forms and Special Ends in Creation.* Church was simply portraying what was in the air of 1855.[15] He had assimilated the typology of science very naturally—one might even say, instinctively. He had grown up in a tradition which would have prepared him to look for parable and prophecy in nature.

Within the past dozen or so years scholars of Puritanism have been delineating the contours of seventeenth-century New England Calvinist thought and its legacy in American intellectual life. In *The Puritan Origins of the American Self,* Sacvan Bercovitch examines the rigorously articulated rationale which served so effectively to shape the social structure and set in motion the divine revolution of the Massachusetts theocracy. His characterization of Puritan typology alerts us to the potential application of that system in both historical and geographical guise:

In its original form, typology was a hermeneutical mode connecting the Old Testament to the New in terms of the life of Jesus. It interpreted the Israelite saints, individually, and the progress of Israel, collectively, as a foreshadowing of the gospel revelation. . . . With the development of hermeneutics, the Church Fathers extended typology to post scriptural persons and events. Sacred history did not end, after all, with the Bible; it became the task of typology to define the course of the church ("Spiritual Israel") and of the exemplary Christian life. In this view Christ, the "anti-type," stood at the center of history, casting His shadow forward to the end of time as well as backward across the

Old Testament. Every believer was a *typus* or *figura Christi,* and the church's peregrination, like that of old Israel, was at once recapitulative and adumbrative. In temporal terms, the perspective changed from anticipation to hindsight. But in the eye of eternity, the Incarnation enclosed everything that preceded and followed it in the everlasting present.[16]

The Puritan community was one whose identity was defined typologically, a community prefigured in the Old Testament. Of the community's leaders, one after another was perceived as a Nehemiah, a Jacob, a Moses, a David, a Solomon—as a prophet among the self-styled New Israelites who had, in crossing the Atlantic, made their exodus to a new world. On these wilderness shores God's Chosen People might erect a "New Jerusalem," build "the City of God."

As scrupulous Calvinists the Puritans of course submitted themselves to the discipline of the community, presumably, but not assuredly, the community of the Elect. As members of this holy nation, they were the world's Saving Remnant. While the reign of Christ was the ultimate goal of history, the individual was not to model himself directly after the Son of God. It would be presumptive so to identify oneself with Jesus, the anti-type. Rather, the individual would seek to emulate the prophet of old, the type who had himself prefigured Jesus. Integral to this spiritual code was the subordination of the self to the community of the church and the anticipation of the ultimate

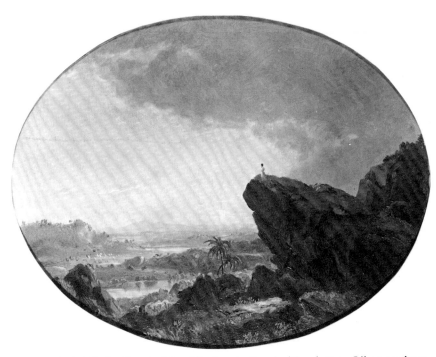

193. Frederic Edwin Church. *Moses Viewing the Promised Land*, 1846. Oil on academy board. 0.241 x 0.311 (9½ x 12¼ in). Collection of Dr. Sheldon and Jessie Stern. Photo: Kennedy Galleries (not in exhibition)

fulfillment of history with the advent of the Kingdom of God. Subjectivism and self-indulgence were constrained through subservience to Old Testament typology and the mode of discourse of the prophets. The regimen demanded of the individual a watchful eye toward the peculiar symptoms of his time and place. Rather than fossilizing and becoming irrelevant, the Puritan ethos proved to be extraordinarily responsive to circumstances of the moment and capable of assimilating the new. The historical process was itself the revolution by means of which the world would be redeemed. In his mysterious ways God directed his Elect to accomplish his ends. For "those with eyes to see, and ears to hear" the divine revelation was ever immanent.

Bethune, Bushnell, McCosh—each in his writings exemplifies the discipline and the dynamic of the Puritan principle. And so, too, does Church. Note the titles of his early subjects, drawn from the Bible and *Pilgrim's Progress*: *Moses Viewing the Promised Land* (1846; fig. 193), *The Deluge* (one in 1846, another in 1851; locations unknown), *Christian on the Borders of the Valley of the Shadow of Death* (1847; Olana, Hudson, New York), *Christian and his Companion by the River of the Water of Life* (1848; location unknown), *The Plague of Darkness* (1849; location unknown). Promise, purgation, pilgrimage reflect the prophetic typology of Puritanism, but expressly New World subjects also fit the typology with significant frequency: *Quebec Viewed from the Chaudière* (c. 1845; Wadsworth Atheneum, Hartford, Connecticut), *The Reverend Thomas Hooker and his Party on their Journey Through the Wilderness, 1636* (1846; Wadsworth Atheneum), *The Charter Oak* (1846; Olana, Hudson, New York), *West Rock, New Haven* (1849; New Britain Institute of American Art, New Britain, Connecticut). These represented the scene of General Wolfe's martyrdom to the cause of Anglo-Saxon hegemony in North America; a band of exiles destined to found a "chosen Israel" on the banks of the Connecticut; the tree in which the most "democratic" charter of any colony was securely hid; the hill in a cave of which the three regicides found safety in 1661—more than a century before the symbolic regicide of George III. To a reader of George Bancroft's *History of the United States* (1844), the epic history of the period, all these sites would have been hallowed by associations which prefigured the Revolution and American independence.

The artist carried the typology into his own day. West Rock stands as a reminder of the past while it guards the pristine pastoral scene before it, sanctifying Connecticut's present. *New England Scenery* (1851; George Walter Vincent Smith Museum, Springfield, Massachusetts), is a manifesto of the ideals which are to set the type for the nation's expansion. The youth at the foot of the tree in *Mt. Ktaadn* (1853; fig. 194) envisages Maine's interior as it will be in his manhood, a "middle ground" (to quote Leo Marx) between the city and the wilderness. Even now a glorious sky seems to herald that dreamed-of future.[17] Later in the decade, Church's horizons would reach out beyond such parochially Puritan confines in time and space, as his imagination came to be nourished by a larger typology of national and natural history.

That so many subjects painted in his youth could be thus informed connotes the origins of Church's own self-identity, an identity that gave direction to his entire career. "A nineteenth century type of the Puritan," his friend Charles Dudley Warner characterized the painter. Church "followed the Trinitarian Congregational worship of his parents."[18] The ethos of New England was in his blood. While we are primarily concerned with how that identity affected his work, it was also to exhibit itself in nonpictorial terms. This is literally the case in his avoidance of sketching and painting on the Sabbath. And in that fateful last winter before the Civil War the painter would stay up into the night with Theodore Winthrop discussing, while others slept, the signs of the conflict that would soon engulf the nation. Within only months Church's companion of those wakeful nights would fall a martyr to the great cause of freedom. Humorously rather than tragically symptomatic of the depth of the painter's Calvinism is Jervis McEntee's mournful reflection: "I think one trouble with Church and the Osborns, too, perhaps, is that they are too heavily weighted with their Presbyterian strictures to have a very good time."[19] Nineteenth-century Puritanism would have a profound bearing on both the content and the style of Church's art. One cannot separate what he painted from what he believed.

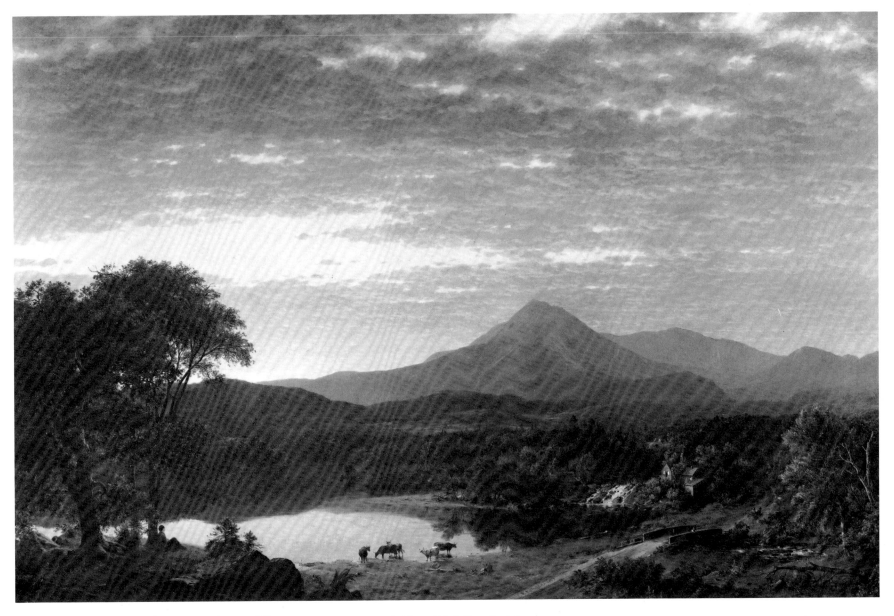

194. Frederic Edwin Church. *Mt. Ktaadn,* 1853. Oil on canvas. 0.921 x 1.403 (36¼ x 55¼ in). Inscribed, l.c.:
F. E. Church—1853. Yale University Art Gallery, New Haven, Connecticut; Stanley B. Resor, B.A. 1901, Fund

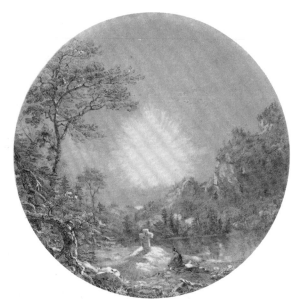

196. Thomas Cole. *The Cross in the Wilderness*, c. 1844. Pencil; white, gray-green, and greenish brown chalk on gray illustration board. Inscribed, l.l.: *T. Cole*. Diameter: 0.186 (7⁵/₁₆ in). John Davis Hatch Collection. Photo: National Gallery of Art, Washington

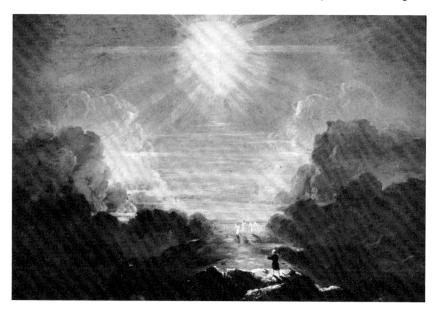

195. Thomas Cole. *The Pilgrim of the Cross (The Vision)*, c. 1846-1847. Oil on canvas. 0.365 x 0.518 (14³/₈ x 20³/₈ in). The Brooklyn Museum, New York; Gift of Misses Cornelia and Jennie Donnellon (not in exhibition)

* * * *

As a consideration of Church's beliefs clarifies his work and helps us to qualify his relationship to luminism, so too will a consideration of his artistic milieu help us further to qualify that relationship. A close look at the work and world views of two very dissimilar landscape painters, for example, each resembling Church in some ways, contrasting with him in others, should serve as touch stones to his art. One is Church's teacher, Thomas Cole; the other, John F. Kensett. Religiously and aesthetically Church stands between the two. Interestingly, it is in his picturing of the atmosphere, the arena of light-action, that the similarities and differences between Church and these two painters come into sharpest focus.

Cole's attitude toward light is substantially different from the attitude toward light exemplified by Kensett. From the very outset of his career Cole's interest in light seems to have been conditioned by his absorption in chiaroscuro. For him light and dark were interdependent; within a composition they acted in concert to produce the desired emotional affect. They were indispensible to his primary pictorial concern, which was "expression." Light and its concomitant dark were instruments of mood, protagonists in the painted drama. Gradations of light-dark were disposed strategically between poles—calm and excitement, repose and agitation, death and life. Light, in effect, was an actor on the stage of the artist's soul. Its absence could personify evil; its presence, good. Indeed, as Cole in his later years became the evermore devout churchman, he focused with increasing deliberateness on the soul's ordeal in its lonely pilgrimage on earth. It was at this period that Cole embarked on his series, the Cross and the World. In the fifth and last of the series, *The Pilgrim of the Cross at the End of His Journey* (c. 1846-1847), illustrated here by the oil sketch for it, the association of light with Christ is made explicit through the form of a radiant silvery white cross (fig. 195; see also fig. 196). Whether we are looking at Cole's Pilgrim, his *Home in the Woods* (c. 1846; Reynold House Museum of American Art, Winston-Salem, North Carolina), or his *Schroon Mountain* (1838; Cleveland Museum of Art), the painter's stance in the landscape is neither that of the Puritan or the transcendentalist. Instead, it is the stance of a soul nurtured in the tradition of the English dissenters of Lancashire.[20] Cole's God, Cole's Savior, has more to do with the next world than with this world. For him, life on earth was essentially a striving for purity of spirit, a preparation for the life after death. Virtually nothing, it would seem, of the ideology of New England's Elect surfaces on the pages of his soul-searching journals. Cole stood alone in nature, looking for intimations of immortality.

While in his last years the painting of religious allegories was to become the consuming interest of Cole, he was at the same time making progress in his portrayal of the visible world about him. By the mid-1840s a change was clearly taking place in Cole's procedures and perceptions. Sketching in oil from nature was becoming a more frequent practice with him. There is a vividness of

197. Frederic Edwin Church. *The Catskill Creek*, c. 1845. Oil on panel. 0.299 x 0.406 (11¾ x 16 in). Olana State Historic Site, Taconic Region, New York State Office of Parks and Recreation, Hudson, New York. Photo: Frick Art Reference Library (not in exhibition)

198. Thomas Cole. *Home in the Woods*, c. 1846. Oil on canvas. 1.118 x 1.676 (44 x 66 in). Reynolda House, Inc., Winston-Salem, North Carolina (not in exhibition)

perception in the studies which Church, coming to Catskill, New York in 1844 at age eighteen, was straightway, to emulate. Interestingly, none of Cole's oil sketches from nature quite match the perceptual snap of Church's transcript of the Catskill Creek (fig. 197), which probably dates from the pupil's second summer with the teacher. Even by this early date it could be that the pupil was pressing the teacher to look more sharply. A performance, such as the one illustrated by this panel, could well have prompted Cole's remark: "Church has the finest eye for drawing in the world." Influences could easily have gone both ways at Catskill. Certainly, a fresh visual intensity marks Cole's work of the time. It shows not only in oil sketches but also in other media. This is especially noticeable in pencil sketches, which, aided by Chinese white, convey the illusion of light. Alongside these, Cole's pencilled impressions recorded in the sketchbooks of earlier years look like linear neoclassical abstractions—tracings rather than perceptions.

Cole's visual breakthrough of the mid-1840s was almost immediately registered on canvas. With *Home in the Woods* (c. 1846; fig. 198), for example, no earlier Cole quite compares in vividness. Yet the painting is not a celebration of the act of perception. The painter has not taken the tack that his luminist successors in the 1850s and sixties would pursue. Rather, Cole has incorporated into the old system of his art the new sense of reality seized first in his sketches.

Vivid perception is used to make a dream—the scene is an imaginary composition—appear real. Cole has simply extended his range of expression to attain an unprecedented degree of freshness, purity, newness. *Home in the Woods* is a vision suspended at the threshold of the virgin wilderness. Here the virtuous pioneer and his family live in harmony in a pristine American Eden. The concept and the structure of the painting are conventional, for the composition harks back to a formula institutionalized in the eighteenth century. A plate from a book published by the English connoisseur of landscape, the Reverend William Gilpin (fig. 199), illustrates those precepts which are known to have played a role in the genesis of Cole's style some twenty years before.[21] However, Cole has burdened the formulaic composition with a narrative—he would have considered it "historical"—content that goes beyond mere landscape connoisseurship. *Home in the Woods* is redolent with effects and details that conspire to illustrate a moral. The "expression" of the light, of the color, of the form, is pregnant with the spirit of a new start in civilization: eagerness, enthusiasm, energy, elation. Like the evergreens within it, the vision partakes of eternal life.

Home in the Woods can, if considered in isolation from the rest of Cole's oeuvre, be deceiving, in that it may invite inference that the artist was wholeheartedly endorsing a popular vision of the self-reliant pioneer, the archetypal hero of American expansionism. However, hidden in the scene, as

199. William Gilpin. *Lake Windermere*, 1808. Aquatint. 0.100 x 0.165 (3¹⁵⁄₁₆ x 6½ in). Plate IX, *Observations on . . . Cumberland and Westmoreland* (London, 1808), I (not in exhibition)

200. Thomas Cole. *Schroon Mountain*, 1838. Oil on canvas. 1.010 x 1.600 (39¾ x 63 in). The Cleveland Museum of Art; The Hinman B. Hurbut Collection (not in exhibition; at right)

Gray Sweeney has pointed out, is a cross, effected by a post and beam at the angle of the cabin, signaling a commitment that supercedes Jacksonian notions of Manifest Destiny and American perfectibility.[22] To view the painting in a proper context it should be considered alongside the artist's *Schroon Mountain* of 1838 (fig. 200).

Schroon Mountain is a virtual transcript from an Adirondack sight, a sight ideally made by nature for Cole. In the foreground, all is portrayed as struggle, strife, and suffering. Forms are blasted; colors are fiery. Further into the scene a storm drenches flaming autumn foliage, seemingly to quench fire. In the distance to the right, undulating contours of the mountain's shoulder suggest muscles gathering superhuman strength. Over the whole looms a pyramid, its thrust animated by a spirit that wills to break free of the world of gravity into the pure, ethereal sky. To the poet-painter Thomas Cole this ready-made natural drama proffered release from "this vale of tears," which it is man's sad fate to endure throughout his fleshly existence. *Schroon Mountain* presented a vision perfectly attuned to a mind burdened by a sense of man's fallen state. Here, nature for a moment might solace the individual pursuing his lonely pilgrimage through a sinful world. Poetically, *Schroon Mountain* spoke to the afflicted of a realm beyond the physical and the temporal, pointed to the soul's immortality. No wonder the painter considered the scene "our grandest view."

Cole's conception of time seems, for all practical purposes, to have been defined with reference to recorded human history. The above two works would mark the outer limits of time in his schema. To Cole the region of Schroon Mountain had the aspect of nature "unchanged," an aspect which "the scene has worn for thousands of years." The Indians in their canoe on the lake or hidden amidst the forest trees of the foregound exist outside of history. They are simply part of nature. In the presence of this scene Cole's thirst to transcend the world of historical time, and hence of sin and suffering, could be slaked. In the poem by the painter that Noble, his biographer, links with the scene, Cole fancies himself ascending an "ever-lasting throne," there on "the vast mountain peak" to wear "a spirit's form."[23]

Home in the Woods would seem to represent Cole's turn from a sight that has not changed in time to a sight that has not been in time. It is a vision of things beyond the horizon, belonging to a moment that history cannot corrupt; it is the paradise of a yeoman and his family living in an eternal present that will never be more real than a beautiful idea. *Home in the Woods* reflects a bright nostalgia for an ever-elusive future. It is the dream of hope.

Cole's yearning to transcend symbolically the time of a fallen world may have been answered in *Schroon Mountain*, because the scene appears intrinsically endowed with a structure of transcendence already implanted in the artist's

mind. That structure, I suggest, would have been that of *The Transfiguration* by Raphael, illustrated here by an engraving which—not insignificantly—was once in Church's possession (fig. 201). Perhaps no single easel painting was more revered by the romantic generation than this late work by Raphael, a work alive with the spirit of religion, redolent of the sublimity of Michelangelo, premonitory of the drama of the baroque, rich in its gradations of expression. Indeed, to Cole, expression was "the soul of this picture." Expression animated the whole. The painter of historical landscape—that landscape that enacts a drama—would have appreciated the breath-taking dynamics of Raphael's composition, powerfully generated by varying reciprocities of centrifugal and centripetal force. Resolving the drama of the whole, and foil to the supergravity of the figures in the lower foreground, is the weightless figure of Christ, "lifted from the earth," as Cole put it, "like a bright exhalation."[24] The depressed foreground of *Schroon Mountain,* peopled by its shattered trees, and the lifting pyramid beyond and above are the analogous poles of the Adirondack scene. To the romantic Thomas Cole *Schroon Mountain* must have appeared a natural transfiguration.

Cole's art is pervasively anthropomorphic. Even the way he applies paint to the canvas is emotionally expressive. In *Home in the Woods* the pigment varies from smooth (as the glass of a mirror) to sharp (as the resin of pine). His handling itself helps make the dream seem real. In *Schroon Mountain* the pigment first appears to writhe in the torment of metaphorical flames, then to float in the balm of ether. Cole's sensuous touch is as personal as is his vision.

The subjectivism of Cole reflects an orientation to nature very distant from that of the man who in 1859 painted *Shrewsbury River* (fig. 202), John F. Kensett. The contrast between this masterpiece of luminism and the two Coles just considered becomes more apparent if one compares *Shrewsbury River* to other canvases by Kensett which date from earlier in the decade. His *Sunset, Camel's Hump, Vermont* (c. 1851; fig. 80), for example, is typical of the artist at this date and quite emphatically brings Cole to mind as its composition reflects those principles laid down by Gilpin and followed by Cole (cf. fig. 203). In one sense, in fact, *Camel's Hump* is nearer to the aesthetic of Gilpin than are *Schroon Mountain* and *Home in the Woods,* for, in contrast to Cole, neither the English connoisseur's nor Kensett's landscapes was "historical." Still, Cole normally observed Gilpin's prescriptions, departing from them principally when expression demanded forms which the landscape connoisseur had counseled against. Thus, for example, the carefully fashioned mountain range in *Home in the Woods* abides by the advice that accompanies the plate from *Observations on the Mountains and Lakes of Cumberland and Westmoreland* illustrated in figure 203. Cole is careful to see to it that the silhouettes of the various masses do not run exactly parallel to one another, and thus he avoids an effect which Gilpin would have deemed "disgusting." On the other hand, in *Schroon Mountain* Cole ignored the connoisseur's counsel and focused—for reasons which are well apparent to us—on a wedge-shaped peak that Gilpin would doubtless have

considered not quite graceful enough to please.[25]

Shrewsbury River must have been a very daring sight for Kensett to have put onto canvas in 1859. Its boldly flat and empty composition seems a quiet rejection of both Gilpin and Cole; its message seems to be that less is more. There is not a hint of the narrative or drama of Cole. Gilpin's precepts are almost willfully violated. Consider the mountain. Its profile, which would impress Gilpin as "disgusting," would impress Cole as inexpressive. Contrast it with the mountain labeled the "easy line" in Gilpin's engraving, a line so suggestive of the draped arms and shoulders of the Apollo Belvedere (see fig. 188) that one cannot help but suspect a conscious human bias on Gilpin's part. How far, indeed, from that classic paradigm of grace is Kensett's stolid and inert lump! Yet, for Kensett, this immobilized and ungainly mountain mass is

201. After Raphael, *The Transfiguration,* 1517. Engraved by H. Robinson; entitled: *He was Transfigured before Them.* 0.157 x 0.110 (6³/₁₆ x 4⁵/₁₆ in). Olana State Historic Site, Taconic Region, New York State Office of Parks and Recreation, Hudson, New York. Photo: Tony Novak (not in exhibition)

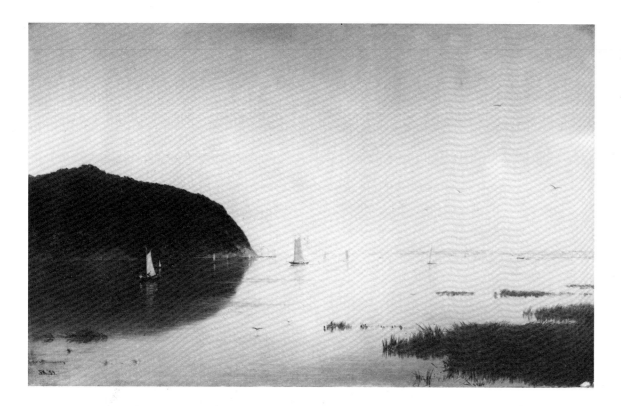

202. John Frederick Kensett. *Shrewsbury River*, 1859. Oil on canvas. 0.457 x 0.762 (18 x 30 in). Inscribed, l.l.: *J F K '59*. The New-York Historical Society, New York

203. William Gilpin. *An Explanation of the Shapes and Lines of Mountains*, 1808. Line engraving. 0.210 x 0.146 (8¼ x 5¾ in), sheet size. Plate III, *Observations on . . . Cumberland and Westmoreland* (London, 1808), 1 (not in exhibition; at right)

just what he required to grasp the unconscious in matter and to confer upon the earth that gravity and permanence necessary as foil to the human ephemera of sailboats flitting over nature's surface. The still, spare monumentality of *Shrewsbury River* appears almost to mock the earnest, intensely personal histrionics of Thomas Cole. And Kensett's handling, so self-effacing that it is almost invisible, seems a tacit admonishment to the demonstrative pigment of his predecessor. Through negation and stasis he was effecting a hushed exit from the stale conventions of Gilpin, the sentimental anthropomorphisms of Cole, the clutter of both.[26]

The implied space and time of *Shrewsbury River* are, seemingly, no longer limited by the parochial scale of man's recorded history. Unobtrusively this painting brings the spectator in touch with a universe that is superhuman. Barbara Novak's invocation of Emerson's words comes automatically to mind:

"I become a transparent eyeball: I am nothing; I see all; the currents of the Universal Being circulate through me; I am part or parcel of God."[27] It was out of New England Unitarianism that the Concord philosopher fashioned transcendentalism. *Shrewsbury River* resonates with Emerson's dictum: the image's all but anonymous creator inadvertently becomes a visual spokesman for His emotion.

* * * *

He has attained the distinction—that rarest distinction—of being a painter without a manner, almost without a style. His pictures are not tinged with his own personality. He paints, not nature according to Mr. Church, but simply nature. His eye, like every other man's, is a camera with a brain behind it; but his brain gives him the power to transfer to

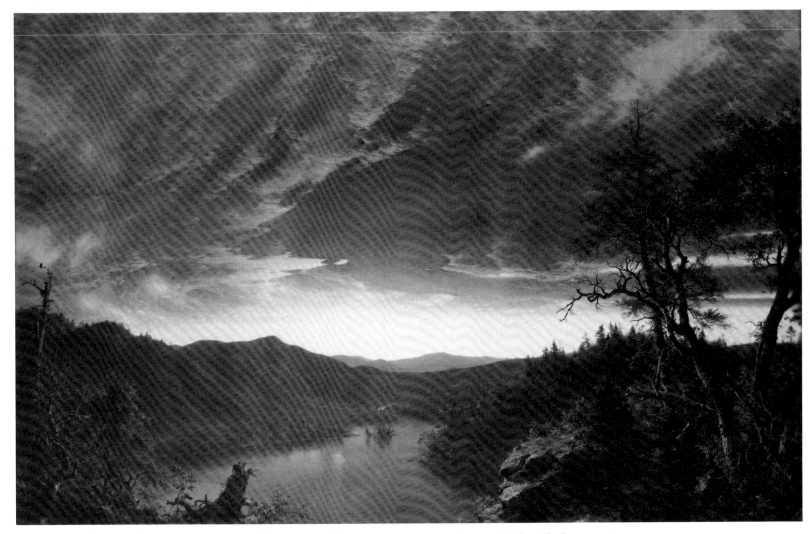

204. Frederic Edwin Church. *Twilight in the Wilderness,* 1860. Oil on canvas. 1.016 x 1.625 (40 x 64 in). Inscribed, l.r.: *F.E. Church 60.* The Cleveland Museum of Art; Purchase, Mr. and Mrs. William H. Marlatt Fund

canvas the vanishing forms and tints and shadows thrown upon his eye, unaffected by the medium through which they have passed, except by selection, combination, and unification. It is this absence of any signs of mood or manner in his works that we attribute the charm of a deficiency in feeling which is sometimes brought against him. [Unidentified review of *Twilight in the Wilderness,* Church scrapbook, Olana]

These words of 1860, on first reading, appear to apply just as well to *Shrewsbury River* as to *Twilight in the Wilderness* (fig. 204), Church's great challenge of that year to his fellow-landscapists. The characterization of

Church's non-manner, almost non-style, does indeed suggest Kensett. But, whereas Kensett would seem in his masterpiece of 1859 to reject Cole's concept of anthromorphic landscape, Church was to adapt that very concept with a sense of detachment that parallels the sense of detachment of the luminist. The dissemblance of art has so enthralled the critic that the mood, the feeling of *Twilight in the Wilderness* elude his recognition. Still, there is as much poetry and drama to be discovered here as there is in *Home in the Woods* or *Schroon Mountain.*

206. & 207. Frederic Edwin Church. *Twilight in the Wilderness,* 1860. Details, fig. 204. The Cleveland Museum of Art

205. Frederic Edwin Church. *Twilight, "Short Arbiter Twixt Day and Night,"* 1850. Oil on canvas. 0.813 x 1.219 (32 x 48 in). Inscribed, l.c.: *F. E. Church '50.* Collection of the Newark Museum, New Jersey (see plate 3)

Though Church's mastery over the representation of atmosphere came only after the experience and study of years, the prospect of that mastery was intimated at least as early as his *The Ox-Bow* (fig. 19) and *Moses Viewing the Promised Land* (fig. 193), works dating from his days of tutelage under Thomas Cole. *Moses* is especially suggestive, for Church's depiction of the subject demonstrates how he, like the prophet within the scene, was compelled to gaze directly into the light of the sun. Probably it was no later than 1845 that Church attempted to paint his first twilight. Dawn and dusk were soon to become his favorite subjects, subjects which of course directed his attention to the problems of painting air and vapor. By 1850, the year that he exhibited *Twilight, "Short Arbiter Twixt Day and Night"* (fig. 205), Church had become associated with the painting of splendid skies. In the years that followed, one sensational twilight after another—sometimes a sunrise, more often a sunset—proceeded from his easel in a parade of celestial displays that climaxed in the early 1860s with *Twilight in the Wilderness* (figs. 204, 206-207) and *Our Banner in the Sky* (1861; private collection).[28]

What is of especial interest here, however, is not the cataloguing of those celestial landmarks, but the examination of Church's technique in capturing the illusion of atmosphere on the two-dimensional surface. There is, for example, a marked difference between sketches which date from around 1850 and those which were made some five or ten years later. The Mt. Desert study

208. Frederic Edwin Church. *Landscape, Sunset,* c. 1850. Oil on lightweight cardboard. 0.203 x 0.318 (8 x 12½ in). Cooper-Hewitt Museum, New York, The Smithsonian Institution's National Museum of Design, 1917-4-505A

210. Unidentified photograph of clouds, c. 1855-1860. Olana State Historic Site, Taconic Region, New York State Office of Parks and Recreation, Hudson, New York (not in exhibition)

209. Frederic Edwin Church. *Sunset, Hudson, New York,* c. 1855-1860. Oil on lightweight cardboard. 0.215 x 0.312 (8⁷/₁₆ x 12¼ in). Cooper-Hewitt Museum, New York, The Smithsonian Institution's National Museum of Design, 1917-4-1313

(c. 1850; fig. 87), undoubtedly the basis for the sky in *Beacon Off Mt. Desert* (1851; fig. 88), reveals the essential points to be noted about the earlier sketches. Here there is an edginess, a paintiness, that causes the cloud bars overhead to look unnaturally solid. The brushstrokes recall Cole's taste for thick pigment, which he had found suitable to expressive treatment.

It should be observed that it was not Cole's practice to make oil studies which focused primarily on the sky. When he did study the sky it would be through the medium of a pencil or ink drawing, accompanied by word notations. Seldom, if ever, in the rendering of skies, did he manage to get away completely from the linearity of his draftsmanship. Soft, for example, as the clouds of Cole's *View Across Frenchman's Bay from Mt. Desert Island, After a Squall* (fig. 107) of 1845 may appear, there is an edge, still, that separates their substance just a little too crisply from the surrounding air. Sketching directly from the sky in oil, with the first-hand evidence of nature as his imperative, Church persisted until he had purged the artificiality of the line from his vision. By the mid 1850s his clouds are no longer disturbed by the jarring opacity remarked in *Beacon Off Mt. Desert* and the study used for that painting. There is no surfeit of pigment; no unnatural border inadvertently solidifies the cloud vapors in a twilight study which probably dates from the later 1850s (fig. 208). In *Twilight in the Wilderness* the discipline of careful study achieved its consummation.

211. Frederic Edwin Church. *Icebergs, Newfoundland,* 1859. Pencil and white gouache on brown paper. 0.275 x 0.454 ($10^{13}/_{16}$ x $17^{7}/_{8}$ in). Inscribed (and underscored), l.c.: *2. Beautiful luminous reflected light;* u.r. and c.r.: *July 4th/59;* and l.r.: *Cape Johns and Gull Island July 4th/59.* Cooper-Hewitt Museum, New York, The Smithsonian Institution's National Museum of Design, 1917-4-293

If there is still less of Church in *Twilight in the Wilderness* than in the study, it would be due, in part, to meticulous execution in the studio as compared to the haste of the out-of-doors. Also, at the easel, the painter could have had available, for study, photographs such as the one illustrated in figure 210. With heaven's light penciled on the spot with the brush, and heaven's light penciled through the camera lens onto the plate, Church was readied to "transfer to canvas the vanishing forms and tints and shadows thrown upon his eye, unaffected by the medium through which they have passed." As he subordinated his hand to the hand of the Creator, Church's painting became the type for nature's Bible. As his Puritan forebears had emulated the manner of the prophets of the Old Testament, the artist was emulating the manner of nature.

By the end of the 1850s all the obtrusive qualities of Cole's treatment of the pigment had vanished. Church had willingly surrendered himself in the process of recording nature's truth. Oil studies of the aurora borealis and of moonlight, with cloudless skies—almost brushlessly—recreate the earth's atmosphere (figs. 189, 191, 192). But even without the benefit of color Church's observation of an Arctic scene executed in pencil and Chinese white (fig. 211) startles us with its saturation of light and air.

* * * *

No account of Church's feats of representation of atmospheric phenomena would be complete without reference to the artist with whom and to whom he was repeatedly compared, both at home and abroad. Americans must have derived the keenest satisfaction from reading British reviews equating Church's "aerial perspective" with J. M. W. Turner's and proclaiming the New Englander the heir of "England's great Raphael of landscape."[29] At Olana there is a large (14 x 21¼ inches) engraving by T. A. Prior after J. M. W. Turner's *Tower and Castle of Heidelberg* (fig. 212). If we compare this print with another print at Olana, a small engraving after Claude Lorraine's *Embarcation of the Queen of Sheba* (fig. 213), we can see mirrored in the two prints the difference between the mature and the immature Frederic Church. The engraving after Claude is as linear and edgy as any work by Church painted at age eighteen or twenty; in the engraving after Turner line and edge are effaced as in works painted by Church at age thirty-six or forty. Between painting *Moses Viewing the Promised Land* (fig. 193) and *Sunrise Off the Maine Coast* (1863; fig. 214) Church had become an "atmospherist."

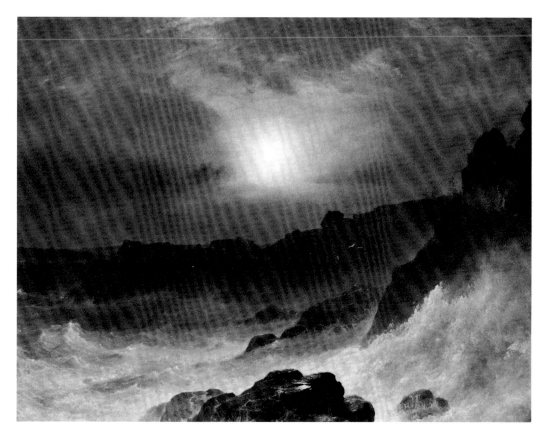

212. After James Mallord William Turner. *The Town & Castle of Heidelberg.* Engraved, 1849, by T. A. Prior. 0.368 x 0.539 (14 x 21¼ in). Olana State Historic Site, Taconic Region, New York State Office of Parks and Recreation, Hudson, New York (not in exhibition; below, at left)

213. After Claude Lorraine. *Embarcation of the Queen of Sheba.* Engraved by J. C. Varrall. 0.012 x 0.016 (4¹¹⁄₁₆ x 6¼ in). Olana State Historic Site, Taconic Region, New York State Office of Parks and Recreation, Hudson, New York (not in exhibition; below, at right)

214. Frederic Edwin Church. *Sunrise Off the Maine Coast,* 1863. Oil on canvas. 0.915 x 1.220 (36 x 48⅛ in). Inscribed, l.r.c.: *F. E. Church 1863.* Wadsworth Atheneum, Hartford, Connecticut; Bequest of Mrs. Clara Hinton Gould. Photo: E. Irving Blomstrann (at left)

215. Frederic Edwin Church. *Labrador,* 1859. Oil on paper. 0.095 x 0.302 (3¾ x 11⅞ in). Cooper-Hewitt Museum, New York, The Smithsonian Institution's National Museum of Design, 1917-4-745A

In Church's early works the various parts tend to be separately perceived, itemized feature by feature. This is particularly noticeable in the oil on panel transcript of about 1845 which is reproduced in figure 197. This Catskill scene, already familiar to the reader, echoes perceptual habits of the young painter's mentor. Cole's *Home in the Woods* (fig. 198) comes to mind as an example. The tendency is to particularize distinctly the several features of the landscape. While fading blues signify "aerial perspective" there seems, all the same, to be no air. Such airlessness might be attributed to the peculiarities of atmosphere which happened to prevail at the moment: broad daylight in North America. But the same airlessness might prevail in a Cole at any other time of day and in any other latitude or longitude indicated in his painting. To think of the wholeness of atmosphere was in keeping neither with Cole's habits of perception, nor with his habits of conception. To him trees, mountains, clouds, bodies of water were autonomous characters to be incorporated into a poetical or dramatic—but not natural—harmony. Light, even, was thus autonomous, still another landscape character with a role to play. Nature supplied the parts for the whole, but the whole itself was formed by the artist's will. The unity of a landscape by Cole resided in its creator's temperament, and not in nature's atmosphere.

In his oil studies Cole was more concerned with the local hue and tone, and he habitually chose to paint from nature in broad daylight as did his pupil—witness Church's *The Catskill Creek* (fig. 197). What catches one's eye in comparing this early transcript executed under Cole's supervision with one executed barely five years later at Mt. Desert is the shift in Church's objectives in sketching out-of-doors (see fig. 87).[30] He was becoming more concerned with nature's whole than with nature's parts, recording in oil as best he could the influence of light on sky, earth, and water. His eyes were already set on a course that would lead him on to climes, warm, humid, and verdant, as in Jamaica, to climes hot, dry, and arid, as in the Holy Land—a course that would lead him indeed to any clime he could get to, even the Arctic.

Studies Church made off the coast of Labrador (figs. 215-217) parallel his verbal observations about the skies of northern latitudes in a broadside for *The Icebergs (The North)* (plate 19):

THE SEA. From the brightness of an iceberg the eye is so affected that the sea appears very dark. Accordingly the beholder here looks out through a gradually widening avenue to the broad water, and finds it a very dark purple or violet. . . .
THE SKY. From the same optical causes that the sea is dark, the sky is sombre, rather than a luminous azure. . . .[31]

As the painter rid his atmosphere of traces of his self and submitted his will to the will of God a new "unity" appeared on the canvas, not a unity imposed upon nature by a temperament, as we saw with Cole, but nature's own unity. In the mind of the critic of *Twilight in the Wilderness* "the absence of any signs of mood or manner" had "the charm of a deficiency in feeling" for which some viewers reproached the painter. Yet without the whole of nature's truth before

216. Frederic Edwin Church. *Labrador,* 1859. Oil on paper. 0.203 x 0.302 (8 x 11⁷⁄₈ in). Cooper-Hewitt Museum,
New York, The Smithsonian Institution's National Museum of Design, 1917-4-818

217. Frederic Edwin Church. *Labrador,* 1859. Oil on paper. 0.109 x 0.303 (4¼ x 11⅞ in). Cooper-Hewitt Museum, New York, The Smithsonian Institution's National Museum of Design, 1917-4-802

him on the canvas the spectator could not discern the hand and mind of the Creator.

Light and the elements were effectively united on Church's canvas. The painted part was fused with the painted whole. All, thus, was "of a piece," nature's piece.[32] And so spectators before *Twilight in the Wilderness* would forget that they were looking at an easel painting hanging on the wall of a Broadway gallery—not the reality itself, as in the Adirondacks, the White Mountains, or the interior of Maine.

How that representation of nature, which marks the work of Church's maturity, was achieved brings the discussion back to the engraving of Heidelberg (fig. 212). It could easily be that Church's acquiring a fine print after Turner was occasioned by the reading of *Modern Painters,* especially the inspired chapters in volume 4 on "Turnerian Mystery."[33] An engraving of the caliber of the one illustrated here would have been an invaluable adjunct to John Ruskin's text. Every form is seen through a layer of air. There are, in contrast with the print after Claude (fig. 213), no sharp lines to deprive space of air, atmosphere of life. Surely it must have been as much with the help of prints after Turner as with photographs of skies that Church—always, of course, consulting his own studies—accomplished his goal of recreating nature on the canvas.

One wonders, too, if knowledge of Turner's sketching on white ground motivated Church's gradual abandonment, in the early 1850s, of the ochre- or salmon-colored ground that had been standard with him as long as he was under Cole's sway. Sketching in oil, rather than in watercolor as did Turner, Church could all the same do better with a lighter ground in his pursuit of atmospheric truth. Whether or not Turner's example encouraged this particular move by Church, the English master's great triumphs in the representation of light bear directly upon similar triumphs on the part of his American heir. That Church could have painted the *Andes of Ecuador* had he not by 1855 seen an engraving after Turner seems almost unthinkable. This painting and another Turneresque triumph, *Morning in the Tropics* (1877; fig. 128), bracket Church's greatest years. And between them are still other triumphs that visibly lay tribute to the English genius, among them *Cotopaxi* (fig. 225), *Aurora Borealis* (1865; fig. 190), *Sunrise Off the Maine Coast* (fig. 214).

In *Sunrise Off the Maine Coast* the effect of the sun burning through the mist-filled atmosphere leaves nothing to be desired of Turner, though in painting it Church may have specifically taken up the gauntlet thrown before him the very year, 1863, that the picture was painted: "Mr. Church seems to disdain commonplace themes [while Turner] needed only a craggy inlet and a

roaring chaos of surf and one wild sea-bird for a theme."[34] The most telling distinction to be made between the Englishman's stance in nature and that of his American emulator is suggested by the well-known story behind Turner's painting of *The Snowstorm*. Turner had himself lashed to the mast of a ship where for four hours he lived, figuratively as well as literally, in the eye of a storm.[35] Such a physically subjective immersion in the elements would be a rite too sensuous for the Calvinist conscience. Yet there is a sense of rite observed in Church's *Sunrise*, albeit one more of the spirit than of the flesh: on the virgin, unpeopled shore of the New World, the painter for a moment experiences an epiphany.

Alongside this elemental revelation of 1863, Church's juvenile *Grand Manan Island, Bay of Fundy* (fig. 53), painted eleven years before, carries the spectator's eye back into a more static, less immediate dispensation of nature. We seem to stand outside the scene, looking not, to be sure, at the Queen of Sheba and her entourage but, still, at someone who might have migrated from that classic arcadian port to the Bay of Fundy. There is much of Claude to be remembered in *Grand Manan Island*. Here we cannot "breathe" as we can before "the living" scene of Mt. Desert painted hardly a decade later. *Sunrise Off the Maine Coast* speaks of more than just the inspiration of Ruskin and his hero. It speaks of the maturing of an American painter's world view. In a word, it speaks of the hand of the Creator, just now lifted from the freshly formed face of his new world, a "stern and rockbound coast," designed to temper the spirit of his Chosen People.

* * * *

I suppose [the] heavens to mean that part of creation which holds equal companionship with our globe, . . . [a] heavenly plain of . . . waters, as it were, glorified in their nature, no longer quenching the fire, but now bearing fire in their own bosoms; no longer murmuring only when the winds raise them or rocks divide, but answering each other with their own voices from pole to pole; no longer restrained by established shores, and guided through unchanging channels, but going forth at their pleasure like the armies of angels; no longer hurried downwards for ever, moving but to fall, nor lost in the lightless accumulation of the abyss, but covering the east and west with the waving of their wings, and robing the gloom of the farther infinite with a vesture of divers colors, of which the threads are purple and scarlet, and the embroideries flame. This, I believe, is the ordinance of the firmament; and it seems to me that in the midst of the material nearness of these heavens God means us to acknowledge His own immediate presence as visiting, judging, and blessing us. "The earth shook, the heavens also dropped, at the presence of God." [John Ruskin, *Modern Painters*, 4, pt. 5, chap. 6, sect. 8-9]

One feature of the discussion of atmosphere in the fourth volume of *Modern Painters* is particularly germane to the topic of Church's relationship to luminism. It is Ruskin's insistence upon the express spirituality of atmospheric phenomena. He cites passages from the Bible which illustrate how the Deity literally has revealed himself in the visible heavens to his prophets and his people. And he insists that the Deity continues right into the present so to reveal himself. The God of *Modern Painters* is a God who is not abstract and aloof from man but is human and close at hand. Ruskin's God understands the need of common people for signs. And so the artist is summoned to stand in nature, poised to discern the revelation from on high. Clouds, "spirits of the air,"[36] will bear tidings of the divine will which, visible to all, are first perceived by prophet eyes. The Creator of Ruskin's world is democratic; he is equally mindful of the clay of mankind and of his chosen leaders.

How Ruskin himself might implement his preaching is a matter of immediate interest here. The most apt illustration is to be found in volume 3 of *Modern Painters*. Here plates after the author's own studies of cloud effects compel thoughts of the supernatural. One, in particular, *The Lombard Apennine*, would appear to be intended, though Ruskin does not so specify, as the very illustration of his prescriptions.[37] At one point in the text he advises the artist to behold the heavens as would a prophet of the Old Testament. At another point he advises the artist to paint landscape as Michelangelo would, had the divinely inspired genius lived in the nineteenth century. While the manifestations of Puritan self-denial were beyond Ruskin's discernment (he never recognized the spirituality mirrored on Church's canvases), that self-denial only meant that the Puritan painter would eschew the Anglican's over-explicit evocation of the Sistine ceiling in the alpine sky.

The archetypes of art were as much imprinted on Church's mind as was Michelangelo on Ruskin's, or Raphael on Cole's. He had assimilated them into the subtleties of Calvinist thought. In the great temple of nature the typological mind of New England would have watched the clouds—and, for that matter the mountains—for configurations of Genesis (cf. figs. 218, 219). That there is a kinship between the sublime rush and sweep of forms in Michelangelo's *Creation of the Sun and Moon* and Church's sketch is not the result of pure chance. The attraction to the numinous in nature issues from a susceptibility of mind. Ruskin was simply confirming habits of religious imagination that were ingrained in romantic Christian consciousness. While Church himself, out of Puritan prudence or out of Puritan discipline, disdained comment on the meaning of his art, his associates, conveniently for us, reflect in their words the suggestiveness of nature's wonders. So, for example, Church's companion of 1859 in the North Atlantic, the Reverend Louis Noble, with Bible in hand and mind, revels in Arctic revelations. In the realm of icebergs and midnight twilights he beholds "Solomon in all his glory," "the lion lying down with the Lamb," "The City of God." The clergyman stands amidst "the glorious visions of St. John," while the painter sketches the "Power and the Beauty" of the white iceberg, "bathing in the bosom of Purity." Then:

As I sit and look at this broken work of the Divine fingers,—only a shred broken from the edge of a glacier, as it is—whisper these words of Revelation: "and hath washed their robes, and made them white in the blood of the Lamb." It hangs before us, with the sea and the sky behind it, like some great robe made in heaven.

In this realm of "endless grace of form and outline!—Endless, endless

218. Michelangelo. *Creation of the Sun and Moon*, 1508-1512. Fresco. Sistine Chapel, Vatican, Rome. Photo: Alinari (not in exhibition)

219. Frederic Edwin Church. *Study of Landscape and Sky*, c. 1855-1860. Oil on paper. 0.229 x 0.305 (9 x 12 in). Cooper-Hewitt Museum, New York, The Smithsonian Institution's National Museum of Design, 1917-4-323C (not in exhibition)

Beauty!"[38] Noble's mind is free—free to associate form and idea. He is a pastor-poet spontaneously sanctifying his holiday. "Strange, supernatural": Church jotted these words on paper alongside an iceberg sketched in pencil and white gouache.[39] Church's sketch and Noble's whisper are religious impressions, impressions which tacitly reaffirm Ruskin's assertion that the Deity continued to reveal himself in nature.

* * * *

Such a sunrise! The giant Alps seemed literally to rise from their purple beds, and putting on their crowns of gold to send up a hallelujah almost audible.
[Washington Allston, *Letters*][40]

While they do not describe a particular painting, Washington Allston's words of 1803—not unlike the exclamations of Louis Noble—are informed with an eye for the supernatural. It is interesting that Church owned an engraving, *Moonlight* (fig. 220), after Allston's *Moonlit Landscape* (fig. 13), a painting of some significance for the study of luminism. John Wilmerding has noted the extraordinariness of this modest canvas of 1819, so "acutely prophetic of the luministic painting" of the mid-century, so charged with "evocative" silhouettes, so reminiscent of that "sense of the sublime and magical" that distinguishes the artist's earlier work.[41]

Why might Church have had the engraving? Some of his nightscapes evoke it. Certainly its expression of suspense and mystery are echoed in features of *Twilight in the Wilderness* and *Cotopaxi* (Allston said that even the vapors of the atmosphere might speak to the human soul). Both men shared a concern with the spiritual. Yet they were hardly kindred spirits. Allston sought for the divine in things not fully material, in events not wholly of this earth. He painted the miracles of the Bible. But his God, unlike the God of Church, could suspend the laws of the material world if he so chose. Allston's God would have seemed vague, distant, and inaccessible to Church, if Bushnell's thoughts about the relationship of God to his creation and his creature are any guide. For the mid-century theologian God was always immanent: the material and immaterial, the flesh and the spirit, the natural and the divine had become one in Christ. God manifested his will through the laws of nature and the forces of history. Bushnell's faith was more practical, more down to earth, more democratic. He said that "every man is sanctified according to his faith; for it is by this trusting of himself to Christ that he becomes invested, exalted, irradiated, and finally glorified in Christ." The individual soul is "flooded" with "a wondrously luminous joy." As "the light of God is revealed within," spirit and flesh become one in a holy incandescence.[42]

In the Cooper-Hewitt Museum there is an extraordinary oil study by

Church, extraordinary because it seems graphically to embody the very words of Bushnell (fig. 221). Above, a dazzling white sun "irradiates" mist-filled air in a glory of silvery gold. Below, a dashing, sparkling rapids reflects the gentle heavenly light beheld so near at hand. As was the theologian in thought, so is the painter in sight thrilled by the immanence of God and the Son of God. Church's study betokens an experience of the holy far removed from the vague abstractions, the unnatural miracles of Allston. Indeed the study reveals spontaneously what *Andes of Ecuador* reveals by design (fig. 186).

The immediacy of the divine manifestation that distinguishes mid-nineteenth-century liberal Calvinism, suited as it is to the capacities of the common person, echoes in a curious way the baroque of the Counter-Reformation. Comparison of the natural sunburst of Church's sketch with the contrived sunburst of Bernini's *Ecstasy of St. Theresa* (1645-1652) becomes irresistible (fig. 222). How Protestant is the one, how Catholic the other! For Church, and for Bushnell, no priest, no saint, is called upon to mediate between the individual and his God. No sensate paroxysm of ecstasy is needed to wed spirit and flesh. Just words and light. Out of the Protestant Reformation comes belatedly the Puritan baroque, or better—in reference to the nineteenth century—the "natural baroque." Indeed, the latter characterization is hardly amiss, as Church's viewers were given to comparing his landscapes to cathedrals. Pure nature would not tolerate the sensuous distortions that rendered the churches of Giovanni Lorenzo Bernini, or even more so those of Borromini, abhorrent to Protestant sensibilities.

Such sensibilities doubtless have to do with Church's ignoring of baroque Rome. Fascinatingly, however, he became enamoured of a more congenial derivative of the style in Mexico, the Churrigueresque, a style distinguished by its dissolving—hence dematerialized—surfaces. At Olana is a watercolor (not by Church) of the interior of the Dominican Chapel of the Rosary in Puebla, Mexico (fig. 223).[43] Alongside the watercolor Church's study of early morning in the wilderness (fig. 221) itself becomes suggestive of an out-of-doors sanctuary. Equally close in spirit to that study is a gilded cloth "collage" at Olana of an Annunciation (fig. 224). This charming tourist souvenir, presumably a copy after a late-medieval northern, or possible Sienese, prototype, is undoubtedly an object with which Church would have been more at home than Bernini's *Ecstasy of St. Theresa*. Dematerialized in shining, almost luminous embroidery, its sunburst, angel Gabriel, dove, and Virgin belong to the painter's world of spiritualized light.

* * * *

But as we stand gazing on our ascending Lord, a cloud wraps Him from our view, and we hear, as it were, a voice saying, "why stand ye here, gazing?" and bidding us return to the observations of things clearly within range of our vision.
[James McCosh, *Typical Forms and Special Ends in Creation*, 1856][44]

Church's luminous transcript of the natural sunburst is compellingly re-

220. After Washington Allston, *Moonlit Landscape*. Engraved by George B. Ellis; titled *Moonlight*. 0.070 x 0.110 (2¾ x 4³⁄₁₆ in). Olana State Historic Site, Taconic Region, New York State Office of Parks and Recreation, Hudson, New York (not in exhibition)

miniscent of the fifth scene of Cole's Cross and World series, in which the Christian pilgrim, about to depart his earthly life, is confronted in the heavens by a glowing, silvery white cross (compare figs. 195 and 221). The comparison is significant as it serves to illustrate the distinction between allegory and typology. Cole's image is explicit; Church's, implicit. The latter's reticence about interpreting his own meaning points to the Calvinist precept that one must never *assume* that he is unmistakably of the Elect nor that he has directly, unequivocally, received assurance of his salvation or redemption. Even Moses, standing on the mount, did not with his eyes behold God (fig. 193). In the New Dispensation of divine light intimated in the study of morning atmosphere there is a sense of the immediacy of the divine presence as spirit and matter become one. Yet Church, the new Israelite, like Moses the old Israelite, does not behold his God directly.

The language of Noble, Church's companion in the North Atlantic, the language of Ruskin, the language of the painter's admirers reflects this Protestant diffidence toward the overt recognition of the divine. Noble speaks of effects that are "almost supernatural." Ruskin proposes that the landscape painter look at nature "as if" or "as though" he were one of the prophets of the Old Testament. Critics would commend Church for getting "the suggestion of the scene." The artist himself said that it was "the effect suggested" by a sunset that inspired him to paint *Our Banner in the Sky*. It was under the duress of the Civil War that Church responded thus to nature, and his sharing of the

perception with compatriots through the medium of a chromolithograph published in the early weeks of conflict was done more out of zeal for the national cause than out of desire for profits. Church, addressing himself to the country at large, perhaps felt a peculiar necessity to be explicit on this occasion.

Church would have been alone in nature when heaven favored him as seer with its sign of promise for the Union. It was quite otherwise on the night of December 23, 1864, when he and millions in the north together witnessed a spectacular display of northern lights. Herman Melville was only one among the many who interpreted the phenomenon as a portent of imminent victory for the Union. Spectators before Church's *Aurora Borealis* (fig. 190) would, in 1865, have remembered that terrestrial halo of a "million blades that glowed the muster and disbanding."[45]

One reason for the intense interest in atmosphere on Church's part is that the atmosphere was at once incomparably expressive and incomparably ductile. In the presence of the hushed beauty of a perfect sunrise, sketched in the privacy of nature, one might hear "the still small voice of calm" of his Maker. In the presence of the sublime beauty of a twilight translated from the actual into the ideal on canvas, one might, with the multitude, behold the heavens declare the glory of the Almighty. Such celestial superlatives seemed the very voice of prophecy speaking, in a moment, of things past, present, and to come. For an age fascinated by time, and a people conscious of linear advancement toward a culmination of history, the atmosphere could appear as time compressed, distilled, charged. Nowhere else in nature did so much change so fast. To Louis Noble icebergs seemingly telescoped the processes of nature. In one he fancied a whole "age of ruin" recorded by the action of a single summer. But with a twilight even a change of minutes could be detected. Church's atmospheres, as we have seen, are fraught with suggestiveness for the mind poised to contemplate in wonder upon Creation. The air enveloped the earth in mystery, hinting at nature's infinity, so Ruskin told his readers. The sky, as the passage quoted above from *Modern Painters* declares, can speak at once to the common man and to the seer of things ultimate.[46]

* * * *

But the main point for us now is to get ourselves ready for the grand struggle we are in, by duly conceiving the meaning of it, and receiving those settled convictions that will stay by us in all the changing moods we are to pass, and the discouragements we are to encounter. This immense enthusiasm, bursting forth spontaneous, in a day, and fusing us into a complete unity—how great and thrilling a surprise has it been to us! I know of nothing in the whole compass of human history at all comparable to it in sublimity. It verily seems to be, in some sense, an inspiration of God; and it is even difficult to shut away the suggestion that innumerable sacrifices and prayers laid up for us by the patriot fathers of the past ages, were being mixed in now with our feeling, and, by God's will, heaving now in our bosom.

[Horace Bushnell, *Reverses Needed,* 1861][47]

221. Frederic Edwin Church. *Study of a Sunrise,* c. 1855-1860. Oil on paper. 0.210 x 0.143 (8¼ x 5⅝ in). Cooper-Hewitt Museum, New York, The Smithsonian Institution's National Museum of Design, 1917-4-1364 (not in exhibition; above)

222. Gian Lorenzo Bernini, *The Ecstasy of St. Theresa,* 1645-1652. Marble. Santa Maria delle Vittoria, Cornaro Chapel, Rome. Photo: courtesy Bernard S. Myers, *Art and Civilization* (New York and London, 1967) (not in exhibition)

Church's readiness to espy the spirit of the hour in the phenomena of the atmosphere was matched by an equal readiness to espy that spirit wherever on the globe's surface it might be encountered. Viewers thanked the painter for catching the "soul" of Niagara in his great canvas of 1857 (Corcoran Gallery of Art, Washington, D.C.). Two years later Church portrayed for those same viewers the "spirit" of the Ecuadorian uplands in *The Heart of the Andes* (Metropolitan Museum of Art, New York; see also fig. 187). A painting would be received as a "revelation of tropical landscape," a "revelation of a new phase of God's creation." Happily for his public Church was "endowed with a power to translate great subjects greatly." The *Andes of Ecuador* (fig. 186) would be a case in point. In the painting the artist imaged the union of nature and typology: "A vast unrolling, apocalyptic vision of nature opened by the pioneers of science," so Edgar Richardson once characterized it, though it was a generalized vision, one not readily joined to a nation's crisis of the hour.[48]

Quite different from *Andes of Ecuador* and more acutely cogent in its typology is Church's *Cotopaxi* (1862; Detroit Institute of Arts), a small version of which is shown here (1863; fig. 225). The public's commentary on *Cotopaxi* in 1863 constitutes an extraordinary historical document. It is remarkable how consistently the words of the painting's first viewers are imbued with the spirit of a nation caught up in the throes of a heroic struggle for survival, running parallel to Bushnell's words of 1861. *Reverses Needed* was delivered as a response to the altogether unexpected Union defeat at Bull Run in the first summer of the Civil War. Bushnell's discourse is a feat of inspirational typology. Commencing with a verse from Proverbs, "If thou faint in the day of adversity, thy strength is small," the minister proceeds through some twenty-seven pages to lace together, out of the Bible and American history, an impassioned summons to all his compatriots to suffer and to sacrifice in the blood and fire of war that the nation may fulfill its holy destiny. "We are born into government as we are into atmosphere," he writes. But the nation has been only once born, out of the mind of man. It must now be reborn, in the spirit of God that it and its people may be regenerated.

Pervading the discourse is the thrilling sense of the immanence of history's great contest between the forces of darkness and the forces of light, of an Armageddon in one's own time. Actually, Bushnell does not name the battle envisioned by the evangelist. Bushnell remains cautious about how much he may presume. "If I were a prophet, I would dare . . . ," he starts a sentence whose conclusion is left to the listener. As with Church, Bushnell's typology remains implicit, subject to the discipline expected of the Elect.

That Church and Bushnell breathed the same atmosphere of patriotic zeal we can be sure. Each suspecting the preordained prophet in himself, addressed himself, in accordance with his talents, to a common perception of the war's divine significance. Painting an Andean scene, Church would speak of the war only in the form of parable. Hardly a clue is offered in his printed sheet for *Cotopaxi*'s viewers. The text reveals that Church knows his geology as well—it should be noted—as Bushnell knows his Bible. One phrase stands out: "the newly risen sun." For an artist who loved puns (he even signed letters with a picture of a church, an object which appears, interestingly, in many of his paintings), indulgence in a sanctified pun need not have been sacrilegious. Indeed, the characterization, "the newly risen sun," is respectfully reiterated in any number of descriptions of *Cotopaxi*. Critics repeatedly stressed the point that the painting was a challenge to the mind of the beholder. In keeping with the reticence of the Puritan, Church made no prescription as to how *Cotopaxi* might be interpreted. The picture might suggest nothing; it might suggest anything. One scripture-minded viewer associated the lofty height of a volcano with "the City of God." Volcanoes, he continued, were "crested with the pillar of cloud by day and the pillar of fire by night, . . . pillars of warning rather than of guidance, like those which led the Israelites out of the land of bondage."[49]

Just the fact that a spectator could be prompted in the presence of the painting to invoke Genesis is itself indicative of the presence of the biblical type in the thinking of the age. One need only turn to Bushnell's discourse to see how the sacred word informed his perceptions of the historical moment. But it will be less with the Bible in print than with the Bible in stone that we are concerned, for of more consequence to our understanding of *Cotopaxi* is, I think, its "natural" typology. *Cotopaxi* made an enormous impression on the New York art public of 1863, probably for the very reason that the painting envisaged the great national drama then in progress. It mirrored the present ordeal; it prophesied its outcome. In the painting are reflected the emotional temper, the moral urgency, the collective will of the present and the promise of ultimate peace. Even a French visitor responded in kind. He saw the painting as a struggle between the forces of light and the forces of darkness: "la lumière . . . et les ténèbres."

The tension of a heroic contest of elements and the signs of resolution to follow are perceived in the words of countless spectators: "presiding and transcendent" amidst the "warring elements" looms the "monarch" of the landscape, the "beautiful" yet "terrible" volcano. As the principal "personage" in the drama, Cotopaxi "asserts itself" as the agent to which all else in the scene is "subordinate." It spews forth a "lurid" canopy of smoke across the sky, spreads a "sulphurous" veil before "the god of day." The heat which issues from the "rumbling nether fires" of the earth melts the murky white snow which has mantled the great "pyramid." Innumerable streamlets pour across the plains, joining to flood a great "new chasm."

"Gray" Cotopaxi flaunting its lofty black "plume" is "the demon" of the landscape, the analogue of Bushnell's divinely ordained war, the evil necessary to waken the people from spiritual complacency and test their readiness to suffer in the struggle for the world's redemption.[50] The hero of God's universe in this metaphysical drama is "the newly risen sun," whose glaring "red disc" "burns" with "portentous heat," illuminating the smokey mist, and plunging its "dull fire" like an "inextinguishable torch" upon the glinting "metallic" surface of the lake. In the waters of this "coppery" reservoir are gathered, as though in a crucible, the spirits of a united people whose common will is now to be fired, fused, and forged as the instrument of God.

The imagery of flame and sword pervades the descriptions. Yet, no one mentions, though it is there for all to see, the luminous, almost molten cross, which, uniting sun and earth, air, water, and land, consecrates the hour. Out of the heat of battling elements, out of the cosmic baptism of fire and shedding of blood, will come redemption. Emerging from the lake rapids "capriciously" descend into a cool, bluish mist, where the eye detects "the faintest suspicion of a rainbow." Here, and in the "vivid, emerald greens" of the "whispering" paramo grass, just now "refreshed" by water and by light, is reflected the "clear translucent" sky to the windward side of the volcano far in the distance. "Gloom," finally, is purged by "Heaven's fair light." On Church's great canvas "power, beauty, sublimity and pathos" become "blended in one harmonious whole."

Cotopaxi is a geological parable, a proverb drawn from the sacred "volume in stone." The canvas is as charged with the spirit of prophecy as is Bushnell's discourse. "The word, the meaning and the expression" of the great Andean volcano becomes a "revelation" to "those who have eyes to see and a mind to understand."[51] *Cotopaxi* is nature's type for the regeneration of America.

As with the Bible itself there are many different perceptions of *Cotopaxi*. Some deemed the painting "cold." An art form, addressed primarily to a mind nurtured in Calvinism, would inevitably strike some as forbiddingly "intellectual," "deficient in feeling." Yet one spectator was moved to exclaim: "'Cotopaxi' is 'The Heart of the Andes' throbbing with fire and tremulous with life."[52] Bushnell's text was seething with fire and life, but the seething was reined in by the spirit of the Puritan. Indeed, some applauded the restraint and dignity with which Church had portrayed a subject that others might have treated melodramatically. Just as the hour of national crisis called for personal discipline, for subordination of the self to the community, and for obedience of the community to the ordinance of God, so the stern volcano on the canvas demands a steeling of the national will. To those who would heed the word of nature, Church's *Cotopaxi* declares: first resolution, then consecration, finally, redemption.

What a contrast with the *Andes of Ecuador*! That earlier painting is a joyous paean to a divine universe. The very composition appears to soar in exultation. All, as it were, becomes a resurrection. The light of the sun expands without effort to touch and bless the whole earth. The atmosphere itself bears the

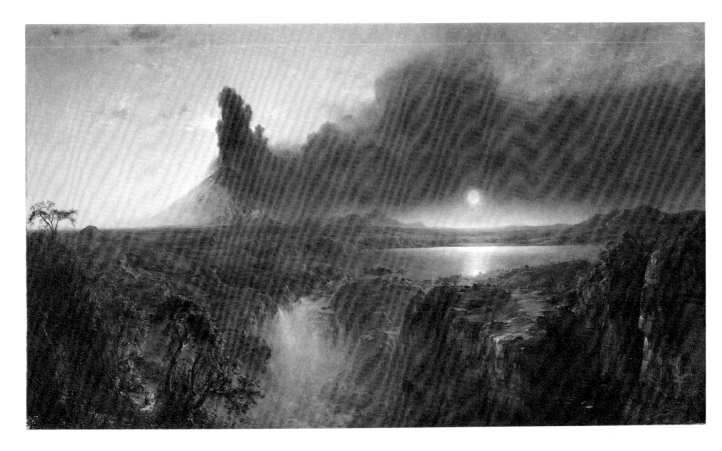

225. Frederic Edwin Church. *Cotopaxi*, 1863. Oil on canvas. 0.889 x 1.524 (35 x 60 in). Reading Public Museum and Art Gallery, Reading, Pennsylvania (see plate 18)

higher message of the painting. In *Cotopaxi*, however, the sun must suffer for the evils of this world. To one viewer its light seemed "scarce" able to "pierce the war-clouds" that would eclipse it. To another, "the volcanic vapors" seemed "transfigured and infused with light into a thousand delicate and fitful tones of color." How the mood of the sun might be interpreted depends upon whose gospel we are reading—a troubled Mark's or a serene John's. The atmosphere of a single painting could be viewed in differing religious lights, as we have seen in *Cotopaxi*. Or the religious tenor of the atmosphere could vary among works. Bound to the earth in the spirit of sacrifice, as in *Cotopaxi*, or ascending from the earth in the spirit of transcendence, as in *Andes of Ecuador*, the cross of light shone upon God's people, both in the hour of trial and in the hour of triumph.

* * * *

No lover of nature on this continent, no one who has bivouacked in the Adirondacks, explored the hills of New Hampshire or the forests of Maine, will but imagine he has

beheld the very scene. The time is about ten minutes after the disappearance of the sun behind the hill-tops. The air is clear and cool; the whole of the landscape below the horizon lies in transparent shadow; but the heavens are a-blaze. A-blaze, except the horizon gradually varying [in] tint, which passes from the silvery white to the faintest blue and the tenderest apple green; and into which the distant mountains thrust their broad, rich purple wedges. From this clear zone of tender light the clouds sweep up in flaming arcs, broadening and breaking toward the zenith, where they fret the deep azure with the dark golden glory. The pines show here and there their sharp black points against the sky; the stream gives back a softened vague reflection of the splendor which glows above it; the stillness of the twilight, and the solemnity of undisturbed primeval nature brood upon the scene; and that is all the picture.
[Review of *Twilight in the Wilderness*, in *New York Albion*][53]

Pregnant with beauty, not a leaf is stirred,
 Nature seems hushed in silent prayer,
No sound of man, or beast, or hum of bird,
 Breaks on the magic stillness of the air.
[J.I.Y.(?), "Church's Twilight." Unidentified clipping, from Church's scrapbook, Olana]

It were easier to untwist all the beams of light in the sky, separating and expunging one of the colors, than to get the character of Jesus, which is the real gospel, out of the world. [Horace Bushnell, *Nature and the Supernatural*][54]

"Our fathers brought forth" Just what does that mean? Not simply that they introduced something onto this continent. If so, where was it before they brought it in? And how could it be called a new nation if merely transferred? No, "Bring forth" cannot mean anything like "introduce from abroad." Lincoln is talking about generation on the spot. The nation is rightly called new because it is brought forth maieutically, by midwifery; it is not only new, but newborn. The suggested image is, throughout, of a hieros, gamos, a marriage of male heaven ("our fathers") and female earth ("this continent"). And it is a miraculous conception, a virgin birth. The nation is conceived by a mental act, in the spirit of liberty and *dedicated* (as Jesus was in the temple) to a proposition."
[Gary Wills, *Inventing America*][55]

In the discussion of *Cotopaxi* I have been mindful of two studies of the sanctifying American mind of the Civil War era. One is Ernest Tuveson's *Redeemer Nation* (Chicago, 1968). In an analysis of "The Battle Hymn of the Republic" Tuveson demonstrates how, almost stanza by stanza, the phrasing of Julia Ward Howe's Union anthem is stoked with the imagery of the Book of Revelation. It is an imagery that goes beyond metaphor to become reality. "The Battle Hymn of the Republic" is, in effect, a transposed Apocalypse. The other study is the "Prologue" to Gary Wills' *Inventing America*. The quotation given above encapsules the essence of his theme: that Abraham Lincoln, through evoking the cadence and phraseology of the Bible, sanctified for his age a profoundly secular document of the eighteenth century, the Declaration of Independence.

A painting such as *Cotopaxi* or *Twilight in the Wilderness* accomplishes in pictorial terms what "The Battle Hymn of the Republic" and "The Gettysburg Address" accomplish in song and speech. *Cotopaxi,* painted in 1862, abounds in the purgative imagery of the apocalyptic. The "demon" volcano brings war, the "newly risen sun" brings peace. And, although painted a year before Bull Run, *Twilight in the Wilderness* in its pictorial language resonates, too, with the written language of John the Evangelist. Indeed, the description of the painting quoted above seems almost a translation into natural history from the Book of Revelation. Church's great twilight of 1860 is a wilderness Apocalypse. Standing before the painting a new Adam could witness the second beginning of history in his New World.[56] Curiously though, in keeping with Adamic innocence, it is a benign issuing in of the millennium, one not precipitated by demon elements, for *Twilight in the Wilderness* connotes also birth as well as purgation. It is in this regard that Wills' study becomes particularly illuminating for the student of Church's paintings, not only in view of what he might learn from the content but also from the style of the painting. Church, I will propose, sanctifies America—and does so with as much style as Lincoln.

Twilight in the Wilderness (figs. 204, 206-207) is vibrant in the expressiveness of its parts, rich in the suggestiveness of its features. It fuses the unity of nature with the unity of art, fuses the actual with the ideal. The reality of a wilderness spectacle is seized upon the canvas. Each feature is acting in accordance with the other, each, in its own way, is expressive. So the pines, in the words of the critic for the *New York Albion,* "show here and there their sharp black points against the sky." There is alertness here. "The stream gives back a softened vague reflection of the splendor which glows above it." The water on the earth is responding appropriately to the action in the sky, where "clouds sweep up in flaming arcs, broadening and breaking towards the zenith," there to "fret the deep azure with dark golden glory." Like a heavenly chorus, the clouds sing a silent "Hallelujah!" They play a major role in this cosmic drama. The role of the stilled air is more passive; it is to be "clear," "cool," "transparent": quietly indispensable to the whole.

All features will thus have their parts to play. Note how Church seems to have invested features with the expressiveness and meaning of art as well as of nature. "The distant mountains thrust their broad, rich purple wedges" against the distant sky. We may think of these thrusting wedges as so many Schroon Mountains brought down to earth, where they now hold fast to the continental bend (cf. fig. 200). In their accelerated undulation may be perceived Gilpin's Apollonian grace (figs. 188, 203) joined to the power of the Sistine ceiling (fig. 218). Low to the horizon from the left, the God of Light would seem to propel the arrow from his bow. In this region of the sky's cloud vapors suggest a mystic genesis of superhuman energy, worthy of a Michelangelo. A cloudlet, transfigured in luminous gold by a sun unseen beyond the earth, races low across the heavens: it is the mystic dove in vapor, the holy spirit of a twilight annunciation, racing through the heavens (cf. fig. 224).[57] If we follow the implied trajectory of this "spirit of the air," we behold in the right foreground three trees "interlacing their boughs," as an observer in 1860 chose to note. One of the arboreal company reaches up aspiringly, posturing more stiffly than its cousins in Cole's *Home in the Woods* (fig. 198). Another tree is poised ecstatically. A third seems to bow in reverence as though it were the recipient of heaven's grace. "Pregnant with beauty, . . . Nature seems hushed in silent prayer." Is this untenanted wilderness the mythic virgin continent? The new nation "brought forth" by the marriage of heaven and earth?

Church, like others of his day, instinctively sanctified. The impulse was second nature. On his Arctic holiday, it will be recalled, Noble christened his vision. Icebergs could be anything and everything the imagination chose. But in the Old Testament, skies, not icebergs, spoke of God. And, as the author of *Modern Painters* reminded his readers, God speaks in the present as well. (Bushnell, for one, would have agreed.) Ruskin and Church might recognize the Sistine ceiling in the heavens or, better, the heavens in the Sistine ceiling. And so, too, might Church have recognized Raphael's *Transfiguration* in his conception of *Twilight in the Wilderness* (fig. 204). As we have observed, the dynamics of Raphael's composition were animated by the reciprocal interac-

tion of centrifugal and centripetal forces that are ultimately resolved in the figure of the ascending Christ. Cole did not object, as many did, to the separation in the composition between upper and lower. Indeed, in his own *Transfiguration, Schroon Mountain,* that separation corresponded to the implicit meaning for him of the scene: redemption is of the next world, not of this. Interestingly, Bushnell, who did believe in redemption within this world, felt that Raphael had, in the figures of Christ and the Apostles, clothed the "supernatural" in the "natural." But he saw "no bond of union" between the heavenly and the earthly scenes.[58] In effect *The Transfiguration* was "really two pictures." *Twilight in the Wilderness* compellingly evokes the powerful structure of Raphael's sublime painting, but Church's composition is unified. And in contrast with the mountains and skyline of Cole's painting, Church's mountains and skyline are low rather than high. Unlike his teacher, Church binds his aspirations to this world. Indeed, what makes *Twilight in the Wilderness* so different from *Schroon Mountain* is the liberal Calvinist theology of the nineteenth century that, in effect, composes it. On the canvas of the Protestant Frederic Church—in contrast to that of the Catholic Raphael Sanzio—the celestial and the terrestrial are united.[59] A Puritan transfiguration joins heaven and earth, as the triune God of history and nature enters time and space to create his Holy Nation. *Twilight in the Wilderness* was a vision of the Second Coming of the Son of man, inspiring America's Elect in 1860.

* * * *

In the woods, we return to reason and faith. There I feel that nothing can befall me in life,—no disgrace, no calamity (leaving me my eyes), which nature cannot repair. Standing on the bare ground,—my head bathed by the blithe air and uplifted into infinite space,—all mean egotism vanishes. I become a transparent eyeball; I am nothing; I see all; the currents of the Universal Being circulate through me; I am part or parcel of God.
[Emerson, *Nature*][60]

Who is a finer master of English than Mr. Emerson? Who offers fresher thoughts in shapes of beauty more fascinating? Intoxicated by his brilliant creations, the reader thinks, for the time, that he is getting inspired. And yet grazing in the field of nature is not enough for a being whose deepest affinities lay hold of the supernatural, and reach after God. Airy and beautiful the field may be, shown by so great a master; full of goodly prospects and fascinating images; but, without a living God, and objects of faith, and terms of duty, it is a pasture only—nothing more. Hence the unreadiness, the almost aching incapacity felt to undertake any thing, by one who has taken lessons at this school. Nature is the all, and nature will do every thing, whether we will or no.
[Bushnell, *Nature and the Supernatural*][61]

In his spirit, his heroic cheerfulness, he was still young, hopeful of the world, [and] as clear and sweet in his Christian character as he was decided in his luminous rendition of the atmosphere of the distant mountains of his great picture. He saw and felt the divinity of both worlds.

[Charles Dudley Warner, "Frederic Edwin Church," 1900][62]

The words of Emerson and Bushnell, juxtaposed as they are in the company of Warner's tribute to his late friend, may serve to bring into focus the contrast between the world view that a masterpiece of luminism can so cogently suggest and the world view which appears to inform Church's vision. A few comparisons between Church's work and works representative of various norms of luminist sensibility serve to place Church both visually and spiritually on the luminist chart. But needed first, as preparation for the conclusions which will be drawn in this essay, are a few remarks about how Church's relationship to luminism has been taken note of—or not taken note of—by students of the movement.

In his pioneer studies of luminism, written at a time that the phenomenon was just being identified, John I. H. Baur made no mention of Church. Yet there was one tantalizing observation in his article of 1948 which is pregnant in its implications: "Thomas Cole seems often to have painted in an atmospheric vacuum."[63] From the vantage point of contemporary scholarship it is easy enough to recognize in the teacher's deficiency the opportunity for the pupil whose career was dawning simultaneously with luminism. Both Cole's style and his death left a vacuum which Church would fill in the decades ahead. These circumstances have much to do with the distinctiveness of Church's relationship to luminism. First Baur and subsequently Barbara Novak in her landmark work of 1969 identified the luminist sensibility as one of passivity, quiescence, timelessness, effected on the canvas through monotones.[64] It is a sensibility indeed far removed from the assertive, active atmospheres in which light habitually appeared on Church's canvases. Theodore Stebbins was the first to take note of the higher-keyed regions of luminist sensibility and recognized the critical role played by Church in the formative years of the movement. Stebbins noted the seminal influence of *Twilight in the Wilderness* in the 1860s. That archetype of American sunsets brought to fruition a series of brilliant sunsets—and sunrises—that date back to the later 1840s at a moment, he points out, when no other major Hudson River school painter was exhibiting a comparable interest in effects of light. In that same early phase in Church's development John Wilmerding has remarked affinities between Church and Lane that suggest the possibility of the latter's influence as early as 1849 and the likely chance that the paths of the two men would have crossed at Mt. Desert in 1850.[65]

Stebbins, Wilmerding, and William Gerdts, all detect light effects which are presciently luminist at dates even as early as Church's months of instruction under Cole. At the present there appears to be considerable consensus that Church, especially through the medium of twilight atmospheres, was gravitating toward luminism in the years leading up to 1860. There is less consensus about Church's relationship to luminism after that date. Stebbins views *Twilight in the Wilderness* as signaling the conclusion to Church's involvement with this aesthetic, after which Church "went his own way." Wilmerding

regards Church's bold use of pigments newly introduced in the 1850s, especially the manipulation of cadmium reds and yellows, as the painter's "singular contribution to luminism"; but he adds that Church's "handling of composition and paint only peripherally borders on luminism." Wilmerding sees important affinities with the luminist canon continuing in Church's work as late as the radiant *Morning in the Tropics* of 1876-1877 (fig. 128).[66] This effectively would carry luminism in Church down to the end of the movement itself. It seems altogether inevitable that opinions on Church would vary as the nature of luminism is still in the process of being defined.

Does the sensibility of luminism constitute the guiding principle of American landscape painting in the quarter century after 1855? Or, is that sensibility one of several that run parallel through the period? Certainly in Church's case it would appear that luminism is most satisfactorily viewed as only part, though an important part, of the picture. At the very heart of the distinction would appear to be the contrast between Church's and the luminist's attitude toward "gradation." In luminist atmosphere the concept of gradation seems to apply primarily to the objective, essentially optical perception of nuances of tone. Though with Church the perception may be no less objective, the concern is for nuances of expression. With his teacher the concept of gradation was inseparable from human feeling; and as Cole marvelled at the gradations of expression in Raphael's *Transfiguration,* so Church marvelled at the gradations of expression throughout nature. The atmosphere offered perhaps the richest, surely the most spiritually quickened, repertoire of emotive effects. Unlike George Ellis' engraving (fig. 220) after Allston's *Moonlit Landscape* (though it too is in Church's collection), an oil-spattered engraving after James Suydam's *Long Island Sound* (fig. 226) exemplifies the understatement that marks the classic luminist with a scene whose composition would doubtless have scandalized Gilpin. Suydam, one of the most rarefied spirits of the luminist school, consistently dealt with effects of relative calm and repose. It would be unthinkable for him to have attempted the suspense and excitement of Allston's vision. Each scene is enveloped in an aura of silence; but in the one, nature has been hushed to attend a human mood. In the other, a nature that does not wait upon man needs no voice. As the sun retires the lighthouse awakens to illuminate the night. With Suydam the cosmic cycle is the occasion of tranquil reverie and wonder. To limit one's range to the visual realm of a Suydam is virtually to preclude the suggestion of the supernatural.

In evoking the Almighty Church might be prompted by the supernaturalism of Allston. But with Suydam there is too little with which to evoke the Almighty—only enough to evoke the Over-Soul. Of the convinced luminists, Heade alone would venture close to the realms frequented by Allston's imagination. The painter of *Thunderstorm Over Narragansett Bay* (fig. 63) presents us with a special case within the ordinance of the school. Ingeniously, in this suspenseful spectacle, the religiously equivocal Heade would seem to have caught the Almighty unprepared to manifest himself.

226. After James Suydam. *Long Island Sound.* Engraved, 1863, by S. V. Hunt. 0.146 x 0.228 (5⅜ x 9 in). Olana State Historic Site, Taconic Region, New York State Office of Parks and Recreation, Hudson, New York (not in exhibition)

The polar opposites in the expressions of the two copy engravings illuminate the principle of gradation in Church's art. For example, the *Moonlit Landscape,* a composition that is as tense as Suydam's is relaxed, actually exaggerates the wakefulness of Allston's original oil (cf. fig. 13). The animated expression is echoed in several features on the right side of *Cotopaxi:* the surface of the water, the distant hills, the disk of light. To the left of the volcano, however, the atmosphere bears a visage as tranquil, almost, as that of Suydam's sky.[67] And the water that brings the gentle light directly to the foreground in *Long Island Sound* is reminiscent of the serenity of the river's surface in *Twilight in the Wilderness.* Yet in the latter instance, the body of water is responding to a sky very different from Suydam's, for Church's sky is every bit as spell-binding as is Allston's. The luminous, thrusting shapes of the latter's clouds, so primed to reveal the wondrous, may indeed have been on Church's mind in 1860 as, painting his twilight miracle, he sought to portray the supernatural. To complete this cycle of comparison and contrast between the two engravings and Church's work, it should finally be noted that the sun hovering over the sound in Suydam's scene is as much in harmony with the elements as the sun hovering over the lake in Church's Andean scene is at strife with the elements. Church inherited Cole's mastery of the gradations of expression. Painting in the era of luminism it was the perceptual and spiritual comprehensiveness of his atmosphere, the urge to encompass every last atom, every last word of the firmament of nature's Bible—indeed, the instinct to see *all* of God's "Design" with

"Intelligence"—which makes Church unique. The eye of the classic luminist, of a Suydam, a Fitz Hugh Lane, a Kensett, looks not to interpret God's handiwork, but to merge with a nature which is itself God. For Emerson, gradation exemplified the self-contained system of the universe. For Church gradation articulated the typology of Creation. The one accords with the ways of the Over-Soul, the other with the ways of the Almighty.

There is a passivity about luminist vision which connotes a stance before nature significantly different from Church's. The luminist paints the scene offered by nature. He is more editor than composer. *Cotopaxi,* for example, though it depicts an actual landmark, is not a transcript of any one view of the volcano. In the painting a whole region has been characterized. What the spectator sees is the artist's interpretation of a chapter in the book of nature. One passage alone, that of the sun and the lake, might be compared to the whole of *Long Island Sound.* In the Suydam print there is the luminousness which anyone might see while standing by the shore. In *Cotopaxi* there is a luminous cross that only the eyes of the would-be Elect might see; Church on his canvas forges nature's parts to shape a spiritual whole. In contrast to the passive luminist, Church conceives of light as an expressive character, or a suggestion, or sometimes, as we have seen in *Cotopaxi,* a sign of the supernatural.

Such conceptions of light evoke the example of Cole. At the same time, we realize that Cole never mastered atmosphere as did his pupil. Church's interest in atmosphere compares more closely as a feat of observation to the interest in atmosphere of Lane, Martin Johnson Heade, Sanford Gifford, and Kensett. But in each case there is a distinction to be made between Church and whichever luminist one chooses to compare with him. Lane's genius in catching subtleties in the gradation of light and hue was never subordinated to the religious discipline that is endemic in Church's vision. No viewer, anxious for some intimation that he may be of the Elect, will find any hint of a divine earnest in the presence of, say, *Brace's Rock* (fig. 91). Here there is no Creator with "still small voice of calm" speaking to his creature, no separation between self and site. *Brace's Rock* is more ocular trance than natural epiphany, more the vision of a home-made transcendentalist seer than of a self-styled Israelite prophet.

While for decades Church and Heade were close friends the subject of religion must have been passed over in relative silence, conveniently eclipsed by their constant exchanges of shop talk and wit. Not in any way an establishment type, the unorthodox, somewhat alienated Heade seems to have had no inclination to picture the hopes of believers in the myths of the age. The features of his landscapes seem to eschew any suspicion of the anthropomorphic. Certainly his doggedly horizontal canvases will not admit of the theatrics of a *Twilight in the Wilderness.* There can be plenty of mystery in Heade's atmospheres, but the effect is more unearthly than supernatural. With Church he could probably have discussed the science of Humboldt more comfortably than the science of McCosh, and the drama that Heade would paint portrays a nature which would seem to be concerned only with itself. In *Thunderstorm Over Narragansett Bay* (fig. 63) he captured a moment of almost unbearable suspense. We wait for the eerie silence to be shattered by the thunderclap, wait for the tension of the elements to be resolved. But the resolution will be one solely of material forces. The storm will break and elements will be returned to equilibrium. Nature will go on, heedless of man, offering him no sensible parable. The strife of the elements in Church's *Cotopaxi* was witnessed in safety at a great distance (fifty miles according to the broadside), where the contemplating viewer might "interpret the lesson of things that the sun shines on as well as of the shining itself."[68] Heade's spectator sees humanity engulfed in the strife of the elements and is offered no sure refuge. Perhaps the religiously equivocal, aesthetically esoteric Heade is better attuned to the spirit of our time than the spirit of his.

In 1880 the author of Sanford Gifford's obituary in the *Art Journal* complained, "It had long been the wish of his admirers that he would give the world some large and 'important' picture that would do for his reputation what the 'Heart of the Andes' did for Church's." Any number of Church's large paintings would do as well to make the same point. Gifford's *Twilight on Hunter Mountain* (1866; fig. 85) is no such clarion call as *Twilight in the Wilderness.* Indeed, Gray Sweeney has interpreted the painting as a disturbingly eloquent indictment of man's invasion of virgin nature. *Hunter Mountain* may well be one of luminism's most urgent and timely statements, rare as it is powerful. Superficially, at least, Gifford's *October in the Catskills* (1880; fig. 4) resembles *Andes of Ecuador,* but the only symptom of reverence, aside from a vague sense of the "divinity of light" on Gifford's part, is the posture of the tree to the left leaning eagerly forward. Neither the drama of the soul, to recall Cole, nor the revelation of prophecy, to recall Church, moved Gifford to paint this canvas. Light-suffused air against a barely visible Catskill backdrop is the subject here. The same governing interest in light would claim his attention on the Acropolis. There, Gifford, according to his own words, chose to paint "not a picture of a building," namely the Parthenon, "but a picture of a day" (cf. fig. 30).[69] How different from Church's picture! From Athens in April of 1869 the latter wrote, "The Greeks gave a God-like air to all they did." As Gifford's shimmering *Ruins of the Parthenon* captured the air of the present, Church's firm *Parthenon* (fig. 29) captured the air of those "God-like" Greeks of the past—captured the type of classic form. On his canvas the elate and virile splendor of the columns, at once solid and luminous in the golden-red light of sunset, endures from civilization's genesis. The Parthenon seems no less tangible than the fluted Doric fragment which Church had at hand two years later in his studio when he painted the monument.[70] Church was only the luminist when it served his purposes to be so. He looked at the Parthenon for inspiration, not for light.

At an early point in this essay a discussion of Cole and Kensett was intro-

duced to prepare the way to locate Church's place in the discipline of luminist vision. Outside that visual discipline would be *Schroon Mountain, Home in the Woods,* and *The Pilgrim of the Cross.* Inside, as its very exemplar would be *Shrewsbury River.* Church's place is between these extremes. While he with Puritan reserve, discarded his teacher's overt literalism, he did not, in contrast to Kensett, discard Cole's concept of historical, dramatic landscape. But instead of locating his aspirations in ideal landscapes, actual or imagined, and removed from history's imperatives of the present, Church, as would-be member of the Elect located his aspirations according to those very same imperatives. Like Cole's, Church's God was personal. Unlike Cole's, his God was immanent in the processes of human and natural history. While Cole's *Home in the Woods* was to be a solace for the spectator, Church's *Twilight in the Wilderness* was to be a promise to the spectator. Cole's scene is a happy vision of a sanctified home. It is a pleasant dream, a respite from reality. Church's scene is a wondrous vision of a sanctified nation. It is a thrilling revelation which "enraptures" the beholder, inspires him to go forward into the world.

Church transforms the pictured poem of his teacher into a realized miracle. Cole's nature speaks of God. Church's nature speaks as God, directing man, the divine creature, and agent of His will. Without man this world has no purpose, for the world was created to be man's home. But, given free will, man fell, and with his fall began historical time and the necessity for the divine revolution which must be carried ever forward by the world's Saving Remnant, the Elect. Church's art is thus guided by a sense of progression and ultimate destiny. Before his canvas the spectator, as one of the Chosen People of God's nation, becomes protagonist.

With Cole, Church shared a sense of Christian concern. With Kensett, Church shared a sense of geological—cosmic—time and space. Like Cole, Church responded to the human in nature. Like Kensett, Church did not display his person in the handling of paint. But where Church and Kensett resemble one another the motivations differ. Church was praised for "the sublime repression of himself." The painter's hand did not intrude between the viewer and God's nature.[71] As a Cotton Mather was bound to the mode of speech and discourse of the type of the Old Testament prophet, so the nineteenth-century Puritan painter found himself morally bound to the type of nature. It would have been the concern to paint in the manner of the Elect that converted Church into a human camera. No such Calvinist discipline is intimated in Kensett's handling of his medium. There is discernable in Kensett no will to self-expression which must be subjugated. Kensett, like his prototype, indeed his type, Emerson, does not appear to conceive of himself as a fallen being, with a will to rebel, with a need for redemption. Like Thoreau, Kensett seems never to have "quarrelled" with his creator. He is indeed become "part and parcel of nature." As "transparent eyeball" the self evaporates. Kensett does not stand before nature as protagonist. He is not God's agent; there is no sense of separation between seer and seen. He does not, like the type of Church, say,

Moses, stand apart from nature, looking as a separate being upon the landscape, interpreting the divine meaning of the scene before his eyes.[72] With Kensett, in contrast to Church, there is no message behind the face of nature to be "seen by those who have eyes to see and a mind to understand."

Unlike *Twilight in the Wilderness, Shrewsbury River* is eventless (cf. figs. 204 and 202). The moment is not, as in Church's painting, "about ten minutes before the disappearance of the sun." Time is not fleeting; there is no aura of suspense, no sense of tension, no anticipation of resolution. *Twilight in the Wilderness* captures the moment one has been waiting for, the day's exquisite climax: for an instant one glimpses the supernatural in the natural. Church's spectator, as it were, *finds* himself in a divine universe, Kensett's *loses* himself in a divine universe. The God of the one is personal; the God of the other, impersonal.

"Truly 'there is an evangel in art as well as books,' and Church is among the prophets."[73] No Lane, no Heade, no Gifford, no Kensett, no painter of an essentially luminist vision could have provoked such a declaration—because no painter whose primary concern was the gradation of light in the earth's atmosphere could have spoken so to the spectator whose primary concern was with the revelation of God's action in nature and in history. The luminist's God would appear to be a God of being rather than a God of action. And, unless God acts there is nothing to prophesy. But if God does act, he must do so by temporal means to achieve his great object: to bring forth the Kingdom of Heaven. That great object for a Bushnell, a McCosh, a Bethune could only be effected through the incarnation of God in the world of relative time and space. And so God manifested himself on earth in the form of his Son, Christ, born of the Holy Spirit, Redeemer of mankind. If God is thus perceived in human terms, then history and nature will be perceived in human terms; for God is all-powerful, all-pervasive. Hence the anthropocentrism of Church's art. Hence the Apocalypse, Virgin Birth, Transfiguration, Second Coming in the guise of the American wilderness. Hence the cross of a redeeming or a resurrected Christ burning or glowing in the guise of Andean air.

Church's is a Trinitarian universe. And Kensett, as the very picturer of the transcendentalist eye, portrays a universe that must, at least in spirit, have been Unitarian. And certainly the God in whom his paintings would seem to glory is no more human in form than Emerson's Over-Soul. No wonder, the luminist's trees, mountains, water, and clouds do not gesture, do not posture.

A critic once in the mid-1850s called for the American artist to portray the "unconsciousness" of nature. Did Kensett know that he had done this when he painted *Shrewsbury River?* Whether he knew so or not, *Shrewsbury River* was, in 1859, a stroke of transcendentalist genius, just as, a year later, *Twilight in the Wilderness* was a stroke of Calvinist genius. If Kensett may be identified as a Unitarian luminist, then Church may be identified as a Trinitarian luminist or, rather, a luminist Trinitarian. For he was, as the luminist was not, "a nineteenth century type of the Puritan." And so Church's landscape, unlike the landscape of

the luminist, was the "type" of nature's Bible; his light, unlike the light of the luminist, the "type" of God. As Kensett, the "transparent eyeball," looked innocently at nature, Church, the watchful would-be prophet of the Elect, searched nature intently for the revelation behind the fact. Rather than a transcendentalist luminist, Church was a Christian atmospherist, who "saw and felt the divinity of both worlds."

But to picture Church for the late-twentieth-century mind in the light of Warner's memorial to him is to emphasize the painter's difference from us or almost to reassign him to the oblivion where in 1900 his reputation languished. Our understanding and his reputation are better served if we remember that in his prime his contemporaries went in droves to see, and wrote reams about, his paintings; that he could not walk the streets of New York without being embarrassed by the attention of passersby; that he was applauded when he appeared in his box at the opera. We do him and ourselves justice if we think of Church as a man who portrayed the great visions of his day on canvas. To think of *Cotopaxi* as the *Guernica* of our Civil War is to be close to the mark. Better still, perhaps, we might view it as the *Oath of the Horatii* of its time and place. As Jacques-Louis David's great picture galvanized the ideals of Frenchmen in 1784 and 1785, so Church's great picture galvanized the ideals of Americans in 1862 and 1863.

With each people there was in the public mind a configuration of thought ready to be symbolized. That configuration for an *Andes of Ecuador,* a *Twilight in the Wilderness,* a *Cotopaxi* was shaped by America's typology of the hour. As the artist's vision was readied by the type of the Apollo, the Sistine ceiling, *The Transfiguration,* so was the public's vision readied by the type, say, of I John 1:5, Proverbs 24:10, Mark 13:26-27. On his great canvases Church caught the atmosphere of the hour—for a moment illuminated the world. And the world thanked him for it: "He shows us in the splendid play of light, and air, and clouds that which we do not see, or seeing do not perceive."[74]

Notes

1. Henry Theodore Tuckerman, *Book of the Artists: American Artist Life* (New York, 1867), 375.

2. Cf. Matthew 13:1-17.

3. Cf. Barbara Novak, *American Painting of the Nineteenth Century: Realism, Idealism, and the American Experience* (New York, 1969), *passim*.

4. See David C. Huntington, *The Landscapes of Frederic Edwin Church: Vision of an American Era* (New York, 1966); *Art and the Excited Spirit: America in the Romantic Period* [University of Michigan Museum of Art] (Ann Arbor, Mich., 1972).

5. The sources of these and the majority of quotations cited briefly in the essay are (unless otherwise indicated) to be traced either in my *Landscapes of Frederic Edwin Church* or my "Frederic Edwin Church, 1826-1900: Painter of the Adamic New World Myth" (Ph.D. diss., Yale University, 1960). Some additional unidentified quotations are to be found in the F. E. Church clippings file of the New York Public Library or in the xerox copy, at Olana in Hudson, New York, of Church's scrapbook, which, alas, disappeared during or right after the campaign to preserve Olana, between 1964 and 1968.

6. Charles Dudley Warner, "Frederic Edwin Church" (1900), chap. 5. A copy of this manuscript is at Olana. This is the best source of information about the painter's early years. Warner did not live to complete the biography. He writes that Church developed an intimate friendship with Bethune.

7. Bethune, *An Oration Before the Phi Beta Kappa Society of Harvard University* (Cambridge, 1849), 40-41, 27.

8. In my monograph of 1966 I erroneously gave Bushnell's first name as Asa and his religious affiliation as Unitarian. For discussions of Bushnell's theology and the religious controversies at Hartford, see: William Alexander Johnson, *Nature and the Supernatural in the Theology of Horace Bushnell* (Lund, Sweden, 1963); Barbara M. Cross, *Horace Bushnell, Minister to a Changing American* (Chicago, 1958); H. Shelton Smith, ed., *Horace Bushnell* (New York, 1965). While Warner does not mention Bushnell, he remarks that Church, while "adhering to the lines laid down in his inherited faith, . . . was essentially liberal in his belief"; see Warner, "Church," chap. 5.

9. Horace Bushnell, *Nature and the Supernatural* (New York, 1858) and *Sermons for the New Life* (New York, 1858).

10. James McCosh, *Typical Forms and Special Ends in Creation* (Edinburgh, 1856; New York, 1881). The first American edition was published in 1857; the edition followed here is the one of 1881. It is interesting to note that Church's edition was published at a date when McCosh was endeavoring to accommodate Darwinism to Calvinism—or vice versa.

11. An invaluable resource for the student of American art who may be interested in pursuing the application of typology to landscape painting is James Moore, "The Storm and the Harvest: the Image of Nature in Mid-Nineteenth Century American Landscape" (Ph.D. diss., Indiana University, 1974). The implication of the differences in orientation to geology between Church and his teacher Cole is a provocative topic which cannot be considered in discussions of the two painters in this essay. Ellwood Parry is currently pursuing a study of the role of the science of geology in Cole's art.

12. McCosh, *Typical Forms*, 322, 331-332.

13. Theodore Winthrop, "The Heart of the Andes" in *Life in the Open Air and Other Papers* (Boston, 1863), 344; Winthrop describes the spectator as a "demi-god."

14. McCosh, *Typical Forms*, 409.

15. In a way that complements the approach taken in this essay, Barbara Novak examines the relationship between religion and landscape in "American Landscape and the Nationalist Garden and the Holy Book," *Art in America, 60*, no. 1 (1972): 46-57.

16. Sacvan Bercovitch, *The Puritan Origins of the American Self* (New Haven, 1975), 35-36; I am especially grateful for the stimulation of Sacvan Bercovitch, one of my colleagues at the National Humanities Institute, Yale University, during 1975-1976. I take this occasion to express my deep appreciation to the National Endowment for the Humanities and the organizers and fellows of the institute for providing me with that invaluable experience. This essay is essentially an outgrowth of that year.

17. The significance of the "middle ground" to American experience is explored by Leo Marx in *The Machine in the Garden* (New York, 1964). The mountain in Church's painting is adapted from studies of Katahdin but the intervening landscape is fictional.

18. Warner, "Church," chap. 5.

19. Jervis McEntee, "Diary," May 19, 1885; Archives of American Art, Washington, D.C. I am indebted to Garnett McCoy for calling this passage to my attention. William H. Osborn was the owner of a number of works by Church, among them *Beacon Off Mt. Desert* and *Andes of Ecuador.*

20. The subject of Cole's religious background and his own religious life is examined in Alan Peter Wallach, "The Ideal American Artist and the Dissenting Tradition: A Study of Thomas Cole's Popular Reputation" (Ph.D. diss., Columbia University, 1973).

21. For an extended discussion of the subject of the relationship of Gilpin's principles to the development of Cole's style, see Earl Alexander Powell, "English Influences in the Art of Thomas Cole (1801-1848)" (Ph.D. diss., Harvard University, 1974), chap. 2; also Powell's three articles, "Thomas Cole and the American Landscape Tradition," *Arts Magazine, 52*, no. 6 (Feb. 1978): 114-123; no. 7 (Mar. 1978): 110-117; no. 8 (Apr. 1978): 113-117. Cole's correspondence with Robert Gilmore abounds in references to Gilpin; see Howard S. Merritt, "Correspondence between Thomas Cole and Robert Gilmore, Jr.," *Baltimore Museum of Art Annual, 2* (1967): Appendix I, 44-81.

22. J. Gray Sweeney, *Themes in American Painting* [Grand Rapids Art Museum] (Grand Rapids, Mich., 1977), 73-74.

23. For references to Schroon Mountain see: Louis LeGrand Noble, *The Life and Works of Thomas Cole* (1853; rev. ed., Cambridge, Mass., 1964), 177-179, 185. The season, the sky, and the foreground and high vantage point depart from the artist's on-the-spot pencil study, but the painting is essentially a transcript of the scene, if a poetic one; cf. Howard S. Merritt, *Thomas Cole* [exh. cat., Memorial Art Gallery, University of Rochester] (Rochester, N.Y., 1969), no. 35.

24. Noble, *Cole*, 118.

25. William Gilpin, *Observations on Several Parts of England, Particularly the Mountains and Lakes of Cumberland and Westmoreland, Relative Chiefly to Picturesque Beauty, Made in the Year 1772* (London, 1808), *I*: 88-90. Cole obviously regarded one of the mountain configurations proscribed by Gilpin as expressively versatile: that one designated "Alps" in fig. 203. In a sketch for *The Expulsion* Cole appears to suggest a tormented alpine Laocoön; in *Youth* of the Voyage of Life series, alpine peaks express the buoyant spirit of his subject: see Merritt, *Thomas Cole*, nos. 16 and 42.

26. That Kensett was not always so radical in his compositions at this date or in the years that followed goes without saying. But even his more conventional compositions are chastened by the freshness of his vision.

27. Barbara Novak, *American Painting of the Nineteenth Century: Realism, Idealism, and the American Experience* (New York, 1969), 110. See also *Selections from Ralph Waldo Emerson*, ed. Stephen E. Whicher (Boston, 1957), 24.

28. A color reproduction of *Our Banner in the Sky* may be found in *American Painting, Drawings and Sculpture of the 19th and 20th Centuries* (New York, 1978).

29. The characterization appears in W. P. Bayley "Mr. Church's Pictures—Cotopaxi, Chimborazo and the Aurora Borealis," *Art Journal* (London), 17 (Sept. 1865): 265-267.

30. That Cole conceived of the role of the oil study, made outdoors, quite differently from the mature Church is betrayed by his complaint that "the glare of light destroys the true effect of colour and tone of Nature"; Theodore Stebbins, Jr., *Close Observation: Selected Oil Sketches by Frederic E. Church* (Washington, 1978), 6.

31. *"The North" Painted by F. E. Church from Studies of Icebergs Made in the Northern Seas in the Summer of 1859.* The broadside was printed for the exhibition of the painting *The Icebergs (The North)* in Boston in 1861. Recently rediscovered, the painting sold at auction in New York October 25, 1979 (see plate 19).

32. That the whole be "of a piece" was a concept basic to academic theory. See, for example, the comments of Sir Joshua Reynolds on Rubens and Poussin in Reynolds' *Discourses on Art*, ed. Robert R. Wark (San Marino, Calif., 1959), 86-87 (Discourse V).

33. The writings of Ruskin, including volumes from editions of 1852 and 1856 of *Modern Painters* are solidly represented on the shelves of Olana's library.

34. Any number of engravings after Turner are suggested in this challenge; the comment appears in an unidentified review of *Cotopaxi*.

35. Cf. A. J. Finberg, *The Life of J. M. W. Turner*, 2nd ed. rev. with supplement by Hilda F. Finberg (Oxford, 1961), 390.

36. Winthrop, "Heart of the Andes," 256; Winthrop's pamphlet, impregnated with Ruskins' ideas and with typology, reads almost as a manifesto of Church's art.

37. Pl. 14. It is reproduced in Huntington, *Landscapes of Frederic Edwin Church*, fig. 62.

38. Louis LeGrand Noble, *After Icebergs with a Painter,*
A Summer Voyage to Labrador and Around Newfoundland (New York, 1861), 251, 223, 158, 177, 262.

39. Cooper-Hewitt Museum, no. 1917-4. 298.

40. In Jared B. Flagg, *The Life and Letters of Washington Allston* (1892; New York, 1969), 58-59.

41. John Wilmerding, *A History of American Marine Painting* (Boston, 1968), 58.

42. Bushnell, *Sermons*, 104, 121.

43. The watercolor by Jesus Martinez Carrion of this sanctuary is surprisingly suggestive of the atmospheric effects of Olana's court hall. Church's concern for effects of light in his house is reflected in a comment once made to a visitor there: "Fortunately the soft golden atmosphere glorified everything the day you called"; Frederic E. Church to Charles F. Olney, Nov. 30, 1896 (Archives of American Art).

44. See p. 532 in the 1881 edition (see n. 10 above). These, the final lines of the book, are discussed in Moore, "The Storm and the Harvest," 102ff.

45. Herman Melville, "Aurora Borealis Commemorative of the Dissolution of Armies at the Peace" (May 1865).

46. *Modern Painters*, 4, pt. 5, chap. 6, sect. 8-9.

47. Horace Bushnell, *Reverses Needed: A Discourse Delivered on the Sunday after the Disaster of Bull Run in the North Church, Hartford* (Hartford, 1861), 8.

48. See Edgar Richardson, *Painting in America: The Story of 450 Years* (New York, 1956), 223.

49. *New York Tribune*, Mar. 24, 1863.

50. In Moore, "The Storm and the Harvest," chap. 7, there is a discussion of the typology of hardship and trial.

51. *New York Times,* Mar. 17, 1863.

52. *New York Times,* Mar. 17, 1863.

53. F. E. Church clipping file, New York Public Library.

54. Bushnell, *Nature and the Supernatural*, 331-332, as quoted in Johnson, *Bushnell*, 104.

55. Gary Wills, *Inventing America: Jefferson's Declaration of Independence* (New York, 1978), xv-xvi.

56. For a discussion of *Twilight in the Wilderness* as a natural apocalypse see my *Landscapes of Frederic Edwin Church*, 78-83.

57. Though the context is different a London viewer of Church's *Chimborazo* likened a cloud in the painting to "some dove-winged messenger of peace coming once more, perhaps—who knows? for the last time"; as quoted in a clipping from the *Eclectic Magazine* (Dec. 1865), 689, pasted in Church's scrapbook. The original
source was W. P. Bayley, "Mr. Church's Pictures," *Art Journal*, 27 (Sept. 1865): 265-266.

58. Mary Bushnell Cheney, *Life and Letters of Horace Bushnell* (New York, 1880), 156.

59. The same essential point is to be made about Church's *Niagara* (1857; Corcoran Gallery of Art, Washington) in my *Art and the Excited Spirit*, 14; the painting may be considered a sidewise *Transfiguration*. Roger Stein in an investigation of the typological dimensions of Copley's *Watson and the Shark* has noted a similarly Protestant adaptation of Raphael's *Transfiguration*; cf. Stein, *Copley's "Watson and the Shark" and Aesthetics in the 1770s* (State University of New York, 1976).

60. Whicher, ed., *Emerson*, 24.

61. Bushnell, *Nature and the Supernatural*, 68-69, as quoted in Cross, *Bushnell*, 109.

62. Warner, "Church," chap. 5.

63. John I. H. Baur, "Early Studies in Light and Air by American Landscape Painters," *Brooklyn Museum Bulletin*, 9, no. 2 (Winter 1948): 3.

64. Novak, *American Painting, passim.*

65. Theodore E. Stebbins, Jr., *The Life and Works of Martin Johnson Heade* (New Haven and London, 1975), 107-108, and *Luminous Landscape: The American Study of Light, 1860-1875* [Fogg Art Museum] (Cambridge, Mass., 1966); John Wilmerding, *American Marine Painting*, 170, and "Fire and Ice in American Art" in *The Natural Paradise*, ed. Kynaston McShine [Museum of Modern Art] (New York, 1976).

66. Stebbins, *Heade*, 107-108; William H. Gerdts, "On the Nature of Luminism" in *American Luminism* (New York, 1978); and Wilmerding, *American Marine Painting*, 170, and "Fire and Ice," *passim*, as well as his essay "The Luminist Movement: Some Reflections," 120-121 herein.

67. The balance of sun and lighthouse in *Long Island Sound* is a quiet parallel to the balance of sun and volcano in *Cotopaxi*. The peacefulness of the Suydam print may have been on Church's mind when he painted a serene twilight scene (paired with an equally serene moonlit scene) in 1865 as a memorial to his two infant children who died that year. The two paintings are at Olana.

68. "Church's Cotopaxi," *New York Times*, Mar. 17, 1863.

69. The quotations pertaining to Gifford are to be found in Nicolai Cikovsky, "Introduction" in *Sanford Robinson Gifford, 1823-1880* [University of Texas Art Museum] (Austin, 1970), 14 and n. 19.

70. This "relic" of civilization is at Olana today; it measures nine inches from arris to arris.

71. The entire quotation reads: "It seems to me the secret is in the artist's earnestness and modesty,—in the 'sublime repression of himself.' He seems to display the Lord's beauty, and not his own skill: his flowers bloom, ice shimmers, and waterfalls weave their rainbows, to the praise of nature, the glory of God,—not Church. There is no machinery visible, no rehearsal-work: no one observes how the paint is spread; you would as soon stretch out your hand to feel the texture of an angel's wing; you do not think of texture. It is a vision." ("Church's Picture of 'The North'"; unidentified clipping in Church's scrapbook, Olana.)

72. Intriguingly suggestive of Church's *Moses Viewing the Promised Land* is Kensett's *Berkeley Rocks, Newport* (1856; Vassar College Art Gallery Poughkeepsie, N.Y.), which is reproduced in John K. Howat, *John Frederick Kensett* [exh. cat., American Federation of Arts] (1968), no. 22. A figure on a bluff wearing, it would appear, the clerical garb of the eighteenth century, looks out upon an expanse of sea presided over by a dramatic sky filled with bright red clouds. Here for a moment Kensett evokes Cole and Church, but the subject is quite atypical for the artist.

73. "Church's Picture of 'The North'" (unidentified source in Church's scrapbook, Olana).

74. Unidentified source, Church clipping file, New York Public Library.

Plate 17. Martin Johnson Heade. *Thunderstorm Over Narragansett Bay*, 1868.
Amon Carter Museum, Fort Worth, Texas. Photo: Linda Lorenz (see fig. 63)

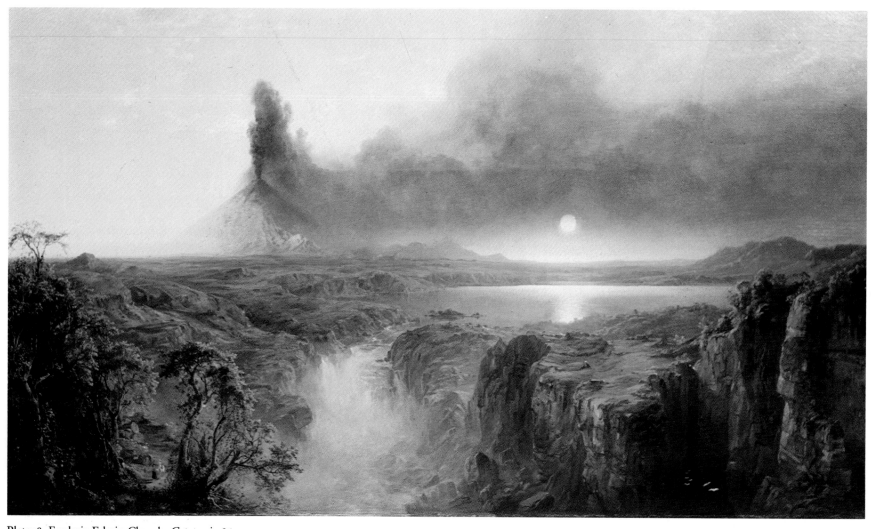

Plate 18. Frederic Edwin Church. *Cotopaxi*, 1863.
Reading Public Museum and Art Gallery, Reading, Pennsylvania (see fig. 225)

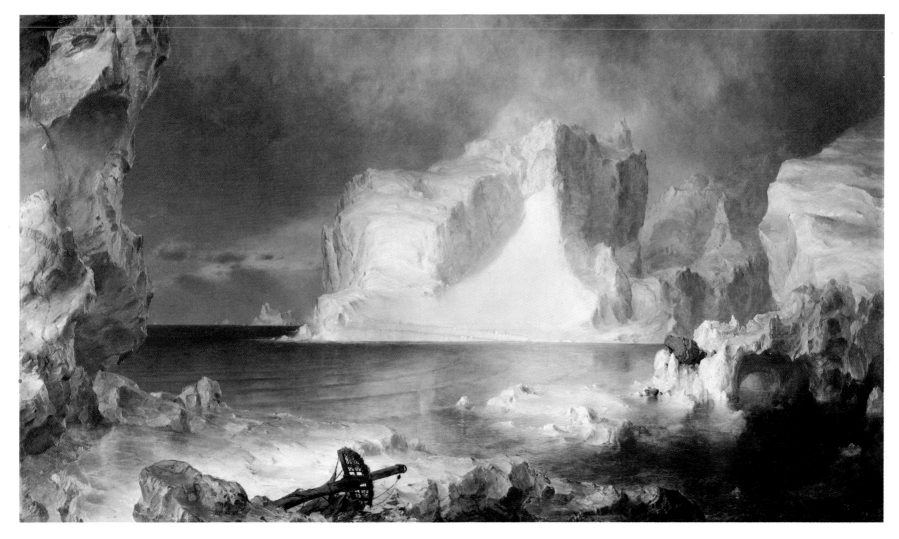

Plate 19. Frederic Edwin Church. *The Icebergs (The North)*, 1861. Dallas Museum of Fine Arts, Anonymous gift
Photo: Sotheby Parke Bernet (see fig. 18)

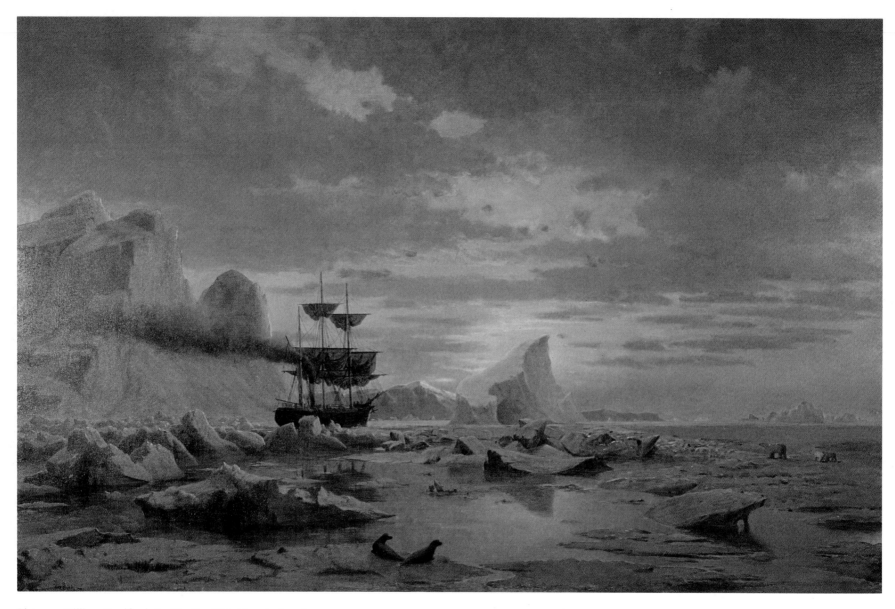

Plate 20. William Bradford. *Ice Dwellers Watching the Invaders*, c. 1870.
New Bedford Whaling Museum, New Bedford, Massachusetts;
Gift of William F. Havemeyer, 1910 (see fig. 56)

Plate 21. William Bradford. *Labrador Coast,* c. 1860.
The Cleveland Museum of Art; Purchase, Mr. and Mrs. William H. Marlatt Fund (see fig. 138)

Plate 22. Sanford Robinson Gifford. *On the Nile*, 1872.
Eugene B. Sydnor, Jr. Photo: Herbert P. Vose (see fig. 39)

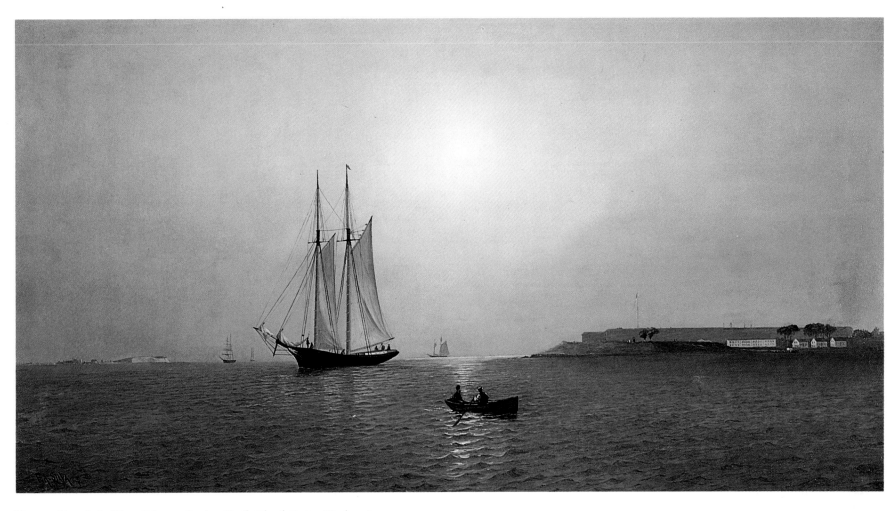

Plate 23. Francis A. Silva. *Schooner Passing Castle Island, Boston Harbor,* 1874.
The Bostonian Society, Old State House, Boston; Gift of Mrs. Vernon A. Wright, 1939.
Photo: Richard Cheek (see fig. 347)

Plate 24. William Trost Richards. *Lighthouse on Cape Cod*, 1865.
Mrs. James H. Dempsey. Photo: The Cleveland Museum of Art (see fig. 60)

Plate 25. William Trost Richards. *Paradise, Newport,* 1877.
National Gallery of Art, Washington, D.C.;
Adolph Caspar Miller Fund and Pepita Milmore Memorial Fund, 1979 (see fig. 155)

Plate 26. Frederick DeBourg Richards. *Across the Marshes,* c. 1877.
Private collection. Photo: Helga Photo Studio (see fig. 149)

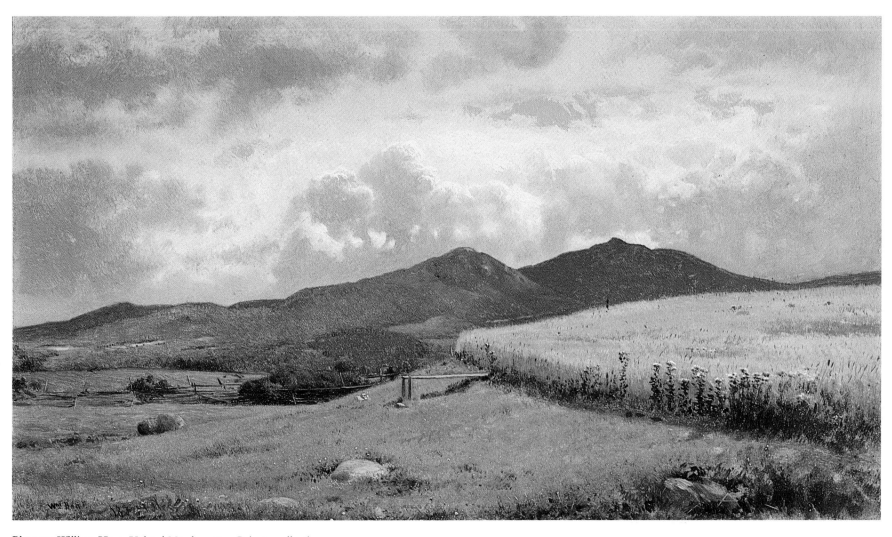

Plate 27. William Hart. *Upland Meadow*, 1872. Private collection.
Photo: Helga Photo Studio (see fig. 31)

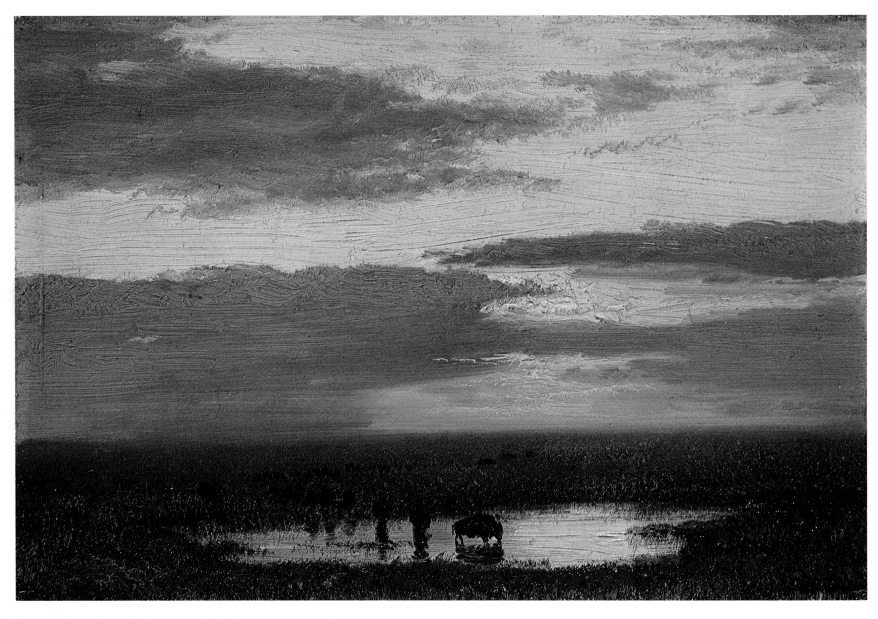

Plate 28. Albert Bierstadt. *Buffaloes on the Prairie,* 1881.
Collection of Dr. and Mrs. M. S. Mickiewicz.
Photo: Vose Galleries (see fig. 133)

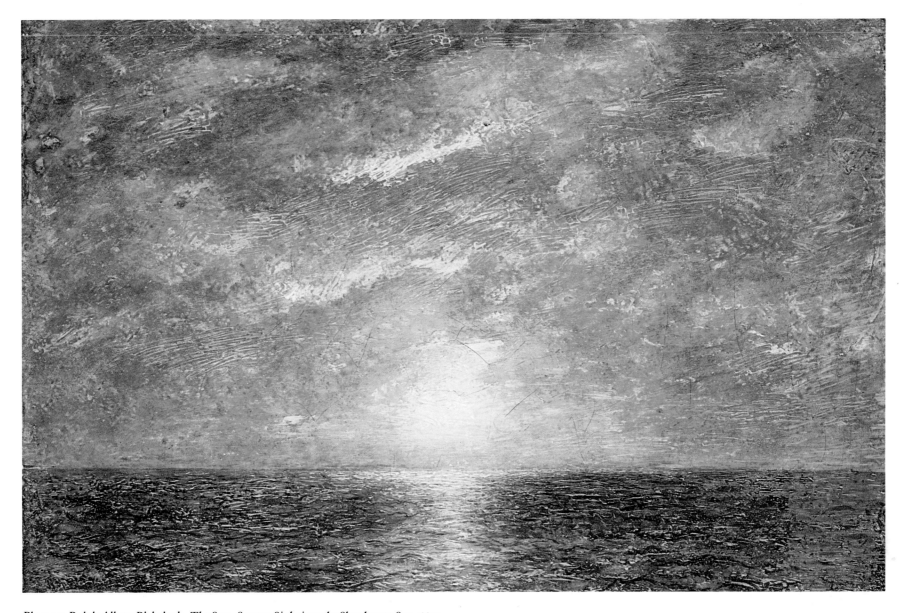

Plate 29. Ralph Albert Blakelock. *The Sun, Serene, Sinks into the Slumberous Sea,* 1880s.
Museum of Fine Arts, Springfield, Massachusetts;
The Horace P. Wright Collection. Photo: David Stansbury (see fig. 185)

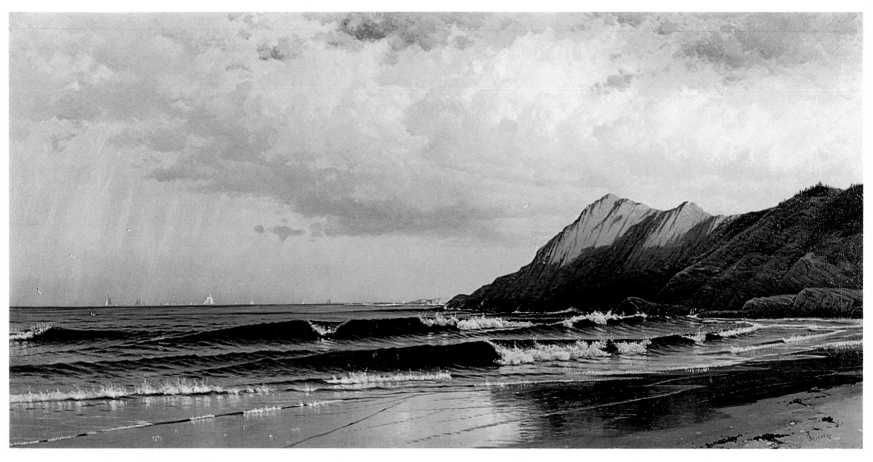

Plate 30. Alfred Thompson Bricher. *Time and Tide*, c. 1873.
Dallas Museum of Fine Arts; Foundation for the Arts Collection,
Gift of Mr. and Mrs. Frederick M. Mayer (see fig. 144)

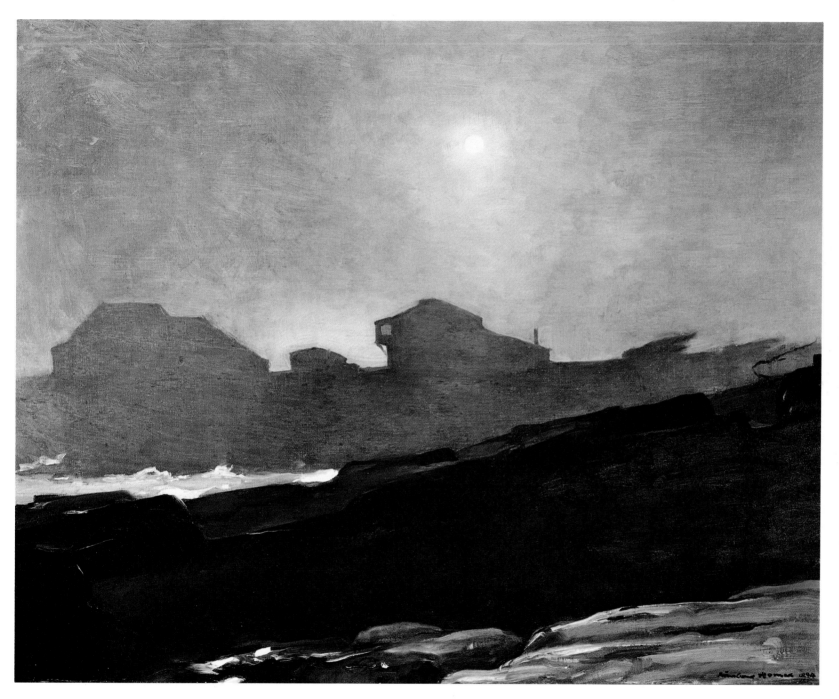

Plate 31. Winslow Homer. *The Artist's Studio in an Afternoon Fog,* 1894. Memorial Art Gallery of the University of Rochester, Rochester, New York; R. T. Miller Fund (see fig. 348)

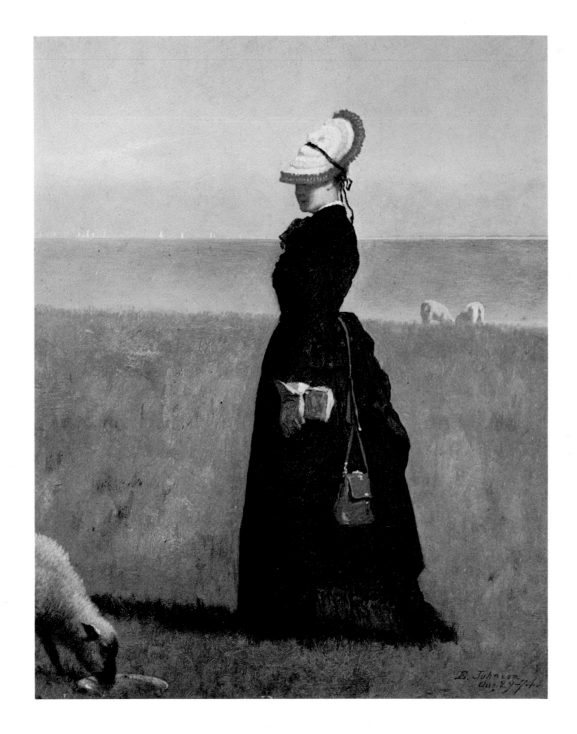

Plate 32. Eastman Johnson. *Lambs, Nantucket*, 1874.
From the Collection of Mr. and Mrs. Paul Mellon, Upperville,
Virginia. Photo: Hirschl and Adler Galleries (see fig. 175)

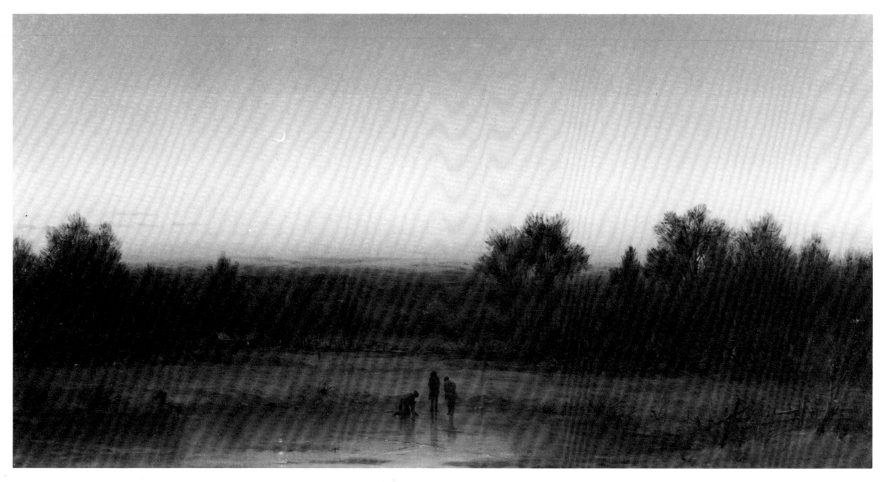

233. Sanford Robinson Gifford. *A Winter Twilight*, 1862. Oil on canvas.
0.394 x 0.804 (15½ x 30¹¹/₁₆ in). Private collection. Photo: Ken Strothman

Luminism in Context: A New View

Theodore E. Stebbins, Jr.

Introduction

ON SEVERAL OCCASIONS, NOTABLY ON THE PRESENT OCCASION, it has been shown that after 1850 a small number of American painters—most of whom knew one another—began to paint tonal, realistic landscapes that were often horizontal in form and quiet in mood.[1] These paintings tend to minimize human subjects or associations in favor of land, water, and sky. Brushwork is subtle, the palette restricted, and there are few signs of the artist's presence. These are windows on a world that is empty and generally serene, where time moves slowly.

The concept of luminism has been a useful one: through the "discovery" of this type of painting, we have come to see qualitative and stylistic relationships between the work of recognized artists such as John F. Kensett and Sanford Gifford and that of others whose work had once been virtually lost, particularly Martin Johnson Heade and Fitz Hugh Lane. However, the term also carries with it certain risks, chief among them being the temptation it offers to take the luminist paintings out of context. These paintings are part of the artistic production of an extraordinary era in America and in the world. In studying them as products of American culture, we dare not overlook their crucially important relationship to European history and to European painting.

Luminism as we define it is largely the product of two decades, and two rather distinct modes can be distinguished even in this limited period. The early style, which flourished between 1855 and 1864, primarily in the hands of Kensett and Lane, is seen at its best in compelling, realistic views with water and reflections such as Kensett's *Shrewsbury River* (1859; fig. 202), and Lane's *Owl's Head, Penobscot Bay, Maine* (1862; fig. 113). During the next decade, 1865-1875, many more artists took up this mode, and the style became more varied: in general one sees an increasingly romantic, introspective mood. Gifford achieved this through the gentle and evocative depiction of heat and

humidity in the Egyptian desert or on Claverack Creek; Heade, by creating a sense of slowly changing, palpable light and shade; and the late Kensett, through simplified, abstracted compositions. The early luminist paintings look for their source more to traditional marine painting (and to the early work of Frederic Edwin Church as seen in *West Rock, New Haven,* 1849; New Britain Museum of American Art, New Britain, Connecticut), whereas the later style, especially in Gifford's hands, evidences an admiration of J. M. W. Turner's effects (as well as those of the later, tropical Church).

Changing Critical Views

This volume is based upon the premise that luminism is important, that it is worth seeing and deserves our attention. Yet each generation of art historians since the 1860s has written intelligent surveys of American painting that largely or totally overlook the phenomenon. The paintings were there for them to see, but the works somehow seemed unimportant. The leading critic of the sixties, Henry T. Tuckerman, writing in 1867, did not know of Lane, who had been isolated in Gloucester; yet Tuckerman knew all the other landscape painters well and admired their work. Heade, for example, received only a short notice in Tuckerman's history; his luminous qualities were singled out for praise, the critic writing that Heade "especially succeeds in representing marsh-lands, with hay-ricks, and the peculiar atmospheric effects thereof," but then going on to give his primary attention to Heade's still lifes and tropical pictures. Of the luminists, Tuckerman particularly admired Kensett, whom he thought to have a claim to being "one of the three foremost men of our landscape art" (with Church and Albert Bierstadt).[2] He honored Kensett's thoughtful, kind personality; his ability to "locate" a landscape, making it geographically recognizable; and his "fidelity to detail." Considering Kensett's subjects he admired

227. John Frederick Kensett. *Landscape,* 1852. Oil on canvas. 0.914 x 1.270 (36 x 50 in).
Richard Manoogian. Photo: Brenwasser (not in exhibition)

228. John Frederick Kensett. *Lake George,* 1858. Oil on canvas. 0.613 x 0.921 (24⅛ x 36¼
in). Collection of Jo Ann and Julian Ganz, Jr., Los Angeles (not in exhibition)

equally the mountain views, the waterfalls, the rivers, and the coastal scenes. Tuckerman saw Kensett's works as "strong, clear, and true" but remarked on the artist's abilities with light only in an offhand way.[3] In fact, Kensett's concentrated interest in light stems from the fifties, when he made a dramatic conversion to a luminist style. This can be demonstrated clearly in the comparison of his view of Lake George (fig. 227) of 1852 with a painting of the same subject executed just a few years later (fig. 228): the earlier picture is a rugged, picturesque view of the lake painted with vigorous brushwork, a broad range of hues, and energetic trees and clouds, whereas the later one is calm, the brushwork invisible, and the range of color narrowed as a pervasive bluish hue unifies and flattens the whole. The earlier *Lake George* looks to Thomas Cole, while the later one experiments with a new direction and foretells the luminist style which Kensett was mastering at that time. Interestingly, however, the work of the sixties (which is what Tuckerman would have known best) was actually less "luminous" in terms of the artist's concern with light; many of the late paintings of the shore such as *Beach at Newport* (1850-1860; fig. 2) or *Eaton's Neck, Long Island* (1872; fig. 83) are well drawn and powerfully composed but have little sense of real light. In fact, Kensett's most telling treatment of light occurs in interior woodland scenes, for example *Catskill Waterfall* (1859; Yale University Art Gallery, New Haven, Connecticut), and in traditionally com-

posed mountain and lake views such as the *Lake George* of 1869 (fig. 229), with its superb, tonal depiction of water, distant mountains, and dramatic clearing sky, which can hardly be called "luminist."

Gifford is treated quite differently by Tuckerman. For one thing, the critic comments that his paintings are "often destitute of exceptional picturesqueness," which is quite true in traditional terms. It has not been recognized how anti-picturesque luminism was, how the style in fact rejected the rules of landscape art that had prevailed in the English-speaking world, and beyond, since the late eighteenth century. British theorists such as Price and William Gilpin would have found Gifford's work to be unacceptable: it lacked the required "abrupt and rugged forms," the "broken touches" of brushwork, the variation of line and topography, even the blasted trees or stumps that were often "the very capital sources of picturesque beauty." Church, Bierstadt, and much of the rest of the Hudson River school continued to operate within a traditional picturesque canon, while Gifford and Kensett in their luminist paintings simply rejected it.

Tuckerman speaks of one of Gifford's paintings as "photographing in color a foggy day in early autumn on the Bronx River with its pale sunlight, leafless trees, and still water," and of another as "depicting only sea and sky . . . with no accessories—bare, solitary, vast, elemental nature."[4] The critic here recognizes

229. John Frederick Kensett. *Lake George,* 1869. Oil on canvas. 1.121 x 1.686 (44⅛ x 66⅜ in). The Metropolitan Museum of Art, New York, Bequest of Maria DeWitt Jesup, 1915 (not in exhibition)

the qualities of luminism in Gifford's work, though of course he coins no term for the style. He even notes that other painters were involved ("Gifford has also been successful in the experiment which, of late, has been tried by several American landscape-painters, to reproduce the effects of a misty atmosphere . . .") and he saw in these paintings what we see and admire today—"a flood of that peculiar yellow light born of mist and sunshine."[5]

The other major critic of the period was James Jackson Jarves, the pioneer collector of Italian primitives, whose book *The Art-Idea* first appeared in 1864. If Tuckerman recognized the luminists and their style (though not quite ranking them with William Page, Charles L. Elliot, Daniel Huntington, Emanuel Leutze, George Loring Brown, Church, and Bierstadt as the *best* of their time), then Jarves—much more the voice of the future—rejected them outright. Kensett's art was considered "a little sad and monotonous," while Gifford's tone was "artificial and strained," his work "conventional and untrue."[6] Jasper Francis Cropsey, Heade, and others were "realistic to a disagreeable degree, Heade only by color affording any sensuous gratification or relief from the dreamy intellectuality of the others."[7]

Jarves stood at an opposite pole to Tuckerman: he believed in the painting of ideas rather than facts, in spiritualism rather than materialism. His heart lay in France and Italy, and he rejected England, to which Tuckerman and so many

others had looked for aesthetic leadership since Benjamin West's time. Anything English was anathema to Jarvis: "There is as little affinity between the art of England and that of America as between their politics"; rather, he proclaimed, it was "French art [which is] the natural friend and instructor of American art. . . . We cannot have too much of it."[8] The young painters whom Jarves admired were the French-trained men whose style supplanted that of the Hudson River school and luminism during the 1870s, and whose reputations rose accordingly. Jarves was as optimistic about the future of our painting as Tuckerman had been, but for quite different reasons, as he wrote: "On looking at Allston, Babcock, Hunt, LaFarge, Inness, and Vedder, it really seems as if the mantle of Venice had fallen upon America. . . ."[9]

It is always tempting to consider a school or style that one admires to be "progressive," but to do this with luminism would be misleading indeed. Luminism may better be seen as a last-ditch attempt to make the Hudson River school style of Asher B. Durand and Church serve the complex psychic and aesthetic needs of post-Civil War America. In the hands of Gifford and Heade, some of the most intelligent and poignant of American paintings were created, but the attempt to make it a lasting style could not succeed. The mode was too fragile, too English, too subtle to survive. Its heyday lasted for little more than a decade, and by 1875 or 1880 it was as surely finished as the Hudson River school, out of which it had grown.

In one sense luminism in America can be seen as resulting from a literal reading of the great English critic John Ruskin, whose *Modern Painters* had been widely read here during the 1850s. Ruskin was immensely gifted and equally inconsistent, and his writings can be used to prove nearly anything. But two of his favorite causes over a long career were the work of J. M. W. Turner—with its warm yellows and reds, its dramatic effects of storm and sunset at sea, its rich brushwork and simple compositions—and the very different paintings of the Pre-Raphaelites—with their literary, sentimental subjects, bright jarring colors, and ever-detailed and careful brushwork. Painters like Gifford unite Ruskin's two loves in a way that few English painters did, literally combining the tightly realistic technique of the Pre-Raphaelites with the atmospheric effects and the palette of Turner.

The years during which the best luminist pictures were made, from 1855 to 1875, were exactly those which saw the rise of a small group of Americans working in something close to the Pre-Raphaelite style. These men—J. W. Hill, N. A. Moore, W. T. Richards, Henry and Thomas Farrer—were also New Yorkers; like the luminists, they were closely allied to the Hudson River school, they exhibited at the National Academy of Design, and they also were carrying on a quintessentially British style in the face of increasing French influence. They were primarily watercolorists, whereas the luminists were more oil painters, but there were close links: one thinks of Heade's *Lake George* (1862; fig. 75) with its astonishingly taut realism or of Kensett's woodland interiors, both so close in conception to Hill's art.

By 1880 it was clear to nearly everyone that the "English" styles—luminism, Pre-Raphaelitism, and the conventional Hudson River manner as well—had become old-fashioned and had gone out of favor. George Sheldon's *Hours with Art and Artists* (1882) sums up the new tendency, praising the French-trained teachers at the new Art Students League and noting the present availability of the works of Jean-François Millet, Jean-Baptiste-Camille Corot, "and other leading lights of modern aesthetic inspiration." George Inness' criticism of Pre-Raphaelite work ("the most frightful conglomerations") was cited, as was his statement of the proper end of art, now seen to be the painting "not of an outer fact but of an inner life."[10] Sheldon discussed the leaders among the French (Gustave Boulanger, Charles Frère, Jean Baptiste Detaille, Fortuny, Jean Meissonier) as well as the most progressive Americans whom they had influenced (Winslow Homer, William Merritt Chase, Abbott Thayer). In addition, he recognized that certain of the Hudson River school realists of the sixties (such as George Smillie) were properly developing a new Barbizon mode in the seventies ("this change was in the direction of breadth of treatment").[11]

Indeed, the change which Sheldon notes was a sudden and dramatic one for a number of younger landscape painters, including Smillie, Alexander Wyant, Homer Dodge Martin, and David Johnson. Each of these men had worked successfully in a tight, conventional Hudson River format during the 1860s, but in the years 1872-1874 each one of them developed a radically altered style which came to satisfy the new taste for looser brushwork, generalized, nontopographical subjects, and emphasized breadth and mood. Then and for years after, this new style was called *impressionism*, though it looked to the earlier Barbizon style rather than to French impressionism (which style was reaching maturity at exactly this time) for its roots.

Sadakichi Hartmann's influential *History of American Art* of 1902 reflects critical judgment at the turn of the century. Lane was unmentioned, as ever, and by this point Heade was thought unworthy of more than passing notice. Kensett is discussed briefly, it being noted that he was technically deficient despite his years in Europe ("his pictures were so thinly painted that they almost appear 'flat' to us").[12] But luminism was discussed implicitly: "He [Kensett] and Sanford R. Gifford were the first to strive for more pleasing colour harmonies and a more careful observation of atmospheric changes, the play of sunlight in the clouds and misty distances."[13] The author goes on to make a case for the progressive nature of this work, declaring that "these lyrical attempts were really forerunners of the modern school, as it was not so much things as feelings that they tried to suggest."[14] As in much of the criticism of the past, there are important clues in Hartmann's book, particularly in his suggestion that if the luminist style does look ahead at all, it is not to Thomas Eakins and Winslow Homer nearly so much as to the later George Inness and to Dwight Tryon.

E. P. Richardson's admirable *American Romantic Painting* of 1944, the first modern survey, fails to take note of the rediscovery of Heade or Lane, which was just then occurring as Maxim Karolik was beginning to collect their work. Only one of Gifford's works (the very late *Tivoli*, 1879; Metropolitan Museum of Art, New York) is reproduced in Richardson's book, although it illustrates five paintings by Kensett, including three river and shore scenes. Looking through the book as a whole, one would never divine the existence of luminism. The same thing can be said of the pioneering exhibition of the following year, *The Hudson River School*, organized by Frederick A. Sweet.[15] Though there were two paintings by Heade, including *Thunderstorm Over Narrangansett Bay* (1868; fig. 63), one by Gifford, and eight by Kensett (including four luminous coast scenes), one could only conclude from the exhibition as a whole that in fact the painting of water, skies, and light in horizontal formats was of very little interest to the American school even during the 1860s and 1870s.

A careful student of the field would have had to change this view in 1948, with the publication of the Karolik Collection catalogue by the Museum of Fine Arts, Boston.[16] Here for the first time a large number of paintings by Heade and Lane were published together, along with several by Kensett and other luminist painters. Popular and scholarly interst in the phenomenon of luminism dates from this point, especially from John I. H. Baur's introduction to this catalogue and from his subsequent essays on the subject.

Several points may be made from all this. First, we are inclined to overlook the degree of selectivity which the art historian inevitably employs. There are a number of traditional bases for selecting certain pictures or certain types for exhibition or scholarly investigation: the basis may be historical, the paintings being ones which contemporary critics or popular opinion of the period of execution thought most important; or it may be "art historical," the objects being ones which can be shown to have been most influential upon their times, or on later work, or most reflective of earlier tradition; or it may be cultural, in the sense that a given group of objects gives clearest insight into the history, economics, or some other aspect of the culture which produced them; or the paintings may be seen simply as *typical* examples of the artistic production of the period. None of these reasons—and there are obviously other possibilities—have been presented with much conviction as underlying the discovery of the luminist phenomenon. Rather, two other justifications have been given for our attention: first, that the paintings and the phenomenon of a group of related works are "important" (e.g. beautiful) and have been mistakenly overlooked by earlier scholars; and secondly (as has been recently proposed by Barbara Novak), that the works are significant because they are seen as part of the indigenous American cultural and artistic mainstream (the latter being conceived as tonal, linear, nonpainterly, lucid, and conceptual).[17] If we are truly to come to grips with luminism, some difficult questions pertaining to the style must be asked: How typical is it of the art of the period? How reflective of the national culture? How American, how "native," is the style? And how is it that our time is the first to see its beauties fully?

The Luminist Minority

In answer to the first question, it may be noted that luminist paintings are rare, and they surely are far from typical of the art of their time in America. Even if we consider *only* Heade, Lane, Gifford, and Kensett, we find more nonluminist pictures than luminist ones. Only about half of Heade's oeuvre, for example, consists of landscape paintings, and there are many of these—including the early ones, many of the South American, and most of the later Florida scenes—that do not deal with light in luminist fashion. Much the same is true of Lane and Kensett. Though their oeuvres consist mainly of landscape and seascapes (including marine views), Lane did many topographical scenes, ship portraits, and storm pictures—all nonluminist—and Kensett frequently depicted waterfalls, lakes, and interior woodland scenes in the traditional Hudson River school manner. Gifford, however, presents a different case. Though he frequently did nonluminist pictures—his early work and his woodland scenes and architectural views—most of his finished paintings *are* consistent with luminism as we have defined it. Among the major painters (that is, excluding A. T. Bricher, Francis A. Silva, and such), he is the most consistent luminist; and as we have seen, critics since his own time have recognized the special qualities of color and light in his work.

Indeed, to take another view, most of the major painters of the period did no luminist pictures at all, or very few. Among the Hudson River school, Church, who can be considered the spiritual father of the luminist style, did few paintings which would qualify; Bierstadt did a handful only, primarily in the early sixties; and Thomas Moran none at all—each preferred to do great aerial topographical views. Asher B. Durand did none, W. T. Richards a few only, and Worthington Whittredge practically none. Inness, Alexander Wyant, and Homer Dodge Martin, as we have seen, worked in a very different, nonluminist style. Similarly, the landscapes of John LaFarge, Elihu Vedder, and William Morris Hunt developed along French lines. Whistler's did also; his compositions bear superficial similarities to luminist ones, but with entirely different intention and effect. There are brief, nearly luminist moments in the works of Winslow Homer, such as *An Adirondack Lake* (1870; fig. 44), and Thomas Eakins, particularly in *Max Schmitt in a Single Scull* (1871; fig. 179). But both paintings are figurative compositions, not landscapes *per se*; both painters worked with rich surfaces and strong complex compositions in a style far closer to the "French" mainstream in America than to luminism. This is also true of Ralph Blakelock and Albert Pinkham Ryder, two landscapists coming to maturity at this time: there is what might be thought a fleeting and rather painterly "luminist" moment in each man's oeuvre during the early seventies, but again a close comparison shows a superficial resemblance only.

It is also possible to take a broader view of the art scene at the time, to try to ascertain how many landscapes were being painted and the extent to which these landscapes were luminist. There is no doubt that New York's National Academy of Design held the leading exhibition in America each year, and here, if anywhere, one would expect luminism to dominate. Taking the 1867 exhibit as an example, one finds in fact that less than a third of the paintings were landscapes at all (about 30 percent), with an equal number of genre scenes. Portraits and ideal figure pieces make up another 30 percent, with a small representation of still lifes, animal pictures, architectural studies, and history paintings. Judging from the artists and titles, we may deduce that there may have been about 30 luminist pictures among the 600 shown, or about 5 percent of the total.

A smaller National Academy exhibit in 1874 contained about the same proportion of landscape—under a third—with figure, portrait, and still-life categories all reduced but genre increased to almost 40 percent of the show. Luminist landscapes number about twenty, again some 5 percent.

The first annual exhibition at the Yale School of Fine Arts, held in 1867 and directed by Daniel Huntington, was a conservative reflection of the New York pattern of that year. A number of European paintings were included (by Verboeckhoven, Spitzweg, Kobell, Calame, Achenbach, and others), and there was less genre and more history painting (by Rossiter, Read, White, and Gray). More landscapes were shown in New Haven, however—about 40 percent of the American paintings—and the relative number of luminist views seems also to have been higher than in New York. These calculations are of course imperfect as they are based on titles alone; and, we have included as "luminist" in the Yale show *Claverack Creek* by Frederick Y. Chubb and J. C. Wiggin's *Late Afternoon: Paltz Point, Shawangunk Mountains,* for example, without knowing the paintings themselves. Nonetheless, it is clear that the new Barbizon style had not yet been felt in New Haven. The foreign pictures were primarily German, and considerable numbers of drawings and watercolors by the Farrers, J. W. Hill, Henry Roderick Newman, and C. H. Moore must have added to both the luminist and British tone of the exhibition.

The situation in Boston was quite different, and a look at the Boston Athenaeum exhibitions suggests again how much a localized, New York phenomenon luminism was. Landscapes accounted for only 16 percent of Boston's 1867 exhibition, with historical and religious pictures, genre, and portraiture each being seen in equal amounts. There were many copies after old masters and relatively few contemporary Americans. Of the latter, only Edward Moran was shown in depth, and there were practically no luminist landscapes. Moreover, this pattern continued in Boston. At the 1873 exhibition, for example, historical and religious subjects accounted for a third of the show; figurative and portrait paintings accounted for nearly as many; landscape was the third-ranking category, with about 20 percent, with genre just behind. Here at least one finds Martin Johnson Heade's *Newport Sunset,* but again a paucity of other luminist pictures.

All this suggests that luminism was never dominant, in terms of numbers of paintings, influence, or impact on the public or the critics. It surely was never a

"movement"; rather it can be identified as a stylistic phenomenon: one of the divergent courses the Hudson River school took late in its life. And far from being the progressive "mainstream," it actually represented a deadend—and a retrogressive, British-oriented one at that.

As we have noted, luminism occurred primarily during two decades, of which the second—from 1865 to 1875—was the most productive. Heade, Gifford, and Kensett (until his death in 1872) were working at the very peak of their capacities, as can be seen from numerous examples mentioned here. And they were not alone, for this decade appears now to have been an extraordinarily creative one for American artists, for the luminists and many others as well. It was during this decade that Bierstadt and Thomas Moran produced the most powerful of their great western panoramas. Church was slightly past his prime as we see it, but still painted his two major Jamaican views *Rainy Season in the Tropics* (Fine Arts Museums of San Francisco) and *The Vale of St. Thomas* (Wadsworth Atheneum, Hartford, Connecticut) at the start of the decade, and of course climaxed his success with the building of his home Olana in 1871. And among the realists, Worthington Whittredge did the best of his richly painted woodland scenes during this time; and W. T. Richards, many of his tautly realistic, close-up nature studies. Cropsey and James and William Hart carried on Durand's realistic pastoral tradition, as did David Johnson, Wyant, and Martin, with the latter group making a creative and generally successful transition to a Barbizon-influenced style around 1873 as has been seen.

Perhaps the key landscape specialist of the post-Civil War era was George Inness, who represents the generation after Church's even though the two artists were nearly exact contemporaries. Church's realistic art was at its best during the fifties; as has been often said, it bore the optimistic spirit of Manifest Destiny, though it became irrelevant and empty in the post-war years, when the nation and its tastes changed so much. Inness, on the other hand, uniquely succeeded in evolving from a pure Hudson River style in the late forties to a clear panoramic one in the fifties, then gaining increasing richness and sophistication during the sixties and seventies before reaching a final style—abstract, subjective, and painterly—during the eighties. He was never better than during the "luminist decade," which for him ranged from *Peace and Plenty* (1865; Metropolitan Museum of Art, New York)—a warm yet heroic celebration of the war's end—to *The Monk* (1873; Addison Gallery, Andover, Massachusetts), where symbolic shapes and colors dominate. Church's style was "native" (and English) in that he had never been abroad to study but was trained by the British-born Cole, and he was not equipped to absorb or understand the new French styles ("those baleful foreign influences," as he called them). Inness, on the other hand, was comfortable with European and especially French art, having been to Italy in 1850, France in 1853-1854, and both countries from 1870 to 1874, and this must have aided his own evolution immensely.

Equally important to Inness for the introduction of the Barbizon style to America was William Morris Hunt, who worked with Thomas Couture and Jean-François Millet before returning in 1855 to head the Boston school, though his finest work lies not in landscape but in the early portraits of women executed in a style stemming from Jean-Auguste-Dominique Ingres. Hunt's most successful student was John LaFarge, who became a figure of great importance. It was LaFarge who, with his decorations for Trinity Church, Boston, in 1875 began the American mural tradition. He was an innovator in stained glass, in which work he reached real heights; and during this decade he produced powerful landscapes such as *Paradise Valley* (private collection) and still lifes, including *Flowers on a Window Ledge* (c. 1862; Corcoran Gallery of Art, Washington, D.C.) and *Vase of Flowers* (1864; Museum of Fine Arts, Boston). There were other significant talents working in still life as well, notably Heade (whose finest traditional flower pictures date from 1865-1870, with the best of the orchid and hummingbird paintings coming in 1875), George Lambdin, and G. H. Hall.

As we have seen, during this decade interest was swinging away from landscape toward figurative painting of various kinds. Portraitists remained active with G. P. A. Healy, Daniel Huntington, and Charles Elliott being Eakins' ablest contemporaries. History painting in the tradition of Benjamin West was still carried on, as seen in the Yale exhibition, and Hunt, LaFarge, Hall, and others worked in more modern styles. Robert Weir's *Taking the Veil* (1863; Yale University Art Gallery, New Haven, Connecticut) represents the old style and was one of the popular pictures of the period, as it was widely reproduced and then exhibited at Philadelphia in 1876. His son John F. Weir painted two of the major history pictures of that time: *Gun Foundry* (1866; Putnam County Historical Society, Cold Spring, New York) and *Forging the Shaft* (1877; Metropolitan Museum of Art); both were also rare celebrations in paint of America's new industrial might. William Rimmer was at the height of his career, with *Flight and Pursuit* (Museum of Fine Arts, Boston) being executed in 1872. Frank Currier, Thomas S. Noble, and Frank Duveneck (one thinks of his *Turkish Page,* 1876, Pennsylvania Academy, Philadelphia) brought back from Munich a strong painterly style in keeping with the times.

Genre painting regained its popularity in this decade, largely through the preeminent work of Eastman Johnson and Winslow Homer. Johnson was at his height during this period, producing fine interior scenes such as *Not at Home* (c. 1872-1880; Brooklyn Museum, New York), and family portraits including *The Hatch Family,* 1871 (Metropolitan Museum of Art, New York), as well as his outstanding series of maple sugaring and cranberry harvest scenes. His style was a sophisticated, painterly one, resulting, as was the case with so many American artists, from long years of study abroad. Much the same is true of Homer, who reached maturity as a painter just as the decade began, with *Prisoners from the Front* (1866; Metropolitan Museum of Art, New York), then went on after his French trip to paint *The Bridle Path* (1868; Sterling and Francine Clark Art Institute, Williamstown, Massachusetts)—with its superb

light effects and completely convincing forms—*Snap the Whip* in 1872 (Butler Institute of American Art, Youngstown, Ohio) and *Breezing Up* in 1874 (National Gallery of Art, Washington, D.C.). Homer's work has everything to do with light, but one has to strain to see any connection with luminism.

This was the climax of American genre as we understand the term—the painting of plain, rural folk celebrating their own simple virtues and those of their land. Like much landscape painting, this was a reminiscent, idealized art. It was taken up by many others—J. G. Brown, Thomas Hovenden, E. L. Henry, and Seymour Guy, for example—all of whom did their outstanding work during this brief period. And closely related was the work of the leading animal painters, A. F. Tait and James and William Beard. Tait painted heroic visions of the hunter and his quarry for an urban clientele, and the Beards—as in James' *Parson's Pets* (1875; private collection)—skillfully made fun of society's foibles by depicting animals playing human roles.

A whimsical strain runs through the painting of the 1870s, and, in certain isolated pictures, one finds a visionary, magical quality that is not repeated again. In William Beard's *The Wreckers* (1874; Museum of Fine Arts, Boston), Thomas Moran's *Scene from Hiawatha* (Baltimore Museum of Art), John F. Weir's *Christmas Bell* (1865; private collection), and—best known—in Elihu Vedder's *Lair of the Sea Serpent* (1864; Museum of Fine Arts, Boston) one senses a belief in witches and fairies, in mysterious dreamlike animals and wondrous taut visions that would soon fade. The same magical spirit exists in Heade's *Gremlins in the Studio* (private collection) and in his *Thunderstorm Over Narragansett Bay* (1868; fig. 63).

Thomas Eakins was eight years younger than Homer, but—perhaps owing to his extensive travels in Europe and his training under Jean Léon Gérôme and Léon Bonnat in Paris—he reached artistic maturity during these same years. His was a French style, adapted to American subjects and American taste. In the five years after his return from abroad in 1870, he did the great series of hunting scenes, the boating pictures, *William Rush Carving His Allegorical Figure of the Schuylkill River* (Philadelphia Museum of Art), and a number of superb portraits including his masterpiece, *The Gross Clinic* (1875; Jefferson Medical College, Philadelphia).

The Cultural Context

Thus, a great deal besides luminism happened in American painting during the decade after the Civil War. The period is not only one of the richest in our art history but is also extraordinarily complex in the variety of styles and subjects. It was a time of disparate, competing manners and has proved to be, for the historian of taste, particularly fecund, in the dramatic changes that occurred in the early seventies. Other arts blossomed as well. The American Society of Painters in Water Colors was founded in 1866, and its exhibits over the next decade demonstrate the creative and popular growth in this medium.

Henry Hobson Richardson, who went to study at the Ecole des Beaux-Arts in 1860, returning in 1865, not only gained recognition as an architect with his Brattle Square Church in 1872 but also established the modern idiom "Richardson Romanesque" with Trinity Church, also in Boston, in 1872-1876. With such contemporaries as Frank Furness in Philadelphia and, in New York, Richard Morris Hunt, brother of the painter, he firmly established architecture as a profession in America. Their work was based directly on French models, and it constituted a rejection of English Gothic which had been so popular during the previous decades. Much the same thing happened in sculpture: William Rimmer replaced the traditional neoclassic mode with a modern French style and produced *his* masterpiece, *The Dying Centaur* (Museum of Fine Arts, Boston), in 1871. And surely the period's immense enthusiasm for art is seen in the founding in 1870 of the first two great public art museums in America, the Metropolitan in New York and the Museum of Fine Arts in Boston, followed by Washington's Corcoran Gallery in 1874, and the Philadelphia Museum in 1876. Indeed, what happened during this decade in the visual arts was akin to the flowering of American literature in the works of Nathaniel Hawthorne, Herman Melville, Henry David Thoreau, and Walt Whitman between 1850 and 1855 that F. O. Matthiessen described in his book *American Renaissance*. After a long, innocent Jeffersonian era, when the frontier was open and the future seemed limitless (and Europe unnecessary, for the society or for its artists), the nation in her imperfect maturity after the war now turned again to Europe. Henry Adams received much of his education there; and Mark Twain (who called this "The Gilded Era") searched there in *Innocents Abroad* (1869), as Henry James did in *The Madonna of the Future* (1873) and *Roderick Hudson* (1876). And the painters of this generation—unlike Mount, George Caleb Bingham, and Church—relied on European and particularly on French training. American painters in France during 1866 included Homer and Eakins, James McNeill Whistler and Vedder, Mary Cassatt and W. T. Richards; and Church passed through on his long trip of 1867-1868. Of the luminists, Gifford made extensive trips in 1855-1857, then again in 1868-1869, while Kensett had worked abroad from 1840 to 1847, and Heade had made one or perhaps two European trips, also during the forties.

This period, which has drawn the attention primarily of political and economic historians, has been studied mainly in reference to the debilitating, radical Reconstruction (which the historian Claude Bowers called "The Tragic Era"), followed by the panic of 1873 and the ensuing depression. This was the time that modern America was born, and the old Emersonian dreams were given up forever: the nation would now be urban, not agricultural, with industrialism dominant and the slums accepted as permanent fixtures. The sail was supplanted by steam, and Darwinism came to replace a traditional belief in humanitarian reform. Great new fortunes were made, speculators prospered, and corruption invaded every corner of society. The nation was divided politically, torn by racism, and had suffered from the shattering trauma of a bloody

230. John Brett. *The British Channel Seen from the Dorsetshire Cliffs*, 1871. Oil on canvas. 1.061 x 2.127 (41¾ x 83¾ in). The Tate Gallery, London (not in exhibition)

231. Edward Lear. *Khanea, Crete,* 1864. Watercolor and pen on paper. 0.178 x 0.533 (7 x 21 in). The Toledo Museum of Art, Toledo, Ohio (not in exhibition; above)

war which had wounded or killed so many young men, North and South.

Walt Whitman summed up the era best in an essay of 1871 called "Democratic Vistas": "Society, in the states, is cankered, crude, superstitious and rotten Never was there, perhaps, more hollowness at heart than at present The depravity of the business classes of our country is not less than has been supposed, but infinitely greater. The official services of America, national, state, and municipal, in all their branches and departments, except the judiciary, are saturated in corruption, bribery, falsehood, maladministration, and the judiciary is tainted."[18] Modern historians have echoed Whitman, Allan Nevins discussing the period under the title, "The Moral Collapse,"[19] and George M. Frederickson in his useful study of intellectual life in the period concluding: "Instead of purging the nation once and for all of self-seeking, materialism, and corruption, the war opened the floodgates for the greatest tide of personal and political selfishness the nation had ever seen."[20]

The post-war era would seem an unlikely time for a great flowering in the arts. A literary historian wrote of the war: "The nation was unified, but at terrible cultural expense."[21] This was apparently true, if by "culture" we mean literature, for not a single important novel appeared in the four years following the war;[22] even after that, notwithstanding the work of Twain and James, Bret Harte and William Dean Howells, there was still no literary renaissance. (Interestingly, literary taste at the time was strongly British, and Charles Dickens, William Thackerary, and Walter Scott were widely read.) But in painting there occurred an era of enormous vitality and accomplishment, of stylistic experimentation and diversity, and, as we have seen, luminist landscapes represented only one of many paths. Numerous exhibitions were held throughout the country, with artists roaming more and more widely in search of picturesque subjects. Dealers became established in the larger cities, and patronage was plentiful for both Europeans and American pictures as vast new

fortunes were being quickly made.

No one has seriously studied this period's culture with its seeming anomaly of high artistic productivity in the face of moral depravity. It may be that art has little to do with morality, as one thinks of the Renaissance popes or the aristocracy of eighteenth-century France or the sudden maturation of abstract expressionism in 1946-1947 following a world war. The knowledge that the Reconstruction era coincided with great artistic productivity may lead us, in turn, to a revised view of America at the time. For this was, after all, a time of great growth. Every section prospered, except for the South, and there were boom years from 1869 to 1873. The West was settled, with the transcontinental railroad uniting East and West in 1869. A uniform national currency, a modern communications system, and the best railway in the world were established, and many industries—including oil, steel, and meat—matured and prospered.

Prosperity and patronage encourage the artist as nothing else does, yet they do not necessarily coopt the painter. Most, or perhaps all, of the art of this complex period in fact seems distinctly nostalgic in mood. This is clearly the case for Eakins, with his moody, withdrawn women seated in old-fashioned chairs in their aged dresses, as it is for Homer, with his preoccupation with the ideal, virtuous women and children of America's rural past. Tait memorialized a world where men had to hunt and fish to survive, and E. L. Henry evoked specific historical places and events. The Hudson River school celebrated the vanishing wilderness of the West or pastoral places closer to home which progress somehow had spared. And the luminists went even further to a pure and untroubled world indeed, where there is no sign of modern developments. Here a farmer stands quietly in the hayfield with his small son, and the worst possible worry is a quick, warm shower. Rivers and harbors contain only sailboats, gliding or drifting along; there are no steamboats, no cities, no factories—only the hush of a fragile moment suspended in time.

232. Edward Lear. *Sunset on the Nile*, 1860s. Oil on canvas. 0.241 x 0.463 (9½ x 18¼ in). Private collection (not in exhibition)

233. Sanford Robinson Gifford. *A Winter Twilight*, 1862. Oil on canvas. 0.394 x 0.804 (15½ x 30¹¹⁄₁₆ in). Private collection. Photo: Ken Strothman

Luminism in Europe

Recent scholars have come to consider luminism as quintessentially American. It has been seen as part of a native tradition that can be traced back at least to Copley, whose work is objective, realistic, linear, and nonpainterly. One writer contends that "luminism is one of the most truly indigenous styles in the history of American art."[23] The question of national style is not irrelevant, of course; the problem is not so much that the old question "What is American about American art?" has been asked too often, but rather that it has been so frequently answered wrongly. To discuss luminism, for example, as if the only contemporaneous European painting was French impressionism is misleading. Luminism may in fact be "indigenous" to some extent, but it is impossible to discuss this at all without consideration of the highly realistic and frequently luminous romantic landscape paintings that were being made all over Europe during the mid-nineteenth century.

If we are right in considering luminism to be a "British" style in America, then we naturally look to English and Scottish painting for homegrown parallels. Particularly among the Pre-Raphaelites and their associates, there are frequent paintings and watercolors that recall our luminist pictures. The exhibition of British art held in New York and Boston in 1857-1858 included many works of the Pre-Raphaelites as well as *The Glacier of Rosenlani*, 1866, by John Brett (1831-1902) and *View on the Campagna of Rome* by Edward Lear (1812-1888); both of the latter worked in a manner close to luminism. Brett's

highly detailed views of the fifties gave way to broad, luminous seascapes, and his *British Channel Seen from the Dorsetshire Cliffs* (1871; fig. 230), shares the luminist view in its abstract, horizontal composition—simply a band of water and a band of sky—its empty foreground, and its concern with evanescent light effects. The style was carried on with little variation for the next two decades, and Brett's great panoramic view, *The Norman Archipelago* (1885; City Art Gallery, Manchester, England), is still luminous and tightly handled, now with delicate pinks and greens prevailing.

Edward Lear, better known in his own day for his nonsense verse, was an indefatigable traveler and watercolorist, who worked more consistently in a luminist mode than any of his countrymen. In watercolor after watercolor (there are 3400 at Harvard alone) he employed a long horizontal format, a foreground defined only by rocks or shore, and a distant view consisting largely of sky and water (see, for example, *Khanea, Crete*, 1864; fig. 231). The rarer oils follow the same format and are even closer to American luminism in their coloration and handling. In *Sunset on the Nile* (fig. 232) dating from the sixties, the tones of the sky are very close to those of Gifford's *A Winter Twilight* (1862; fig. 233), in the imperceptible transition from blue at the top to lemon yellow and then a dramatic band of clear deep red on the horizon. Lear's work is luminist in its hues and its careful brushwork, though it can be distinguished from the Americans' work in its greater emphasis on foreground figures and in the unnaturally great sense of clarity in the depiction of distant rocks and shore.

Much the same can be said of William Dyce's *Pegwell Bay, Kent—A Recollection of October 5th, 1858* (1860; fig. 234) with its luminist colors, format, and handling and greater detail and concern with the foreground figures. Other British painters of the same generation worked in modes even closer to

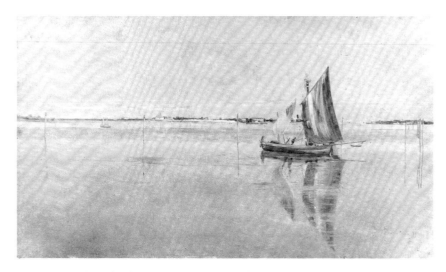

236. J. W. Inchbold. *The Certosa, Venice, from the Public Gardens,* 1860s. Oil on canvas. 0.381 x 0.711 (15 x 28 in). City Art Gallery, Leeds, England (not in exhibition)

235. E. B. Cooke. *On the Nile,* 1862. Oil on paper on canvas. 0.196 x 0.282 (7¾ x 11⅛ in). City Art Gallery, Manchester, England (not in exhibition)

234. William Dyce. *Pegwell Bay, Kent—A Recollection of October 5th, 1858,* 1860. Oil on canvas. 0.635 x 0.890 (25 x 35 in). The Tate Gallery, London (not in exhibition; below)

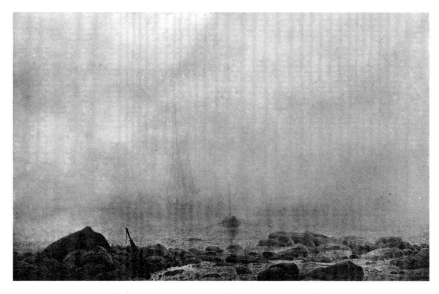

237. Caspar David Friedrich. *Mist,* 1807. Oil on canvas. 0.390 x 0.510 (15⅜ x 20¹⁄₁₆ in). Kunsthistorisches Museum, Vienna (not in exhibition)

luminism: Edward W. Cooke in *On the Nile* (1862; fig. 235), for example, depicts the clear, dramatic twilight colors reflecting off the water much as Gifford or Church would, and J. W. Inchbold frequently turned to luminism, as in *The Certosa, Venice, from the Public Gardens* (1860s; fig. 236), where a luminous view

of sea and sky is broken only by a drifting sailboat. In addition, mention should be made of Lord Leighton and the "Etruscan School," a group made up largely of Englishmen whose landscape studies are usually horizontal, architectonic, and "marked . . . by a very precise sense of tonal relationships,"[24] thus closely related to the luminist style.

Of the English, Brett and Lear are closest to the luminists; their work relates to the international style of the period in its high realism, its frequent horizontality, and its tonalism, though it varies from the American manner in its typical narrative content. However, the English at this time seldom concentrate on the land itself, and they do not search pantheistically for meaning and mood in nature's shapes and tones in the way the contemporary Germans, and sometimes the Americans, do.

Robert Rosenblum has written of the northern romantic tradition, suggesting its continuity from Friedrich to Mark Rothko, and it is indeed in the work of Caspar David Friedrich and other German artists that one can find both precursors and close parallels to American luminism.[25] To be sure, most of Friedrich's paintings are closer to Washington Allston or Thomas Cole in

purpose than to the luminists; typically a human figure, a tree, or a boat plays both an important compositional role and a psycho-symbolic one, and his landscapes are far less accessible and more foreboding than those of the Americans. However, a few of the most "neutral" of his compositions bear a marked resemblance to Lane and Heade. *Mist* (1807; fig. 237) recalls both Americans' work in composition and shape, in the softly painted band of foreground rocks, and in the treatment of ships approaching out of the fog in a calm sea—one particularly thinks of Heade's *The Stranded Boat* (1863; fig. 120). Similarly, Friedrich's *View of a Harbor* (c. 1815; fig. 238) resembles Lane's *Boston Harbor* (1850-1855; fig. 239). Though the former's vertical composition condenses the scene, both depict a calm harbor at sunset with men at work on the huge, quiet ships, and both make use of a foreground rowboat that leads into the composition.

Among the Germans of this generation should also be mentioned K. F. Schinkel (1781-1841). His *Landscape Near Pichelswerder* of 1814 (Folkwang Museum, Essen, West Germany) is an extraordinarily subtle study of light, with pale blues, yellows, and pinks of the morning sky above the green field

238. Caspar David Friedrich. *View of a Harbor,* c. 1815. Oil on canvas. 0.900 x 0.710 (35⁵⁄₁₆ x 28 in). Staatliche Schlösser und Gärten, Schloss Charlottenhof, Potsdam, German Democratic Republic (not in exhibition)

239. Fitz Hugh Lane. *Boston Harbor,* c. 1850-1855. Oil on canvas. 0.668 x 1.067 (26¼ x 32 in). Museum of Fine Arts, Boston; M. and M. Karolik Collection, by exchange (below)

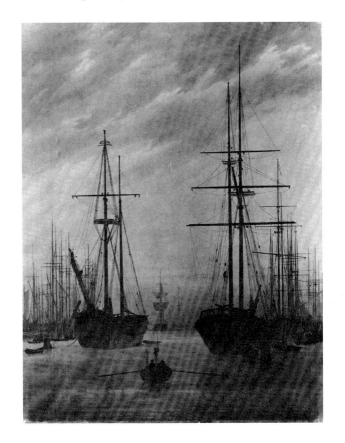

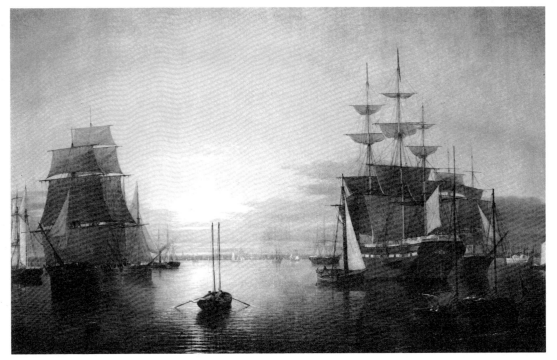

240. Friedrich J. E. Preller. *Norwegian Coast at Scudesnaes*. Pencil, 0.154 x 0.253 (6¹⁄₁₆ x 10 in). Graphit Staatl, Kunstsammlungen, Dresden. Photo: Museum of Fine Arts, Boston (not in exhibition)

241. Louis Gurlitt. *Coast Near Mölle,* July 1833. Pencil. 0.223 x 0.343 (8³⁄₄ x 13½ in). Location unknown

with its winding river. In keeping with its early date, this is still a classical landscape to some extent, with an emphasis on the foreground foliage and figures; but its treatment of light and simplicity of composition relate closely both to Friedrich and to luminism.

Friedrich influenced a number of his contemporaries in Dresden, including Carl Gustav Carus (1789-1869) and the Norwegian J. C. Dahl (1788-1857). The latter's collection, including several Friedrich oils, formed the basis of the National Gallery in Oslo. Much of Dahl's own work is equally "luminist," particularly the highly detailed *Kronborg by Moonlight*, 1828 (National Gallery, Oslo), and *Sailing Ship at Copenhagen*, 1830 (Thorwaldsen Museum, Copenhagen)—the latter a study of a single ship with a rowboat on a calm sea, which also resembles Lane's work.

Another major Dresden figure of the period was Friedrich J. E. Preller (1804-1878), who is best known for his classical landscapes and for his portraits, but who also created a series of pencil drawings of the Norwegian coast (for instance, *Norwegian Coast at Scudesnaes*; fig. 240) which precisely parallel the Newport drawings and watercolors of W. T. Richards and William S. Haseltine dating from the 1860s and early seventies. Preller's touch is lucid and sharp as he outlines the short and the large rock in the central middle ground—recalling *Brace's Rock* (see figs. 11, 71, 94)—and then lifts his eyes to the flat horizon with its distant ship. Both his technique and aesthetic seem virtually indistinguishable from those of the luminists.

A number of German painters of the nineteenth century traveled abroad to seek suitable landscape subjects, and the forests and seashore of Norway became popular in a way that the White Mountains and the Newport coast did for Americans. Louis Gurlitt (1812-1897), for example, who had been influenced by Dahl and by Christian Morgenstern, studied under Christian Eckersberg in Copenhagen. While there, he made a series of coastal drawings very similar to Preller's: his *Coast Near Mölle* of July 1833 (fig. 241) depicts a point of land that resembles Owl's Head, in a strong hatched style that suggests Kensett or Casilear.

Georg Saal (1818-1870) also traveled to Norway, where he painted a wide range of subjects in a style very like that of the Hudson River school. His *View of Trondhjem in Norway* (fig. 242) with its high vantage point, its detailed handling, its composition with distant ships to the left and the landscape stretching out to the right, and its concern with sky and light recalls Kensett's *View Near Cozzens Hotel, West Point* (1863; fig. 243). Other of his paintings are closer to Bierstadt in subject, though *Nordkap*—the subject of a lithograph—in its use of light on high cliffs and surf relates to Church's *Grand Manan Island, Bay of Fundy* (1852; fig. 53) and to W. T. Richard's watercolors and oils of the cliffs of the same island.

Luminous paintings appear frequently in German art up to about 1875, after which the German style generally becomes more painterly and expressive, as it does in America. The Hamburg painter Julius Prömmel (c. 1805-?), for exam-

242. Georg Saal. *View of Trondhjem in Norway.* Oil on canvas. 0.475 x 0.672 (18¾ x 26½ in). Kunsthalle, Karlsruhe, Federal Republic of Germany (not in exhibition)

243. John Frederick Kensett. *View Near Cozzens Hotel, West Point,* 1863. Oil on canvas. 0.508 x 0.864 (20 x 34 in). Inscribed, l.c.: *JF K '63.* The New-York Historical Society, New York

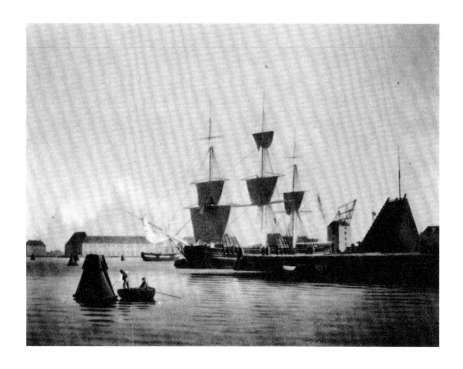

244. Julius Prömmel. *Copenhagen Harbor*, 1817. Oil on canvas. 0.600 x 0.760 (23⅝ x 30¹⁄₁₆ in). Kunsthistorisk Plodearkiv, Copenhagen. Photo: Museum of Fine Arts, Boston (not in exhibition; at left)

245. Jacob Gensler. *Beach at Laboe*, 1842. Oil on paper. 0.210 x 0.463 (8¼ x 18¼ in). Kunsthalle, Hamburg. Photo: Museum of Fine Arts, Boston (not in exhibition)

246. Maximilian Haushofer. *View of the Mountains*, 1855. Oil on canvas. 0.279 x 0.413 (11 x 16¼ in). Private collection (not in exhibition; opposite page)

ple, studied both in Copenhagen and later in Italy; his view of *Copenhagen Harbor* (1817; fig. 244) is very close to Lane's harbor views in composition but recalls works by slightly later painters, such as Silva, in its glossy, hard handling. Another Hamburg man of the same period, Jacob Gensler (1808-1845), studied in Munich and Vienna and in 1841 journeyed to Holland and Belgium. On his return he executed a series of luminist oil sketches on paper, many of which are at the Kunsthalle, Hamburg. These are very close stylistically and technically to the oil sketches which Gifford and Whittredge made on their western trips, and they are all but indistinguishable from Heade's work in the same medium. Gensler's *Beach at Laboe* (1842; fig. 245) is remarkably like Heade's *Rye Beach* (1863; William Benton Museum of Art, University of Connecticut, Storrs): both depict empty beach scenes in a nearly monochromatic manner using an extremely horizontal format, a flat horizon where dark sea meets the light sky, a brushy depiction of storm clouds—and even the form of incised inscription is the same. Similarly, there are German equivalents to the more colorful and painterly oil sketches of Church and Bierstadt in the subtle works of Christian Morgenstern (1805-1867), who also lived in Hamburg.

German luminism appears in many centers besides Dresden and Hamburg. It is seen in the work of Maximilian Haushofer (1811-1866), an influential and popular Munich painter whose *View of the Mountains* (1855; fig. 246), makes a telling comparison with the work of the Americans, and particularly with

Gifford. Haushofer's palette is similar to Gifford's, favoring browns, with a subtle transition to lighter tones in the distant mountains and then to a pale orange sky which gradually becomes blue overhead. Brushwork is even less visible than in Gifford's work—in fact, Heade and Gifford look almost painterly in comparison to much northern romantic art. Yet one would not mistake this for an American picture, despite similarities of subject, composition, color, and handling; for a more ominous mood prevails here, and the scene is less penetrable: the trees are dense, the shadows forbidding, and there is no easy access for the viewer. In the paintings of the Americans, particularly Gifford and Heade, there is always a rationally ordered recession into space, and the viewer's eye zig-zags from left to right, from the foreground to one point of interest then another, as it gains the far horizon. This quality is not, of course, exclusively American. There are some pictures from England, Germany, Denmark, and Russia that simply cannot be distinguished from American work on formal or stylistic grounds, for example *Marsh Scene, Evening* (Museum Folkwang, Essen, West Germany) by Adolf Lier (1826-1882). Lier had studied successively in Dresden, Munich, and Paris and then in 1865 traveled to England—and this painting, with its close similarity in composition and color to the work of Brett and Cooke, may well date from after the latter trip.

Some of the connections between Germany and Denmark in this era have already been suggested, and as one would expect, there was a strong group of

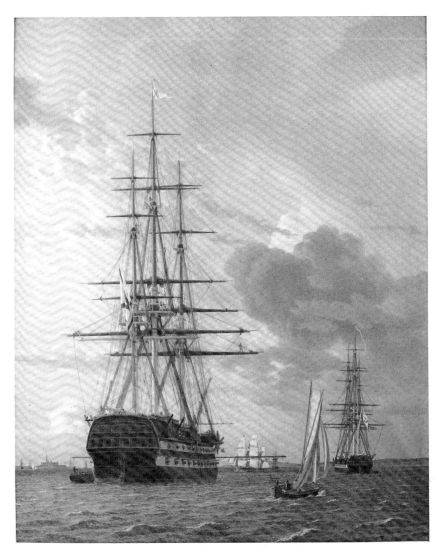

Danish luminist painters. In fact, Danish work at times resembles American luminism more than German art does, as it is more objective and less emotionally wrought. This can be seen at the beginning of the Danish school in the work of Christian W. Eckersberg (1783-1853), the so-called "father of Danish painting."[26] After studying in Paris under Jacques-Louis David and then in Rome (where so many of the northern romantics went), he returned to Copenhagen in 1818 an accomplished master of portraiture—as evidenced by the superb *Portrait of Thorwaldsen* (1814; Royal Academy of Arts, Copenhagen)—as well as of history and religious paintings, genre, and still life. His marine paintings such as the *American Sailing Ship*, 1831, or *Russian Ship at Anchor*, 1829 (both Statens Museum for Kunst, Copenhagen; see fig. 247), are as crisp and luminous as anything Robert Salmon ever did. Like much of Salmon's work, *Russian Ship* is still a somewhat classical painting, with each of the complex groups of ships of various sizes in perfect balance with the others while the blues and grays of the water, hulls, and sky are interwoven with equal care. One finds none of the emotional intensity or mystery of Friedrich's *View of a Harbor:* for the Danish artist, as for the American, nature is a pleasant place.

D. H. Anton Melbye (1818-1875), a much-honored and most successful student of Eckersberg, painted more truly luminous marine views than his teacher. In his *Marine* (Copenhagen) or in *A Frigate and a Brig Under Sail* (1844; fig. 248) one finds the same softness of light, the slight blurring of detail in favor of an overall tonal unity, that one sees in Kensett's *Shrewsbury River* (1859; fig. 202), or Heade's *Becalmed, Long Island Sound* (1876; fig. 249).

247. Christian Ekersberg. *Russian Ship at Anchor,* 1829. Oil on canvas. 0.631 x 0.510 (24¹³/₁₆ x 20¹/₁₆ in). Statens Museum for Kunst, Copenhagen. Photo: Museum of Fine Arts, Boston (not in exhibition)

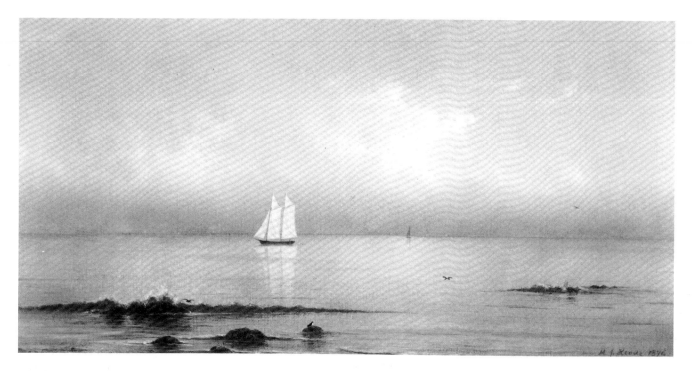

249. Martin Johnson Heade. *Becalmed, Long Island Sound*, 1876. Oil on canvas. 0.381 x 0.762 (15 x 30 in). Inscribed, l.r.: *M.J. Heade 1876*. Private collection. Photo: Herbert P. Vose

248. D. H. Anton Melbye. *A Frigate and a Brig Under Sail*, 1844. Oil on canvas. 0.471 x 0.575 (18⁹/₁₆ x 22⁵/₈ in). Thorvaldsens Museum, Copenhagen (not in exhibition; at left, below)

Other major Danish landscapists of this generation were Christian Købke (1810-1848) and Johan T. Lundbye (1818-1848), both of whom made numerous luminous landscapes. Købke was particularly prolific, and one series of views including *View from Kastelsvolden* (1840s; fig. 250) and *Shore Scene* (c. 1836; fig. 251) remind one of Kensett's carefully composed coastal views: the latter painting is particularly close, with tall trees and shoreline to the left, and the quiet river stretching far into the distance on the right. Lundbye, unlike Købke, painted landscape exclusively. His *Danish Coast* also recalls Kensett in composition, and the *Zealand Landscape*, 1840 (both Ny Carlsberg Glyptothek, Copenhagen), again parallels luminism in its horizontality, its interest in light, and its attention to detail.

In addition, Dankvart Dreyer (1816-1852) made very subtle atmospheric studies on the Jutland heaths; and his *View of Assens* (1830s; Fyens Stiftmuseum, Odense, Denmark) recalls Whittredge's Newport views in its flat horizon with sea beyond. Better known in his own day was Dreyer's contemporary Martinus Rorbye (1803-1848), a Norwegian-born student of Lorentzen and Eckersberg. After travels to Paris, Italy, Greece, and Turkey, he was elected a member of the Copenhagen Academy in 1838 and, in the decade before his early death, became well known as an innovative stylist in portraiture, genre, and landscape. His *Beach at Blokhusene* (1848; fig. 252), a finished painting remarkably like the oil sketches of Gensler and Heade discussed above, depicts beach, sea, and sky

250. Christian Købke. *View of Kastelsvolden,* 1840s. Private collection. Photo: Museum of Fine Arts, Boston (not in exhibition)

251. Christian Købke, *Shore Scene,* c. 1836. Statens Museum for Kunst, Copenhagen (not in exhibition)

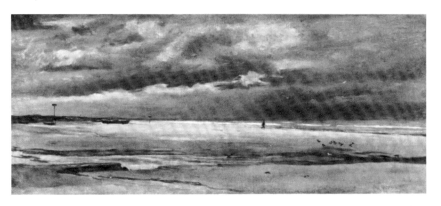

252. Martinus Rorbye. *Beach at Blokhusene,* 1848. Oil on canvas. 0.206 x 0.484 (8¼ x 19¹/₁₆ in). Art Museum of Sorø, Denmark. Photo: Museum of Fine Arts, Boston (not in exhibition)

within a simple horizontal format and studies both the vastness of nature and the quality of changing light effects. Related coastal and heath views, all depicting empty, stark landscapes with dramatic, flat horizons and great skies above, were painted by Hans Gabriel Friis (1839-1892), Peter W. C. Kyhn (1819-1903), and J. A. B. La Cour (1837-1909): the latter's *Sea Scene with Rocky Coast* (fig. 253) is typical of this school. Finally, mention should be made of the very different but equally luminous landscapes of Christian Zacho (1843-1913), another product of the Copenhagen Academy, who later studied with Bonnat in Paris. His *Summer's Day on the Banks of the Rivulet in Saebygaard Wood (Jutland)* (fig. 254)[27] depicts an interior forest scene with the same delicacy of touch, subtlety of sunlight and reflection, and warm palette that one finds in Gifford's *Indian Summer on Claverack Creek* (1868; fig. 127) and that typify the latter's work.

Luminism, or something very like it, can be found everywhere in Europe. In France one would cite the landscapes of Emile Foubert (?-1910/11) or Alexandre Calame (1810-1864), and in Italy the works of the Florentine Macchiaioli, as William Gerdts has pointed out;[28] but the tradition weakens significantly as one moves south. The strongest parallels are found, not surprisingly, in northern countries whose cultures were most like America's. There are close parallels in England, Germany, and especially Denmark, with its youthful and largely imported artistic tradition.

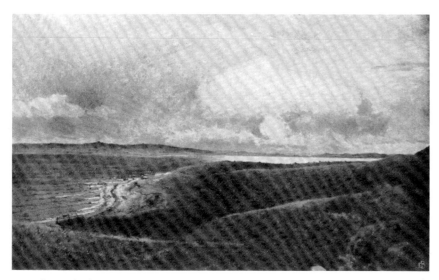

253. Janus Andreas Bartholin La Cour. *Sea Scene with Rocky Coast*. Location unknown

254. Christian Zacho. *Summer's Day on the Banks of the Rivulet in Saebygaard Wood (Jutland)*. Location unknown

255. Grigory Soroka. *The Fisherfolk*, c. 1845-1850. Oil on canvas. 0.670 x 1.020 (26⅜ x 40⅛ in). Russian Museum, Leningrad. Photo: Museum of Fine Arts, Boston (not in exhibition)

Most closely related of all is the work of Russian painters, who were about the same distance from the art centers of Paris and Rome, London and Hamburg, as were their American counterparts. While in most European countries the luminist variants predate their American counterparts, this is not the case in Russia. There, the parallel between styles appears to be nearly exact. For example, the forerunner of "Russian luminism" is *The Fisherfolk* (c. 1845-1850; fig. 255) by Grigory Soroka (1823-1864), who was himself a student of the great Alexey Venetsianov. Soroka's painting corresponds precisely in mood, construction, and style to William Sidney Mount's *Eel Spearing at Setauket* (1845; fig. 256). In shape and in the perfect balance of the composition, in the pervading calm of the view across the water to an inhabited shore, and even to the simple boat with its standing figure and the diagonals of oar and pole, the pictures echo one another. The critic Smirnov points out that *The Fisherfolk* was a masterpiece in Soroka's oeuvre, that it "embodies the very essence of . . . the artist's native place,"[29] that it is harmonious, tranquil, yet deeply emotional—all true also of Mount's work.

Two studies of the Pontine Marshes by A. A. Ivanov (1811-1868) date from 1838: they are fine luminous pictures, empty, atmospheric, tenderly colored in a manner reminiscent of Friedrich, and extremely horizontal (see fig. 257). They are exceptions (paralleling Cole's *Lake Scene*, 1844; Detroit Institute of Arts) that predate the main body of Russian luminism. Ivanov's advanced work must be due, at least in part, to his thorough training and his extensive travels: after a

256. William Sidney Mount. *Eel Spearing at Setauket,* 1845. Oil on canvas. 0.737 x 0.915 (29 x 36 in). Inscribed, in shadow under boat: *Wm. S. Mount.* New York State Historical Association, Cooperstown

decade at the academy, St. Petersburg, he went to Italy in 1830 on a grant from the Institute for the Encouragement of Art, also visiting Germany and Austria; he then moved to Rome permanently in 1831.

Liev Felixovitch Lagorio (1826-1905) received his education at St. Petersburg and traveled widely in France and Italy. His seascapes of the 1870s, such as *Ship at Sea* (Aivazovsky Gallery, Feodosia, U.S.S.R.), depict old-fashioned square riggers on dark seas, much in the manner of James Hamilton, and their flat horizons and dramatic light effects also recall the work of the Philadelphia painter. Quite different, but also nearly identical in spirit and style to American painting is Lagorio's *Crossing the Terek* (fig. 258) which so much recalls Worthington Whittredge's *Crossing the Ford, Platte River, Colorado* (1870; fig. 259).

The most important group in mid-nineteenth-century Russian art was the *Peredvizhniki* ("the Itinerants") whose members, encouraged by the political reforms of the 1860s, developed a "brilliant and distinct national style."[30] Even before the group's founding in 1870, many of the painters involved exhibited regularly at the Tretyakov Gallery, founded in Moscow in 1856. In the early years, history and genre paintings of popular and "democratic" subjects dominated; however, some of the founding members were landscape specialists whose work of the sixties and later relates closely to luminism. For example, a founding member of the group was Lev Lvovich Kamenev (1833-1886), who studied in Moscow and then traveled in Germany and Switzerland. His *Landscape* (1871; Tretyakov Gallery, Moscow), recalls Gifford and McEntee in its horizontality and its hazy light effects. And in the following year he made several vertical woodland views, which are close to Whittredge's. His style is related to that of Aleksey Petrovich Bogolyubov (1824-1896), also an "Itinerant," who studied in St. Petersburg at the academy, was influenced by Ivan Aivazovsky, then traveled on a grant (1854-1860) to study in Paris with Jean Baptiste Isabey and in Düsseldorf with Andréas Achenbach. In the years just before settling in Paris for good (1873), he executed fine, warm woodland scenes reminiscent of Gifford and calm, empty harbor views as well.

Another founder was M. K. Klodt von Jurgensburg (1832-1902), a St. Petersburg man who won a traveling grant from the Academy of Arts, like so many of the best Russian painters, and between 1858 and 1861 worked in Switzerland and France. As director of the academy's landscape class beginning in 1871, Jurgensburg was an influential figure whose stylistic development typifies the "mainstream" of the Russian school. *Highway in Autumn* (1863;

257. A. A. Ivanov. *Pontine Marshes*, 1838. Oil on canvas. 0.315 x 0.944 (12⅜ x 37³⁄₁₆ in).
Tretyakov Gallery, Moscow. Photo: Museum of Fine Arts, Boston (not in exhibition)

258. Liev Felixovitch Lagorio. *Crossing the Terek*. Aivazovsky Gallery, Feodosia,
U.S.S.R. (not in exhibition)

260. M. K. Klodt von Jurgensburg. *Ploughing*, 1872. Oil on canvas. Tretyakov Gallery,
Moscow. Photo: Museum of Fine Arts, Boston (not in exhibition)

Tretyakov Gallery, Moscow) like Bierstadt's *Sunset on the Prairie* (1861; fig. 134),
depicts a dramatic sunset sky above a flat horizon. Both paintings have a sense
of great space: they speak to the power and drama of nature through striking
colors and a stark composition. In the early seventies, the work becomes more
domestic in scale: his *Ploughing* (1872; fig. 260) recalls Homer and especially
Eakins in the sharp lighting of a single figure in a field. His dramatic placement
of the farmer and his horse in the middle ground recalls Eakins' similar
compositions (of exactly these years) that depict hunters in the same flat fields;
both painters had an exquisite ability to make the commonplace moving and
memorable. Then, for a last example, in *Timbered Landscape at Noon* (1876;
Tretyakov Gallery, Moscow) one finds a change both in style and subject: forms
are now blurred, light more diffuse, and a sense of loss pervades the scene as a
single tall tree to the left anchors a simple horizontal composition.

There are many coincidences of style and subject between Russian and
American landscape. The early landscapes of Arkhip Ivanovich Kuindji (1841-
1910), who was self-taught before studying at the St. Petersburg Academy in
1868, are comparable to American works. His very horizontal landscapes of c.
1872-1873 recall Wyant and Martin, while the many views after 1880 that depict a
winding river in a marsh inevitably bring Heade to mind. Kuindji's *Morning on
the Dnieper* (1881; fig. 261) is typical in its emptiness, its low, flat horizon with
emphasis on light and sky, and the details of foreground grasses and flowers.
His later work continues the same themes, but with increasingly strident light
effects (again, like Heade); and the paintings after 1890, like those of his great
contemporaries Levitan and Savrasov, are quite different in mood as they
become more symbolist than luminist.

However, of all of the Russians, in fact of all European painters, the one
whose work consistently relates to American developments and particularly to
luminism is Ivan Konstantinovich Aivazovsky (1817-1900). He studied at the
academy, St. Petersburg, and with the French marine specialist, Philippe
Tanneur, who had come at the request of the Czar in 1835. He then traveled on
an academy grant through Europe, to England, France, Holland, and Italy. In
1844 he returned and immediately gained an important place in the Russian art
world, as he was quickly appointed painter to the naval general staff. Making
his home in Feodosia between extensive voyages, Aivazovsky founded an art

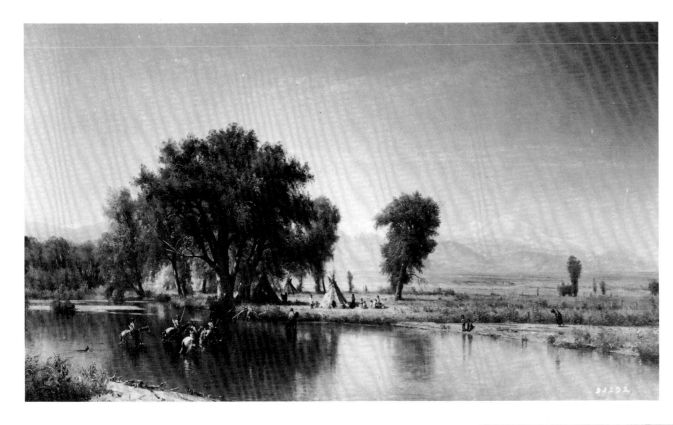

259. Thomas Worthington Whittredge. *Crossing the Ford, Platte River, Colorado*, 1870. Oil on canvas. 1.023 x 1.756 (40¼ x 69⅛ in). Inscribed, l.r.: *W. Whittredge*. The Century Association, New York. Photo: Frick Art Reference Library

school there in 1865 and a gallery in 1880, and by the end of his long career he had produced over six thousand paintings.

The very early works, such as *View of the Coast Near St. Petersburg* (1835; Tretyakov Gallery, Moscow), are moody and symbolic and suggest Friedrich's influence. However, his vision and his sense of light were enlarged through his travels, as seen in *The Coast at Amalfi* (1841; Russian Museum, Leningrad). The following years find his style matured in the marvelously luminous *Bay of Naples by Moonlight* (1842; Aivazovsky Art Gallery, Feodosia, U.S.S.R.), a study in dark blues of sea and sky contrasting with the bright orange moonlight, and especially in *Seashore: Calm* (1843; fig. 262). The latter retains a classical element in the figure group to the right but otherwise is a pure study of calm green and yellow sea and the warm, hazy sky, broken by the verticals of the standing figure to the right and the masts of a becalmed ship to the left. Both of these pictures parallel Lane's achievements a few years later, and the closeness of the two painters is made even clearer by *Reval (Tallinn)* also 1844 (fig. 263). Composition, mood, light, the glassy, calm sea, foreground rowboats, sagging sails—all remind one of Lane's harbor scenes. The shape of the painting, the large area of sky, and the distant city view relate especially to Lane's *Boston Harbor* (fig. 239).

261. Arkhip Ivanovich Kuindji. *Morning on the Dnieper*, 1881. Oil on canvas. 1.050 x 1.670 (41⁵⁄₁₆ x 65¾ in). Tretyakov Gallery, Moscow (not in exhibition)

262. Ivan Konstantinovich Aivazovsky. *Seashore: Calm,* 1843. Oil on canvas. 1.140 x 1.870 (44⅞ x 73⁵⁄₁₆ in). Russian Museum, Leningrad. (not in exhibition)

263. Ivan Konstantinovich Aivazovsky. *Reval (Tallinn),* 1844. Oil on canvas. 1.180 x 1.880 (46⁷⁄₁₆ x 74 in). Central Naval Museum, Leningrad. (not in exhibition)

Aivazovsky's work becomes increasingly expressive, and it calls to mind first one American painter and then another. *The Ninth Wave* (1850; Russian Museum, Leningrad), with its huge, transparent cresting green wave is a powerful romantic image, executed as Bierstadt did on several occasions, as in *Seal Rocks, San Francisco* (c. 1872; collection of Sandra and Jacob Y. Terner, Beverly Hills, California). *Icebergs* (Aivazovsky Art Gallery, Feodosia, U.S.S.R.) echoes Bradford's characteristic composition, with the dark ship outlined against the greens, blues, and pinks of the iceberg. *A Beach Scene at Sunset* (fig. 264)[31] with its flat sea and central becalmed strip recalls Heade's *Becalmed, Long Island Sound* (fig. 249), while *The Black Sea* (1881; fig. 265), with its simple composition of dark, foaming waves below and luminous sky above, brings to mind Heade's *Off Shore: After the Storm* (c. 1865; Museum of Fine Arts, Boston). And the dramatic *Rainbow,* with shipwreck and survivors' lifeboat in the mist, recalls several of Winslow Homer's pictures, particularly the watercolor *The Ship's Boat,* 1883, at the New Britain Museum of American Art, New Britain, Connecticut.

One additional figure should be mentioned, the Russian-born painter and watercolorist Eugen Dücker (1841-1916), as his career gives additional evidence—if any is needed—of the extraordinary internationalism of the luminist style. Dücker was trained at the St. Petersburg Academy, 1858-1863, then received a major travel grant which enabled him to journey to Germany, France, Belgium, Holland, and Italy. He was elected a member of the academies at St. Petersburg, Berlin, and Stockholm, and he taught for a

number of years at Düsseldorf. His paintings of restful, flat seas in a luminist style (for example, *Evening at Sea,* 1876; fig. 266) were influential at the time in providing an alternative to the "rougher, romantic marine views" of Andréas Achenbach.[32]

From all of this discussion we should not conclude that there *is* no American style, for there surely is—just as there are Russian, Danish, and French styles. However, it should be clear that nineteenth-century romantic art grew in similar ways throughout the Western world, and for the moment the parallels and similarities among the arts of various nations may be as important as any distinctions. The Americans, after all, were in the same position as the Danes and the Russians in their distance from the great art centers and in their reception of so much style and direction through artists' travel, from books and engravings, and from the importation of foreign artists and ideas. This does not mean that Aivazovsky's art should not be considered "indigenous" (e.g. originating or produced naturally in a particular land or region) to Russia, or Lane's to America, so long as the qualities of either man's art or style are not thought to be *uniquely* Russian or American.

We surely have much research to do in the analysis of style and influence. We have been so busy with our pro-French bias, trying to understand how Gifford could have missed Courbet in Paris, or whether Homer saw Monet, that we have not fully investigated what he and the other Americans did see and how it affected them. Similarly, we know now that the visual diet at home was far more eclectic than has been supposed, that modern painters of every national-

264. Ivan Konstantinovich Aivazovsky. *A Beach Scene at Sunset*. Oil on canvas. Location unknown. Photo: Museum of Fine Arts, Boston

266. Eugen Dücker. *Evening at Sea,* 1876. Oil on canvas. 0.580 x 0.960 (22⅞ x 37⅝ in). Galerie G. Paffrath, Düsseldorf. Photo: Helena Paffrath (not in exhibition)

265. Ivan Konstantinovich Aivazovsky. *The Black Sea,* 1881. Oil on canvas. 1.490 x 2.080 (58¾ x 81⅞ in). Tretyakov Gallery, Moscow. Photo: Museum of Fine Arts, Boston (not in exhibition)

ity were exhibiting regularly in New York, Boston, and elsewhere. We know that Church collected Melbye drawings (given the group at Olana); that Aivazovsky traveled to America at least once; that a "Lane" and a "Gifford" and, indeed, a luminist style are found in virtually every country. The style was an international one, with local variation, and there was certainly far more contact among the individual national schools than has been suspected. Almost all of the Americans traveled widely, and a great many contemporary European pictures were also being exhibited here. Almost every painter mentioned here, for example, was represented at the Philadelphia fair of 1876 (Aivazovsky by seven paintings), and most had been seen here before that.

Thus, American painters seem to have been no more derivative than the painters of England, Denmark, or Russia. To examine the context in which they worked, to understand the limited role of landscape and of luminism within American painting in the years 1855-1875, to explore the anomaly of great artistic productivity in this time of supposed moral and cultural collapse, and to seek European parallels and precursors for our artists—as I have tried to do here—by no means denigrates the remarkable achievements of American luminists; rather, it may help us to understand those achievements better.

Notes

1. This article was inspired by the work of William Gerdts, and it was written only with the skillful and perceptive research aid of Elizabeth Prelinger, National Endowment for the Arts intern in the Paintings Department, Museum of Fine Arts, Boston. Our necessarily wide-ranging research made extensive use of the extraordinary resources of the Fine Arts Library at Harvard's Fogg Art Museum, and we are most grateful for the great cooperation of its staff, as we are to the Photography Department of the Museum of Fine Arts, Boston.

2. Henry T. Tuckerman, *Book of the Artists* (New York, 1867), 512.

3. Tuckerman, *Artists,* 512.

4. Tuckerman, *Artists*, 525.

5. Tuckerman, *Artists*, 527.

6. James Jackson Jarves, *The Art-Idea* (1864; Cambridge, Mass., 1960).

7. Jarves, *Art-Idea,* 193.

8. Jarves, *Art-Idea,* 182.

9. Jarves, *Art-Idea*, 208.

10. George W. Sheldon, *Hours with Art and Artists* (New York, 1882), 52.

11. Sheldon, *Hours,* 170.

12. Sadakichi Hartmann, *History of American Art* (Boston, 1902), 35.

13. Hartmann, *American Art*, 55.

14. Hartmann, *American Art,* 56.

15. Frederick A. Sweet, *The Hudson River School* [exh. cat., Art Institute of Chicago and Whitney Museum of American Art] (Chicago and New York, 1945).

16. John I. H. Baur, Introduction in *M. and M. Karolik Collection; American Paintings 1815-1865* (Boston, 1949).

17. Barbara Novak, *American Painting of the Nineteenth Century: Realism, Idealism, and the American Experience* (New York, 1969).

18. Walt Whitman, "Democratic Vistas" in *The Portable Walt Whitman* (New York, 1978), 325-326.

19. Allan Nevins, *The Emergence of Modern America, 1865-1878* (New York, 1927), chap. 3: "The Moral Collapse."

20. George M. Frederickson, *The Inner Civil War: Northern Intellectuals and the Crisis of the Union* (New York, 1965), 183.

21. James D. Hart, *The Popular Book: A History of America's Literary Taste* (Berkeley, Calif., 1963), 157.

22. Nevins, *Modern America,* 229.

23. Novak, *American Painting,* 95.

24. *The Etruscan School* [exh. cat., Fine Art Society, Ltd.] (London, 1976). On English landscape in general see also Allen Staley, *The Pre-Raphaelite Landscape* (Oxford, 1973) and Leslie Parris, *Landscape in Britain, c. 1750-1850* (London, 1973).

25. Robert Rosenblum, *Modern Painting and the Northern Romantic Tradition* (London, 1975). See also Kermit S. Champa, *German Painting of the 19th Century* [Yale University Art Gallery] (New Haven, 1970) and *Caspar David Friedrich, 1774-1840: Romantic Landscape Painting in Dresden* [Tate Gallery] (London, 1972). For Germans in Scandinavia see Olaf Klose and Lilli Martius, *Skandinavische Landschaftsbilder, Deutsche Künstlerreisen von 1780 bis 1864* (Neumünster, 1975).

26. See Henrik Bramsen, *Danske Marinemalere* (Copenhagen, 1962); Vagn Poulsen, *Danish Painting and Sculpture* (Copenhagen); Mario Krohn, *Maleren Christen Købkes* (Copenhagen, 1955); *Dänische Maler* (Leipzig, 1924).

27. Location unknown; see *The World's Columbian Exposition,* official catalogue, Royal Danish Commission, 1893, no. 157.

28. William H. Gerdts, "On the Nature of Luminism" in *American Luminism* [exh. cat., Coe Kerr Gallery] (New York, 1978).

29. G. Smirnov, *Venetsianov and His School* (Leningrad, 1973), 22.

30. A. Lebedev, *The Itinerants* (Leningrad, 1974), 7. See also N. Novouspensky, *Aivazovsky* (Leningrad, 1972); Barsamov, *Aivazovsky in the Crimea* (1972); E. Korotkevich, "Introduction" in *Landscape Masterpieces from Soviet Museums* [exh. cat., Royal Academy of Arts and Glasgow Art Gallery and Museum] (London, 1975); John E. Bowlt, "A Russian Luminist School? Arkhip Kuindzhi's Red Sunset on the Dnepr," *Metropolitan Museum Journal,* 10 (1975), 119-129; and *The Art of Russia 1800-1850* [exh. cat., University of Minnesota Gallery] (Minneapolis, 1978).

31. Present location unknown; sold at Sotheby, London, Oct. 16, 1974, cat. no. 131.

32. Ulrich Thieme-Becker, *Allgemeines Lexikon der Bildenden Künstler* (Leipzig, 1914), "Eugen Dücker" 10: 52.

268. Sanford Robinson Gifford. *Lago d'Orta*, 1868. Pencil on pair of sketchbook pages. 0.121 x 0.451 (4¾ x 17¾ in). Inscribed, l.r.: *Isola san Julio—Lago d'Orta—Julio 21st—1868—*. The Brooklyn Museum, New York; Gift of Miss Jennie Brownscomb

Luminist Drawings

Linda S. Ferber

IN HIS IMPORTANT ARTICLE OF 1948, "Early Studies in Light and Air by American Landscape Painters," John I. H. Baur observed that much American landscape painting at mid-century "shows an extraordinary generic similarity."[1] The same may be said of many of the landscape drawings of the period, which share with the paintings that "peculiar clarity, spaciousness and feeling for palpable air."[2] While drawings have not been considered in previous investigations of luminist style, it does seem logical to hope to discover in the landscape draftsmanship of the period a style or approach to composition and light that might parallel some of those particular characteristics in oil paintings related to the luminist vision. In fact, drawings, being the private documents that they are, often reveal much about the processes of picture making and may therefore yield some further insight into the pervasive yet elusive phenomenon of luminism.

The drawings discussed here parallel in date those paintings representing the high-water mark of luminist style, from about 1850 to 1876. These same years saw the rise of interest in watercolor and a sharp increase in the use of the medium by American artists. We will refer from time to time to these related works on paper but will concentrate primarily upon an examination of black and white drawings, since these required only the simplest equipment—a pencil and a sheet of paper—easily obtained and eminently portable, thus perfectly suited to the landscape painter's roving search for subjects. The predominance of pencil work here is an accurate reflection of both its universal use as a medium and the great range of effects attainable with such simple means. The generally modest dimensions of most landscape drawings offered no impediment to generosity and even grandeur of vision. The widest and deepest of vistas, such as Sanford Gifford's *Lago Giardini* (1868; fig. 267—see also fig. 268) might be successfully captured in the smallest of pocket sketchbooks.

The drawings these painters produced are as varied in subject and approach as their paintings—in size, medium, technique, and degree of finish. They are firmly united, however, in the commitment to the examination of landscape, to the recording of terrain and topography, as well as to the more fugitive phenomena of light, atmosphere, and weather. It is particularly fascinating to observe both the contrasts and the parallels in the way these phenomena were recorded by different hands. Gifford and John F. Kensett, for example, are fluent draftsmen in their closely comparable records of a rolling vista of hills and fields (see figs. 269-270)—in the quick, sure manner with which their pencils seek out the major lines defining the terrain, assign areas of light and shadow, erupt into lively calligraphics denoting the complexities of foliage. Contrast this energetic manner with the slow-moving hand of Fitz Hugh Lane, carefully, deliberately—even somewhat haltingly—tracing the profile of the Cape Ann coast like a mapmaker (see fig. 271). Compare the way Gifford in his drawing of an Adirondack lake (fig. 272) is primarily interested in the bare mountain wall as a foil for the play of light and shadow over broad planes, while William Haseltine seeks out every fissure and surface irregularity of the boulders comprising the rocky coasts of Nahant and Mt. Desert (figs. 273, 280). Gifford, Aaron Draper Shattuck, David Johnson, and William Hart realize their landscape vistas almost wholly in outline. Delicate and often quite minimal modulations of tone within those outlines suffice to suggest detail and texture. In their drawings of Lake George, Johnson, Shattuck, and Gifford (figs. 274-276) allow the untouched surface of the sheet to function both as the broad planar surface of the lake and the sky above. An anonymous Gloucester, Massachusetts, draftsman, on the other hand, chose to present an elaborate array of surface detail and texture, thoroughly articulating foliage, rocks, and water in an impressive display of ability to manipulate the pencil point (fig. 277). W. T. Richards, at the height of his enthusiasm for the English critic John

267. Sanford Robinson Gifford. *Lago Giardini*, 1868. Pencil on pair of sketchbook pages. 0.121 x 0.451 (4¾ x 17¾ in). Inscribed, l.c.: *Giardini—Sette 14th;* l.r.: *x city.* The Brooklyn Museum, New York; Gift of Miss Jennie Brownscomb

Ruskin, was capable of tours de force of such detailed and essentially linear pencil work. In another mood at a later date, however, he might sacrifice detail to pure tone to capture the atmospheric glow that pervades his small work *Coastal Scene* (c. 1882; fig. 154).

The range of internal modeling and texture might be further enriched by the use of washes over a line drawing. The nearly monochromatic washes in the harbor views by Albert Van Beest (see fig. 279) and William Bradford serve to articulate lights and shadows in the sky and to enliven the reflective water surfaces, as well as to strengthen the silhouetted shapes of sailing vessels. Transparent polychrome washes might be applied to annotate color or the fall of light as in Haseltine's *Mt. Desert* (c. 1860; fig. 280) or C. H. Moore's *Landscape* (Fogg Art Museum, Harvard University, Cambridge, Massachussetts). While removed from the realm of strict black and white, these works nevertheless remain tinted drawings rather than watercolor paintings since line, not color, remains their dominant feature. Even in more richly painted examples such as Richards' *Moonlight on Mt. Lafayette, New Hampshire* (1873; fig. 281) and D. J. Kennedy's *Moonrise in a Fog* (1886; fig. 282) we might note that the improvisatory nature of watercolor is never exploited. Rather the medium is consistently handled with delicacy and precision of touch to record the subtlest nuances of light and reflection. This touch is thoroughly consistent with the luminist approach in the black and white media as well as painting in oils. Even in a limited survey we can see how strong landscape draftsmanship was in mid-century America. For example, the drawings by Gifford show relatively little development from a strong early style. Comparison of his early

and late work in pencil suggests that within a few years of embarking on his career, Gifford was already a highly competent landscape draftsman—a pattern repeated in the development of Richards, Jasper Francis Cropsey, and Kensett among others.

Although drawings are even more subject to the vicissitudes of fate than paintings, impressive numbers of them have survived. There are sizable deposits in public collections by Thomas Cole, Asher B. Durand, Frederic Church, Lane, Richards, Haseltine, Kensett, and John W. Casilear.[3] The names of the latter two artists have both been tentatively assigned to a group of over two hundred drawings acquired by the Detroit Institute of Arts in 1949.[4] The long-standing confusion between the hands of these two artists reflects the strong stylistic parallels we recognize in many of the landscape drawings of the period and points up how little is really known about the development of that common style. While the materials for a study of American works on paper exist in some abundance, as we have seen, American drawings in general have only recently begun to be examined systematically and in depth. Monographic studies often include representative graphic work but generally demonstrate a viewpoint that considers it primarily in relation and as accessory to oil paintings. Relatively little attention has been directed toward drawings as independent works.

The publication in 1962 of the two-volume catalogue of the M. and M. Karolik collection of American drawings and watercolors did much to reveal the great range and richness of American works on paper. A number of exhibitions have also offered glimpses of the high quality of American draw-

269. Sanford Robinson Gifford. *Palmer Hill, Catskill Mountains,* September 26, 1849. Pencil on white paper. 0.146 x 0.222 (5¾ x 8¾ in). Inscribed, l.l.: *Palmer Hill—Catskill Mts. Sept. 26th.* Vassar College Art Gallery, Poughkeepsie, New York (above)

270. John Frederick Kensett. *New England Landscape,* 1848-1850. Pencil on beige paper. 0.203 x 0.286 (8 x 11¼ in). Lyman Allyn Museum, New London

ings. Knowledgeable collectors such as John Davis Hatch and Paul Magriel have generously allowed selections from their private collections to be shown (see, for example, fig. 283). In the area of landscape in particular, the Brooklyn Museum in 1969 organized an important exhibition, *Drawings of the Hudson River School,* which represented the first attempt to survey the graphic work of the native landscape school. In his recent ambitious book, Theodore E. Stebbins, Jr., undertook the first major effort to investigate and establish a historical framework for the development of works of art on paper in America, from earliest times to the present. The program of inquiry outlined by Stebbins in this study will undoubtedly guide those who will approach narrower aspects of the subject in the future. In a survey of the scope of *American Master Drawings and Watercolors,* Stebbins' treatment of the landscape drawings of the period under consideration here is necessarily brief. He makes clear, however, that these artists "viewed drawing and sketching as valuable in themselves."[5]

The large numbers in which the drawings have survived corroborates this observation, suggesting that the regular practice of drawing from nature was very much a part of the American landscape painter's routine. Casilear advised Kensett in a letter of 1832: "Attend closely to your drawing as you know 'tis the very essence of our art. . . ."[6] The very preservation of these drawings by the artists (most drawing caches are found still in family hands) offers evidence that they were, indeed, valued beyond an immediate practical use. The artists

themselves not only preserved their own drawings but on occasion collected those of their fellows as well. Drawings were often presented as tokens of respect and friendship.[7] Cropsey, for instance, compiled an album (Metropolitan Museum of Art, New York) in which drawings and watercolors by contemporaries and associates were carefully preserved.[8]

As these albums might imply, the practice of drawing itself was associated not only with study but also with a certain informal sense of congenial fraternity among artists. The various sketch clubs founded by artists during the first half of the century were formed both "for the promotion of mutual intercourse and improvement in impromptu sketching."[9] These gatherings provided occasions for social activity among professional artists and an opportunity to practice drawing from memory. While eventually sketching was abandoned and social activity prevailed, the sketch clubs were, for a time, active forums in which to exchange criticisms and absorb influences. Cole, Durand, and Casilear were all sketch club members and perhaps might in some way have been instrumental in transplanting this congenial practice into the open air. Outdoor sketching forays to favored spots were often made in concert and were—to judge from contemporary reports—highly convivial in nature. Durand's own trip with Cole to Schroon Mountain in 1837 (in company with Mrs. Cole and Mrs. Durand) seems to have been a turning point in his decision to concentrate upon landscape painting.[10] While apparently without such

271. Fitz Hugh Lane. *Western Shore of Gloucester Outer Harbor,* 1857. Pencil on paper. 0.229 x 0.711 (9 x 28 in). Inscribed, l.c.: *F.H. Lane del.* Cape Ann Historical Association, Gloucester, Massachusetts

inspiring company, Gifford, nevertheless, recorded the importance of such outdoor sketching forays in turning him to landscape painting: "Having once enjoyed the absolute freedom of the Landscape painter's life, I was unable to return to portrait painting. From this time my direction in art was determined."[11] Durand himself on his own summer sketching excursions was often in company with other artists including Casilear, Kensett, Samuel Colman, Alvan Fisher, and the Hart brothers.[12] Kensett's sketching companions at various times included—besides Durand and Casilear—Cropsey, Benjamin Champney, and Frederic Church.[13]

The columns of *The Crayon* regularly recorded the summer and fall peregrinations of landscape painters. An exchange of humorous letters in the 1856 issue debated the merits of West Campton and North Conway—both favorite sketching grounds in the White Mountains. They draw a vivid picture for us of these excursions and suggest how close-knit a group both the older and younger generations of landscape painters seem to have been. "Poppy Oil," anonymous defender of West Campton, noted that he found among the artists there on his arrival "Mr. Durand and his family, Messrs. Gerry, Pope and Williams of Boston, and Mr. Thorndyke and Mr. Richards of New York. Mr. Ordway of Boston had just left. Since then two other Boston artists have returned homewards, and their places are at present filled by . . . Messrs. Gay and Wheelock."[14] "Mummy" (Alvan Fisher), advocate for North Conway, counted among his fellow painters at that spot, "the scholarly and thoughtful Huntington," Hubbard, Stillman, Post, Suydam, Colman, Shattuck, Hotch-

kiss, and Champney.[15] Such lists lend weight to "Poppy Oil's" claim that should anyone "make any allusion to a 'room,' you will be at once told that it can't be thought of,—that every corner is occupied by 'the artists'." He goes on to outline what must have been a fairly regular routine: "At half-past six we breakfast, and afterwards if the weather is bad, . . . we chat, or read, or write, or go out into the barn and make studies of the cattle. . . . When the day is fair, we sally out with our traps, in twos or threes, or perhaps a committee of the whole for the morning study." He recorded that in "the evenings . . . we assemble in gay gossip about the hearth,"[16] undoubtedly exchanging ideas and perhaps comparing sketches. "Flake White," another pseudonymous artist-correspondent from North Conway the summer before, had noted, in fact, that "the artists here are in the habit of calling on each other, and discussing the merits of various studies."[17]

Such convivial outings continued into later decades. A page from a Gifford sketchbook of 1877 (fig. 285) records not only the scenery of Maine's Mt. Katahdin but the fellow members of what he playfully dubbed "The Katadin Tea Party." Among the "Landscape Painters" present were Robbins, De Forest, and Church along with "Holly: Engineer and Metalurgist [sic]; Laurson: Architect" and Gifford who listed himself simply as "Fisherman." It is likely that Gifford's nonartist friends not only fished but might have produced sketches of their own as well. Drawing from nature was central to the landscape experience not only of professional painters but of the amateur as well. On his first visit to Gloucester in the summer of 1871, W. T. Richards wrote of being

272. Sanford Robinson Gifford. *Adirondacks,* August-September 1866. Pencil on paper. 0.146 x 0.229 (5¾ x 9 in). Vassar College Art Gallery, Poughkeepsie, New York

273. William Stanley Haseltine. *Egg Rock, Nahant,* 1860s. Pencil and watercolor on paper. 0.347 x 0.556 (13⅝ x 21⅞ in). Permanent Collection of the High Museum of Art, Atlanta; Gift of Helen H. Plowden, 52.20. Photo: Jerome Drown

275. Aaron Draper Shattuck. *Lake George,* 1858. Pencil on paper. 0.308 x 0.473 (12⅛ x 18⅝ in). Inscribed, l.r.: *Lake George. Oct. 2ᵈ 1858.* Private collection. Photo: Helga Photo Studio

guided locally by an individual sounding very much like a serious amateur: "a gentleman of Gloucester, whose native taste and former experiments in scenery had given him a good knowledge of the picturesque parts of the country."[18] One wonders whether the fine pencil drawing of 1872, recording in detail a Gloucester inlet by an unknown but clearly trained hand, might be an "experiment in scenery" by just such a gentleman. In 1867, Henry Tuckerman counted among the accomplishments of a cultured person the ability "to sketch a little from nature."[19] This is undoubtedly what the ladies of the Horicon Sketch Club are doing in S. R. Stoddard's photograph of 1882 (fig. 286). Seated on one of the islands in Lake George, they are sketching one of the favorite vistas of the nineteenth century: the broad surface of the lake ringed by heavily wooded mountains also seen in drawings by Casilear, Shattuck, Johnson, and Gifford. Stoddard's charming photographic record of the informal communal pleasures of outdoor sketching acquires a slightly ironic tinge when we recollect that it was to be the camera of today's ubiquitous shutterbug that would ultimately replace the amateur pausing to "sketch a little from nature."

In the earlier years of the nineteenth century able draftsmanship was seen as a very important element in the education of the American citizen. This belief was embodied in the instruction books—the so-called drawing manuals—which were published in great numbers during the nineteenth century. There seems little doubt that young artists made ready use of the basic instruction in these books, as we will see. The major audience to which the manuals addressed themselves, however, was the general public, the fledgling amateur draftsman. In his recent thorough study, Peter Marzio has established the importance of the American drawing books published before the Civil War: "They represent the first serious attempt by professional artists to educate the untrained populace. . . . Enchanted by the rise of a political democracy, the drawing promoters sought to build an artist democracy of citizen artists: a nation of draftsmen."[20]

This sanguine view of the possibilities of such training was explicitly stated

274. David Johnson. *Tongue Mountain, Lake George*, 1872. Pencil on paper. 0.305 x 0.470 (12 x 18½ in). Inscribed, on rock, c.l.: *DJ .72* (*DJ* is in monogram); and underscored l.l.: *Tongue Mountain. Lake George*. Private collection

276. Sanford Robinson Gifford. *View at Lake George,* August 29, 1848. Pencil on paper. 0.146 x 0.232 (5¾ x 9⅛ in). Inscribed, on opposite page at lower edge: *From the Pinacle* (illegible)—*Narrows—Black Mt.—Shelving Rock, Lake George Aug 29th, 1848.* Vassar College Art Gallery, Poughkeepsie, New York (below)

in *The Crayon* in 1856: "when a good knowledge of elementary drawing shall become a part of every common school education, the true milennium [*sic*] of Art will be inaugurated."[21] While the manuals dealt with all branches of subject matter, the drawing promoters, whom Marzio has dubbed the art crusaders, viewed nature—particularly American nature—as the strongest potential "source for a democratic art."[22] A good deal of instruction is to be found, therefore, in the general practice of landscape drawing and a number of manuals devoted their entire attention to the depiction of scenery. The choice of American scenery to serve as illustration and model in such manuals was "intended to give the reader a sense of pride in America and an art which could capture its natural beauty."[23] For example, Fessenden Nott Otis in his *Easy Lessons in Landscape* (1851) informed his student-reader that the "complicated character of Foliage . . . place[s] a faithful representation of it among the most difficult of the works of Art."[24] He offered in his illustrations examples not of a general tree type, but of specific native species: the birch, ash, oak, maple, and beech. The similarity of the "stenographic methods" he advocated for each type of foliage with that found in early sketches by Kensett and Richards suggests that as young students they consulted similar manuals for basic instruction in drawing.[25] Marzio goes on to observe that "a sectionalism characterized most manuals. . . . In short, the landscape imagery of the northeastern section of America became the dominant imagery of the drawing books and it came to

277. Anonymous. *View of Gloucester,* 1872. Pencil heightened with Chinese white on paper. 0.254 x 0.435 (10 x 17⅛ in). Inscribed, l.l.: *Gloucester, July 23ʳᵈ '72/M.L.B.* Private collection. Photo: Helga Photo Studio.

symbolize American subject matter for a democratic art."²⁶ The amateur, or for that matter the young Kensett or Richards, might then not only learn how to draw a tree but also which tree to draw; their taste in landscape was molded even as their hand was trained.

The famous books and portfolios of American landscape prints based on drawings and watercolors by English topographers such as William Birch's *The Country Seats of the United States* (1808), William Guy Wall's *Hudson River Portfolio* (1820-1828), and William Bartlett's *American Scenery* (1840)—skillfully blending topographical record and picturesque interest—have long been recognized as having played an essential role in the development of interest in landscape in the United States and in establishing a repertoire of subjects for painters. It is clear from recent research like Marzio's that the focus upon local scenery in American drawing manuals must also have played a significant role in this development. There seems little question that these popular publications not only reflected the strong native bias for landscape subjects but probably also did much to establish and influence that taste as well. Moreover, it does not seem at all farfetched to trace an element of the genuine popularity of landscape as a subject in American painting—with both artist and patron— to the common experience of drawing from nature as a kind of patriotic gesture by both professional artist and devoted amateur.

As commendable as it might have been, drawing from nature was by no means to be learned or practiced only as an end in itself, as an article on "Elementary Drawing" in an 1855 issue of *The Crayon* makes clear: "We generally look at drawing as an accomplishment, something complete in itself rather than what it truly is, a means for becoming better acquainted with Nature."²⁷ The practice was thought to develop both perceptual and spiritual acuity. Gifford testified in this vein that his sketching forays into the Catskills and Berkshires in 1846 "opened my eyes to a keener perception and more intelligent enjoyment of Nature."²⁸ *The Crayon* continued, emphasizing the particular benefits of approaching nature, sketchbook in hand: "The habit of fixing the mind intently on Nature to draw her minuter traits, enables us to see many things which are lost entirely in a first impression; it would be worth the while to every lover of Nature to set determinedly at drawing portions of landscape. . . . It would repay the most laborious exertion."²⁹ While he does not offer instruction in sketching, William Cullen Bryant's remarks to the "lover of Nature" in the oft-quoted lines from "Thanatopsis" run parallel: "To him who in the love/of nature holds communion/with her visible forms, she/speaks a various language." In an essay of about 1850, W. T. Richards described his own "solitary walks . . . mid wild tangled woods" where his companions were "some spirit stirring poem or some modest sketch book,"

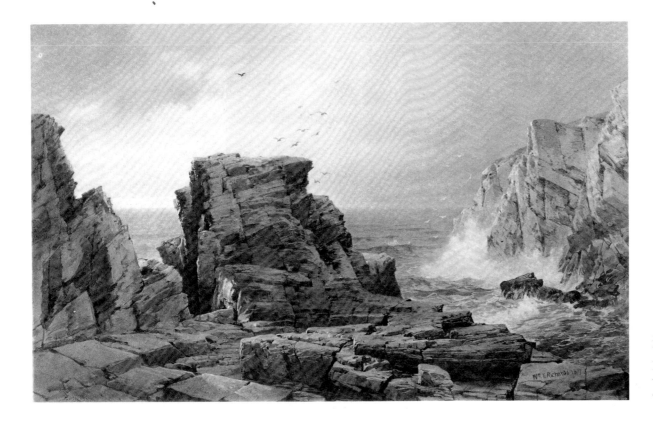

278. William Trost Richards. *A Rocky Coast,* 1877. Watercolor on paper. 0.563 x 0.915 (22³/₁₆ x 36 in). Inscribed, l.r.: *Wᵐ. T. Richards 1877.* The Metropolitan Museum of Art, New York; Bequest of Catharine Lorillard Wolfe, 1887

both of which added a dimension of "heartfelt spiritual enjoyment" to his experience of nature.[30] Drawing, like poetry, was plainly perceived as an important means of "holding communion" with nature's "visible forms" and was—like poetry—very much a part of the ritual of landscape appreciation. Developing out of the eighteenth-century taste for the picturesque, such appreciation was influenced by English and American nature poetry and, after 1843, by the English critic John Ruskin's ideas about landscape as well and became an act of religious devotion for the romantics of the nineteenth century. This ideal union of painter and poet is celebrated and commemorated in Durand's *Kindred Spirits* of 1849 (New York Public Library) where Bryant himself and the recently deceased Thomas Cole—sketch portfolio in hand— are shown gazing together upon the hallowed vista of Kaaterskill Clove.

While the intention of the authors of the drawing manuals was to offer a practical course of self-instruction, they were not insensible to the ultimate purpose of this exercise for the true romantic—be he artist or amateur. Not only were "the beauties of Nature" to be recorded, but the lessons of nature were to be learned. In the preface to *Easy Lessons in Landscape,* Otis noted that

his "series of lessons in landscape drawing" would guide the learner in an easy, systematic, and intelligent manner . . . to the lessons which nature on every hand has presented to her loving students."[31] Just what these lessons might have been is not difficult to discern. A year before Otis, Richards, just beginning his career as a landscape painter, wrote: "Purest and most holy lessons may be learned from Nature. Lessons . . . stamped with such gigantic impress as if God's own hand had drawn them there."[32] His remarks present a remarkably close parallel to those of Asher B. Durand writing five years later in the "Letters on Landscape Painting" that "the external appearance of this our dwelling place . . . is fraught with lessons of high and holy meaning only surpassed by the light of Revelation."[33]

The purpose here is not to rehearse the well-known religious reverence for nature that was shared by Americans of the middle quarters of the nineteenth century and that was a touchstone of the native landscape school of that period, but rather to point out how central the act of drawing from nature was to this landscape experience. Drawing itself was perceived as a form of revelation. "In learning to draw," wrote *The Crayon* in 1855, "he learns also to see; and it may

279. Albert Van Beest. *New Bedford from Fairhaven,* c. 1855. Pen, brown and gray wash on paper. 0.319 x 0.721 (12⁹/₁₆ x 28³/₈ in). Museum of Fine Arts, Boston; M. and M. Karolik Collection

280. William Stanley Haseltine. *Mt. Desert,* c. 1860. Pencil and wash on paper. 0.559 x 0.379 (22 x 14¹⁵/₁₆ in). Inscribed, l.l.: *Mt Desert/July 2s.* Cooper-Hewitt Museum, New York, The Smithsonian Institution's National Museum of Design (at right)

safely be said that no one *sees* Nature but an artist."[34] Nowhere was the importance of drawing from nature as both ritual and pedagogical exercise to be more explicitly stated than in Durand's "Letters" published in *The Crayon* that same year.

When Durand wrote the "Letters" he had been president of the National Academy of Design since 1845 and would serve until 1861, thus standing for over fifteen years at the formal head of the nation's major art establishment. That a landscape painter might attain such a lofty rank indicates the prestige and popularity of the landscape as a subject in mid-century America. It is even tempting to consider the "Letters" Durand's own presidential addresses in the tradition of Reynolds' *Discourses.* As early as 1867, Tuckerman acknowledged the importance of these documents as illustrations of Durand's "theory," and he referred to them as "some pleasing and precious written testimony in the shape of a few letters on landscape-painting."[35] Their importance for us lies in their value as a compendium of practical advice and philosophical observation by the acknowledged leader of a cohesive group of landscape painters to which most of the artists mentioned here belonged. We are justified, therefore, in accepting the "Letters" as an outline and statement of current practice addressed most particularly to the student desiring to "devote your whole time and energies to the study of Landscape Art."[36]

While the "Letters" have long been known especially for their advocacy of plein-air painting, their equally consistent stress upon the importance of drawing has not generally been discussed. For Durand, the veritable "alphabet" of art was to be found "in the practice of drawing."[37] This practice forms the main topic of his second letter in which he wrote, "A moment's reflection will convince you of the vital importance of drawing," and he instructed the student of landscape (in traditional academic pedagogical procedure) to forego painting and "practice drawing with the pencil till you are sure of your hand."[38] The seriousness of this initial step is underscored in the following paragraphs, in which Durand casts the student of landscape painting quite literally as a novice undertaking a kind of trial by ordeal; the novice learns through the acquisition of drawing skills the first steps in the ritual of nature worship, which for Durand and his contemporaries constituted "the true Religion of Art."

You will say that I impose on you a difficult and painful task: difficult it is, but not painful nor ungrateful, and let me assure you that its faithful performance is accompanied by many enjoyments that experience only can enable you to appreciate. Every

282. David Johnston Kennedy. *Moonrise in a Fog,* 1886. Pencil, watercolor, and Chinese white on gray paper. 0.248 x 0.556 (9¾ x 21⅞ in). Inscribed, l.l.: *Philadelphia;* l.r.: *D.J.Kennedy, 1886.*—; on original mount: *Moonrise in a Fog.* Private collection. Photo: Helga Photo Studio

281. William Trost Richards. *Moonlight on Mt. Lafayette, New Hampshire,* 1873. Watercolor on paper. 0.213 x 0.359 (8⅜ x 14⅛ in). Inscribed, l.l.: *Wᵐ T. Richards 73.* The Metropolitan Museum of Art, New York; Gift of Rev. E. L. Magoon, 1880

step of conscious progress that you make [in drawing], every successful transcript of the chosen subject, will send a thrill of pleasure to your heart, that you will acknowledge to give you the full measure of compensation. As a motive to meet with courage and perseverance every difficulty in the progress of your studies, and patiently to endure the frequent discouragements attending upon your failures and imperfect efforts, so long as your love for Nature is strong and earnest, keeping steadily in view the high mission of the Art you have chosen, I can promise you that the time will come when you will recall the period of these faithful struggles with a more vivid enjoyment than that which accompanies the old man's recollections of happy childhood. The humblest scenes of your successful labors will become hallowed ground to which, in memory at least, you will make many a joyous pilgrimage and . . . kiss the very earth that bore the print of your oft-repeated footsteps.[39]

It is important to keep in mind that these lines refer not to painting but to learning to draw landscape. We have already encountered in the drawing manuals the notion of sketching as an element in the appreciation and even veneration of natural beauty. For Durand, addressing himself not to the amateur but to the serious student of landscape, the practice assumed an even loftier and overtly religious purpose. The lessons of nature learned through drawing would exert an "influence on the heart and mind" and would be "of high and holy meaning." The true purpose of art, for Durand and his contemporaries, was "impressing the mind through the visible forms of material beauty, with a deep sense of the invisible and immaterial."[40] The key to knowledge of these "visible forms of material beauty" was drawing.

Durand was not alone at mid-century in urging a dedicated and rigorous program of drawing and study from nature as essential to the artistic and spiritual education of the landscape painter. In his *Elements of Drawing* (1857), one of the most popular drawing books published during the second half of the nineteenth century,[41] John Ruskin also recommended a concentrated regime of drawing, not from patterns in manuals, but directly from nature. The student, Ruskin wrote, "will find, on the whole, that the best answerer of questions is perserverance; and the best drawing-masters are the woods and hills."[42] Ruskin's influence in America, first established in the early 1840s with the publication of the volumes of *Modern Painters,* was widespread and enthusiastic. An important key to this enthusiastic reception was that Ruskin's ideas about nature and landscape reinforced and corroborated already existing ideas and attitudes. Roger Stein in *John Ruskin and Aesthetic Thought in America, 1840-1900* writes that the fundamental importance of Ruskin's writings in America in the years before the Civil War was "his identification of the interest in art with morality and religion as well as with the love of nature, his ability to build a loose but convincing system where art, religion, and nature were inextricably intertwined."[43] Such an aesthetic struck a responsive chord in America, where a domestic Wordsworthian tradition, an attitude of reverence toward nature, especially American nature, already existed. While his writings appealed to a broad popular audience, Ruskin's ideas held a special appeal for American landscape artists. Even established figures like Durand and Church responded

283. Frederic Edwin Church. *Magdalena River, New Granada (Ecuador),* 1853. Pencil, touched with white on ivory wove paper. 0.179 x 0.272 ($7^1/_{16}$ x $10^3/_4$ in). Inscribed, l.r.: *F. E. Church.* John Davis Hatch Collection. Photo: National Gallery of Art, Washington, D.C.

to his influence and his demand for complete fidelity to nature in art.[44] In fact, much of Durand's insistence in the "Letters" upon careful and devoted study from nature in both pencil and in oils reflects his familiarity with and belief in Ruskin's eloquent discourses on truth to nature. In the *Elements of Drawing* Ruskin delivered his familiar message concentrating upon the drawing medium. The "chief aim and bent of the following system," he wrote, "is to obtain . . . a perfectly patient and . . . delicate method of work, such as may ensure . . . seeing truly. For I am nearly convinced, that when once we see keenly enough, there is very little difficulty in drawing what we see."[45] Like Durand, he also stressed the practice of detailed drawing from nature as a means of heightening perception: "I believe that the sight is a more important thing than the drawing; and I would rather teach drawing that my pupils may learn to love Nature, than teach the looking at Nature that they may learn to draw."[46]

There were a number of artists in America, most of them younger men, upon whose method and style Ruskin's exhortations to complete fidelity to nature had a great impact during the 1850s and 1860s.[47] Early in 1863 in New York, T. C. Farrer founded the short-lived Association for the Advancement of the Cause of Truth in Art, which also included W. T. Richards and C. H. Moore as members.[48] Its philosophy concerning truth to nature in art was drawn from Ruskin, and the association's official organ *The New Path* placed particular

284. John William Casilear. *Hudson Highlands,* 1860s. Pencil, touched with white on buff wove paper. 0.232 x 0.352 (9³/₁₆ x 13⅞ in). John Davis Hatch Collection. Photo: National Gallery of Art, Washington, D.C.

value and emphasis upon draftsmanship echoing and even surpassing Durand in stressing its importance: "Drawing is the business of a true artist's life; it is the foundation of everything good in Art; without it there is *nothing,* and with a thorough knowledge of it everything is possible. No man can ever give too much time and effort to its study, or do too much work in simple light and shade."[49] In the "Articles of Organization," Ruskin's famous exhortation in the conclusion of the first volume of *Modern Painters,* his demand for fidelity to nature was wed to the association's demand for strong draftsmanship: "the right course for young Artists is faithful and loving representation of Nature; 'selecting nothing and rejecting nothing,' seeking only to express the greatest amount of fact. It is moreover, their duty to strive for the greatest attainable power of drawing."[50] The meticulous detail with which Henry Farrer depicted beached rowboats, dwelling upon the construction and weather-worn surface, must owe something to his Ruskinian training. The fact that both Moore and Richards were members of the association is certainly of more than coincidental interest when we compare the elaborate detail, accuracy, and intense particularization with which they depict the species of boulders and rocky ledges in *Landscape* and *A Rocky Coast* (fig. 278; see also fig. 291). Both were extraordinary draftsmen, clearly undertaking and mastering their duty as ardent Ruskinians "to strive for the greatest attainable power of drawing."

While Durand stressed in the "Letters" the vital importance of drawing, he was surprisingly casual in suggesting where this key to the "Studio of Nature"

might be acquired; he simply assumed of his student "that you possess the necessary knowledge of drawing and readily express with the lead pencil the forms and general character of real objects."[51] This was not unusual. The student seeking to study with an accomplished master was required to have mastered certain basic skills, and drawing was one of these.[52] To acquire and perfect these fundamental skills, a student might turn to the several sources which Durand suggested in his first "Letter": "books and the casual intercourse with artists, accessible to every respectable young student, will furnish you with all the essential mechanism of the art."[53] The communal nature of landscape sketching expeditions is an example of the "casual intercourse with artists," as is the habit among some artists of sharing and discussing sketches. One "respectable young student" recorded just such an exchange at North Conway with none other than Durand himself. Although he refers here specifically to a plein-air oil sketch, the painting could as easily have been a drawing:

Mr. Durand happened to call that day to see a brother-artist at the hotel, I ventured, though I suffer extremely from diffidence, to call his attention to my big sketch of the Conway Valley. He looked at it silently for a little time, and, after two or three good whiffs of his cigar, remarked, "You will find it better to finish as you go on, and to pay more attention to the careful drawing of the forms. . . ." I felt a little sobered, but grateful, for this candid advice, and resolved to go to work in earnest.[54]

Our ambitious young student then turned to "Mr. Champney" to "give me a hint" about going on with another sketch. Durand himself stressed the continuing benefits of such exchanges, generously admitting "many an useful lesson has been taught me by intercourse with professional brethren—even often from the student and the tyro."[55]

A second useful source for the student was the instruction book—a category which included the drawing manuals discussed above. On this subject Durand wrote: "All that I might say on the various colors and mediums, tools, or what not, necessary for your purpose, including dissertations on design, composition, effect, color and execution, would only be a repetition of what has been already written and published throughout the land, and which you can readily procure of the colorman and the bookseller."[56] We have noted the importance of the manuals in establishing a general taste for landscape subjects and in encouraging the regular practice of sketching from nature. We should also say a word here about the general style promulgated by the manuals and which applied equally to figure and landscape subjects. That style can best be characterized as fundamentally linear.

Marzio quotes Bowen in *The United States Drawing Book* (1838): "begin with those great lines which bound the principal masses, and from these . . . proceed to the smaller ones."[57] Durand shared this linear bias, instructing his student to take "pencil and paper, . . . and draw with scrupulous fidelity the outline or contour of such objects as you shall select," stressing "the continual demand for . . . exercise in the practice of outline."[58] American draftsmen of this period did

286. Seneca Ray Stoddard. *The Horicon Sketching Club,* 1882. Silverprint photograph. 0.133 x 0.216 (5¼ x 8½ in). Collection of Maitland C. DeSormo

285. Sanford Robinson Gifford. *The Katadin Tea Party,* September 1877. Pencil on brown paper. 0.115 x 0.216 (4½ x 8½ in). Inscribed, at l., under top drawing: *At the Inlet (west);* at r., under bottom drawing: *Church Robbins Deforest Landscape Painters Holly Engineer & Metalurgist Laurson Architect Gifford Fisherman The Katadin Tea Party.* Vassar College Art Gallery, Poughkeepsie, New York

think primarily and often solely in terms of line, a fact amply illustrated by the drawings under discussion here. William Hart's White Mountain views, for example, are enriched both with pencil shading and the application of Chinese white (figs. 292-293). It is clear, however, that the artist first conceived of his drawing in careful outline as did Johnson and Shattuck in their views of Lake George. Some source for this common characteristic of the drawing (and even much of the painting) of the period should be sought in the mode of instruction offered by the manuals.

We have already pointed to the similarity of early drawings by some artists to illustrations in the manuals. Driscoll notes that while we do not know that Kensett studied books such as Benjamin H. Coe's *Drawing Book of Trees* (1841), there is, nevertheless, a marked similarity between Coe's plates and Kensett's early drawings.[59] W. T. Richards may also have learned certain pictorial conventions from one of the many books available. His softly modeled, rather flat rocks and his type of tree in the early drawings of the 1850s are close, for instance, to conventional landscape models in Bowen's *The United States Drawing Book.*[60] Richards had also been a student at Philadelphia's Central High School, where Rembrandt Peale, author of *Graphics* (1834)—one of the most influential American drawing books of the first half of the century—had established the curriculum and for years taught draftsmanship.[61] It is interest-

288. John Frederick Kensett. *North from Storm King,* 1860s. Pencil touched with white on cream wove paper. 0.226 x 0.353 (9¹⁵/₁₆ x 14¹⁵/₁₆ in). John Davis Hatch Collection. Photo: National Gallery of Art, Washington, D.C.

287. Jasper Francis Cropsey. *The Hudson River at Hastings,* 1885. Pencil on heavy buff wove paper. 0.304 x 0.484 (12 x 19¹/₁₆ in). Inscribed, l.r.: *The Hudson River at Hastings/J.F.C.June 1885.* National Gallery of Art, Washington, D.C.; John Davis Hatch Collection

ing to note that years later Thomas Eakins was also a student at the high school where the exercise in mechanical drawing and perspective undoubtedly influenced the formation of his mathematically precise, linear draftsmanship.[62]

A preliminary survey reveals that a number of artists represented here shared some common sources of influence in the formation of their drawing styles—in an indirect manner through the manuals, as in the case of Richards and Kensett, and more directly through periods of tutelage under the same teachers. Both Richards and Haseltine, for example, studied in the early 1850s with Paul Weber (1823-1916), Richards informally and Haseltine formally.[63] German-born and trained, Weber brought with him to Philadelphia in 1848 the meticulously detailed linear style characteristic of that school in both drawing and painting, a style which we know Americans found particularly attractive, judging from the success of the Düsseldorf Gallery in New York and the number of Americans actually studying in Germany. Haseltine's biographer recorded that Weber "grounded him thoroughly in the technique of drawing, of which [Weber] was a past-master, inculcated accuracy and developed in him that exceptional sense of values which was always to characterise [sic] [his] works."[64] The same characterization might apply to Richards' own drawings and there are interesting parallels as well between their paintings of the 1860s and those of the 1870s which might be traced in part to this common early instruction (see figs. 294-296).

It is also interesting to note that a number of important landscape painters received their earliest instruction in drawing from the authors of the manuals themselves. In the early 1840s, before beginning study with Thomas Cole, Church's parents "placed him" with Benjamin Coe to learn drawing.[65] C. H. Moore while in his teens also took drawing lessons from Coe where his fellow pupils were William and Henry James.[66] Sanford R. Gifford recalled his own early training—probably typical of many young students—in a letter of 1874: "I came to New York in 1845 and placed myself under the direction of John Rubens Smith, an accomplished drawing master, with whom I studied drawing, perspective and anatomy. At the same time I drew from the Antique and the life at the National Academy of Design, and attended the lectures on anatomy at the Crosby St. Medical College."[67] We recall that the following year Gifford was to make the sketching expedition into the Catskills that opened his "eyes to the beauties of nature" and determined him to forsake the antique, anatomy, and the portrait for the "absolute freedom" of the landscape painter's life. Even George Inness received his initial instruction in drawing according to the methodical linear discipline of the drawing master, from one "Barker in Newark, who gave him first a copy-card to work from, then a block of plaster . . . to train the hand to make the form, to train the eye to see."[68]

All of these artists were, of course, to go beyond the pictorial conventions and formulas by which they were first trained, to develop personal styles—pushing beyond conventions of the picturesque and the drawing manuals to their own landscape vision. However, William Morris Hunt—a major influ-

289. Henry Farrer. *Beached Boat*, c. 1870-1875. Watercolor on paper. 0.203 x 0.268 (8 x 10¹⁵⁄₁₆ in). Inscribed, on back: *H. Farrer.* Private collection. Photo: Helga Photo Studio

290. Alfred Thompson Bricher. *Boats on the Shore*, c. 1880-1900. Watercolor. 0.178 x 0.254 (7 x 10 in). The George Walter Vincent Smith Art Museum, Springfield, Massachusetts. Photo: Jill Gibbons Hammond

ence upon the drawing style of the later nineteenth century and spokesman in his lectures for a vision and attitude to light antithetical to the philosophy of luminism—testified to the lingering and powerful influence of such early training and discipline in seeing nature in controlled linear terms. "We are all cursed," he remarked, "by the nonsense of our early teachers. I took lessons like the rest of you, with a pointed pencil and a measure; and to-day I feel the restraint which that way of beginning imposed upon me—so strong is the impression made by early lessons."[69] It is just such "measure" and "restraint" that, despite the variations of personal manner, seem to underlie the landscape vision of mid-century drawings.

One must also seek some element of the strong bias for linear emphasis among these American draftsmen and painters in the disciplined linear systems of engraving. The study of engravings themselves had, from the very beginning of the practice of painting in America, provided an important source of models and self-instruction. Continuing in this tradition, Durand reminded his student in the "Letters" "that a fine engraving gives us all the greatest essentials of a fine picture."[70] Durand himself had enjoyed a first career as one of America's foremost engravers. Only in the late 1830s had he begun to concentrate upon landscape painting,[71] bringing to both his draftsmanship and his painting

technique the precision and emphasis upon clear outline born of his long experience with the purely linear vision of the engraver.

The number of American painters who shared with Durand a background in the craft of engraving is impressive. Casilear apprenticed in this trade under Durand's first master and partner Peter Maverick and also studied with Durand himself. He made his fortune as a bank-note engraver and only ceased the practice around 1857.[72] Kensett was the son of an engraver and began to learn the trade as a child. In 1829 he went to work engraving bank notes, vignettes, and maps, and according to a family source he did not turn his attention to painting until 1840.[73] Doubtlessly his close friendship with fellow engravers and artists Durand and Casilear was to provide initial inspiration for his landscape painting. W. T. Richards' earliest employment as an artist was as a draftsman of ornamental metalwork for a Philadelphia manufacturer of chandeliers and lamps beginning about 1850. During this time he also studied wood engraving.[74] Lane began his formal career as an apprentice draftsman and lithographer in the 1830s by working for the Boston firm of William S. Pendleton, where his fellow apprentice Benjamin Champney recalled, "He was very accurate in his drawing, understood perspective and naval architecture perfectly, as well as the handling of vessels, and was a good, all-round

draughtsman."[75] It is also worth recalling that Eakins' father was a writing master who schooled his son in an old-fashioned penmanship, whose lingering influence might be traced not only in the manner in which that artist signed his drawings and paintings but also in the fundamental linear discipline of his style.[76] Winslow Homer was an experienced draftsman in both lithography and wood engraving before he began to paint in oils, and a number of his subjects appear in more than one media. The contained, linear figures in both *High Tide: the Bathers* (1870; fig. 298) and *Dad's Coming* (1873; fig. 177) appeared contemporaneously as wood engravings in magazine illustrations;[77] both groups were silhouetted against a taut, luminist horizon. Whereas the artist retained the classic clarities of composition in the oil version (*Dad's Coming*) of *Waiting For Dad* (the title given the engraving), Homer altered both horizon and placement of the figures in *High Tide,* introducing a spatial tension that reinforces the peculiar ambiguities sensed in this interesting painting.

This early training in the methodical linear systems of drawing for various reproductive methods—metal engraving, wood engraving, and lithography—as well as in topographical and ornamental draftsmanship produced in many American artists a vision insistent upon accuracy of detail, achieved through linear discipline, an emphasis on outline and contour, and a mastery of subtle tonal gradations. These same qualities are those often cited as components of the luminist style or vision. This shared vision, encouraged by the influence of the drawing manuals and the drawing masters and reinforced by the web of influences and cross-influences within the close-knit community of the landscape painters, lies at the heart of the similarity in style noted by Baur and evident in many mid-century drawings. An examination of the drawings noted here reveals this common core and the subtle distinctions of personal vision as well. While our artists may range in media, they do tend to use those media in a manner consistent with a luminist vision.

Martin Johnson Heade's three drawings from the so-called Plum Island River series of about 1867-1868 (figs. 41, 42, 78) offer the sole examples here of work in charcoal—a medium that was rarely used by the artists under consideration.[78] The medium was hardly unknown, of course, but its use in landscape was not encouraged. John Chapman neither explained nor advocated its use in his very popular *The American Drawing Book* (1858).[79] Durand mentions the use of charcoal as a supplementary excercise only in passing and stresses, as we have seen, the use of the pencil instead.[80] One gathers that charcoal lacked the sharp point, fine line, and ease of control deemed so important to detailed mid-century landscape drawings. Charcoal's popularity as a medium was established, in fact, only with the rise in the 1870s of the less-detailed, suggestive interpretation of landscape that was to mark the demise of the luminist vision.[81]

Heade's choice of such an unconventional medium for what is certainly an unconventional group of drawings was in its way thoroughly characteristic of this artist. Although a close intimate of a mainstream figure like Church, Heade remained curiously apart in personality and practice from his more

291. William Trost Richards. *Rocks by the Sea,* 1880s. Oil on paper. 0.305 x 0.229 (12 x 9 in). The George Walter Vincent Smith Art Museum, Springfield, Massachusetts

292. William Hart. *White Mountain Range from Jefferson Hill,* 1859. Pencil and white wash on brown paper. 0.312 x 0.480 (12¼ x 18⅞ in). Inscribed, l.r.: *Wm Hart 1859;* on back: *E.L.Magoon 1861.* Vassar College Art Gallery, Poughkeepsie, New York. Photo: Peter A. Juley & Son

convivial fellows. As Stebbins has noted, he was an exception among landscape painters of the period in that he drew and sketched infrequently, seemingly not placing much importance on a routine deemed by his contemporaries vital to the landscape painter's creative process.[82] His life-long obsessive treatment, in what is recognized as a classic luminist style, of the salt marsh as a subject leads one to speculate that Heade worked out the solutions to his pictorial problems not in drawings but in the act of painting the long series itself. Certainly the Plum Island River drawings should not be viewed as studies for translation into another medium but, rather, as finished and complete works in themselves—a parallel exploration in another material of a favorite theme. It is particularly fascinating and revealing to trace in the series the progressive simplification, the reduction and refinement of elements, into the distillation of the final image where mast, cloud, and birds, moving ever closer, finally lock into place—their physical convergence suggesting the carefully plotted relationships and balances which underlie the entire work.[83] Heade maintains razor-sharp edges and a total, even rigid, control over transitions from light to

dark which become more subtle as the series progresses. Far from yielding to the soft and suggestive possibilities of this tractable medium, rather, Heade succeeds in bending it to his own peculiar vision.

In addition to the continuity of subject matter in these drawings, we note the regular consistencies in Heade's choice of both the size and the shape of his paper, factors which represent as important an expressive element in the artist's vision as the pictorial motif itself. The shape of the sheet was more important than its dimensions. In *The American Drawing Book,* Chapman urged his reader-student to pay particular attention to this matter:

The peculiar shape of a picture, and its adaptation to a given place or purpose, may have a very important influence on its composition; while, on the other hand, the character of the subject may as well regulate the form of the picture. . . . The shape and composition of a picture should as far as possible harmonize, not contrast with, one another, and the selection of both should be consistent with the subject.[84]

In fact, the element of picture shape is one of the most important aspects of classic luminist style: the decided preference for horizontal compositions, in

293. William Hart. *Moonlight on Mt. Carter, Gorham,* 1859. Pencil and white wash on brown paper. 0.312 x 0.480 (12¼ x 18⅞ in). Inscribed, l.c.: *Wm Hart 1859.* Vassar College Art Gallery, Poughkeepsie, New York. Photo: Peter A. Juley & Son

which landscape elements are compressed into a panoramic format and seem to flow laterally rather than to converge neatly upon a single vanishing point as in the more traditional rectangular landscape format. Heade's drawings—all nearly the same size and precisely twice as long as they are high—offer the ultimate demonstration of classic luminist composition. His format seems also ideally suited to what Chapman referred to as "the character of the subject." The horizontal, very nearly monotonous topography of Heade's characteristic marsh subject is admirably suited to this shape, which the artist used in his canvases as well.

An artist might choose to work upon a sheet already trimmed to such proportions—as did Heade, along with Worthington Whittredge (see fig. 299), Van Beest, and Louis R. Mignot (see fig. 300)—or he might alter a regular rectangle of paper by dividing his sheet into horizontal zones. Richards compressed his drawing of breaking waves into a radically horizontal format simply by isolating it on the rectangular page between lightly ruled pencil lines. Shattuck neatly bisected his sheet, presenting two different panoramic views of

Lake George in an upper and a lower zone. While such an expedient certainly allowed for additional sketching surface, one feels that expressive rather than practical motives were of first consideration in these instances. Gifford's drawings of Giardini and other Italian coastal views, begun on one sketchbook leaf, will consistently extend over a portion of the adjoining page; Gifford thus exploited the panoramic format of the open sketchbook. In his pencil records of the Gloucester coast, Lane actually joined separate sheets to form a kind of topographical panorama.

The panoramic format is, in fact, intimately linked to the topographical landscape tradition. The harbor views of New York, New Bedford, and Gloucester by Mignot, Van Beest, and Lane hark back ultimately to seventeenth-century Dutch prototypes. Nor was the topographical tradition new to America. One has only to recall early examples such as Lauren Bloch's *View of New Amsterdam,* a wash drawing of 1650 (New-York Historical Society, New York), William Burgis' six-foot panoramic engraving of New York City of 1721 (private collection), or Francis Guy's painting of about 1803, *View of Baltimore*

294. William Trost Richards. *East Hampton Beach,* 1871-1874. Watercolor on composition board. 0.457 x 0.812 (18 x 32 in). Inscribed, l.l.: *Wm. T. Richards;* title on back in pencil. Collection of the High Museum of Art, Atlanta; Gift of Mr. and Mrs. Emory L. Cocke, 70.32. Photo: Jerome Drown

from Chapel Hill (Brooklyn Museum, New York), to realize that the straightforward interest in recording the prosaic facts of topography and man-made inroads on the new world reflected in these works long preceded the romantic and emotional response to pure landscape, characteristic of the nineteenth century. The format of the panorama, whose long axis echoes the horizon itself, allowed an artist or draftsman ample latitude to trace, literally, the lay of the land. The tradition, grounded in documentation, did not die with the rise of landscape painting proper but continued as an alternate current, sometimes mingling with the mainstream. Albert Bierstadt's *The Bombardment of Fort Sumter* (c. 1863; fig. 301) with its startling bird's eye view is, for instance, actually cast quite firmly in this topographical mode—even to the elevated viewpoint which allows us to read the coastline like a map in three dimensions.

Around mid-century, however, there may also be traced in paintings like Cropsey's *Bareford Mountains, West Milford, New Jersey* (1850; fig. 302), Church's *Mt. Desert, Moonlight* (c. 1860; fig. 189), Heade's *Lake George* (1862; fig. 75), Bierstadt's *Sunset on the Prairie* (1861; fig. 134), and Gifford's *Hook Mountain, Hudson* (1866; fig. 84) a preference among landscape painters for a panoramic format that does not derive from topographical but, rather, from expressive needs. Certainly by this time the earlier standard Claudian landscape composition was perceived as old-fashioned. The panoramic shape, conforming to the horizontality of the earth itself, undoubtedly offered a more natural framework

for landscape painters. Most important for the development of the classic luminist composition was the gradual abandonment of even vestigial foreground framing elements that contained and controlled the view. Church's *Niagara* (1857; Corcoran Gallery of Art, Washington, D.C.) is—as David Huntington has eloquently written—the major monumental statement of this mid-century adaptation of the panoramic format primarily for expressive rather than topographical purposes.[85] At first glance, *Niagara* might seem to conform to a topographical model similar to Bierstadt's *The Bombardment of Fort Sumter.* We hang suspended without a conventional foreground above the falls while the eye is freed to travel—swift and unimpeded—deep into space. As was his habit, Church studied the falls in numerous drawings and oil sketches from many angles.[86] From these multiple impressions and experiences he synthesized in the final painting a radically simplified image which operates at once as a convincing view of the falls themselves as well as a compelling vision of their relentless power and energy. The monumental panoramic format underscores the unending lateral flow of water. The open-ended composition confirms the suggestion of a force that will not be contained. In a quiet manner and on a radically different scale the panoramic drawings of Heade, Johnson, Shattuck, and Gifford also suggest an unlimited space that belies their small size.

We have noted the intimate link of the panoramic with the topographical,

295. William Trost Richards. *Shipwreck*, 1872. Oil on canvas. 0.610 x 1.167 (24 x 42 in). Inscribed, l.r.: *Wm. T. Richards 1872*. The Pennsylvania Academy of the Fine Arts, Philadelphia

296. William Stanley Haseltine. *Rocks at Nahant*, 1865. Oil on canvas. 0.542 x 0.875 (21⁵/₁₆ x 34⁷/₁₆ in). Inscribed, l.r.: *W. S. Haseltine 1865*. The Mariner's Museum, Newport News, Virginia

297. Alfred Thompson Bricher. *Rocks in Surf,* 1871. Oil on canvas. 0.286 x 0.546 (11¼ x 21½ in). Inscribed, l.l.: *ATBRICHER* (*ATB* is in monogram). Mr. H. Richard Dietrich, Jr., Philadelphia. Photo: Helga Photo Studio

where the overriding interest in accuracy of landscape information may at times approach the cartographical, as with Bierstadt's painting and in several of Lane's drawings. This emphasis upon factual precision led to the use by draftsmen of various devices—some mechanical and others mathematical—that assured accuracy of detail and spatial relationship even beyond the artist's required attention to the laws of linear and aerial perspective. Common among optical aids to accuracy were the camera obscura and camera lucida. Their main function was to project the view by means of a lens onto a surface where it might be traced by the artist. The part played by such optical devices in the pictorial construction and design of American paintings has been investigated and discussed at length by Lisa Andrus.[87] Our major purpose here is to point out that the medium to which these devices were applied and in which their influence shows most plainly is drawing.

Lane was undoubtedly introduced to the use of a drawing machine in his early career as a topographer, and he continued to make use of the device in his later drawings as well. Andrus recognizes the traces of the drawing machine in Lane's work in "the slight bow in the horizon distorted by refraction through a lens" as well as in the general style. This style is characterized by compression into a very long, narrow format, an emphatically clear definition of spatial zones, and the recording of objects in almost pristine outline (see fig. 303). The two latter characteristics were also promoted by the drawing manuals as Andrus has pointed out.[88] These distinctive features may be found in many of Lane's drawings. They may be said, in fact, to characterize his general approach

to draftsmanship, whether or not a drawing machine was directly involved in the creative process. Moreover, a number of drawings by other hands may also be described in these same terms: Gifford, Johnson, Shattuck, Casilear, Durand. While these artists probably did use drawing machines on occasion, what seems more intriguing is Andrus' suggestion of what might be termed a kind of drawing machine aesthetic or approach in the style of their topographical drawings: that tendency to refine the vista to a pure linear profile.[89]

In his study of Durand, David Lawall has noted parallel characteristics in the development of that artist's drawing style. He points out "the greater measure of abstractness" in the panoramic drawings, suggesting a kind of topographical throwback "indicative of their function as sources of information about the disposition of land at a particular geographical location."[90] He notes further the general stylistic progression in Durand's drawings to a "more dominantly linear" style; in Durand's latest panoramic drawings, Lawall says, "nearly everything that is transitory in nature has been omitted in favor of the large, simple relationships of earth, water, and sky."[91] Although none of these drawings exhibit the "definite mechanical quality" that Andrus sees as the result of the use of such tools,[92] they do share that strong ordering in planes and controlled linear outlines that we have called a kind of drawing machine aesthetic and that Lawall, in the case of Durand, calls "a highly intellectual and linear austerity."[93] A very different approach to the panorama is seen, for instance, in the drawing by Van Beest, whose fussy detail, lively movement, flicker of light and shadow, and breezy atmosphere are in sharp contrast to the

drawings of Durand, Lane, Gifford, Shattuck, and Johnson, in which all extraneous detail of object and meteorological phenomena has been distilled to a pristine outline with minimal, or no suggestion of, shadow. These images seem to capture through that very linear austerity the stillness, the timelessness, the balance associated with the luminist vision. The intriguing links of such vision with the character of mechanical vision invite continuing investigation.

Optical devices such as the camera obscura and camera lucida were not the only aids to accuracy to which the draftsman might resort in his efforts to define and measure space. He might use something as simple as Hunt's maligned "pointed pencil and measure" or something as complex as one of Eakins' elaborate perspective studies. The former is evident in Richards' drawing, *Waves* (c. 1870; fig. 304), in which he experimented at the upper margin with several lines—plainly ruled—as if seeking the most effective proportion of sky above to sea below his horizon line—also ruled. An emphasis upon both horizon and horizontality is natural to the coast, where the meeting of earth and sky is unobscured by the irregularities of terrestrial features. Nonetheless, it is clear in a number of the paintings as well as the drawings here that many of these artists imposed a very emphatic horizon line—razor sharp and taut, unobscured by clouds or aerial mist—and even resorted to the ruled line. Still, where the use of the ruler or straight edge is not as obvious as in the Richards, one feels it operating in the clear demonstration of the horizon—as in the marine watercolors of D. J. Kennedy and even in panoramic vistas of large inland bodies of water, such as Shattuck's and Johnson's views of Lake George. In these two works, subtle but repetitive tiny vertical accents are set up by faint reflections along the distant shore of the lake; they march with regularity across the broad expanse of bare paper that is the water, measuring off spatial intervals like the marks on a ruler. In this way, unobtrusive controls established by the balance of horizontal and vertical accents are incorporated into the pictorial structure of these drawings of Lake George. One senses the control but does not readily perceive the means, as in the finished paintings of strict luminists such as Heade and Lane. Whereas Heade appears to have worked out his compositions on the canvas, Lane depended upon careful preliminary pencil studies. A precisely plotted and ruled grid is superimposed on a number of the panoramic drawings, not just for use in transfer but as a kind of framework or

298. Winslow Homer. *High Tide: the Bathers*, 1870. Oil on canvas. 0.660 x 0.965 (26 x 38 in). Inscribed, l.l.: *Winslow Homer—1870—*. The Metropolitan Museum of Art, New York; Gift of Mrs. William F. Milton, 1923

299. Thomas Worthington Whittredge. *View from Mr. Field's Farm at Newport,* c. 1859. Pencil on buff paper. 0.083 x 0.238 (3⁵⁄₁₆ x 9³⁄₈ in). Vassar College Art Gallery, Poughkeepsie, New York

300. Louis Remy Mignot. *New York at the Entrance of the Hudson from Hoboken,* 1846. Graphite on cream wove paper. 0.106 x 0.264 (4³⁄₁₆ x 10³⁄₈ in). Inscribed, l.l.: *New York et l'entrée de l'Hudson from Hoboken/46.* Private collection

301. Albert Bierstadt. *The Bombardment of Fort Sumter,* 1861. Oil on canvas. 0.606 x 1.727 (26 x 68 in).
The Art Collection of The Union League of Philadelphia

armature. This purely conceptual geometrical framework expresses frankly the principal means by which Lane imposed an overriding sense of order upon his view of nature, maintained control of his design, and assured its correct transfer to the canvas.[94]

A careful comparison of the paintings *Norman's Woe* (1862; fig. 32) and the *Babson and Ellery Houses, Gloucester* (1863; fig. 37) with their ruled preparatory drawings (figs. 33, 38) is highly instructive. Lane generally followed the configuration of the drawings closely in establishing the profile of the land and disposition of objects in space. In subtle adjustments of contour, edge, and spatial interval, however, the artist tightened, compressed, and concentrated his image on the canvas, introducing into each painting the peculiar clarity of his atmospheric light, which is barely, if at all, indicated in the drawings. The major alteration from drawing to painting is, of course, the radical increase in the expanse of sky, the source of this hyper-clear and effective light. Water, left simply as reserved areas of paper in the drawings, is transmuted in both paintings into a polished surface that not only mirrors but intensifies aerial light. The grid, as Andrus has noted, becomes largely invisible in the finished paintings, its influence felt rather than seen, a mystery which only heightens each work's expressive power.[95]

A variation upon Lane's straightforward grid is the barely visible network of ruled lines that underlies Richards' seemingly casual drawing of a favorite motif: waves breaking upon a flat sandy beach. We have already noted the parallel ruled lines in this drawing isolating the motif into a narrow strip on the rectangular page. Close examination also reveals a ruled diagonal marking the junction of surf and sand and a fanlike pattern of straight lines radiating from a point on the horizon. Each line acts as a coordinate beneath the irregular crest of a breaking wave, thus imposing a linear perspective upon the restless moving water. This ruled underpinning operating beneath the flux of water is explicit here in this drawing. It is also felt in Richards' paintings of waves of this period and in those of his contemporaries, Kensett, Alfred Bricher, James Suydam, Heade, and Lane, who treated that most painterly of subjects—moving water—in an essentially linear manner.

Drawings such as those reviewed above, which frankly reveal a linear or geometrical framework, invisible beneath the polished surface of oil paintings, offer particular insight into the mode of luminist composition. Whether the drawing is made with the aid of machine, grid, or linear perspective, the impulse is the same: a quest for some means to organize, measure, and control the flux of nature.

302. Jasper Francis Cropsey. *Bareford Mountains, West Milford, New Jersey,* 1850. Oil on canvas. 0.591 x 1.020 (23¼ x 40⅛ in). Inscribed, l.l.: *J.F. Cropsey/1850*. The Brooklyn Museum, New York

The other key to luminist style is, of course, found in a common preoccupation with effects of aerial light. In paintings, treatment of light may range from the pristine clarity of Lane's *Norman's Woe* (1862) to the suffusing glow of Kensett's *View Near Cozzens Hotel, West Point* (1863; fig. 243). While many of the artists here engaged in plein-air painting by mid-century—capturing directly in oils the effects of outdoor light and color—this did not diminish the key position of drawing in recording the impact and experience of scenery and meteorological effects. The modes of recording such phenomena were various. As mentioned earlier the application of monochromatic or polychromatic washes expanded the artist's means of recording effects of light and color to a range nearly as broad as that found in painting with oils. Hart, working in pencil on brown tinted paper, made effective use of Chinese white for those areas in sky and water of most intense light—be it sun or moon. Eschewing watercolor and white, many cultivated the habit of inscribing extensive verbal notes about light and color on the line drawings themselves. Such notes may be found on Cropsey's *View from Mt. Willard, N.H.* (1852; Addison Gallery of American Art, Andover, Massachusetts). Church, who regularly sketched in oils on the spot, also produced scores of elaborately annotated drawings such

as a pencil study of Cotopaxi dated June 26, 1857 (Olana, Hudson, New York). A number system superimposed on the image corresponds to a key in the lower margin where effects of light and color were carefully noted. The series of numbers in the sky, for instance, charts the successive bands of aerial color created by the interaction of light and atmosphere with the smoke and gases issuing from the volcano. In contrast to Church is Lane who neither painted in plein air nor annotated his drawings.[96] In fact, Lane, whose treatment of light is among the most subtle and sensitive of mid-century landscape painters, was, according to a contemporary source, prevented by "physical infirmity" from painting out of doors.[97] His drawings are primarily conceived in outline indicating that the subtle and convincing effects of light and color in the paintings based upon these drawings originated in the mind and memory of the artist.

While their interpretations of landscape were very different, the practice of drawing was for Church and Lane, as well as for their contemporaries, central to the realization of their personal vision. In the conclusion of his second "Letter," Durand had proposed an artistic declaration of independence from the "Old World": "why should not the American landscape painter, in accordance with the principle of self-government, boldly originate a high and independent style, based on his native resources?"[98] This survey of American landscape painting and drawing suggests that there was, indeed, a thriving native school and that luminism in its various manifestations was a central element in this "high and independent style."

303. Fitz Hugh Lane. *Looking Westerly from Eastern Side of Somes Sound Near the Entrance,* 1855. Pencil on paper. 0.222 x 0.667 (8³⁄₄ x 26¹⁄₄ in). Inscribed, u.r.: *by F. H. Lane,September 1855.* Cape Ann Historical Association, Gloucester, Massachusetts

304. William Trost Richards. *Waves,* c. 1870. Pencil on paper. 0.254 x 0.356 (10 x 14 in). The George Walter Vincent Smith Art Museum, Springfield, Massachusetts (below)

1. John I. H. Baur, "Early Studies in Light and Air by American Painters," *The Brooklyn Museum Bulletin, 9,* no. 2 (1948): 7.

2. Baur, "Early Studies," 7.

3. Among the large and important deposits of drawings by American landscape painters to be found in public collections are those by Church in the Cooper-Hewitt Museum, New York; Cole in the Detroit Institute of Arts; Durand in the New-York Historical Society; Lane in the Cape Ann Historical Association in Gloucester, Mass.; and W. T. Richards in both the Cooper-Hewitt and Brooklyn museums, New York.

4. John Paul Driscoll, *John F. Kensett Drawings* [exh. cat. Pennsylvania State University Museum of Art and Babcock Galleries] (University Park, Pa., and New York, 1978), 17-20.

5. Theodore E. Stebbins, Jr., *American Master Drawings and Watercolors, A History of Works on Paper from Colonial Times to the Present* (New York, 1976), 108.

6. John W. Casilear to John F. Kensett, Nov. 19, 1832, quoted in Driscoll, *Kensett Drawings,* iii.

7. Stebbins, *American Master Drawings,* 113-114.

8. *Album* (Metropolitan Museum of Art, New York, Charles and Anita Blatt Fund 1970. 9.1-30).

9. Thomas S. Cummings, *Historic Annals of the National Academy of Design* (Philadelphia, 1865), 111.

10. David B. Lawall, *Asher Brown Durand: His Art and Art Theory in Relation to His Times* (New York, 1977), 5.

11. S. R. Gifford to O. B. Frothingham, Hudson, Nov. 6, 1874, quoted in Ila Weiss, *Sanford Robinson Gifford (1823-1880)* (New York, 1977), 26.

12. Lawall, *Durand,* 728-745 *passim.*

13. Driscoll, *Kensett Drawings,* 5, 7.

14. "Poppy Oil," "Letter from West Campton, September 9, 1856," *The Crayon, 3* (1856): 317.

15. "Mummy," "Letter from North Conway, October, 1856," *The Crayon, 3* (1856): 348.

16. "Poppy Oil," "Letter from West Campton," 317-318.

17. "Flake White," "Letter from North Conway, September 25, 1855," *The Crayon, 2* (1855): 217. While "Flake White" in this passage refers specifically to studies in oil,

we may assume, I believe, that the same customs and procedures applied to sketches in pencil.

18. W. T. Richards to George Whitney, Gloucester, June 10, 1871; in the collection of Edith B. Price, Virginia Beach, Va., and Mrs. James B. Conant, New York.

19. Henry T. Tuckerman, *Book of the Artists* (New York, 1867), 34.

20. Peter C. Marzio, "The Art Crusade: An Analysis of American Drawing Manuals, 1820-1860," *Smithsonian Studies in History and Technology, 34* (1976): 70.

21. "Drawing Teachers," *The Crayon, 3* (1856): 60.

22. Marzio, "The Art Crusade," 52.

23. Marzio, "The Art Crusade," 17.

24. Fessenden Nott Otis, *Easy Lessons in Landscape* (New York, 1851), 6.

25. Driscoll, *Kensett Drawings,* 12; Linda S. Ferber, *William Trost Richards (1833-1905): American Landscape and Marine Painter* (New York, 1979), 7.

26. Marzio, "The Art Crusade," 17.

27. "Elementary Drawing," *The Crayon, 1* (1855): 305.

28. S. R. Gifford to O. B. Frothingham, Hudson, Nov. 6, 1874, quoted in Ila Weiss, *Gifford,* 26.

29. "Elementary Drawing," 305.

30. W. T. Richards, "Lansdowne" (essay delivered before the Forensic and Literary Circle, Philadelphia, c. 1850-1851); in the collection of Edith B. Price, Virginia Beach, Va. and Mrs. James B. Conant, New York.

31. Otis, *Easy Lessons in Landscape,* 1.

32. W. T. Richards, "Flowers," (essay delivered before the Forensic and Literary Circle, Philadelphia, October 1, 1850); in the collection of Edith B. Price, Virginia Beach, Va., and Mrs. James B. Conant, New York, quoted in Ferber, *William Trost Richards,* 8.

33. Asher B. Durand, "Letters on Landscape Painting, 2," *The Crayon, 1* (1855): 34.

34. "Elementary Drawing," 305.

35. Tuckerman, *Artists,* 196.

36. Durand, "Letters on Landscape Painting, 1," *The Crayon, 1* (1855): 1.

37. Durand, "Letters on Landscape Painting, 3," *The Crayon, 1* (1855): 66. Stebbins has drawn attention to Durand's emphasis on drawing in the "Letters" in *American Master Drawings,* 121.

38. Durand, "Letters, 2," 34.

39. Durand, "Letters, 2," 34.

40. Durand, "Letters on Landscape Painting, 4," *The Crayon, 1* (1855): 97.

41. Marzio, "The Art Crusade," 57.

42. John Ruskin, *The Works of John Ruskin,* ed. E. T. Cook and Alexander Wedderburn (London, 1904), *15: 19.*

43. Roger B. Stein, *John Ruskin and Aesthetic Thought in America, 1840-1900* (Cambridge, Mass., 1967), 41.

44. David B. Lawall, *A. B. Durand: 1796-1886* [exh. cat. Montclair Art Museum] (Montclair, N.J., 1971), 18. David C. Huntington, *The Landscapes of Frederic Edwin Church: Vision of an American Era* (New York, 1966), 44-45.

45. Ruskin, *Works, 15: 13.*

46. Ruskin, *Works, 15: 13.*

47. See: William F. Gerdts, "The Influence of Ruskin and Pre-Raphaelitism on American Still-Life Painting," *American Art Journal, 1* (1969): 80-97 *passim.* Ferber, *William Trost Richards,* chap. 4 *passim.*

48. Association for the Advancement of the Cause of Truth in Art, unpublished minutes, Jan. 27, 1863-Feb. 23, 1865, Ryerson Library, Art Institute of Chicago.

49. "Good Work in the Academy Exhibition," *The New Path, 1* (1863): 22.

50. "Association for the Advancement of Truth in Art," *The New Path, 1* (1863): 11.

51. Durand, "Letters, 1," 2.

52. For the basic skills, see Marzio, "The Art Crusade," 69.

53. Durand, "Letters, 1," 2.

54. "Flake White," "Letter from North Conway," 217.

55. Durand, "Letters, 1," 2.

56. Durand, "Letters, 3," 66.

57. John T. Bowen, *The United States Drawing Book* (Philadelphia, 1838), 9, 10, quoted in Marzio, "The Art Crusade," 83, n. 17.

58. Durand, "Letters, 2," 34.

59. Driscoll, *Kensett Drawings,* 12.

60. Ferber, *William Trost Richards,* 7.

61. Ferber, *William Trost Richards,* 3. Marzio, "The Art Crusade," 20, 21.

62. Charles E. Slatkin and Regina Schoolman, *Treasury of American Drawings* (New York, 1947), 24.

63. Ferber, *William Trost Richards,* 16. Helen Haseltine Plowden, *William Stanley Haseltine* (London, 1947), 18-19.

64. Plowden, *Haseltine,* 28.

65. David C. Huntington, *Frederic Edwin Church* [exh. cat., National Collection of Fine Arts et al] (Washington, D.C., 1966), 25.

66. Frank J. Mather, Jr., *Charles Herbert Moore: Landscape Painter* (Princeton, 1957), 4.

67. S. R. Gifford to O. B. Frothingham, Hudson,

Nov. 6, 1874, quoted in Weiss, *Gifford,* 14.

68. George Inness, Jr., *Life, Art and Letters of George Inness* (New York, 1917), 268, 271.

69. William Morris Hunt, *Talks on Art, First Series* (Boston, 1896; rpt. ed., New York, 1976), 64.

70. Durand, "Letters, 3," 66.

71. Lawall, *Durand: His Art and Art Theory,* 5.

72. Daria Rigney, "John William Casilear" (seminar report presented at Columbia University, New York, Mar. 19, 1979).

73. Driscoll, *Kensett Drawings,* 9.

74. Ferber, *William Trost Richards,* 4.

75. John Wilmerding, *Fitz Hugh Lane* (New York, 1971), 19; Benjamin Champney, *Sixty Years' Memories of Art and Artists* (Woburn, Mass., 1900), 10, quoted in Wilmerding, *Fitz Hugh Lane,* 20.

76. Sylvan Schendler, *Eakins* (Boston, 1967), 6, 13.

77. John Wilmerding, *Winslow Homer* (New York, 1972), 88. *High Tide* appeared in *Every Saturday,* Aug. 6, 1870, 504 and *Dad's Coming* appeared as *Waiting for Dad* in *Harper's Weekly,* Nov. 1, 1873, 969.

78. Theodore E. Stebbins, Jr., dates the drawings to this period in his *The Life and Works of Martin Johnson Heade* (New Haven and London, 1975), 56.

79. John G. Chapman, *The American Drawing-Book: A Manual for the Amateur and Basis of Study for The Professional Artist* (New York, 1858).

80. Durand, "Letters, 3," 67, quoted in Stebbins, *Heade,* 56.

81. William Morris Hunt, a key figure in the rise of that more suggestive interpretation of landscape, was known for introducing widespread use of charcoal among American artists: "Once I was at Berville's shop in Paris, and he wanted me to buy a box of materials for charcoal-drawing. . . . I give you my word, that box was the beginning of all the charcoal-drawing that's been done in America; of my having any class, in fact" (William Morris Hunt, *Talks on Art, Second Series* [Boston, 1898; rpt. ed., New York, 1976], 87). While Hunt's claim is, no doubt, exaggerated, Stebbins plausibly suggests him as an important element in Heade's interest in the charcoal medium (Stebbins, *Heade,* 56-57).

82. Stebbins, *Heade,* 48.

83. The sequence of drawings discussed here is that established by Stebbins in *Heade,* 283-285, nos. 379-388.

84. Chapman, *The American Drawing-Book,* 291.

85. Huntington, *Landscapes of Frederic Edwin Church,* 68-71. Theodore E. Stebbins, Jr., *Close Observation: Selected Oil Sketches by Frederic E. Church* (Washington, D.C., 1978), 27-28.

86. Huntington, *Church,* 67.

87. Lisa Andrus, *Measure and Design in American Painting 1760-1860* (New York, 1977), chap. 6 *passim.*

88. Andrus, *Measure and Design,* 67, 210, 214.

89. Andrus, *Measure and Design,* 212.

90. Lawall, *Durand: His Art and Art Theory,* 322.

91. Lawall, *Durand: His Art and Art Theory,* 322-323.

92. Andrus, *Measure and Design,* 207.

93. Lawall, *Durand: His Art and Art Theory,* 324.

94. Wilmerding, *Lane,* 60. Andrus, *Measure and Design,* 66-67.

95. Andrus, *Measure and Design,* 68.

96. Wilmerding, *Lane,* 52.

97. Joseph L. Stevens, Jr. to Samuel Mansfield, Boston, Oct. 17, 1903, quoted in Wilmerding, *Lane,* 51.

98. Durand, "Letters, 2," 35.

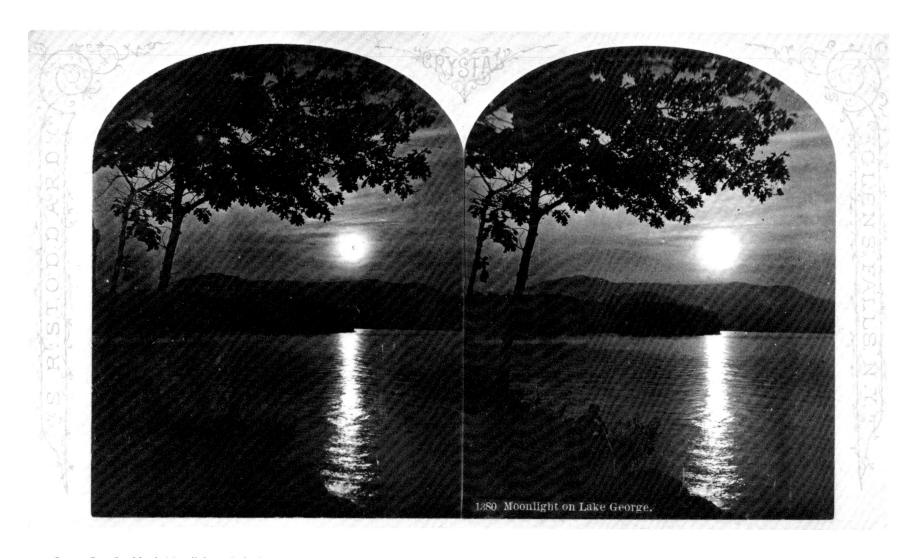

1380 Moonlight on Lake George.

329. Seneca Ray Stoddard. *Moonlight on Lake George (no. 1380)*, c. 1875-1880. Stereograph.
Private collection. Photo: National Gallery of Art, Washington, D.C.

"New Eyes"—Luminism and Photography

Weston Naef

LIGHT IS CONNECTED TO PHOTOGRAPHY BY A CAUSE AND EFFECT relationship more immediate than the similar relationship between what a painter sees (for which light is essential) and how that perception is finally translated into shades of light and dark on paper or canvas. For light in photography acts in the capacity of both the brush and the pigment. Though the painter's treatment of light is slower, it is not necessarily any more conscious or deliberate an act than that of the photographer. Moreover, no trace of light can be obscured in the photograph as it is an extremely malleable medium. Indeed, light is such a fundamental ingredient of the photograph that the style of its treatment by the photographer is as readable as a fingerprint.

That the attention given to light by photographers in forming their compositions followed a parallel course of development to the emergence of the same concern by luminist painters is perhaps demonstrated by the belief during the 1840s that photography, called "photogenic drawing," was thought to draw its own image with light as the instrument. This archaic phase (1840-1859) is represented by the Daguerrean picture, in which, because of limitations of the process itself, treatment of outdoor light and space seldom occurred. The classic phase of nineteenth-century photography (1860-1880) is reflected in works that focused on scenes in nature and, correspondingly, on the use of light as a resource, not merely as a condition. It was at this time that the undisputed monuments of luminist photography were first created. The late phase, extending through 1900, grew out of the classic phase as photographers used new materials which made possible more literal effects.

Between 1840 and 1850 photographers stationed themselves in their studios, receiving customers off the street whom they photographed under skylights designed for the soft, even light traditional to portraiture. Even the drama of Rembrandtesque lighting was difficult to achieve because daguerreotype plates could not absorb extremes of dark and light simultaneously. The great majority of all photographs made before 1860 were portraits done either in the studio or in portable, artificial environments created by itinerant portrait photographers. On the rare occasions when a Daguerrean took his equipment outdoors the subjects were city views, rural occupational views, or natural wonders such as Niagara. The rise of a class of professional landscape photographers was dependent on the introduction of negatives on glass that made the pursuit commercially feasible as well as artistically satisfying.[1] This, combined with a widespread interest in rendering moods of nature, encouraged photographers to take their equipment outdoors and to focus on true wilderness settings. Indeed, the government in this instance acted as an unusually effective patron of the arts by encouraging the transition from studio-oriented works to outdoor scenes through its sponsorship of photography on the post-Civil War western explorations. Much outdoor photography before 1865 was done by persons unaccustomed to the natural setting, including portraitists taking a fling at landscape (though portraitists rarely had the tenacity or incentive from a commercial point of view to produce such views) and amateurs. The latter—many of them very talented—were among the most active outdoor workers. Though they were otherwise untrained in either the practice of art or its history, nonetheless their sense of subject and handling are often rooted in the stylization, simplicity, and frontality that characterize folk-art paintings, drawings, and lithographs. After 1885, photographers, like their counterpart painters and sculptors, were better trained. The proliferation of paper print views during the preceding decade had made high quality images by master photographers obtainable in the world's major cities; Roger Fenton, Gustave Le Gray, Edouard Baldus, Francis Frith, and such reputable establishments as the London Stereoscopic Company and E. and H. T. Anthony in New York, all had sales agents in far-flung places. Just as painters and engravers of the Renaissance and baroque periods often received part of their visual education through paintings and engravings, so it was possible for a photographer to perfect his craft by studying finely visualized photographs.

Moreover, the ascendance of art academies in the 1850s produced a body of matriculants many of whom now chose to pursue photography instead of the traditional studio disciplines.

The earliest extant body of American camera-art to demonstrate a systematic concern for the outdoors and its attendant light was the production of the partnership of Albert S. Southworth and Josiah J. Hawes of Boston. They began making daguerreotypes after separately learning the process in 1840 from J. B. F. Fauvel-Gouraud, the first American representative of the French licensees of Daguerre's camera and instructional manual.[2] The series of photographs they made in and about the Mt. Auburn Cemetery in Cambridge, Massachusetts, are the earliest surviving American photographs whose major motifs emerge from the surrounding environment through an orchestration of the light falling on them. The most stunning of these compositions (fig. 305) shows several ranks of white tombstones that emerge from the dark background of grass and trees. The silvered-copper daguerreotype plate is here unequalled at recording the luminescence of the stones flecked with variable patterns of light falling through the trees. So it is also with the larger tombs of

W. Read and S. O. Mead (fig. 306)—whose coincidentally rhyming names are echoed in the identical architecture of the structures. The play of light on stone and the faithfulness with which it is captured are the elements in this representation that distinguish one tomb from the other.

In spirit, the Mt. Auburn Cemetery series relates to the paintings of Fitz Hugh Lane and of Robert Salmon, both of whom favored a similar crystalline light. Southworth and Hawes were exceptional in their time for attempting a series of outdoor views. Because daguerreotype plates are *unica* and not easily or faithfully replicated, there was little commercial incentive to produce landscape scenes for profit. They could not be sold for a price equal to the time and effort expended to make a nonreplicable image.

No work from the early years of the Southworth and Hawes studio has been conclusively identified, and the bulk of the surviving images dates from the 1850s, thus denying us an opportunity to study the evolution of these men from apprenticeship to a mature style as is fully possible with painters of their generation. Nonetheless in their portraiture Southworth and Hawes may be classed stylistically with the late phase of neoclassicism in the gentle light, erect

305. Albert S. Southworth and Josiah J. Hawes. *Unidentified Plots, Mt. Auburn Cemetery, Cambridge, Massachusetts,* c. 1850. Whole-plate daguerreotype. International Museum of Photography at George Eastman House, Rochester, New York (not in exhibition)

306. Albert S. Southworth and Josiah J. Hawes. *W. Read and S. O. Mead, Mausolea, Mt. Auburn Cemetery, Cambridge, Massachusetts,* c. 1850. Whole-plate daguerreotype. International Museum of Photography at George Eastman House, Rochester, New York (not in exhibition)

posing, and concern for rendering nuances of costume. There are, however, a few exceptions such as Southworth's *Self-Portrait* (International Museum of Photography at George Eastman House, Rochester, New York, 74: 193:1127) and *Lemuel Shaw* (Metropolitan Museum of Art, New York, 38.38.34) where the deep shadows of strongly focused light show more in common with French romantic portraiture than with neoclassicism. Likewise, the Mt. Auburn Cemetery images share common elements with romantic landscape and fit stylistically with native American romantic realism. Nonetheless, while their roots are in the romantic epoch, Southworth and Hawes constitute the first American photographers to attempt a systematic treatment of light as the essential ingredient of landscape.

There is no surviving body of daguerreotypes by one maker that completely parallels the first generation of luminist painters typified by Fitz Hugh Lane, with his seascapes of mirrorlike clarity of water and form, ruler-sharp horizon, and filmy atmosphere. Southworth and Hawes touched on the style; but, since they were obliged to spend most of their time in their portrait studio, they spent relatively little time photographing outdoors, thus limiting their potential for producing a significant body of landscape work. Nonetheless, the luminist character of the Mt. Auburn Cemetery studies stands out when compared to the work of J. W. Black, a younger Boston contemporary of Southworth and Hawes, who worked on the infant glass-plate process that yielded paper prints. Black's White Mountain series of c. 1856 may hold the distinction of being the earliest surviving series of full-plate American photographs that probe wilderness nature (fig. 307). In the flatness of light and concern for chiaroscuro rather than optical precision, however, Black's views are more closely related to the Hudson River school of painting and, indirectly, to French Barbizon painting, than to the luminism of Southworth and Hawes. Black was more concerned with the intertwined web of relationships among the natural orders, rather than the flat, open spatial structure and serene light that a slightly later generation of photographers saw as being of fundamental beauty in nature.

The generation of painters who emerged in the 1850s and 1860s had at their disposal a new range of technical possibilities created by the introduction of chemical dye colors—chrome and cobalt yellow, cobalt violet, and zinc white—that changed the look of painting. Likewise the transition by photographers from daguerreotypes on silvered copper sheets to mammoth albumen negatives on glass dramatically changed the look of photographs. The new materials brought a new character to subjects that invited photographers to work with a concentrated process of observation. The power of glass negatives to resolve detail reduced the need for photographers to rely on literary associations in the choice of motifs. Indeed certain photographers began to see

nature as a temple deserving of thoughtful compositions and extremely faithful rendering, a quality historian John Baur has called pantheistic realism. Others have noticed the relationship of this nature-consciousness to Emersonian transcendentalism, where light equated a divine presence. However, when Ralph Waldo Emerson decreed that we see with "new eyes" *and declared, "Our age is ocular," he heralded a new epoch for all visual arts. The philosophy of

307. James Wallace Black. *Artists Falls, North Conway (New Hampshire)*, 1854. Salt print. The Metropolitan Museum of Art, New York; Promised Gift of Warner Communications, Inc. (not in exhibition)

* Ralph Waldo Emerson, *Journals, 4:* 321; quoted in Hans Huth, *Nature and the American* (Berkeley, 1957), 89.

Emerson and his follower, Henry David Thoreau, is of particular pertinence to photography which was the medium best able to render the immediacy of observed phenomena, though there is no documentation that any of the photographers under consideration here actually read Emerson or Thoreau. Few letters, diaries, or personal libraries have survived from photographers of this period, and it is from our historical perspective that an association is invoked. Nonetheless, because photography made possible the full union of the artist and his subject, it was a medium tailored to Thoreau's philosophy if not vice versa.

Carleton E. Watkins and Timothy H. O'Sullivan emerged simultaneously with the classic phase of luminist painting and stand parallel to Martin Johnson Heade, Sanford Gifford, and John F. Kensett in their tendency to simplify compositions, their fondness for low horizon lines, their attraction to solid forms in nature, their desire to model palpable space, and above all their belief in the transcendent beauty of nature. Watkins emigrated to California from Oneonta, New York in the backwash of the gold rush and in 1854 is listed as a clerk in the book and stationery emporium of G. W. Murray.[3] As is typical of most photographers of his epoch, little is known of Watkins' early years as a photographer other than that sometime in the mid-1850s he left clerking to work in the San Jose branch studio of Robert Vance, San Francisco's legendary Daguerrean portraitist. Daguerreotype portraits by Watkins have not been identified and his earliest photographs to survive are from his famous 1861 expedition to Yosemite when the first mammoth-plate photographs of the site were made, a series that was as advanced technically and aesthetically as any European photographer, and much grander in scale than anything that had been systematically produced in America before.

How or from whom Watkins learned the craft of the landscapist—fundamentally different in its requirements from portraiture—is not clear. A possible formative influence on Watkins' eye were photographs by master eastern and European photographers whose work Watkins would certainly have seen at Vance's establishment in the form of stereographs—photographs made with a twin-lensed camera that, when viewed through a stereoscope, gives the illusion of three-dimensional space. Vance advertised that he stocked the largest inventory of stereoscopic photographs in San Francisco—over six hundred views, including scenes from Egypt and the Eastern Mediterranean, the Orient, and "portions of the Eastern United States."[4] Indeed, the best examples of landscape photography being done anywhere in the world were in stereographs by Europeans such as Roger Fenton, Francis Frith, Charles Soulier, and John Soule and by the American, Frederick Langenheim. Watkins himself came to be a master of stereographic photography, sales of which were the staple of his livelihood. It is not unreasonable to think that the most capable European and American landscapists were Watkins' teachers through the best possible mode of instruction, the photographs themselves.

Watkins' known work commences in 1861, the year he told his biographer that

308. Carleton E. Watkins. *The Three Brothers—4480 Feet—Yosemite,* 1861. Albumen print from mammoth-plate negative. The American Geographical Society of New York (not in exhibition)

he first visited Yosemite to photograph, using an enormous camera capable of receiving eighteen-by-twenty-one-inch glass plates and a smaller twin-lensed stereo camera. The dating of these mammoth plates is derived from a unique set of glass stereographs in the National Park Service museum at Yosemite, a set originally owned by Professor Spencer Baird of the Smithsonian Institution. Through comparative analysis it is possible to deduce that *The Three Brothers—4480 Feet—Yosemite* (1861; fig. 308) is from the first visit to Yosemite. Typical of the style of picturesque romanticism in both painting and photography of this time is the combination in one view of deep shadow and bright sunlight, as well as a composition closed at the edges by an enframement of trees. Between 1861 and 1866 Watkins worked his way around Yosemite creating the tightly composed studies that served to identify the key natural motifs and the best points from which they might be viewed. Despite the traces of human settlement in the valley, including a hotel and barns and corrals for beasts of burden and farm animals, Watkins studiously omitted them from all but a few of his Yosemite views. He sought to create the impression of Yosemite as an Edenic paradise. Watkins consistently attempted to delimit the perimeters of his compositions by the closure of trees and cliffs, while he simultaneously

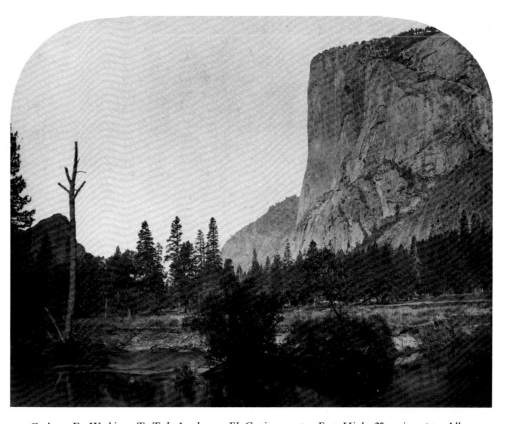

310. Carlton E. Watkins. *Tu-Toch-Anula, or El Capitan, 3,600 Feet High, Yosemite*, 1861. Albumen photograph. 0.381 x 0.508 (15 x 20 in). Daniel Wolf. Photo: International Museum of Photography at George Eastman House, Rochester, New York

309. Carleton E. Watkins. *Mirror View, El Capitan, Yosemite (no. 38)*, c. 1866. Albumen photograph. 0.530 x 0.411 (20⅞ x 16³/₁₆ in). Private collection, New York. Photo: The Metropolitan Museum of Art, New York

focused attention on three or four elements such as a tree and two enframing rock formations in *Down the Valley, Yosemite (no. 37)* (1861?; Boston Public Library). Between 1861 and 1866 Watkins' style evolved toward compositions that were less and less delimited by artificial compositional devices. He began to translate his visions into more specifically optical phenomenon with real and implied light and space. *Mirror View, El Capitan (no. 38)* (c. 1866, fig. 309; see also fig. 310) introduces a reflection that turns the world upside down since the rendering of the cliff in the water is more detailed and stronger in definition that the nonreflected cliff. The visual ambiguity between real world and reflected world is very strong. The diagonally placed fallen log serves to expand

the composition beyond the actual edge of the picture, thus psychologically opening it up.

The evolution of Watkins' style is exceptional in nineteenth-century photography. To date such systematic growth has been identified in very few European or American photographers. Few worked for a sufficiently long period—oftentimes less than a decade—for stylistic change to occur, while others did not leave a sufficiently well dated oeuvre to permit tracing of such evolution as there might have been.

Watkins was apparently influenced during this period of stylistic change by various outside influences that included Albert Bierstadt and Bierstadt's writer-friend Fitz Hugh Ludlow, both of whom he met, and Clarence King, who was perhaps the most important American Ruskinian after William Stillman.[5] In 1866 Watkins traveled about Yosemite in the company of King and his associates on the California Geological Survey directed by Josiah Whitney, for which Watkins was commissioned as photographer that season—the first

311. Carleton E. Watkins. *A Storm on Lake Tahoe (California)*, c. 1880-1885. Albumen photograph. 0.388 x 0.540 (15¼ x 21¼ in). Private collection, New York. Photo: The Metropolitan Museum of Art, New York

photographer since the Civil War to be engaged in a government survey. The changes in Watkins' style soon after this time can be ascribed at least in part to the influence of a philosophical point of view such as King could have supplied. Conversely, King had displayed no particular love of photographs before 1867; and yet it can be speculated that Watkins and his photographs were formative influences on King, who will turn up again in this narrative in the context of O'Sullivan, who was commissioned by King to photograph on the fortieth parallel survey beginning in 1867.

King graduated from Yale University's Sheffield Scientific School in 1862 and spent the following year in New York, where he became involved with the Society for the Advancement of Truth in Art, a group highly influenced by the writing of John Ruskin.[6] Ruskin had great admiration for photographs, as they embodied many of the principles he valued in art; in turn the Ruskinians saw in the photograph a medium capable of recording the minute aspects of nature, like the texture of granite or a forest thicket, which resisted treatment with brush or pencil. King had great respect for visual artists and was an occasional collector of paintings and drawings, although he is not documented as having had an active interest in photography until 1867. He moved in a circle of artists,

and his love of art remained for the rest of his life. Thus, when King arrived in San Francisco in 1863 to work as a volunteer with Whitney's California Geological Survey, his head was filled with ideas far beyond the narrow field of applied geology, and he was famous for camp-fire conversation about art and aesthetics. In addition to being a Ruskinian, King was also a pantheistic anti-Darwinian, whose theory of catastrophism was framed to prove that evolution could not have taken place because of all the sudden violent geological changes that had occurred in earth's history. King was firmly opposed to the concept that man evolved from primates and hoped to prove by geological evidence that "if catastrophes extirpated all life at oft repeated intervals from the time of its earliest introduction, then creation must necessarily have been oft repeated."[7] King invoked the cosmogony of Sanskrit, Hebrew, and Islam as well as the Bible, when he quoted in a very fundamentalist way. King's nature-oriented spiritualism can be traced directly to Emerson and Thoreau.

Watkins' style cannot be traced specifically prior to 1875, the year it appears his entire collection of negatives up to that time was lost through bankruptcy to his next-door-neighbor, Isaiah Tabor, who continued to print those negatives with his own name in place of Watkins'. The loss necessitated Watkins making

312. Carleton E. Watkins. *Columbia River,* 1868. Albumen photograph. 0.400 x 0.515 (15¾ x 20¼ in). Daniel Wolf

an entirely new set of negatives. In remaking his original negatives Watkins often did not prospect for new motifs or viewpoint, but rather set his camera up on many of the identical sites of his earlier visits, to duplicate as closely as possible the original perspective, especially in the Yosemite series. The new negatives differed from the original set only in so far as the motifs themselves had changed over the years: trees grew, others fell, riverbeds eroded, and occasionally a structure was built where one had never existed before. Watkins selected the identical season and time of day. However, for non-Yosemite views, Watkins labeled the post-1875 work as his New Series, identified on paper labels pasted onto the mounts. Between 1875 and 1880 Watkins ventured south in California to the terminus of the Southern Pacific Railroad in Tucson, Arizona, and north to Lake Tahoe using the privilege of a private Union Pacific railroad car to haul his photographic wagon. Watkins' photographs after 1875 demonstrate an even greater degree of evolution away from tight, contained compositions to broadly treated motifs typified by *A Storm on Lake Tahoe* (c. 1880-1885; fig. 311), which closely parallels the storm themes of Martin Johnson Heade.

The rarity of the new series mammoth-plate prints suggests Watkins did not

sell enough to recover economically from his 1875 setback. During the later years he retired into the role of a failed genius, having lost the national importance he had in the 1860s. Although he is listed in the business directories of San Francisco as having a studio until 1906, the paucity of surviving work from that period suggests he must have been very inactive. *Winter View of Cape Horn from Bridal Veil* (fig. 313; see also fig. 314) can be attributed to Watkins' 1870s trip through the Pacific Northwest. In this photograph Watkins creates an open, meditative composition by showing a section through the riverbank that we are invited to extend horizontally in either direction beyond the edges of the photograph. Compositionally it is related to *Yosemite Valley from Sentinel Dome (no. 93)* of 1866 (private collection), which, however, is spatially more complex. Thematically, Watkins has clearly abandoned an Edenic vision of wild nature, and in a rare instance of the winter landscape evokes a stygian barrenness that is new to his style.

Watkins' two most important late projects were commissions he undertook to photograph the Kern County Land Company property near Bakersfield, and to photograph the Phoebe Appleton Hearst hacienda, near Pleasanton.[8] Many of those studies and similar ones such as the *Berkshire Ranch* of about 1885

313. Carleton E. Watkins. *Winter View of Cape Horn from Bridal Veil*, c. 1875. Albumen print from imperial-plate negative. Private collection. Photo: The Metropolitan Museum of Art, New York (not in exhibition)

314. Carleton E. Watkins. *Cape Horn, Oregon*, 1868. Albumen photograph. 0.391 x 0.521 (15⅜ x 20½ in). Private collection, New York. Photo: The Metropolitan Museum of Art, New York

(private collection) rely entirely on optical effects such as the shimmering light on the tree leaves and the random patterns formed by intersecting plots of land and the shadows cast by features marking their perimeters. The completely open quality of these compositions and their overriding concern for effects of light indicate how deeply those elements were a part of Watkins' consciousness; they cannot be dismissed as fleeting affectation absorbed from the outside. No other photographer of his generation so fully expressed an understanding of stylistic issues pioneered by painters of his generation.

Timothy H. O'Sullivan, born of an Irish immigrant family that settled in Staten Island, New York, was a mere twenty-one years old when he photographed at the Battle of Bull Run for Brady's Photographic Corps. While Watkins meditated on the paradise of Yosemite, O'Sullivan was mired in the inferno of Civil War battlefields. Brady's Photographic Corps consisted of perhaps two dozen individuals including such talented men as George Barnard, A. J. Russell (see fig. 315), and Alexander Gardner. Gardner was a Scotsman who had been brought to this country by Brady in the 1850s to manage the Washington portrait gallery about the time daguerreotypes, at which Brady was a specialist, were being replaced by paper prints from glass-plate negatives. After aiding Brady transform his operation from metal to glass plates, Gardner, in association with his son James, established his own

Washington studio and was soon advertising for sale a series entitled Photographic Incidents of the War published in competition with Brady's. Gardner's task as an illustrator was somehow to encapsulate in single images the meaning of battle statistics.

Forty-four of the one hundred photographs appearing in Gardner's *Photographic Sketch Book of the War* (1865) were by O'Sullivan. The most often reproduced image in the set of original mounted photographs in two volumes was O'Sullivan's *The Field Where General Reynolds Fell* printed from a negative made early in the morning of July 4, 1863 (fig. 316). Only hours before, a three-day battle that pitted ninety thousand Union troops against seventy-five thousand Confederates had ended in a Union victory with fifty-one thousand dead on both sides. O'Sullivan created a flat, open composition bathed in serene light not unlike the kind of composition that Heade, Gifford, or Kensett might have applied to landscape alone. The out-of-focus background has a purely photographic effect that flattens the space and permits full attention to be concentrated on the corpses arranged like a still life. In framing his image so it intersects the bodies at the extreme left and right edges, O'Sullivan invites us to read the scene as a slice through a motif that is repeated beyond the

as did the Yosemite of Watkins or the Yellowstone of Jackson, even though little of the area had been photographed before.

During the survey, O'Sullivan was constantly on the move from one desolate site to another, many of them unlike any landscape he had seen in his life. Pyramid Lake, Nevada, for example, was named for its conical island (fig. 317), that, like the nearby tufa formations, were the result of ancient volcanic activity. James Wood has written of this series that

one senses that for O'Sullivan a photograph was equally an image chosen and organized by the artist and a specimen of preexisting physical fact recorded by the technician. The perfectly balanced tension between these subjective and objective concerns is a central characteristic of his work.[9]

During the time he worked for King, O'Sullivan did not have great freedom of choice over his subjects since they were selected to be photographed on the basis of their scientific relevance by King or his associates. O'Sullivan's relationship to his subjects was, of necessity, not unlike that of the folk artist to his subjects; in the latter case, the artist was often confined by certain limiting parameters. Weathervanes and quilts must perform their appointed functions;

315. Andrew Joseph Russell. *Weber Valley, from Wilhelmina Pass, Utah,* 1867-1868. Albumen photograph. 0.228 x 0.309 (9 x 12⅛ in). Private collection. Photo: Janet Lehr

perimeters of this photograph. The solution is not unlike that of Watkins' *Yosemite Valley from Sentinel Dome (no. 93)* (c. 1866; private collection), where we are invited to imagine the landscape repeated beyond what we actually see represented. Watkins, however, worked untouched by the war and had the comparative luxury of returning repeatedly to the Eden of Yosemite Valley to sift out the ideal time of day and season for each view. Not only was O'Sullivan confronted by motifs that resisted meditative treatment, but he was constantly on the move with his darkroom installed in a horse-drawn wagon each day confronting unfamiliar motifs. He could not return to contemplate subjects he had seen many times before.

O'Sullivan's motifs changed dramatically when he became associated with Clarence King's United States Geological Survey of the Fortieth Parallel, an expedition that departed via sea from New York to San Francisco on May 8, 1867 for a two-year campaign of scientific exploration. As director of the survey, King was a firm believer in the useful application of photography to the needs of a topographic survey. This exploration along the fortieth parallel encompassed some of the most barren regions of Nevada, Utah, and Arizona that for good reason had not heretofore been adequately charted. Once photographed by O'Sullivan, moreover, few of the motifs entered the realm of national myth

316. Timothy H. O'Sullivan. *The Field Where General Reynolds Fell,* July 4, 1863. Albumen print from full-plate negative. International Museum of Photography at George Eastman House, Rochester, New York (not in exhibition)

317. Timothy H. O'Sullivan. *Pyramid and Tufa Domes*, 1868. Albumen photograph. 0.200 x 0.270 (7⅞ x 10⅝ in). The National Archives, Washington, D.C.

318. Timothy H. O'Sullivan. *Desert Sand Hills Near the Sink of Carson*, 1868. Albumen print from full-plate negative. The Library of Congress, Washington, D.C. (not in exhibition)

their actual appearance emerges from the collective body of traditional patterns and designs. Very rarely did folk artists invent new functions or new designs; rather they worked with what was given to them. O'Sullivan, who on the King survey was instructed as to his motifs, allowed his visual imagination to come to bear in selecting the point of view from which the photograph would be made, the framing of the subject, the kind and intensity of light, and the choice of including otherwise extraneous elements. *Desert Sand Hills Near the Sink of Carson* (1868; fig. 318) rises above its function as a geological document to become a sublime work of art by virtue of the photographer's handling, not for any reason inherent in sand dunes. The deployment of the horse-drawn wagon and the compositional choices that resulted in the flanking of the white sand hill by two darker shapes cause this to function simultaneously as geological specimen and fantasy landscape.

O'Sullivan returned to the West again in 1871, having spent the 1870 season on the naval expedition to Panama's Isthmus of Darien conducted by Lt. Comdr. Thomas O. Selfridge, who had been sent by the government to prospect for possible routes for a canal through Panama. Back in the continental United States O'Sullivan traveled west via the newly completed transcontinental railroad to participate in the Geological Surveys West of the One-Hundredth Meridian conducted by Lt. George M. Wheeler of the Army Corps of En-

gineers. In contrast to King, Wheeler was a West Pointer and a career officer with little interest in either the arts or the philosophical controversies that surrounded contemporary science. O'Sullivan was sent out, accompanied by an enlisted man from the main party for days at a time, when he had complete freedom over the choice of his motifs. As a result, they become more topographical and pictorial than photographs made during the King survey.[10]

Cañon of the Colorado River, Near Mouth of San Juan River, Arizona (1873; Boston Public Library) is, on the surface, a spatially open composition orchestrating light and space at the expense of any dramatic intensification of the canyon, though it is the primary motif. At the heart of this photograph is an unstated subject, that of the enormity of geological time. Perhaps more so than any other photographer of his epoch, O'Sullivan concerned himself with pictorializing the passage of time. Time is the unstated subject of *Rock Carved by Drifting Sand* (1871; fig. 319), just as it is in *Ancient Ruins in the Cañon De Chelle* (1873; fig. 320), both of which are composed with visual cues to help decipher the overlay of the elements of time. The carved rock in the former becomes a still-life arrangement, with a carefully placed bottle and tin cup to bridge the gap between the modern era and the distant past. Likewise, the Canyon De Chelle ruins are associated with O'Sullivan's day, represented in the posed figures, a more distant human time represented in the ruins of a native

American dwelling, as well as geological time, represented by the scars of erosion on the cliff itself. O'Sullivan's treatment of Green River, Colorado (1870s; fig. 321) in a series of exposures from the same viewpoint establishes beyond a doubt his intentional concern for time and how it can be expressed by light. The evidence of geological time is represented in the eroded canyon, while lunar time is expressed by the patterns of light and shadow that not only differ from one image to the next but also transform the far side of the river from an undulating sequence of ravines to a barely modulated bas-relief effect. Textures, details, and entire formations metamorphose as the light changes. O'Sullivan's series brings to mind Claude Monet's series of haystacks and his varying façades of Rouen Cathedral; yet however similar to Monet in general effect, the precise reasons for O'Sullivan's series remain unknown, while Monet's "art for art's sake" motivation is beyond doubt.

O'Sullivan left historians with only circumstantial evidence for why and how his concern for time and light grew to the point we see in 1873, the last year he spent in the West. Like his contemporary Eadweard Muybridge, he was diverted either by differing personal concerns and sometimes by events outside his control from single-mindedly pursuing a track of homogeneous stylistic evolution as did Watkins. O'Sullivan returned to Washington, D.C., where he died prematurely leaving to other photographers the opportunity of germinat-

320. Timothy H. O'Sullivan. *Ancient Ruins in the Cañon De Chelle, New Mexico,* 1873. Albumen print from full-plate negative. Boston Public Library (not in exhibition)

319. Timothy H. O'Sullivan. *Rock Carved by Drifting Sand,* 1871. Albumen print from full-plate negative. The Library of Congress, Washington, D.C. (not in exhibition)

321. Timothy H. O'Sullivan. *Green River, Colorado,* 1870s (two of six exposures from the same viewpoint at different times of day). Albumen prints from full-plate negatives. The Library of Congress, Washington, D.C. (not in exhibition)

ing the seed he had fertilized.

The person who in 1880 would revolutionize the understanding of the relationship between light, time, and motion in photography was the English-born Eadweard Muybridge. It was he who found a final solution to the problem of recording motion with a camera when he fused the principles of landscape photography, to which light is the fundamental means by which forms are articulated, with methods photographers had devised for stopping motion in scenes of people moving through city streets. O'Sullivan showed how the passage of time could be indicated by sequential exposures from the same viewpoint made at sufficient intervals for the light to change and, therefore, for the subject (as it is recorded by the camera) to change.

By the mid-1860s a symbiosis of the technical and aesthetic ingredients of both painting and photography had begun, and investigations led to the appreciation of photography as a medium of expression uniquely capable of dealing with the passage of time. Painters and photographers wished to expand the range of subjects through their materials. Fitz Hugh Lane, for example, taped together sheets of paper from his sketch pad to create strongly horizontal formats. Photographers had, from the earliest days of the medium in the 1840s, made sequential exposures that created a panoramic effect when placed side by side. Watkins' three-part panorama of San Francisco was exhibited in the 1867 Paris Exposition, and Muybridge, perhaps motivated by the competitive instinct, created in Watkins' footsteps a six-part panorama. Both Watkins and Muybridge followed in the tracks of those as yet unidentified Daguerrean photographers who in the 1840s had laid the foundations for making San Francisco the most frequent subject of panoramic renderings of any city in the world. Muybridge orchestrated his composition with careful attention to the light reflected off buildings and its play against the dark earth, the silvery ocean, and atmospheric distance. In an otherwise silent and uninhabited image, the one suggestion of life (e.g., motion) is the trail of smoke left by a departing steamship.

Between 1868 and 1872 Muybridge made numerous strictly landscape photographs treating many of the same subjects as Watkins but rendering them in a decidedly more melodramatic style, whose references are to European picturesque romanticism rather than the serene precision of Watkins or O'Sullivan. During the years Watkins and O'Sullivan spent most of their time in the wilderness, Muybridge, who spent his share of time out of town, also made a concerted campaign of reporting through photographs daily life in San Francisco and on the nearby ranches and small towns of northern California. Using the small format twin-lensed stereo camera, Muybridge was able to probe the waterfront and business district and even range to such fleeting subjects for those times as prison work gangs, classrooms with students, and agricultural fieldworkers. The thread unifying these subjects is that they are animate and thus require the photographer to devise ways of stopping their motion or creating the illusion that motion is stopped.

The automatic shutter had yet to be perfected and photographers of the 1860s and 1870s made their exposures manually by removing the lens cap and replacing it. Manual operation determined that the minimum exposure was approximately 1/25 of a second, an interval insufficient to stop fast action. This meant that until about 1880 the photographer had to choose his point of view so the direction of motion was not parallel to the film plane and to keep sufficiently distant from the subject to that the parallax effect diminished the telltale blur of a subject in motion. Muybridge mastered these elementary procedures and became confident that if he could devise a rapid shutter for a stereo camera, he could capture the gait of a cantering horse, which he succeeded in doing in 1878 (fig. 322).[11] By striving to stop the motion of the horse Muybridge had clearly separated the issue of physical motion from the echoed effect of motion as it is symbolized by light changing through lunar motion.

About the same time that he had made the daily-life studies, Muybridge had already tackled the rendering of pure light in a series of photographs of clouds and backlighted coastal scenes using the same type of stereo cameras as he had used for his urban and landscape views. At this time it was not possible to record clouds and landscape on the same plate without sacrificing detail in one subject or the other. Muybridge began experimenting with ways to combine clouds from one negative with landscape from another. In certain cases he

322. Eadweard J. Muybridge. *Horse and Rider in Motion*, 1878. Multiple exposure albumen photographs. The Metropolitan Museum of Art, New York (not in exhibition)

realized an atmospheric stage set as in *Volcan Queszaltenango, Guatemala* (private collection), where the illusion of steam is created by printing one negative of clouds over another of rocks. Such experiments derive from the romantic style that was being replaced and indicate how uncertain Muybridge was over the artistic application of his experiments. Despite their enormous historical importance, neither the cloud studies nor the first motion studies show the concentrated power of observation that was so fundamental to the compositions of Watkins and O'Sullivan and to the broader art styles of the sixties and seventies. The photographs of Muybridge, however, proved indispensable for more than a generation of painters, including the likes of Eakins, who flourished in the last quarter of the century.

Eastern photographers had begun experimenting with special effects obtainable with the stereographic camera three or four years before Muybridge in the West pushed the issue of light and motion to its full conclusion. John Soule, a Boston photographer who was an exact contemporary of Watkins, made the earliest firmly dated photograph in America that addressed itself to the primary subject of light and atmosphere. His *Marine Study by Moonlight* (1863; fig. 323) focuses on two sailboats near the horizon that take their form from backlighting, an effect that photography renders better than any other visual medium. The photograph is a piece of fine artifice resulting from an underexposed negative made with the camera facing into the sun, a point of view that ensured an effect of shimmering light upon the water. Simultaneously with Soule, Watkins had begun to experiment with reflections of various kinds, one of which was to use the water as a mirror to turn the world upside down and in which light as a subject is subordinate to masses and space. He also made a subtler series of reflections in which water is used as a lens to reflect light through the lacework of foliage. His still-life composition of the *Victoria Regia* in San Francisco's Golden Gate botanical garden uses the water on which the plant floats as both a lens and a mirror. It reflects light which gives form to the plant and reflects a pattern from the greenhouse windows that introduces an element of graphic design. Only the camera could render the out-of-kilter overlaying of light and pattern convincingly, and in so doing Watkins proved that luminism could extend to still life as well as landscape.

The stereo camera would prove to be the means by which the most sustained and influential body of work dealing with light and atmosphere would be produced.[12] The users of this camera were primarily in the eastern United States and adopted photographic luminism as a near trademark. However, before light became a central issue in the vernacular photography of the East a decade of photographs of the New England landscape were spun from the mold of picturesque romanticism and were related to the White Mountain and Hudson River schools of painting. Photographers and painters of the White Mountains such as Benjamin Champney, John W. Casilear, and Asher B. Durand were related stylistically to the Hudson River school in their quest for environments of perfect intimacy, rather than those of Edenic grandeur. In this

323. John P. Soule. *Marine Study by Moonlight*, 1863. Albumen stereograph. Private collection (not in exhibition)

style are the true roots of American landscape photography for the stereographs produced by Frederick and William Langenheim, G. Stacy, John Moran, John Soule, Edward Anthony, F. B. Gage, and the anonymous camera operators working for the New York Stereoscopic Company, the Edinburgh Stereoscopic Company of New York (two pioneer publishers of photographs), and E. and H. T. Anthony. If one location must be cited as the birthplace of American landscape photography, it is that of the White Mountains, which was perhaps the first mountainous wilderness area to receive the attention of an audience consisting primarily of city dwellers. J. W. Black's brief series of photographs (Metropolitan Museum of Art, New York; see fig. 307) made in the late 1850s, besides being aesthetic and nondocumentary in spirit, are also among the very few large-plate photographs of a region that were replaced most frequently by small-format stereographs in the 1860s and 1870s.[13] Among the earliest systematic treatment in stereographs of the White Mountains was that by John Soule done in August 1861. His images range from open, lyrical compositions with deep atmospheric perspective, which, in keeping with the tenets of picturesque romanticism, deal with the image of man and his works dwarfed in nature (as in his *North Conway and White Mountains—from Sunset Hill (no. 78)*, c. 1861-1865; fig. 324) and with genre subjects such as *Haying Scene (no. 147)*. The most successful photographs in Soule's White Mountain series are tightly composed views of waterfalls, cascades, and pools that were named

after their discoverers and which he sometimes subtitled in personal ways such as *Thompson's Cascades—Soule's Delight (no. 15)* (1861-1865; fig. 325), subjects that suggest his appreciation for the closed-in intimacy of certain natural motifs. Soule did not by any means confine himself to the White Mountains. He traveled the routes from Portland, Maine to New York City, occasionally photographing landscape, but concentrating his attention on urban views. His fine series of Boston and New York City are equalled by few other photographers, and it might be noted that he was also interested in instantaneous effects such as the *Marine Study by Moonlight* (fig. 323). He photographed New York Harbor capturing the South Ferry and other vessels moving full tilt (stereo no. 289), maintaining about the same degree of interest in stopped-motion effects as Watkins did, though both were far less experimental than Muybridge in this regard.

Next to Soule in importance for White Mountains work stands Benjamin W. Kilburn and his brother Edward Kilburn, who established Kilburn Brothers in the White Mountain community of Littleton, New Hampshire, in 1865. Benjamin Kilburn photographed many of the same general sites as Soule, though with a much stronger emphasis on routes of transportation, vehicles, buildings, and figures in landscape. Kilburn lacked Soule's understanding of the rhythms and harmonies of nature, but he did have a fine sense for rendering its most intimate details and capturing even the dynamic tensions of rocks in their

No. 78. NORTH CONWAY AND WHITE MOUNTAINS—from Sunset Hill, North Conway, N. H.

324. John P. Soule. *North Conway and White Mountains—from Sunset Hill (no. 78)*, c. 1861-1865. Stereograph. Private collection. Photo: National Gallery of Art, Washington, D.C.

No. 15. THOMPSON'S CASCADES—SOULE'S DELIGHT. *White Mtns.*

325. John P. Soule. *Thompson's Cascades—Soule's Delight (no. 15)*, 1861-1865. Stereograph. Private collection. Photo: National Gallery of Art, Washington, D.C.

environment such as Kilburn's *Flume above the Boulder (no. 122)* (c. 1865; fig. 326). He also pioneered the application of the close-up point of view as a visual device for rendering the character of a place. His studies of rock and ice formations required perseverance and considerable technical dexterity in manipulating normally quite viscous wet collodion at temperatures that even further reduced its fluid quality and light sensitivity. His attention to the particular in photos of the lichens on rocks (stereo no. 182) and to plant still-life compositions, as well as his sense of order in an arrangement he made of regional butterfly specimens (stereo no. 89), has much in common with O'Sullivan's objectivity as seen in the latter's geological studies made on the King and Wheeler surveys. It is also related to the quasi-scientific rock studies by the painters Haseltine (see figs. 146-147), Richards (see fig. 291), and Bricher (see fig. 297).

Effects of light and atmosphere are among the most attractive pictorial subjects in both painting and photography for the general public. It was natural, therefore, that photographers who plied their craft near tourist attractions would introduce such into their catalogues. Perhaps the most frequently visited natural monument in the East was Niagara Falls, where two photographers worth our attention flourished between about 1870 and about 1890: George Barker and G. E. Curtis (no relative of Edward S. Curtis, photographer of the North American Indian). There is little specific biographical data about Barker or Curtis; but if any two photographers who issued separate bodies of work of the same region can be described as having a collective vision, it is they. Both concentrated on the falls, ice formations, the city of Buffalo, and the landscape surrounding the falls. Barker, who seems to have begun photographing Niagara in the mid-1860s (see fig. 327), wintered in Florida, and his travels are recorded in stereographs along the route south, as well as in some

full- and mammoth-plate prints of Florida. Curtis, who commenced work at Niagara before 1870, issued his stereographs on bright orange mounts nearly identical with those used by Barker (see fig. 328). It cannot be ascertained whether Barker and Curtis got their moonlight effects from a single negative exposed in broad daylight that was altered at the printmaking stage or if three negatives—one of the sun, another of the clouds, and the third of the landscape—were made and superimposed. In any event the effects we see, like those of Muybridge and Soule slightly earlier, are the result of manipulating the photographic process and do not represent a natural rendering of any single point in time. In spirit they violate the luminist principle of honesty to the

327. George Barker. *Sunset—Niagara River (no. 608)*, c. 1870-1875. Stereograph. Private collection. Photo: National Gallery of Art, Washington, D.C.

326. Benjamin W. Kilburn. *Flume Above the Boulder (no. 122)*, c. 1865. Stereograph. Private collection. Photo: National Gallery of Art, Washington, D.C.

328. G. E. Curtis. *Horse Shoe Fall, Moonlight (no. 79)*, 1870. Stereograph. Private collection. Photo: National Gallery of Art, Washington, D.C.

subject in the medium of representation, but visually they are related to its principles.

Seneca Ray Stoddard, a contemporary of Curtis and Barker, established himself in Glens Falls, New York as a publisher of stereographs of upper Hudson River tourist sites, many of which were favorite haunts of painters in the luminist style (see fig. 329). His list of views includes Lake George (visited by Heade and Kensett in the 1870s), Saratoga, Luzerne, the Adirondacks, Ticonderoga, Lake Champlain, and Au Sable Chasm (see, for example, figs. 330-334)—the latter motif having something in common with the grander Arizona canyons photographed by O'Sullivan on the Wheeler Survey. Stoddard commenced work in the late 1860s and by the mid-1870s did moonlight views of Lake George strongly influenced by Curtis and Barker (see fig. 329). Like other photographers concerned with effects of light, he too held the stopping of motion as a favorite motif. Among the instantaneous views he lists are the *Fireman's Tournament* in Glens Falls of July 4, 1870, the decoration ceremonies of the civil war monument there, and stop-motion views of Glens Falls. Remarkable enough, Stoddard's views of this region are among the few professional studies of landscape of the northeast in full-plate format before the late 1880s. The White Mountains were the subject primarily of the stereo camera, and thus Stoddard occupies a singular position as the chief counterpart of those working west of the Rocky Mountains (see, for example, figs. 9, 96-97, 160-165, among others). The parallel between Stoddard's style of the eighties and luminist painting has been lucidly described here (p. 142): "horizontal

order, balanced tonal contrasts, open surfaces of silvery water, and low sunlight faced centrally across the view, its reflection a vertical bar perfectly intersecting the shoreline's horizontals" make Stoddard's work a textbook example of the parallel in photography to luminist painting.

Examples of luminist painting and photography were increasingly available to the public; and when in the mid-1880s amateur photographers increased in numbers, it was natural for a certain number of them to look toward accomplished image-makers as their models. The invention of factory-prepared dry plates for negatives, more than any other invention, encouraged the rise of serious amateur photography. A more general concern for effects of light and atmosphere was made possible by the invention of panchromatism in film plates, creating equal sensitivity to all colors. Thus was eliminated the camera's color blindness for the sky, a major shortcoming of wet collodion plates which were more sensitive to blue than to other colors.[14] The widespread availability of lenses with shutters and easily adjustable apertures was the third ingredient that attracted amateurs to photography. This new technology, combined with the panchromatic dry plates, made it possible to capture even the most fleeting effects of light and atmosphere—such as those in Barker's sunset view of the

329. Seneca Ray Stoddard. *Moonlight on Lake George (no. 1380)*, c. 1875-1880. Stereograph. Private collection. Photo: National Gallery of Art, Washington, D.C.

330. Seneca Ray Stoddard. *Little Tupper Lake, Adirondacks*, 1888. Silverprint photograph. 0.163 x 0.216 (6⁷⁄₁₆ x 8½ in). The Library of Congress, Washington, D.C.

582 Split Rock Mountain, Lake Champlain. Copyright 1890, by S. R. Stoddard, Glens Falls, N. Y.

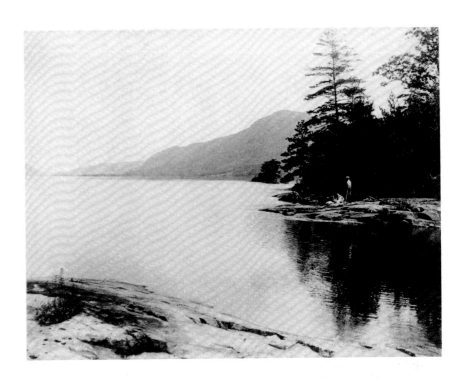

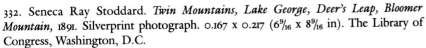

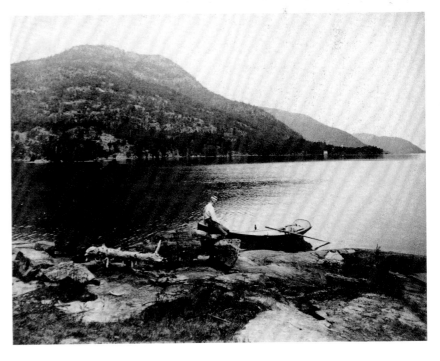

332. Seneca Ray Stoddard. *Twin Mountains, Lake George, Deer's Leap, Bloomer Mountain*, 1891. Silverprint photograph. 0.167 x 0.217 (6⁹/₁₆ x 8⁹/₁₆ in). The Library of Congress, Washington, D.C.

331. Seneca Ray Stoddard. *Split Rock Mountain, Lake Champlain*, 1890. Silverprint photograph. 0.165 x 0.216 (6½ x 8½ in). The Library of Congress, Washington, D.C. (opposite page)

333. Seneca Ray Stoddard. *Lake George, Black Mountain from the Southwest*, 1890. Silverprint photograph. 0.165 x 0.219 (6½ x 8⅝ in). The Library of Congress, Washington, D.C. (above, at right)

334. Seneca Ray Stoddard. *Lake George, French Point from South*, 1890. Silverprint photograph. 0.167 x 0.219 (6⁹/₁₆ x 8⅝ in). The Library of Congress, Washington, D.C.

East River, New York (1888; fig. 335)—provided one had the vision and interest to follow the idea through to its logical conclusion. It is not uncommon to find a luminist-inspired photograph every now and then in family albums representing a momentary concern for that particular effect by the photographer. It was very uncommon, however, to return to such motifs over a period of months or years in a sustained pattern as was the case with Henry L. Rand, an amateur whose familiarity with painters and possibly other photographers undoubtedly formed the starting point for the rendering of his own perceptions.[15]

Rand, who resided in Cambridge, Massachusetts, was a person of independent means who could be away from his office for extended periods. His

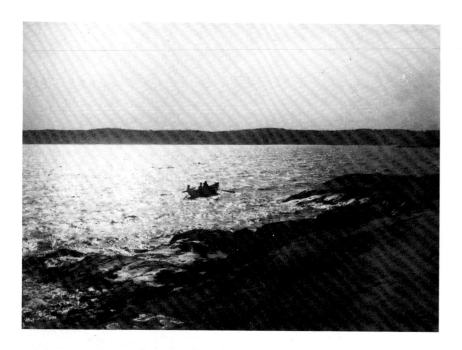

336. Henry L. Rand. *Across the Bay, Gloucester,* 1892. Platinum photograph. 0.117 x 0.164 (4⅝ x 6½ in). Southwest Harbor Public Library, Southwest Harbor, Maine. Photo: National Gallery of Art, Washington, D.C.

339. Henry L. Rand. *Moonlight on the Upper Saranac,* c. 1897. Platinum photograph. 0.122 x 0.172 (4¹³⁄₁₆ x 6¾ in). Southwest Harbor Public Library, Southwest Harbor, Maine. Photo: National Gallery of Art, Washington, D.C. (above, at right)

335. George Barker. *New York—East River—Sunset,* 1888. Stereograph. Private collection. Photo: National Gallery of Art, Washington, D.C.

favorite haunts were Gloucester (fig. 336) and Mt. Desert Island where he summered in Southwest Harbor (fig. 337). Following in the footsteps of his master-artist predecessors Lane and Heade, he visited Rye Beach, Marblehead, Rockport, Pigeon Cove, the marshes of Little River and Rowley, Braces Cove Pond, Cow Island Pond, and the Penobscot Bay off Castine. He even visited the upper Hudson River Valley to do a moonlight study of Saranac Lake that suggests a familiarity with the photographs of Stoddard.

Rand built a summer cottage in Southwest Harbor on Mt. Desert Island, christening it "Fox's Den," and was among the first rusticators to settle in that village.[16] What distinguishes Rand is that he worked in the same region as key luminist painters and he pursued his work in a contemplative manner, in methodical steps that led him from run-of-the-mill subjects to his concern for atmospheric effects. Indeed the process of his evolution is documented in carefully kept notebooks (Southwest Harbor, Maine, Library). At first he only recorded the date and place of his exposures; but in the winter of 1891, after producing some three hundred negatives on the new panchromatic dry plates, he began to record the lens used and the exposure time. By late summer 1891 he commenced to notice and record even the atmospheric conditions under which the negatives were made. On August 21 he made exposure number 366 under "very cloudy" conditions, and on October 4 he photographed a sunrise for the first time. November brought him to a series of exposures on "very dull" and "overcast" days, while the spring of 1892 leads to attempts to photograph late afternoon rain. His experiments with rainy and cloudy day exposures did not

337. Henry L. Rand. *Somes Sound, Looking South,* 1893. Platinum photograph. 0.117 x 0.170 (4⅝ x 6¹¹⁄₁₆ in). Southwest Harbor Public Library, Southwest Harbor, Maine. Photo: National Gallery of Art, Washington, D.C.

yield results of great visual interest because the atmosphere became a homogeneous gray. The effects were too subtle for the materials available. In the summer of 1892 in Southwest Harbor Rand began to work with the fog that often enshrouds Maine coastal regions, and his *Island House Slip, Thick Fog* (fig. 338) is the most successful of the studies of heavy atmosphere. This composition gains its strength from the fine gradation of tone from rich foreground to pearlescent fogbank. The outlined shapes of the boats actually give to the fog a definition that without them is lacking.

A decade earlier Curtis, Barker, and Stoddard faked their "moonlight effects." These photos were actually made in broad daylight, producing an artificial effect that is distinguished by a path of light reflected from the water that extends from middle ground to the horizon. In unmanipulated photographs of sunset from this period light filters from above as in Rand's *Moonlight on the Upper Saranac* (fig. 339) of about 1897. The most stunning of Rand's atmospheric seascapes, *Off Sandy Hook,* from June 1897 (fig. 172), reduces sky and water to a nearly homogeneous gray that nevertheless allows the special character of both sky and water to remain. Rand was no doubt ignorant of

Gustave Le Gray's *Brig Upon the Water* of 1856/1857, a monumental work in the history of photography that was faked to give the moonlight effect; it was nevertheless the subject of great praise in its time. Le Gray would surely have taken pleasure in knowing his idea had been pushed to its natural conclusion in such a fine way, and with a skill that equalled his in its unpretension.

The concern for light and atmosphere does not abruptly cease for photographers in the 1910s; however, the attitude toward these elements changed dramatically after 1900. The picture postcard was introduced in the mid-1890s and with it the postcard aesthetic that has changed very little even until today. Light and atmosphere are the raw ingredients of sentimentality, and, while color photographs of luminist effects were not possible until the 1940s, mechanically applied color became an accepted practice. The commercialized results inevitably lack the dignity and conviction of true luminist works, although they are not far removed from the manipulations of Barker, Curtis, and Stoddard.

We also find in the early 1890s the emergence of psychological realism, a style related to but distinct from luminism. In painting this is exemplified by

338. Henry L. Rand. *Island House Slip, Thick Fog*, June 1892. Platinum photograph. 0.112 x 0.164 (4⅜ x 6½ in). Southwest Harbor Public Library, Southwest Harbor, Maine. Photo: National Gallery of Art, Washington, D.C.

Thomas Eakins, who with the assistance of his wife, Susan Macdowell Eakins, also made photographs.[17] The great majority of Eakins' photographs are portraits and figure studies that probe human character, physiognomy, and in the most explicit of the nudes, the fundamentals of male and female sexuality. In his few landscape photographs Eakins used landscape as a context for figures or other subjects. *Sailboats on the Delaware River* (Philadelphia Museum of Art) is a vehicle for treating the interlocking geometrics of the boat sails. *Beach at Manasquan, New Jersey* exists in two examples, one (collection Gordon Hendricks, New York) significantly cropped in the area of the sky, has broad, open luminist space not unlike the beach drawings of William Trost Richards (see fig. 304), or Alfred T. Bricher's beach scene (see fig. 290). The footprints in the sand beginning at the bottom center edge leading off into the distance are a psychological element, not a formal one. Possibly Eakins' most explicitly luminist photograph is that of his two nephews by a tree reflected in the pool near Avondale, Pennsylvania (collection Gordon Hendricks, New York). The Huckleberry Finn aspect of the two boys gives this a literary association absent in, for example, Watkins' reflection studies of the late 1860s (fig. 309), that concern themselves completely with light and form to the exclusion of the human subjects that Eakins so favored.

The question of whether luminism had its parallels in photography must be answered in the affirmative so long as there is a consensus that luminism is a style encompassing several general concerns in American landscape art. These concerns include the use of crystalline light, love of atmospheric phenomena, an appreciation for the transcendent spiritual beauty of nature, love of flat, open, very palpable space, simplification of forms, and an affinity for the scientific and an avoidance of literary associations. The work of more than a dozen photographers—more will certainly be added to the list formed by this exhibition—establish a thread stretching from the mid-1860s to the 1910s. As such, the concern by photographers with these formal and compositional issues apparently emerged from the lead established by painters. Ironically, photographs and not etchings or lithographs proved to be the most natural graphic equivalent to painting. Photography perhaps even surpassed painting in realizing some effects, such as rendering the immediacy of observed phenomena and in being the most direct possible expression of the artist's intense concentration upon nature, resulting in the picture itself being an embodiment of pure thought. As such the relationship between painting and photography has never been so close or so honest.

Notes

1. Weston J. Naef in collaboration with James N. Wood, with an essay by Therese Thau Heyman, *Era of Exploration: The Rise of Landscape Photography in the American West, 1860-1880* [exh. cat., Albright-Knox Art Gallery and Metropolitan Museum of Art] (New York, 1975). This book concentrates on the photographs of Carleton E. Watkins, Timothy H. O'Sullivan, Andrew J. Russell, William Henry Jackson, and Eadweard J. Muybridge.

2. Robert A. Sobieszek and Odette M. Appell, *The Spirit of Fact: The Daguerreotypes of Southworth & Hawes, 1843-1862* [exh. cat., International Museum of Photography at the George Eastman House] (Boston, 1976). Of the 107 images catalogued, only 2 are dated by the authors to before 1850.

3. On Watkins see Naef, *Era of Exploration,* 79-124; Paul Hickman, "Carleton E. Watkins, 1829-1916," *Northlight, 1* (Jan. 1977), entire issue; *California History: Special Issue: Carleton E. Watkins* with the following contributions: Richard Rudisill, "Watkins and the Historical Record," 216-219; Pauline Grenbeaux, "Before Yosemite Art Gallery: Watkins' Early Career," 220-242; Nanette Sexton, "Watkins' Style and Technique in Early Photographs," 242-251; Peter Palmquist, "Watkins—the Photographer as Publisher," 252-257; Laverne Mau Dicker, "Watkins' Photographs in the California Historical Society Library," 266-267.

4. *California Magazine and Mountaineer* (Nov. 1861), n.p.

5. Elizabeth Lindquist-Cock, "Stillman, Ruskin, and Rossetti: The Struggle between Nature and Art," *History of Photography, 3* (Jan. 1979): 1-14.

6. David H. Dickason, *The Daring Young Men: The Story of the American Pre-Raphaelites* (Bloomington, Ind., 1953), 53.

7. Quoted in Naef, *Era of Exploration,* 73.

8. Hickman, "Watkins," 9.

9. Naef, *Era of Exploration,* 129.

10. The change in O'Sullivan's role is documented in the records of the Geological Exploration of the Fortieth Parallel, RG 57, The National Archives of the United States, Washington, D.C.; records of the United States Geographical Surveys West of the 100th Meridian, RG 77, National Archives, and papers of that survey at Western Americana Collection, Beinecke Rare Book and Manuscript Library, Yale University, New Haven, Conn.

11. *Eadweard Muybridge: The Stanford Years, 1872-1882* [exh. cat., Stanford University Museum of Art] (Stanford, Calif., 1972), with essays by Robert Bartlett Haas, Anita Ventura Mozley, and Françoise Forster-Hahn. In this context see especially Mozley, "Photographs by Muybridge 1872-1880: Catalog and Notes on the Work," on the Stanford experiments.

12. William Culp Darrah, *Stereo Views: A History of Stereographs in America and their Collection* (Gettysburg, 1964), and his *The World of Stereographs* (Gettysburg, 1977) are the standard introductions to the subject.

13. Thomas Southall, "White Mountains Stereographs and the Development of a Collective Vision" in *Points of View: The Stereograph in America—A Cultural History,* ed. Edward W. Earle (Rochester, 1979).

14. Hermann W. Vogel (German, 1834-1898), the chief inventor of panchromatic film plates, is discussed by Josef Maria Eder, *History of Photography,* trans. Edward Epstean (New York, 1945), "Chapter LXIV. Discovery of Color-Sensitizing of Photographic Emulsions: In 1873 Professor H. W. Vogel Discovers Optical Sensitizing," 457-464.

15. The Henry L. Rand Collection is in the custody of the Southwest Harbor (Maine) Library, in albums prepared and annotated by him.

16. Rand's next-door neighbor was William Lyman Underwood (see William Bagnall, *William Lyman Underwood: Photographer* [Westwood, Mass., 1977]) who was also an extremely serious and prolific amateur photographer of the day. Despite their friendship the two had dramatically different styles, with Underwood concentrating on wild animals taken at night from his specially rigged canoe. The stylistic differences between Rand and Underwood suggest how deliberate the underlying aesthetic premises were.

17. Gordon N. Hendricks, *The Photographs of Thomas Eakins* (New York, 1972).

343. Albert Bierstadt. *Sunrise, Yosemite Valley,* c. 1870. Oil on canvas. 0.924 x 1.331 (36⅜ x 52⅜ in).
Inscribed, l.r.: *ABierstadt.* Amon Carter Museum, Fort Worth, Texas

White Light in the Wilderness
LANDSCAPE AND SELF IN NATURE'S NATION

Albert Gelpi

for Perry Miller 1905–1963

I

PERRY MILLER'S MONUMENTAL STUDIES of colonial and romantic American culture comprise a magisterial argument that the distinctive and determining experience of the New World was the confrontation between civilization and nature.[1] From the first, Americans were making clearings in the woods, contriving a society in the wilderness; all of the social and religious assumptions which carried them across the heaving seas were put to the test, subjected to a terrain and climate and elemental conditions which seemed indifferent to, even opposed to, the structures of society and the monuments of culture. William Bradford, the governor of the Plymouth colony, writing his account of the first encounter with the New World barely a decade after the landing in 1620, interrupted his plain-spoken narrative with an editorial aside that amounts to a prose poem, as he marveled at the courage of the Pilgrims under the threat of that first winter, awed still at their resolute endurance in the face of fear:[2]

But hear I cannot but stay and make a pause, and stand half amased at this poore peoples presente condition; and so I thinke will the reader too, when he well considers the same. Being thus passed the vast ocean, and a sea of troubles before in their preparation (as may be remembred by that which wente before), they had now no freinds to wellcome them, nor inns to entertaine or refresh their weatherbeaten bodys, no houses or much less townes to repaire too, to seeke for succoure. It is recorded in scripture as a mercie to the apostle and his shipwraked company, that the barbarians shewed them no smale kindnes in refreshing them, but these savage barbarians, when they mette with them (as after will appeare) were readier to fill their sids full of arrows then otherwise. And for the season it was winter, and they that know the winters of that cuntrie know them to be sharp and violent, and subjecte to cruell and feirce stormes, deangerous to travill to known places, much more to serch an unknown coast. Besides, what could they see but a hidious and desolate wildnernes, full of wild beasts and willd men?[3]

The Puritans could cite Scripture in support of their perilous migration; they could take heart by thinking of themselves as God's Chosen People, fleeing the scourge of tyranny like the Israelites under Moses. But they found no land of milk and honey, nor even a Pisgah whence they could "vew from this willdernes a more goodly cuntrie." Indeed, "the whole countrie, full of woods and thickets, represented a wild and savage heiw," and if "the hidious and desolate wildernes" did not itself claim them, then the "wild beasts and willd men" who inhabited it might.

Anne Bradstreet, the first published poet of the New World, was on the flagship *Arabella* when it arrived at Massachusetts Bay in 1630; and she later told her children that when "I changed my condition and was married, and came into this country. . . . I found a new world and new manners, at which my heart rose. But after I was convinced it was the way of God, I submitted to it and joined to the church at Boston."[4] Settlements like Boston and later Andover raised a defense perimeter against the depredations of nature, and the church safeguarded fallible human nature from the incursions of the devil; but when she sought comfort or pleasure in landscape, she had to turn back to the English pastoral scene she had left behind, bright with purling rivulets and nightingale-song. There her imagination could rest secure—as it could not with the woods outside her door.

However, even from the start the Puritans did not take nature as simply demonic and threatening—creation fallen from grace. Since they believed that nothing occurred except by Providence, they taught themselves to read daily experience, and most especially momentous events, as revelations in which "God discovered somewhat of his mind" and disposition toward them, both individually and communally.[5] It was this unshakable sense that everyday occurrences might turn out to be "types" or symbols of divine wrath or favor that impelled them to keep diaries and journals, write biographies and autobiographies and histories.

As the Puritans survived the rigors of the winters and other adversities, as

they learned to trust themselves to the stony land they were gradually domes-ticating, they even came at times to view the New World as their own Canaan: Eden regained by God's regenerate nation. Construing the Book of Revela-tion, Samuel Sewall published in 1697 a little book entitled *Phaenomena quaedam Apocalyptica ad Aspectum Novi Orbis configurata,* which he translated in the subtitle as *some few Lines towards a description of the New Heaven As It makes to those who stand upon the New Earth.* Rhapsodizing over the coastal marshland near Newbury that Martin Johnson Heade would paint again and again a century and a half later, Sewall envisioned his native ground as God's kingdom revealed on earth in anticipation of the light of heaven:

As long as *Plum Island* shall faithfully keep the commanded Post; Notwithstanding all the hectoring Words, and hard Blows of the proud and boisterous Ocean; As long as any Salmon, or Sturgeon shall swim in the streams of *Merrimack;* or any Perch, or Pickeril, in *Crane-Pond;* As long as the Sea-Fowl shall know the Time of their coming, and not neglect seasonably to visit the Places of their Acquaintance: As long as any Cattel shall be fed with the Grass growing in the Medows, which do humbly bow down themselves before *Turkie-Hill;* As long as any Sheep shall walk upon *Old Town Hills,* and shall from thence pleasantly look down upon the River *Parker,* and the fruitfull *Marishes* lying beneath; As long as any free and harmless Doves shall find a White Oak, or other Tree within the Township, to perch, or feed, or build a careless Nest upon; and shall voluntarily present themselves to perform the office of Gleaners after Barley-Harvest; As long as Nature shall not grow Old and dote; but shall constantly remember to give the rows of Indian Corn their education, by Pairs: So long shall Christians be born there; and being first made meet, shall from thence be Translated, to be made partakers of the Inheritance of the Saints in Light.[6]

A notebook kept in the mid-eighteenth century by the greatest of New England theologians, Jonathan Edwards, constitutes the most extended Puri-tan argument for a typological reading of nature. Edwards' entries, descriptive and reflective, accumulated evidence of the providential plan by which "natural things were ordered for types of spiritual things." And reigning over the whole of the visible creation—rivers and trees, grasses and grain, creatures of the earth and air—is the radiant sun; through the consistent association with Christ, the sun becomes, almost by a pun, a manifestation of the divine Son, God's light illuminating a darkened world. The reiteration of this theme throughout *Images or Shadows of Divine Things* gathers to a tremendous paean to the "Divine and Supernatural Light." The sun, in the "vast profusion" of its "light and heat" is the "bright image of the all-sufficiency and ever-lastingness of God's bounty and goodness"; the daily vanquishing of the dark oblivion of night constituted the supreme "type of the death and resurrection of Christ."[7]

However, for Edwards as for the earlier Puritans, nature presented two faces: "As thunder and thunder clouds . . . have a shadow of the majesty of God, so the blue skie, the green fields, and trees, and pleasant flowers have a shadow of the mild attributes of God, viz., grace and love of God, as well as the beauteuous rainbow." To fallible human beings in a darkened world the light-process itself works both creatively and destructively: "The sun makes

plants to flourish when it shines after rain; otherwise it makes them wither"; "As the SUN is an image of Christ upon account of its pleasant light and benefits, refreshing life-giving influences, so it is on account of its extraordi-nary fierce heat, it being a fire of vastly greater fierceness than any other in the visible world, whereby is represented the wrath of the Lamb."[8] Similarly, in scriptural and in natural symbolism, "the beautifull variety of the colours of light was designed as a type of the various beauties and graces of the spirit of God," whereas "white, which comprehends all other colours, is made use of in Scripture often to signify holiness, which comprehends all moral goodness and virtue. . . ." Thus, "one and the same white light, though it seems to be an exceeding simple thing, yet contains a great variety of rays. . . ."[9] So to our fallen senses the white light of God's spirit splinters into the color spectrum of our piebald existence.

2

Edwards could still argue that "the book of Scripture is the interpreter of the book of nature,"[10] and *Images and Shadows of Divine Things* abounds in biblical verses which validate as they extend a typology of nature. However, by the time the new energies of romanticism began to enliven the literary scene in the new Republic, the anagogic link between the Bible and nature had weakened to the point where nature, even when still invoked as moral and religious in its import and influence, need not, and generally did not, carry any strict doctrinal or ecclesiastical signification. A high church Episcopalian New Yorker like James Fenimore Cooper could join the Congregationalists, Presbyterians, and Un-itarians of New England in the romantic cult of nature. At the same time, the shift of emphasis from Scripture to nature (the latter word now often elevated to a capital letter) did signal a momentous and far-reaching psychological change: from God's word to nature's "word," from the spirit-father to the earth-mother, from a primary relation to and contention with the masculine archetype to primary relation to and contention with the feminine archetype. Edwards instinctively designated the sun with the masculine pronoun, because it symbolized the son of the spirit-father, but just as instinctively later writers used the feminine pronoun for the maternal matrix, the womb of nature from which physical life in all its variety emerged and to which it in time returned. Most especially male writers and artists experienced the natural scene as, psychologically and imaginatively, the realm of earth, virgin and mother. As the autobiographical and expository and polemical writings of the colonial and revolutionary periods gave way to the new poetry and fiction and philosophy of nature, so the portraits and historical canvases of the seventeenth and eighteenth centuries were displaced by a sudden interest in landscape painting. Where previously there had been only cramped glimpses of nature through a window or in the background in order to establish the profession or social status of the individuals portrayed, now human figures were included in paintings not as personalities but merely as small and anonymous witnesses to

340. William Trost Richards. *Lake Squam from Red Hill*, 1874. Watercolor on paper. 0.221 x 0.343 (8¹¹⁄₁₆ x 13½ in). Inscribed, l.r.: *Wᵐ T. Richards. 1874*. The Metropolitan Museum of Art, New York; Gift of Rev. E. L. Magoon, 1880

the encompassing scene. John Vanderlyn's *Ariadne Asleep on the Isle of Naxos* (1814; Pennsylvania Academy of Fine Arts, Philadelphia) can be seen as a transitional painting. It is dominated by a human figure; in fact, it is the first notable American painting of a nude woman. However, she is not historical but mythic and symbolic. Classically chaste as she is, she foreshadows romantic nature painting: a kind of Ingres nude in the wilderness. Her body is depicted against the landscape, unconscious as nature itself; in fact, her body is presented as landscape, her contours repeating and paralleling the lines and masses and shapes of the surrounding scene.

Moreover, the romantic viewed the mother with much the same ambivalence that the Puritan had felt toward the Father. She, like he, had a face of blessing and a face of wrath. She could be the protective, nursing mother and the devouring, emprisoning, castrating mother; and behind her unpredictable, vacillating moods lay the inscrubability of the Father's white light. The two faces of nature exemplified the distinction which Edmund Burke had made in his vastly influential *Ideas of the Sublime and the Beautiful* (1754) and which aestheticians like Uvedale Price, William Gilpin, and Archibald Alison elaborated in the 1790s for the romantics. In England, and a few decades later in America, writers as well as painters would have conceived of and responded to landscapes in terms of the categories of the beautiful, the sublime, and the picturesque (which exhibited the features of the sublime in a less extreme

manner). Nature presented her nurturing aspect as the beautiful, characterized by smooth, round, and regular shapes, uniform light, balance and proportion, a sense of harmony and rest, and a scale more or less compatible with the human. A beautiful landscape welcomed and sustained and included the human presence and frequently developed into the pastoral and even the agricultural scene. In sharp contrast, nature's threatening visage was the sublime landscape, characterized by irregular, jagged, and angular shapes, strong contrast of dark and light, abrupt changes in proportion, dynamic tension between contending forces, a repetition of elements to suggest infinite possibility, and a vastness of scale which dwarfed and overwhelmed the human. The serenely beautiful face of nature as mother elicited loving trust and submission from us as her "children"; her sublime aspect provoked a more complicated response—a dual response, at once attraction and repulsion, fear of the force that draws us on, apparently to our annihilation.

Thomas Cole's *Expulsion from the Garden of Eden* (1824; fig. 67) divides the canvas neatly into contrasting halves: on the right, the paradisal world from which Adam and Eve are being expelled into the sublime and savage wilderness on the left. The streams of Eden drop off into dizzying waterfalls; the verdant trees are juxtaposed with the twisted and torn trunks and branches outside, blasted by the force of wind and thunderbolt; the smiling, sunny skies are played off against storm clouds churning around a brighter but still obscured

341. Sanford Robinson Gifford. *Coming Rain, Lake George,* 1879. Oil on canvas. 0.457 x 0.807 (18 x 31¾ in).
Inscribed, l.r.: *S. R. Gifford 187* [*9*]. Private collection. Photo: Helga Photo Studio

center; the modest and harmonious proportions of Eden give way to declivities of mountains, with rocks piled in a succession of beetling crags up to the vortex of clouds which hides the mystery of light. And in the very center a rough passageway in a towering rock formation, suggestive at once of a Gothic arch and a vaginal opening, through which the diminutive figures of our first parents have just been driven by God's messenger the archangel Gabriel. His figure is invisible in the stone archway, but strong blades of light penetrate the outer darkness, the longest angled directly at the figures fleeing in guilty terror.

In contrast, Asher Durand's *Kindred Spirits* (1849; New York Public Library) bespeaks in its very title a different attitude. Conceived as a tribute to Cole after his death, the painting shows Cole and his friend William Cullen Bryant, larger and more individual than figures usually are in landscape paintings, standing together on a ledge and peacefully surveying the prospect of which they are a part. A tree in full leaf arches over to enfold them in a restful bower with a brook at their feet. The stream issues from a waterfall seen in the distance and mountains rise up in the background, but a golden haze holds the entire scene in its ambience, composing even the humped and rounded mountains into a radiant concord. It is not just the poet and the painter who are kindred spirits; they are kindred with the spirit of the scene. And it is generally true that within the Hudson River school Durand was inclined to paint nature in her beautiful aspects, where Cole alternated and contrasted the beautiful with the sublime.

The young Republic proclaimed itself nature's nation, a society created in and of a wilderness unparalleled in beauty and sublimity—particularly the daunting challenge of the sublime. Not even the Alps could compare with a massive continent of unnamed mountains and streams and plains. Niagara Falls and the Great Stone Bridge of Virginia, the Catskills and the Alleghenies were but the harbingers of the land "vaguely realizing westward," as Robert Frost would imagine it. Since the sublime, overpowering as it was to the human spectator, represented a much deeper revelation of the spirit of nature, the scale and variety of the sublime in the New World came to be felt as the source of our unique character and opportunity as a developing people. Perhaps the progress of the Republic, founded on the sustaining influence of nature, might even allow us to break the cycle of rise and fall which turned Europe into a graveyard of ruins and monuments. Such was the august theme of George Bancroft's mammoth *History of the United States* (1834-1874).

But the challenge of the sublime presented a moral dilemma to the settlers building nature's nation. What if, in clearing the wilderness to raise our cities, we were thereby laying waste to the source of our moral character, thus allowing egoistic acquisitiveness to squander our resources and our unique historical opportunity? Was economic and social expansion inimical to nature? Such was the lesson of Cole's series of paintings the Course of Empire (1836; New-York Historical Society, New York) and of American romancers from Cooper to Fitzgerald and Faulkner. Cole was Cooper's favorite painter, and the Course of Empire helped to shape Cooper's later allegorical romance *The Crater* (1847); in turn Cole showed his respect by painting *The Last of the Mohicans* (1827; Wadsworth Atheneum, Hartford). Cooper and Cole inspired each other with good reason; they shared the same fears for the American future, and their tragic reading of history saw the seeds of downfall sown in the greed and pride of the settlers. *The Crater* and the Course of Empire portray human egotism violating the holism of nature, and both resolve the dilemma through the triumph of nature over the self-destructiveness of society.

On the other hand, although neither Cole nor Cooper could find reassurance in Bancroft's sanguine expectations for American destiny, and although their patrician status separated them from the lower classes who went out to settle the land, they were still close enough to the real wilderness to know that the opposition between nature and society could not be read simply in terms of aggression against nature. They had to acknowledge the threat which nature seemed to pose to the individual and society, no matter how loudly we exulted about nature's nation. When the pathless forest closed us round, when sublime heights beetled above and deeps yawned below, could we do otherwise than fend for ourselves: open a way, subdue the wilds, fence a space where we could be safe with our kind? Many felt the compulsion Anne Bradstreet had expressed: to withdraw into civilization and be "joined to the church at Boston." Meantime, the pioneers carved up the land, spanned the distances, felled the trees, reared protective walls, profiteered from earth's resources, driving before them the Indians and wild beasts ever westward. Such a reading of American destiny, just as tragic as Cole's and Cooper's lament for the wilderness violated by human egoism, sees the doom of nature rooted in her challenge to the vulnerable human ego.

From the challenge arose the myth of the pioneer: the version of the universal hero indigenous to our historical situation and the archetype behind our native brand of rugged individualism. Was the pioneer a man of the woods, or against the woods? Did he go to the wilderness to draw his moral and religious character from nature's breast, or did he venture out for the sake of the community, to challenge her sovereignty, vindicate his manhood, and blaze a trail through her thickets as the vanguard of patriarchal society? Did Cooper's Natty Bumppo represent the type of the frontiersman, or an idealization actually antithetical to the real frontiersmen? In the ambiguity of the answer, as we shall see, lies the profundity of the *Leatherstocking Tales*.

Certainly Washington Irving's biography *Christopher Columbus* (1831) presented the first and archetypal American in contention with the natural and psychological forces arrayed against him on his exploratory voyage. Lone leader of a small band across the seemingly unbounded expanse of the ocean, he proved his moral as well as physical mettle by holding them resolutely to their westward course. In Irving's account it was the steady light of his mind and will against the dark ocean and the fears of the craven crew. Unswervingly confident of providential favor, Columbus embodied the "masculine" control of consciousness over physical nature and his own unconscious. No wonder that

he appeared a hero to his men and a god to nature's children, the dark people of the forest who come out to greet them on shore.* To them "the white men had come from the skies." But even this noble Columbus stooped to pandering to the gold lust of his crewmen: "He promised them land and riches, and everything that could arouse their cupidity, or inflame their imaginations, nor were these promises made for purposes of mere deception; he certainly believed that he could realize them all." And of course it was the forces of rapine and plunder which won out; Columbus' exploit brought him poverty, rejection, imprisonment.[11]

Improbable as it may at first seem, "Rip Van Winkle" (1819) offers a complementary version of the encounter between man and nature. Irving's adaptation of a German folktale to American circumstances is genuinely mythic, and like most good comedy has a serious point. To begin with, the fable slyly undercuts the Puritan-American work ethic. Rip is the first American folk-figure to stand opposed to the model of Benjamin Franklin, the bustling, practical go-getter busy with the business of living. He heads a long list of American counter-culture dropouts who, for one reason and another, refused to subscribe to the power of the profit motive, scribbling highways across the continent to thread together the economic centers reared on the wilderness they despoiled: from Thoreau and Whitman to Jack Kerouac and Allen Ginsberg, from Natty Bumppo and Huck Finn to Faulkner's Ike MacCaslin. But "Rip Van Winkle" is more than a charming tale of how a twenty-year nap in the Catskills allowed the town beatnik to outlive the termagent wife who demanded that he work and earn and provide, so that he could live out his venerable age, beloved by all, on his own easygoing terms.

The fact that the sexual roles of the husband and wife have been reversed points to the deeper mythic configuration. Ironically Dame Van Winkle's shrill, driving tones speak for the patriarchal norms and demand that Rip function in society as a husband and father should. But Rip has a softer, more feminine nature: "a simple, good-natured fellow" with "little of the martial character of his ancestors," "a kind neighbor," and "a great favorite among all the good wives of the village." "If left to himself, he would have whistled away his life in perfect contentment; but his wife kept continually dinning in his ears about his idleness, his carelessness, and the ruin he was bringing on his family." When he slouched off to the mountains, he was retreating from wife and adult male responsibilities and retrogressing to the bosom of mother nature. He took his gun along to justify the excursion, but he was not really there to hunt; he was

*Historical paintings showing the encounter of white men with Indians characteristically depict the whites bathed in light and the Indians overshadowed by the forest, their figures somewhat obscured by the trunks and foliage from which they have not fully emerged. Such is the image, from Benjamin West's *Penn's Treaty with the Indians* (1771; Pennsylvania Academy of Fine Arts, Philadelphia) to Albert Bierstadt's *The Landing of Columbus* (1893?; Newark Museum).

seeking the peace of unconsciousness, and that was just what he found:

In a long ramble of the kind on a fine autumnal day, Rip had unconsciously scrambled to one of the highest parts of the Kaatskill mountains. He was after his favorite sport of squirrel-shooting, and the still solitudes had echoed and re-echoed with the reports of his gun. Panting and fatigued, he threw himself, late in the afternoon, on a green knoll, covered with mountain herbage, that crowned the brow of a precipice. From an opening between the trees he could overlook all the lower country for many a mile of rich woodland. He saw at a distance the lordly Hudson, far, far below him, moving on its silent but majestic course, with the reflection of a purple cloud, or the sail of a lagging bark, here and there sleeping on its glassy bosom, and at last losing itself in the blue highlands.

On the other side he looked down into a deep mountain glen, wild, lonely, and shagged, the bottom filled with fragments from the impending cliffs, and scarcely lighted by the reflected rays of the setting sun. For some time Rip lay musing on this scene; evening was gradually advancing; the mountains began to throw their long blue shadows over the valleys; he saw that it would be dark long before he could reach the village, and he heaved a heavy sigh when he thought of encountering the terrors of Dame Van Winkle.[12]

The shift from the beautiful landscape in the first paragraph to the sublime landscape in the second is the first warning that nature may be more risky and threatening than Rip wanted to recognize. In fact, he was not just napping in the lap of the nurturing mother; he was sinking unwittingly into an oblivion that would wipe out the years of his manhood. He was "losing himself," swallowed up by the "long blue shadows" of the "deep mountain glen, wild, lonely, and shagged."

The next paragraph tells us that as he was preparing to "descend," there arose from the womb of darkness first a voice calling his very name, and then a little old man: an aged child, a homunculus of Rip, dwarfed and emasculated by his infantile regression. The gnomish figure conducted Rip through the sublime scenery, finally through a ravine into "a hollow, like a small amphitheatre, surrounded by perpendicular precipices. . . ." There he was initiated into a band of other aged children, playing games of tenpins and gratifying themselves orally with drafts of liquor until "at length his senses were overpowered, his eyes swam in his head, his head gradually declined, and he fell into a deep sleep." Upon awaking, he was an old man with a rusted rifle; and although upon returning home he found his wife long dead and himself free to ignore the hustle of the now-American town, he had bought his independence only at the cost of his life and manhood. Irving makes Rip's loss of identity explicit: "Rip's heart died away at hearing of these sad changes in his home and friends, and finding himself thus alone in the world. . . . He doubted his own identity. . . ." Seeing his lost self in his son, now grown to manhood, Rip cried out: "I'm not myself—I'm somebody else—. . . I'm changed, and I can't tell what's my name, or who I am!" He was not man enough for the woods, or for the town.

The "Postscript" to "Rip Van Winkle" supplies, in a few paragraphs, the

myth underlying the story; it leaves no doubt about the risk to the pioneer from the great mother and her agents:

The Kaatsberg, or Catskill Mountains, have always been a region full of fable. The Indians considered them the abode of spirits, who influenced the weather, spreading sunshine or clouds over the landscape, and sending good or bad hunting-seasons. They were ruled by an old squaw spirit, said to be their mother. She dwelt on the highest peak of the Catskills, and had charge of the doors of day and night to open and shut them at the proper hour. She hung up the new moons in the skies, and cut up the old ones into stars. In times of drought, if properly propitiated, she would spin light summer clouds out of cobwebs and morning dew, and send them off from the crest of the mountain, flake after flake, like flakes of carded cotton, to float in the air; until, dissolved by the heat of the sun, they would fall in gentle showers, causing the grass to spring, the fruits to ripen, and the corn to grow an inch an hour. If displeased, however, she would brew up clouds black as ink, sitting in the midst of them like a bottle-bellied spider in the midst of its web; and when these clouds broke, woe betide the valleys!

In old times, say the Indian traditions, there was a kind of Manitou or Spirit, who kept about the wildest recesses of the Catskill Mountains, and took a mischievous pleasure in wreaking all kinds of evils and vexations upon the red men. Sometimes he would assume the form of a bear, a panther, or a deer, lead the bewildered hunter a weary chase through tangled forests and among ragged rocks; and then spring off with a loud ho! ho! leaving him aghast on the brink of a beetling precipice or raging torrent.

The favorite abode of this Manitou is still shown. It is a great rock or cliff on the loneliest part of the mountains, and, from the flowering vines which clamber about it, and the wild flowers which abound in its neighborhood, is known by the name of the Garden Rock. Near the foot of it is a small lake, the haunt of the solitary bittern, with water-snakes basking in the sun on the leaves of the pond-lilies which lie on the surface. This place was held in great awe by the Indians, insomuch that the boldest hunter would not pursue his game within its precincts. Once upon a time, however, a hunter who lost his way, penetrated to the Garden Rock, where he beheld a number of gourds placed in the crotches of trees. One of these he seized and made off with it, but in the hurry of his retreat he let it fall among the rocks, when a great stream gushed forth, which washed him away and swept him down precipices, where he was dashed to pieces, and the stream made its way to the Hudson, and continues to flow to the present day; being the identical stream known by the name of the Kaaterskill.

In repeating the earlier shift from the beautiful to the sublime, the "Postscript" presents the great mother both in her beneficence and in her vengefulness. The Manitou, or Indian spirit, is her emanation, manifesting himself in various animal shapes to lure the hunter to his death. The fairy tale points the moral. "Once upon a time . . . a hunter who had lost his way, penetrated" to "the favorite abode of this Manitou," where he dwelled in the inner sanctum of the squaw-mother. The details of the scene insist upon the intermingling of masculine and feminine: "It is a great rock or cliff on the loneliest part of the mountains, and, from the flowering vines that clamber about it, and the wild flowers which abound in its neighborhood, is known by the name of the Garden Rock. Near the foot of it is a small lake, the haunt of the solitary bittern, with water-snakes basking in the sun on the leaves of the pond-lilies which lie

on the surface." Breaking into this holy of holies where masculine and feminine spirit are conjoined, the hunter "beheld a number of gourds placed in the crotches of trees." The violation is completed in his seizure of the gourd, but the rape is revenged by his death on the rocks in the stream sprung from the fallen gourd. The concluding sentences remind the reader that this same stream still flows and gives the mountains their name. "Rip Van Winkle" is a comic tale, and its protagonist is spared the violent end suffered by the marauder of the "Postscript." He escaped that extreme fate precisely because he was not such a hunter, any more than he was a hero like Columbus, but his story nonetheless illustrates the psychic and moral challenge and risk in the encounter with nature, especially for those softer and weaker than she. And were there any of us not so?

Cooper's *Leatherstocking Tales* constitutes the fullest literary exploration of the pioneer myth. *The Deerslayer* (1841) tells of Natty Bumppo's initiation into manhood. The first of Cooper's landscapes in *The Deerslayer* establishes the necessity for the pioneer to maintain himself not just within but against the wilderness:

Whatever may be the changes produced by man, the eternal round of the seasons is unbroken. Summer and winter, seedtime and harvest, return in their stated order with a sublime precision, affording to man one of the noblest of all the occasions he enjoys of proving the high powers of his far-reaching mind, in compassing the laws that control their exact uniformity and in calculating their never-ending revolutions. Centuries of summer suns had warmed the tops of the same noble oaks and pines, sending their heats even to the tenacious roots, when voices were heard calling to each other, in the depths of a forest, of which the leafy surface lay bathed in the brilliant light of a cloudless day in June, while the trunks of the trees rose in gloomy grandeur in the shades beneath. The calls were in different tones, evidently proceeding from two men who had lost their way, and were searching in different directions for their path. At length a shout proclaimed success, and presently a man of gigantic mold broke out of the tangled labyrinth of a small swamp, emerging into an opening that appeared to have been formed partly by the ravages of the wind and partly by those of fire. This little area, which afforded a good view of the sky, although it was pretty well filled with dead trees, lay on the side of one of the high hills, or low mountains, into which nearly the whole surface of the adjacent country was broken.

"Here is room to breathe in!" exclaimed the liberated forester as soon as he found himself under a clear sky, shaking his huge frame like a mastiff that has just escaped from a snowbank. "Hurrah! Deerslayer, here is daylight, at last, and yonder is the lake."[13]

By a fictional convention as old as storytelling, the journey into nature involves and narrates an inward journey; the quest represents, as well, an engagement with the psyche, more specifically with the unconscious. The passage acknowledges immediately that the wilderness presents a temporal as well as a spatial challenge to the individual ego-consciousness: not just vastness but its unbroken and ongoing cycle. "The eternal round of the seasons" spells the death of the individual. Nature cares about the ecological system but not about the particular being, and the cycle absorbs "the changes produced by man" in his

attempt to secure himself against death. That solemn fact affords "to man one of the noblest of all the occasions he enjoys of proving the high powers of his far-reaching mind." For the only strategy against the mother who in time mindlessly devours all her children to spawn the succeeding generation seemed to lie in the powers of consciousness itself; if the mind could "calculate" the "never-ending revolutions" of the seasons and "compass" the laws that "control" them, then consciousness would, in a sense, have comprehended and contained the unconscious workings of nature. Henry David Thoreau began *Walden* with such an intention: "To anticipate, not the sunrise and the dawn merely, but, if possible Nature herself!"[14] And the circular structure of the book contrives to seal off and seal in his consciousness of the cyclic movement.

But the temporal threat is matched by a spatial threat as well. So in Cooper's description of the "virgin wilderness," the spring sun in the clear sky lit only the "leafy surface," while down below the surface tree trunks rose in "gloomy grandeur" from "tenacious roots" to form a "tangled labyrinth." Separate voices called out from the dark womb, lost and searching for the way out. First one "man of gigantic mould," then another emerged into a "little area, which afforded a good view of the sky." The "liberated forester" exclaimed to his fellow: "Here is room to breathe in! . . . Hurrah! Deerslayer, here is daylight, at last, and yonder is the lake." The rest of the romance alternates between Lake Glimmerglass under the open sky and the surrounding thickets with savage Mingoes lurking in shadow.

When Cooper described nature as the moral and psychological matrix for his narratives, he had in mind not only memories and impressions of the Hudson River Valley, but paintings of those scenes by landscapists like Cole, Durand, and their successors. Cooper even introduced this passage with a flourishing reference to the picture "we design to paint." What's more, the conception of the scene, with sun and sky crowning a shadowy wilderness, corresponds to a typical composition in landscape painting throughout the century. Albert Bierstadt's *The Rocky Mountains* (1863; Metropolitan Museum of Art, New York) is just one large-scaled instance. The picture rises from a dark forest foreground, in which an Indian encampment is dimly seen, through various and lightening shades of earth colors in the middle ground up steep slopes to the dazzling snows of the mountaintops and one craggy peak blending into the brilliantly clear heavens. And the colossal size of the canvas, more than six feet by ten, emphasizes the sublimity which reduces the human to insignificance.

The ambiguities which the first landscape in *The Deerslayer* introduces anticipate the contrasts between pairs of characters. To begin with, the contrast between the two woodsmen who have just broken free of the forest. Hurry Harry took nature as an enemy and matched his immorality to what he took to be her amorality. In their first conversational exchange he invites Natty to test himself against the feminine adversary: "fall to, lad, and prove your manhood on this poor devil of a doe, with your teeth, as you've already done with your rifle." Deerslayer's reply immediately sets him off as speaking for nature herself:

"Nay, nay, Hurry, there's little manhood in killing a doe, and that too out of season. . . ." In fictional romances the double aspect of the feminine is conventionally personified in the contrast between the two principal female characters, typically a blonde and a brunette. In *The Deerslayer* Cooper presents variations on the types in the Hutter sisters: Hetty, docile, virtuous, and innocent to the point of simple-mindedness; and Judith, whose exotic beauty and sexual energy are felt by all the men, even Natty, and whose force of character is felt by the men as threatening. Much of the plot turns on the crossed relationships of the two pairs, which leaves them all unmarried and unattached at the end of the book. Hetty naively longs for the crude Hurry Harry, knowing that he loves Judith, who in turn falls immediately in love with Natty, who, virgin bachelor that he is, holds himself aloof from all women and expends his emotional responses on the natural scene.

Cooper's intention is to show that Natty Bumppo does not need any human love because he is so finely tuned to the beauties of nature and her moral influence. Here is a verbal picture of Lake Glimmerglass that recalls many of the works of the period:

But the most striking peculiarities of this scene were its solemn solitude and sweet repose. On all sides, wherever the eye turned, nothing met it but the mirrorlike surface of the lake, the placid view of heaven, and the dense setting of woods. So rich and fleecy were the outlines of the forest that scarce an opening could be seen, the whole visible earth, from the rounded mountaintop to the water's edge, presenting one unvaried hue of unbroken verdure. As if vegetation were not satisfied with a triumph so complete, the trees overhung the lake itself, shooting out toward the light; there were miles along its eastern shore where a boat might have pulled beneath the branches of dark, Rembrandt-looking hemlocks, "quivering aspens," and melancholy pines. In a word, the hand of man had never yet defaced or deformed any part of this native scene, which lay bathed in the sunlight, a glorious picture of affluent forest grandeur, softened by the balminess of June and relieved by the beautiful variety afforded by the presence of so broad an expanse of water.[15]

Natty's response is a spontaneous overflowing of powerful feelings: "This is grand!—'tis solemn!—'tis an edication of itself, to look upon!" Wordsworth would not have recognized the dialect, but he would have recognized Deerslayer's sentiment that anyone living in such a place should be "moral and well-disposed."

Chapter II closes with another description of Glimmerglass which might also, except for the slight rhetorical floridity and the lapses into clichéd diction, be placed next to descriptions of the beautiful in *Walden:*

The spot was very lovely, of a truth, and it was then seen in one of its most favorable moments, the surface of the lake being as smooth as glass and as limpid as pure air, throwing back the mountains, clothed in dark pines, along the whole of its eastern boundary, the points thrusting forward their trees even to nearly horizontal lines, while the bays were seen glittering through an occasional arch beneath, left by a vault fretted with branches and leaves. It was the air of deep respose—the solitudes that spoke of scenes and forests untouched by the hands of man—the reign of nature, in a word, that

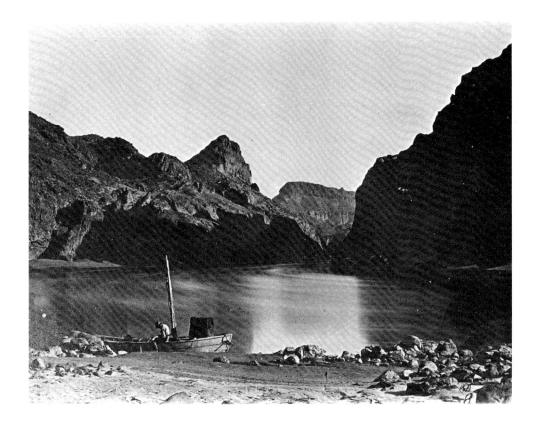

342. Timothy H. O'Sullivan. *Black Cañon, Colorado River, From Camp 8, Looking Above, Arizona*, 1871. Albumen photograph. 0.203 x 0.276 (8 x 10⅞ in). Boston Public Library, Print Department

gave so much pure delight to one of his habits and turn of mind. Still, he felt, though it was unconsciously, like a poet also. If he found a pleasure in studying this large and, to him, unusual opening into the mysteries and forms of the woods, as one is gratified in getting broader views of any subject that has long occupied his thoughts, he was not insensible to the innate loveliness of such a landscape either, but felt a portion of that soothing of the spirit which is a common attendant of a scene so thoroughly pervaded by the holy calm of nature.[16]

Leatherstocking is an unconscious poet, without the words to articulate his vision adequately. But the concluding sentence of the passage makes the point that his receptivity to the physical beauty that nature presents to his senses gives him "unusual" access to the religious "mysteries and forms" which the woods symbolized and made visible. Surely Cooper was thinking of paintings he had seen when, later in the book, he tried to verbalize more fully the moral effects of sense impressions:

The day had not yet advanced so far as to bring the sun above the horizon, but the heavens, the atmosphere, and the woods and lake were all seen under that softened light which immediately precedes his appearance and which, perhaps, is the most witching period of the four-and-twenty hours. It is the moment when everything is distinct, even the atmosphere seeming to possess a liquid lucidity, the hues appearing gray and softened, with the outlines of objects diffused, and the perspective just as moral truths that are presented in their simplicity without the meretricious aids of ornament or glitter. In a word, it is the moment when the senses seem to recover their powers in the simplest and most accurate forms, like the mind emerging from the obscurity of doubts into the tranquillity and peace of demonstration.[17]

The remarkable thing about Leatherstocking is that he felt as much in peaceful harmony with the sublime as with the beautiful. While most men cowered before nature at her most awesome and overwhelming, "he loved the woods for their freshness, their sublime solitudes, their vastness, and the impress that they everywhere bore of the divine hand of the Creator."[18] He loved mother nature for manifesting the father-spirit. He found (and founded) his identity in the Creator and his visible creation in nature, and so secure was he in that revelation that he wanted only to live in her pathless woods. But as an ideal Natty presented two different sorts of difficulty: first, he represented the rejection of human relationships and social community; and, second, he represented an ideal unattained and unattainable by ordinary humans living in community. Leatherstocking and society ended up as adversaries, and so with a

deepening sense of outrage and depression Cooper saw in the advancing waves of pioneers and settlers a corrupt community displacing all that Natty personified.

3

The consonance of the real and the ideal: the romantic mystique of nature, of the sublime as well as the beautiful, rested on that consonance. But it was the task of the romantic to substantiate the hypothesis in experience and in artistic expression. Leatherstocking and Hetty Hutter seemed, even to the other characters in the novel, special, too good for earthly existence. In Cooper's word pictures the moral tended to detach itself from the descriptive details. Thoreau urged scrupulous attention to naturalistic data because a fact "will one day flower in a truth,"[19] but the prose of his journals often alternates between philosophical abstractions and scientific observation. Cole too drew out the religious and allegorical significance of his paintings in verses as well as letters and journals, but the constant readjustment of the real and the ideal created, alternately, paintings of actual prospects like *The Ox-bow of the Connecticut River* (1836; Metropolitan Museum of Art, New York), viewed from a deliberately elevated and spectacular perspective, and for imaginative distillations of the sublimity of the Catskills, crowded with concrete details selected back in the studio from the myriad sketches executed in the forest and field. In much the same way Bierstadt would at times paint Mt. Hood or the Yosemite Valley (see fig. 343) and at other times try to compose the many wonders he had witnessed in the Rocky Mountains or the Sierras into a single canvas. Nevertheless, the conviction of the convergence, or coexistence, of the real and the ideal allowed the romantics to trust personal revelation in nature over religious orthodoxies and social institutions, and the gradual subversion of that ecstatic conviction during the course of the nineteenth century undermined the romantic synthesis.

It was, of course, the New England transcendentalists who gave the most philosophical statement of the correspondence between the real and the ideal, and between the self and nature in spirit. Ralph Waldo Emerson began his great manifesto *Nature* (written in the same year, 1836, as Cole was painting the tragic allegory of the Course of Empire) with the fullest account he would ever offer of such an epiphanic revelation. It is a familiar passage, but it demands extended consideration because it can be seen as the experiential basis for the philosophical reflections of Emerson's subsequent writings. Emerson introduces the moment by specifying the eye as the primary organ:

To speak truly, few adult persons can see nature. Most persons do not see the sun. At least they have a very superficial seeing. The sun illuminates only the eye of the man, but shines into the eye and heart of the child. The lover of nature is he whose inward and outward senses are still truly adjusted to each other; who has retained the spirit of infancy into the era of manhood.[20]

As in Edwards, the sun is the preeminent type in nature, and as with Emerson's

343. Albert Bierstadt. *Sunrise, Yosemite Valley*, c. 1870. Oil on canvas. 0.924 x 1.331 (36⅜ x 52⅜ in). Inscribed, l.r.: *ABierstadt*. Amon Carter Museum, Fort Worth, Texas

fellow-romantics the child symbolizes the individual's new sense of capacity—not the regression which cost Rip his identity, but the visionary wisdom to be matured in selfhood. The paragraph goes on to recount Emerson's experience:

Crossing a bare common, in snow puddles, at twilight, under a clouded sky, without having in my thoughts any occurrence of special good fortune, I have enjoyed a perfect exhilaration. I am glad to the brink of fear. In the woods too, a man casts off his years, as the snake his slough, and at what period soever of life, is always a child. In the woods is perpetual youth. Within these plantations of God, a decorum and sanctity reign, a perennial festival is dressed, and the guest sees not how he should tire of them in a thousand years. In the woods, we return to reason and faith. There I feel that nothing can befall me in life,—no disgrace, no calamity (leaving me my eyes), which nature cannot repair. Standing on the bare ground,—my head bathed by the blithe air, and uplifted into infinite space,—all mean egotism vanishes. I become a transparent eyeball; I am nothing; I see all; the currents of the Universal Being circulate through me; I am part or parcel of God.

The setting is unprepossessing enough: the icy slush of the Concord common under the waning light of the early winter evening; but in a few dramatic sentences the empty twilight is charged with dazzling presence. The reference to the snake transforms the old image of the serpent who doomed us to sin and death into an image of rebirth, associated with the child and the New Testa-

ment. Consequently, Emerson says, no calamity can "befall" him as long as he has the child's eyesight. In "Experience" he would define "the Fall of man" as "the discovery we have made that we exist."[21] That is, a fall into consciousness, and so into self-consciousness, which splits mind from matter, subject from object, psyche from the body it occupies. Emerson's vision subsumes the shattered and sundered world through the correspondence of self and nature in the omnipresence of spirit.

The language of the passage measures the experience for us. The first sentence contains the whole metamorphosis in which the terror of the sublime is overcome, as it was for Leatherstocking, by a deeper sense of security: "I have enjoyed a perfect exhilaration. I am glad to the brink of fear." The next few sentences distract us from the intensity of the moment through discursive and explanatory remarks that place the experience in a philosophical and religious context. Then the compounded negations of "nothing can befall me in life,— no disgrace, no calamity (leaving me my eyes), which nature cannot repair" turn into full affirmation. "Standing on the bare ground" picks up the participial phrasing of "crossing a bare common" and returns us to the generative moment, the words now quickened and integrated by the alliteration and assonance, the logical syntax suspended in the breathless staccato of the climactic realizations: "—all mean egotism vanishes. I become a transparent eyeball; I am nothing; I see all; the currents of the Universal Being circulate through me; I am part or parcel of God." The series of linked puns on "I, eye, ego" makes the distinctions and connections. I am not ego—but eye. I am nothing, and yet as eye I am. I exist in God—the "I am Who am" of Genesis; yet God exists in me, I am nothing but his vessel. When the circuit is complete, nature and the psyche are concentered in being, and the paradox of being both part and parcel falls away.

A passage which discards egotism with so many first-person pronouns may seem naive or deceptive, but in specifying "mean egotism" Emerson was deliberately saying that identity is not merely a function of ego, which defnes and defends the limits of consciousness, but of another range of psychic realization, at once more inclusive and integrative, transpersonal as well as individual, constellating the mysteries above and below consciousness around the ego. Emerson was making precisely the distinction Carl Jung would make between the ego and the self, in which the individual discovers identity through a recognition of the psychological life shared with all beings, grounded in being itself and individuated in the person. In "Self Reliance" Emerson described the "aboriginal Self, on which a universal reliance may be grounded" as "that source, at once the essence of genius, of virtue, and of life, which we call Sponaneity or Instinct. . . . In that deep force, the last fact behind which analysis cannot go, all things find their common origin."[22] Thus Emerson's summons, at the beginning of *Nature,* to make "an original relation to the universe" becomes a search for our "common origin," and the quest ends by healing the breach between subject and object and recovering the organic,

holistic relation between self and nature which the fall into consciousness had opened:"The greatest delight which the fields and woods minister is the suggestion of an occult relation between man and the vegetable. I am not alone and unacknowledged. They nod to me, and I to them."[23]

This sense of correspondence between self and nature inspired the two great testaments of Emersonian self-reliance: *Walden* and *Leaves of Grass.* In the fifth section of "Song of Myself" (1855), which, as the generative moment for Walt Whitman's epic, is comparable to Emerson's epiphany on the common, the unification of body and soul into personal identity awakens a sense of participation in the whole scale of being from the Creator himself down to the tiniest of his creatures:

> And I know that the hand of God is the promise of my own,
> And I know that the spirit of God is the brother of my own,
> And that all the men ever born are also my brothers, and the women
> my sisters and lovers,
> And that a kelson of the creation is love,
> And limitless are leaves stiff or drooping in the fields,
> And brown ants in the little wells beneath them,
> And mossy scabs of the worm fence, heap'd stones, elder, mullein
> and poke-weed.[24]

Similarly in *Walden* (1854) Thoreau describes the lake (think again of Glimmerglass, and of the number of paintings with lakes) as "the landscape's most beautiful feature" because it is "earth's eye" in which "the beholder measures the depth of his own nature."[25] The "transparent eyeball" again: nature tallying the seer. No wonder Emerson followed Edwards in taking the sun as nature's primary type. And no wonder so many romantics described and painted so many sunrise and sunset scenes: they sing the eye's hymn to the light. *Walden* begins and ends with a cock's crow to the new day: "Only that day dawns to which we are awake. There is more day to dawn. The sun is but a morning star."[26] And in "Song of Myself": "We also ascend dazzling and tremendous as the sun,/We found our own O my soul in the calm and the cool of the day-break."[27]

Barbara Novak was perhaps the first art critic to find in the almost obsessive concern with the texture and tonalities of light, especially among those painters associated with the luminist style, a visual expression of the philosophical stance of Emerson and the transcendentalists.[28] Luminism designates not a movement but a style of landscape painting, which is the central concern of this volume. The term, coined by John Baur in 1954, is defined in terms of "a polished and meticulous realism in which there is no sign of brushwork and no trace of impressionism, the atmospheric effects being achieved by infinitely careful gradations of tone, by the most exact study of the relative clarity of near and far objects, and by a precise rendering of the variations in texture and color produced by direct or reflected rays."[29] Thus luminism as a critical designation can be considered to look back to Cole and Durand and to include second-

344. Martin Johnson Heade. *Duck Hunters in the Marshes,* 1866. Oil on canvas. 0.762 x 1.524 (30 x 60 in). Inscribed, l.c.: *M.J.H. 66.* Private collection. Photo: Herbert P. Vose (see plate 15)

generation Hudson River painters like Frederic Church, John Kensett, and Sanford Gifford, as well as painters of the New England sea coasts and harbors like Fitz Hugh Lane and Martin Johnson Heade, and genre painters like William Sidney Mount, who portrayed Whitman's Long Island, and George Caleb Bingham, who caught Mark Twain's Mississippi River world.

In the paintings of Lane and Heade beautiful nature welcomes and sustains the human presence; the paintings share the stillness and serene composure that irradiate *Walden* and Emerson's reflections in verse and prose. The canvases are mostly sky, each object is fixed in the suffusing light, and the light is so organic to man's world (it came to Emerson, after all, on the town common) that it shines equally on the streets and sails and harbor of Gloucester, on the curious hayricks of the Newbury marshes (fig. 344), on the Maine coast and the

beaches of Narragansett Bay. And Huck Finn's description of the dawn he saw from his river raft is a luminist view that Clemens the river pilot shared with Bingham's boatmen and trappers:

Not a sound, anywheres—perfectly still—just like the whole world was asleep, only sometimes the bull-frogs a-cluttering, maybe. The first thing to see, looking away over the water, was a kind of dull line—that was the woods on t'other side—you couldn't make nothing else out; then a pale place in the sky; then more paleness, spreading around; then the river softened up, away off, and warn't black any more, but gray; you could see little dark spots drifting along, ever so far away—trading scows, and such things; and long black streaks—rafts; sometimes you could hear a sweep screaking; or jumbled up voices, it was so still, and sounds come so far; and by-and-by you could see a streak on the water which you know by the look of the streak that there's a snag there in a swift current which breaks on it and makes that streak look that way; and you see the

mist curl up off of the water, and the east reddens up, and the river, and you make out a log cabin in the edge of the woods, away on the bank on t'other side of the river, being a wood-yard, likely, and piled by them cheats so you can throw a dog through it anywheres; then the nice breeze springs up, and comes fanning you from over there, so cool and fresh, and sweet to smell, on account of the woods and the flowers; but sometimes not that way, because they've left dead fish laying around, gars, and such, and they do get pretty rank; and next you've got the full day, and everything smiling in the sun, and the song-birds just going it![30]

I would even venture to suggest that Emerson's account of a sculptor-friend who metamorphosed the dawn light into the statue of a shining youth calls to mind Hiram Powers' white marble figures of Eve and the fisher boy and the Greek slave girl. Emerson describes the metamorphosis:

He rose one day, according to his habit, before the dawn, and saw the morning break, grand as the eternity out of which it came, and for many days after, he strove to express this tranquillity, and lo! his chisel had fashioned out of marble the form of a beautiful youth, Phosphorus, whose aspect is such that it is said all persons who look on it become silent.[31]

White light personified in human form: so preternaturally perfect was the luminosity of Powers' marble that the spectator could feel, in Hawthorne's words, that "one of those small blue stains, which sometimes occur in the purest statuary marble, would convert the Eve of Powers to a monster."[32] Powers was able to convince even prudish spectators of the inviolate chasteness of the nude female form in white marble, and Horatio Greenough could have chosen no better medium to apotheosize George Washington as the Great White Father of his country.

<div align="center">4</div>

However, Emerson's serene assertion that "A man is a god in ruins"[33] and that he need but assemble these parts to recover his divine capacity came to seem, to some, myopic and, to others, vicious in the false aspirations which it raised only to doom. Edgar Allan Poe understood better than almost anyone else in Emerson's America the aspiration to the ideal and the terror which defeat aroused in the would-be seer. "Ligeia," published two years after *Nature,* turns on whether human beings can rise to godlike powers and, through strength of will, exceed the mortal limits of time and space. The story invokes the romance convention of the blonde and brunette heroines, only to invert it and show the triumph of the brunette over the blonde. Through his raven-haired Ligeia, whose "divine" eyes seemed to perceive the "circle of analogies" linking together all the "objects of the universe," the narrator was initiated into "the many mysteries of the transcendentalism in which we were immersed." When mortal illness threatened her with the common human lot, Ligeia resisted death to the very end, desperately addressing God directly with Emerson's own words: "Are we not part and parcel in Thee?"[34] But Ligeia represents the aspiration of the narrator himself, and after a second marriage to the fair-haired

Rowena, he half-unconsciously willed her death in order that Ligeia could return in Rowena's body. It is not clear in the story whether Ligeia's resurrection as a zombie was only a delusion of the narrator's drugged and fevered imagination or a nightmare come true, but in either case the story indicates that the human effort to realize its godlike pretensions ends in madness, perversity, and monstrosity. The individual can only pit himself against nature in an effort doomed except in the creation of an artwork about his own doom. Works of art that depict the harmony of nature lie; but that lie constitutes the superiority of art to nature. For "no such paradises are to be found in reality as have glowed on the canvas of Claude," and "no position can be attained on the wide surface of the *natural* earth, from which an artistic eye, looking steadily, will not find matter of offence in what is termed the 'composition' of the landscape."[35] For Poe the artist's eye, repelled by nature's deficiencies, compensated by depicting what the inner eye glimpsed or invented of its own hopeless ideals.

The mystique of light haunts many dark romantic parables. Nathaniel Hawthorne's "Young Goodman Brown" (1835) can be read as a grotesque parody on Cooper's theme of the hero's initiation into the ways of the woods. This young, "good man" left the security of town and hearth and his new wife's bed to venture into the forest at nightfall, only to discover himself a fiend among fiends:

The road grew wilder and drearier, and more faintly traced, and vanished at length, leaving him in the heart of the dark wilderness, still rushing onward with the instinct that guides mortal man to evil. The whole forest was peopled with frightful sounds; the creaking of the trees, the howling of wild beasts, and the yell of Indians; while, sometimes, the wind tolled like a distant church-bell, and sometimes gave a broad roar around the traveller, as if all Nature were laughing him to scorn. But he was himself the chief horror of the scene, and shrank not from its other horrors.[36]

Because Hawthorne understood Anne Bradstreet's fear of the wilds better than Emerson could, he imagined his character refusing the security of social and religious institutions and instead journeying to "the heart of the dark wilderness," "the heart of the solitary woods," where—ironically—he met the townsfolk and church elders in a witches' meeting celebrating the communion of the human race in evil. Goodman Brown's disillusionment overshadowed the rest of his life. Emerson sensed the natural world returning his acknowledgment; but when nature and human kind seemed linked in corruption, nature laughed Goodman Brown to scorn. For "he was himself the chief horror"; "all through the haunted forest there could be nothing more frightful than the figure of Goodman Brown." Hawthorne concludes the story with an epistemological question that only complicates the dilemma: "Had Goodman Brown fallen asleep in the forest, and only dreamed a wild dream of a witch-meeting?"[37] The daylight world and the nighttime—which was the illusion and which the reality? Had Brown attained a deeper insight into nature and human nature, or had he only projected his own conviction of sinful guilt on the rest of the world?

Hawthorne let the story remain suspended in ambiguity. He had pledged himself to tell "the truth of the human heart," even in its ambiguity, and it is clear that for other romantics as well the journey out into nature and the journey down into the psyche had become very problematical indeed. The idyll of the Deerslayer became more and more difficult to maintain, and the tragic implications of the "Postscript" to Rip Van Winkle's excursion into the wilderness returned in full force. Poe's *Narrative of Arthur Gordon Pym* (1838) recounts three sea adventures of the protagonist, each longer, more physically violent, more morally and metaphysically ambiguous than the previous one. The final voyage takes Pym, on board the *Jane Guy,* to the ends of the earth, and beyond.* At the climax of *Pym* the narrator and crew of the *Jane Guy* journeyed farther and farther south, stopping at an island in which everything, including even the teeth of the natives, was black. Their seeming simplicity and innocence turned out to be calculated duplicity; these primitives were cunning savages, and only Pym and one companion managed to escape massacre by setting off in a small craft on the wide Antarctic Sea with a single captive. Soon they were caught in an irresistible current driving them to the pole. (Poe's imagination was drawn to the Arctic regions and the pole as an *ultima thule,* just as were the imaginations of explorers and of artists like William Bradford and Frederic Church.) The water turned white, to the increased terror of the quavering black man. Propelled with accelerating speed, they were enveloped in a snowlike precipitation, as sky and sea sublimely met; finally, at the pole itself, under a darkness illumined by a lurid white glare, a cataract of the white precipitation parted like a curtain to reveal, as they shot through, a huge, shrouded figure, immaculately white.

Thoreau said that the only time he was frightened during his sojourn at Walden occurred when on his walking back the mile or so from Concord one day, all visible objects and landmarks were obliterated in a snow storm; he felt disoriented and effaced by the faceless white. In the psyche, as in nature, the mortal mystery of blackness seemed to yield and point to the ineffable mystery of whiteness, and so much did Poe seem to his nineteenth-century readers the man who explored the shadow realm and beyond that even so optimistic an

*The black and white symbolism which dominates the imagination of the romantics betrays a racist bias, just as the conventional associations with the masculine and feminine betrays a sexist bias. One need only think of the stereotypes of the blonde and brunette woman, of the treatment of Indians in Cooper's romances or in Irving's *A Tour on the Prairies* in terms of the noble savage or the bestial savage, of the treatment of blacks in *Pym* or in Herman Melville's "Benito Cereno" (1855). My argument here leads me to focus on the moral and metaphysical questions which the color and sexual symbolism were struggling to express; but I also want to acknowledge that the biases and stereotypes, which in part informed the symbolism, served to perpetuate the prejudice against and oppression of women and racial minorities in American patriarchal society.

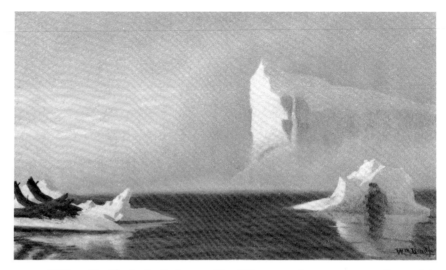

345. William Bradford. *Arctic Ice,* c. 1882. Oil on panel. 0.203 x 0.305 (8 x 12 in). Inscribed, l.r.: *Wm Bradford.* Private collection. Photo: Graham Gallery (not in exhibition)

idealist as Whitman once confessed, almost reluctantly, to seeing himself as Poe on a fearful voyage to destruction:

In a dream I once had, I saw a vessel on the sea, at midnight, in a storm. It was no great full-rigg'd ship, nor majestic steamer, steering firmly through the gale, but seem'd one of those superb little schooner yachts I had often seen lying anchor'd, rocking so jauntily, in the waters around New York, or up Long Island sound—now flying uncontroll'd with torn sails and broken spars through the wild sleet and winds and waves of the night. On the deck was a slender, slight, beautiful figure, a dim man, apparently enjoying all the terror, the murk, and the dislocation of which he was the centre and the victim. That figure of my lurid dream might stand for Edgar Poe, his spirit, his fortunes, and his poems—themselves all lurid dreams.[38]

Moby-Dick (1851) is the greatest of metaphysical sea adventures, and it too hunts the darkness to unmask the mystery of white. On one level at least, the romance can be read as a testing-out of transcendentalist hypotheses. During the crucial years after his time at sea, when he began to explore his own mind and psyche, Herman Melville had discovered Emerson's prophetic pronouncements and ingested them enthusiastically; he said that he loved intellects like Emerson's which dove to the depths of things. But soon he came sadly to admit that Emerson seemed to have a defect of the heart that rendered him incapable of acknowledging the power of blackness—as, for instance, Hawthorne did. In "The Mast-head" chapter Melville's narrator Ishmael warns the reader of the self-destructiveness of succumbing to nature on Emersonian assumptions. "Young Platonists" like himself, aloft in the rigging, were so lulled by the movement of the ship rocking to the rhythm of the sea and

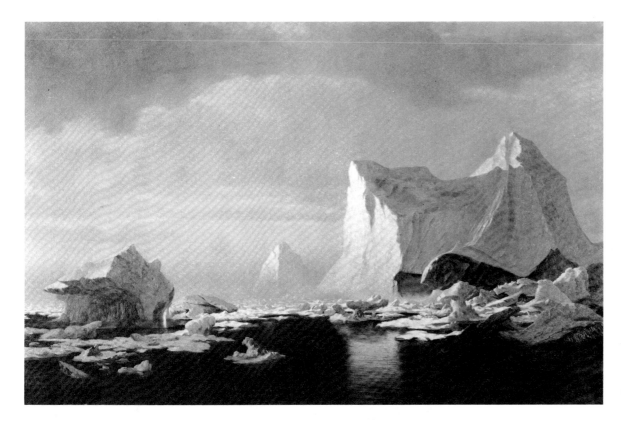

346. William Bradford. *In Polar Seas,* 1882. Oil on canvas. 0.711 x 1.117 (28 x 44 in). Inscribed, on reverse: *In Polar Seas. Painted by William Bradford 1882.* Private collection

by the blending cadence of waves with thoughts, that at last he loses his identity; takes the mystic ocean at his feet for the visible image of that deep, blue, bottomless soul, pervading mankind and nature; and every strange, half-seen, gliding, beautiful thing that eludes him; every dimly discovered, uprising fin of some undiscernible form, seems to him the embodiment of those elusive thoughts that only people the soul by continually flitting through it.

The next and last paragraph of the chapter undercuts such trusting identification. When the nurturing mother turned vicious, perhaps she only masked the father's fury; for from the elevation of the masthead the individual could literally lose himself in "the inscrutable tides of God":

There is no life in thee, now, except that rocking life imparted by a gently rolling ship; by her, borrowed from the sea; by the sea, from the inscrutable tides of God. But while this sleep, this dream is on ye, move your foot or hand an inch; slip your hold at all; and your identity comes back in horror. Over Descartian vortices you hover. And perhaps, at mid-day, in the fairest weather, with one half-throttled shriek you drop through that transparent air into the summer sea, no more to rise for ever. Heed it well, ye Pantheists![39]

The following chapter, "The Quarter-deck," presents for the first time in the book Captain Ahab's demonic version of transcendentalism. When the pious mate Starbuck berated the captain for obsession with revenge on the white whale, Ahab explained his outrage in terms of the Platonic doctrine of the correspondence between nature and spirit, embodied most sublimely in Moby-Dick:

All visible objects, man, are but as pasteboard masks. But in each event—in the living act, the undoubted deed—there, some unknown but still reasoning thing puts forth the mouldings of its features from behind the unreasoning mask. If man will strike, strike through the mask! How can the prisoner reach outside except by thrusting through the wall? To me, the white whale is that wall, shoved near to me. Sometimes I think there's naught beyond. But 'tis enough. He tasks me; he heaps me; I see in him outrageous strength, with an inscrutable malice sinewing it. That inscrutable thing is chiefly what I hate; and be the white whale agent, or be the white whale principal, I will wreak that hate upon him.

Moby-Dick was merely the symbolic mask for the ultimate truth, and for Ahab that could only be the Void or a malign God. In either case Ahab had vowed to strike a blow for human dignity, even in defeat, by turning obeisance to defiance. Invoking the sun as the traditional type for God's presence in nature,

347. Francis A. Silva. *Schooner Passing Castle Island, Boston Harbor,* 1874. Oil on panel. 0.559 x 0.965 (22 x 38 in). Inscribed, l.l.: *F. A. Silva/74.* The Bostonian Society, Old State House, Boston; Gift of Mrs. Vernon A. Wright, 1939 (see plate 23)

he thundered back to Starbuck: "Talk not to me of blasphemy, man; I'd strike the sun if it insulted me."[40]

Ahab is the most dramatic figure in the book—but doomed; and Melville is careful to distinguish between Ahab's association of the whale with evil, whether by divine decree or chance, and Ishmael's growing conviction that the ambiguity of Moby-Dick's meaning is summed up in his color, or lack of color. The great chapter "The Whiteness of the Whale" employs a catalogue of metaphors to evoke Ishmael's bewilderment. Because both life and death, the lamb and the polar bear, the wedding veil and the shroud are white, the human response, in Ishmael's view, has to be ambivalence. The sublime arouses "two . . . opposite emotions in our minds";[41] we are drawn most to what makes us fear most for ourselves, because the mystery of whiteness seems to promise at once our apotheosis and our extinction.

Does apotheosis spell the extinction or the completion of consciousness? Or could it be, to put it more plainly, that the achievement of self—the realization of the concentricity of the personal and the transpersonal, the finite and the infinite, the individual and the universal—exacts both the surrender of the ego in all its protective defences *and* the utilization of the ego to integrate needs that press in from other psychic dimensions above and below consciousness? It was in the ambiguities of these questions that Emily Dickinson, in the early 1860s when she was embarking on her remarkable voyage of self-exploration, initiated her life-long habit of wearing only white—a symbolic bridal gown,

burial dress, and goddess-raiment all in one. She knew Emersonian moments in the garden and private moments of ecstatic self-awareness, yet there were times when she could be as grim about the confrontation with nature as any of her adventuring male contemporaries. There is no evidence that she read *Pym* or *Moby-Dick,* but she eliminated none of the terror of the disaster by condensing it into two terse, wittily understated quatrains:

> Finding is the first Act
> The second, loss,
> Third, Expedition for
> the "Golden Fleece"
>
> Fourth, no Discovery—
> Fifth, no Crew—
> Finally, no Golden Fleece—
> Jason—sham—too.[42]

Pierre, or the Ambiguities (1852) is Melville's most extended account of moral and psychological disintegration, written just after *Moby-Dick,* when he had hoped that Ishmael's open-eyed stoicism and capacity for human relationships had delivered him from smashing against the white whale's bulk along with the rest of the *Pequod*'s crew. *Pierre* is as complex a book as *Moby-Dick,* but it is noteworthy for our argument here that Pierre's gradual collapse accompanies a shift in the sense of the landscape, even the same landscape, from the beautiful to the sublime. Pierre grew to young manhood nurtured by the pastoral peace and loveliness of Saddle Meadows and now loved a fair-haired maiden with the Wordsworthean name of Lucy, associated repeatedly with white as the color of chastity and innocence. Pierre felt strangely drawn to a towering, egg-shaped rock formation (his name, after all, means stone). Known as the Memnon Stone, it is the symbol of his embryonic self, which should grow to the heroic proportions of Memnon, the colossus whose statue stood at the Egyptian Thebes. But the impending tragedy is foreshadowed by the fact that sometimes the Memnon Stone loomed before Pierre as the Terror Stone. Consequently, later in the convolutions of the plot, when Pierre found himself involved with his hitherto-unknown sister Isabel, dark and sensual and alone except for his love, when their incestuous relationship had driven them away from Lucy and Saddle Meadows to the hell of New York City, the symbolic change from country to city is accompanied by a corresponding change in Pierre's vision of the mountain which dominated Saddle Meadows (Melville ruefully dedicated the romance to Mt. Greylock in the Berkshires). Where the peak had been called the Delectable Mountain, with suggestions of Bunyan's allegory of paradise and Christian redemption, it was now the Mount of the Titans. In Pierre's prophetic dream, the scattered, broken boulders at the foot of the mount became the prone figure of the titan Enceladus, cast down from the heights by the Olympian gods and writhing up, armless in defeat, in a futile gesture of defiance. Pierre's fate is written in the transition from Memnon to Enceladus, and he found death at last, together with both the blonde and

brunette heroines, locked within the stone cell of a prison. Melville invoked the formula of the Cooper romance in order to demolish it, and he introduced the sublime description of the Enceladus landscape with a rejoinder—and a rebuke—to Emerson:

Say what some poets will, Nature is not so much her own ever-sweet interpreter, as the mere supplier of that cunning alphabet, whereby selecting and combining as he pleases, each man reads his own peculiar lesson according to his own peculiar mind and mood.[43]

In one way and another Poe, Hawthorne, Melville, and Dickinson took as their subject consciousness itself. For them the drama lay less in the mind's effort to apprehend nature—as it did for Cooper and Emerson, Thoreau and Whitman—than in the devising of images and plots as symbols of their psyche's "peculiar" moods and states. An expedition into those unknown regions flirts with, and often ends in, disaster, and their psychic landscapes and seascapes call to mind the haunted canvasses of "symbolic" painters like Ralph Blakelock and Alfred Pinkham Ryder: in Blakelock, spectral meadows, shadowy Indian encampments, towering trees lacily etched against a lurid sky; in Ryder, fragile, lone boats on the empty sea under an ominously clouded sky, a sublunary world of impending doom in which the light metamorphoses shapes, or drives them into shadow. Where Cole painted *The Last of the Mohicans,* Ryder painted "The Haunted Palace," Poe's verse-allegory of madness, under the title *The Temple of the Mind* (1885?; Albright-Knox Gallery, Buffalo), and Blakelock spent years in a mental institution. All of these romantic painters and writers created their own psychological landscapes, and even a "realist" like Winslow Homer was as reclusive and ideosyncratic as they. His years at Tynemouth in 1881 and 1882 changed his sense of nature; thereafter he turned from pastoral farm scenes and sunny spas with light-haired ladies to paint men who risked themselves to the sea, and statuesque women whose dark brooding matched the sky and water by which they watched, and finally to paint (often without a human spectator included in the scene) the elemental contention of wind and wave and rock which he witnessed all alone during long winters on the Maine coast (fig. 348).

This vision of nature cast its shadow not just on artists and imaginative writers but also on such historians as Francis Parkman and Henry Adams. George Bancroft found philosophical confirmation for his progressive reading of American history in transcendentalism, but Parkman's expedition to the West and sojourn among the Sioux, recounted in *The Oregon Trail* (1847), fixed the tragic sense which informs his later volumes about the encounter of the French and British with the New World, composed during the same decades in which Bancroft was writing and revising his *History of the United States. The Oregon Trail* offers many sublime prospects which Parkman noted as worthy of a painter or a romancer:

We were on the eastern descent of the mountain, and soon came to a rough and difficult defile, leading down a very steep declivity. The whole swarm [of Indians] poured down together, filling the rocky passageway like some turbulent mountain-stream. The mountains before us were on fire, and had been so for weeks. The view in front was obscured by a vast dim sea of smoke, while on either hand rose the tall cliffs, bearing aloft their crests of pines, and the sharp pinnacles and broken ridges of the mountains beyond were faintly traceable as through a veil. The scene in itself was grand and imposing, but with the savage multitude, the armed warriors, the naked children, the gayly apparelled girls, pouring impetuously down the heights, it would have formed a noble subject for a painter, and only the pen of a Scott could have done it justice in description.[44]

Parkman's experience of the prairies and mountains, of the buffaloes and the Indians, who themselves seemed to him "a troublesome and dangerous species of wild beast," led him to view all existence as a biological battle for survival, dramatized not in the symbol of the leviathan, but—just as effectively—in the minuscule life of a spring pool:

I lay down by the side of a deep, clear pool, formed by the water of a spring. A shoal of little fishes of about a pin's length were playing in it, sporting together, as it seemed, very amicably; but on closer observation, I saw that they were engaged in cannibal warfare among themselves. Now and then one of the smallest would fall a victim, and immediately disappear down the maw of his conqueror. Every moment, however, the tyrant of the pool, a goggle-eyed monster about three inches long, would slowly emerge with

348. Winslow Homer. *The Artist's Studio in an Afternoon Fog,* 1894. Oil on canvas. 0.607 x 0.769 (23⅞ x 30¼ in). Inscribed, l.r.: *Winslow Homer 1894.* Memorial Art Gallery of the University of Rochester, Rochester, New York; R. T. Miller Fund (see plate 31)

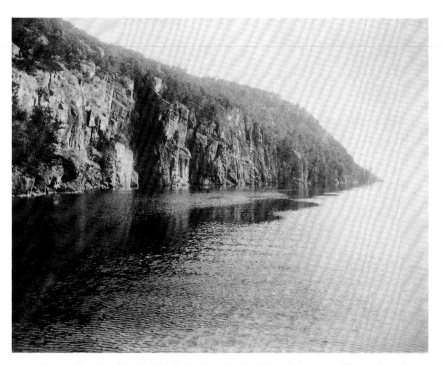

349. Seneca Ray Stoddard. *Adirondacks, Barn Rock, Lake Champlain,* 1890. Silverprint photograph. 0.167 x 0.219 (6⁹/₁₆ x 8⅝ in). The Library of Congress, Washington, D.C.

350. Seneca Ray Stoddard. *The Palisades of Lake Champlain,* 1890. Silverprint photograph. 0.165 x 0.217 (6½ x 8⁹/₁₆ in). The Library of Congress, Washington, D.C.

quivering fins and tail from under the shelving bank. The small fry at this would suspend their hostilities, and scatter in a panic at the appearance of overwhelming force.

"Soft-hearted philanthropists," thought I, "may sigh long for their peaceful millennium; for, from minnows to men, life is incessant war."[45]

In *The Education of Henry Adams* (1907) Adams constructed his third-person autobiography so as to demonstrate how experience stripped him of eighteenth-century assurances, subverted romantic hypotheses, and made him a typical modern in his intellectual awareness of moral and spiritual paralysis. The original subtitle was *A Study of Twentieth-Century Multiplicity.* Adams' initiation into the amoral indifference of nature (now no longer capitalized by writers) ended in an apocalyptic vision of the whole system dissipating itself entropically. When Emerson wrote "Nature is symbol of Spirit,"[46] he was revising—and reviving—Edwards' typological sense, but a further declension in New England belief deprived Parkman and Adams of any typological conviction at all. Even more than Parkman, Adams was a nineteenth-century mind which seemed to spell out the exhaustion of the old norms and sanctions. The twentieth century began with a spirited rejection of romanticism in the name of modernism. And the modernist aesthetic—advanced by such innovators as Picasso and Stravinsky, Joyce and Eliot—developed explicitly from

a sense of radical alienation from nature and argued for the creator's consequent responsibility to devise order from the random and disjointed elements of experience.

5

But the profound need to ground human nature in a primary relationship with the natural world, the profound longing to source meaning and identity in that relationship abides and expressed itself in the midst of modernism, in inheritors of the romance like William Faulkner and John Steinbeck and especially in certain poets. The central question in Robert Frost's poetry is: "what to make of a diminished thing"—diminished because technology has made the world smaller and more cramped, diminished because skepticism has constricted the range of speculation and vision. Darwinian and pragmatic as his agnostic father, Frost was New Englander enough to confront nature with the aspirations he learned from his Emersonian mother: wary of absolutes but wary, too, of closing off any transcendental possibilities. Peering down into the peculiarly still and clear waters of a well to read nature, as his forebears had done since Bradford and Winthrop, Frost moves from observation to question:

Once, when trying with chin against a well-curb,
I discerned, as I thought, beyond the picture,
Through the picture, a something white, uncertain,
Something more of the depths—and then I lost it.
Water came to rebuke the too clear water.
One drop fell from a fern, and lo, a ripple
Shook whatever it was lay there at the bottom,
Blurred it, blotted it out. What was that whiteness?
Truth? A pebble of quartz? For once, then, something.[47]

The hesitant pace, the qualifications, the indefinite pronouns prepare the reader for the indeterminacy of the ending. "What was that whiteness?" Did the fact flower into a truth, as Thoreau said it would? It is a conclusion in which nothing is concluded, and the uniqueness of even so indeterminate a glimpse through the surface is contained in the repetition of the italicized "*Once*" in the final phrase. The sonnet "Design" ponders a drama of death, in which a white spider kills a white moth on a strangely white heal-all, and asks whether this tiny insight into the mystery of white conceals—or reveals—"the design of darkness." In his self-protective ambivalence Frost, like many a woodsman before him, came to engage nature as a beloved adversary, maintaining an open space for himself against her encroachment. He could not be Natty Bumppo, but he strove to contain his contention with her so that he would not turn out to be Hurry Harry. One of Frost's last poems describes his life-long struggle with nature as still an honorable draw:

In winter in the woods alone
Against the trees I go.
I mark a maple for my own
And lay the maple low.

.

I see for Nature no defeat
In one tree's overthrow
Or for myself in my retreat
For yet another blow.[48]

On the opposite coast Robinson Jeffers urged an opposite solution to the problem; Jeffers' pantheism drew him to see the quenching of consciousness in unconscious nature as the only way for ego-ridden individuals to participate in the divinity of the material universe. Where Emerson as "transparent eyeball" rejected "mean egotism" for a larger selfhood, where Thoreau saw Emerson's small pond at Walden as "earth's eye" in which the depth of human nature was reflected (again remember Parkman's pool), Jeffers extolled the vast Pacific as "eye of the earth"—timelessly oblivious to human strife:

. . . this dome, this half-globe, this bulging
Eyeball of water, arched over to Asia,
Australia and white Antarctica: those are the eyelids that never close;
 this is the staring unsleeping
Eye of the earth; and what it watches is not our wars.[49]

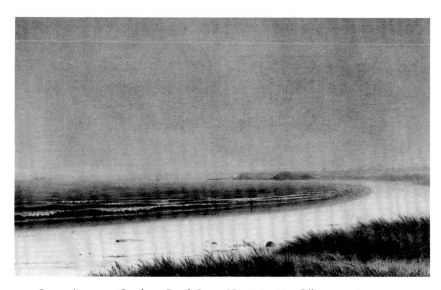

351. James Augustus Suydam. *Beach Scene, Newport,* 1860. Oil on canvas. 0.241 x 0.413 (9½ x 16¼ in). Inscribed, l.c.: *J.A.Suydam 1860.* The Lano Collection. Photo: Geoffrey Clements

In a late poem which bears comparison with the Frost quatrains above, Jeffers tells of a vulture which inspected him as possible prey, as he lay on a hillside above the ocean:

. . . I tell you solemnly
That I was sorry to have disappointed him. To be eaten by that beak
 and become part of him, to share those wings and those eyes—
What a sublime end of one's body, what an enskyment; what a life
 after death.[50]

Others sought something between Frost's self-defence and Jeffers' self-surrender. Ezra Pound has been considered an anti-romantic modernist, but the designation is only partly correct. *The Cantos* matches *Leaves of Grass* in the sustained attempt to affirm a source for personal identity and social order in natural process. Pound's colossal and sometimes ruthless ego made the effort particularly vexed, but when that ego was broken in the prison camp at Pisa amidst the rubble of a world war, he could *see* as never before. The climax of *The Cantos* occurs in Canto 81 when an apparition of the goddess' eyes came to him in his tent, revealing himself and the natural world anew:

there came new subtlety of eyes into my tent,
whether of spirit or hypostasis,
 but what the blindfold hides
or at carneval
 nor any pair showed anger
 Saw but the eyes and stance between the eyes,
colour, diastasis,

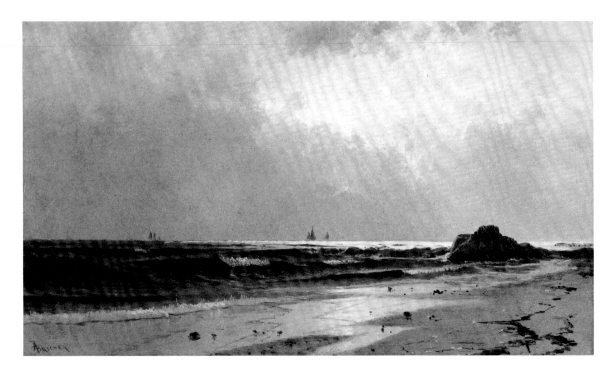

352. Alfred Thompson Bricher. *Seascape*, c. 1875. Oil on canvas. 0.257 x 0.413 (10⅛ x 16¼ in). Inscribed, l.l.: *AT-BRICHER (ATB* is in monogram). Mr. and Mrs. Erving Wolf. Photo: Thomas Feist

careless or unaware it had not the
 whole tent's room
nor was place for the full Εἰδὼς [Knowing]
interpass, penetrate
 casting but shade beyond the other lights
 sky's clear
 night's sea
 green of the mountain pool
 shone from the unmasked eyes in half-mask's space.[51]

Within the natural round, Aphrodite enlightens the human heart, revealing the power of love to topple ego and free the transformed individual to find a humble place, secure in the holism of nature:

The ant's a centaur in his dragon world.
Pull down thy vanity, it is not man
Made courage, or made order, or made grace,
 Pull down thy vanity, I say pull down.
Learn of the green world what can be thy place
In scaled invention or true artistry,
Pull down thy vanity,
 Paquin pull down!
The green casque has outdone your elegance.[52]

One of the most important Chinese characters for Pound combined the pictographs of the sun and the moon into an ideogram for "the total light process, the radiation, reception and reflection of light."[53] Through "the white light that is allness," "all things that are are lights." Pound concluded his translation of one of the Confucian texts with an acknowledgment of "the tensile light, the Immaculata. There is no end to its action."[54] Like the union of sun and moon, the conventionally "masculine" light is designated here by the feminine form "Immaculata." A conjunction: not light as spirit-father, but as mother nature, and light in nature as the coexistence of opposites. On the one hand, light is shadowed in things, fractured into the color-spectrum; on the other hand, all things, whatever their shade, are lights.

In the end, Pound came to experience natural process as the operation of "the total light process." And therefore "learn of the green world what can be thy place": it is a psychological impulse, a religious and moral imperative to which most of the writers cited in this essay—Cooper and Emerson and Melville, Thoreau and Poe, Hawthorne and Whitman and Dickinson—would have given assent. Or would have wished, with all their hearts, to be able to lend assent.

Notes

1. Cf. particularly *Errand into the Wilderness* (Cambridge, Mass., 1956) and *Nature's Nation* (Cambridge, Mass., 1967).

2. I want to develop my argument about literary attitudes toward landscape by arranging a sequence of verbal landscapes which stand as analogues for and comments on the painting of the period as illustrated in the exhibit and this book.

3. William Bradford, *History of Plymouth Plantation*, reprinted in *The Puritans: A Sourcebook of Their Writings*, ed. Perry Miller and Thomas H. Johnson, rev. ed. (New York, 1963), *1: 100-101*.

4. *The Works of Anne Bradstreet*, ed. Jeannine Hensley (Cambridge, Mass., 1967), 241.

5. *The Puritans, 1: 143*.

6. *The Puritans, 1: 377*.

7. *Images or Shadows of Divine Things*, ed. Perry Miller (New Haven, Conn., 1948), 45, 70, 58, 60.

8. *Divine Things*, 49, 83, 97.

9. *Divine Things*, 61-62.

10. *Divine Things*, 109.

11. Irving's account of the first voyage to the New World occupies Books III and IV of *The History of the Life and Voyages of Christopher Columbus*. Cf. Washington Irving, *Works*, Geoffrey Crayon Edition (New York, 1882-1883), *10: 201, 165*.

12. "Rip Van Winkle" was included in Irving's *Sketch Book* (1820). Cf. *Works, 2: 50-76*. The passage quoted here appears on pages 58-59, and the "Postscript" on pages 75-76.

13. *Works of James Fenimore Cooper* (New York, 1859-1861), *5, The Deerslayer*, 15-16.

14. *The Writings of Henry David Thoreau*, Walden Edition (Boston, 1906), *2, Walden*, 19.

15. Cooper, *The Deerslayer*, 33.

16. Cooper, *The Deerslayer*, 45.

17. Cooper, *The Deerslayer*, 358.

18. Cooper, *The Deerslayer*, 299.

19. "Natural History of Massachusetts" in *The Writings of Henry David Thoreau, 5, Excursions and Poems*, 130.

20. *The Complete Works of Ralph Waldo Emerson*, Centenary Edition, ed. Edward Waldo Emerson (Boston, 1903-1904), *1, Nature, Lectures and Addresses*, 8-10.

21. *Complete Works, 3, Essays: Second Series*, 75.

22. *Complete Works, 2, Essays: First Series*, 63-64.

23. *Complete Works, 1, Nature*, 10.

24. "A Song of Myself," sect. 5, in *Leaves of Grass*, Comprehensive Reader's Edition, ed. Harold W. Blodgett and Sculley Bradley (New York, 1965), 33.

25. *Walden*, 206-207.

26. *Walden*, 367.

27. "Song of Myself," sect. 25, *Leaves of Grass*, 54.

28. Barbara Novak, *American Painting of the Nineteenth Century: Realism, Idealism, and the American Experience* (New York, 1969), 96-99, 105, 110-111, 122-123.

29. *The Brittanica Encyclopedia of American Art* (Chicago, 1974), 354.

30. *The Adventures of Huckleberry Finn*, ed. Sculley Bradley, Richmond Croom Beatty, E. Hudson Long and Thomas Cooley (New York, 1977), 96.

31. "The Poet," in *Complete Works, 3, Essays: Second Series*, 24.

32. "The Birth-mark" in *The Works of Nathaniel Hawthorne*, Centenary Edition (Columbus, Ohio, 1974), *10, Mosses from an Old Manse*, 38.

33. *Complete Works, 1, Nature*, 71.

34. *The Collected Works of Edgar Allan Poe, Tales and Sketches*, ed. T. O. Mabbott (Cambridge, Mass., 1978), *2: 313, 314, 316, 319*.

35. "The Domain of Arnheim" in *Tales and Sketches, 3: 1272*.

36. "Young Goodman Brown" in *Nathaniel Hawthorne, 10, Mosses from an Old Manse*, 83.

37. "Young Goodman Brown" in *Nathaniel Hawthorne, 10, Mosses from an Old Manse*, 89.

38. "Edgar Poe's Significance" in *Specimen Days, Prose Works 1892*. ed. Floyd Stovall (New York, 1963), *1: 232*.

39. *Moby-Dick*, ed. Harrison Hayford and Herschel Parker (New York, 1967), 139-140.

40. *Moby-Dick*, 144.

41. *Moby-Dick*, 164.

42. Poem 870 in *The Poems of Emily Dickinson*, ed. Thomas H. Johnson (Cambridge, Mass., 1955), *2: 647-648*.

43. *Pierre, or the Ambiguities* (New York, 1957), 402.

44. *The Oregon Trail* (New York, 1949), 257-258.

45. *Oregon Trail*, 252, 254-255.

46. *Complete Works, 1, Nature*, 25.

47. "For Once, Then, Something" in *The Complete Poems of Robert Frost*, ed. Edward Connery Latham (New York, 1969), 225. Cf. also p. 120.

48. *Poems of Frost*, 302, 470.

49. "The Eye" in *The Double Axe and Other Poems*, ed. William Everson and Bill Hotchkiss (New York, 1977), 126.

50. "Vulture" in *The Beginning and the End* (New York, 1963), 62.

51. Canto 131 in *The Cantos of Ezra Pound* (New York, 1972), 520.

52. *The Cantos*, 521.

53. *Confucius: The Unwobbling Pivot, The Great Digest, The Analects*, trans. Ezra Pound (New York, 1951), 20.

54. *Confucius*, 187; *The Cantos*, 179, 429.

Bibliography

Linda L. Ayres

I GENERAL SOURCES

ANDRUS, Lisa F. *Measure and Design in American Painting 1760-1860*. (Ph.D. dissertation, Columbia University.) Reprint, Garland Series. New York, 1977.

BARSAMOV, Nikolai. *Aivazovsky in the Crimea*. Moscow, 1972.

BAUR, John I. H. "American Luminism, A Neglected Aspect of the Realist Movement in Nineteenth-Century American Painting." *Perspectives USA, 9* (Autumn 1954): 90-98.

_____. "Early Studies in Light and Air by American Painters." *Brooklyn Museum Bulletin, 9,* no. 2 (Winter 1948): 3, 7.

_____. "Trends in American Painting, 1815 to 1865." In *M. and M. Karolik Collection of American Paintings, 1815 to 1865*. Cambridge, Mass., 1949.

BERCOVITCH, Sacvan. *The Puritan Origins of the American Self*. New Haven, 1975.

BOWLT, John E. "A Russian Luminist School? Arkhip Kuindzhi's Red Sunset on the Dnepr." *Metropolitan Museum Journal, 10* (1975): 119-129.

BRAMSEN, Henrik. *Danske Marinemalere*. Copenhagen, 1962.

The Britannica Encyclopedia of American Art. Chicago, 1974.

BROWN, Milton Wolf, et al. *American Art: Painting, Sculpture, Architecture, Decorative Arts, Photography*. Rev. ed. New York, 1979.

BURKE, Edmund. *An Essay on the Sublime and Beautiful*. 1756. Edited by Henry Morely. New York, 1886.

Caspar David Friedrich, 1774-1840: Romantic Landscape Painting in Dresden. (Exhibition catalogue. Tate Gallery.) London, 1972.

CHAMPA, Kermit S. *German Painting of the 19th Century*. New Haven, Conn., 1970.

The Crayon: A Journal Devoted to the Graphic Arts and the Literature Related to Them. New York, 1855-1861 (monthly).

CUMMINGS, Thomas S. *Historic Annals of the National Academy of Design*. Philadelphia, 1865.

CURRENT, Karen, and Current, William. *Photography and the Old West*. New York, 1978.

Dänische Maler. Leipzig, 1924.

DARRAH, William C. *The World of Stereographs*. Gettysburg, Pa., 1977.

DAVIDSON, Gail; Hattis, Phyllis; and Stebbins, Theodore E., Jr. *Luminous Landscape: The American Study of Light 1860-1875*. (Exhibition catalogue. Fogg Art Museum, Harvard University.) Cambridge, Mass., 1966.

DICKASON, David H. *The Daring Young Men: The Story of the American Pre-Raphaelites*. Bloomington, 1953.

EARLE, Edward W., ed. *Points of View: The Stereograph in America—A Cultural History*. Rochester, N.Y., 1979.

EMERSON, Ralph Waldo. *Nature*. Boston, 1836.

GERDTS, William H. "On the Nature of Luminism." In *American Luminism*. (Exhibition catalogue. Coe Kerr Gallery.) New York, 1978.

GERNSHEIM, Helmut, and Gernsheim, Alison. *The History of Photography*. London, 1969.

HARTMANN, Sadakichi. *History of American Art*. Boston, 1902.

HIPPLE, Walter John, Jr. *The Beautiful, the Sublime and the Picturesque in Eighteenth Century British Aesthetic Theory*. Carbondale, Ill., 1957.

HOWAT, John K. *The Hudson River and Its Painters*. New York, 1972.

_____ et al. *19th Century America, Paintings and Sculpture*. (Exhibition catalogue. Metropolitan Museum of Art.) New York, 1970.

Detail, fig. 339

HUTH, Hans. *Nature and the American*. Berkeley, Calif., 1957.

JARVES, James Jackson. *The Art-Idea*. New York, 1864.

KANT, Immanuel. *The Critique of Judgement*. 1790. Translated by James Creed Meredith. Great Books of the Western World, *42*. Chicago, 1952.

KLOSE, Olaf, and Martius, Lilli. *Skandinavische Landschaftsbilder*. Neumünster, Federal Republic of Germany, 1975.

KOROTKEVICH, E. *Landscape Masterpieces from Soviet Museums*. (Exhibition catalogue. Royal Academy of Arts.) London, 1975.

KROHN, Mario. *Maleren Christen Købkes*. Copenhagen, 1955.

LEBEDEV, Aleksandr. *The Itinerants*. Leningrad, 1974.

LINDQUIST-COCK, Elizabeth. *The Influence of Photography on American Landscape Painting, 1839-1880*. (Ph.D. dissertation, New York University.) Reprint, Garland Series. New York, 1977.

MARZIO, Peter C. "The Art Crusade: An Analysis of American Drawing Manuals, 1820-1860." *Smithsonian Studies in History and Technology, 34* (1976).

MATTHIESSEN, Francis Otto. *American Renaissance, Art and Expression in the Age of Emerson and Whitman*. London and New York, 1941.

MCCOUBREY, John, ed. *American Art, 1700-1960, Sources and Documents*. Englewood Cliffs, N.J., 1965.

MCSHINE, Kynaston, ed. *The Natural Paradise: Painting in America, 1800-1950*. (Exhibition catalogue. Museum of Modern Art.) New York, 1976. Essays by Barbara Novak, Robert Rosenblum, and John Wilmerding.

MILLER, Jo. *Drawings of the Hudson River School, 1825-1875*. (Exhibition catalogue. Brooklyn Museum.) Brooklyn, N.Y., 1970.

MILLER, Perry. *The Life of the Mind in America, From the Revolution to the Civil War*. New York, 1965.

MONK, Samuel H. *The Sublime*. Ann Arbor, Mich., 1960.

MOORE, James. "The Storm and the Harvest: The Image of Nature in Mid-Nineteenth Century American Landscape." Ph.D. dissertation, Indiana University, Bloomington, 1974.

NAEF, Weston J., and Wood, James N. *Era of Exploration: The Rise of Landscape Photography in America*. New York, 1974.

NEWHALL, Beaumont. *The History of Photography*. New York, 1964.

NOVAK, Barbara. "American Landscape: Changing Concepts of the Sublime." *The American Art Journal, 4*, no. 1 (Spring 1972): 36-42.

_____. "American Landscape and the Nationalist Garden and Holy Book." *Art in America, 60*, no. 1 (1972): 46-57.

_____. *American Painting of the Nineteenth Century: Realism, Idealism, and the American Experience*. New York, 1969.

_____. "Grand Opera and the Small Still Voice; American Landscape Painting." *Art in America, 59* (Mar. 1971): 64-73.

_____. "Influences and Affinities: The Interplay Between America and Europe in Landscape Paintings before 1860." In *The Shaping of Art and Architecture in Nineteenth-Century America*. New York, 1972.

_____. *Nature and Culture: American Landscape and Painting, 1825-1875*. New York, 1980.

NOVOUSPENSKY, Nikolai N. *Aivazovsky*. Leningrad, 1972.

O'GORMAN, James, and Wilmerding, John. *Portrait of a Place, Some American Landscape Painters in*

Gloucester. (Exhibition catalogue. Cape Ann Historical Association.) Gloucester, Mass., 1973.

PARRIS, Leslie. *Landscape in Britain, c. 1750-1850.* London, 1973.

Philadelphia: Three Centuries of American Art. (Exhibition catalogue. Philadelphia Museum of Art.) Philadelphia, 1976.

POULSEN, Vagn. *Danish Painting and Sculpture.* Translated by Sigurd Mammen. 2nd ed. Copenhagen, 1976.

RICHARDSON, Edgar. *Painting in America, From 1502 to the Present.* New York, 1965.

————, and Wittmann, Otto, Jr. *Travelers in Arcadia, American Artists in Italy, 1830-1875.* (Exhibition catalogue. Detroit Institute of Arts.) Detroit, Mich., 1951.

ROSENBLUM, Robert. *Modern Painting and the Northern Romantic Tradition.* London, 1975.

RUSKIN, John. *The Elements of Drawing; in Three Letters to Beginners.* London and New York, 1857.

SCHILLER, Friedrich. *On the Aesthetic Education of Man.* Translated, with introduction, by Reginald Snell. New York, 1955.

SHEPARD, Lewis A. *American Painters of the Arctic.* (Exhibition catalogue. Amherst College.) Amherst, Mass., 1975.

SMIRNOV, Gleb B. *Venetsianov and His School.* Leningrad, 1973.

STALEY, Allen. *The Pre-Raphaelite Landscape.* Oxford, 1973.

STEBBINS, Theodore E., Jr. *American Master Drawings and Watercolors. A History of Works on Paper from Colonial Times to the Present.* New York, 1976.

STEIN, Roger. *John Ruskin and Aesthetic Thought in America, 1840-1900.* Cambridge, Mass., 1967.

SWEENEY, J. Gray. *Themes in American Painting.*

(Exhibition catalogue. Grand Rapids Art Museum.) Grand Rapids, Mich., 1977.

SWEET, Frederick A. *The Hudson River School and the Early American Landscape Tradition.* Chicago, 1945.

TUCKERMAN, Henry A. *Book of the Artists, American Artist Life.* New York, 1867.

WEIR, John F. "American Landscape Painters." *New Englander, 32,* no. 122 (Jan. 1873): 140-151.

WILMERDING, John. *American Art.* London and New York, 1976.

————. *Audubon, Homer, Whistler, and 19th Century America.* New York, 1972.

————. *A History of American Marine Painting.* Boston and Salem, Mass., 1968.

————, ed. *The Genius of American Painting.* New York and London, 1973. Introduction, 13-23.

II ARTISTS

Allston, Washington
Georgetown, S. C., 1779—
Cambridgeport, Mass., 1843

ALLSTON, Washington. *Lectures on Art and Poems.* New York, 1850.

FLAGG, Jared B. *The Life and Letters of Washington Allston.* New York, 1892.

GERDTS, William, and Stebbins, Theodore E., Jr. *A Man of Genius: The Art of Washington Allston (1779-1843).* (Exhibition catalogue. Museum of Fine Arts, Boston.) Boston, 1979.

The Paintings of Washington Allston. (Exhibition catalogue. Lowe Art Museum.) Coral Gables, Fla., 1975.

RICHARDSON, Edgar P. *Washington Allston.* Apollo edition. New York, 1967.

Bierstadt, Albert
Solingen, Germany, 1830—New York, N.Y., 1902

Albert Bierstadt, 1830-1902. (Exhibition catalogue.

Santa Barbara Museum of Art.) Santa Barbara, Calif., 1964.

HENDRICKS, Gordon. *Albert Bierstadt.* (Exhibition catalogue. Whitney Museum of American Art.) New York, 1972.

————. *Albert Bierstadt, Painter of the American West.* New York, 1974.

LUDLOW, Fitz Hugh. *The Heart of the Continent: A Record of Travel Across the Plains and in Oregon, with an Examination of the American Principle.* New York, 1870.

TRUMP, Richard S. *Life and Works of Albert Bierstadt.* (Ph.D. dissertation, Ohio State University.) Reprint. Ann Arbor, Mich., 1965.

Bingham, George Caleb
near Charlottesville, Va., 1811—
Kansas City, Mo., 1879

BLOCH, E. Maurice. *The Drawings of George Caleb Bingham.* Columbia, Mo., 1975.

_____. *George Caleb Bingham.* (Exhibition catalogue. National Collection of Fine Arts.) Washington, D.C., 1967.

_____. *George Caleb Bingham, The Evolution of an Artist and A Catalogue Raisonné.* 2 vols. Berkeley and Los Angeles, 1967.

CHRIST-JANER, Albert. *George Caleb Bingham: Frontier Painter of Missouri.* New York, 1975.

_____. *George Caleb Bingham of Missouri.* New York, 1940.

MCCUE, George. *Bingham's Missouri.* (Exhibition catalogue. Nelson Gallery-Atkins Museum.) Kansas City, Mo., 1975.

MCDERMOTT, John F. *George Caleb Bingham.* Norman, Okla., 1959.

Blakelock, Ralph A.
New York, N.Y., 1847—Elizabethtown, N.Y., 1919

GEBHARD, David, and Stuurman, Phyllis. *The Enigma of Ralph A. Blakelock, 1847-1919.* (Exhibition catalogue. The Art Galleries, University of California.) Santa Barbara, Calif., 1969.

GESKE, Norman A. *Ralph Albert Blakelock, 1847-1919.* (Exhibition catalogue. Nebraska Art Association.) Lincoln, Nebraska, 1974.

Ralph Albert Blakelock Centenary Exhibition. (Exhibition catalogue. Whitney Museum of American Art.) New York, 1947.

YOUNG, J. W. *Catalogue of the Works of R. A. Blakelock, N.A. and of his Daughter Marian Blakelock.* (Exhibition catalogue. Young's Art Galleries.) Chicago, 1916.

Bradford, William
Fairhaven, Mass., 1823—New York, N.Y., 1892

BRADFORD, William. *The Arctic Regions. Illustrated with Photographs Taken on an Art Expedition to Greenland, with Descriptive Narrative by the Artist.* London, 1873.

WILMERDING, John. *William Bradford, 1823-1892, Artist of the Arctic: An Exhibition of his Paintings and Photographs.* (Exhibition catalogue. DeCordova Museum.) Lincoln, Mass., 1969.

Bricher, Alfred Thompson
Portsmouth, N.H., 1837—New Dorp, Staten Island, N.Y., 1908.

BROWN, Jeffrey R. *Alfred Thompson Bricher, 1837-1908.* (Exhibition catalogue. Indianapolis Museum of Art.) Indianapolis, Ind., 1973.

Church, Frederic Edwin
Hartford, Conn., 1826—New York, N.Y., 1900

BAYLEY, W. P. "Mr. Church's Pictures—Cotopaxi, Chimborazo and the Aurora Borealis." *Art Journal* (London), *17* (Sept. 1865): 265-267.

HANSON, Bernard. *Frederic Edwin Church: The Artist at Work.* (Exhibition catalogue. Joseloff Gallery, University of Hartford.) Hartford, Conn., 1974.

HUNTINGTON, David C. *Frederic Edwin Church.* (Exhibition catalogue. National Collection of Fine Arts.) Washington, D.C., 1966.

_____. "Frederic Edwin Church, 1826-1900: Painter of the Adamic New World Myth." Ph.D. dissertation, Yale University, New Haven, Conn., 1960.

_____. *The Landscapes of Frederic Edwin Church, Vision of an American Era.* New York, 1966.

NOBLE, Louis Legrand. *After Icebergs with a Painter, A Summer Voyage to Labrador and Around Newfoundland.* New York, 1861.

STEBBINS, Theodore E., Jr. *Close Observation: Selected Oil Sketches by Frederic E. Church.* (Exhibition catalogue. Cooper-Hewitt Museum of Decorative Arts and Design.) Washington, D.C., 1978.

WARNER, Charles Dudley. "Frederic Edwin Church." 1900. (Unpublished manuscript, copy on deposit at Olana.)

WINTHROP, Theodore. "The Heart of the Andes." In *Life in the Open Air and Other Papers.* Boston, 1863.

Cole, Thomas
Bolton-le-Moors, England, 1801—
Catskill, N.Y., 1848

MERRITT, Howard S. *Thomas Cole.* (Exhibition catalogue. Memorial Art Gallery of the University of Rochester.) Rochester, N.Y., 1969.

NOBLE, Louis Legrand. *The Course of Empire, Voyage of Life and Other Pictures of Thomas Cole, N.A.* New York, 1853.

_____. *The Life and Works of Thomas Cole.* John Harvard Library edition. Cambridge, Mass., 1964.

POWELL, Earl A. "English Influences in the Art of Thomas Cole (1801-1848)." Ph.D. dissertation, Harvard University, Cambridge, Mass., 1974.

_____. "Thomas Cole and the American Landscape Tradition." *Arts Magazine, 52*, no. 6 (Feb. 1978): 114-123; no. 7 (Mar. 1978): 110-117; no. 8 (Apr. 1978): 113-117.

SEAVER, Esther Isabel. *Thomas Cole, 1801-1848, One Hundred Years Later.* (Exhibition catalogue. Wadsworth Atheneum.) Hartford, Conn., 1948.

WALLACH, Allan Peter. "The Ideal American Artist and the Dissenting Tradition: A Study of Thomas Cole's Popular Reputation." Ph.D. dissertation, Columbia University, New York, 1973.

Cropsey, Jasper Francis

Rossville, N.Y., 1823—
Hastings-on-Hudson, N.Y., 1900

BERMINGHAM, Peter. *Jasper F. Cropsey, 1823-1900, Retrospective View of America's Painter of Autumn.* (Exhibition catalogue. University of Maryland Art Gallery.) College Park, Md., 1968.

TALBOT, William S. *Jasper F. Cropsey, 1823-1900.* (Exhibition catalogue. National Collection of Fine Arts.) Washington, D.C., 1970.

_____. "Jasper F. Cropsey, 1823-1900." Ph.D. dissertation, New York University, New York, 1977.

Durand, Asher Brown

Jefferson Village, N.J., 1796—
Jefferson Village, N.J., 1886.

DURAND, John. *The Life and Times of Asher B. Durand.* New York, 1894.

Detail, fig. 89

LAWALL, David B. *A. B. Durand, 1796-1886.* (Exhibition catalogue. Montclair Art Museum.) Montclair, N.J., 1971.

_____. *Asher B. Durand: A Documentary Catalogue of the Narrative and Landscape Paintings.* New York, 1978.

_____. *Asher Brown Durand: His Art and Art Theory in Relation to His Times.* (Ph.D. dissertation, Princeton University.) Reprint, Garland Series. New York, 1978.

Eakins, Thomas

Philadelphia, Pa., 1844—Philadelphia, Pa., 1916

CASTERAS, Susan. *Susan Macdowell Eakins, 1851-1938.* (Exhibition catalogue. Pennsylvania Academy of the Fine Arts.) Philadelphia, 1973.

DOMIT, Moussa M. *The Sculpture of Thomas Eakins.* (Exhibition catalogue. Corcoran Gallery of Art.) Washington, D.C., 1969.

GOODRICH, Lloyd. *Thomas Eakins.* New York, 1933.

_____. *Thomas Eakins.* (Exhibition catalogue. Whitney Museum of American Art.) New York, 1970.

_____. *Thomas Eakins, A Retrospective Exhibition.* (Exhibition catalogue, National Collection of Fine Arts.) Washington, D.C., 1961.

HENDRICKS, Gordon. *The Life and Work of Thomas Eakins.* New York, 1972.

_____. *The Photographs of Thomas Eakins.* New York, 1972.

_____. *Thomas Eakins: His Photographic Works.* (Exhibition catalogue. Pennsylvania Academy of the Fine Arts.) Philadelphia, Pa., 1969.

HOOPES, Donelson F. *Eakins Watercolors.* New York, 1971.

MCHENRY, Margaret. *Thomas Eakins Who Painted.* New York, 1946.

PORTER, Fairfield. *Thomas Eakins.* New York, 1959.

ROSENZWEIG, Phyllis. *Thomas Eakins in the Hirshhorn Museum Collection.* (Catalogue of the collection.) Washington, D.C., 1977.

SCHENDLER, Sylvan. *Eakins.* Boston, 1967.

SIEGL, Theodor. *The Thomas Eakins Collection.* (Catalogue of the collection of the Philadelphia Museum of Art.) Philadelphia, 1978.

Gifford, Sanford Robinson
Greenfield, N.Y., 1823—New York, N.Y., 1880

CIKOVSKY, Nicolai, Jr. *Sanford Robinson Gifford.* (Exhibition catalogue. University of Texas Art Museum.) Austin, Texas, 1970.

Gifford Memorial Meeting of the Century. The Century Association. New York, 1880.

WEISS, Ila. *Sanford Robinson Gifford.* (Ph.D. dissertation, Columbia University.) Reprint, Garland Series. New York, 1977.

Hamilton, James
Entrien, Ireland, 1819—San Francisco, Calif., 1878

JACOBOWITZ, Arlene. *James Hamilton, 1819-1878, American Marine Painter.* (Exhibition catalogue. Brooklyn Museum.) Brooklyn, N.Y., 1966.

Haseltine, William Stanley
Philadelphia, Pa., 1835—Rome, Italy, 1900

PLOWDEN, Helen Haseltine. *William Stanley Haseltine, Sea and Landscape Painter (1835-1900).* London, 1947.

Heade, Martin Johnson
Lumberville, Pa., 1819—St. Augustine, Fla., 1904

MCINTYRE, Robert G. *Martin Johnson Heade.* New York, 1948.

STEBBINS, Theodore E., Jr. *The Life and Works of Martin Johnson Heade.* New Haven and London, 1975.

_____. *Martin Johnson Heade.* (Exhibition catalogue. Whitney Museum of American Art.) New York, 1969.

Hillers, John K.
Hanover, Germany, 1843—Washington, D.C., 1925

DELLENBAUGH, Frederick S. *A Canyon Voyage.* New Haven, Conn., 1926.

FOWLER, Don D., ed. *"Photographed all the Best Scenery," Jack Hillers's Diary of the Powell Expeditions, 1871-1875.* Salt Lake City, 1972.

KELLY, Charles, ed. "Journal of W. C. Powell, April 21, 1871-December 7, 1872." *Utah Historical Quarterly, 16-17* (1948-1949): 472-473.

STEWARD, Julian H. "Notes on Hillers' Photographs of the Paiute and Ute Indians Taken on the Powell Expedition of 1873." *Smithsonian Miscellaneous Collections, 98,* no. 18 (1939).

Homer, Winslow
Boston, Mass., 1836—Prout's Neck, Maine, 1910

BEAM, Philip. *Winslow Homer at Prout's Neck.* Boston, 1968.

DAVIS, Melinda D. *Winslow Homer: An Annotated Bibliography of Periodical Literature.* Metuchen, N.J., 1975.

DOWNES, William Howe. *The Life and Works of Winslow Homer.* Boston and New York, 1911.

FLEXNER, James Thomas, and the Editors of Time-Life Books. *The World of Winslow Homer, 1836-1910.* New York, 1966.

GARDNER, Albert Ten Eyck. *Winslow Homer, American Artist: His World and His Work.* New York, 1961.

GOODRICH, Lloyd. *The Graphic Art of Winslow Homer.* (Exhibition catalogue. Whitney Museum of American Art.) New York, 1968.

Detail, fig. 77

_____. *Winslow Homer*. New York, 1945.

_____. *Winslow Homer*. New York, 1959.

_____. *Winslow Homer*. (Exhibition catalogue. Whitney Museum of American Art.) New York, 1973.

_____. *Winslow Homer's America*. New York, 1969.

GROSSMAN, Julian. *The Echo of a Distant Drum: Winslow Homer and the Civil War*. New York, 1974.

HANNAWAY, Patti. *Winslow Homer in the Tropics*. Richmond, Va., 1973.

HENDRICKS, Gordon. *The Life and Works of Winslow Homer*. New York, 1979.

HOOPES, Donelson F. *Winslow Homer Watercolors*. New York, 1969.

WILMERDING, John. *Winslow Homer*. New York, 1972.

Inness, George
Newburgh, N.Y., 1825—Bridge of Allan, Scotland, 1894

CIKOVSKY, Nicolai, Jr. *George Inness*. New York, 1971.

_____. *The Paintings of George Inness*. (Exhibition catalogue. University of Texas.) Austin, 1965.

DAINGERFIELD, Elliott. *George Inness: The Man and His Art*. New York, 1911.

INNESS, George, Jr. *The Life, Art and Letters of George Inness*. New York, 1917.

IRELAND, LeRoy. *The Work of George Inness, An Illustrated Catalogue Raisonné*. Austin and London, 1965.

WERNER, Alfred. *Inness Landscapes*. New York, 1973.

Jackson, William Henry
Keesville, N.Y., 1843—New York, N.Y., 1942

JACKSON, Clarence S. *Picture Maker of the Old West, William H. Jackson*. New York, 1947.

JACKSON, William Henry. "Field Work." *Philadelphia Photographer*, 12 (1875): 91.

_____. *Time Exposure, the Autobiography of William Henry Jackson*. New York, 1940.

_____, and Driggs, Howard R. *The Pioneer Photographer*. New York, 1929.

NEWHALL, Beaumont, and Edkins, Diana. *William H. Jackson*. New York and Fort Worth, 1974.

Johnson, Eastman
Lowell, Maine, 1824—New York, N.Y., 1906

BAUR, John I. H. *Eastman Johnson, 1824-1906. An American Genre Painter*. (Exhibition catalogue. Brooklyn Museum.) Brooklyn, N.Y., 1940. Reprint. New York, 1969.

CROSBY, Everett U. *Eastman Johnson at Nantucket*. Nantucket, Mass., 1944.

HILLS, Patricia. *Eastman Johnson*. (Exhibition catalogue. Whitney Museum of American Art.) New York, 1972.

_____. *The Genre Painting of Eastman Johnson: The Sources and Development of His Style and Themes*. (Ph.D. dissertation, New York University.) Reprint, Garland Series. New York, 1977.

Kennedy, David Johnston
Port Mullin, Scotland, 1816/17—Philadelphia, Pa., 1898

"The David J. Kennedy Collection." *Pennsylvania Magazine of History and Biography*, 60, no. 1 (1936): 71.

KENNEDY, D. J. "Autobiography." (Unpublished manuscript, deposited at the Museum of Fine Arts, Boston.)

Philadelphia: Three Centuries of American Art. (Exhibition catalogue. Philadelphia Museum of Art.) Philadelphia, 1976. 373-374.

Kensett, John F.
Cheshire, Conn., 1816—New York, N.Y., 1872

DRISCOLL, John Paul. *John F. Kensett Drawings*. (Exhibition catalogue. Museum of Art, Pennsylvania State University, and Babcock Galleries, N.Y.) University Park, Pa., 1978.

HOWAT, John K. *John Frederick Kensett, 1816-1872*. (Exhibition catalogue. American Federation of Arts.) New York, 1968.

JOHNSON, Ellen. "Kensett Revisited." *The Art Quarterly*, 20, no. 1 (Spring 1957): 71-92.

SIEGFRIED, Joan C. *John Frederick Kensett, A Retrospective Exhibition*. (Exhibition catalogue. Hathorn Gallery, Skidmore College.) Saratoga Springs, N.Y., 1967.

Lane, Fitz Hugh
Gloucester, Mass., 1804—Gloucester, Mass., 1865

Paintings and Drawings by Fitz Hugh Lane at the Cape Ann Historical Association. (Catalogue of the collection.) Gloucester, Mass., 1974.

WILMERDING, John. *Fitz Hugh Lane*. New York, 1971.

Detail, fig. 152

_____. *Fitz Hugh Lane, 1804-1865, American Marine Painter.* Salem, Mass., 1964.

_____. *Fitz Hugh Lane, the First Major Exhibition.* (Exhibition catalogue. DeCordova Museum.) Lincoln, Mass., 1966.

_____. *Paintings by Fitz Hugh Lane.* (Exhibition catalogue. Farnsworth Art Museum.) Rockland, Maine, 1974.

Martin, Homer Dodge
Albany, N.Y., 1836—St. Paul, Minn., 1897

MARTIN, Elizabeth. *Homer Dodge Martin, A Reminiscence.* New York, 1904.

MATHER, Frank Jewett. *Homer Martin, Poet in a Landscape.* New York, 1912.

Mount, William Sidney
Setauket, Long Island, N.Y., 1807—Setauket, Long Island, N.Y., 1868

COWDREY, Mary Bartlett, and Williams, Hermann Warner, Jr. *William Sidney Mount, 1807-1868, An American Painter.* New York, 1944.

Drawings and Sketches by William Sidney Mount, 1807-1868, in the Collections of the Suffolk Museum and Carriage House at Stony Brook, Long Island, N.Y. Stony Brook, N.Y., 1974.

FRANKENSTEIN, Alfred. *Painter of Rural America. William Sidney Mount, 1807-1868.* (Exhibition catalogue. National Gallery of Art.) Washington, D.C., 1969.

_____. *William Sidney Mount.* New York, 1975.

Muybridge, Eadweard
Kingston-on-Thames, England, 1830—Kingston-on-Thames, England, 1904

BROWN, Lewis S., ed. *Animals in Motion.* New York, 1957.

HAAS, Robert Bartlett. *Muybridge Man in Motion.* Berkeley, 1976.

HENDRICKS, Gordon. *Eadweard Muybridge, The Father of the Motion Picture.* New York, 1975.

HOOD, Mary V. Jessup, and Haas, Robert Bartlett. "Eadweard Muybridge's Yosemite Valley Photographs, 1867-1872." *California Historical Society Quarterly, 52,* no. 1 (Mar. 1963): 5-26.

MACDONNELL, Kevin. *Eadweard Muybridge. The Man Who Invented the Moving Picture.* Boston, 1972.

MOZLEY, Anita V., et al. *Eadweard Muybridge: The Stanford Years, 1872-1882.* (Exhibition catalogue. Stanford University Museum of Art.) Stanford, Calif., 1972.

MUYBRIDGE, Eadweard. *Animal Locomotion.* Philadelphia, 1887.

O'Sullivan, Timothy
New York, N.Y., c. 1840—Staten Island, N.Y., 1882

HORAN, James David. *Timothy O'Sullivan, America's Forgotten Photographer.* New York, 1966.

NEWHALL, Beaumont, and Newhall, Nancy. *Timothy H. O'Sullivan, Photographer.* New York, 1966.

Rand, Henry L.
Dedham, Mass., 1862—
Southwest Harbor, Maine, 1945

Bar Harbor (Maine) *Times*, May 31, 1945. Obituary.

Richards, Frederick DeBourg
Wilmington, Del., 1822—?, 1903

Philadelphia: Three Centuries of American Art. (Exhibition catalogue. Philadelphia Museum of Art.) Philadelphia, 1976. 363-364.

Richards, William Trost
Philadelphia, Pa., 1833—Newport, R.I., 1905

FERBER, Linda. *William Trost Richards, American Landscape and Marine Painter, 1833-1905.* (Exhibition catalogue. Brooklyn Museum.) Brooklyn, N.Y., 1973.

_____. *William T. Richards (1833-1905): American Landscape and Marine Painter.* (Ph.D. dissertation, Columbia University.) Reprint, Garland Series. New York, 1979.

He Knew the Sea. (Exhibition catalogue. New Britain Museum of American Art.) New Britain, Conn., 1973.

Russell, Andrew Joseph
Nunda, N.Y., 1830—Brooklyn, N.Y., 1902

RUSSELL, Andrew J. *The Great West Illustrated in a Series of Photographic Views Across the Continent: Taken Along the Line of the Union Pacific Railroad, West from Omaha, Nebraska.* New York, 1869.

_____. "On the Mountains with the Tripod and Camera." *Anthony's Photographic Bulletin, 1* (1870): 35.

Salmon, Robert
Whitehaven, England, 1775—
Boston, Mass., c. 1845

WILMERDING, John. *Robert Salmon, The First Major Exhibition.* (Exhibition catalogue. DeCordova Museum.) Lincoln, Mass., 1967.

_____. *Robert Salmon, Painter of Ship and Shore.* Boston and Salem, Mass., 1971.

Shattuck, Aaron Draper
Francestown, N.H., 1832—Granby, Conn., 1928

FERGUSON, Charles B. *Aaron Draper Shattuck, N.A., 1832-1928.* (Exhibition catalogue. New Britain Museum of American Art.) New Britain, Conn., 1970.

Stoddard, Seneca Ray
Wilton, N.Y., 1844—Glens Falls, N.Y., 1917

DE SORMO, Maitland C. *Seneca Ray Stoddard, Versatile Camera-Artist.* Saranac Lake, N.Y., 1972.

STODDARD, Seneca Ray. *Lake George: A Book of To-Day.* Albany, N.Y., 1873.

_____. *Old Times in the Adirondacks, The Narrative of a Trip into the Wilderness in 1873.* Edited by Maitland De Sormo. Saranac Lake, N.Y., 1971.

Suydam, James Augustus
New York, N.Y., 1819—North Conway, N.H., 1865

BAUR, John I. H. "A Tonal Realist: James Suydam." *The Art Quarterly, 13,* no. 3 (Summer 1950): 221-227.

Watkins, Carleton
New York, N.Y., 1829—Napa, Calif., 1916

ANDERSON, Ralph H. "Carleton E. Watkins, Pioneer Photographer of the Pacific Coast." *Yosemite Nature Notes, 32* (Apr. 1953): 34-39.

California History. Special Issue Carleton Watkins, 55 (Fall 1978).

COPLANS, John. "Carleton Watkins and Yosemite." (Exhibition brochure, Daniel Wolf, Inc.) New York, 1978. Reprinted as "C. E. Watkins at Yosemite." *Art in America*, Nov.-Dec. 1978, 100-108.

HICKMAN, Paul. "Carleton E. Watkins: 1829-1916." *Northlight, 1* (Jan. 1977). Entire issue on Watkins.

TURRILL, Charles B. "An Early California Photographer: C. E. Watkins." *News Notes of California Libraries, 13* (1918): 32.

Whistler, James A. McNeill
Lowell, Mass., 1834—London, England, 1903

GETSCHER, Robert H. *The Stamp of Whistler.* (Exhibition catalogue. Allen Memorial Art Museum.) Oberlin, Ohio, 1977.

PENNELL, Elizabeth R., and Pennell, Joseph. *The Life of James McNeill Whistler.* 2 vols. London and Philadelphia, 1908.

PRIDEAUX, Tom, and the Editors of Time-Life Books. *The World of Whistler, 1834-1903.* New York, 1970.

SUTTON, Denys. *James McNeill Whistler, Paintings, Etchings, Pastels, & Watercolours.* London, 1966.

_____. *Nocturne: The Art of James McNeill Whistler*. London, 1963.

WEINTRAUB, Stanley. *Whistler, A Biography*. New York, 1974.

WHISTLER, James McNeill. *The Gentle Art of Making Enemies*. London and New York, 1890. Reprint. 1943.

_____. *Ten O'Clock*, Portland, Maine, 1916.

YOUNG, Andrew McLaren. *James McNeill Whistler*. (Exhibition catalogue. M. Knoedler & Co.) New York, 1960.

Whittredge, Thomas Worthington
Springfield, Ohio, 1820—Summit, N.J., 1910

BAUR, John I. H., ed. *The Autobiography of Worthington Whittredge*. Reprint. New York, 1969.

DWIGHT, Edward H. *Worthington Whittredge (1820-1910), A Retrospective Exhibition of an American Artist*. (Exhibition catalogue. Munson-Williams-Proctor Institute.) Utica, N.Y., 1969.

Woodbridge, Louise Deshong
Chester, Pa., 1848—Chester, Pa., 1925

Chester (Pa.) *Times*, Oct. 31 and Nov. 5, 1925.

Detail, fig. 330

Index

328